The
EMPRESS
of ART

The
EMPRESS
of ART

CATHERINE THE GREAT AND THE
TRANSFORMATION OF RUSSIA

SUSAN JAQUES

PEGASUS BOOKS
NEW YORK LONDON

THE EMPRESS OF ART

Pegasus Books LLC
80 Broad Street, 5th Floor
New York, NY 10004

Copyright © 2016 by Susan Jaques

First Pegasus Books cloth edition April 2016

Interior design by Maria Fernandez

Library of Congress Cataloging-in-Publication Data is available.

ISBN: 978-1-60598-972-3

10 9 8 7 6 5 4 3 2 1

Printed in the United States of America
Distributed by W. W. Norton & Company

For Carlene Jaques
in loving memory

CONTENTS

INTRODUCTION

C atherine the Great is one of history's most compelling figures: a tenacious German princess who seized Russia's throne from her husband just days before his "accidental" strangulation. Inspired initially by the progressive ideas of the French Enlightenment, Catherine II went on to rule her adopted country for thirty-four years in a less-than-enlightened fashion—crushing the Turks, peasant rebellions, and any other Romanovs with claims to the throne. Outwitting her political rivals, she transformed Russia from a northern backwater to global superpower, snatching large parts of Poland and annexing the strategic Crimea Peninsula—the basis for Vladimir Putin's recent land grab. Styling herself heir to her illustrious grandfather-in-law, Peter the Great, she Westernized Russia while celebrating its language, religion, and history.

Catherine shocked contemporaries with her sexually liberated lifestyle—from extramarital affairs and illegitimate children to a string of official favorites. "God grant us our desires, and grant them speedily" was her favorite toast, a reference to her cougar-like appetite for handsome young men. With enough power, intrigue, and passion for several lifetimes, Catherine II has been the subject of numerous biographies. Volumes of what she called her "scribbling"—including three memoirs and correspondence with

philosophers, art advisers, and favorites—have given historians plenty of material to work with. Writing in French, German, and Russian, Catherine reveals public and private personas often at odds—at once imposing and down-to-earth, extravagant and hardworking, sensual and prudish, witty and emotionally needy.

Focused on Catherine's brazen imperialism and sensational private life, historians have paid less attention to her *other* passion—arguably her most lasting legacy and the area in which she triumphed as an enlightened ruler. Catherine the Great was one of history's greatest patrons of art and architecture, both in scale and quality. Under her patronage, Russia experienced a cultural renaissance the likes of which Europe hadn't seen since the reign of England's Charles I. Her unprecedented spending spree brought thousands of Old Master paintings, sculptures, furniture, silver, porcelain, and engraved gems to Russia. She left her adopted country the world-class Hermitage Museum and transformed Russia's swampy capital into a sophisticated cultural center.

From the start, Catherine mobilized art and architecture to legitimize her shaky claim to rule and reinvent herself as Russia's enlightened ruler. Knowing that paintings were synonymous with power, Catherine quickly amassed a collection of the stature that had taken France, Austria, and Saxony's royal houses centuries to assemble. By snatching up entire collections once owned by Europe's rich and powerful, she declared Russia's ascending wealth and prestige. To enhance her court's cachet, Catherine entertained frequently and lavishly. If the French court was dining on Roettiers silver and Sèvres porcelain at Versailles, she would set an even more magnificent table for her guests at the Winter Palace.

As G. N. Komelova writes, "Her absolute power allowed her to use the arts and architecture as a weapon of state policy, for self-glorification and self-assertion. Indeed her patronage of the arts was crucial to fostering her image as an enlightened monarch."[1] Catherine herself contributed to the view that her collecting was purely political. Early on, she described her collecting compulsion: "It's not for the love of art, but for voracity. I'm not a connoisseur, I'm a glutton."[2] The empress agreed with Austria's Prince de Ligne that she had mediocre taste and "no conception of either painting or music."[3]

In fact, Catherine applied the same energy and ambition to art and architecture that she did to governing. The "glutton" soon bought Ligne's art collection. She read widely on art and architecture, collected engravings and drawings, and even produced her own architectural drawings. An armchair traveler, Catherine turned to her exquisite albums of prints and engravings for inspiration—from an exact replica of Raphael's Vatican Loggia for the Winter Palace to Josiah Wedgwood's "Green Frog Service" decorated with hundreds of views of England. Combining her knowledge of antiquity and passion for engraved gems, Catherine ordered the extraordinary Sèvres Cameo Service with mythological and historical scenes. Before long, Catherine was offering advice to her talented art scouts.

Catherine's collecting debut came in 1764, the same year she placed her former lover, Stanislaus Poniatowski, on Poland's throne. Motivated more by revenge than connoisseurship, she plucked up a paintings collection earmarked for Prussia's Frederick the Great. Though the works turned out to be mixed in quality, their arrival in St. Petersburg inspired Catherine to launch an imperial picture gallery. Impatient for masterworks, Catherine set her agents loose in the auction houses of Paris, Berlin, and Amsterdam—connoisseurs like Russian diplomat Dmitry Golitsyn, Denis Diderot, and Frederic Melchior Grimm. In addition to buying Old Masters, Catherine's scouts commissioned contemporary artworks on her behalf—from Jean-Antoine Houdon's sculptures of Voltaire and history paintings by Sir Joshua Reynolds to neoclassical pictures by Anton Raphael Mengs and Angelica Kauffman.

Catherine collected on a scale so shocking that England and France issued laws forbidding the export of large quantities of art. For more than three decades, she pursued art as a form of diplomatic warfare using the same cunning tactics and surprise attacks of her military. An opportunist, she exploited the misfortunes of others—including those of political rivals Frederick the Great and the Duc de Choiseul, France's anti-Russian war minister. By targeting the cash-strapped heirs of celebrated private collectors, Catherine amassed the prestigious collections of "Saxon Richelieu" Heinrich von Brühl, France's treasurer Pierre Crozat, and England's longest-serving prime minister, Sir Robert Walpole.

Adding to Europe's anxiety, Catherine was snatching up its art treasures at the same time she was grabbing territory. Two wars against the Ottoman Empire in 1768–74 and 1787–92, and the annexation of the Crimean Peninsula in 1783 gave Russia a foothold in southeastern Europe and the northern shores of the Black Sea. Three partitions of Poland added another 185,000 square miles to Catherine's empire, including much of Ukraine, Belarus, and Lithuania, and increased Russia's population from 23 to 37 million. Russia became a global naval and commercial power and Catherine found herself running one of the world's wealthiest empires.

As she did with art, Catherine used architecture to increase Russia's prestige. She began by constructing granite quays on the Neva's mud-clogged banks. "Building is a devilish affair," Catherine confided to her Paris-based agent Melchior Grimm. "It eats money and the more one builds, the more one wants to go on; it is an illness like drunkenness."[4] To display her growing artworks in stylish fashion, Catherine added the Small and Large Hermitages to the Winter Palace.

The years between 1775 and 1787 mark a period of peace for Russia and the height of Catherine's extraordinary building binge. To reinvent Russia's image, she established a building commission and personally reviewed and approved some 300 projects. With an innate sense for trends, Catherine championed neoclassicism, a movement inspired by the discovery and excavations of the ancient cities of Pompeii and Herculaneum. To Catherine, neoclassicism was refined, elegant, virtuous, and monumental—the opposite of the ornate baroque and rococo styles of her predecessors. Thanks to her sponsorship and influence as a tastemaker, classical buildings soon lined the Neva.

Neoclassicism was also the perfect complement to Catherine's political ambitions. She saw herself as protector of the Byzantine heritage and a champion of antiquity, responsible for the continuance of the artistic ideals of the ancient Greeks. The ultimate aim of her two wars with the Turks was the "Greek Project"—an unrealized plan to drive the Turks from Constantinople and resurrect a Greek Christian empire on the Mediterranean. A sense of belonging to European culture inspired Catherine's fascination with the ancient world—one she recreated in numerous buildings and monuments.

To achieve her goal, Catherine imported European architects who created a style known as Russian Classicism. Among the most talented was Italian Giacomo Quarenghi, who created many of her most beautiful buildings. These include the Neva suite of staterooms at the Winter Palace, the Hermitage Theatre and the Raphael Loggia, and the Alexander Palace, Catherine's wedding gift for her grandson. Superbly generous with her favorites, Catherine also commissioned the Marble Palace and Gatchina for Gregory Orlov, and Tauride Palace for Gregory Potemkin. After the deaths of many of her lovers, Catherine bought back her extravagant gifts from their heirs—from palaces and paintings to porcelain and silver.

At Tsarskoe Selo, the Romanov's summer retreat south of St. Petersburg, Catherine hired Scottish architect Charles Cameron to redo her private apartments inside Catherine Palace (named for Peter the Great's second wife, Catherine I). Adjacent to the vast palace, Cameron added the Agate Pavilion, a luxurious spa complex with ground floor baths and an upstairs suite of richly furnished rooms lined in jasper and amber. Nearby, busts of Greek and Roman notables decorated the Cameron Gallery, where Catherine enjoyed views of her park—including a lake representing the Black Sea and a replica of Constantinople.

Catherine filled her new palaces with decorative art from the most prestigious foreign artisans. Though the empress disliked the French monarchy for interfering with her political ambitions, she was a Francophile when it came to Gobelins tapestries, Sèvres porcelain, Roettiers silver, and Auguste gold. Hundreds of pieces of masterly furniture arrived from the workshop of celebrated German craftsman David Roentgen. Catherine also kept St. Petersburg's jewelers busy—from the imperial regalia and diamond-studded snuffboxes to gems to decorate her military dress uniforms. Of all her collections, Catherine was most smitten with carved gems. Contracting what she called "cameo fever," Catherine amassed some 10,000 antique and Renaissance cameos and intaglios, one of the world's finest collections.

Art collecting, begun as a shrewd political calculation, grew into a passion. Catherine was still collecting at the end of her life, taking advantage of the flooded art market caused by the French Revolution. When she died in 1796, Russia's imperial art collection boasted some 4,000 Old Master paintings, 10,000 drawings, 10,000 engraved gems, and thousands of decorative

objects. Catherine's successors tried to follow in her very large footsteps. While the 19th century saw continued growth for art and architecture in Russia, the 20th century proved catastrophic.

The nationalization of private and imperial art collections following the 1917 Revolution added to the Hermitage's vast holdings. But by the late 1920s, the cash-strapped Soviet government raided the museum. In just under five years, over 24,000 pieces were sold overseas, including Fabergé eggs, crown jewels, porcelain, sculptures, and paintings. Among these treasures were many of Catherine's paintings. Fifty masterpieces vanished from the Hermitage. Twenty-one of these landed at the National Gallery of Art in Washington, D.C., secretly acquired from the Soviets by U.S. Secretary of the Treasury Andrew Mellon.

The opening of the National Gallery in 1941 coincided with the start of the Nazi's 900-day Siege of Leningrad, one of history's deadliest occupations. Among the many efforts to preserve Russia's cultural heritage was the evacuation of Hermitage treasures to the Urals and the battle to save the historic ensemble of buildings. After World War II, the tables were turned and the Soviets looted art in Germany. Since then, Russia has spent decades restoring many of Catherine's damaged palaces.

Despite the trauma and losses of the last century, St. Petersburg and the State Hermitage Museum continue to embody Catherine's extraordinary patronage. The empress would surely have been pleased by the three million-plus visitors from around the world who poured through her museum in 2014, the 250th anniversary of her first paintings acquisition from Berlin.

Fate may have brought Catherine to Russia, but as she noted in her memoirs, "Fortune is not as blind as people imagine. It is often the result of a long series of precise and self-chosen steps. . . ." Here, then, is the story of her remarkable artistic journey.

PART ONE

EXTREME MAKEOVER

CHAPTER ONE

This Heavy Thing

On Sunday, September 22, 1762, Catherine II emerged from her apartments at Moscow's Kremlin to a fanfare of trumpets. She wore a luxurious silver silk brocade gown embroidered in gold with double-headed eagles, trimmed with lace sleeves and bertha around the low neckline. Matching silver silk heels peeked from beneath the gown's gold-braided hem. Seven gentlemen-in-waiting followed behind her, maneuvering the long velvet train. As her confessor sprinkled the path before her with holy water, Catherine made her way from Krasnoye Kryltso, the beautiful red porch of the Palace of Facets, to the Cathedral of the Assumption, where she had married eighteen years earlier.

In just three months since seizing power from her husband, Catherine had organized the most extravagant coronation money could buy. For the 33-year-old widow, the event marked the launch of a public relations blitz designed to transform her public image from obscure German princess to "Empress and Autocrat of All the Russias." Catherine spared no expense

for the elaborate eight-day spectacle, turning Moscow into a giant stage set with triumphal arches, illuminations, and deafening cannonades. Catherine's likeness—painted by the best Russian and European artists—appeared throughout the streets of the city. Waiting in the wings was Catherine's lover Gregory Orlov, a handsome hero of the Seven Years' War and father of her six-month-old son, Alexei.

While Catherine's coup d'état certainly raised considerable concern abroad, it did not cause much of an uproar at home, where power grabs were standard fare among the Romanovs. Celebrated French philosopher Voltaire called Peter III's murder a "trifle" and "family matters in which I do not interfere."[1] Peter III's grandfather Peter the Great banished his first wife, Eudoxia, to a nunnery, so he could marry his Lithuanian mistress, Martha Skavronskaya, the future Catherine I. When his eldest son, Grand Duke Alexei, sided with his mother, Peter I had him tried for treason, tortured, and executed.

Foolishly, Peter III chose to forgo a coronation. Catherine would not make the same mistake. New treasures glimmered in the intimate icon-filled royal chapel. Treated like sacred objects, the imperial regalia—crown, scepter, and orb—could only be touched by Catherine and the high priest. For her investiture, Catherine donned the ermine imperial mantle decorated with a diamond-studded blue saltire—the insignia of the Order of St. Andrew the First Called, the highest Russian order of chivalry. Founded by Peter the Great, the order was named for Russia's patron saint, whom Jesus had called first to be a disciple, and who was later martyred on an X-shaped cross.

The late Empress Elizabeth's lover, Alexei Razumovsky, approached the throne carrying a gold silk cushion with the imperial crown. In the tradition of Byzantine emperors before her and Napoleon fifty years later, Catherine placed the crown on her own auburn head. Catherine stood before the diamond- and ruby-studded throne holding the imperial scepter in her right hand and the orb in her left. The scepter had been hurriedly made two weeks earlier when it was discovered the old one had gone missing. The orb, a long-standing emblem of sovereignty in the Eastern Empire, was also new. A gleaming hollow ball of red gold, the orb was encircled with two rows of diamonds and topped by a large sapphire and cross. But the pièce de résistance was Catherine's crown.

For his coronation as emperor in 1730, Peter the Great replaced his predecessor's 14th-century sable-trimmed Cap of Monomakh with a crown, linking Russia to the West. Following his lead, Peter's niece and daughter, Empresses Anna and Elizabeth, chose their own Western-style crowns. Determined to make a powerful personal statement, Catherine placed a rush order for her own new crown with court jeweler Jérémie Pauzié. The quintessential St. Petersburg goldsmith, Pauzié had earned Empress Elizabeth's favor with stunning combinations of precious gems and decorative stones. It was Pauzié's new benefactress who gave him the commission of a lifetime.

Catherine delegated the project to her cultivated chamberlain, Ivan Betzkoy. The illegitimate son of Russian Field Marshal Prince Ivan Trubetskoy and his Swedish mistress, Betzkoy had been promoted to General Major by Empress Elizabeth for helping her seize power. When Elizabeth asked Betzkoy to attend Catherine's mother, Johanna Elizabeth of Holstein, whom he'd known for two decades, rumors swirled that Catherine was actually Betzkoy's daughter. One of the few people who enjoyed unlimited access to Catherine on a daily basis for most of her reign, Betzkoy was her unofficial education minister; founding president of the Imperial Academy of Arts; and head of the Diamond Workshop, the Peterhof Grinding Mill, and Siberian gem mining.

Princess Ekaterina Dashkova, Catherine's closest female friend, describes in her memoirs how Betzkoy came to oversee the prestigious commission. When Betzkoy asked Catherine to whom she owed her throne, she replied, "the Almighty and the vote of my subjects." To which Betzkoy replied, "I am the most unfortunate of men . . . if you do not recognize in me the one person who has gained the crown for you. Didn't I incite the Guards for rebellion? Didn't I lavish money on the populace?" ". . . Since I owe you my crown," replied Catherine, "what person but you can I entrust with its preparation for the coronation? Therefore, I rely on your good management in this matter and put all the diamond-cutters of my empire under your supervision."[2]

Jérémie Pauzié, one of Russia's most celebrated diamond cutters, took his inspiration from ancient Byzantium. Two gold and silver half spheres represented the eastern and western empires of Rome. Five thousand large

and small diamonds adorned the entire surface in a spectacular pattern of laurel wreaths, oak leaves, and acorns, symbolizing the temporal power of the monarchy. To outline the edges of the miters, Pauzié added two rows of gleaming large white pearls, seventy-five in all. The arch between the spheres was topped with a nearly 400-carat ruby red spinel (reported to be the world's second largest), framed with diamonds, and capped with a diamond cross.

The spinel had been acquired nearly a century earlier in Peking (Beijing) by Nicholas Spafary, Russia's envoy to China. After much bargaining, the diplomat bought the enormous stone in 1676 for the high price of 2,672 rubles. Under Betzkoy's watch, the precious spinel appears to have been removed from Empress Anna's crown and placed atop Catherine's. The empty spot on Anna's crown was quickly filled by a large red tourmaline, a gift from Alexander Menshikov to Catherine I, his beautiful former mistress and Peter the Great's second wife.

Jérémie Pauzié details the plum commission in his memoirs: "A few days after having ascended to the throne, Her Majesty summonsed me to tell me that she had instructed her chamberlain, Monsieur de Betsky, to inspect the treasuries of the court. Her Majesty asked me to melt down everything that no longer seemed to be appropriate to modern taste. The resulting material was to be used for a new crown that she wanted for her own coronation. Her Majesty asked me to consult Monsieur de Betsky on everything. I was delighted with this order because it relieved me of any responsibility which I might have had in relation to those who administered the treasury. I decided to accept completely and utterly the decisions of Monsieur de Betsky (who for his part was only desirous of realizing his own ambitions) and I contented myself with assisting him in everything that involved me . . ."

"An excellent and well-qualified jewel-setter was recommended: he was a Frenchman by the name of Aurole, and he carried out his work splendidly," Pauzié continued. "From all the items I chose what was most suitable, and, as the empress wanted the crown to remain unaltered after the coronation, I chose the largest stones—diamonds and cultured gems, which were not suitable for modern settings—and thus I created one of the richest objects that have ever existed in Europe. Despite the great care which we took to

make the crown as light as possible, using only essential materials to fix the stones, in the end it still weighed five pounds."[3]

In a record two months, Pauzié created one of the world's most breathtaking crowns, a tour de force of gold and silver, diamonds and pearls, and an extraordinary spinel. In addition to the precious stones from the treasury, a pound of gold and twenty pounds of silver were purchased for the crown at 86,000 rubles. Pauzié sent Catherine an invoice for 50,000 rubles. At the time, the crown was valued at two million rubles—roughly an eighth of the annual state budget of the Russian Empire. Thrilled with the result, Catherine declared that she'd somehow manage to hold "this heavy thing" on her head during the four-hour ceremony.

Now, removing her magnificent crown, Catherine walked toward the iconostasis where the gates opened. Inside the holy sanctuary, she was anointed by the Archbishop of Novogrod and received communion. Catherine proceeded to venerate the icons at the two adjacent Cathedrals—the Cathedral of the Archangel Michael, the former royal necropolis, and the Cathedral of the Annunciation. From there, Catherine moved to the opulent Palace of Facets. Named for the diamond-shaped white limestone on its east façade, the box-shaped palace was the former throne room of Russia's sovereigns—where Ivan the Terrible celebrated the taking of Kazan in 1552 and Peter the Great fêted his victory over Sweden at the 1709 Battle of Poltava.

Under the vaulted ceiling, surrounded by floor-to-ceiling paintings, Catherine awarded decorations, jeweled swords, and ranks. Among these, she named Gregory Orlov adjutant general and gave all five Orlov brothers titles of count. For her loyalty during the coup, Princess Dashkova was named one of some twenty ladies-in-waiting. At the afternoon banquet, singers and musicians entertained Catherine and hundreds of guests. The empress sat alone at a dais beneath a silk canopy, flanked by her ladies-in-waiting and senior male courtiers. Clergy and gentlemen of the third rank filled two more tables, with lower-ranking guests relegated to an upstairs hall and gallery. Servants in elegant livery were warned to look after the silver and report any drunken colleagues. That night, with the buildings of the Kremlin illuminated, Catherine appeared on the front steps of the Red Staircase to savor the moment. Moscow was ablaze with fireworks, a fitting finale for her triumphant day.

The celebration continued with ceremonial dinners and masquerades. One three-day ball, dubbed Triumphant Minerva, took place in the streets of Moscow with over four thousand participants. Despite the cold fall weather, people stood on balconies and rooftops to get a glimpse of their new empress as she rode by in a magnificent gilt carved carriage driven by eight Neapolitan horses adorned with colored cockades. Symbolically, Catherine chose the carriage that Peter the Great ordered from France's Royal Gobelins Factory for Catherine I's coronation. Built by the finest craftsmen in the court of Louis XIV, the coach sported six-foot-tall wheels and painted side panels. Two men jumped out from the back of the carriage to open the door for the empress; four more men ran alongside as bodyguards. So that Catherine would not have to look at the back of the coachman, a small page sat facing the carriage.

A few weeks after Catherine's coronation, over 120,000 Muscovites queued up to see the dazzling imperial regalia when it went on public display. After nearly ten months in Moscow, Catherine took the crown, orb, and scepter back to St. Petersburg, where she made her public re-entry in June 1763, the first anniversary of her accession. But Catherine would have to wait a few more months before moving into the Winter Palace, in the throes of a major refurbishment.

Catherine's predecessor Empress Elizabeth bought five buildings along the Neva River and demolished them to make room for an enormous Winter Palace. Unlike her father, Peter the Great, who disliked ostentation, Elizabeth ordered Francesco Bartolomeo Rastrelli (son of Peter's court sculptor Carlo Rastrelli) to build a vast, opulent palace. After seizing power, Catherine sent Rastrelli packing and hired an international design team to redo his ornate interiors. Among the many changes, France's Jean-Baptiste Vallin de la Mothe, Russia's Yury Velten, and Italy's Antonio Rinaldi turned the isolated southeastern corner of the first floor into Catherine's private apartments. They transformed the formal state bedroom into a diamond room, replacing an alcove with a glass treasure cabinet. Here, surrounded by gems and opulence, Catherine liked to play cards for diamonds with members of her inner circle.

"Her room is like a priceless jewel case," raved German naturalist Johann Gottlieb Georgi. "The regalia is laid out on a table under a great crystal

globe through which everything can be examined in detail . . . the walls of the room are lined with glass cabinets containing numerous pieces of jewellery set with diamonds and other precious stones as well as insignia and portraits of her Imperial majesty, snuff boxes, watches and chains drawing instruments, signet rings, bracelets, sword belts and other priceless treasures among which the Empress chooses presents for giving away."[4]

Two decades later, when Catherine transferred the imperial jewels from the diamond chamber to her new addition, she'd keep the imperial regalia close. Jérémie Pauzié's extraordinary Coronation Crown was worn by each of Catherine's successors, from her son Paul I to Russia's last tsar, Nicholas II.

CHAPTER TWO

THE BRIGHTEST STAR
OF THE NORTH

Catherine no longer had to hide her relationship with Gregory Orlov and installed him in the Winter Palace in an upstairs apartment connected to hers by a private staircase. But rumors persisted about how she came to the throne. Peter's sudden death after just six months in power led to widespread speculation about Catherine's involvement. Few believed her court's official press release: ". . . We received the news to our great sorrow and affliction that it was God's will to end the life of the former emperor Peter III by a severe attack of hemorroidal colic." Catherine went on to ask her 20 million subjects to "bid farewell to his earthly remains without rancor and to offer up prayers for the salvation of his soul."[1]

Even supporters like Count Nikita Panin, who expected Catherine to rule as regent for her young son Paul, learned she had no intention of sharing power with the sickly eight-year-old. On top of this, Catherine

was soon suspected of complicity in the 1764 murder of Ivan VI—the former tsar who had been deposed and imprisoned since childhood by Empress Elizabeth. "The ways of God are wonderful beyond prediction," a relieved Catherine wrote Panin on learning of the 22-year-old's prison death. "Providence has given me a clear sign of its favor by putting an end to this shameful affair."[2]

Paranoid about conspirators like herself, Catherine went to work shoring up allies in the Orthodox Church and the nobility. To buy support, she paid out 1.5 million rubles during the first six months of her reign. By the following spring, she had also gifted over 21,000 male serfs.[3] Catherine showered her co-conspirators and supporters with titles, jewels, and property. Those who participated in the coup received silver services and medals with her portrait. Through a combination of gifts and charisma, Catherine won over Russia's elite.

Working in Catherine's favor was a tradition of Russian tsarinas. Catherine II was the last of four 18th-century female rulers, starting with Peter's widow, Catherine I (1725–1727), followed by his niece Anna Ioannovna (1730–1740), and his daughter Elizabeth Petrovna (1741–1761). Anna Ioannovna had become tsarina unexpectedly after Peter the Great's fourteen-year-old grandson Peter II died on the eve of his wedding. Famous for her big cheeks (which Thomas Carlyle compared to a Westphalian ham), she ruled for a decade before naming as her heir her nine-month-old great-nephew Ivan. Under the regency of his mother, Anna Leopoldovna, Ivan VI's rule lasted less than two years. That's when Peter the Great's 32-year-old daughter Elizabeth seized power. After imprisoning the toddler tsar and his family and throwing away the key, Elizabeth proceeded to reign for two decades. In 1742, to insure that her father's line continued to rule, the childless Elizabeth selected her German-born nephew, Peter of Holstein-Gottorp, as heir. Three years later, she chose Sophie Friederike Auguste of Anhalt-Zerbst, the future Catherine II, to be his bride.

While gender didn't present an issue for Catherine in Russia, it was a huge problem in Europe, where she was caricatured as licentious and a regicide. The Hapsburgs had long banned female rule until Charles II passed a law that his daughter Maria Theresa could reign (she still shared the throne with her husband, Francis I, and later her son, Joseph II). As

a non-Russian woman who appeared to have bumped off her husband, Catherine found herself in a precarious position. Without a legal claim to Russia's throne, she quickly needed to find other ways to legitimize her reign. "To consolidate her newly acquired power, she [Catherine] had to establish her public credibility on foundations denied her by race, lineage or law," writes historian Antony Lentin. "A good reputation was not just flattering to her ambition; it was essential to her security."[4]

As a survival tactic, Catherine began promoting herself through the Enlightenment's most influential leaders, cultivating relationships within the cosmopolitan, intellectual community known as the "Republic of Letters." As Grand Duchess, Catherine had put her "eighteen years of boredom and seclusion" to good use. In addition to learning Russian and studying Russian history, Catherine devoured the works of the French *philosophes* who championed rational, secular government and enlightened absolutism by which rulers could improve their subjects' lives.

Through long running correspondences in French—along with financial backing and gift giving—Catherine enjoyed great press with two of the Enlightenment's most prominent thinkers, Francois-Marie Arouet de Voltaire and Denis Diderot. Both men sang Catherine's praises throughout Europe. Diderot would become one of Catherine's cleverest art scouts, negotiating some of her finest acquisitions. Their support gave Catherine intellectual and social clout, and helped polish her tarnished image internationally.

The month of Catherine's coronation, Voltaire lauded her offer to print Denis Diderot's thirty-two-volume *Encyclopédie*, then banned in France. "You are surely the brightest star of the north, and there has never been any as beneficent as you; Andromeda, Perseus, and Calisto are not your equal," wrote Voltaire, signing his letter "Your temple-priest."[5] In 1765, Catherine won Diderot over by buying his library for an enormous sum and sending him fifty years of salary in advance for its custodianship. ". . . I am as emotional as a child, and the true expression of the feeling with which I am filled dies on my lips," gushed Diderot. ". . . Oh Catherine! Remain sure that you rule as powerfully in Paris as you do in St. Petersburg."[6] Catherine did not succeed, however, in wooing Diderot's colleague Jean d'Alembert to St. Petersburg as Paul's tutor. Declining a generous salary,

palace, and ambassador rank, the mathematician recalled Catherine's press release about Peter III's death: "I am also prone to hemorrhoids which in Russia is a severe complaint," he wrote Voltaire; "I prefer to have a painful behind in the safety of my home."[7]

Catherine's letters to Voltaire seem spontaneous; in fact she worked hard on what Anthony Lentin calls "miniature masterpieces of artifice."[8] Unlike his dramatic falling out with Frederick the Great after an extended stay in Germany resulted in a strong mutual dislike, Voltaire never stopped supporting Catherine. His public praise increased despite Catherine's aggressive foreign policy with Turkey and Poland. Flattered by Catherine's attention and gifts, Voltaire hoped the empress would implement his ideas across Russia. "I love her to the point of madness" and "I am an old fool in love with Catherine" he wrote friends and heads of state. To Catherine he wrote, "You have inspired me with something of a romantic passion."[9]

Another of Catherine's lifetime correspondents was Frederic Melchior Grimm, a Parisianized German whose handwritten *Correspondance litteraire* arrived twice a month. Grimm's reports featured the latest literary gossip and artistic news, including Denis Diderot's commentary on Paris exhibitions. Welcome in all the salons of Paris, Grimm provided Catherine cultural and social contacts. He soon became her closest adviser and propaganda agent, entrusted with everything from art acquisitions to selecting a wife for her son. Unlike Catherine's carefully composed letters to Voltaire, her 1,500 letters to Grimm are highly personal and informal, with updates on her love life, the books she was reading, and her newest paintings.

Catherine's image makeover wasn't limited to her letter writing campaign. No woman sovereign since Elizabeth I distributed more portraits of herself. Like England's queen, Catherine manipulated her image to communicate just how she wanted to be viewed—benevolent, enlightened, and cultured. Fully committed to self-advertising, Catherine saw that her idealized likeness graced everything from jeweled snuffbox covers, medals, and carved gems to oil paintings, sculpted portrait busts, and tapestries. Starting with state portraits to celebrate her accession, Catherine helped fashion her highly ritualized images.

Catherine believed her best asset was her likeability, not her looks. ". . . The truth is that I never considered myself very beautiful, but people

like me, and that, I assume, is my strength," she wrote.[10] She expressed surprise when men like the Swedish ambassador found her beautiful. "I was tall and very well-built," she recalled in her memoirs, "but I should have been more plump; I was rather thin. I preferred not to use powder, my hair was a beautiful chestnut colour, was very thick and well set . . ."[11] On meeting Russia's "sumptuously attired" empress for the first time, French envoy Count de Ségur confessed to be "so astounded by her majestic air, the grandeur and nobility of her bearing, her proud gaze and somewhat artificial pose that I became totally oblivious to everything else around me."[12]

Catherine's favorite portraits capture the charisma and confidence noted by contemporaries. Among her many coronation portraits, she liked Fedor Rokotov's portrayal best. Using quick brushstrokes and a palette of silver-blues and brown-golds, the former serf managed to portray the empress as both regal and human, seated on her throne with a small crown on her head and orb beside her. Recognizing Rokotov's talent, Catherine had him create six more of her portraits. The first of these went to Gregory Orlov, for which Catherine paid 500 rubles. Catherine also ordered enamel on copper copies of Rokotov's portrait from court miniaturist Andrei Cherny to decorate snuffboxes, gifts to courtiers and foreign ambassadors.

More than any other artist, Vigilius Eriksen helped shaped Catherine's public image. Producing some thirty portraits of the empress during his fifteen years in St. Petersburg, the Dane proved his claim that "a portrait painter is just as important at court as a painter of historical events."[13] Duplicates of his canvases were distributed throughout Europe, including the courts of Prussia, Denmark, and England. As a young artist, Eriksen had left Copenhagen for St. Petersburg in 1757 when the Danish Academy refused to include his portraits in competition. After Empress Elizabeth's death in December 1761, he won favor with the young Grand Duchess with *Portrait of Catherine in Mourning* (Catherine hid her pregnancy with Gregory Orlov's baby under her bulky black mourning robes). By showing Catherine paying tremendous respect to Elizabeth, the portrait proved an effective propaganda tool.

In Moscow at the time of Catherine's coronation, Eriksen was granted a number of sittings. In *Catherine II, Empress of Russia* (c. 1765) he depicted his patroness from below, heightening the picture's drama. Eriksen

showed her regalia in splendid detail—from her ermine-trimmed robe and diamond-studded crown to the scepter, orb, and blue sash fastened at the hip with the blade of the Order of St. Andrew. To play up Catherine's embrace of Russia, Eriksen included the crowned double-headed eagle in gold embroidery on her dress and in diamonds on her necklace. Catherine quickly commissioned duplicates for the courts of Europe. Catherine sat several times for *Portrait of Catherine in Front of a Mirror* (c. 1762–64), a fascinating glimpse into her private and public personas. Turning to face the viewer, a charming Catherine stands before a mirror in a silver embroidered dress, her head tilted, holding a fan. In contrast, Eriksen uses Catherine's reflection in the mirror to capture her gravity and determination.

One of Catherine's favorite paintings was Eriksen's *Portrait of the Empress on Her Horse Brilliant* (1762). Sword in hand, Catherine sits atop her white horse, wearing the bright green and red uniform of the elite Preobrazhensky regiment, high black boots, and a gold-braided fur-trimmed black tricorn. The date of her coup, June 28, 1762, is carved on a tree to the left. "I put on a guards uniform and appointed myself a colonel, which was received with great enthusiasm," Catherine wrote her former lover Stanislaus Poniatowski (future King of Poland). "I mounted my horse; we left only a few men from regiment to guard my son who remained in town. I then put myself at the head of the troops and the whole night we rode towards Peterhof."[14] Peter III abdicated the following day and Catherine proclaimed herself empress.

Like her predecessor Elizabeth, Catherine possessed both traditional male and female qualities. "I sooner had a man's than a woman's spirit, but I wasn't mannish," Catherine wrote in her memoirs, "because together with the mind and character of a man I had the appeal of a very pleasant woman."[15] Catherine loved Eriksen's equestrian portrait and hung the original in the throne room at Peterhof Palace, where her husband had abdicated. She ordered multiple copies from Eriksen, who varied the size, format, and background details. Catherine hung a version of the painting flanked by Eriksen's equestrian portraits of Gregory and Alexei Orlov at the Winter Palace. Catherine's portraiture inspired Russia's elite. Following her lead, members of the nobility sat for portraits and formed portrait galleries at their country estates and city palaces.

In addition to paintings, Catherine had herself depicted in sculpture, a medium that was enjoying a revival thanks to the antiquity craze known as neoclassicism. Among Catherine's numerous marble portraits, the standouts are a group of vivid busts by Russian sculptor Fedot Shubin. Born in the northern White Sea region to a family of bone carvers, Shubin left at age nineteen for St. Petersburg where his talent was discovered by a family friend, polymath and writer Mikhail Lomonosov. After graduating with honors from the Academy of Fine Arts, Shubin traveled to Paris, where Diderot and Dmitry Golitsyn introduced him to sculptor Jean-Baptiste Pigalle. At Pigalle's suggestion, Shubin began sculpting figures from paintings by Nicolas Poussin and Raphael. Later, in Rome, he studied the famous busts and statues of antiquity.

It's there Shubin produced his first classically inspired portrait bust of Catherine, for which he probably used an engraving of one of Vigilius Eriksen's portraits. In a subtle portrayal evoking Roman statuary, Shubin crowned Catherine with a laurel wreath, the ancient symbol of victory. Like the elegant women of classical antiquity, Catherine's hair is pushed back to show her forehead. Back in St. Petersburg as court sculptor, Shubin created other portraits of the empress. Among his most popular later portraits was a 1783 marble bust and bas-relief of Catherine wearing a laurel wreath that was copied in bronze, gesso, and porcelain. Catherine gave a number of Shubin's portrait busts as gifts, including a copy to her art-loving cousin, Sweden's Gustav III.

Catherine's iconography reflected her passion for history and antiquity. She loved to be depicted as Minerva, continuing a tradition dating back to Alexander the Great.[16] Though Catherine wasn't the first woman to be represented as the Roman goddess of war, wisdom, and the arts, she took the allegory to new heights. Classical imagery not only linked Russia to contemporary Europe, it suggested Russia's ties to ancient Greece and Rome. Painters and sculptors portrayed Catherine as a laurel-crowned goddess in classical robes and sandals and a warrior in helmet and armor.

To mark her coronation, Catherine hired German-born medalist Johann Georg Waechter to coin a silver medal depicting her as Minerva in armor. The reverse side shows Catherine receiving a crown from a kneeling allegorical figure of Petersburg. Catherine sent gold versions of the medal as

gifts to Voltaire and Diderot. On the fifth anniversary of her coronation, Catherine had goldsmith Jean Pierre Ador insert the medals into the lids of silver and gilt snuffboxes—gifts for her co-conspirators. The inscription in Russian read: "By God's grace Catherine II Empress and Autocrat of all the Russias. Behold thy salvation."

Catherine also had her portraits woven in silk. Among the owners of these tapestries was Voltaire, who wrote the empress about Princess Dashkova's 1771 visit to his Swiss estate: "As soon as she entered the drawing-room, she noticed your portrait in mezzo-tint, embroidered in satin, and garlanded with flowers. . . . There must be some magic power in your image; for I saw Princess Dashkova's eyes brim with tears as she looked at the portrait. She spoke to me about your Imperial Majesty for four whole hours, and it was as if she had only spoken for four minutes."[17]

Sensitive to her German roots, Catherine also used portraiture to advertise her devotion to Russian tradition and the Orthodox Church. In 1767, after accepted the title "Mother of the Fatherland," Vigilius Eriksen created a portrait of Catherine dressed in a sleeveless jacket with a fur border and a *kokoshnik*, the traditional Russian headdress. Italian artist Stefano Torelli followed this with a portrait of the tsarina wearing a magnificent pearl- and gem-adorned *kokoshnik* and veil, pearl earrings, bracelet, and elaborate pearl necklace.

Catherine managed her image carefully, instituting strict quality control. In 1766, she demanded that a version of Eriksen's coronation portrait en route from St. Petersburg to Copenhagen's Christianborg Castle make a long detour to Moscow so she could personally approve the canvas. Other pictures, like Torelli's equestrian portrait, did not meet her exacting standards. ". . . In my opinion, there is a horse and a figure on the horse and I don't like either, nor is the rest very good," she wrote.[18] Swedish portraitist Alexander Roslin created a full-length state portrait with Catherine dripping ermine and diamonds and pointing to a bust of Peter the Great, inscribed "That which was begun will be completed." But in a letter to Melchior Grimm, Catherine complained that she looked like a "plain and boorish Swedish cook."[19] Catherine had Fedor Rokotov replace Roslin's face with a more youthful version, while keeping the original figure and accessories.

Catherine's reach was global. In today's parlance, she encouraged her images to go viral, instructing Russia's ambassadors to give her portraits away as gifts through their embassies. The first of many engravings of the empress was created after a profile portrait by Verona-born Pietro Antonio Rotari. Along with thousands of these engravings, original oil paintings and variants of the originals were circulated by the hundreds, making Catherine recognizable across the continent. "I've ordered that my portraits be bought from Eriksen at any cost," Catherine wrote Grimm in 1778. "Furthermore, there are tons of them in my gallery that are being copied from the Roslin. Everyone will have one, and it's all the same to me whether they have them or not. I swear all the portraits of my predecessors are mostly lying around in attics. I myself have two or three wardrobes filled with them."[20] Despite this comment, Catherine worked hard to market herself. The results were not always positive. As her army began aggressive military actions against Poland and Turkey, Catherine became the object of satire by British political cartoonists.

Throughout her rule, Catherine would update her official portrait, changing the imagery to reflect the current political environment. As W. Bruce Lincoln writes, Catherine "shone as sovereign, mother and goddess all rolled into one."[21] Significant events inspired new commissions—from her smallpox inoculation to Russia's military victories against the Ottoman Empire. To mark the silver anniversary of her reign, Dmitry Levitsky produced the highly symbolic allegorical *Portrait of Catherine II as Lawmaker in the Temple of Justice*. Dressed in a toga with a laurel wreath on her head, Catherine is depicted as the priestess of Themis, burning poppies at an altar, symbolizing her self-sacrifices for Russia. At her feet are law books and the scales of justice, while an eagle lurks in the background. Levitsky's work was widely celebrated, but Catherine's head isn't by the artist. It's a copy of Fedor Rokotov's original—the one she liked best.

CHAPTER THREE

THE AMBROSIA OF ASIA

O n the day of her coup, while Catherine was addressing cheering regiments in St. Petersburg, her husband, Tsar Peter III, was nursing a bad hangover at his new summer palace at Oranien-baum. He wouldn't get to enjoy it much—or celebrate his name day at a gala at nearby Peterhof. Dressed in a borrowed green Guards uniform, her hair perfectly coiffed, Catherine mounted a white stallion and led 14,000 men out of St. Petersburg south to Oranienbaum. There, a handful of Guards officers, headed by her lover's ruthless brother Alexei Orlov, aka "Scarface," arrested Peter III. A week later, after a midday meal at nearby Ropsha, Peter's captors tried to suffocate him with a mattress. When the tsar escaped, they strangled him with a scarf. Catherine's takeover was complete—and unexpectedly easy. In the biting words of Peter III's idol Frederick the Great, "He allowed himself to be dethroned like a child sent off to bed."[1]

Catherine's loveless marriage was a disaster from the start. Though Peter was a year older than Catherine, his behavior was immature and childlike.

". . . There is nothing worse than having a child-husband," she wrote her mother's friend in Hamburg, Madame Bielke. "I know it by experience, and I am one of those women who believe that it is always the fault of the husband if he is not loved, for in truth I would have loved mine very much, if it had been possible to do so, and if he had had the kindness to want it."[2] With the childless Empress Elizabeth growing anxious for a Romanov heir, she encouraged 25-year-old Catherine to have an affair with "handsome as the dawn" Count Sergey Saltykov. Many historians believe Saltykov may have fathered her son, the future Paul I.

In contrast to Catherine, her German-born husband disliked everything about Russia, including its religion. Just as Russia was enjoying an advantage in the hard fought Seven Years' War, the newly crowned Peter III made peace with Frederick the Great. Peter's pro-Prussian policies and inappropriate conduct, on top of overly extravagant spending even by Russian imperial standards, alienated important constituencies, including the army, the Church, and the courtiers. Enmity between the imperial couple was also reaching a boiling point, with a drunk Peter at one point threatening to have Catherine arrested. Though Peter backed off, writes Robert Massie, Catherine understood that he wanted to end their marriage. "Things took such a turn that it was necessary to perish with him, by him, or else to try to save oneself from the wreckage and to save my children, and the state," she would later write in her memoir.[3] Plotting alongside Catherine was her lover Gregory Orlov and his four brothers, who mustered support of Russia's powerful Guards regiments. When Catherine proclaimed herself empress, most Russians breathed a sigh of relief.

Given Peter's bloody, ignoble end, it's surprising that Catherine did not stay clear of Oranienbaum, the Romanov's summer compound on the Gulf of Finland, once the coup was complete. In fact, in her first commission as tsarina, Catherine hired Peter's court architect, Antonio Rinaldi, to build her private dacha on the estate. Oranienbaum's original resident, Peter the Great's powerful associate and Field Marshal Alexander Menshikov, built a lavish main palace around the same time his mentor was constructing Peterhof, five miles to the west. As a symbol of its luxury and status, Menshikov named the property Oranienbaum, German for "wild orange tree," after the citrus trees that grew in the conservatory. Menshikov

ran the Empire during the reign of Peter's widow, Catherine I. After her death, Menshikov was exiled to Siberia by the aristocracy. A decade later, Peter's heirs confiscated Oranienbaum; in 1743, Empress Elizabeth gave the property to her nephew Peter.

As Grand Duchess, Catherine gardened at Oranienbaum and bought land adjoining the estate, dreaming of her own dacha. At age twenty, she was already showing signs of her theatrical interests. "For this I ordered the Italian architect Antonio Rinaldi to build in an isolated part of the woods a large platform for an orchestra of 60 musicians and singers," Catherine recalled in her memoirs. "I also ordered the Italian court poet to write some verses and the chapel master Araja to compose the music. On the garden's main passage, an illuminated stage and curtain were put up, and in front of them a table was set for dinner . . . After the first course, the curtain, which was hiding the main passage, rose, and the spectators saw approaching from afar about twenty bulls transporting the moving orchestra, which was adorned with garlands, and they were surrounded by as many dancers as I could find. Everybody jumped up from their table to get a better view of the beauty of the symphony and the spectacle."[4]

Antonio Rinaldi had been recruited to work in Kiev and Baturin by Cyril Razumovsky, hetman of the Ukraine and younger brother of Elizabeth's favorite, Alexei Razumovsky. From there, Rinaldi moved on to Oranienbaum, where he designed a miniature rococo-style palace with fortifications to please the military-obsessed Peter III. For her own retreat, Catherine chose a charming wooded area on the upper park behind Menshikov's palace. Catherine and Gregory Orlov had been lovers for just over a year, and she had borne his son, Alexei, in secrecy two months before her coup. "Nature was unusually generous when it came to his physique, intellect, heart and soul," she wrote about the handsome war hero.[5] She wanted a place that was "hers and hers alone"—a secluded setting for trysts with her lover during the long White Nights of summer.

In July 1768, Catherine invited forty guests to a luncheon and garden tour of her new palace. Their first glimpse of the ochre and yellow dacha was its reflection in an ornamental lake. With twenty-eight ground floor rooms and nine reception rooms, the long one-story palace was modest in size for a royal residence. But there was nothing modest about the interiors,

some of century's most lavish and elegant. Critic Alexander Benois called the palace "one of the foremost places in the history of eighteenth century art . . . a work of art with such integrity, such harmony, such superb execution—such a grand, exquisite knick-knack that, looking at it, one simply has to fall in love. The painted patterns, the stucco ornament, the paintings, the architectural details—all of these are linked in a single inseparable whole that has in its purely musical effect something in common with the sonatas of Haydn and Mozart."[6]

To help create these harmonious interiors, Rinaldi recruited a team of compatriots that included Venetian fresco virtuoso Giambattista Tiepolo, Bolognese brothers Giuseppe and Serafino Barozzi, and Stefano Torelli. In addition to the graceful mythological ceiling paintings created on site by Torelli and Barozzi, over a dozen large canvases arrived from the Venetian Academy of Arts to adorn the remaining ceilings. Scagliola (artificial marble) and delicately modeled stucco work also adorned walls and ceilings. Using local and foreign varieties of wood, Russian craftsmen executed Rinaldi's intricately patterned parquet floors.

Rinaldi was a master of rococo. Derived from *rocaille*, French for "shell," the decorative style had swept through Europe and Russia after its start in Louis XV's France. In choosing chinoiserie, an ornamental offshoot of rococo, Catherine and Rinaldi were right on trend. Since the earliest contacts with China in the 16th century, Europeans had been smitten with the East. Peter the Great's envoys to China brought back caravans of luxurious silk, porcelain, silver, and tea. By Catherine's day, this infatuation had spread to architecture, garden pavilions, and interior décor.

As work began on Catherine's Chinese Palace, Frederick the Great was completing a Chinese Teahouse at Sanssouci, his summer palace in Potsdam. George III's architect William Chambers had just built Europe's most ambitious chinoiserie garden structure at London's Kew Gardens—a brightly colored, towering pagoda with bell-carrying golden dragons. Chambers was one of the few European architects who actually visited China; most had no firsthand knowledge of Asia. The popular teahouses and pagodas, tapestries, furniture, and porcelain they produced had little basis in reality, representing what David Porter calls "a fairy-tale fascination with distant images of unimaginable grandeur, wealth, and strangeness . . ."[7]

But to Catherine, ardent disciple of the Enlightenment, chinoiserie represented more than a whimsical twist on rococo. Central to Enlightenment thought was the concept of a shared humanity across cultures. Voltaire had praised the Celestial Kingdom, where life, honor, and property were protected by law—the kind of enlightened rule Catherine aspired to in Russia. Catherine intended for her guests to experience a completely new environment as they entered her dacha—a kind of virtual tour of exotic lands and cultures. She recreated a similar experience with eastern "exotica" at the Winter Palace, about which she wrote Melchior Grimm: "This museum forms a corner, which you enter through China, to get to China you go through Turkey, which in turn is entered via Persia. . . . here everything is imbued with the ambrosia of Asia."[8]

At the east end of the dacha, sunlight streamed through the French windows along both sides of the exquisite pink and blue Hall of Muses. Guests found themselves surrounded by pastel murals of the Nine Muses by Stefano Torelli. These include Urania, muse of astrology; Thalia, muse of comedy; and Terpsichore, muse of dancing and singing. Calliope, the muse of epic poetry, holds the *Odyssey*, the *Iliad,* and the *Aeneid.* Floral and musical motifs in the ceiling and walls are echoed in the patterns of the parquet floor.

In the breathtaking Bugle Bead Cabinet, a dozen silk embroidered panels of colorful birds, bouquets, and plants covered the walls. Adding a dreamy effect were some two million milky glass bugle beads—sewn horizontally onto the panels by nine Russian needlewomen. The eighteen-month-long project was supervised by Marie de Chele, a former actress with a French theatrical troupe in St. Petersburg. Each hanging was fixed to the wall in a gilded frame carved in the shape of a palm tree and topped by a small dragon. The supplier of the beads, Mikhail Lomonosov, had revived the lost art of glass mosaic. Lomonosov designed two inlaid glass mosaic tables for the cabinet, using some ninety different colors (one with a trompe l'oeil game of cards), and a spectacular matching mosaic floor (replaced in the 19th century by a wood floor after the glass design).

From the Bugle Bead Cabinet, guests entered the palace's largest room, the oval-shaped Great Hall. Facing each over the main doors are profile bas-reliefs of Peter the Great and Empress Elizabeth by French sculptress

Marie-Anne Collot, set in blue and red smalt glass and decorated with gilded copper and enamel. Bright blue and pink scagliola covered the walls along with *The Abduction of Ganymede* and *Juno and a Genius* by Torelli. The highlight of the magnificent reception room was Giambattista Tiepolo's ceiling painting *Mars Resting* surrounded by delicate plasterwork in pink, gray, white, and gilt. Tiepolo executed the mythological scene just before leaving Venice for Madrid in the spring of 1762 to work for Spain's Charles III.

More opulence awaited in the west wing with a trio of chinoiserie state rooms. The Small Chinese Cabinet featured elegant painted Chinese silk wall coverings in reds, green, dark blue, and gold, along with a geometric patterned parquet floor with latticework and bowls of flowers. A chinoiserie mantel with a geometric design topped the rococo fire screen. Chinese dragons spread their wings in the corners of the geometrically patterned ceiling. For the Large Chinese Room, the Barozzi brothers combined walrus ivory with twenty types of wood to create intricate wall panels featuring landscapes, figures, and exotic birds. Atop the marquetry floor were pieces of Chinese furniture and cabinets and a fireplace adorned with Chinese and Japanese porcelain. Overhead, surrounded by dragons and palm fronds, was *The Marriage of Europe and Asia* symbolizing Russia's growing empire. Large mirrors covered the walls and ceiling of Catherine's glittering gold and white Chinese Bedroom. A French writing desk and cabinet adorned the Golden Study, the empress's small private library.

At Catherine's request, Rinaldi also designed the three-story blue and white Sliding Hill Pavilion to the northwest of the Chinese Palace, used for the popular sport known as *montagne russe*. Capped with a dome resembling a bell or Chinese hat, the Pavilion was lavishly ornamented with columns, pilasters, and decorative vases, along with balustrades along the perimeters of the ground floor and two main stories. A large spiral staircase led to the third story "starting platform." From a covered colonnaded gallery, Catherine and her guests watched courtiers careen down the third of a mile long wooden slope in four-wheeled gilded carts decorated in the shape of ancient chariots, gondolas, and saddled lions and bears.

Catherine entertained guests in the airy, sunlit Round Hall, whose windows looked out on the sea and park. Using a pale palette of green, pink, yellow, and blue, the Barozzi brothers created exquisite wall and door

decorations, including deer leaping in a circle around a low, trellis patterned dome. Rinaldi designed the beautiful pink, blue, and green artificial marble floor with arabesque motifs. Also on the ground floor, Serafino Barozzi created the Porcelain Room, where gilded monkey-shaped brackets supported shelves of Meissen porcelain. Like those of the Chinese Palace, Rinaldi's parquet floors were a tour de force of design. Oak, maple, birch, rosewood, box, mahogany, ebony, Persian walnut, and amaranth were used to create sophisticated motifs of plants, flowers, branches, wreaths, and leaves. The rich woodcarving continued throughout the pavilion, along with painted ceilings and murals.

With its rococo images of muses, art, and love, the whimsical Chinese Palace embodied Catherine II's personality and youthful taste. It also marked the start of what would become an extraordinary three-decade building spree. But for Catherine, the intimate, secluded retreat also had deep romantic associations with Gregory Orlov, whom she described as "A hero . . . like the Ancient romans . . . and is of just such bravery and magnanimity."[9] When their relationship ended, so did Catherine's interest in Oranienbaum. In thirty years, she visited less than fifty times. Though Catherine's interest in rococo was brief, she remained a fan of chinoiserie, creating an entire Chinese Village at Tsarskoe Selo.

CHAPTER FOUR

COLLECTING DEBUT

During Peter III's doomed reign, he signed a hugely unpopular peace treaty with Prussia, which was one of the final straws that caused the nobility, army, and Church to desert him in favor of Catherine. When she became empress, Catherine didn't renege on the disadvantageous agreement, but she soon exacted her revenge. In 1764, she snatched a paintings collection from under the nose of Frederick the Great. Best known for establishing Germany's military culture, Frederick II first made headlines at age eighteen when he tried to escape his physically abusive father by fleeing to England with a childhood friend. Accused of treason and threatened with the death penalty by his father, Frederick was forced to watch his friend's execution from his jail cell. Frederick's trauma-filled childhood and adolescence produced a deceitful politician and mean-spirited adult. Maria Theresa called Frederick "the evil man" after he conquered Silesia and started the War of the Austrian Succession, one of three wars he waged during his forty-six-year rule. Two centuries

later, Adolf Hitler admiringly described Frederick's Prussia as "the germ cell of the Reich."

To escape the stresses of the battlefield and distance himself from the court in Berlin, Frederick retreated each spring to the yellow hilltop palace in Potsdam he called Sanssouci, French for "without cares." The King personally sketched plans for the palace, sending them from the battlefield to his team of architects. Joining Frederick for "table talks" to discuss art, literature, philosophy, and science were some of Europe's greatest minds, including Voltaire, who stayed for three years and described Prussia's leader as "a man who gives battle as readily as he writes an opera." After dinner, Frederick's guests adjourned to the gold and white music room to listen to their royal host play the flute.

At age thirty-two, Frederick's preoccupation with death led him to order a crypt on the upper terrace of Sanssouci's vineyard beside that of his pet whippets (ignoring his uncle's wishes, Frederick William II buried him in Potsdam's Garrison Church; his remains were moved to Sanssouci in 1991). Initially, Frederick collected contemporary French paintings by Antoine Watteau, Francois Boucher, and Nicolas Lancret. But under the influence of his intellectual guests, Frederick's taste shifted to Old Masters—primarily history paintings by baroque celebrities like Caravaggio, Rubens, and Rembrandt. In 1754, Frederick turned down ten Lancrets. Frederick saw himself as a connoisseur, paying large sums for paintings like Caravaggio's *Doubting Thomas*. Tellingly, Frederick did not hang any portraits of relatives at Sanssouci—not even of his beloved mother or sister. He banned women from his entourage, including his unloved wife, and surrounded himself with guards, secretaries, and army officers.

In 1755, just months before he started the Seven Years' War, Frederick broke ground on his new picture gallery, a short distance from the palace. "I am building a picture gallery at Sanssouci, another silliness, if you like, but the world is like that, and if you wanted to record only the reasonable things which men do, history would be very short," he wrote his sister.[1] A central tribuna separated the long vaulted gallery into east and west wings. Only the most precious materials would do. As a stunning backdrop to his antique sculptures, Frederick imported a rare dark green stone extracted from Roman ruins in North Africa for the gallery walls. Beneath the gilded

central dome was a striking diamond-shaped floor made of white Carrera marble and a yellow marble, giallo di Siena.

Frederick hung his gilt-framed canvases baroque style, with two to three rows of pictures filling the walls. Paintings were often grouped around contrasting themes—war and peace, youth and age, love and death, and various kinds of love: religious, sensual and maternal. Masters and pupils were also grouped—from Rubens and van Dyck to Rembrandt, Lievens, and Bols. Conspicuously absent were depictions of the martyrdom of saints, war scenes, and hunting scenes. "The collection, which the King had assembled rather haphazardly, with the assistance of agents and not too competent advisers, contained works of prestige, which princes everywhere liked to acquire: paintings with famous signatures, even though they were occasionally false," writes Helmut Börsch-Supan.[2]

For many years, Frederick had been assisted with his collection by Johann Ernst Gotzkowsky—an ambitious Berlin merchant who'd made a fortune as a haberdasher, jeweler, and textile maker. Born in Poland in 1710 and orphaned at age five, Gotzkowsky became the largest employer in Berlin and personal confidant to Prussia's young king. Frederick hired the skilled businessman to run a silk factory and turn the struggling Royal Porcelain Factory into a prestigious operation like Saxony's Meissen. Through his contacts with agents, distributors, and foreign ambassadors, Gotzkowsky acquired artworks from Paris, Rome, Venice, and Amsterdam. Gotzkowsky's own painting-filled home became a hub of Berlin society. Among his guests were Prussia's Prince Henry along with British biographer James Boswell, who developed a crush on Gotzkowsky's wife.

The Seven Years' War slowed but didn't stop Frederick's art collecting. Four years into the conflict, Gotzkowsky assembled a cache of paintings for his royal patron—works by Correggio, Carlo Maratta, Titian, Giulio Romano, and Luca Giordano. By 1761, Frederick's art-loving chamberlain, the Marquis d'Argens, called Sanssouci's new picture gallery the most beautiful after Rome's Saint Peter's. Gotzkowsky proceeded to assemble another group of pictures for Frederick, mainly Dutch and Flemish. But his timing was bad. The crippling war—called "the first World War" by Winston Churchill—had cost half a million Prussian lives and left the country in ruins. After Frederick declined the paintings, Gotzkowsky found himself in the middle of a financial crisis.

The businessman had speculated in the Russo-Prussian grain trade, entering into a risky deal to buy grain from the Russian army as it left Poland. With the price of the grain collapsing by over 75 percent and his Amsterdam bank going under, Gotzkowsky faced bankruptcy.

As a way out, the businessman approached Russia's envoy in Berlin, Prince Vladimir Sergeyevich Dolgorukov, offering Frederick's paintings as partial payment of his (221,000 thaler) debt to the Russians. Frederick got involved, using Gotzkowsky's pictures to stabilize Prussia's shaky relations with Russia, whose grain he needed to feed Pomerania and Poland. In the summer of 1763, after a great deal of diplomatic correspondence and finagling between Gotz-kowsky, his debtors, and the foreign ministries of Berlin and St. Petersburg, Catherine green-lighted the deal. To settle his debt, Gotzkowsky agreed to send Catherine 225 pictures plus 90 unnamed paintings.

Catherine was delighted. In addition to showing up her political rival, she was able to contrast Russia's healthy treasury with that of Prussia. There may have also been an element of personal satisfaction for the German-born empress. Frederick had played matchmaker in her miserable marriage, convincing Empress Elizabeth that she was the right choice for her nephew Peter. To enhance her family's prestige, Frederick had even promoted Catherine's uninspiring father, Christian August of Anhalt-Zerbst, to field marshal. With the match, Frederick thought he had secured Prussia's influence at the Russian court.

Frederick's strategy completely backfired. Prussia's king quickly learned not to underestimate Catherine. "Her spheres of activity encompass every-thing, no aspect of government escapes her," he wrote about Catherine. ". . . She's a living reproof to all those drowsy monarchs on their thrones who have no comprehension of the plans she is executing."[3] One of those plans was to gain Russian access to the Black Sea through Poland. While the ink was drying on the Berlin paintings deal, Frederick congratulated Catherine for the election results of the new Polish king.

The previously fall, Catherine exploited Augustus III's death to extend Russia's influence over Poland. After making peace with Frederick, Cath-erine convinced him to back the election of her former lover, Stanislaus Poniatowski, as Poland's new king. The couple had met four years after Catherine's affair with Sergei Saltykov, when the charming, well-traveled

young Polish nobleman was appointed secretary to England's ambassador to Russia. Their relationship produced a daughter, Anna, named for Empress Elizabeth's older sister and Peter III's mother. Peter, who knew of Catherine's affairs, reportedly quipped: "God knows where my wife gets her pregnancies. I have no idea whether this child is mine and whether I ought to take responsibility for it."[4] He wouldn't have to. After being snatched away at birth like her older brother Paul, the frail baby died at fifteen months. Neither Peter nor Poniatowski accompanied Catherine and Empress Elizabeth for Anna's burial in the Alexander Nevsky Monastery. Catherine's three-year romance with Stanislaus ended tearfully when it threatened to undermine her husband's reputation.

In August 1764, while Poniatowski was "elected" unanimously and installed as Catherine's "wax doll" in Poland, the Berlin paintings arrived at the Winter Palace. Though the quality was uneven and six canvases were wrongly attributed to Peter Paul Rubens, the crates contained works by important 17th-century Dutch and Flemish artists. These included *Cook in the Larder* by Frans Snyder, *Allegorical Family Portrait* and *Christ and the Woman of Samaria at the Well* by Jacob Jordaens, Hendrik van Balen's *Venus and Cupid*, Jan Steen's *Revelers*, and Jan Cossiers's *Concert*. With *Old Man at a Casement*, Catherine thought she'd snagged a Rembrandt. It wasn't until well into the 19th century that the painting was reattributed to Govaert Flinck, Rembrandt's talented pupil and chief rival. Jean-Baptiste Oudry's *Pointing a Partridge* delighted Russia's dog-loving empress. In his prolific career, the Frenchman produced a number of this type of distinctive hunting dog picture, including many starring Louis XV's kennel.

The gem of the Gotzkowsky pictures turned out to be *Portrait of a Young Man Holding a Glove* (c. 1640) by Frans Hals, an artist who today ranks with Rembrandt and Johannes Vermeer in the pantheon of Dutch "Golden Age" masters. Along with Rembrandt, Hals is credited with reinventing portraiture, achieving lively, memorable depictions with broad brushstrokes and stark contours. "His paintings are imbued with such force and vitality that he seems to surpass nature herself with his brush," wrote poet and fellow Haarlemer Theodorus Schrevlius. "This is seen in all his portraits, so numerous as to pass belief, which are colored in such a way that they seem to breathe and live."[5]

When the three-quarter-length portrait arrived at the Winter Palace, it was listed in the inventory as "a good portrait of an officer . . . two hundred and fifty reichsthalers, with a seal [i.e. monogram—I.A.S], painted by master Frans Hals."[6] Most scholars date the picture to around 1640 when Hals's palette became increasingly monochromatic. With light framing his face, the mustachioed young man looks directly at the viewer, his brown-gloved hand resting on his black doublet. To the right of the sitter's head, Hals added his monogram "FH."

The arrival of the Berlin pictures whetted Catherine's appetite for a picture gallery to rival those of Frederick the Great and Saxony's late Augustus II. As part of Peter the Great's fixation with the West, he imported European art, mainly Dutch and Flemish. An avid sailor since his youth, Peter was especially fond of seascapes. He displayed his art at his Summer Palace and European-style *Kunstkammer* (the latter also featured curiosities, minerals, and spectacular Scythian gold objects). Elizabeth, a fashion and jewelry aficionada, made one large purchase of Western art—115 pictures for her new palace at Tsarskoe Selo. Paintings were hung like tapestries from floor to ceiling, separated from each other by narrow gilded frames. Rather than incorporate any of the Romanov's art into her new picture gallery, Catherine started from scratch.

While the Gotzkowsky deal fell in her lap, Catherine's subsequent buys would demonstrate a proactive, calculated strategy. Catherine was self-deprecating about her new hobby, downplaying her taste and knowledge. Perhaps to throw off competitors and appear non-threatening to her courtiers, Catherine declared herself a "glutton" for art, not a connoisseur. But as early as 1758 as Grand Duchess, she had hinted at her sophistication when describing nobleman Ivan Shuvalov's new St. Petersburg palace ". . . furnished very opulently but tastelessly, there were many pictures, but most of them only copies."[7]

As in other areas, Catherine was a quick study. She devoured art history titles, collected architectural drawings, and carefully learned everything she could about the European art market. Before long, the empress was counseling her advisers. "Read the descriptions of the paintings which the antique dealers are selling," she told Melchior Grimm. "By constantly studying catalogues of the paintings which I purchase, I have learned to describe what I see."[8]

31

CHAPTER FIVE

BUILDING FRENZY

I t can't be done; therefore I shall do it." In 1703, Peter the Great
famously opened "a window on to Europe" by founding St. Petersburg
at the mouth of the Neva on the coast of the Baltic. Located just five
hundred miles south of the Arctic Circle, the land he wrested from Sweden
was inhospitable at best—marshy swampland and waterways frozen five
months of the year. With near maniacal obsession, Peter forced workers
north to consolidate the riverbanks and build houses, shipyards, arms fac-
tories, brickyards, and sawmills. As in Amsterdam, the new buildings were
supported by tree trunks sunk into the muddy ground. In the process, some
100,000 construction serfs and construction workers, including Swedish
prisoners of war, died from exhaustion and disease, giving St. Petersburg
the name "the city built on bones."

Nine years after the foundations were laid, Peter moved Russia's capital
one thousand miles north from Moscow to St. Petersburg, and ordered
everyone to follow. To ensure his new capital rivaled the European capitals

he'd visited, Peter invited Western architects, artists, and craftsmen. Aristocratic families like the Shuvalovs, Shermetevs, Yusopovs, and Stroganovs built mansions along the Neva and its tributaries. With the tsar's input, Domenico Trezzini designed the imperial Summer Palace, along with the spired Peter and Paul Cathedral (where Peter and his successors would be buried). Since Peter wanted his capital to be fireproof and stone had to be shipped at a huge expense from other areas of Russia, kilns were quickly fired up. To maximize stone for St. Petersburg, Peter ordered a moratorium on masonry construction throughout the rest of the empire. Brick, tile, glass, and cement were also produced in great quantity.

Peter personally chose the location of many of St. Petersburg's most important buildings, including the heart of the capital, the Admiralty, with a 230-foot-tall tower topped by a weathervane in the form of a crown and ship. From this landmark, three main radial streets fanned southward intersecting a series of canals. The northeastern most of these streets, Nevsky Prospect, became St. Petersburg's main thoroughfare. There was a uniform plan to the city, and the early architecture was simple and utilitarian, with wood and brick houses plastered and painted to look like stone. After centuries of isolation, direct trade with Europe was now possible thanks to the creation of the empire's largest port. "In the history of the art of urban planning in the late 17th and early 18th centuries, there is nothing can be compared with Russia's northern capital," write Dmitry Shvidkovsky and Yulia Revzina. "No other European country, whether on their home territories or in their colonies, had tried to found a city on such a scale, let alone the capital of an empire."[1]

But in the six decades since its founding, St. Petersburg's appearance had been spoiled by muddy banks, wooden docks, and rundown pilings. Determined to change that, Catherine hired architect Yury Velten (the son of Peter the Great's chef) in 1763 to finish the two-mile-long Palace Embankment with Finnish red granite. In the 1770s and 1780s, Velten completed the ambitious project, facing twenty-four more miles of riverbank and the walls of the Peter and Paul Fortress, creating a unified look and handsome backdrop for Catherine's buildings. "The Neva is dressed up in granite/the bridges hang across the water/the islands are covered in dark green orchards," wrote Alexander Pushkin a generation later.[2]

The Neva Embankment was just the start of Catherine's dramatic makeover of St. Petersburg. The discovery of the ancient Roman cities Herculaneum and Pompeii in 1738 and 1748 had unleashed a craze across Europe for classically inspired architecture. Not only was Catherine aware of the power of architecture to express Russia's wealth and prestige, she realized the benefit of linking her reign with the very latest architectural style. Allocating vast resources for construction, Catherine shifted her hand-picked team of architects away from Empress Elizabeth's baroque and rococo styles toward the more refined neoclassicism. "I am building, I will build, and will encourage others to build . . . ," she wrote in 1766.

Before she was done, Catherine lined the capital with neoclassical palaces, mansions, churches, and public buildings, transforming St. Petersburg into Russia's political, cultural, and economic center. The empress became a self-described building addict. "As you know," she wrote Melchior Grimm, "the building frenzy is as powerful as ever with us, and hardly any earthquake can have knocked down as many buildings as we are putting up . . . building is a devilish thing: it devours money, and the more you build, the more you want to build; it is a sickness, like drinking, or else it's a sort of habit."[3]

Catherine's urban planning extended beyond Russia's capital. Less than three months into her reign, she established a Commission for the Construction of St. Petersburg and Moscow to give Russia "a more European appearance" and bring architectural uniformity to its cities. Catherine actively collaborated with her architects, reviewing and approving over three hundred projects across Russia. To lure skilled construction workers, she ordered advertisements placed in foreign newspapers. Tver, the first town to be redone in 1763, became a model for Archangel and Kazan. After the center of Tver burned down, Catherine's commission took over, creating a prototype for towns with a main street that ran into two big squares—one for administrative buildings and the other for shops. To reduce the fire risk, side streets were required to be 75 feet wide. In 1765, the Commission sponsored a competition for a plan for St. Petersburg. The winning plan featured broad straight thoroughfares for the capital intersected by beautiful squares. Wooden structures were banned, as were residences taller than the Winter Palace.

One of Catherine's most important early public commissions was a new home for St. Petersburg's Academy of Fine Arts. Though the Academy had been founded by Empress Elizabeth in 1757 to foster Russian talent, Catherine relaunched the institution to signal her enlightened rule. In 1764, Catherine reorganized the Academy after the prestigious Academy of Painting and Sculpture in Paris that had centralized authority for the arts and imposed a standard of taste in France. St. Petersburg's Academy adopted France's hierarchy of genres which ranked history painting first, followed by portraiture, landscape, and genre painting. According to Rosalind Gray, Catherine liked the idea of a constant supply of official art to glorify her reign.[4]

Catherine commissioned Jean-Baptiste Vallin de la Mothe and Alexander Kokorinov to design a new home for the Academy near Peter the Great's *Kunstkammer*. In June 1765, the third anniversary of her accession, Catherine's court, diplomatic corps, scholars, painters, and writers turned out for the groundbreaking ceremony. On the roof of the Academy's neoclassical building stood a statue of Minerva, with a face resembling Catherine's. Above the conference hall, a small cupola housed Ivan Prokoviev's statue of Catherine. To mark the opening, poet Alexander Sumarokov wrote: "Our descendants will see you, Petropolis, in a new guise—you will be the Rome of the North . . . you will become . . . a timeless monument to Peter the First and Catherine the Second. Your architecture will serve a most useful purpose, for it will give a glorious example to other cities."[5]

To promote Russian art, the Academy launched public exhibitions after the famous Parisian Salons. The inaugural exhibition in August 1762 became an annual event from 1765 on, opening each year on June 28, the anniversary of Catherine's accession. The empress was a regular at the weeklong exhibition capped by a public award assembly. Ironically, the institution founded to cultivate homegrown talent was dominated by French faculty, including de la Mothe. Despite Catherine's patronage of the Academy and support of Russian portraitists, she proceeded to fill the Hermitage with foreign art. Surprisingly, she owned just two Russian paintings.

English scholar William Coxe was among the empress's critics. "The sovereign may rear artists, like foreign plants in a hot bed, at a prodigious

expence, [*sic*] and by constant cultivation; but unless the same care is continued when they are brought to maturity, they will sicken by neglect," wrote Coxe in the 1770s. ". . . If those who excel are not distinguished, they cannot feel that noble spirit of emulation which excites to excellence. As the nation, however, is gradually drawing towards a higher state of civilization and refinement; these institutions must be productive of more extensive and permanent effects."[6]

Catherine soon tapped de la Mothe and Velten for a highly personal commission at the Winter Palace. Before the Berlin paintings arrived at the palace, Catherine had assembled a gallery in the mezzanine of her private apartments. The diamond room, dressing room, bedroom, boudoir, study, and library had just been elegantly redone in the early neoclassical style, heated with handsome stoves decorated with painted and gilded tiles. From Catherine's private rooms, a staircase led to the entresols and Chinese Rooms. While beautiful, these rooms were too small for entertaining and showing off her rapidly expanding painting collection.

Just east of the Winter Palace, Velten designed a two-story addition overlooking the courtyard. Known as the South Pavilion, the new wing featured luxe first floor apartments for Gregory Orlov connected to Catherine's rooms by a private passage. To this, Vallin de la Mothe built a Neva-facing North Pavilion to house Catherine's pictures. The Frenchman lightened the austere three-story façade with tall window lintels and semicircular tops along with sculptures of Flora and Pomona (goddesses of flowers and fruit). Together, the North and South Pavilions became known as the Small Hermitage after the French *ermitage*, meaning a quiet place or a hermit's dwelling. The name would later extend to the whole complex of buildings adjoining the Winter Palace. Joining the pavilions was a Hanging Garden above the former imperial stables. Over the garden's vaulted ceiling, workers installed a rolled lead roof covered with soil and planted with trees and shrubs. As an extension of the Hanging Garden, Catherine also built a glassed-in Winter Garden.

"A great number of parrots and other birds from different parts of the world are kept in this winter garden," wrote Johann Georgi, "likewise there are good local song birds, wild hens etc. which, in their majority, all fly about freely and nest in the gallery's shrubbery, except for the big ones

on a tether. . . . Sometimes in the summer, for the sake of fresh air, the birds are placed in a special section made of wire netting so that it seems as if they were in the open air. Suchlike diversity of the fine birds and the simultaneous singing of the local ones etc is quite entertaining. Typically there are also some small animals here, fine monkeys, rabbits, white guinea pigs etc, roaming about free or on a leash."[7] But the entertaining birds took a toll on the art. One of Catherine's advisers observed that her marble figure of Love was covered with bird droppings.

Catherine hosted her first reception in the Small Hermitage in February 1769, inviting the English ambassador and his wife to dinner. From Orlov's apartments, Catherine and her guests proceeded to the Small Hermitage where they played cards until 10 P.M. and then dined until midnight. Three more Hermitage luncheons followed that month and became regular events in the fall and winter. Several times a month Catherine held Hermitages for sixty to eighty guests. Foreign ministers, generals, courtiers, and ladies-in-waiting attended Catherine's Grands Hermitages enjoying Italian opera, balls, and banquets. Though the empress described herself as tone deaf (she reportedly had to be given a sign when to applaud), concerts, opera, and ballet became an obligatory part of life at court.

In contrast to her large official balls, Petite Hermitages offered Catherine an escape from official duties. These invitation-only Thursday night dinners featured dinner, charades, poetry readings, dances, and conversations about art. The exclusive A-list included the Count de Ségur; Count Cobenzl; Prince de Ligne; field marshals Princes Golitsyn, Shuvalov, and Stroganov; and Princesses Dashkova and Branitskaya. One of Catherine's favorite entertainments was the literary game, consisting of scrambled questions and answers composed by members of her coterie and read out loud.

Art formed the perfect backdrop for Catherine's soirées, inspiring conversation among guests. "The appearance of this Hermitage did not fully correspond to its name," observed Ségur, "since on its threshold the beholder's eyes are struck by the enormous scale of its halls and galleries, the wealth of its furnishings and decoration, the multitude of paintings by Great Masters and by the pleasant 'winter garden,' whose green foliage, flowers and birdsong appear to have brought Italian springtime to the snowy North. The outstanding library seems to suggest that the Hermit

of these halls prefers the illumination of philosophy to monastic privations. A history of the world in portraits is also to be found in a comprehensive collection of medals representing all races of mankind from all centuries."[8]

With candles burning and a quartet of musicians playing, Catherine invited her guests into the dining room, decorated with ninety of her Berlin paintings. To insure privacy, Catherine dismissed the servants. An invisible system of pulleys and trap doors hoisted dishes from the kitchen below on a *table volant*, or flying table (an invention used by Empress Elizabeth and Frederick the Great). "We dined at a mechanical table," wrote lady-in-waiting Countess Varvara Golovina. "The plates were let down on a special rope attached to the table and beneath the plates lay a slate on which we wrote the name of that dish which we wished to receive. Then we pulled on the rope and in a little while the plates returned with the desired dish. I was overcome with admiration for this little whim."[9]

To add to the informality, Catherine and her guests spoke Russian and wore Russian-style dress, whereas in the formal settings of court or state functions, they would speak French and wear Western-style clothing. With characteristic humor, Catherine posted special rules of behavior in the gallery connecting the Winter Palace and Small Hermitage. "Titles should be left at the door like hats, the more so swords, seniority and arrogance; guests should make merry but nevertheless not spoil, crush or gnaw anything; they should not speak very loudly, so that the others would not have a headache; nor should they argue heedlessly, nor sigh deeply or yawn, thereby preventing others from partaking of the entertainments; they were not to drink excessively, should eat with appetite and not wash their dirty linen in public."

Guests who violated Catherine's rules were subject to "severe" punishment. "If any shall infringe the above, on the evidence of two witnesses, for any crime each guilty party shall drink a glass of cold water, ladies not excepted, and read a page from the Telemachida out loud [a tongue twisting poem by Vasily Trediakovsky]. Who infringes three points on one evening shall be sentenced to learn three lines from the Telemachida by heart. If any shall infringe the tenth point, he shall no longer be permitted entry."[10]

CHAPTER SIX

MY FALCON,
MY GOLDEN PHEASANT

Count Gregory Orlov and his four brothers orchestrated the coup that dethroned Peter III and brought Catherine to power. She never forgot this, and generously rewarded the brothers with lavish gifts and titles. Alexei would be named admiral of Russia's naval fleet, Feodor was decorated during the first Russo-Turkish War, and Vladimir appointed president of the Academy of Sciences. To Gregory Orlov, who wore her diamond-studded portrait around his neck, Catherine expressed her passion in letters: "My angel, my lord, my inestimable little Grigory with honeyed lips, my falcon, my golden pheasant."

To show off her handsome lover, Catherine hosted a jousting tournament in the summer of 1766 in the meadow facing the Winter Palace. Crowds gathered on the rooftops and in the square in front of the Palace, where a wooden amphitheater was erected for spectators. Catherine headed the

Slavic team, while Alexei and Gregory Orlov headed the Turkish and Indian teams, respectively. Each had over one hundred cavalry and infantry along with knights on horseback, ladies in chariots, and musicians. As part of the tourney, galloping knights beheaded dummies representing Moors while both men and women hurled spears. Catherine personally awarded gold medals and jewels to those with the best historical costumes.

Increasingly, Catherine and Orlov spent time together thirty miles southwest of St. Petersburg at Gatchina. Named for the village of Khotchino, captured by the Swedes in the early 17th century, the wooded property was one of Catherine's many extravagant gifts to her lover. After gaining the forested land for Russia during the Northern War, Peter the Great had given it to his sister, Natalia Alexeyevna. After the tsarevna's death, Gatchina grange had a succession of owners until it was bought by Catherine from relatives of diplomat Prince Boris Kurakin, Peter's well-educated brother-in-law.

To design Orlov's new lakeside estate, Catherine hired Antonio Rinaldi, fresh from the Chinese Palace at Oranienbaum. Inspired by the castles he'd seen in England, Rinaldi combined elements of a fortified medieval knight's castle, a royal hunting lodge, and a stately English home. Breaking ground in 1766, Rinaldi chose the highest part of a hill overlooking the south side of the mirror-like White Lake. The three-story central block was adorned with coupled Doric and Ionic pilasters and flanked by a pair of octagonal towers and semicircular wings. To tie the monumental estate to its natural surroundings, Rinaldi created an open passageway with arcades on both fronts of the central building.

In a departure from the traditional stuccoed brick façade, Rinaldi faced the residence with a weathered, yellow-hued limestone from the nearby Pudost River. Inside, Rinaldi combined rococo with the emerging Classicism. This transitional style is best seen in the large White Hall, where restrained geometric pilasters and frames contrast with rococo curls, acanthus leaves, sea shells, and scrolling parquetry floors. In a nod to his talented architect, Orlov hung Shubin's bas-relief of Rinaldi in the room connecting the White Hall and Antechamber.

During Gatchina's construction, Catherine often stayed with Orlov for days, passing the time boating on the lake, strolling the grounds, and

playing cards. Catherine took an active interest in the project, involving herself in details of its construction and interiors. Rinaldi updated Catherine with letters. "Just the third day as I came back from Gatchina, where I was for the second time, and where I spent six days," he wrote in June 1767. "Already started erection of the house from solid stone with solution and placing of gratings of the cellars." But Orlov was unhappy with the slow pace of the project. In September, Catherine wrote state secretary Ivan Chernishov about his impatience. "The landlord of Gatchina is sad that even the ground floor of his house this summer hasn't been finished yet."[1]

In 1769, Catherine recruited British landscaper Charles Sparrow to improve the natural beauty of the surrounding park—a project in which she was personally involved. An avid hunter, Orlov envisioned Gatchina as a hunting estate. A large section in the park's northern region was established as a game reserve for deer, wild goats, and hares. The woods were divided into squares, with large areas cleared to provide a good view in all directions; trees and shrubs were planted around the natural contour of White Lake.

In 1765, possibly to mark Orlov's appointment as General of the Artillery in charge of armory, Catherine ordered a breakfast and toilet service from the Imperial Porcelain Factory that combined baroque, rococo, and neoclassical motifs. The toilet service included a mirror in a porcelain frame and essentials—from dental tools to shaving accessories. Painter-decorator Nasar Koslov and miniaturist Andrei Cherny collaborated on the breakfast service, creating painted military scenes, trophies, emblems, and motifs. Each piece sported Orlov's monogram "GGO" in gold Cyrillic letters topped with a count's coronet. Even the fluted coffee spoons and other utensils featured small oval medallions with the count's initials.

Some pieces of the Orlov Service were rimmed in gold by virtuoso goldsmith-jeweler Jean Pierre Ador. Born in Berne, Switzerland, Ador spent nine years in London before returning to Geneva, a center for enamel, clock making, and watchmaking. Like many goldsmiths, Ador was lured to Russia by Catherine's deep pockets. Early in her reign, Ador set up a workshop in St. Petersburg, working primarily for her court. In his ten-year contract with the Imperial Chancellery, Ador agreed to not use anything less than eighteen-carat gold (for which he would pay the taxes). In 1768, Catherine commissioned him to create another gift for Gregory Orlov.

Considered one of Ador's masterpieces, the eleven-inch, tulip-shaped Vase with Classical Figures was capped with a perforated cover to allow fragrance to permeate the air. Swags of leaves, chiseled in olive-green gold, surround scroll cartouches set with painted oval medallions of Flora and Ceres, representing spring and summer. Beneath the lion's head–shaped handles are enamel scenes: Hercules killing the Nemean lion and a lion attacking 6th century B.C. Greek athlete Milo of Croton. Topping it all off is a pair of reclining gold putti on green-gold clouds, representing friendship between lovers. The cherubs support an oval shield with Gregory Orlov's monogram G.O. in gold Cyrillic letters on a royal blue enamel background.

Catherine's largesse continued. In 1768, she again tapped Rinaldi to build Orlov a city residence with one of the best addresses in St. Petersburg. The Marble Palace was situated at the end of the Palace Embankment facing the Citadel, with one wing running along the Neva River and the other along "Millionaire's Row." Catherine instructed her architect to use newly discovered marble from the Urals and Siberia over 1,000 miles away, along with marble from Greece and Italy. A row of polished pink-veined flat marble pilasters topped with blue-gray Siberian marble created a striking contrast to the gray granite background. Across the palace's façade faced with pink, white, and blue-gray marble, Catherine penned the inscription: "In grateful friendship."

To please his patroness, Rinaldi toned down his signature baroque and rococo styles in favor of neoclassicism. Unlike the private Chinese Palace and Gatchina, the Marble Palace was intended to impress the public. Rinaldi lessened the severe effect of the two-story pilastered building with a series of window niches in the center of each main façade. The entrance featured a clock tower with a broken pediment described by architectural historian George Heard Hamilton as "a last baroque intrusion in a design which was settling into the soberer mood of Neo-Classicism."[2]

Inside, Rinaldi chose a rich color palette, facing the first floor with pink and the second and third floors with light gray stone. Inside the veined blue-gray marble Entrance Hall, Rinaldi installed a series of arches and groups of martial trophies in relief by two of Russia's finest sculptors— Fedot Shubin and Michael Kozlovsky. The blue-gray marble continued

in the spectacular grand staircase adorned with a pair of Shubin statues personifying Morning and Night. Lapis lazuli and precious marble from the Urals lined the walls of the first floor ballroom, considered among the most opulent and elegant of all Russian neoclassical interiors.

Upstairs in the Great Hall, Rinaldi used more lapis lazuli along with green, yellow, and gray marble, and pink marble pilasters. The Hall featured an enormous ceiling painting and two large classical reliefs in white marble. To complete the palace's interiors, Catherine transferred paintings from the Hermitage, including Carle van Loo's *Self-Portrait*; François Lemoyne's *Woman Bathing* and *Jupiter and Io*; Jean-Baptiste Pater's triptych, *Dance Beneath the Trees*; and a series of women's heads by Pietro Antonio Rotari. A drawings album showing the palace art includes a pair of landscapes by Dutch painter and printmaker Abraham Bloemaert. Following Catherine's lead, Gregory Orlov created a portrait gallery at Gatchina in 1778, along with galleries for paintings, sculpture and antiquities, a *kunstkammer*, and an arsenal.

The Marble Palace achieved the desired "wow" effect. William Coxe described the "superb edifice" in glowing terms: "The front is composed of polished granite and marble, and finished with such nicety, and in a style so superior to the contiguous buildings, that it has the appearance of having been transported to its present spot, like the palace in the Arabian Tales, raised by the enchantment of Aladdin's lamp. It contains forty rooms on each floor, and is fitted in a style of such profusion and splendor, that the expense of the furniture has exceeded 200,000 pounds."[3] Swiss mathematician Jean Bernoulli raved: "I saw a beautiful palace which the Empress is building for Prince Orlov and which is nearly ready. It is embellished with marble doors and window cornices, statues etcetera. The walls of the staircase are faced with marble panels. It's absolutely the most beautiful palace in St. Petersburg and, although smaller, surpasses even that of the Tsar."[4]

Gregory Orlov tried to please the brainy Catherine. He studied French and tried unsuccessfully to invite the French philosopher Jean-Jacques Rousseau to Gatchina where "the air is pure, the water extraordinary, and pleasant spots for walking are propitious for thought."[5] Orlov spent hours searching the night sky with his telescope at his rooftop observatory at Gatchina. He conducted simple science experiments, describing

to Catherine how a glass filled with water would crack after it freezes. Despite these efforts, Orlov remained a good-natured soldier at heart; his highest appointment was chief of the artillery. French envoy Louis de Breteuil wrote Catherine's nemesis, the Duc de Choiseul, that Orlov was "very handsome, but . . . very stupid." And after meeting Orlov in Paris, Denis Diderot likened him to "a boiler always boiling but never cooking anything."[6]

What Orlov wanted more than anything was to co-rule Russia with Catherine. But marriage would risk Catherine's political power. Though she felt increasingly estranged from her son Paul, whose militaristic bent eerily resembled that of her late husband, his existence legitimized her rule. As adviser Nikita Panin told her bluntly, "A Madame Orlov could never be empress of Russia."[7] Before Gatchina and the Marble Palace were finished, cracks began appearing in their relationship.

RUSSIA IS A EUROPEAN NATION

CHAPTER ONE

A Monument to Peter and to You

Peter I became Russia's sole ruler in 1696 after the death of his disabled half-brother Ivan V. During the first year of his reign, the 25-year-old also became the first Russian tsar to travel to Western Europe. It was no ordinary vacation. For the next eighteen months, Peter worked in the naval shipyards of Britain and Holland, studied mathematics and astronomy, learned printing, and visited art museums. The effect of these experiences could not have been more profound. Peter returned home with instruments and weapons, medicines and surgical instruments, clocks and lathes. Most of all, he was hell-bent on modernizing Russia.

Peter inherited a vast, decentralized kingdom rife with corruption. His roughly 10.5 million subjects—about a quarter of the world's population—were divided into the nobility, peasantry, urban dwellers, Cossacks, and clergy. Following centuries-old tradition, Russians men dressed in robes,

wore beards, and slept with their shoes on—a practice widely seen as barbaric by Westerners. They lacked many of the basics enjoyed by European countries like Spain, Portugal, Britain, and France, who reaped great profits from their overseas colonies. In addition to its economic and social isolation, Russia was distanced from the West by its religion, Christian Orthodoxy, and Cyrillic language.

The day after his return from Europe, Peter began modernizing Russia, personally cutting off the beards of boyars who came to greet him. Edicts soon followed mandating Western attire for boyars and their servants, merchants and craftsmen, and courtiers. Peter aligned Russia's calendar with that of Europe, simplified Russia's Cyrillic alphabet, and established the first Russian newspaper and printing house. In a blow to the Church, Orthodox schools were replaced with secular ones.

Compared to European countries benefiting from technological advances, Russia's economy was underdeveloped and stagnant. In a complete overhaul, Peter oversaw the construction of some two hundred new factories, along with mines to tap Russia's rich natural resources. He launched the metallurgy industry and designed weapons for a professionalized army and navy. Though serfs were no better off, free peasants moved from farms to towns, working at weaving mills and other factories. Foreign experts arrived to teach the latest ship-building and manufacturing techniques. Schools for mathematics, medicine, and navigation sprang up in Moscow and St. Petersburg; an astronomical observatory followed, along with a Naval Academy, engineering school, and a hospital like one Peter had seen in Amsterdam.

Peter divorced his wife, appointed himself emperor, and created a new Senate and nine collegia. Following the Anglicans, he weakened the powerful Orthodox Church, replacing the patriarchate with a Holy Synod, which he headed. Financed by Church monies, Peter's new naval fleet and reorganized Western-style army allied with Denmark-Norway and Saxony to battle Sweden in the Great Northern War. Three years into the war, Peter acquired what became St. Petersburg; additional territories were won in Estonia, Latvia, and Finland. After two decades of war, Peter had turned Russia into the Baltics's dominant power.

Catherine, who idolized her grandfather-in-law, picked up right where Peter left off. Embracing Westernization, she began importing European

art treasures along with foreign architects and artists. Inspired by Europe's intellectual movement, the Enlightenment, Catherine proposed reforms to Russia's legal code. (Like Peter, Catherine did not succeed in modernizing Russian agriculture, which remained dependent on serfdom for another century.) Throughout her reign, Catherine relentlessly pursued Peter's expansionist foreign policy, adding the Crimea and large portions of Poland and the Ukraine. Peter the Great was a constant presence in Catherine's life—from numerous references in her letters to the ring she wore with his portrait and her snuffbox with his image on horseback. "I take it with me," Catherine wrote about the box, "because I'm always asking myself what he would have done in this situation."[1]

One of Catherine's most effective uses of art as imperial propaganda was her monumental equestrian tribute to Peter. Catherine's own inscription on the plinth in Russian and Latin—"To Peter I from Catherine II"—left no doubt about her intentions. By aligning herself with Russia's greatest tsar, the minor German-born princess with no legal claim to the throne secured much-needed legitimacy for her reign.

Until Peter the Great began collecting sculpture, the art form had been absent in Russia because of the Orthodox Church's prohibition of graven images. To mark his victories in the Great Northern War, Peter had commissioned a triumphal statue of himself from Florentine sculptor Carlo Bartolomeo Rastrelli (father of Winter Palace architect Francesco Bartolomeo Rastrelli). Catherine rejected the unfinished baroque work and looked to France, whose public spaces were filled with monumental bronzes. The job of hiring a French sculptor fell to Ivan Betzkoy, who sought help from Prince Dmitry Golitsyn, Russia's well-connected ambassador at the court of Versailles.

On the strength of Denis Diderot's glowing endorsement, the prestigious commission was awarded to Étienne-Maurice Falconet, a modeler at the Sèvres porcelain factory. Not only did Falconet submit the lowest bid, he turned down Golitsyn's offer of 300,000 livres, insisting his payment be just two thirds that sum. The decision reflected the sculptor's deeply held conviction that great art has no relationship to its cost. Still, Falconet's selection stunned the Parisian art world. Of the five better-known sculptors in the running, Falconet's resume was the least relevant for the project.

A modeler of small cherubs and nymphs, Falconet had never sculpted a horse, had never cast a bronze statue, and had limited experience with official portraiture.

But to Catherine, Falconet's selection served a double purpose. The artist was closely connected with the influential French *philosophes* whose support she counted on. At the same time Falconet was producing Peter's tribute, he would be the empress's liaison to the West, giving her further entrée into the competitive Paris art market. It didn't hurt that Falconet could also help Catherine outshine her political rival, Louis XV, whom she disliked for what she saw as his indecision and weakness. "There may be artists who are as talented as he, but none, I dare say, is his match in intellect," Catherine wrote about Falconet.[2]

For the middle-aged sculptor, the call from Russia's empress represented the opportunity of a lifetime—a chance to prove his talent on a monumental, heroic scale. While his rivals were busy creating grandiose equestrian statues abroad—Vanache in Dresden, Larcheveque in Stockholm, and Saly in Copenhagen—Falconet had been stuck making table decorations at Sèvres. In 1763, Falconet had written Count de Marigny, Madame de Pompadour's brother and director of the king's buildings: "I am almost 50-years-old and have not accomplished anything which deserves fame."[3]

Born in 1716 in the St. Denis quarter of Paris, Falconet hailed from a modest family of artisans and laborers. During an apprenticeship with his maternal uncle, a master marble cutter, Falconet developed an ambition to become a sculptor and began experimenting with clay and wood. At eighteen, Falconet began a second apprenticeship in the busy Versailles workshop of court sculptor Jean-Baptiste Lemoyne II. During his decade in Lemoyne's atelier, Falconet assisted in some of his mentor's greatest commissions, including the Basin of Neptune group at Versailles and the equestrian monument of Louis XV at Bordeaux. At twenty-three, Falconet married Anne-Suzanne Moulin, a cabinetmaker's daughter. He soon found himself in an unhappy marriage with an unsupportive wife and a growing family to support. Three of the couple's children died in infancy; only the eldest, Pierre-Étienne, survived into adulthood and became a painter. Their troubled relationship would worsen in St. Petersburg.

Self-conscious about his lack of formal education, Falconet taught himself Latin, then Italian and Greek. Like Catherine, Falconet's intellectual curiosity led him to read voraciously—science, political theory, religion, philosophy, and aesthetics. He became enamored with Socrates, who had trained as a sculptor and whom he thought he resembled. This admiration led Falconet to adopt an austere lifestyle, which included plain clothes and thriftiness. Much to his wife's dismay, Falconet divided his time between sculpting and writing about the theory and history of sculpture. Falconet exchanged letters and gifts with artist-writer Sir Joshua Reynolds, who would teach his son painting in London.

After nine years of marriage, Falconet's wife died. The thirty-year-old widower left Lemoyne's studio to practice on his own, taking with him a beautiful teenage model, Marie-Anne Collot, with whom he probably began an intimate relationship. But Falconet's career was hampered by his quarrelsome personality. Fiercely jealous of his artistic independence, Falconet resented any outside advice. When the Academy finally admitted the 38-year-old, doors began to open. It's there he made influential friends like François Boucher, the favorite painter of Louis XV's powerful mistress, Madame de Pompadour, and Jean-Baptiste-Marie Pierre, first painter to the Duc d'Orléans. Still the contentious Falconet managed to make enemies like sculptor Jean-Baptiste Pigalle and painter Jacques-Louis David.

With Boucher's backing, Madame de Pompadour appointed Falconet director of sculpture at the Royal Manufacture of Porcelain in Sèvres in 1757. The arrival from China of translucent glazed ceramics had sparked demand, and France was hurrying to catch up with Saxony's Meissen, Europe's first porcelain factory. During nearly a decade at Sèvres, Falconet adopted Madame de Pompadour's decorative taste. Once a week, he'd arrive at the factory by barge along the Seine, bringing models of shepherdesses, milkmaids, and nymphs to be turned into small, unglazed biscuits. To supplement his income, Falconet worked for members of the Marquise's inner circle. Though Falconet credited his patroness for paying well, his wrote critically that "She had neither the time nor the talent to cultivate" a love for the arts.[4]

A church commission brought Falconet to the attention of Denis Diderot, who invited him to write an article about sculpture for the

Encyclopédie in 1760. Over the next five years, the two bonded over art and philosophy, eventually publishing their correspondence. Observing parallels between Falconet and Jean-Jacques Rousseau, Diderot nicknamed his friend "the Jean-Jacques of sculpture." "Here is a man who is endowed with genius, and who has all kinds of qualities compatible and incompatible with genius," wrote Diderot, ". . . for he has plenty of finesse, taste, wit, tact, sweetness, and grace; for he is boorish and polite, affable and abrupt, tender and hard; for he models clay and marble, and he reads and mediates; for he is gentle and caustic, serious and gay; for he is a *philosophe*, he believes in nothing, and well knows why . . . there is no man more eager for the approval of his contemporaries and more indifferent to that of posterity. He carries this philosophy to an incredible point, and he told me a hundred times that he would not give an ecu to insure the immortality of the most beautiful of his statues."[5]

Ironically, the sculptor so indifferent to posterity was about to create St. Petersburg's most iconic landmark and the inspiration for later portraits, including that of Napoleon. Falconet's equestrian tribute to Peter the Great was the first work of its kind to feature a horse rearing up on its back legs. Cast in two hollow bronze shells with most of the weight borne by the horse's hind legs, the seventeen-foot-tall bronze is considered a feat of technical virtuosity. Wrought with challenges and controversy, the project took a dozen years to complete and another four years to unveil.

Inspired by Falconet's statue, Alexander Pushkin wrote "The Bronze Horseman: A Petersburg Tale" in 1833. Pushkin's young hero Evgeny lost his fiancée and house in the deadly Neva flood in November 1824 (the flood killed 569 people and destroyed some 300 buildings). Stopping before Falconet's statue of Peter the Great, Evgeny curses at the tsar for building Russia's capital on the Neva. Suddenly, Peter and his horse come to life, chasing the petrified clerk through St. Petersburg's deserted streets. Published posthumously in 1837, the epic poem was so popular that the equestrian statue became known as the Bronze Horseman.

The project had its start in Paris, where Dmitry Golitsyn drew up a contract for 25,000 livres a year plus living expenses, and allowed Falconet to have two sculptors and a plasterer as assistants. For the fiercely independent Parisian, the most important provision was that he would only have

to answer to Catherine II. After much coaxing, Falconet left Paris with his assistant, eighteen-year-old Marie-Anne Collot, by stagecoach in September 1766. Meanwhile, their baggage traveled separately on a packet boat from Rouen. Twenty-five large bundles contained supplies, books, prints, and artworks—including Collot's portrait busts of Diderot and Golitsyn, models of most of Falconet's statuary, and François Boucher's *Pygmalion and Galatea*—a gift from Paris's Royal Academy to St. Petersburg's new Academy of Fine Arts. That same year, St. Petersburg's Academy named Boucher an honorary member.

Falconet and Collot extended their month-long journey to Russia to six weeks, stopping in several German cities including Berlin to see Andreas Schlüter's equestrian statue of Frederick William I, Elector of Brandenburg, at Charlottenburg Palace (it was Frederick William I who gave Peter the Great Schlüter's famous Amber Room, stolen by the Nazis from Catherine Palace during World War II). From there, the couple proceeded north via Konigsberg and Memel. At Riga, the seaport Russia had recently won from Sweden, they were welcomed by Ivan Betzkoy's aide-de-camp, Martin Carburi.

Until their permanent residence at St. Petersburg's old Winter Palace was ready, Falconet and Collot lived in a rental on Admiralty Meadow. The old palace had been built by Francesco Bartolomeo Rastrelli in 1755 as temporary quarters for Empress Elizabeth's court until her opulent new Winter Palace was ready. Carburi turned the kitchen into the artists' private quarters; the theatre became Falconet's atelier. Behind the studio, Carburi built a large shed and several workshops. Conveniently, the studio was a ten-minute walk from the Neva facing Senate Square, the site chosen for Peter the Great's monument.

Catherine rolled out the red carpet for Falconet, flattering the middle-aged sculptor and making him feel her intellectual equal. She solicited his advice on a variety of artistic projects and paintings and asked him to recommend individuals for various positions. As the first French intellectual to visit her court, Falconet was a stand-in for Voltaire and Diderot. "M. Diderot recommends his friend to me," Catherine wrote the celebrated Parisian Salon hostess Madame Geoffrin shortly after his arrival in October. "I have acquired a man without equal, Falconet, who is the friend of the soul of Diderot."[6]

Catherine began a correspondence with Falconet that lasted eleven years and totaled some two hundred letters. Most of their exchanges concern the tsar's statue, which Falconet aptly referred to as "a monument to Peter and to You." In addition, the empress engaged her well-read sculptor in dialogues about literature, philosophy, religion, and politics. Catherine set the informal tone for their letters early on, writing, "You thank me for the confidence I place in you but it is I who should thank you for choosing me among my confreres." A delighted Falconet found himself the focus of attention in one of the world's most dazzling courts and the empress's adviser on art matters. After Catherine addressed the sculptor as *"Votre Haute Naisance,"* implying his nobility, Falconet gushed: "High born! How that pleases me! For I was born in a garret!"[7]

Louis XV had scarcely noticed Falconet, but Catherine's warm welcome and the sculptor's role as her cultural attaché caused anxiety at the highest levels in Paris. Marquis de Bausset, the French ambassador in St. Petersburg, informed the Duc de Choiseul, Louis XV's minister of foreign affairs that "the empress singles Falconet out on every occasion." After learning that Catherine planned to use Falconet as her headhunter in France, Bausset warned Choiseul: "the empress would like to attract into her empire many of our artists and scholars . . . She has expressly asked [Falconet] to write to all his friends and assure them that they would be welcome here and to encourage them to come." An indignant Choiseul criticized Catherine's efforts "to use Falconet as an instrument of seducing other artists."[8]

Before Falconet left Paris, Diderot had weighed in on the tribute, proposing a huge allegorical fountain. "Mount your hero on a fiery steed placed on a precipitous rock which will serve as a foundation," Diderot urged his friend. "Let him drive barbarism before him. Have limpid waters flow between the crevices of the rock. . . . I see on the far side the love of the people, their arms raised toward their ruler . . . showering him with blessings; on the other side I see the symbol of the nation lying on the earth enjoying ease, rest and security. The figures placed around your basin will form a sublime whole. . . ." But Falconet had a much simpler vision. "Barbarism, devotion of people, the symbol of the nation are inappropriate," Falconet replied. ". . . Peter the Great is sufficient unto himself. . . . My Czar does not carry a baton. He extends his right hand over his country.

He leaps upon a rock which serves as a foundation, the symbol of the difficulties he has surmounted. There is my Peter the Great with the paternal hand and the gallop on the creviced rock."[9]

To lend authenticity to Peter's steed, Catherine loaned Falconet two of her favorite horses from the imperial stables. Equerries rode the horses at full gallop on the top of an artificial hill, where they would stop suddenly, causing the animals to rear. For the figure of the tsar, a tall cavalry general with a similar build to Peter's was enlisted to pose. Falconet first modeled his subject in the nude, prompting Catherine to write from her galley on the Volga River in spring 1767: "I hope upon my return that Peter's attire will be complete. I have been told that after my departure he already existed but in a state of great undress."

A week later, the empress wrote: "My respects to Peter fully clothed. He has a physiognomy, action, an expression—and you have studied the head of his charger. That is what you tell me and I regret I cannot see him."[10] When Falconet submitted his first design to Catherine, she advised him to trust his own judgment and that of posterity. "My posterity is Your Majesty, The other may come when it will," wrote Falconet. "How can you submit yourself to my opinion?" Catherine replied in characteristic self-deprecating style. "I do not even know how to draw. The merest schoolboy knows more about sculpture than I do."[11]

Meanwhile, Catherine took notice of Falconet's talented young assistant, Marie-Anne Collot, a fine sculptor in her own right. Diderot, who loved Collot "like his own child," saw her as an ideal companion for Falconet and encouraged him to marry "Mademoiselle Victoire." Thanks to Diderot, Collot received her first commissions from *salonnière* Madame Geoffrin and Dmitry Golitsyn, who described her ability as nothing short of miraculous. "To her talent she joins a splendid character and the highest moral principles. She does not lack in esprit. It is rendered most piquant by her purity, innocence, and lack of affectation," raved Melchior Grimm, Catherine's Paris-based correspondent.[12]

In 1767, soon after St. Petersburg's Academy of Arts named Falconet a foreign honorary associate, Collot became the institution's first woman foreign associate, as well as the youngest member. This honor allowed Collot to show her works at Academy exhibitions, an excellent venue for

advertising her talent. But Catherine did not pose for artists until they proved themselves with "testers"—a strategy she also used to vet potential lovers. In this case, the tester was Anastasia Sokolova, Ivan Betzkoy's Paris-raised daughter. Too fidgety to sit still and awestruck by the young female sculptor, Sokolova proved a challenging subject. Still, Collot easily passed Catherine's test, becoming the empress's official portrait sculptor.

In 1769, Collot created a portrait bust of the forty-year-old empress as a gift for Voltaire. With an open, rounded forehead, slight smile, and double chin, Collot succeeded in capturing Catherine's energy and charisma. The same year, to celebrate her army's victories over the Turks, Catherine commissioned her bas-relief profile portrait crowned with a laurel wreath. Inspired by the portrait bust for Voltaire, Collot also created a second medallion of Catherine wearing the traditional Russian headdress, a *kokoshnik*—a big hit with the empress. "Because she's so talented at medallions would she make few more for me?" Catherine wrote Falconet. "For instance, of Peter the Great and his daughter Empress Elisabeth?"[13]

Catherine kept Collot busy with some twenty-five portrait commissions. Between 1766 and 1770, the young artist sculpted Gregory Orlov, Grand Duke Paul and his first wife Natalia Alexeievna, along with family members of Lord Cathcart, England's ambassador to Russia. Eager to add more portrait busts to her art collection, Catherine confided to Falconet that she'd like to own likenesses of Henry IV and his celebrated minister, the Duke of Sully. In Catherine's youth, Henry IV's biography was among her favorite books; in her memoirs, she recalled that the French king had been a model for her as a ruler. But a marble shortage in St. Petersburg caused a delay for these projects. "How come she [Collot] doesn't have enough marble?" Catherine asked Falconet. "My impatience is huge . . . [to see a good stock of marble]."[14] In the meantime, Collot wrote to her former employer, Lemoyne, who sent her masks that he'd made of both Henry and Sully. In the summer of 1768, Collot used these images to sculpt the bearded and mustachioed king and his bald statesman.

Catherine also asked Falconet if Collot could improve a series of mediocre bas-reliefs she'd acquired for the Chinese Palace at Oranienbaum. In 1770, Catherine commissioned Collot to sculpt a marble bust of Diderot for the Hermitage. Collot received so many commissions from the empress,

she didn't know what to work on first. Falconet wrote to Dmitry Golitsyn complaining that his protégée had only been paid for one of the portrait busts she'd produced. In response, Catherine quickly promised her 12,000 livres, and a 1,000-ruble raise to her annual salary of 16,000 livres. As added thanks, Collot also received a precious box and a gold watch.

In 1767, Catherine hired Collot to sculpt Falconet. Swamped with other projects, Collot didn't finish the one-and-a-half-foot-tall bust until six years later. Considered her masterpiece, the vivid, affectionate portrayal shows Falconet with a wry smile and mischievous expression, looking younger than his age, in work clothes with a knotted tie. Falconet confided to Diderot that the bust did not make him look handsome. "Your head is not as ugly as you think," replied Diderot. "You are not handsome, but you have some character and finesse. That bust looks like you because she's doing it in marble and she knows you inside and out."[15]

CHAPTER TWO

MAKE PEACE WITH YOUR ENEMY

I n April 1767, with Peter's tribute in progress, Catherine embarked on a voyage along the Volga River. She didn't travel light. Eleven specially equipped galleys were needed to accommodate her 2,000-person entourage. Joining the empress on her galley at Tver were Gregory Orlov, his brother Vladimir Orlov, and her three state secretaries. Nikita Panin stayed in Moscow with her son Paul, as did Alexei Orlov, who was recovering from illness.

After five days of sailing, Catherine wrote to Jean-François Marmontel, whose novel *Belisarius* she'd just finished reading: "I do not know where to mark my letter from, as I am on a vessel in the middle of the Volga with weather bad enough that many ladies would call it a terrible storm."[1] To pass the time between stops, Catherine and her coterie translated *Belisarius* along with a selection of articles from Diderot's *Encyclopédie* into Russian. To continue this effort, Catherine launched the Society Striving for the Translation of Foreign Books, whose translations included classics like

the *Iliad*, modern writings by Jonathan Swift, and works by the French philosophes Voltaire, Rousseau, and Montesquieu.

Catherine had become an avid reader during her unhappy marriage. She devoured titles in German, her native tongue, along with French, which she'd learned as a young girl and was her second language. The affection-starved grand duchess read whatever she could get her hands on—from escapist romances to philosophy and history. By the time Paul was born, her personal library included works by Plato, Plutarch, Cicero, Baronius, Montesquieu, and Voltaire. In 1753, some of Catherine's books were destroyed in a palace fire, including Bayle's *Dictionary*, which she'd been consuming volume by volume.

After seizing power, Catherine's reading list expanded to include writers who supported her style of enlightened despotism. She appointed a dedicated librarian and began to systematically grow her holdings. In 1764, Catherine made her first bulk acquisition, buying the library of diplomat Baron Johann Albrecht Korff, former director of St. Petersburg's Academy of Sciences. Three years later, in parallel with her paintings collection, Catherine established the Hermitage Library. Books for Catherine would always be "good company," writes Frank Brechka.[2] She continued enjoying novels and comedies, including Cervantes's *Don Quixote*, the *Arabian Nights*, Richardson's *Pamela*, and Sterne's *Tristram Shandy*.

Books also helped inform Catherine's economic policy, including works by Mercier de la Rivière, the Abbés Badeau and Galiani, and Turgot. One of the main purposes of her Volga cruise was to inspect progress at a series of riverfront towns. When she seized power, Catherine discovered that Elizabeth had left Russia's treasury bankrupt. One of Catherine's first decrees allowed anyone to start a new factory outside the overcrowded cities of St. Petersburg and Moscow. Soon, there were large textile plants south of Moscow, linen factories in Yaroslov, and leather and candle-making businesses in the central Volga region. Like Peter the Great, Catherine invited foreign experts to Russia to improve manufacturing. From England, she recruited Admiral Knowles to build warships and dockyards. Workers from the Tula steelworks traveled to England to study the making of barometers, thermometers, and mathematical instruments. During Catherine's reign, factories tripled in number—from one thousand to over three thousand.

Catherine also achieved major economic gains by abolishing export duties. Russia's primary exports were timber, hemp, flax, raw leather, furs, linen, cloth, and iron. By 1765, three-quarters of Empress Elizabeth's debt was repaid, and a budget deficit had been turned into a surplus. Three years later, after the Treaty of Kyakhta was signed, camel caravans were going to and from Manchuria. Russia exported furs, leather, and linens to China, importing cottons, silks, tobacco, silver, and tea. This growth in trade along with an expansion of paper money led to an economic boom. In addition, Catherine continued Peter the Great's policy of confiscating Church property. Hailed by Voltaire, the strategy gave the state a third of Russia's land and serfs and earned vast sums from grain farming.

In July, Catherine's river cruise ended near Moscow, where she convened a legislative commission of 564 delegates to reform Russia's legal code. Inspired by Montesquieu and other Enlightenment thinkers, Catherine had spent the past two years drafting the Nakaz, or Instruction, her strikingly liberal political manifesto. Opening with "Russia is a European power," Catherine's program included equality for all citizens under the law and an end to serfdom, torture, and corporal punishment in schools. Catherine had the Nakaz printed in many languages so all of Europe could admire her enlightened rule. Deeming it too radical, Choiseul had Catherine's manifesto banned in France.

Catherine's reforms also proved ahead of their time at home. Russia's wealthy landowners, to whom Catherine owed her crown, strongly opposed her proposed reforms to serfdom that threatened to reduce their sizable profits. Ever pragmatic, Catherine disbanded the commission and withdrew her Nakaz from circulation. During the rest of her reign, Catherine would unite Russia's nobility behind her by expanding their privileges, including serfdom. Though the legislative commission failed to pass any reforms, the effort was a public relations coup, the centerpiece of Catherine's public image as a humane and enlightened ruler. Voltaire hailed her Nakaz as the finest monument of the century.

Imperialism provided Catherine a much-needed distraction from nagging domestic issues. Since installing her former lover Stanislaus Poniatowski on the Polish throne four years earlier, Catherine had begun sending her army into Poland—part of her strategy to gain access to the Black Sea, considered

vital for Russia's economy and defense. Turkey, a neighbor of both Russia and Poland, had wrongly assumed Poland would remain a weak buffer state. By 1768, Sultan Mustafa III had caught on to Catherine's scheme, issuing the empress an ultimatum to withdraw her troops from Poland. Aware that the Ottoman Empire had fallen into decline while her own military had become own of Europe's strongest, Catherine didn't flinch. Her army continued the incursions into Poland, further enabled by Stanislaus's continued support.

Goaded by France's Duc de Choiseul, who viewed Russia's growing might as an existential threat to France, the sultan declared war on Russia on September 25, 1768. Supported by France and Austria, Turkey launched military actions against Russia in Ukraine and in the Caucasus. By the spring of 1769, Catherine's troops occupied Azov and Taganrog and defeated two large Turkish regiments near Khotin. Led by General Rumyantsev, the Russian army won victories in Moldavia and Wallachia. Despite these successes, the war was proving a burden on even Russia's robust economy. In 1770, Catherine allowed Rumyantsev to enter peace negotiations with the Turks provided they free her ambassador in Con-stantinople, a condition they refused. Desperate to prevent further Russian conquests, Frederick the Great sent his younger brother Prince Henry to St. Petersburg for a three-month stay. Henry's mission—to persuade Catherine to make peace with Turkey—failed miserably, as she was determined to reap maximum territorial gains from the conflict.

With the Russo-Turkish War still raging, Peter the Great's equestrian statue had become a subject for international interest and discussion, espe-cially among Falconet's Parisian critics. The sculptor's difficult personality was even starting to fray the patience of his friend Diderot, who cautioned him in September 1768: "One could say that your habitual practice of addressing yourself to marble has made you forget that we are made of flesh. You are quick to take offense, easy to wound, you have sarcasm or irony perpetually on your lips. . . . It takes a very tough person, enthusiastic about your fine qualities, to remain your friend. I doubt that you are sincerely and truly loved by anyone except me and your young disciple. You are a bizarre mixture of tenderness and harshness."[3]

From the start, the unyielding Falconet clashed with Ivan Betzkoy, Catherine's petty bureaucratic arts minister. Betzkoy's concept for the

statue included allegories, trophies, and lengthy inscriptions about Peter the Great's achievements, all of which Falconet rejected. Jealous of Falconet's access to Catherine and resentful of his complete rejection of his ideas, Betzkoy became obsessed with discrediting the sculptor. Falconet aggravated the situation by running to Catherine with their squabbles. In May 1769, Falconet complained that Betzkoy was forcing him to take a pupil he didn't want. "The most important thing for you, for me, and for your work is that you are left in peace," Catherine responded. "Therefore you will not take a pupil."[4] Repeatedly, Catherine found herself placating her touchy sculptor. "We'll carry on, you and I," she wrote. "You will make a beautiful horse despite the evil tongues of those who envy you. . . . Let them talk. Everything is as it should be and you have the tokens of their esteem. Overcome all obstacles and make fun of the rest! Obstacles exist in the world in order to be swept aside by worthy people." Diderot too advised Falconet in 1769: "Work, my friend, work with all your strength. Above all create a beautiful horse because it is said you will fail. . . . I will embrace your feet if you prove they have lied."[5]

The following spring, Falconet exhibited his life-size model of the tsar atop a wild, rearing horse in the sculpting shed behind his studio. The plaster composition caused something of a sensation among Petersburgers who expected him to follow the classical and Renaissance equestrian tradition symbolized by the statue of Marcus Aurelius in Rome. The only equestrian statue from antiquity to survive, the larger-than-life bronze depicts Aurelius fully in control of his steady steed, his hand outstretched. In response to the negative reaction to his own model, Falconet wrote a treatise panning the emperor's horse for being unnatural and badly proportioned.

Peter the Great's wardrobe caused more controversy. Instead of traditional armor and saddle, the tsar wore a belted mid-calf-length shirt with a flowing cape and sat atop a bearskin. Similar to the garb of Volga boatmen, the shirt caused a stir since Peter the Great famously forbade traditional Russian clothing in favor of Western fashions. "You know I would not put Russian garments on him any more than I would put Russian garments on Julius Caesar, Pompey, or Scipio," Falconet wrote Diderot, hoping to enlist his support. "His is a garment of all nations, all peoples, all times," Diderot responded. "It is a simple and unpretentious garment, attractive without

being overbearing." Meanwhile Russia's clergy complained that Falconet's seemingly Roman tunic had turned the tsar into a pagan monarch. In the face of persistent criticism, Falconet appealed to Catherine. "Monsieur Falconet, I repeat what I've been telling you all along," she replied, "disregard the blabbermouths, even though there may be respectable persons among them."[6]

Even the snake under the horse's rear hooves drew criticism. The allegory of envy or evil being trampled turned out to be more practical than symbolic. "They have not made, as I have, the calculation of forces which I need," a defensive Falconet wrote Catherine. "They do not know that if their advice were followed, the work would not survive at all." To which the empress replied, "There is an old song which says, 'what will be, will be.' That is my response to the serpent."[7] Even after the clay version of the statue was finished, Falconet continued to need reassurance. "At last the curtain is raised," he wrote Catherine. "I am, as expected, at the public's mercy. My atelier is always full. But what I find somewhat peculiar is that not one of the local visitors has breathed a word; it is just as if I did not exist, even though I know that they are rather pleased with it. . . ." "If they don't say a word to you, it is because they are tactful," Catherine replied. "Some don't count themselves clever enough, some may hold back for fear of displeasing you with their comments, some finally cannot see anything there. Don't see the dark side in everything, the way so many Frenchmen do."[8]

Falconet's next challenge was sculpting Peter's head. For models, he turned to Rastrelli's bronze portrait bust of Peter in armor, and the tsar's life and death masks with his bulging eyes, large nose, and heavy jowls. But after three failed attempts at the head, Falconet turned to his twenty-year-old protégée, who reportedly sculpted the head the night before statue went up. Though Falconet did not include Collot's name next to his on the statue, he insisted she had sculpted Peter's laurel-crowned head. "I did not make the head of the hero," wrote Falconet. ". . . That portrait, bold, colossal, expressive, and eloquent, is by Mlle Collot . . ."[9] English chaplain William Tooke confirmed her role: "Mademoiselle Collot acquired such great reputation by composing the head of the hero, that she was employed to make a bust of the empress in marble, and engaged by many of the nobility in works of like nature for them . . ."[10]

Falconet's equestrian statue was intended to stand on an artificial hill of stones rather than a traditional decorated pedestal. But this idea was superseded by Marin Carburi, who convinced Catherine and Betzkoy that a solid stone would be stronger. A shadowy figure, Carburi had fled Venice in 1759 after slashing the face of a woman who rejected his advances, landing in St. Petersburg as a fugitive two years later. In late 1768, after an extensive search led by Carburi, an enormous Ice Age granite boulder was found some eight miles from St. Petersburg in a marshy area near the Gulf of Finland. Buried in the swampy forest, covered in thick moss, the gray monolith known as "Thunder Rock" had a fissure believed to be from a lightning bolt. According to local legend, Peter the Great had climbed the boulder to look out over the Finnish Gulf.

Falconet wanted to shape Thunder Rock to play up its resemblance to a cliff. Since the shaping would reduce the boulder's weight, he thought it made sense to do it before the move. But Catherine was too impatient to wait. Hauling a three-million-pound boulder through four miles of bogs and forest to the sea and on to St. Petersburg was a herculean challenge, but the politically savvy empress knew the risky venture would reap enormous rewards. She sponsored a competition for plans to move the gigantic boulder to Senate Square. Carburi's prizewinning scheme involved lifting the giant boulder from the ground, installing it on a platform, and transferring it to a chassis to be rolled downhill to a large pier in the Bay of Kronshtadt.

The first effort in April 1769 failed miserably, with the boulder and machinery sinking into the marshy soil. In November, with the ground frozen, Carburi tried again. To the beat of a drummer, workers operated winches and capstans, slowly lifting one side of the boulder. After each foot of upward movement, wooden blocks were positioned underneath the rock, and levers and fulcrums were adjusted. To prevent the boulder from crashing onto the platform, Carburi used six restraining lines on the boulder's upper side and several enormous jackscrews below. As the wood supports were gradually removed, the boulder descended slowly. After two backbreaking months, Thunder Rock came to rest on the platform without a dent.

The next challenge was moving the boulder to a metal sledge, which rolled over five-inch copper balls, like modern ball bearings. The bottom

part of the track had to be continually torn up from behind and rebuilt in front of the slowing advancing rock. To pull the rock forward, two teams of thirty-two men rotated a spool that wound up cables attached to the boulder. An enormous barge was waiting, supported on each side by a warship to prevent it from sinking. In August 1770, Thunder Rock was finally pulled onto the barge. From there, it moved slowly across the gulf and was towed up the Neva River to the Neva Pier in St. Petersburg.

In September, on the eighth anniversary of her coronation, Catherine and thousands of her subjects welcomed the granite megalith. The following month, the empress took Prussia's Prince Henry to see the Karelian granite boulder being installed in the middle of Senate Square. Catherine's two-year, 70,000-ruble gamble had paid off. She exploited Thunder Rock to the hilt, commemorating the feat with a medal featuring the monolith along with her portrait. Catherine's official poets likened the boulder's dramatic journey by land and sea to the building of the Egyptian pyramids and the Colossus of Rhodes. Catherine received great press in Europe, where the achievement was reported as a spectacular feat of engineering.

With Thunder Rock delivered to Senate Square, Carburi demanded more money and recognition from Ivan Betzkoy, who was basking in the limelight. Falconet's appeals to Catherine on Carburi's behalf further alienated the empress. Meanwhile, the sculptor took a chisel to the huge granite mass like a block of marble, carving the base into a dramatic smooth and polished shape. He sliced seventeen feet off the height and added what he'd removed to the length so it ultimately measured fifty feet. The result was compared to a crouching sphinx and a rising wave, a dramatic platform for Peter and his rearing horse.

But the honeymoon between the empress and her sculptor was over. Catherine no longer asked Falconet to court, and her patience with the self-righteous artist was growing thin. When Falconet complained that Betzkoy was distracting him by building near his studio, Catherine wrote back with terse advice: "Make peace with your enemy as I have done with the Sultan."[11]

CHAPTER THREE

My Prodigal Son

During the second half of the 18th century, art collecting was heating up in a number of major European centers, especially Paris. From the 1760s to the end of century, the French capital was the main source for Catherine's expanding picture gallery. Taking its lead from Holland and Flanders, the Paris art market had professionalized by the late 1760s, with a small number of highly trained men honing expertise in all areas of fine art. As wealthy merchants began competing with nobility, prices soared and canvases changed hands frequently.

Rival dealers and agents played a central role in frenzied auctions, where competition was fierce for top quality paintings with prestigious provenances. Surprisingly, works by trendy Dutch and Flemish artists like Gabriel Metsu, Gerard Dou, David Teniers, and Philips Wouwerman fetched more than pictures by Old Masters such as Rembrandt and Rubens. Smitten by Wouwerman's work, Catherine would amass some fifty of the Dutch artist's paintings.

Deception was commonplace, along with controversies over attributions. In this contentious setting, no one could compete with Catherine's cosmopolitan ambassador, Dmitry Golitsyn. Hailing from an illustrious family of Russian military leaders and diplomats (his father was Field Marshal General M. Golitsyn), the well-connected diplomat counted among his circle Voltaire, Diderot, Melchior Grimm, and Geneva collector François Tronchin. A collector himself, Golitsyn never missed an opportunity and was instrumental in shaping Catherine's gallery. Though he began by buying individual paintings, Golitsyn soon conceived the effective strategy of acquiring entire collections for the empress.

Golitsyn's successes began in 1766 when he snagged at auction a small trove of French and Dutch paintings assembled by French court portraitist Jacques André Joseph Aved. Many of Aved's portraits were later attributed to Jean-Baptiste-Siméon Chardin, with whom he enjoyed a long friendship. A member of the Académie des Beaux-Arts, Aved also became one of the foremost connoisseurs of his day with a cache of Rembrandt engravings and canvases by Gerrit Dou, Anthony van Dyck, Tintoretto, Claude Lorrain, and Nicolas Poussin, the leading exponent of 17th-century French Classicism. Golitsyn's most important buy for Catherine was Poussin's early masterpiece *Tancred and Erminia*. Based on an episode from a 16th-century poem by Torquato Tasso, *The Liberation of Jerusalem*, the dramatic twilight composition depicts the sacrifice of Erminia, daughter of the king of Antioch, who rushes to help the crusader knight Tancred, victorious but badly wounded by a giant. Taking a sword, Erminia cuts off her magical hair to bind her lover's wound.

The following year, Golitsyn acquired half a dozen 17th-century Dutch and Flemish paintings from the posthumous sale of Jean de Julienne, noted collector and patron of Antoine Watteau. Julienne had made a fortune producing cloth in a factory adjacent to the royal Gobelins factory. In addition, he'd invested heavily in the South Sea Bubble, shrewdly cashing out before the crash. The Julienne auction, one of the most publicized in 18th-century Paris, took place over fifty-four days at the prestigious Salon Carré in the Louvre, the official exhibition space of the Académie. After competing against many of the leading European collectors, including Frederick the Great, Golitsyn snagged several works for Catherine: *Peasant Wedding* by

David Teniers II, *Doctor's Visit* by Gabriel Metsu, and *Study of a Cat's Head* by Frans Snyders. One of the many bidders to come away empty-handed was Horace Walpole, son of England's prime minister Sir Robert Walpole. "I heard from Paris that I had no success at the sale of monsieur Julien's cabinet where everything sold as extravagantly as if the auction had been here," wrote a disappointed Walpole.[1]

In addition to auctions in Paris, The Hague, and Amsterdam, Golitsyn bought directly from collectors. His most brilliant find was Rembrandt's *The Return of the Prodigal Son*, regarded as a Hermitage masterpiece. In 1768, just before moving from Paris to his new post at The Hague (where he spent the next twenty-eight years), Golitsyn purchased the monumental work from André-Joseph, Marquis D'Ancezune, Duc de Caderousse. The marquis had acquired the painting in Bonn two years earlier for 6,000 livres after the death of its owner, Clemens Augustus, Archbishop of Cologne. For just slightly more, Golitsyn snapped up the canvas for Catherine, who awaited the painting's arrival with great impatience and described it in a letter as "My Prodigal Son."

With a textured surface, varied brushstrokes, and a fall palette all characteristic of Rembrandt's late work, historians have dated *The Return of the Prodigal Son* to 1688. In fact, the work was still in Rembrandt's studio when he died the following year. The famous parable of the impoverished son returning to his father's house and falling to his knees resonated with the aging artist. Like the prodigal son, Rembrandt lost everything at the end of his life—from his loved ones to his elegant canal-front home and studio in Amsterdam. Years of overspending, financial mismanagement, and accumulated debt combined with an economic depression in Amsterdam had all contributed to the artist's financial ruin.

Dmitry Golitsyn's luck continued in Brussels. In the spring of 1768, he bought several paintings for Catherine from Prince de Ligne, followed by the paintings and drawings collection of Count Johann Carl Cobenzl, Maria Theresa's plenipotentiary minister in the southern Netherlands. Like his better-funded boss, Charles-Alexander, Duke of Lorraine, Cobenzl was a passionate collector. During his tenure in Brussels, the diplomat and statesman founded the Academy of Arts and the School of Drawing. Cobenzl decorated his Brussels home with exquisite marquetry

furniture, Sèvres porcelain, and a small but choice trove of forty-six paintings. Among the Flemish and Dutch works to arrive at the Winter Palace were Russia's first three authentic paintings by Flemish baroque artist Peter Paul Rubens—*Roman Charity*, *Statue of Ceres*, and *Portrait of Charles de Longueval*. Cobenzl's cache also included Gerrit Dou's *La Devideuse*, Rembrandt's *Polish Nobleman*, and Jan Davidsz de Heem's *Vase of Flowers*.

The real treasures of the Cobenzl collection were drawings—some 4,030 of them. Since the 17th century, Europe's royal art collections had included works on paper and Catherine was intent on founding a prestigious cabinet in Russia. From the 15th and 16th century came sheets by Albrecht Dürer, Hans Holbein the Younger, and Piero di Cosimo. The 17th and 18th centuries were represented by giants like Rubens (some two dozen sheets), van Dyck, Rembrandt, Poussin, Claude Lorrain, and Antoine Watteau. The collection was especially rich in Italian, French, and Flemish schools, including 120 French crayon portraits, the largest such collection outside France. One of the highlights was a black and red chalk portrait of Charles IX by François Clouet, master of the crayon portrait. Clouet used this drawing for his full-length portrait of the king (now in the Kunsthistorisches Museum, Vienna).

In the early 1760s, Cobenzl entrusted his nephew, Philipp Cobenzl, with organizing and cataloguing his remarkable drawings. Each drawing arrived at the Winter Palace glued onto a dark violet card, along with an engraved cartouche featuring the artist's handwritten name. Classified by author and school, the drawings were arranged in alphabetical order in special folders and wooden boxes with a bound manuscript catalogue. Catherine kept the Cobenzl trove and her subsequent drawings acquisitions within close reach in her library.

With advice from the trendsetting Diderot, Dmitry Golitsyn also commissioned works for Catherine from contemporary French artists. A critic of the prestigious Paris salons, Diderot had unique access to the latest in French art. Diderot hated the erotic paintings of François Boucher and his protégée Jean-Honoré Fragonard, believing their work to be beautiful but without moral content. "Degradation of taste, color, composition, character, expression, and drawing have kept pace with moral depravity," he wrote about Boucher's sensual pastorals. "What can we expect this artist

to throw onto the canvas?"[2] Instead, Diderot steered Catherine toward French painters Jean-Baptiste Greuze, Jean-Baptiste-Siméon Chardin, Joseph-Marie Vien, and Louis-Michel van Loo, along with Venetian-trained Francesco Casanova.

Though Chardin was schooled in the rococo style, he gave his modest still lifes a sublime sense of mystery. Catherine liked Chardin's *Still Life with Attributes of the Arts* so much that she kept it at the Winter Palace instead of giving it to the Academy as planned. In 1766, after Diderot praised Greuze's *Paralytic* as an "outstanding example of moral painting," Golitsyn bought it for Catherine. "Hasn't the brush been consecrated to debauchery and vice long enough?" wrote Diderot. "Should we not be pleased to see it compete with drama in an effort to move, instruct, correct and invite us to virtue? Be brave, my friend Greuze. Paint moral pictures and go on painting them!"[3]

Diderot combed Paris's salons, studios, and picture galleries on Catherine's behalf. In 1768, he tipped her off about the impending auction of the prestigious collection of Jean-Louis Gaignat, Louis XV's late secretary. As an official at the Palace of Justice, Gaignat had displayed his paintings, furniture, and decorative arts at his home on the tony rue de Richelieu. He was also one of 18th-century France's premier bibliophiles. ". . . His [book] collection was regarded as perfect; it was said that 'no one in the commonwealth of letters had ever brought together such a rich and admirable assembly,'" wrote Charles Isaac Elton.[4] Diderot took a more sarcastic view, writing Catherine that Gaignat "had collected some wonderful works of literature almost without knowing how to read and some wonderful works of art without being able to see any more in them than a blind man."[5]

The following February, Diderot found himself competing for Gaignat's paintings against serious collectors like the Duc de Choiseul. Because of the high demand, Diderot had to settle for just five works for Catherine: Jean-Baptiste van Loo's *Triumph of Galatea*, three nude bathers by Geritt Dou, and Bartolomé Esteban Murillo's *Rest on the Flight into Egypt*, which Falconet described as "a painting to speak of on one's knees."[6] Diderot failed to nab Rembrandt's *The Carpenter's Family*, which wound up at the Louvre. Catherine was not about to let another such opportunity get away again.

CHAPTER FOUR

THE SAXON RICHELIEU

E ven with the Russo-Turkish War underway, Catherine instructed her diplomats and art scouts to keep an eye out for masterworks. In 1768, Russia's ambassador to Dresden, Prince Andre Belosselsky, advised Nikita Panin of the impending sale of Count Heinrich von Brühl's coveted art collection. Saxony's controversial former chancellor had been found guilty of misappropriating large amounts from the Saxon Treasury and after his death in 1763, Brühl's property was sequestered. Five years later when the sequestration was lifted, Brühl's debt-ridden heirs were forced to sell his paintings and drawings.

"The pictures, the nature cabinet, and the weapons, I wish to have a catalogue and also would like to know whether they will sell wholesale and what it will cost," Catherine wrote Belosselsky. From a catalogue of nearly 1,000 paintings, Catherine marked the pictures she wanted, provided that "the pictures are by those artists under whose names they are listed in the catalogue."[1] Belosselsky brokered the deal for 90,000 rubles, or 180,000

Dutch guilders. "Everyone here is amazed at how little it cost us," he bragged.[2] More importantly to Catherine, Brühl's coveted paintings put her picture gallery on the map.

A chartered ship carrying the artworks sailed for Hamburg in 1769. When the artworks finally arrived at the Winter Palace quay, Catherine could barely contain her excitement. Inside the packing crates were such treasures as Rembrandt's *Portrait of an Old Man in Red*, Rubens's *Perseus and Andromeda*, Poussin's *Descent from the Cross*, and Watteau's *An Embarrassing Proposal*, along with some twenty pictures by popular Haarlem landscape artist Philips Wouwerman. Brühl's prestigious works on paper collection was almost an afterthought—fourteen large leather-bound in-folio albums crammed with some 1,020 Old Master sheets by French, Dutch, and Italian masters. Among the artists represented were Paolo Veronese, Poussin, Rembrandt, Jacob Jordaens, and Sebastien Bourdon. Lucas Conrad Pfandzelt, the Hermitage's first professional restorer, hurriedly worked to repair some of the canvases damaged during the long voyage. Court chronicler Jakob von Stahlin drew up a detailed inventory of 346 of the paintings, arranged alphabetically by artist's name.

The man responsible for the treasure trove was an unlikely connoisseur. At age eighteen, Heinrich von Brühl joined the Dresden court of Friedrich August I, Elector of Saxony, as a lowly page. In 1697, Augustus the Strong ascended the Polish throne as August II when the Commonwealth of Poland and Lithuania merged with Saxony. The elector's nickname, Augustus the Strong, didn't refer to his military prowess, but rather to his inexhaustible capacity for women and drink. The debauched ruler had 354 illegitimate children, even taking some of his numerous daughters as mistresses.[3] Besides women, Augustus the Strong's other obsession was porcelain, known as "white gold." He famously traded a regiment of six hundred Saxon soldiers for Frederick the Great's cache of Asian porcelain vases.

Though China and Japan had produced porcelain for centuries, the recipe continued to elude Europeans. To expedite the process, Augustus imprisoned a young alchemist, Johann Böttger, until he came up with the basic formula. From his new porcelain factory in nearby Meissen, Augustus ordered hundreds of life-size porcelain birds to decorate his riverfront

Japanese Palace. With the Green Vault to display Saxony's jewels and a new royal picture gallery, Augustus turned Dresden into one of Europe's top art capitals.

When Augustus died in Warsaw in 1733 after a raucous drinking binge, his only legitimate son, Friedrich Augustus II, became joint ruler of Saxony and Poland, taking the name Augustus III. Married to Maria Josepha, daughter of Joseph I, Holy Roman Emperor, the supremely lazy new monarch abdicated all responsibilities to self-serving Heinrich von Brühl. Over the next two decades, Brühl became Saxony's most powerful man. His innumerable titles included prime minister, minister of the royal council, chief of the courts and the civil service, administrator of state, secretary of the treasury, and general.

Brühl proved disastrous as a statesman, shamelessly embezzling from the Saxon treasury and amassing a vast personal fortune of capital, farms, factories, and art. When it came to cultural matters, Brühl was far more successful. As head of acquisitions for the royal picture gallery and director of Meissen, along with Dresden's opera and theatre, Brühl helped the city earn the nickname "Florence on the Elbe." With Brühl's help, Augustus III outbid collectors like Frederick the Great, elevating Saxony's painting collection into one of Europe's most prized. The gem of Augustus's collection, Raphael's coveted *Sistine Madonna*, arrived from Piacenza just before the start of the Seven Years' War.

In parallel with the royal picture gallery, Brühl assembled a private trove of paintings, porcelain, drawings, and sculpture with state monies. Encouraging Augustus's collecting mania as a cover for his own expensive hobby, Brühl was able to leverage the Elector's extensive network of agents. In April 1742, Brühl wrote Samuel de Brais, Augustus's art agent and envoy in Paris to keep an eye out for "favourable opportunities" at a good price, even if they contain "some nudities or other subjects not considered proper by some people . . ."[4]

Unlike Augustus, who didn't care for contemporary French art, Brühl collected works by Boucher, Nattier, and Chardin at the suggestion of Carl Heinrich von Heineken, the influential director of the Elector's Print Room. In thanks for his advice, Brühl arranged for the connoisseur to marry the wealthy daughter of Augustus's chef in 1742. Alchemist Johann

Christoph Adelung described Brühl's picture gallery as "incomparably more magnificent than the king's and an hundred and fifty six ells long, [about 100 yards, or the length of a football field] which is eighteen more than that of Versailles."[5]

Among the many European artists lured to Dresden was Bernardo Bellotto, nephew of the famous Venetian view painter Canaletto. Early on, the young artist appropriated his uncle's techniques, going so far as signing many of his canvases "Canaletto." In 1747, Augustus invited Bellotto to Saxony, commissioning a series of large panoramic views, including Dresden, bucolic Pirna in the Elbe Valley, and the Konigstein fortress. With their mix of photographic detail and creative license, Bellotto's panoramas of Saxony are considered among his finest (the artist's own etchings of his Dresden paintings have been compared to those of Piranesi's views of Rome).

Bellotto's first *veduta*, or view painting, for the elector, *Dresden from the Right Bank of the Elbe above Augustus Bridge*, features the city's splendid baroque riverside buildings. Reflected in the water at the edge of the canvas is Brühl's picture gallery; to its right is his 62,000-volume library. Brühl had commissioned the magnificent Elbe residence a decade earlier from architect Johann Christoph Knöffel. Goethe would later call its terraced garden the "Balcony of Europe." With his impressive debut, Bellotto became Augustus's court painter. The next in his series, *The Neumarkt from the Jüdenhof, Dresden*, included the portly elector inside a careening carriage on route to visit his new picture gallery, converted from the former royal stables.

Bellotto's speed (he could whip up a view painting in six to twelve weeks) allowed him to moonlight for private clients. Anxious to curry favor with the powerful Count Brühl, Bellotto replicated twenty-one of the twenty-five views he'd painted for Augustus. The result was thirteen views of Dresden and eight of Pirna in smaller scale. A lawsuit brought by Bellotto against Brühl's heirs confirms that the count failed to pay the artist the contracted sum of two hundred thaler per painting (ten of these canvases reside at the Hermitage).

In addition to paintings and drawings that adorned his palatial homes, Brühl decorated himself with riches. Each day, the Count chose from

850 snuffboxes, fans, watches, gold and silver magnifying glasses, and spectacles. "A painting of each suit, with the cane and Particular snuffbox belonging to it, was very accurately drawn in a large book, Which was presented to His Excellency every morning by his valet de chamber, so that he might decide upon the dress in Which He wished to appear in continuous day[s]," wrote Scottish traveler John Moore.[6] Brühl liked being known as the "Saxon Richelieu" and enjoyed comparisons to the great Roman art patron Maecenas. Others were far less complimentary. "What a number of wigs for a man without a head!" quipped Frederick the Great about his extravagant nemesis at the Saxon court.[7]

In 1733, Augustus III appointed Brühl director of the Meissen factory, granting him the unprecedented privilege of commissioning porcelain free of charge. Taking full advantage of the freebies, Brühl ordered seven table services and thousands of porcelain figures. British envoy Sir Charles Hanbury-Williams (who a decade later would introduce Catherine to Stanislaus Poniatowski in St. Petersburg) sent home colorful descriptions of Dresden's court where Augustus had an "absolute and avowed hatred to all business" and the queen was "ugly beyond painting and malicious beyond description." As for Brühl, Hanbury-Williams was astounded by his reckless lifestyle and found his palace "in extreme bad taste and extravagance."

The diplomat was impressed however by a dinner party Brühl hosted in 1748. "I was once at dinner where we sat down at one table two hundred and six people [at Count Brühl's]. . . . when the Dessert was set on, I thought it was the most wonderful thing I ever beheld. I fancyd myself either in a Garden or at an Opera. . . . the middle of the Table was the Fountain of the Piazza Navona at Rome, at least eight foot high, which ran all the while with Rose-water, and its said that Piece alone cost six thousand Dollars [thaler]. I verily believe that Count Brühl has above thirty thousand Pounds worth of China in his house."[8]

Of all Brühl's extravagances, the Meissen Swan Service stands out. Commissioned in 1737 to celebrate his marriage, the milky white 2,200-piece dinner service took Meissen five years to produce and is the largest 18th-century porcelain service on record. For three years, Brühl's pastry chef visited the factory twice a month to consult on the service. The maritime theme was a play on Brühl's name, which meant "watery" in German.

An enormous table fountain spouted water from dolphins' mouths into shell-shaped basins. A soup tureen, over one and a half feet tall, featured the mythical sea nymph Galatea and a putto encircled by a billowing drape on the domed cover. Smaller tureens sported Venus in a seashell chariot, dolphins, swans, putti, and nymphs.

Brühl's ostentatious lifestyle included a livery staff equal to that of the Dresden court. "Count Brühl's family, officers and servants included, did not amount to less than 200 persons," wrote Adelung, "he had 12 chamberlains, 12 pages, equerries, stewards, clerks of the kitchen and yeomen of the cellar: with all the train of various denominations found in the most splendid court; in the kitchen are head cooks, 12 inferior, with scullions to the number of about 30; to the cellar and confectionery belong very near a much like number; and as for the servants in the livery they exceed a hundred."

Adlung also observed that in the years he spent in Dresden "never less than 30 dishes of meat were served up to count Brühl's table, and that with such waste, that servants easily found the means to smuggle very costly things out of the house; the standard of a private treat was 50 dishes, and every publick entertainment at least consisted of 80 or 100; since that time I have been at the court of kings where the stated number of dishes for the royal table was only 12, and when the sovereign dined in publick it did not exceed 24 or 30."[9] Roasted swan was one delicacy frequently served at the count's dinners, rewrapped in its beautiful white plumage.

Brühl unsuccessfully tried to justify his conspicuous consumption as boosting Saxony's economy. Aside from his huge Meissen orders that drained the factory's resources, Adelung noted that "the traders of Saxony are little beholden to count Brühl's dissipations; his shoes come from Paris, 100 pair at once, and his wigs by the dozen; and even his tarts used to be sent by post from the same city, that mother of abominations of the earth. Dresden and Leipsic make very good chocolate, but that for his Excellency must come from Rome or Vienna; in short, I scarce saw anything in his house which was either the produce or manufacture of Saxony."[10]

On the eve of Prussia's invasion in September 1756, Augustus III and his court fled the capital. Their first stop was Königstein, the Saxon military base. After the Saxon army suffered a decisive defeat at the foot of

the Lilienstein, the elector and his entourage left for Warsaw where they sat out the entire Seven Years' War. Brühl, an unpopular figure in Poland, was widely seen as a usurper of power who'd accumulated his vast fortune illegally. Still, by raising his rank to a Polish noble, Brühl had been able to hold office and acquire numerous properties. Now, he continued his princely lifestyle in Warsaw—enjoying a residential city palace, a pleasure palace in Mlociny, and two suburban summer houses in Wola and Nowy Swiat. It was all part of Brühl's extensive land holdings that included estates on the outskirts of Dresden and Poland, along with Schloss Knoffel, a luxurious residence between the two capitals.

Meanwhile "Florence on the Elbe" lay in ruins. Frederick the Great's troops destroyed some 225 buildings within Dresden's inner city along with suburbs outside the city walls. The Prussian king seems to have targeted Brühl's estates for plunder, including his famous terrace known only from Bernardo Bellotto's view paintings and a series of engravings by Michael Keyls. In the closing months of 1761, with his main patrons in Warsaw, Bellotto returned to Dresden to find much of the city destroyed, including his own house. Climbing the surviving part of the Kreuzkirche steeple, the Venetian viewed the destruction. His *Ruins of the Church of the Holy Cross* was an eerie omen of Dresden's fate during World War II.

In spring 1763, with peace imminent, the Saxon court returned to devastated Dresden. Rumors of Brühl's two decades of embezzlement became public. About Brühl, economist Johann von Justi wrote: "I have sometimes employed myself in tracing from the commencement of his ministry, and cannot discern in him one single ray of patriotism, one spark of a real concern for the welfare of Saxony. Sway'd by a boundless avarice and ambition, intent only on the aggrandizement of himself and his family . . ."[11] Just three weeks after the death of Augustus III in October, Brühl died of asthma in his silken bed surrounded by his art collection.

Thanks to Catherine, Saxony lost the Polish crown to Stanislaus Poniatowski in 1764 and became a third-rate political power. Returning from exile in Prague and Munich, Saxony's new elector Friedrich Christian held Brühl responsible for the country's financial ruin and issued legal proceedings against his heirs. For the trial, experts catalogued Brühl's possessions—from drawings and Old Master paintings to watches and

wine. Even more valuable than Brühl's lavishly furnished properties was his trove of jewelry. In his will, Brühl had directed that his snuffboxes and other jewelry be evenly divided among his sons. But to pay his enormous debts, the snuffboxes were sold at auction along with most of his estate. "Truly a curious sight," is how James Boswell described an October 1764 sale in Leipzig. "There were upwards of 700 Snuff-boxes in gold and many of them very rich with diamonds."[12]

Among the six hundred Brühl paintings Catherine unpacked was a very large canvas by a precociously talented Renaissance teenager named Tiziano Vecellio. Born in Pieve di Cadore at the base of the Dolomites on the Venetian side of the Alps, Titian trained with mosaicist Sebastiano Zuccato, followed by Gentile Bellini and his brother, Giovanni Bellini, and Giorgione. It did not take long before commissions began pouring in for religious paintings and portraits of Italian aristocrats. Later, as the favorite painter of Holy Roman Emperor Charles V and his son Phillip II of Spain, Titian amassed wealth and status with his portraits, mythological pictures, and religious paintings.

The Flight into Egypt (c. 1506) originally adorned another palace—the ground floor hall of a Venetian palazzo on the Grand Canal (today's Casino of Venice). ". . . In the wood in that picture . . . he painted many animals, which he portrayed from the life; and they are truly natural and almost alive," wrote Vasari in his *Life of Titian*.[13] Two centuries later, Brühl's friend Franceso Algarotti echoed that sentiment calling Titian the "Homer of landscape painters." "His views are so lifelike, so varied, so fresh, they invite you to take a walk in them."[14]

Considered one of Titian's earliest masterpieces, *The Flight into Egypt* depicts the biblical story of the holy family escaping King Herod's massacre of newborn boys, with Mary and the infant Jesus on a donkey and Joseph following behind. In addition to charming animals that animate the canvas (bullock, hawk, fox, and deer), Titian added the mountain peaks of Cadore, a view he enjoyed as a boy. From his mentor Giovanni Bellini, Titian learned to add scenic vistas to a variety of genres. Other influences include Giorgione's mystical landscapes and the detailed botanicals of Albrecht Dürer, working in Venice when *The Flight into Egypt* was painted. While reflecting the influences of his talented colleagues, the painting also

displayed the bold brushwork and exquisite palette that became Titian's signatures.

During the second half of the 19th century, *The Flight into Egypt* was moved from the Winter Palace to Gatchina; in 1924, it went back to the Hermitage. Long neglected, and its terrible condition worsened by a bad 18th-century restoration, the painting was recently resurrected by Hermitage conservators. Twelve years of meticulous conservation revived Titian's luminous colors—from the green foliage and blue sky and stream to Mary's pink dress and Joseph's gold cape.

Among the other Brühl's masterworks on Catherine's checklist were three paintings by Peter Paul Rubens: *Perseus and Andromeda*, *Landscape with a Rainbow*, and an early 1608 oil sketch for the Fermo altarpiece, the *Adoration of the Shepherds*. Each exhibited the energetic, sensual style and brilliant palette that made Rubens so popular in his day. Like Catherine, Rubens was a connoisseur of ancient history, literature, and antiquity, and an avid art collector. Eight years in Italy gave the Antwerp-based artist a profound lifelong appreciation for classical sculpture, Renaissance masters like Raphael and Michelangelo, and the revolutionary new style of Caravaggio. Dubbed the "Appeles of our time" after Alexander the Great's court painter, the prolific artist worked in numerous genres—from history paintings and biblical works to allegorical pictures, portraits, and landscapes. The Flemish master did not lack in confidence. "My talent is such that no undertaking, however vast in size, or diversified in subject, has ever surpassed my courage," he wrote in September 1621.[15]

It was around that time that Rubens painted *Perseus and Andromeda*, considered a masterpiece of the Hermitage. *Perseus and Andromeda* can be interpreted as allegory for Flanders's plight, with the helpless Andromeda representing his embattled homeland and the armor-clad Perseus the forces of Spain. Expressive beyond its small size, the easel painting was likely produced for a private connoisseur's cabinet. Combining thick brushstrokes with fine layers of smooth paint, Rubens created a rich, harmonious composition.

As told by the poet Ovid, Andromeda, the beautiful daughter of Ethiopia's queen Cassiopeia, is about to be sacrificed to a sea monster sent by Poseidon. Perseus, son of Zeus and Danae, arrives to save her on the

back of his magical winged horse Pegasus. As cherubs free Andromeda, the goddess of glory descends from Olympia to crown Perseus with a laurel wreath. Another cherub catches the hero's shield emblazoned with Medusa's petrifying stare, while a cohort flies off with his helmet. Perseus's reward for killing the beast is the lifelong love of the Ethiopian princess, depicted by Rubens as a buxom Flemish woman. In his eagerness to save his daughter, King Cepheus forgot his promise to his brother Phineus that he could marry her. When Phineus crashes his niece's wedding, Perseus uses Medusa's head to turn his army into stone.

Perseus and Andromeda probably remained in Rubens's Antwerp house until his death; an engraving from 1684 depicting the façade of his home shows the painting through the window of the second floor. The story of the heroic bridegroom seems to have had a personal resonance for Rubens. The artist chose the same composition to decorate the courtyard frieze between the second and third stories of his house, a practice used by Italian Renaissance artists like Mantegna and Giorgio Vasari.

As Catherine was hanging her new pictures, she took advantage of another opportunity to connect her reign with Europe's Enlightenment. On June 3, 1769, astronomers around the world readied their telescopes for the rare astronomical phenomenon, the transit of Venus. By timing the entrance and exit of Venus across the sun from latitudes all over the world, scientists hoped to answer astronomy's most pressing question—the distance between the Earth and the Sun and the size of the universe. The rare phenomenon occurs when Venus passes directly between the Sun and Earth. During a transit, Venus can be seen from Earth as a small black disk moving across the face of the Sun.

The Enlightenment's best scientists were coordinating expeditions around the world—from Benjamin Franklin spearheading calculations in the colonies to Captain James Cook transporting scientists to Tahiti. When the last transit occurred eight years before, the only observations in Russia had been recorded by a Frenchman in Siberia. Catherine wasn't about to let that happen again. In 1767, she ordered Vladimir Orlov, director of the Imperial Academy of Sciences, to prepare for the six-hour transit of Venus "with the utmost care." Catherine herself participated in the logistics— from identifying the best locations and building observatories to training

Russian naval officers to take measurements with the most sophisticated telescopes and quadrants available. Before departing for their mission, Russian astronomers met the empress at the Winter Palace.

Shortly after sunrise, a group of astronomers, including Czech Christian Mayer and Finnish-Swedish Anders Johan Lexell, gathered around a refracting telescope on the upper floor of the Imperial Academy of Sciences to view the last part of the transit. Meanwhile, Russian astronomer Stepan Rumovsky coordinated measurements by his compatriots at eight other locations throughout the Empire. Impressively, the combined results from the worldwide measurements were within 4 percent of today's accepted value of 93 million miles. Catherine's government-funded observations helped enhance Russia's prestige abroad. Like her favorite Gregory Orlov, the empress loved observing the night sky with a telescope from a small wooden observatory with large windows on the roof of the Winter Palace.

CHAPTER FIVE

THE EARTH AND SEA TREMBLED

Despite the large taxes and budget problems caused by the protracted war with Turkey, Catherine intensified her search for great art. In fact, she began collecting with a complete disregard for cost. From her perspective, art collecting was a matter of state, vital to her reputation as one of the world's most enlightened rulers. An exceptional picture gallery not only strengthened her status and authority, it heightened Russia's international prestige. As masterworks began arriving at the Winter Palace by the boatload from France, Holland, and England, Catherine grew increasingly discriminating and well informed, lending the same personal attention and energy to collecting as she did to other areas of governing.

After listening to her advisers, Catherine weighed in with her own opinions, making the final decisions. When Melchior Grimm bought a series of gouaches in Paris too quickly, she wrote back: "Do you know that relying on someone else's opinion is not always the best way to form a

correct opinion? You are one of those people who should rely more on yourself than others. ..."[1] Though Catherine was not especially religious, she bought hundreds of paintings that had been produced under patronage of the Roman Catholic Church. On one occasion, the hands-on empress even helped the keeper of the Hermitage collections clean mold from damp artworks.

Catherine's picture gallery was increasingly becoming a reflection of her own taste. Her canvases were generally mounted in gilded, silvered, or simple wood frames, though some were frameless. Paintings were hung to create a pleasing effect, not chronologically or by school. There was one exception to this rule. Catherine's fifty-four Rembrandts enjoyed their own gallery, known as the Billiard Room. Though many of these were later reattributed, the collection was still extraordinary considering that the French royals owned just eight Rembrandts at the time.

Catherine bought most of her paintings sight unseen. If she didn't like a picture, she would often present it as a gift or relegate it to storage. Such was the case with Joseph-Marie Vien's painting *Minerva*, which she donated to the Academy of Fine Arts, and Charles van Loo's works from the L. M. van Loo collection. Though nudity was perfectly acceptable in mythological canvases, eroticizing human sexuality was seen as self-indulgent, a violation of the Enlightenment emphasis on self-control. It's not surprising then that Catherine, ardent disciple of the Enlightenment, banished Guilio Romano's explicitly erotic canvas *The Two Lovers*. In the large six-by-eleven-foot canvas, an old procuress and her dog spy on a semi-undressed couple in their disheveled boudoir. In 1989, Hermitage curators dusted off the long-overlooked painting for a Giulio Romano monograph exhibition in Mantua, where the artist worked for the dashing Duke Federico Gonzaga.

A watershed moment in Catherine's reign—Russia's surprising annihilation of the Turkish fleet in Chesme Bay—inspired a number of propagandistic commissions. Under Catherine's direction, artists and architects mythologized what the empress called Russia's "first naval victory in nine hundred years." It was all the more remarkable since the commander, Alexei Orlov, had never been to sea prior to this naval victory. After her coup eight years earlier, Catherine had compared Russia's rusty naval fleet to herring boats. She quickly set about reorganizing the navy, authorizing up to forty ships of the line, nine frigates, eight bomb vessels and prams,

and 150 galleys. Young Russians were dispatched for training on British ships, and fifty British officers were recruited between 1764 and 1772. In the midst of war with Turkey, having negotiated with Britain friendly ports for her Baltic Sea fleet, Catherine shocked the international community with a daring plan to fight the Turks in the Mediterranean.

"Sir, what news I have for you today!" Catherine wrote Voltaire in September 1770. "My fleet, under the command not of my admirals, but of Count Alexei Orlov, have defeated the enemy fleet, has razed it all to ashes in the port of Chesme. . . . Nearly a hundred ships of every kind were burned to cinders. . . . He [Orlov] found himself with nine battleships facing sixteen Turkish ships-of-the-line. The number of frigates and other men-of-war was still more disproportionate. He did not hesitate, and found the resolution of his officers to be such that they were all of one mind—to conquer or die. . . . They say that the earth and sea trembled with the huge number of exploding enemy ships. . . . War is an ugly thing, Sir. Count Orlov tells me that the day after the burning of the enemy fleet, he saw with horror that the water in the harbor of Chesme, which is not very large, was stained with blood, so many Turks had perished there. . . ."[2]

Catherine turned the war into an art genre, commissioning numerous sculptures, paintings, and decorative artworks to celebrate Russia's victories. French enameler and jeweler Charles-Jacques de Mailly created an inkstand for Catherine with miniatures of key military episodes. In 1771, Catherine wrote Voltaire: "If this war continues my garden at Tsarskoye Selo will soon resemble a game of skittles, because I put up a monument there after each of our glorious battles."[3] The most famous of the empress's war-themed commissions was a series of large paintings depicting Russia's glorious naval expedition into the Aegean. At the recommendation of Johann Friedrich Reiffenstein, the prestigious commission went to Jakob Philipp Hackert.

By selling his classical views of famous Italian sites as souvenirs to Grand Tourists, Hackert had become one of the most successful German painters in Rome. Born into a family of Brandenburg painters, Hackert began his career copying the ideal landscapes of French master Claude Lorraine and 17th century Dutch artists. From 1765 until 1768, Hackert lived in Paris where he was inspired by the celebrated landscape painter Claude-Joseph

Vernet. In 1768, Hackert left for Rome, whose classical ruins and architecture made a profound impression and where he befriended Reiffenstein. Doors opened for Hackert in 1770 when he visited Naples with a letter of introduction to Sir William Hamilton, England's art-loving ambassador.

After accepting Catherine's commission in October 1771, Hackert traveled to Livorno to meet Admiral Alexei Orlov, commander of the Russian fleet. For his successes, Catherine had granted Orlov the honorific surname Chesmensky. Orlov shared details of the battle with Hackert—including specially produced plans of Chesme Bay that indicated the location of the enemy fleets. With Catherine's approval, Orlov extended the commission from two to six pictures. That fall, Hackert executed a number of small preparatory gouache paintings as models for the large oil paintings. Early the next year, Hackert took the first canvas to Livorno for Orlov's approval. But neither Orlov nor Sir Samuel Greig, the Scottish rear admiral who'd masterminded the battle, liked the work. To help Hackert depict the explosive battle more authentically, the Russian naval commanders decided to stage a recreation.

On April 27, 1772, at ten o'clock in the evening, an old sixty-cannon Russian frigate loaded with gunpowder was blown up in the Livorno harbor. From a small boat, Hackert sketched the fiery event, leading him to alter the details of his painting. Later that year, Hackert sent *Destruction of the Turkish Fleet at the Bay of Chesme* to St. Petersburg. The canvas depicts the central episode in the battle—the explosion of the one-hundred-gun Turkish flagship *Ibrahim Hasameddin*, surrounded by ships of the Russian squadron, including Alexei Orlov's sixty-six-gun ship *The Three Bishops* in the foreground.

Thrilled, Catherine ordered another six paintings from Hackert the following year to complete the first series. The remaining subjects were taken from contemporary documents, log book entries, battle charts, and reminiscences of eyewitness sailors. In the 1770s, Catherine decided to dedicate official space at Peterhof Palace to the naval victory, and asked Yury Velten to rework the antechamber as the Chesme Room. Hackert's twelve-work series was arranged in two rows along the three blank walls, including *Burning Turkish Battleships in Chesme Harbor*.

The staged ship explosion rocketed Hackert into overnight celebrity. The artist turned down Catherine's offer to become a court painter in Russia as

commissions poured in from the Queen of Greece and the Kings of Naples and of Prussia. In the second half of the 1770s, Hackert produced copies of the Chesme series for Prince Nicolai Yusupov (fire destroyed the paintings in 1820). Hackert ultimately became Ferdinand IV's court painter in Naples, Italy's third most populous city and a requisite stop on the Grand Tour with its sensational Roman ruins. Working with diplomat Andrey Razumovsky, Hackert also moonlighted as an informant for Russia.

The year 1770 continued to be auspicious for Catherine. In addition to her military triumph at Chesme, she scored several victories on the collecting front. In 1770, Dmitry Golitsyn and Denis Diderot convinced Swiss banker François Tronchin to sell ninety-five of his paintings to Russia's empress. The Geneva-born collector had acquired most of his art in Paris, Amsterdam, The Hague, and London, where his family's banking business took him frequently. After Tronchin & Cie liquidated in 1740, Tronchin returned to Geneva, where he became a political figure and authority on art collecting. In 1757, Swiss portraitist Jean-Etienne Liotard produced a pastel portrait of Tronchin showing him admiring his masterwork, Rembrandt's *Woman in a Bed* (National Gallery of Scotland, Edinburgh). It was Liotard, a collector himself, who encouraged Tronchin to take up collecting.

Tronchin's holdings grew to some 350 pictures, including over 210 Dutch masters. In 1765 Tronchin moved his collection into Les Délices, a property outside Geneva that his brother, Jean-Robert Tronchin, had acquired for Voltaire a decade earlier. That same year, Tronchin published a catalogue of his collection. Tronchin's small intimate Dutch, Flemish, and Italian cabinet paintings included such works as Willem van de Velde's seascape *Ships in the Road*, Emanuel de Witte's *A Protestant Gothic Church*, *Tavern Scene* by Adriaen Brouwer, and Giovanni Battista Maroni's *Portrait of a Man* with the inscription "Know thyself" (possibly the artist's self-portrait). Attributed to Titian at the time, the portrait was described by Tronchin as "of the most choice manner, very finished, and the colour the most precious."[4] In July 1770, Tronchin paid 290 rubles and 56 kopecks to ship his paintings cabinet to St. Petersburg, where it arrived by October. Tronchin's collaboration with Catherine the Great would continue. He sold her more paintings directly, and most importantly, he would soon help her snag her most prestigious acquisition, the Crozat collection.

Around this time, Denis Diderot bought pendants with pictures by history painter Carle van Loo—*The Spanish Conversation* and *The Spanish Lecture*, commissioned in 1754 by Marie-Therese Geoffrin. A correspondent of Catherine II's, Madame Geoffrin hosted a celebrated Paris salon that served as a model for Catherine's own gatherings at the Small Hermitage. In his obituary of van Loo in 1765, Diderot described these two paintings which feature talking and reading aloud, two popular salon activities: "Mme Geoffrin presided over these works, and every day there were scenes that would make you die of laughter," wrote Diderot. "Rarely in agreement on the ideas or on how they should be executed, they disagreed, were reconciled, laughed, wept, uttered insults and sweet words and it was amidst all these vicissitudes that the painting progressed and was completed."[5]

Catherine also turned her attention to restoring paintings with condition issues. In 1770, she ordered the Hermitage custodian, German artist Georg Leopold Pfandzelt, to transfer Lucas Cranach the Younger's *Christ and the Woman Taken in Adultery* from its original wooden panel onto copperplate. Painted after a similar work by the artist's father, Lucas Cranach the Elder (Museum of Fine Arts, Budapest, 1532), the popular subject depicts the famous episode from the Gospel in which Jesus tells the Pharisees: "He that is without sin among you, let him first cast a stone." The painting had arrived from Dresden split and damaged with a Latin inscription on the back noting that it had been mistaken for a work by Albrecht Dürer earlier in the 18th century. Pfandzelt's transfer made headlines and the painting was exhibited before and after treatment. Assisted by Venetian painter Giuseppe Antonio Martinelli, Pfandzelt restored other paintings from the Brühl collection. In 1775, Martinelli succeeded Pfandzelt as custodian of the Hermitage.

In 1771, at the urging of sculptor Étienne-Maurice Falconet, Catherine acquired Claude Lorrain's *Landscape with Christ on the Road to Emmaus* from a Parisian dealer. Also that year, Diderot bought Catherine several works from influential collector and courtier Ange-Laurent de Lalive de Jully, head of protocol at Versailles. Part of a wealthy circle that supported the *philosophes*, Lalive de Jully had invited Diderot to be his guest at La Chevrette, his family's château. Lalive represented a new type of collector that emerged in the final decades of the Ancien Régime, focusing on the art of his countrymen like Jean-Baptiste Greuze.

The middle-aged collector lost his mind around 1765, putting an end to his collecting. The three highly polished works Diderot bought from de Jully were by Dutch artist Gerrit Dou, Rembrandt's talented apprentice. Scouting for Catherine in Brussels, Dmitry Golitsyn soon paid 9,000 livres to a Madame Groenbloedt for a painting formerly owned by de Jully: Anthony van Dyck's early *Family Group*. The identity of the young couple and their adorable baby girl remains a mystery. Until 1893, they were thought to be still life painter Frans Snyders and his family; a subsequent theory identified them as landscape artist Jan Wildens and family.

In late May, Catherine's attention shifted from art to a major emergency. In the nearly seventy years since its founding, St. Petersburg was being ravished by a series of floods and fires. From her window at the Winter Palace, she watched in horror as a fire broke out on Vasilevsky Island, spreading through the crowded merchant warehouses. Strong winds caused the fire to jump to the Kolomna district southwest of the Palace before changing direction and moving north. Catherine responded immediately, dispatching Gregory Orlov to help the city's police chief recruit fire fighters.

"I sent Count Orlov into town with instructions not to return until the last spark is extinguished," she wrote Nikita Panin. "He was there by nightfall on my orders for, catching sight of three places burning in the town, I was on the point of galloping off there myself. He returned at five o'clock and at eleven he galloped off again, for I think the Chief of Police's head was spinning at the sight of so much trouble. . . ."[6] Though Catherine blamed human carelessness for the fire that raged through the capital for two days, she spun a very different story to Voltaire: "There is no doubt that the wind and the excessive heat caused all the damage which will soon be repaired. In Russia, we build faster than in any country in Europe."[7] To reduce the chance of another inferno starting on Vasilevsky Island, Catherine ordered merchants to scatter their warehouses throughout the city.[8]

Dmitry Golitsyn, meanwhile, was still on the lookout for art for the empress. In July, he commissioned local dealers to buy the most outstanding paintings at the posthumous auction of Gerrit Braamkamp. A successful Amsterdam lumber merchant, Braamkamp had built a timber yard and shipyard opposite that of the Dutch East India Company. Over three decades, the businessman amassed the "Temple of Art"—an important

collection of 17th-century Dutch and Flemish art, some 380 works in all. Among the highlights were *The Visit to the Nursery* (1661) by Gabriel Metsu (now owned by the Metropolitan Museum of Art), *The Storm on the Sea of Galilee* by Rembrandt (1633), and *The Dance* by Antoine Watteau.

When Braamkamp died in June, his Amsterdam house was filled with paintings, furniture, jewelry, lacquer work, and silver. With high-quality paintings by popular Dutch artists, the ensuing auction caused a sensation, netting over 250,000 Dutch guilders for Braamkamp's heirs. Two of the most valuable of the 313 lots were hammered to Golitsyn's agents for Catherine: Paulus Potter's *Large Herd of Oxen* (9,050 florin) and Gerard Dou's *Braamkamp triptych* featuring genre scenes on wood panels (14,100 florin). Other Dutch Golden Age canvases secured for Catherine were Gerard ter Borch's *Woman at her Toilette* (1,870 florins) plus works by Philips Wouwerman, Cornelis Coedyk, and Gabriel Metsu.

Alongside barrels of herring, bags of coffee beans, and hundreds of bolts of cotton and indigo, Catherine's newest pictures were loaded into the hold of a Dutch merchant ship, the two-masted *Vrouw Maria*. Besides Catherine's canvases, there were half a dozen Dutch pictures that Golitsyn had bought for himself. On September 5, 1771, the *Vrouw Maria* set sail from Amsterdam. Before entering the Baltic, the ship paid customs duty to pass through the Danish strait. From there, it held a northerly course. At the mouth of the Gulf of Finland, the experienced Captain Reynold Lourens knew to change course to due east to avoid the rocky Finnish shoreline.

But something went terribly wrong. Lourens never changed course. Caught in a storm, the *Vrouw Maria* foundered on the rocks in the Finnish archipelago of Nagu (seven miles southeast of Jurmo). Though the rocks caused only minor damage, shortly afterward the *Vrouw Maria* ran aground again, losing its rudder. A large wave released the ship, but the frantic crew found it leaking rapidly. Lowering anchor, the crewmen manned the pumps, but the ship continued to take on water. At dawn on October 4, the crew safely reached a nearby rock from which they hailed a passing boat. Help arrived the next day, but after several days no progress had been made stabilizing the ship, whose pump was clogged with coffee beans. Only a fraction of the cargo could be salvaged. Five days later, the *Vrouw Maria* sank beneath the waves, taking Catherine's paintings with her.

An urgent correspondence ensued between Russian and Swedish authorities. On October 8, foreign minister Nikita Panin informed his Swedish counterpart that the ship with several crates of valuable paintings belonging to her Imperial Majesty had been lost near Turku, and urged him to help with the recovery. Catherine herself dispatched several expeditions in an effort to raise the *Vrouw Maria*, an indication that the pictures may have been packed in lead boxes sealed with wax and could be salvaged. But with ice expected within weeks, the salvage efforts proved impossible. Attempts to raise the ship the following spring and summer also failed as the wreck's location was lost. In a small consolation, one of the Braamkamp paintings, Pierre Mignard's *Return of Jephtah's Daughter*, survived. Sent on a different ship, it arrived safely at the Winter Palace.

Catherine wrote Voltaire that she felt like Job, who experienced disaster upon disaster, each worse than the preceding one. In the end, Catherine tried to be philosophic about her first setback as a collector. "A mere 60,000 gold pieces are lost," she wrote Voltaire in December. "We shall have to manage without them. 'well, there goes 60 000 écus . . . what can I do . . .' Only console oneself."[9]

PART THREE

WAR AND LOVE

CHAPTER ONE

QUEEN OF FEASTS

I n October 1770, a worried Frederick the Great dispatched his younger brother to St. Petersburg. Prince Henry's mission was to promote a partition of Poland and persuade Catherine to let Prussia broker a peace agreement with the Turks. But with her recent string of military victories, Catherine had no interest in ending the two-year war. Instead of talking peace, Russia's empress threw a lavish party in Henry's honor. Some 3,600 costumed guests filled twenty-one apartments of the Winter Palace.

Wine, vodka, and champagne were already flowing at nine P.M. when Catherine sashayed into the hall wearing a Grecian costume. Trumpets announced the arrival of Apollo, the four seasons, and months of the year played by children. "A great part of the company wore dominos, or capuchin dresses," wrote William Richardson, tutor to the children of Britain's ambassador, Lord Cathcart. "The Empress herself . . . wore a Grecian habit; though I was afterwards told that she varied her dress two or three times during the masquerade. . . . Several persons

appeared in the dresses of different nations, Chinese, Turks, Persians and Armenians."

When a Frenchman dressed as a parrot sounded off in Russian, French, and English, ". . . everybody laughed but Prince Henry, who stood beside the empress, and was so grave and so solemn, that he would have performed his part admirably in the shape of an owl," added Richardson. ". . . At different intervals persons in various habits entered the hall and exhibited Cossack, Chinese, Polish, Swedish and Tatar dances. The whole was so gorgeous, and at the same time so fantastic, that I could not help thinking myself present at some of the magnificent festivals described in the old-fashioned romances."[1] Four orchestras performed during dinner from a large overhead gallery. After dinner, actors staged a tableau vivant. Though the official program ended at midnight, dancing continued until five in the morning.

Catherine wrote to Voltaire about the elaborate soiree, knowing he'd share her description with his influential friends: "At dinner-time, Apollo, the Four Seasons and the Twelve Months made their entry. . . . In a short speech, Apollo invited the company to proceed to the banqueting hall. The hall was oval, and contained twelve alcoves, in each of which a table was set for ten. Each alcove represented a month of the year, and the room was decorated accordingly."[2]

Prince Henry's fête was part of Catherine's ambitious social calendar that featured receptions for rulers and ambassadors, balls and masquerades, and celebrations of family milestones, military victories, and peace treaties. Catherine staged these costly, choreographed productions to bolster the prestige of her court and empire. Catherine proved the consummate hostess, at once imposing and charming. ". . . [H]er majestic head and brow, proud look and dignified deportment made her seem taller than she was," observed France's envoy, the Count de Ségur, noting "her aquiline nose, well-shaped mouth, Saxe blue eyes beneath dark lashes, gentle glance and seductive smile."[3]

Catherine was a stickler for etiquette and ceremony, requiring other monarchs to address her by the dual titles empress and tsarina. Like France's Louis XIV, she received foreign diplomats while seated on a throne on a raised dais. Envoys had to address her in French, the official language of

her court, and kiss her hand. Catherine's own version of Louis XIV's *lever*, or "arising," featured morning meetings revolving around her toilette and breakfast, followed by elegant lunches and teas.

It was during Peter the Great's reign that napkins first appeared on the imperial table—since men no longer had beards with which to wipe their mouths. The tsar's culinary tastes were relatively modest. According to sculptor Andrey Nartov, ". . . His food consisted of cabbage soup, aspic, porridge, grilled [meat] with pickled cucumbers or lemons, corned beef, ham. He was particularly fond of Limburger cheese. All of the above was served by his chef Velten [father of Catherine's architect, Yury Velten]. Of vodkas, Peter the Great preferred anisette. His usual drink was kvass. At dinner, he drank Hermitage wine (red wine from the northern Rhône) and sometimes Hungarian wine [sweet Tokaj]."[4] Peter also popularized English stout, which he'd enjoyed during his visit in 1698.

Peter's youngest daughter, Elizabeth, who enjoyed cross-dressing at her frequent parties, took banqueting to a whole new level. Design aesthetics were so important that her guests often found themselves sitting with their backs to one another. The arrival of imported spices, tea, and coffee led to new types of tableware. At a dinner for forty in 1746, tables were set with 1,300 plates and dishes, along with 300 bonbon pyramids. Exotic menu items ranged from fricassee of nightingale tongues and ragout of deer lips to stewed bear paws and "opened this morning bulls' eyes" in sauce.

The ultimate in excess was the "Empress roast" which called for a lark stuffed with olives placed into a quail, the quail into a partridge, the partridge into a pheasant, pheasant into a capon, and capon into a suckling pig.[5] Dessert took the form of model boats and buildings, along with trompe l'oeil designs for sweetmeats. On one occasion, Elizabeth sent a care package to Frederick the Great with her favorite dish—pasties with *foie gras*, or duck liver.

Privately, Catherine's culinary tastes were more in line with Peter's. According to historians, her favorite dishes were boiled beef with pickled cucumbers and sauce made of dried venison tongues, boiled chicken, roast leg of mutton or beef, hash duck, and stewed mushrooms. The empress reportedly fed table scraps to her pack of Italian greyhounds. Isabel de Madariaga describes how Catherine, an early riser, lit her own fire so as

not to disturb her servants, and began work at five A.M., downing several cups of high-octane coffee.[6]

But understanding the propaganda value of luxurious dining, Catherine entertained frequently and lavishly, earning the moniker "Queen of Feasts." Under her watch, 13 percent of Russia's annual state budget went to the imperial court (versus 2 percent for education). It was not uncommon for Catherine's banquets to feature over one hundred dishes and last hours, sometimes until after midnight.

At Catherine's direction, her imperial chefs whipped up French-inspired delicacies like quail with truffles, pheasants with pistachio nuts, teal with olives, tortoise meat, and whole spit-roasted swans. Fresh oysters for 1,000 guests cost 300 times the annual wage of an average Russian worker. Pies with various fillings accompanied an array of soups. Menu items included stewed lamb with saffron, roast goose hare with noodles, edible offals and giblets, beef tongue, and lamb kidneys. At one imperial gala, Field Marshal Alexander Suvorov caused a panic in the palace kitchen when he ordered cabbage soup and groats.[7]

Typically, a master of ceremonies opened imperial galas with a grand polonaise, followed by waltzes, quadrilles, and a Russian folkdance. Afterwards, the host announced the names of the lucky guests who would sit with Catherine at the imperial dining table. During Elizabeth's reign, dinners were served *à la française*, or French style. In unison, gentlemen of the table would lift platter covers for the entire meal. This made a dramatic impression, but resulted in cold, hard to reach food. To remedy this, Catherine introduced dining *à la russe*, in which each of her guests received an individual serving of separate courses. In between courses, the tables were cleared, cleaned, and reset.

With the hot dish came ceremonial toasts, pronounced standing, champagne glasses in hand. The most important toast was the health of the empress drunk to the accompaniment of trumpets, drums, and cannon fire. On rare occasions Catherine raised a toast to one of her guests, considered a great honor. Last but not least came dessert, from the French word *desservir*—to clear the table. Music, dancing, or other entertainment frequently accompanied this course, which featured mounds of richly decorated fruit, bonbons, pastries, and ices. Popular ice cream flavors included

jasmine, chestnut, and violet. Catherine's favorite, Kolomna pastila, was made of whipped fruit purée.

In addition to the fifty-two Sundays of the year that called for feasting, Russians celebrated sixty-three festivals—twenty-five of which were dedicated to Catherine and her family. Five of these holidays honored the empress: her birthday, April 21; her accession to the throne, June 28; her coronation, September 22; her smallpox inoculation, November 21; and her name day, November 24. Milestones in the lives of Catherine's family members—like the birth of a grandchild, christenings, and name days—were also marked with banquets. Royal marriages, military victories, and visits by foreign dignitaries were opportunities for Catherine to advertise the magnificence of her court. Though rules for Lent and other religious fasts excluded meat, eggs, and dairy products, royal fare still managed to be incredibly rich with white sturgeon, salmon, and caviar with onions; and fish pies filled with mushrooms, peas, and berries.

Serving hundreds of dinner guests required a small army of waiters. Under the supervision of a count steward, court officers sporting German titles carried out specialized tasks. The *kuchenmeister* was the head chef, *tafeldeckers* set the tables, *mundschenk* (cup-bearers) poured alcoholic beverages, and *kaffeeschenk* served tea, coffee, and hot chocolate. *Konditors* and their assistants delivered dessert; table and crockery were the responsibility of buffet and kitchen officers.[8] Traditionally, leftovers were shared among the staff. Catherine and her family members sometimes left sweets behind as a tip. Food was also known to disappear from the imperial kitchen. On one occasion while strolling through her garden, Catherine spotted her staff carrying porcelain piled with peaches, pineapples, and grapes. "They might at least have left me the dishes," she joked.[9]

Inspired by their empress, Russian aristocrats also hired French chefs. Gregory Orlov and Catherine's advisers Prince Nikolay Repnin and Count Ivan Osterman impressed their guests with dishes like "sterlets an arshin, perch from their own pools; asparagus nearly as thick as a cudgel from their own gardens, veal as white as snow from calves nursed in their own cattle yard. Peaches and pineapples also came from their own hothouses; even tasty wine made of berries, something like champagne, was of their own production."[10]

To complement the elaborate cuisine, party planners decorated the Winter Palace to the nines. The sensory experience included cascading fountains, canaries in gilded cages, and staterooms scented with flowers, citrus trees, and perfume burners. Beneath candlelit chandeliers, gold and silver cutlery gleamed and crystal stemware sparkled. At feasts and holidays, the finest Parisian silver graced the tables, often decorated with symbols of the state and the Romanovs. "Silver was the currency of the time, and imperial silver services were akin to putting the state treasury on the table," writes Wolfram Koeppe. Catherine, "one of the most astute patrons of silver services," used them "as propagandistic displays of might."[11]

Right after her coup, Catherine consolidated the Romanov silver, ordering the most valuable objects from the numerous imperial residences transferred to the Winter Palace. Among the luxe items were silver and gold works by Johann Friedrich Köpping, son of Swedish silversmith Claus Jacob Köpping, who'd moved to St. Petersburg during Peter the Great's reign. Among Johann Friedrich's most striking pieces were ten four-branch candelabra, part of a large service he'd created for Elizabeth, along with the Petrovsky Silver Service, a gift from the tsarina to her nephew Peter. After naming Köpping "Court Keeper of Plate," Catherine had him augment the exceptional rococo "Parisian Service" designed for Elizabeth in 1761 by François-Thomas Germain, France's royal goldsmith. Catherine used this service for the most important state occasions.

Catherine amassed "silver products with the same passion that she applied to other art works," ordering fifty services during her reign, writes Marina Lopato, curator of European silver at the Hermitage.[12] Not wanting to rough it while on the road, Catherine commissioned Köpping to produce her First and Second Traveling Services. In 1763, members of the Preobrazhensky Guard regiment accompanied the delivery of imperial silver to Köpping's workshop for the First Service. To make sure that none of the precious metal disappeared, a lieutenant, sergeant, and six soldiers stayed throughout the commission.

During the reigns of Louis XIV and his grandson Louis XV, French luxury brands enjoyed a heyday. Among the ultimate status symbol was a dinner service by one of Paris's renowned silversmiths. Describing herself as "avid" for French culture and art, Catherine enlisted sculptor

Étienne-Maurice Falconet to procure a service "made in the latest fashion" in Paris. "I hear you have some designs for a silver service," Catherine wrote Falconet in early 1770. ". . . I should like to see them if you will show them to me, for I have a mind to order one for sixty people."[13]

The result of this "fantasy" as Catherine called it, was one of the largest orders of French silver ever produced—3,000 pieces from Jacques Roettiers and his son Jacques-Nicolas Roettiers. Members of a distinguished family that had served the French court as medalists and engravers since the 17th century, Roettiers occupied a prestigious location at the Louvre. But the goldsmiths' terms were excessive even for Russia's extravagant empress. In today's currency, the price tag was over $4.3 million, or an average of $1,440 per piece.

"I understand nothing of this way of reckoning," Catherine complained to Falconet. "They want 25,000 livres a month, and a year and a half of work makes, for eighteen months, 450,000 livres, which, I believe, is nearly 100,000 rubles . . . you will have the kindness to explain to these gentlemen, briefly and clearly, how many pieces there will be, what they charge for the silver and what for the work; then we will see if it pleases us to continue."[14] In May, Falconet assured Catherine that Roettiers' designs represented the best. "I believe these approach more nearly than the others good taste in silversmithing."[15]

The following month, Catherine signed the contract for the lavish service, marking the designs she approved, and authorizing monthly installments. The pieces were to be made of the usual standard of silver, slightly higher than sterling. They were also to be marked; the prestige of Parisian silver was so great that marks themselves had become a fashion statement. Catherine weighed in on the smallest design details while Falconet advised on stylistic matters. For the table service, tea service, and coffee service, Roettiers drew on an enormous repertoire of decorative motifs—laurel swags, guilloche and Vitruvian scroll borders, oyster shells, and rosettes.

With the average silver service numbering 200 to 250 items, Catherine's 3,000-piece order was unprecedented. To put the commission into perspective, Count Heinrich von Brühl's extravagant porcelain Swan Service numbered 2,200 pieces. While executing Catherine's order, Roettiers was busy making gold rings for the wedding of the future Louis XVI and Marie

Antoinette, refashioning a toilet service for the bride, and supplying silver objects for engagement gifts. To help complete Catherine's service, Roettiers called in reinforcements from four rival goldsmiths.

Between 1771 and 1773, six shipments containing 2,630 items arrived at the Winter Palace; a final shipment brought the total to 3,000 pieces. Besides the 576 dinner plates and 128 hors d'oeuvres, second course, serving, and dessert plates, there were 40 coffeepots, 16 chocolate pots, and 8 covered *pot à oille*—a special tureen for serving meat stew. Originally introduced from Spain, the soupy stew had become a standard part of French dining by the mid 18th century. Each tureen sported four scrolling legs, a frieze of laurel leaves and berries, and laurel wreath–shaped handles. Though Catherine was pleased with the glamorous service, she complained to Falconet about "two candelabra that are not beautifully designed. These pieces have confirmed my opinion that human figures should never be used for soup!"[16]

Before the Marquis de Juigné left his post as ambassador in St. Petersburg in 1779, Catherine snagged all the tableware from the French embassy. The same year, she ordered a gold coffee service for her two-year-old grandson, Alexander. Also around this time, through Melchior Grimm, Catherine requested designs for a solid gold service from Robert-Joseph Auguste, one of the first Parisian goldsmiths to work in the neoclassical style. "The execution of such a service was a thing so capital and so unique that, if Your Majesty deigned entrust him with it, he would leave and close his workshop, would devote himself entirely to a work of this importance, would make the journey to Russia if necessary," wrote Grimm.

But Catherine was unimpressed. "These designs are exactly what I do not want: they are filled with animal figures and human figures and ornaments that are seen everywhere, and all this prompted me to order that they be sent back," she told Grimm. "Moreover, Monsieur Auguste is frightfully expensive; I fear that he will charge as much for the workmanship as he will for the weight; I bid him adieu."[17] Catherine eventually changed her mind, placing a huge order with Auguste and his assistant Louis-Joseph Lenhendrick for several silver services for her Yekaterinoslav, Kazan, and Nizhny Novgorod residences. Though each service had different decoration, each was engraved with Russia's double-headed eagle.

Catherine also turned the tables at court with luxurious porcelain services. Production of "white gold" Meissen in Saxony had unleashed enormous demand for the luxurious ceramic invented centuries before in China. Earlier in the century, German antiquarian Johann Joachim Winckelmann had criticized porcelain as being "in childish taste" used for "idiotic puppets" on dessert tables.[18] But as aesthetic taste shifted from the playful rococo to the more serious neoclassical style, porcelain became more refined. Catherine's porcelain services weren't just beautiful. Every teacup and sauceboat served as reminders to guests of the power and sophistication of their hostess. Political motifs and decorations advertised Russia's growing wealth and power. Adorned with landscapes, mythological scenes, initials, or poems, tureens and plates inspired dinner conversation. Catherine kept the most valuable porcelain close by in the imperial private apartments and Hermitage in specially made boxes that could be moved in case of fire.

One porcelain service went on permanent display. In 1772, to commemorate Russia's victory over the Turks, Frederick the Great presented Catherine with the Berlin Dessert Service. Scenes from the Russo-Turkish War adorned all 120 dessert plates and Catherine's cipher "C" appeared four times in the openwork borders of palm leaves. Berlin's Royal Porcelain Factory created new molds for the melon-shaped tureens, gilded baskets covered in porcelain grape leaves, and leaf-shaped trays. A thematic porcelain sculpture (*surtout de table*) starring Catherine replaced the traditional sugary table centerpiece known as *pastillage*. Using Vigilius Eriksen's state portrait, Berlin modelers produced the statuette of the empress enthroned beneath a canopy. Surrounding her are female figures personifying the arts and figurines of Russia's ethnic groups, captured Turks, and military trophies.

Catherine kept Russia's own porcelain factories busy filling royal orders. In 1765, she'd reorganized St. Petersburg's Imperial Porcelain Factory founded two decades earlier by Elizabeth. The following year, English entrepreneur Francis Gardner launched Russia's first private porcelain factory. In 1777, Catherine commissioned the first of four large "order services" from the Gardner Factory, sending pieces from the Berlin Dessert Service as models. Being knighted was a great military honor—similar to receiving America's Congressional Medal of Honor. Each year, knights of

Russia's elite imperial orders commemorated their patron saints' feast days at a Winter Palace reception featuring prayers, toasts, and cannon fire from the Peter and Paul Fortress. Gardner's factory decorated the colorful porcelain services with the ribbons, stars and badges worn by members of each order—St. George, St. Andrew, St. Alexander Nevsky, and St. Vladimir.

Catherine's phenomenal entertaining achieved the desired effect. Count de Ségur summed up the impact: "The court of Catherine was the meeting place of all European monarchs and celebrities of her age. Before her reign Petersburg, built in the realm of cold and ice, went almost unnoticed and seemed to be somewhere in Asia. During her reign Russia became a European power. St. Petersburg occupied an important place among the capitals of the educated world and the Russian throne was raised as high as the most powerful and significant thrones."[19]

Like their fashionable empress, Russia's elite set their tables with the finest European silver and porcelain for the first time, and the rest of the continent could not help but take notice. Centuries before trendsetting Kate Middleton, the Catherine the Great Effect was in full swing.

CHAPTER TWO

DRESSED TO "EMPRESS"

N o one could be more imposing than the Empress at times of State," observed lady-in-waiting Countess Golovine, but "no one could be greater, kinder, or more indulgent than she in her private circle."[1] Adding to the pomp and ceremony of the Russian court was the spectacular attire of Catherine and her courtiers. From dazzling jewelry and gold and silver embroidered gowns to silk uniform dresses that matched those of her regiments, Catherine used fashion to further her ambitions and strengthen alliances in the same way she used her art collecting and service commissions.

It was Peter the Great who first made dress part of his sweeping cultural reforms. Having personally trimmed the beards of a group of Russian boyars with a pair of scissors, he issued a clean-shaven decree for all of his courtiers and officials. Anyone refusing to shave had to pay a beard tax. Peter wielded shears on another occasion, this time cutting off the sleeves and bottoms of his guests' long, traditional-style coats. This was the start

of his famous clothing reforms. Between 1701 and 1724, Peter issued seventeen edicts making "Saxon and French" dress compulsory for Russia's urban population.

As European tailors began training Russian apprentices, anyone caught producing or selling Russian garments faced "dreadful punishment." Peter used economic incentives to establish a domestic textile industry that produced wool for army uniforms, linen sailcloth for the navy, and silk for court dress. To set an example, the tsar only wore clothing made from Russian textiles. Despite these developments, many wealthy Russians continued to buy luxurious French silks, Irish linens, and British cottons and wools. The worst infractor was Peter's daughter Elizabeth. When she died, her closets were filled with thousands of pairs of shoes and some 15,000 European-style gowns—made with European, not Russian, textiles.[2]

Like his European counterparts, Peter created a Table of Ranks in 1722—an official list of military, civil, and court ranks and classes that specified uniforms for each branch of state service. Catherine added her own rules, including those for clothing. In general, the higher the rank, the more gold embroidery and decorations were worn. Courtiers had a range of uniforms and dresses for various occasions, like church visits and official receptions. Costumes, hats, and sword hilts were all studded with diamonds.

On September 22, 1770, on the eighth anniversary of her coronation, Catherine initiated a new type of ceremonial court dress, or rather, a reinvention—one that continued until the end of the Romanov dynasty in 1917. To a ball honoring her coronation, Catherine wore a Russian-style dress, something that had not been seen at court in seventy-five years. Around this time, Russian intellectuals began questioning the imitation of French fashion, manners, and language, voicing concerns that Russian culture was in danger of disappearing. In June 1775, to celebrate the peace treaty with Turkey, the Military School for the nobility arranged for a celebration in Catherine's honor. Festivities included an allegorical spectacle, "The Destruction of the Temple of Fashion," and performance of a comedy mocking Russia's passion for French fashion. The popular comedy was performed several times that month.

This nationalism wasn't lost on Catherine. Russian-style dress became mandatory for formal court occasions. On specific holidays, female

courtiers were required to wear white satin gowns under red velvet sarafan-like robes ending in long trains, along with gem-studded Russian tiaras or *kokoshniks*. On August 30, 1775, many of Catherine's courtiers attended a feast day wearing similar dresses. By Catherine's name day celebration that fall, all courtiers were wearing the Russian style.[3] According to Christine Ruane, Catherine hoped Russian court dress would bridge the cultural divide created by Peter the Great's westernization policies. "The initial feelings of inferiority that Russians had felt toward their western European neighbors were replaced by a growing sense of comfort and confidence," writes Ruane.[4] In the early 19th century, Russian empresses began wearing Catherine's "Frenchified sarafan" for their coronations.

Inspired by England's Knights of the Order of the Garter, Peter the Great founded the Order of Saint Andrew, the first of Russia's six military orders. In 1714, he made his wife head of the order of Saint Catherine, the second order in European history exclusively for women. Before Catherine, Russia's knights had worn their specially designed robes only on their order's annual holiday. Catherine increased the orders' prestige by turning the robes into the main form of court uniform and mandatory attire for high ceremonial days. In 1769, Catherine founded the Order of St. George, selecting members for their military victories.

Catherine never forgot that the Guard regiments had helped bring her to power. For parades and regiment festivals, the empress wore dresses of her own design, made to complement the uniform of each regiment. Corresponding to the color of the officers' attire, Catherine's "uniform dresses" combined the predominant French fashion (open dress, farthingale, sometimes a "Watteau pleat") with elements of Russian national costume (a long folded sleeve with an open armhole, and a sarafan-like decoration).[5] The first of these uniform dresses—for the Preobrazhensky Life Guards in 1763—was made of blue silk with red cuffs and collar, with gold lace, bronze stamping, and gilding with gold buttons down the front of dress and coat. Like her male predecessors, Catherine wore these uniform dresses to receive officers at parades and regiment festivals.

Designers took note of the classical craze sweeping Europe, producing light, high-waisted dresses and simpler jewelry. Two decades into her reign, Catherine issued dress reforms to counteract "the immense increase of the

importation of French modes, millineries, and other similar productions, which, without exaggeration, run away with the whole benefit of the trade of Russia."[6] One offender was Catherine's daughter-in-law, Maria Feodorovna, who ordered her dresses from Rose Bertin, Marie Antoinette's personal shopper.

The goal of Catherine's ceremonial and court dress edicts was ". . . to introduce greater simplicity and moderation to preserve their own prosperity for what is best and most useful and to avert from ruinous luxury . . ."[7] One edict specified that gold and silver lace on caftans could not exceed three and a half inches in width. On major holidays, court guests were allowed to wear gold and silver Muscovite brocades; on other holidays and other days silken materials of all kinds; gentlemen were also permitted to wear wool. Male courtiers wore European uniforms; female courtiers wore the empress's hybrid creations at certain ceremonial events. According to Richard Wortman, Catherine's detailed dress requirements were a calculated political move. "Uniformity of dress showed the unity of the supranational court elite . . . the rhetoric and styles of Catherine's reign left little doubt about the predominance of the Great Russian nobility."[8]

Catherine's clothing decree was noticed in Paris, where improved relations between Russia and France resulted in a "fashion for all things Russian." Melchior Grimm informed Catherine that Parisian streets sported "signs with the name of the Russian Empress, cafés and big hotels called *Russia* and even clothing shops with the sign *Russian Dandy*." ". . . [H]ow interesting that the fashion should come from the North," Catherine replied, "but it is even more remarkable that the North, more especially Russia, should be fashionable in France."[9]

It wasn't just Catherine and her courtiers who dressed to impress. Palace servants were required to wear formal green, red, and gold uniforms, along with special footwear and accessories. From the French word *livree*, or "clothes issued by the state and nobility for their entourage and attendants," the livery wardrobe included uniforms for every day, Sunday-best, parade, and mourning wear. Court furriers, footmen, chamberlains, Araps or Black servants, and Cossacks all donned every day and ceremonial livery. Influenced by foreign styles, livery costumes were made by imperial tailors of the highest quality textiles with multiple fittings.

Catherine's lavish entertaining required a larger imperial household staff. Men of the "palace-servant class" enjoyed special rights and privileges, including exemption from personal tributes and servitude. Starting at age sixteen, any Christian subject of the Russian Empire whose trustworthiness had been vetted by the palace police could enter court service. Preference was given to children of the palace-servant class and those who'd served a tour of military duty. Women worked in Catherine's private quarters, the palace kitchens, and laundry.

Catherine's court also became celebrated for its splendid jewelry. In 1714, Peter the Great moved part of the Kremlin Armory collection to St. Petersburg, including spectacular works of European gold and silver. Each of his successors continued to add to the Imperial Treasury. One of the first registers of court jewelry compiled after the death of Peter's widow Catherine I in 1727 included ceremonial jewelry and regalia, brooches, bows, and costume decoration. Empress Anna Ioannovna added luxurious Augsburg gold and silver services. It was Empress Elizabeth who formed the nucleus of the Hermitage jewelry collection with glittering rococo acquisitions. These included spectacular French snuffboxes and diamond-studded *necessaires* (sets of grooming items), and English watches on jeweled chatelaines (attached to the bodice of her dresses).

Elizabeth didn't hesitate to summon court jeweler Jérémie Pauzié to the palace in the middle of the night to share her latest jewelry ideas. He created rings, earrings, snuffboxes, and exquisite gem flower bouquets for the jewelry-loving tsarina, whose habit was contagious. "The ladies of the Court wore amazing quantities of diamonds," wrote Pauzié. "Ladies of comparatively low rank may be wearing as much as ten to twelve thousands roubles worth of diamonds."[10] So not to be out-blinged, Elizabeth decreed that ladies at court could only wear half a hair adornment, on the left side, along with a single *tremblant* (a sparkling hair ornament from the French word for quiver).[11] A full tiara was the sole prerogative of the empress.

Recognizing the symbolic importance of gems, Catherine tapped Pauzié to create her jaw-dropping coronation crown. Diamonds and precious gems were synonymous with power and rank, and Catherine instructed her agents to search the globe for the most beautiful examples. In her quest, Catherine enjoyed a distinct advantage. The discovery of silver and gold in

the Urals combined with continued imports of precious metals gave Catherine unlimited resources. For the next three decades, she added dazzling pieces to the imperial jewelry collection, leaving no doubt about Russia's growing wealth and power.

From her diamond chamber at the Winter Palace, Catherine selected jewels to wear to her official appearances—like a diamond and spinel *esclavage* and matching earrings she pinned to a velvet ribbon worn around her neck. Tiaras, aigrettes, and diamond hairpins completed the look. One of Catherine's ornaments was a silver flower branch dripping in diamonds. To intensify the dazzling effect, the jeweler added colored foils under the transparent stones.

On one occasion, Catherine confided to Prince de Ligne that she could have served Russia better if she had been born a man. "Believe me," he reassured her, "you are so much more impressive in your beautiful embroidered orange red velvet dolman or tunic than a man decked out in boots and shoulder sash can ever be. In addition the five huge diamonds blazing out from your hair are far more effective than a man's hat which is either ridiculously small or ridiculously big."[12]

Catherine's ladies-in-waiting and maids-of-honor followed her lead, sewing or pinning small shimmering diamonds in various shapes onto their garments. They also wore a badge of office—a crowned monogram of Catherine "EII" set in diamonds (*chiffre*) worn on a bright blue ribbon (through a ring on the pendant's back). "Among the manifold signs of wealth which distinguish the Russian nobility there is none more likely to impress the foreigner than the abundance of diamonds and precious stones which glitter everywhere," wrote William Coxe. "In this the gentlemen rival the ladies—many of the nobles are literally covered with diamonds."[13] Catherine and her close circle played card games for diamonds; even her table was set with jewels as James Harris, first Earl of Malmesbury noted. "The dessert at supper was set out with jewels to the amount of upwards of two millions sterling."[14]

With her patronage, Catherine turned St. Petersburg into one of the world's jewelry-making centers. When Jérémie Pauzié returned to Geneva in 1764, a colony of foreign goldsmiths was forming in the capital. Among Catherine's favorite goldsmiths was Leopold Pfisterer, hired by Dmitry

Golitsyn, who extended his six-year contract by thirty-four more years. Swiss goldsmith Jean-Pierre Ador arrived in Russia the year after Catherine's accession and remained until his death in 1784. Johann Gottlieb Scharff, born in Moscow to German parents, arrived in the capital in 1772. Prussian brothers Francois-Claude and Pierre-Etienne Theremin were known for their simple, classical designs. By the end of Catherine's reign, foreign artisans in the capital outnumbered Russian artisans nearly two to one, including fifty-nine master goldsmiths and fifty-one master silversmiths.[15]

To her painted and sculpted likenesses, Catherine added her miniature portraits set in jewelry and medallions. Peter the Great, like his European contemporaries, had awarded his own portrait miniature as badges of office and tokens of gratitude. Catherine followed suit, doling out miniatures of herself set beneath diamonds in rings, pins, watches, bracelet clasps, and medallions. On one occasion, Catherine joked with Ligne: "Since you told me that you would either sell, gamble or lose any diamonds I would give you, here are no more than 100 roubles' worth bordering my portrait in a ring."[16]

Catherine also presented her portrait to Gregory Orlov's younger brother, Alexei Orlov, aka Scarface. "He is a monster in appearance and his strength is beyond belief," wrote British visitor Catherine Wilmot. ". . . He wears the empress's picture set in diamonds of enormous size and instead of a glass, 'tis a single diamond which covers the portrait."[17] In 1768, as a thank-you for inoculating her, Paul, and Gregory Orlov against smallpox, Catherine made British physician Thomas Dimsdale a baron and gave him a diamond-set *boîte à portrait* of herself and the grand duke. Packaged in silk-lined leather boxes, these miniature portraits usually featured Catherine's enamel picture framed in diamonds. Dimsdale reciprocated by presenting Catherine with a pair of greyhounds she named Sir Thomas Anderson and Lady Anderson.

An obsessive gem collector, Catherine also commissioned her portrait in hardstone. In the early 1770s, she gave Gregory Orlov a spectacular pendant with an emerald intaglio carved by Johann Caspar Jaeger. Framed by circular cut diamonds, the gem featured Catherine's portrait in profile, with a laurel wreath and pearl head ornament. Around the same time, Jaeger produced another pendant with Catherine's agate cameo profile portrait

within a brilliant-cut diamond border topped by an imperial crown and attacked to a diamond chain. Agate portrait cameos of Catherine were also set into diamond-bordered rings.

During Catherine's reign, snuffboxes became one of the most coveted royal gifts. Following his European counterparts, Peter the Great introduced snuff to the St. Petersburg court. Sprinkled on the back of the hand and inhaled, the powdered, scented tobacco was so popular that it spawned the creation of elaborate jeweled containers. Collected by royals and aristocrats, these charming boxes represented the height of luxury. According to contemporaries, though Catherine "never carried a snuffbox, nevertheless, the latter were to be found everywhere, on all the tables and window sills in her study. She used tobacco grown especially for her in Tsarskoye Selo near St Petersburg, always taking it with the left hand, because her right hand was meant for the loyal subjects to kiss."[18]

Catherine bought jeweled snuffboxes from the finest goldsmiths in St. Petersburg and Europe. Elizabeth's whimsical rococo boxes in the shape of baskets, fruit, flowers, and women's shoes were replaced by symmetrical neoclassical designs often featuring Catherine's monogram and portrait miniature. In addition to official gifts, Catherine gave snuffboxes with her portrait miniatures to family members on their name days and other occasions; her lovers discovered intimate notes inside their jeweled boxes. In 1768, Catherine sent Voltaire a turned ivory box with her portrait. "I would love to send you verses in exchange for yours," she wrote. "But if one is not clever enough to write good verses, it is better to work with one's hands. Here is how I practice what I preach. I have turned a snuff-box, which I beg you to accept. It bears the impress of the person who has the greatest respect for you. I need not name that person, whom you will easily recognize."[19]

In an earlier letter to Voltaire, Catherine wrote: "My emblem is a bee, flying from plant to plant, and amassing honey to take back to the hive." "If your crest is a bee," Voltaire replied, "you have an incredible hive, it's the largest in the world."[20] Catherine repeated the bee motif in many pieces of jewelry. In one splendid example, Johann Gottlieb Scharff created a silver and cobalt blue enamel snuffbox encircled with diamonds. Beneath a sheet of rock crystal, Scharff's diamond framed oval medallion

contains gold bees flying from a diamond beehive to a rose bush topped with Catherine's motto "Useful" in gold letters. Another Scharff snuffbox featured an enamel miniature of Catherine's beloved Italian greyhound, Lisette, surrounded by two circles of pea-sized diamonds, two circles of slightly smaller emeralds, and hundreds of smaller gems.

During the 1770s, St. Petersburg's goldsmiths began collaborating with miniaturists to create beautiful enamel snuffboxes, watchcases, and miniature portraits with rich fade-proof colors. Among the best known miniaturists were Russians Peter Zharkov and Dmitry Yevreinov and Frenchman Charles-Jacques de Mailly. Ségur owned one such enamel box, decorated with a portrait of Catherine wearing a fur-trimmed hat. In 1768, Catherine presented a spectacular enameled box to Gregory Orlov. The diamond-rimmed gold tabatière by Jean-Pierre Ador and enamellist Kaestner featured enamel miniatures of scenes from her coup d'état (Smithsonian, Washington, D.C.). Ador received his largest imperial commission in 1774 when Catherine ordered thirty gold boxes for a tenth anniversary gift to participants in her coup. Ador incorporated both sides of Johann Georg Waechter's coronation medal: Catherine in profile as the helmeted and armored Minerva on the lid and a related allegorical scene for the base.

Catherine's enormous outlays on fashions, jewelry, and accessories were a public relations bonanza, helping create a sophisticated, cultured image for her court. "The richness and splendour of the Russian court exceed the most extravagant descriptions," raved William Coxe in 1778. ". . . [The] splendor and brilliance of court finery and the profusion of precious gems leave the pomp of other European courts far behind them. . . . Nothing is as amazing as the wealth of precious gems that sparkle on every part of the robes. . . . The most lavish wearing of gems was characteristic for the women at the European courts, but in Russia, the men competed with the women in this: nearly all of the dignitaries were covered with brilliants, [on] buttons, buckles, saber hilts, epaulets, and hats."[21]

꧂

CHAPTER THREE

PEACE OFFERINGS

I n 1771, a catastrophe struck Russia that was beyond even Catherine's control. As it had in 1570 and 1654, plague hit Moscow. At the height of the epidemic in August, nine hundred Muscovites were dying every day. Moscow's Governor-General Saltykov, the city's nobles, and anyone else who could afford to fled the former capital. Amidst the chaos, a rumor quickly spread about an icon of the Virgin thought to possess miraculous healing powers. Desperate peasants and workers rushed to the icon, which hung above the Varvarskiye Gates near the Kremlin. Of course, the crowds spread the disease even further. In an effort to control the contagion, Moscow's Archbishop Ambrosius (an appointee of Catherine), ordered the icon moved inside the Kremlin's Chudov Monastery. In mid-September, a disapproving mob stormed the Kremlin and broke into the 14th-century monastery, hunting down the old prelate and literally tearing him to pieces.

Gregory Orlov volunteered to manage the crisis. ". . . [H]e was convinced the greatest misfortune at Moscow was the panic which had seized

the highest as well as the lowest . . . and that he intended to set out to morrow morning to endeavor to be of what use he could . . . ," wrote British ambassador Lord Cathcart. "He said . . . that he had long languished for an opportunity to do some signal service to the Empress and his country . . ."[1] By the time Orlov and his entourage of doctors and military men reached the city in late September, over 20,000 people had died that month.

It was Orlov's finest moment. He went to work, implementing a series of anti-plague measures and restoring order to the stricken city. His efforts included burning several thousand contaminated houses, disinfecting thousands more, establishing orphanages, reopening public baths, and supplying clean food and clothing. On Orlov's orders, victims were buried in special cemeteries and assemblies were prohibited. Orlov increased the number of quarantine stations and hospitals, and offered his own home as a hospital. By late November, the death rate was falling and order had been restored. The plague's final toll was nearly 57,000 people, roughly a quarter of the city's population.[2]

When Orlov returned to St. Petersburg in early December, Catherine waived the thirty-day quarantine and gave him a hero's welcome. She ordered a medal struck in his honor: "For Delivering Moscow from the Plague" and hired Antonio Rinaldi to design a commemorative arch and triumphal gate at Tsarskoe Selo and Gatchina. At the same time, Catherine was furious with Moscow's fleeing nobility—especially its absent governor. "The weakness of Field Marshal Saltykov passed all understanding," Catherine wrote Alexander Bibikov, marshal of her 1764 Legislative Commission. "I forgot to say in my letter that that old sod of a Field Marshal has been dismissed."[3]

With the plague contained and in remission, Catherine turned her attention to ending the Russo-Turkish War. In late April 1772, a week after Catherine's forty-third birthday, Orlov left for Fokshany in Moldavia as her chief negotiator at the peace talks. "The handsomest man of his generation" is how Catherine described Orlov after seeing him leave for the talks in an embroidered and diamond-studded suit she'd given him. "There is no one whom my plantomania amuses more than Count Orlov," Catherine wrote Frau Bielke, "he spies on me, he imitates me, he mocks me, he criticizes me; but before leaving he left his garden in my charge for this summer,

and this year I will be able to commit indiscretions there in my own way. His grounds [Gatchina] are very near here, and I am very proud that he has recognized my merit as a gardener."[4]

But Catherine had more than gardening on her mind. Threatened by Russia's gains in the Black Sea, Austria and Prussia were demanding compensation. Maria Theresa's son and co-ruler Joseph II was so concerned about Russia's expansion, he negotiated an Austro-Turkish alliance and deployed troops to Hungary to deter further Russian advances in Moldavia and Wallachia. To avoid an Austro-Russian war, Catherine agreed to Frederick the Great's proposal for the First Partition of Poland. Catherine had jokingly referred to Stanislaus Poniatowski, her former lover, as her "wax doll" on the Polish throne. Now he watched helplessly as the Polish-Lithuanian Commonwealth lost 30 percent of its territory and half of its population to placate other warring monarchs. In August 1772, Russian, Prussian, and Austrian troops entered Poland and occupied the agreed-upon territories. The Habsburgs extended their rule into Galacia, less the city of Krakow; Frederick the Great took land between Pomerania. Catherine gained 1.3 million subjects, expanding Russia's territory to the W. Dvina River (near the port city of Riga) and to the Dnieper River, halfway to Minsk.

Meanwhile, the issues at Fokshany were proving too complex for Orlov's diplomatic skills. It didn't help that Catherine was unwavering on Crimean independence. At one point, Orlov astonished Turkish officials by threatening to resume hostilities and hang Russia's Field Marshal Rumianstev for privately expressing concern over his war weary soldiers. To further complicate matters, Sweden's new King Gustav III interfered, encouraging Turkey to keep fighting. Orlov responded by issuing an ultimatum to the Turks, who proceeded to walk out of the peace talks.

As the war with the Ottomans continued, Orlov became preoccupied with his mistresses. "There was hardly a maiden at Court . . . not subjected to his importunings," said Prince Shcherbatov.[5] Though Orlov's licentiousness was common knowledge among foreign diplomats and courtiers, Catherine claims to have learned about his infidelities only after he'd left for Fokshany. After receiving word from his brother that Catherine had taken a new lover, Orlov abandoned his post and raced back to St. Petersburg.

This time, instead of a hero's welcome, Orlov was stopped at the gates of the capital at Catherine's order and directed to Gatchina.

A few days earlier, Catherine appointed 28-year-old Alexander Vasil-chikov, an ensign in the Horse-Guards, her adjutant general. From an old family of Moscow noblemen, the handsome cornet had caught Catherine's eye while on guard duty at Tsarskoe Selo. When Vasilchikov escorted her carriage, Catherine gave him a gold snuffbox engraved "For the good bearing of the bodyguards." Soon, Catherine awarded him the Order of St. Alexander Nevsky and named him gentleman of the bedchamber and chamberlain. In addition to a gift of 100,000 rubles, Catherine gave Vasilchikov an annual salary of 12,000 rubles, jewels, a wardrobe, servants, and a country estate.

Catherine's eleven-year relationship with Gregory Orlov was finally over. As part of a generous settlement that coincided with their breakup, Gregory Orlov received an annual pension of 150,000 rubles, 100,000 additional rubles to establish his household, the Marble Palace in mid-construction, 10,000 serfs, and many other treasures. Though Catherine had commissioned the extraordinary 3,000-piece Roettiers silver service for her own use, she presented it to Orlov as part of the package. He received the first shipment in September 1772 and continued to accept deliveries until 1776.

Meanwhile, to the delight of her art agents, Catherine had become one of Europe's most determined art collectors. Denis Diderot wrote Catherine about a pair of imaginary battle scenes by Adam Frans van der Meulen. The works were painted in 1657 before the Flemish artist left Brussels for Paris to become court painter to Louis XIV and tapestry designer at Gobelins. Diderot had noticed *Cavalry Engagement* and *The Battle* (1657) several years earlier when they were in the collection of painter Louis-Michel van Loo (Carle van Loo's nephew). Diderot wrote Falconet that he'd found Catherine two large van der Meulens in pristine condition. But the asking price of 24,000 francs was exorbitant even for Catherine. Patience paid off. At an auction following van Loo's death in 1771, Diderot bought the two scenes for 10,000 francs. Even at this price, the van der Meulens were the priciest pictures at the sale, fetching more than paintings by Rubens and Rembrandt.

With her new paintings arriving by the boatload, Catherine faced a shortage of wall space in the two galleries of the Small Hermitage. In May 1770, she engaged Yury Velten to build another addition to the Winter Palace. When finished in 1784, Velten's three-story Large Hermitage would harmonize with the adjoining North Pavilion of the Small Hermitage. In addition to spacious first floor picture galleries, Velten added a cabinet to show off the empress's prized medal collection, an elegant Oval Room for drawings, engravings and books, and a billiard room with busts of Russian naval officers. Catherine's new galleries could not come soon enough. She was about to snatch one of the most extraordinary collections in the history of the Hermitage.

CHAPTER FOUR

CROZAT THE POOR

In 1770, Geneva-based collector François Tronchin, whose own paintings had just left for St. Petersburg, alerted Denis Diderot of a once-in-a-lifetime opportunity. Louis-Antoine Crozat, Baron de Thiers, who'd inherited one of France's most valuable painting collections, had died in Paris. His three married daughters were interested in selling their inheritance. Diderot quickly dispatched Tronchin to Paris to examine hundreds of the Crozat paintings and assemble a catalogue.

Before an auction could take place, Diderot went to work, cleverly playing the heiresses against one another and suggesting their best option was to sell the entire collection *en bloc*. In October 1771, after nearly a year of secret negotiations, Baron de Thiers's daughters accepted Diderot's offer. In January 1772, in the presence of a notary, Diderot signed a contract on Catherine's behalf, paying 460,000 livres for 500 works. The sensational deal elevated Catherine to the upper echelon of art collectors.

Among the disappointed collectors was London's Sir Joshua Reynolds, who had his eye on Crozat's five oil sketches by Peter Paul Rubens. "Last summer I went to Paris for a month in order to buy some of the Crozat collection but the Empress of Russia has bought the whole together for 18,000 £ which I think is not above half of what they would have sold for by auction," wrote Reynolds.[1] Just one Crozat masterwork escaped Catherine's grasp. Maintaining her family was descended from the Stuarts, Madame du Barry, Louis XV's last official mistress, snapped up Anthony van Dyck's *Portrait of Charles I.*

Crozat's art collection was considered the finest in France after those of the king and regent. Catherine's clandestine deal sparked outrage in Paris, and there was doubt whether authorities would allow the pictures to leave the country. Catherine enlisted Diderot and his fellow *philosophes* to lobby on her behalf. The Marquis de Marigny, superintendent of royal buildings and Madame de Pompadour's brother, pleaded with Louis XV to buy Crozat's finest French pictures. But Louis refused and the marquis was unable to stop the sale.

In thanks for the extraordinary paintings, Catherine sent Diderot and François Tronchin sable furs "for lining clothes." Unfazed by the firestorm he'd ignited, Diderot wrote his patroness: "I arouse the most genuine public hatred, and do you know why? Because I send you pictures. The connoisseurs are screaming, the artists are screaming, the rich are screaming. In spite of all these screams and screamers, I carry on the same as ever. . . ." In a letter to Falconet, Diderot noted Russia's political ascendancy: "The collectors, the artists and the rich are all up in arms. I am taking absolutely no notice . . . so much the worse for France, if we must sell our pictures in time of peace, whereas Catherine can buy them in the middle of a war. Science, art, taste and wisdom are traveling northward and barbarism and all it brings in its train, is coming south."[2]

The contentious acquisition wasn't lost on Voltaire, who wrote Catherine in March 1772: "Madame, I am well aware that you are no supporter of iconoclasm since you are buying paintings." "Like the [Byzantine] Empress Theodora I do love icons; but I like them to be well painted," Catherine replied, "she kissed hers, whereas I do not."[3] With controversy still roiling, the Crozat pictures were packed into seventeen large wooden crates at the

family's Place Vendôme and transferred to the Louis XV Bridge (today's Concorde Bridge). Despite Diderot's protests, the masterworks sat in a riverfront warehouse for three months waiting for the *Hirondelle* to get a full cargo. It was the beginning of May before the pictures set off down the Seine, and July before they put out to sea.

After the fate of the sunken Bramkaamp pictures the previous fall, the arrival of the paintings in stormy St. Petersburg that November was cause for celebration. Two-thirds of the collection was Italian, including masterpieces like Raphael's *Holy Family* and *St. George and the Dragon* (previously owned by England's Charles I), Giorgione's *Judith*, a Titian *Danae*, and a *Pieta* by Paolo Veronese. Among the Flemish and Dutch gems were Rembrandt's *Danae* and *The Holy Family*, Rubens's *Bacchus* and *Portrait of a Lady-in-Waiting to the Infanta Isabella*, plus half a dozen portraits by Rubens's star assistant, Anthony van Dyck (including a wonderful early self-portrait). From France came works by Poussin, Antoine Watteau (*Actors of the Comedie Francaise*), and Jean-Siméon Chardin (*The Laundress*).

The man responsible for Catherine's splendid new pictures was Baron de Thiers's immensely wealthy and obsessive uncle, Pierre Crozat. Born in Toulouse in 1665, Pierre Crozat became France's third richest man, amassing an estimated fortune of eight million livres (over 64 million dollars today).[4] Pierre was nicknamed "Crozat the poor"—a tongue-in-cheek reference to his even wealthier older brother Antoine, worth 20 million livres and ennobled as the Marquis du Châtel. Antoine had also joined the bureaucracy as a financier and tax collector, becoming a financial backer to Louis XIV's nephew and France's regent, Philippe d'Orléans. With spectacular results, Antoine invested in highly speculative ventures in military supplies and overseas trade; he enjoyed a personal monopoly over exports and imports between France and French Louisiana.

Like Antoine, Pierre Crozat moved to Paris, where he bought himself a position as assistant to the Receveur Général du Clergé, the wealthy, well-connected Pierre-Louis Reich de Pennautier. From Pennautier, Crozat learned how to maximize his personal gain from collecting taxes from the clergy. But Crozat was caught lining his pockets. Instead of succeeding his mentor, Crozat was expelled from the treasury in 1708. The scandal ended Crozat's political career, but not his role in the city's cultural life.

In 1703, Pierre Crozat had bought eight blocks, a total of nearly two and a quarter acres, at the north end of rue de Richelieu in the Montmartre quarter, home to the royal library and stock market. The following year, he hired architect Jean-Silvain Cartaud to build a Roman-style palazzo to show off his growing art collection. The Crozat's newly created coat of arms—silver chevrons and three silver stars—topped the residence's enormous double doors. A series of increasingly elegant rooms furnished with André Charles Boulle's marquetry furniture led to an opulent mirrored gallery spanning the entire width of the house.

It was there, ensconced on a dozen red leather sofas and surrounded by marble busts and bronzes, that Crozat and his guests savored his showiest paintings. Beneath the ceiling painting, the *Birth of Minerva* by history painter Charles de La Fosse, Crozat hung sixteen pictures on red silk damask walls. Among them were Tintoretto's *Birth of John the Baptist* and Veronese's *Finding of Moses*, a Rembrandt, a pair of Rubenses, and a trio of van Dycks. Rather than arrange the works by nationality or subject, Crozat mixed various schools together to maximize their effect. French windows opened onto the formal manicured gardens featuring tiered lawns and colorful flowerbeds.

Directly behind the densely hung Red Cabinet, a small staircase led upstairs to Crozat's private second-floor apartments. Inspired by the 16th-century Medici Tribuna at the Uffizi in Florence, Crozat added a glass-domed octagonal study decorated by La Fosse and sculptor Pierre Legros. Here he kept his prized Rubens and Michelangelo drawings and over one hundred terra-cotta *modelli* and small bronzes. Most important was his beloved engraved gem collection arranged in two handsome marquetry chests. Connoisseur and print dealer Pierre-Jean Mariette likened his friend's gem obsession to "a jealous and passionate lover who cannot be apart from his loved one . . ."[5] More treasures resided nearby in the small blue satin Cabinet Crozat where Titian's *Danaë* hung opposite Rembrandt's *Danaë*, along with Raphael's gem-like *St. George and the Dragon* and *Holy Family*.

In November 1714, just before becoming regent, Philippe II, Duke of Orléans (Philippe the Debauched), dispatched Crozat to Rome to negotiate the purchase of paintings from the cash-strapped heirs of Prince Livio

Odescalchi. The Prince had inherited part of the art collection of Sweden's Queen Christina, built on war booty from the sacks of Munich and Prague during the Thirty Years' War. The Prague trove included paintings amassed by Holy Roman Emperor Rudolf II, another obsessive collector. After Christina's death, the pictures were sold to Odescalchi in 1696 by her heir, the Marquis Pompeo Azzolini.

Prince Livio's heirs rejected Crozat's initial offers of 60,000 and 75,000 Roman ecus. It would take five more years before Crozat secured the 260 paintings for his royal client for 95,000 ecus. But the shipment of the canvases to the Duke of Orléans's gallery at the Palais Royal had to wait until the death of Pope Clement in 1721. The pontiff prohibited the paintings from leaving Rome, believing them too important to the city's cultural patrimony. (After the French Revolution, Louis Philippe d'Orléans [Philippe Égalité] sold over five hundred family paintings to an aristocratic English consortium led by Francis Egerton, 3rd Duke of Bridgewater.)

The Italy trip was a defining moment for Pierre Crozat's own art collection. As part of his commission for the Odescalchi picture deal, Crozat received one hundred drawings from France's royal collection. Like Austria's Cobenzl and Saxony's Brühl, Crozat fell in love with drawings. His Old Master drawing collection featured some 160 sheets by Raphael, along with works on paper by Michelangelo, Titian, Dürer, and Poussin. Through his diplomatic and ecclesiastical contacts in Rome and Venice and agents in Paris, Ghent, Amsterdam, and London, Crozat began buying paintings. Seeking social status, Crozat coveted pictures with illustrious provenances like the Medicis, Duke of Mantua, Charles I, and Cardinals Antonio Barberini, Richelieu, and Mazarin.

Crozat turned his elegant home into a private museum, brimming with some 500 paintings, 350 sculptures, 19,000 drawings, 1,400 engraved gems, Chinese and Japanese porcelains, Italian ceramics, tapestries, silver, and a pair of Egyptian mummies. Each Sunday afternoon, collectors and artists met in the first floor salon to discuss art theory and contemporary painting. From there, they continued upstairs to study their host's drawings and paintings.

Styling himself after Renaissance art patron Lorenzo de' Medici, Crozat rolled out the welcome mat for a number of artists. Charles de La Fosse

and royal decorator Gilles-Marie Oppenord enjoyed rooms for a number of years; sculptor Pierre Le Gros stayed with Crozat when visiting Paris in 1715. Of all Crozat's houseguests, the most famous was Jean-Antoine Watteau. Like another frequent guest, François Boucher, Watteau copied his patron's artworks. Crozat commissioned Watteau to paint the four seasons to decorate the walls of his dining room (the only surviving oval is Ceres, Roman goddess of the harvest, at the National Gallery of Art, Washington). It may have been at Château de Montmorency, Crozat's country estate north of Paris, that Watteau conceived his flirtatious paintings known as *fête galantes*.

Crozat was also patron to a new generation of Venetian artists that included Rosalba Carriera, Sebastiano Ricci and his nephew Marco Ricci, and decorative painter Giovanni Antonio Pellegrini. In the spring 1720, Carriera accepted Crozat's invitation to be his guest in Paris. In her diary, the 44-year-old records the talents she met at Crozat's home, like portraitist Hyacinthe Rigaud, Chardin, Boucher, and Louis-Michel van Loo. Along with commissioning some dozen pastels from Carriera along with portraits of his brother and niece, Crozat entertained the artist in high style, escorting her to the opera and ballet and presenting her with lavish gifts that included a silver dressing table set by goldsmith Thomas Germain.[6]

In *Recueil Crozat*, the first comprehensive history of major European art collections, Crozat ranked himself alongside the art-loving king of Spain and Rome's Barberini family. Co-authored by Mariette, the two volumes featured engravings, along with artist biographies, text, and provenances. Crozat kept his unmatched drawings collection, assembled over fifty-five years, in 202 folios organized by period, school, artist, iconography, and size. At the end of his life, desperately wanting his drawings to stay in France, Crozat offered them to Louis XV for 100,000 livres. Cardinal Fleury foolishly turned down the exquisite trove, stating, "The king already had enough clutter without adding more."[7] In 1740, the 77-year-old bachelor died after a long illness. His small dog was curled beside his bed in a basket lined in red silk; expensive garments filled his wardrobes, along with his curled wigs and a dozen pairs of slippers.

Per Crozat's wishes, Mariette sold his celebrated drawings at auction to benefit Paris's poor. Ironically, many of the best works on paper—including

pen and ink works by Raphael—were bought for the royal cabinet and are now part of the Louvre collection. Crozat bequeathed his five hundred pictures and Paris residence to his nephew, Louis-François Crozat, Marquis du Châtel. After Louis-François's death a decade later (1750), the pictures were divided among his three heirs. A few pictures went to his elder brother, Joseph-Antoine Crozat, Baron de Tugny. The lion's share of the magnificent paintings made a short trip north of the Tuileries Gardens to the Place Vendôme (today's Ritz Hotel), the elegant home of the marquis's younger brother, Louis-Antoine Crozat, Baron de Thiers. Louis XV was among the guests who visited the baron's prestigious gallery.

About thirty of Crozat's paintings that arrived at the Winter Palace were true masterpieces. Among the most exquisite was *Judith*, then attributed to Raphael. But in his compendium, Mariette observed that the vivid colors, soft flesh tones, and landscape were executed according to Giorgione's taste and principles.[8] According to Mariette, *Judith* had been brought from Italy to France in the later part of the 17th century, eventually sold to Parisian collector Pierre-Vincent Bertin from whom Pierre Crozat purchased it around 1711. Crozat had the narrow painting enlarged, adding nine-centimeter-wide strips to both sides.

In the mid 19th century, Crozat's extensions were removed; at the end of the century *Judith* was transferred from its wood panel to canvas. But controversy continued over the painting's attribution. In the 1864 Hermitage catalogue, the picture was attributed to Moretto da Brescia.[9] In 1901, Bernard Berenson pronounced *Judith* an "excellent and invaluable copy" of a lost original by Giorgione, an artist he describes as "more than the rival of Raphael in idyllic charm, the companion of Leonardo in subtlety and refinement . . . and, for sheer energy, almost the peer of Michelangelo."[10] Estonian art connoisseur Karl von Liphart finally confirmed Mariette's hunch—*Judith* was one of just a handful of authenticated works by Giorgione.

Called the equal of Leonardo and Correggio by Vasari, Giorgione remains one of the most mysterious figures in Western painting. Though he died in his early thirties, possibly contracting the plague from his mistress, the Venetian's lyrical landscapes had a tremendous influence on successive generations of artists. It was early in his short career, around 1504, that

Giorgione painted the popular Old Testament heroine. As the story goes, the beautiful Israelite widow went into the enemy camp of Assyrian commander Holofernes to win his confidence. During a banquet, Holofernes became drunk, and later Judith seized his sword and cut off his head, saving the Jewish people. Rather than depicting Judith killing Holofernes, Giorgione depicts her with flowers surrounding her head, in a diaphanous pink robe, sword in hand, glancing down at his bloody head beneath her foot. ". . . [S]he looks at the head with as gracious a smile as if it were a fragrant flower at her feet," wrote Bernard Berenson.[11]

Hermitage conservators discovered traces of hinges that may have once covered a keyhole. A rectangular piece of wood had been inserted and painted over on the right side and slightly under the center of the canvas. It turns out that Giorgione, like his Venetian colleagues Bellini, Veronese, and Titian, produced art to decorate furniture. A highly popular genre in 16th-century Venice, these works adorned everything from armoires and beds to doors and musical instruments. According to Susannah Kathleen Rutherglen, Giorgione's heroine decorated a cabinet door for books or precious objects—either alone on a cabinet, or possibly alongside a pendant of David, Judith's frequent partner in Renaissance art.[12] With the surge in popularity of easel pictures in the 17th century, many Venetian ornamental paintings were removed from their furniture surrounds and turned into independent artworks. Pierre Crozat bought one such picture.

CHAPTER FIVE

THE COACHMAN OF EUROPE

The year of her Crozat triumph, Catherine wrote Voltaire: "You are surprised by my purchase of paintings; I would do well perhaps to buy less at the moment, but lost opportunities are never recovered."[1] Before the Crozat uproar had subsided, Catherine seized another French opportunity.

At a public auction in Paris, Catherine snatched eleven paintings for 440,000 livres from her nemesis, Étienne-François, duc de Choiseul. Considered one of the most refined connoisseurs of the time, Choiseul had amassed a trove of paintings, furniture, and Sèvres porcelain. Among his artworks were some one dozen paintings from the collection of Pierre Crozat, part of the inheritance of his wife, who was none other than Louise-Honorine Crozat.

Like her first acquisition of pictures that was originally earmarked for Frederick the Great, Catherine's main motivation was revenge. As she'd had done with the Prussian King, Catherine enjoyed humiliating the man

125

she dubbed "the coachman of Europe." For a dozen years, Choiseul was the king's de facto prime minister, the most anti-Russian statesman of the *ancien régime*. During his tenure, French and Russian foreign policies were at constant odds. Soon after Catherine seized power, Louis XV wrote: "The object of my policy towards Russia is to remove her [Catherine] as far as possible from the affairs of Europe. Everything which can plunge her into chaos and make her return to obscurity is advantageous to my interests."[2]

Choiseul hailed from an old noble family that had fallen on hard times. Through intrigue and skill, Choiseul became the most powerful person in France after the king, amassing a great fortune along the way. He owed his success to Louis XV's official mistress, Madame de Pompadour. As an ambitious army brigadier, Choiseul earned Pompadour's support by intercepting love letters between the king and his cousin's wife. The grateful marquise rewarded Choiseul by securing his appointments as ambassador to Rome and Vienna, followed by promotions to minister of foreign affairs, minister of war, minister of the navy, and minister of the colonies.

Described as "a wonderful mixture of selfishness and charm and recklessness and exquisite taste,"[3] Choiseul's ability to combine hard work with cheerfulness endeared him to Louis XV who asked him on one occasion what he did to be so loved. "The recipe is very simple your Majesty," Choiseul replied, "it consists in being very fond of myself."[4] In December 1750, Choiseul wed Louise-Honorine Crozat de Châtel, the beautiful seventeen-year-old daughter of Louis-François Crozat, Marquis de Châtel, nephew and heir of the art collector Pierre Crozat (Louise-Honorine's deceased older sister, Antoinette Eustachie, had been Choiseul's mistress). After going to court to secure her father's large inheritance, Louise-Honorine became one of France's wealthiest women. Along with her great uncle's famed Hôtel Crozat on the rule de Richelieu, she inherited part of his fortune and several of his 17th-century Italian paintings, including Tintoretto's *Judith and Holfernes* (Prado, Madrid).

The newlyweds settled into Pierre Crozat's former residence. Thanks to his wife's fortune, Choiseul lived like a king. Though loving at first, Choiseul proved bad husband material. In addition to a string of mistresses, he bad-mouthed his wife behind her back. Contemporaries described Louise-Honorine as a devoted spouse and cultivated woman, appreciated at court

and esteemed by Louis XV. After meeting her in Paris, the charmed Horace Walpole called her "the most amiable and most honest little creature who has ever come out of a fairy egg."[5]

Around 1750, Choiseul began adding to his wife's paintings. Describing his collecting strategy, Choiseul wrote a colleague: "my taste is not for the mediocre . . . I should prefer one beautiful picture to ten ordinary ones."[6] Over the next twenty years, with the help of the art dealers like Basan and Boileau, he assembled one of Europe's finest collections of Dutch and Flemish paintings. Choiseul competed with Catherine at the Gaignat and de Julienne auctions in Paris and bought numbers of works in Holland. By 1770, he owned ten Wouwermans, eight Rembrandts, seven Teniers, six Berghams, five Ter Borchs, and five Metsus along with numerous Ruisdaels and Steens. Choiseul displayed his most prized works in Pierre Crozat's glass-roofed octagonal study.

In 1754, Choiseul was named French ambassador to Rome. "He wore a splendid costume, trimmed with silver and embroidered with gold and a coat with gold lace of unprecedented magnificence," wrote an observer of the new envoy's procession at the Vatican.[7] In 1756, at their Rome residence in the Palazzo Cesarini, Choiseul and Louise-Honorine met visiting French artist Jean-Baptiste Greuze, who painted pendant portraits of the couple. The Duc de Choiseul remained a patron of Greuze, acquiring four more of his paintings. Choiseul also helped launch the career of painter Hubert Robert, the talented son of his valet.

During Choiseul's term in Rome, the city was a gathering place for antiquarians, archeologists, and artists. Encouraged by his friend Abbé Jean-Jacques Barthélemy, archeologist and keeper of the king's antiques cabinet, Choiseul also began collecting antiquities. In 1757, as ambassador to Vienna, Choiseul earned Marie Antoinette's admiration by engineering the Austrian Alliance, sealed by her marriage to the future Louis XVI. In 1758, after a series of political setbacks including the humiliating defeat of French army at Rossbach, Louis XV and the Marquise de Pompadour withdrew from decision making and reinstated a ministerial government. Choiseul joined the royal council as minister for foreign affairs. Before long, Choiseul consolidated his power with promotions to minister of war, minister of the navy, and secretary of state.

In 1764, Choiseul ordered a cornelian intaglio engraved with his arms and set in a ring with a swivel bezel from Aubert, the celebrated Parisian jeweler. That same year, Madame de Pompadour died, and Choiseul unsuccessfully plotted to replace her as Louis XV's official mistress with his sister, the Duchesse de Grammont. Instead, Jeanne Bécu, Madame du Barry, snagged the vacancy. In 1766, in an effort to weaken Catherine, Choiseul convinced Turkey to declare war on Russia. By strengthening the traditional *cordon sanitaire* (buffer states) of Sweden, Poland, and Turkey, Choiseul's plan was to isolate Catherine from the rest of Europe. But Catherine had other plans. Determined to expand Russia, she announced to France's ambassador: "We shall no longer follow anyone's lead. I have money and the finest army in the world." In 1771, Catherine predicted to Voltaire: "This war will win Russia a name for herself."[8] Choiseul's strategy backfired; the Russo-Turkish War proved a huge coup for Russia and its ambitious empress.

Madame du Barry never forgave Choiseul for promoting his sister as royal mistress. On a rainy Christmas Eve in 1770, Louis XV handed his powerful minister a pink slip, banishing him from Paris. Without income from his official appointments, Choiseul went from multimillionaire to relative poverty overnight. Undaunted, Choiseul continued to live beyond his means at Château de Chanteloup, his fify-bedroom château on the Loire in central France. A dramatic ten-tier cascade emptied into the large semi-circular lake used for boating excursions. Choiseul's household numbered 400 servants—50 in livery and 350 in the kitchens and marble stables (for the pedigree Swiss cattle and pigs). Each day at noon, a six-person ensemble gave concerts at which Choiseul often played the flute, and his wife the clavichord. Guests arriving by gilded coaches along an elegant avenue of elms compared the mansion to Versailles. Choiseul hung the Italian paintings from Pierre Crozat's collection in the great picture gallery in one of the château's two long wings.

"Gallantry without delicacy was his constant pursuit," wrote Horace Walpole about Choiseul's notorious private life.[9] A dedicated womanizer, Choiseul's long-term mistress was the beautiful, witty Countess de Brionne. Widowed at twenty-seven when her husband, Louis Charles of Lorraine, Count of Brionne, was killed during a hunting accident, she became

Choiseul's mistress, following him in exile at Chanteloup, where the duke installed her in her own apartments. Despite her husband's numerous infidelities, Choiseul's long-suffering wife professed to idolize him and tried to erase his debts by selling her diamonds and other assets. When Louis XV relieved Choiseul of the post of colonel general des Suisses, an office he thought was a life appointment, he was forced to reduce staff and sell the diamonds and his beloved paintings.

The April 1772 auction created a sensation. Held over four days at Choiseul's home on rue Neuve Grange-Bateliere, the sale surpassed expectations, bringing in 443,174 livres for some 115 paintings. At the time of the sale, Melchior Grimm observed that Choiseul's cabinet "was less that of a connoisseur of art than an amateur who has his paintings scattered throughout the different rooms of his home for his personal enjoyment. His choice excluded all serious, sad, tragic and devout subjects, of high style, and consequently all the Italian paintings; he limited himself to the naiveté and realism of the Flemish school, and to the *galanterie* and *mignardise* of the French school." For this reason, Grimm concluded that Choiseul's taste would not be highly regarded by posterity.[10] Russian vice-chancellor A. M. Golitsyn paid 107,904 livres for eleven paintings—nearly a quarter of the entire amount realized by the sale.[11] Choiseul's adversary Madame du Barry bid successfully on a couple of paintings, including Greuze's portrait of a girl with a black dog for 7,200 livres. Pierre Crozat's splendid Hôtel also sold that year, and was demolished shortly after.

When Louis XVI succeeded his grandfather in 1774, he allowed Choiseul to return to Paris. With his political career over, Choiseul speculated in real estate unsuccessfully. Despite selling his wife's inheritance, her magnificent diamonds, the Hôtel Crozat, and his art collection, Choiseul died deeply in debt at age sixty-five. In 1786, Chanteloup was sold to the Duc de Penthièvre, a grandson of Louis XIV and grandfather of Louis Philippe (the property changed hands several times in the 19th century; its Chinese pagoda is all that survives). After spending a year in jail during the French Revolution, the Duchesse de Choiseul ended up in a convent. Between artworks and Chanteloup, Choiseul squandered her enormous fortune; she died in Paris in December 1801 in relative poverty.

The majority of the Choiseul pictures arriving at the Hermitage were Flemish and Dutch. Popular 17th-century Flemish genre painter David Teniers the Younger was represented by two *Village Festivals*—among twenty-three of the artist's works amassed by Catherine (today the Hermitage owns thirty-three Teniers).[12] Among the arrivals from Paris were *Deer Hunt* by Philips Wouwerman, *The Doctor's Visit* by Gerard Dou, and *Portrait of Susanna Fourment and Her Daughter* by Anthony van Dyck (National Gallery of Art, Washington, D.C.). Along with the Netherlandish works came two charming Spanish pendants—*Boy with a Dog* and its companion *Girl with Fruit* by baroque painter Bartolomé Estaban Murillo (c. 1655–60). These joined Catherine's two other Murillos—*Rest on the Flight into Egypt* from the Jean de Gaignat collection in 1768, and the newly acquired *Holy Family* from Pierre Crozat.

The youngest of fourteen children of a Sevillan barber and his wife, Murillo was orphaned at age ten and adopted into his aunt's family. With the exception of a visit to the court of Madrid in 1658, where he saw works by Velazquez, Murillo spent his entire life in Seville. Murillo's celebrity coincided with Seville's decline—a plague in 1649 killed half the city's population; famine and riots followed in 1651 and 1652. Though Murillo became Seville's leading religious painter, it's his small genre scenes of urchins and homeless children that endeared him to collectors. The scenes were likely inspired by Murillo's own family of nine children (four of whom survived) as well as his parish, where many children eked out a living running errands and selling fruit. The charm of *Boy with a Dog* is the relationship between the laughing boy with the crew cut and his pet. Murillo put a cheerful spin on his subject, showing him outdoors amid ruins, a nostalgic reminder of the fleeting state of childhood. After his death, Murillo's sentimental style was so popular that Spain's king tried unsuccessfully to stop the export of his works.

The Crozat and Choiseul bonanzas were a hard act to follow, but Denis Diderot put the icing on the cake in 1772 with a pair of landscapes by Nicolas Poussin. After learning that Hubert de Brienne, Marquis de Conflans, had lost his shirt at cards, Diderot bought the paintings for 3,000 livres. In 1758, Louis XV rewarded Conflans's distinguished naval career by naming him a marshal of France. But the following year, Conflans was

disgraced after leading the Duc de Choiseul's failed scheme to invade Scotland. Diderot's opportunistic buy added to Catherine's Poussin collection that included *Descent from the Cross* (Heinrich von Brühl) and J. A. Aved's *Tancred and Erminia* and *Rinaldo and Armida*. With their classical imagery, Poussin's highly intellectual paintings held great appeal for Catherine.

Dubbed the "French Raphael" by contemporaries, admired by artists such as Cezanne, Poussin is widely regarded as France's finest 17th-century painter. Born into a ruined noble family from Normandy, Poussin spent most of his career in Rome, painting historical, mythological, and biblical subjects for patrons like Louis XIII and Cardinal Richelieu. In the 1640s, Poussin began setting his heroes in nature, portrayed as majestic and powerful. Drawn from *Metamorphoses* by Ovid, Poussin's favorite ancient author, *Landscape with Polyphemus* (1649) depicts the tragic story of unrequited love against a seemingly peaceful setting of mountains, woods, and streams. After being rejected by the sea nymph Galatea, the one-eyed Cyclops Polyphemus withdraws to a mountaintop at the center of the picture to play out his grief on a flute "made of a hundred reeds." In *Landscape with Hercules and Cacus* (c. 1659) from Virgil's *Aeneid*, slain monster Cacus lies at the feet of Hercules outside the den where he'd hidden the hero's stolen cattle. Nymphs watch the drama from the bank of the Tiber below. Similar in size, the two landscapes were considered companion pieces in Catherine's day; today they are dated a decade apart.

Catherine chose her art scouts brilliantly. With the Crozat, Choiseul, and Conflan acquisitions in Paris, Denis Diderot, Dmitry Golitsyn, and François Tronchin had quickly put her picture gallery on the map. "In the space of a few years," writes Pierre Cabanne, "the author of La Religieuse ravaged the county's artistic capital more effectively than an occupying army could have done."[13]

TIGER IN THE FOREST

As Catherine's spectacular new Paris pictures were being hung at the Winter Palace, the most serious domestic challenge of her reign was developing. In mid-September 1773, a huge crowd gathered at a farmhouse near Yaiksk, southeast of Moscow. Before them stood a charismatic, bearded veteran of the Seven Years' War, Emelyan Pugachev. Acting in a long tradition of pretenders, the Don Cossack claimed to be Tsar Peter III who God had saved from Catherine's assassins.[1] After deposing the "Devil's daughter" and restoring himself to the throne, Pugachev promised to free his people from serfdom, taxes, and military conscription.

In its sixth bloody year, the Russo-Turkish War had taken an enormous human toll, along with heavy tax burden, rising prices, food shortages, and terrible factory conditions. Initially, Pugachev rallied support from a number of the hardest hit groups. His fellow Cossacks resented Catherine's "Moscow Legion," which required them to shave their beards.

Old Believers, who practiced a conservative form of Orthodoxy, wanted freedom from discrimination, which they had been facing ever since the reign of Peter the Great. Enlisting several hundred Cossacks, Pugachev began by attacking forts north of the Caspian Sea. Within weeks, Russia's southeastern borderlands lay in flames. By early October, Pugachev and several thousand supporters stormed Orenburg with bows and arrows, lances, scythes, and axes, massacring and mutilating nobles, officers, women, and children. Soon, Pugachev's base grew to include urban and rural workers, minorities, deserters, and religious dissidents. Turkic peoples of the southern Volga—Kalmyks, Bashkirs, Kazakhs, and Tatars—also joined his rebellion.

By November, Pugachev formed a war college and a court that included members with the titles of Catherine's courtiers. The empress, preoccupied with a new offensive against the Turks, did not concern herself with Pugachev. In a rare political miscalculation, Catherine saw the rebellion as a local matter. While Pugachev was gaining support, Gregory Orlov presented Catherine with a 189-carat diamond at a celebration of her name day at Tsarskoe Selo. "That day an enormous diamond imported from Persia was put on display; it had been deposited in the Bank of Amsterdam for some time, and had only recently been transferred to the Russian court," wrote Prussian ambassador Count Solms. "Prince Orlov acquired this jewel . . . and presented it to Her Majesty, instead of a bouquet of flowers, on her Saint's Day. Her Majesty designed to accept such a gift."[2]

In fact, Catherine's dazzling diamond was a gift to herself. In 1772, she mentioned in a letter to Voltaire that she was negotiating to buy "a diamond the size of an egg." Slightly bluish-green in color, the octahedron stone has been described as resembling half of a pigeon's egg with some 180 triangular and four-sided facets across its surface.[3] Legend has it that the extraordinary diamond was stolen by a French soldier earlier in the century from the eye of a Hindu deity statue in a temple at Srirangam in southern India. After a series of owners, Armenian merchant Gregory Safras sold the diamond to Orlov for 400,000 rubles. Orlov seems to have only paid for the first installment, with the rest of the payment coming from the state coffers.

In February 1774, two months after Orlov presented the diamond to Catherine, Maria Theresa congratulated her daughter Marie Antoinette on rejecting a gift of jewels from Louis XV's mistress, Madame du Barry. It seems Austria's empress couldn't forgive Catherine for accepting the diamond from her lover and parading it in public.[4] Catherine had her court jeweler Troinoki incorporate the exceptional stone into the gold imperial scepter, beneath the golden double-headed eagle. (The scepter, along with other imperial regalia, is on display today at the Kremlin Diamond Fund.)

Catherine next turned her attention not to Pugachev, but to finding a suitable wife for her son Paul. Her husband Peter had suffered from impotence; to make sure the fourteen-year-old grand duke didn't develop the same problems as his father, Catherine had arranged for the services of a young widow, Sophia Chartoryzhkaya, several years earlier, to help give him confidence in his own virility. Smitten with Sophia, the daughter of a former Novgorod governor, Paul fathered her son, Semyon Veliky (he died in the West Indies at age twenty-two).[5] In 1773, with the help of Melchior Grimm, Catherine orchestrated Paul's engagement to Princess Wilhelmina, daughter of Ludwig IX, landgrave of Hesse-Darmstadt.

Upon converting to the Russian Orthodox Church, Wilhelmina took the name Natalia Alekseyevna. Melchior Grimm accompanied the bride's brother, Prince of Hesse-Darmstadt, to St. Petersburg for the September 17 ceremony. With his German birth and contacts with smaller courts, Grimm would also prove a skillful matchmaker for Catherine's future grandchildren. Also arriving in time for the wedding was Denis Diderot. In the decade since Catherine had offered to publish the *Encyclopedie*, Catherine had invited Diderot to St. Petersburg on numerous occasions. The two wedding guests were quickly elected members of the Imperial Academy of Sciences.

After nine years of correspondence, Catherine and Grimm finally met. "His conversation delights me," Catherine wrote Voltaire, "but we have so much to talk about that our exchanges have hitherto had more liveliness than sequence." It was Voltaire, after reading one of Grimm's essays, who'd asked: "How dare this Bohemian have more wit than we?" Grimm was equally pleased with his patroness. "The Empress overwhelmed me with attentions from the start," he wrote Parisian saloniste Marie-Therese

Geoffrin. "I have had the honour to see her almost every day, to dine with her two or three times, and best of all, to talk with her for 1½ or 2 hours alone. She is a charming woman. Once or twice a week she dines in the Hermitage, where everyone is equal. There is no hint of the Empress."[6]

When the wedding celebrations ended, Catherine devoted more time to her dapper correspondent. "She did needlework, and kept me till 10.30 or 11," wrote Grimm. "Soon we were meeting every day, sometimes twice a day. I spend all day from 11 to 11 at the Palace, either in company or in tête-à-tête, only withdrawing from 4 to 6. Thus the winter of 1773–4 passed like a continuous intoxication. Her attentions seemed to increase from day to day, and with it her confidence. Mine too was such that I entered her apartment with the same assurance as that of the most intimate friend, certain of finding in her conversation an inexhaustible store of the greatest interest presented in the most piquant form."[7]

Denis Diderot had left Paris in June shortly after his own daughter's marriage, staying nearly two months with Dmitry Golitsyn in The Hague. Diderot claimed to have a acquired a new soul upon entering Russia, declaring, "I have never known myself more free than when I inhabited the country you call that of slaves, and never more a slave than when I inhabited the country you call that of free men."[8] Completely bored with her favorite, Vasilchikov, Catherine invited Diderot to the Winter Palace every afternoon—some five dozen times over a five month period. Dressed in a plain black suit, he'd arrive with a topic to discuss with the empress—everything from improving commercial competition to anatomy classes for girls.

He quickly discovered that his patroness was hardworking: "This woman combines great affability with surprisingly keen perception; she is alternatively thoughtful and gay; she goes to bed very early; she starts work very early in the morning; her meals are short; she allows herself but two or two and a half hours' recreation. This is when I am able to seize her; and when I do, I assure you it's more like study than anything else: she is stranger to no subject; there is no man in the Empire who knows her nation as well as she."[9]

It was Diderot who'd recommended his friend Falconet to sculpt Catherine's tribute to Peter the Great. Right before Diderot's arrival in Russia, an anonymous attack on Falconet appeared in Grimm's *Correspondence*

litteraire. Falconet believed Diderot had penned the critique, putting a strain on their friendship. Diderot went straight to Falconet's home to patch things up, but when he arrived the sculptor informed him that he had no room for him to stay. What Diderot did not know was that his friend was in the midst of a personal crisis.

In August, Falconet's estranged 31-year-old son Pierre-Étienne had arrived unexpectedly after a five-year London apprenticeship to Sir Joshua Reynolds, hoping to paint the empress. Before Catherine would agree to sit for her portrait, she insisted the young Falconet prove himself with a self-portrait and a portrait of Marie-Anne Collot. Falconet's masculinizing full-length and half-length portraits did not go over well with Catherine, who balked at his "exorbitant" invoice. In another bizarre twist, Marin Carburi, hero of Thunder Rock, fled St. Petersburg that spring after being accused of poisoning two wives for their dowries. (In 1782, Carburi was stabbed to death by disgruntled workers on a plantation he created in his birthplace, Cephalonia, Greece.)

Despite Falconet's cold reception, Diderot congratulated him on the progress of his equestrian statue: "You have created the most beautiful work of this genre in Europe. . . . The hero and the horse together form a handsome centaur in which the human and thinking element marvelously contrasts, through its calmness, with the fiery animal. That hand masterfully commands and protects; that face compels respect and belief. . . . The clothing is simple and without luxury: it embellishes the figure without fussiness; its great taste is appropriate to the hero and to the monument as a whole. The view stops one short and has a powerful impact. One stops and gazes in long contemplation . . ."[10]

Three months later, in early March, Diderot penned a farewell letter to Catherine and left for Paris, taking with him his own half-length portrait. Dmitry Levitsky depicted the aging intellectual deep in thought, with veined temples and a receding hairline. Based on her early Nakaz, Diderot had looked to Catherine with tremendous hope. In their conversations, Diderot tried to direct the empress toward social reform, suggesting ways for Catherine to create a Russian middle class along with an enlightened civil service. He also proposed that she move Russia's capital back to Moscow, calling St. Petersburg a "confused mass of palaces and cottages."[11]

The mutual admiration society between the empress and *philosophe* was over. After six months at Catherine's court, Diderot realized his efforts had fallen on deaf ears. Back in Paris, Diderot described Russia as "the strangest and most unreal of countries . . . I fear they have . . . had too many leaders, followed too many imposters, suffered under too many despots, known too many revolutions, been told too many lies . . ." He went on to pronounce Catherine part of a long line of despots. "For what a difference there is when we see a painting of a tiger . . . and when we meet a real tiger in the forest."[12] For her part, Catherine found Diderot entertaining, but dismissed his ideas in a letter to Voltaire as "useless pretensions."

Years later Catherine described Diderot's ideas to Ségur as "unadulterated nonsense" that if listened to would turn everything "upside down in my empire." "And so speaking to him frankly, I said: Monsieur Diderot . . . You forget in all your plans of reform the difference between our two positions: you work only on paper, which permits everything; it is uniform, supple, and presents no obstacles either to your imagination or to your pen; whereas in my case, poor Empress that I am, I work on human parchment, which is on the contrary irritable and sensitive."[13]

As the grueling Russo-Turkish War finally drew to a close, Catherine, age forty-four, was about to meet her match. Another tiger that she herself had been neglecting to properly acknowledge.

PART FOUR

PEACE AND
PROSPERITY

CHAPTER ONE

SLEEPLESS NIGHTS

I n December 1773, Catherine summoned 34-year-old Gregory
Potemkin from the besieged Ottoman city of Silitria (today's Bul-
garia). "Sir Lieutenant-General and Chevalier," she wrote, ". . . since
for my part I very much desire to preserve fervent, brave, clever, and skillful
individuals, so I ask you not to endanger yourself for naught. Upon reading
this letter, you may well ask: why was it written? To which I can offer you
the following reply: so that you had confirmation of my opinion of you,
for I am always most benevolent toward you. Catherine."[1] Letter in hand,
Potemkin raced back to St. Petersburg.

Catherine and Potemkin had met a decade earlier, the day of her coup,
when the 28-year-old guardsman leaped onto the back of her carriage en
route to the Winter Palace. Noticing that Catherine's saber was missing
the correct sword knot, Potemkin galloped across the square, ripped the
dragonne off his own sword, and handed it to her with a bow. Trained to
ride alongside its fellows in cavalry squadron, Potemkin's horse refused to

leave Catherine's side. Years later, Potemkin joked that he owed everything to a poorly behaved horse.

Potemkin became part of Catherine's inner circle, participating in her 1767 Legislative Commission in Moscow. On one occasion, Potemkin was asked to perform one of his famous impersonations. Everyone fell silent at his perfect imitation of the empress speaking Russian with her thick German accent—except Catherine, who burst out laughing. The couple's growing rapport did not amuse the Orlov brothers. Potemkin soon lost sight in his left eye, although the true cause has never been established. One version of the accident had Alexei Orlov beating him up after a game of billiards. But it would not have any effect on his prowess on the battlefield. At the start of the Russo-Turkish War, Potemkin sealed his reputation as a war hero by defeating four thousand Turks at the Battle of Kagul, and that was only the beginning of his victories. Recognized as one of the best cavalry commanders in Russia, Potemkin was chosen to carry General Rumyantsev's reports from the front line to the empress. Catherine nicknamed him "Alcibiades" after the brilliant Athenian general.

Back in St. Petersburg, Potemkin learned that Catherine had finally ended her long relationship with Gregory Orlov, but had started a rebound affair with a young ensign, Alexander Vasilchikov. After a month as lovers, Catherine moved Vasilchikov into Orlov's former apartment at the Winter Palace. To Potemkin's great frustration, several weeks after his return to the capital, Catherine had still not cut Vasilchikov loose. In January 1774, Potemkin called Catherine's bluff. Potemkin, a former Moscow University theology student, retreated to the Alexander Nevsky Monastery, threatening to take holy vows unless Catherine graced him with her favors. By early February, Catherine dispatched lady-in-waiting and longtime friend Countess Prascovia Bruce to convince Potemkin to join her at Tsarskoe Selo. On February 4, Potemkin traded in his monastic cassock for a uniform and rode in the imperial carriage to meet Catherine. That evening, the couple became lovers.

Five days later, before hosting a formal dinner at Tsarkoe Selo with Potemkin by her side, Catherine wrote Madame Bielke about Emelyan Pugachev and his "gangs of highwaymen." Preoccupied with war against Turkey and the hunt for a suitable wife for Paul, Catherine had dispatched a series of ineffective generals from Moscow to suppress what she thought

was a minor mutiny. Now she believed her new general, Alexander Bibikov, was restoring order in the Orenburg province with a handful of hangings. ". . . [T]hese very rare hangings are a thousand times more effective here than in those places where people are hanged every day," she wrote. "It is very probably that all this will soon come to an end. General Bibikov has everything necessary. And furthermore, something which lacks either sense or order cannot survive once it encounters order and reason."[2] But in a rare misstep, her instinct did not serve her well.

Matters at court continued to distract Catherine. Awkwardly, Alexander Vasilchikov (nicknamed "Ice Soup" by Catherine and Potemkin, possibly because of his frosty behavior after being replaced) hadn't vacated his apartment at the Winter Palace. To expedite his departure, Catherine rewarded him with properties and a 20,000-ruble pension. "General Potemkin is more in fashion than many others," Catherine wrote Grimm. ". . . I have drawn away from a certain excellent but very annoying citizen who has been quickly replaced, I don't know how, by one of the tallest, the funniest, and the most amusing originals of this iron century."[3] Complaining that he felt like a male cocotte, Vasilchikov, acknowledging that he had been beaten out by another suitor, retired to his Moscow country estate with a collection of Western European paintings and sculptures.

Catherine was smitten. Over six feet tall, blue-eyed, with leonine auburn hair, Potemkin was sexual, energetic, and witty. She wrote him love letters several times a day, often expressing her passion in French and state matters in Russian. Catherine called him "twin soul," her "tiger," "hero," "idol," and "dearest friend." In June 1774, she wrote tenderly: "My darling, my dear, my beloved, I have lost all common sense today. Love, love is the reason. I love you with my heart, mind, soul and body. I love you with all my senses and shall love you eternally." Catherine's passion for Potemkin was unlike anything she'd experienced. "In order for me to make sense, when you are with me, I have to close my eyes or else I might really say what I have always found laughable: 'that my gaze is captivated by you,'" she confided.[4]

But consumed by jealousy, Potemkin accused Catherine of having fifteen lovers before him. In her frank response, Catherine swore that besides her impotent husband, she'd only slept with four men before

Potemkin (Saltykov, Poniatowski, Orlov, and Vasilchikov)—". . . the first, chosen out of necessity, and the fourth, out of desperation . . . As to the other three, if you look closely, God knows they weren't the result of debauchery, for which I haven't the least inclination, and had fate given me in my youth a husband whom I could've loved, I would've remained true to him forever. The trouble is my heart is loath to be without love even for a single hour."[5]

In addition to their private chambers, Catherine and Potemkin met regularly for trysts in the *banya* (Russian bath) located in the Winter Palace basement. Because Potemkin was a night owl and Catherine an early riser, they rarely spent the night together. "As soon as I had gone to bed and the servants had withdrawn, I got up again, dressed and went to the doors in the library to wait for you, and there I stood for two hours in a draught; and not until it was nearly midnight did I return out of sadness to lie down in bed where, thanks to you, I spent the fifth sleepless night," she wrote.[6]

Catherine named Potemkin adjutant general in March, and he wasted no time involving himself in matters of state. By April, Potemkin was ensconced in the Winter Palace, having had a suite of rooms redecorated directly below those of Catherine, connected by a private spiral staircase carpeted in green. Potemkin moved a couch into Catherine's apartment, where he liked to lounge in his fur-lined dressing gown and red bandana. "Mr. Tom [Catherine's English greyhound] is snoring very deeply behind me on the Turkish divan General Potemkin has introduced," she wrote Grimm.[7] Soon, Potemkin enjoyed apartments in each of Catherine's palaces.

Catherine knew that marrying Potemkin would be political suicide. Her Russian-born son Paul, seen by many as Peter III's legitimate heir, enjoyed a strong following of his own. Since Paul turned eighteen, pressure was mounting for her to either share power with him, as Austria's Maria Theresa had done with her son, or yield the throne. But the tradition of male primogeniture had ended dramatically in 1722 when Peter the Great changed Russia's long-standing law of succession with a decree that allowed tsars or tsarinas to choose their own heirs. Legally, Catherine had the power to name her successor, male or female, at any time. Though Catherine had proclaimed Paul her heir when she seized power in 1762, as he came of age she increasingly saw him as a threat, fearing revenge for Peter's death. She

rejected suggestions that he co-rule, and rebuffed his attempts to participate in government affairs.

Five months into Catherine's relationship with Potemkin, in early July 1774, the couple is believed to have secretly exchanged vows in the Church of St. Samson. Catherine's confessor, Ioann Pamfilov, is thought to have officiated before witnesses sworn to secrecy: Maria Perekusikhina, Catherine's maid; Alexander Samoliv, Potemkin's nephew; and Yevgraf Chertkov, court chamberlain. In her letters, Catherine mentions the sacred bonds that linked them forever and refers to Potemkin as "dear spouse" or "husband" and to herself as his wife over a dozen times.[8] In hundreds more letters, she names him her lord or master.[9]

Later that month, Sultan Mustafa died. After six years of war, the Ottomans finally signed the Treaty of Küçük Kaynarca. Catherine had accomplished her main objective—gaining unrestricted access to the Black Sea. The war brought southern Ukraine, the northern Caucasus, and the Crimea under Russian control. In the 18th century, the Ottomans ruled today's Greece and most of the Balkans. As part of the treaty, Russia became a protectorate of all Orthodox Christians of the Ottoman Empire, opening a door for Catherine's campaign to liberate the Balkans and Peloponnese. Though the treaty gave independence to the Crimean Khanate, the strategic peninsula became dependent on Russia.

That was the good news for Catherine. Yet, closer to home, Emelyan Pugachev was gaining strength. In 1774, he led 20,000 peasants in the capture of Kazan, setting fire to the city and slaughtering nobles. Later that year, the revolt spread to mining communities in the Urals. As added incentive to his supporters, Pugachev was now offering monetary rewards—100 rubles for a landlord's head or plundered castle, 1,000 rubles and rank of general for ten murdered nobles and ten destroyed castles.[10] Wearing a red Cossack coat and a fur cap with gold tassels, Pugachev would storm into a village. While he dined in the governor's house, nobles were hanged outside on makeshift gallows. By mid-1774, Pugachev's forces had crossed the Volga into territories populated by Russian serfs. Declaring the serfs free, he ordered them to wreak vengeance. Over 1,500 landlords were killed as serfs seized lands, pillaged granaries and warehouses, and set fire to manor houses.

Pugachev's next target was Moscow where 100,000 serfs lived as servants and industrial workers. News of Russia's violent peasant uprising had spread throughout Europe and the American colonies and Catherine feared the public relations fallout as well as the threat to Russian society that was now frighteningly real. At an emergency meeting at Peterhof Palace, the empress declared that she would personally travel to Moscow to fight Pugachev. With strong support from landlords, government officials, and army officers, Catherine responded to the rebels with massive force.

In August, Alexander Suvorov led a crushing defeat of the rebels near Tsaritsyn (later renamed Stalingrad, today Volgograd), forcing Pugachev to flee home to the Don. Suvorov's troops chased the rebel leader to the farthest outback across the steppes. In an effort to save themselves, Pugachev's lieutenants turned him in. Pugachev was brought back to Moscow in an iron cage. In reprisal for the assassination of some 3,000 officials and 2,500 noblemen throughout the countryside, Catherine ordered his followers killed. Hundreds were beheaded and hanged savagely from their ribs by a metal hook; thousands more were flogged or mutilated.

Pugachev begged Catherine for mercy. "If it were only I who he had offended, his reasoning would be correct and I should pardon him; but this is a case involving the Empire which has its laws," she wrote.[11] After a secret two-day trial in the Great Kremlin Hall, Pugachev was taken to Bolotnai Square near the Kremlin on January 10, 1775. In a show of clemency, Catherine allowed Pugachev to be decapitated before being quartered. The pieces of his dismembered body were displayed on a pole in the middle of the scaffold; his head placed on an iron spike.

Deeply shaken, Catherine had Pugachev's village destroyed and rebuilt on the opposite side of the Don as Potemkinskaya. Other places connected with the revolt were similarly renamed; Yaitsk and the Yaik River, where the uprising began, became Uralsk and the Ural; Ural Cossacks replaced the Yaik Cossacks. Catherine blamed Pugachev's success on weak local government. To beef up local control and prevent another uprising, Catherine further decentralized Peter the Great's reforming network of fifty provinces and districts in November 1775. Drawing new boundaries, she appointed nineteen governors with vice-regal status responsible for maintaining law and order (by the end of Catherine's reign, there were forty provinces). Reporting

to Catherine and the senate, each governor received an extravagant gift from the empress—an elegant silver table service made by the finest silversmiths in St. Petersburg, London, Augsburg, and Paris. Eventually the governors would answer to a governor-general appointed by Catherine. At the same time, Catherine abandoned her early interest in reforming serfdom and now granted greater privileges to Russia's upper classes.

The Pugachev Rebellion put Catherine on high alert for other pretenders and internal threats, as Pugachev would not be the last. Several months after Pugachev's execution, the threat came in the form of an adventuress claiming to be Princess Elizabeth, daughter of Empress Elizabeth and Alexei Razumovsky. After many stops and aliases throughout Europe, the Russian-born "princess" landed in Italy where she hooked up with Prince Karol Radziwill, an anti-Russian Confederate Pole. She requested a passport from Sir William Hamilton, British Ambassador to Naples, who mentioned her to Alexei Orlov. In early 1775, Catherine ordered a mafia-style kidnapping. If the locals didn't hand the young woman over, "one can toss a few bombs into the town." But it would be far better to capture her "without noise if possible," she wrote Orlov.[12]

After locating his victim in Pisa, Alexei Orlov courted her with love letters and seduced her into an eight-day affair. Invited to inspect Orlov's fleet in Livorno and lured aboard ship with a promise of marriage, she was immediately arrested and taken to St. Petersburg. The squadron was commanded by Samuel Grieg, the Scottish vice-admiral who had helped engineer the Chesme victory five years earlier. By mid-May, Catherine's abductee was imprisoned in a gloomy dank dungeon at the Peter and Paul Fortress.

Unwisely, the young inmate signed her appeals for better living conditions and an audience with the Empress "Elisabeth." Catherine was not amused. "Send someone to tell the notorious woman that if she wishes to lighten her petty fate, then she should cease playing comedy," she wrote.[13] In early December, after six months of imprisonment, the 23-year-old died of tuberculosis and was secretly buried in the fortress graveyard. Today, she's known as Princess Tarakanova, literally "of the cockroaches." For his role in the kidnapping, Samuel Grieg received a thank you note from Catherine: "I shall always remember your services and shall not fail to give marks of my benevolence toward you."[14]

CHAPTER TWO

ANGLOMANIA

I n June 1774, a notice appeared in several London newspapers adver-
tising tickets to see "a Table and Dessert service." Each day for a month,
carriages created a traffic jam as aristocrats arrived at the Greek Street
showroom to admire plates and serving pieces depicting their own country
estates. "It consists I believe of as many pieces as there are days of the year,
if not hours," wrote Mary Delany, a member of London's "bluestocking"
literary circle.[1]

Ambitious Staffordshire potter Josiah Wedgwood made sure to invite
Queen Charlotte and her brother, the Duke of Mecklenburg-Strelitz,
along with the visiting Swedish royals, to see the exhibit. Not only was
Wedgwood's show a clever marketing ploy, it proved to be a propaganda
coup for his client. By September 1774, Catherine was unpacking the
exhibit—twenty-two crates of her new Green Frog Service.

Wedgwood's "Great Patroness in the North" was a repeat customer. Six
years earlier, Wedgwood persuaded Britain's ambassador to Russia to be his

sales agent. Within a year, Lord Cathcart secured four orders, including a twenty-four-person table service for the Winter Palace. Featuring the scallop-edged "Queen's Shape" from the Queen Charlotte's breakfast service, Catherine's "Husk Service" arrived in fall of 1770, named for its lilac wheat husk borders.

Catherine's second order was far more challenging. While leaving the style and specific decoration to Wedgwood, she required that each piece be hand-painted with a different, topographically accurate British view, preferably Gothic. The order represented the commission of a lifetime, but Wedgwood had one major concern. He'd recently undertaken an ambitious commission for Frederick the Great with scenes of his domains, but it was smaller in scale. "Suppose the Empress should die," the practical potter wrote his partner Thomas Bentley, "it will be a very expensive business."[2] Contacting the empress directly, Wedgwood convinced her that the service she requested—almost 1,000 hand-painted pieces—would cost far more to execute than the £500 suggested by Alexander Baxter, Russian consul in London. In the end, Catherine paid £2,700 for the elaborate Green Frog Service.

Wedgwood's first challenge was finding enough views of English castles, abbeys, country estates, landscapes, ruins, and gardens. To help, Wedgwood hired an artist to "take 100 views upon the road" around his hometown of Staffordshire with a camera obscura.[3] Flattered to have their estates depicted for the "first Empress in the World," British landowners also allowed Wedgwood's artists to sketch from their collections. Hundreds of sketches were submitted to Bentley, who matched the views with the shapes of the various pieces.

In the foreword of his handwritten catalogue for Catherine, Bentley described the romantic views: "The principal subjects are: the ruins, the most remarkable buildings, parks, gardens and other natural curiosities which distinguish Great Britain . . . specimens of architecture of all ages and styles, from the most ancient to our present day; from rural cottages and farms, to the most superb palaces; and from the huts of the Hebrides to the masterpieces of the best known English architects."[4] In the end, the set included a dinner service (680 pieces) and a dessert service (264), for a total of 944 items. Because some pieces like Stowe and Windsor

Castle featured multiple illustrations, the total number of hand-painted views reached 1,222.

The unlikely mastermind behind this unique service was the thirteenth and youngest child from "a dirty spot of Earth" in the Midlands. After years of experimentation, Josiah Wedgwood perfected what he called creamware—an ivory-white earthenware both lighter and stronger than porcelain. Wedgwood's career took off in 1765 when he presented Queen Charlotte with an exquisite creamware breakfast set featuring raised sprigs of green flowers against a gold background. Charlotte and George III were so delighted, they named the 36-year-old "Potter to Her Majesty" and ordered a complete dinner service. The savvy potter quickly rebranded his creamware "Queen's ware."

Though Wedgwood duplicated the "queen's shape" for some of Catherine's pieces, he created new compotiers, cream bowls, and ice cream dishes known as "Catherine shape." After being molded and fired at the Etruria Factory in Staffordshire, the pieces were sent to Wedgwood's Chelsea studios outside of London where some thirty artists copied the chosen views from engravings, topographical books, and pictures. A border of oak sprigs embellished the dinner service; ivy leaves framed the border of the dessert service. Each monochrome scene was painted in sepia enamel—a mix of purple and black pigments that appeared mulberry in color against the cream glaze. At Catherine's request, Wedgwood added a tiny green painted frog on a heraldic shield on each green and purple border.

The Green Frog Service represented Catherine's first large-scale order from a British company. Brimming with political meaning, the celebrated service was a highly visible gesture of diplomacy between Russia and Britain. Ties between the two countries dated back to Peter the Great's 1698 visit when he lived in Greenwich and worked in the Deptford shipyards. Thanks to a 1766 commercial treaty (lasting two decades), Russia enjoyed a thriving trade with England. George III had supported Catherine during the Russo-Turkish War, allowing her fleet to sail through the English Channel and Straits of Gibraltar to the Eastern Mediterranean for the surprise attack at Chesme.

The British Empire had become one of the largest in the world; its stable government was lauded by Voltaire and Montesquieu. Early in her reign,

Catherine had hoped to base Russia's constitutional reforms on Britain's constitution and political structure. She may also have looked to Britain's cultured aristocracy as a model for her own courtiers. In addition to its political message, the Green Frog Service reflected Catherine's self-described "Anglomania" which she shared with Potemkin. Catherine, who spoke fluent German, French, and Russian, took daily English lessons. She chose English physician Thomas Dimsdale to give her a groundbreaking smallpox inoculation and named her beloved Italian greyhounds (a gift from the doctor) Sir Thomas and Duchess Anderson. She had a passion for English landscape gardens which she described to Voltaire in June 1772: "Now I love to distraction gardens in the English style, the curving lines, the gentle slopes, ponds like lakes . . . and I hold in contempt straight lines and twin alleys. . . . I hate fountains which torture water to make it take a course contrary to nature; in a word, my plantomania is dominated by anglomania."[5]

The ultimate armchair traveler, Catherine experienced English country houses and gardens through a rich collection of illustrated books and engravings, along with travel reports by her courtiers. When Catherine's former lover Stanislaus Poniatowski first arrived in St. Petersburg as secretary to the new British ambassador, he shared descriptions of Stowe, Prior Park, Wilton, and Oxford. After seizing power, Catherine ordered the tops of hedges and bushes at Tsarskoe Selo left unclipped. She was also inspired by the gardens created by her second cousin, Prince Franz II of Anhalt-Dessau.

Many of Catherine's imperial parks, including the English Park at Peterhof, were created by English and Scottish landscape gardeners. In 1769, she recruited Scot Charles Sparrow and his brother John to create an English garden at Gatchina. Catherine sent Vasily Neelov and his son on a garden tour of England; they brought back prints of Stowe, Kew, Studley Royal, and Wilton. Neelov was soon collaborating with English gardener John Bush for Catherine's English park at Tsarskoe Selo.

Wedgwood earned just a £200 profit on the service for Russia's empress. Though it was basically a breakeven, the renowned service launched Wedgwood into one of the first global brands, allowing him to become "vase maker to the universe."[6] Wedgwood benefited greatly from the Catherine

Effect. Russia's nobility couldn't get enough of his fashionable creamware. In just the month of August 1789, his firm shipped 18,449 pieces of pottery to Russia.[7]

Until the Revolutionary War temporarily slowed exports, Wedgwood also shipped huge quantities of creamware to the American colonists, whom he supported. Catering to the popularity of classical objects, Wedgwood began creating cameo medallions and urn-shaped vases with swags and garlands. Catherine remained an avid patron, ordering Wedgwood medallions to decorate her new bedroom at Tsarskoe Selo.

⌘

Replacing the traditional imperial crest on her dining service with one thousand tiny frogs may seem eccentric. But like many of Catherine's commissions, the Green Frog Service was part of a sophisticated ensemble. Catherine conceived the unique creamware service to complement a Gothic Revival castle underway ten miles south of St. Petersburg. The castle was originally called Kekerekeksinen, Finnish for "frog marsh," but Catherine preferred the French version: La Grenouillère.

In 1774, Catherine tapped Yury Velten to design the castle for stopovers between the Winter Palace and Tsarskoe Selo. Thanks to his elegant granite Neva embankments and neoclassical South Pavilion at the Winter Palace, Velten had become one of Catherine's favorite architects. Around this time, Catherine also ordered repairs to the frequently used roads between St. Petersburg, Tsarskoe Selo, and Peterhof. Elegant obelisks of colored marble and granite were installed every two thirds of a mile.

The six-year war with Turkey had unleashed a wave of nationalism in Russia. Some historians speculate that by commissioning a neo-Gothic, medieval-style castle, Catherine was likening the Russo-Turkish War to the medieval crusades. Having grown up in Germany and visited her grandfather's 12th-century castle, Catherine was also familiar with medieval architecture. Catherine seems to have steered her architect to Longford Castle in Wiltshire, on the banks of the Avon River, which achieved literary fame as the castle of Amphialus in Sir Philip Sidney's *Arcadia*.[8] The

late-16th-century castle was depicted on a serving dish cover in the Green Frog Service.

From selecting the marshy setting and architectural style, to participating in its neoclassical interior design, Catherine was actively involved in the project. She may even have made drawings for the complex. "I was fortunate to take part in the construction of numerous monuments to Your Imperial Majesty's reign by executing Your Own designs and I continue to keep a collection of drawings made by Your Majesty's hand," Yury Velten later wrote.[9] Both to enhance the medieval effect and help drain the frog-infested site, Velten surrounded his "toy castle" with a moat. Based on a triangular plan, the castle evoked a medieval fortified palace with rotundas on both stories, round stair towers at each of its three corners, and a massive central tower with a crenellated parapet. For an added Gothic touch, Velten added lancet windows and battlements.

Catherine used the Round Hall in the central turret to present the Order of St. George, Russia's highest military honor, to commanders like Field Marshals Kutuzov and Suvorov. For the gatherings, Catherine commissioned the St. George Service from the Gardner Porcelain Factory as a symbol of Russian military glory. On a velvet-covered table in front of the red velvet throne, Catherine placed the Chesme Inkwell by Barnabé Augustin de Mailly. The Parisian goldsmith turned Catherine's order for a writing set into a spectacular piece of jewelry art. To a warship deck made of ormolu, silver, and ebony, de Mailly added cannons, mortars, military trophies, and miniature paintings with episodes of the Russo-Turkish War. Between mortar guns, the lid of a small box in the form of a miniature rug showed the burning of the Turkish fleet in Chesme. The mortar guns doubled as a sandbox and penknife holder; the cannons as candlesticks. True to form, Catherine did not like the mast and had it removed from the inkstand.

From the start, Catherine used her own portraiture to legitimize her reign. Now she reinforced that legitimacy by assembling a portrait gallery of Europe's royal houses, which she would preside over. In 1774, she commissioned Fedot Shubin to produce nearly five dozen white marble portrait medallions of Russia's princes and tsars, from Rurik to Elizabeth I. Displayed on the upper part of the walls of the circular state gallery, each

of Shubin's framed oval low relief portraits featured an inscription with the subject's name and birthday (housed today at the Kremlin Armory, Moscow). In ten adjoining rooms, Catherine hung full-length portraits of the crowned heads of Europe and their families.

Though some of the nearly five dozen portraits were gifts from her ambassadors, the project wound up being an expensive whim, costing over 32,000 rubles. Despite this large investment, the quality of the canvases was uninspired. After a tour of the castle in June 1779, Sir James Harris wrote: ". . . a few days ago [Catherine] carried me with only two of her courtiers, to a country place, where she has placed the portraits of all the crowned heads of Europe. We discoursed much of their several merits; and still more on the great demerits of the modern portrait painters. . . ."[10]

Upstairs, visitors entered a small square room hung with portraits of Catherine with her greyhound on a chair, and Paul and Natalia Alekseyevna. Next came the English Room, with half a dozen portraits. In 1774, a gift of paired portraits of King George III and Queen Charlotte Sophia by Nathaniel Dance arrived, followed four years later by a double portrait of the future George IV and his brother Prince Frederick by American expat Benjamin West. Other rooms displayed portraits of Prussian, Swedish, Hapsburg, Spanish, Portuguese, Dutch, and Sardinian royals. Catherine commissioned several portraits of the French royal family in 1773, including a portrait of Louis XV by Thomir and portraits of Marie Antoinette, Comte Charles d'Artois, and Charles's wife Marie-Therese de Savoie by Alizard.

Catherine had an ironic attitude toward her contemporaries, especially Austria's conservative Maria Theresa, who had sixteen children. The portraits of Europe's crowned heads inspired her to pen an imaginative short story. In *Chesme Palace: The Conversation between Portraits and Medallions*, a palace guard sees the royal portraits come to life and chat with one another. "While an old sentry was making his rounds of Chesme Palace, he suddenly heard a noise. He pricked up his ears and to his great surprise realized that the portraits and medallions that were housed in the palace were exchanging remarks with one another. . . ."[11] In the Prussian Room, "Frederick asks brother Henry who is this bearded man? We should not judge people by their beards."

Catherine also included this exchange among portraits: *Louis XVI:* I seek to do good. *His queen:* I kiss you, majesty, for these marvelous words, and I will honor them by giving a ball for you this evening . . . *Empress Maria-Theresa* (*the queen's mother*): Antoinette so loves society that I fear for the health of her soul . . . *Joseph II:* But she is so beautiful, so lovable, so young."[12]

CHAPTER THREE

A Crowd and Not a City

Ever since becoming seriously ill in Moscow as a teenage bride, Catherine disliked the former capital. During her reign, she would visit what she called the "seat of idleness" just eight times. In early 1762, when her husband commuted the obligation of nobility to serve the tsar at court, Catherine noted in her memoirs that Moscow's nobility "would happily spend their entire lives being taken about all day in a coach and six . . . which hides from vulgar eyes the master's own dirt and the disorder of his household in all matters and especially its economy." She found Moscow's noblewomen disgusting; their servants poorly dressed. "You would hardly dare to say that they were people like us," she wrote condescendingly.[1]

Catherine also disliked Moscow's lack of order and "false air of Ispahan"—a reference to its Asiatic influence dating back to the 13th century Mongol invasion. "Never can a people have been confronted by more objects of fanaticism," she wrote, "more miraculous images at every step, more churches, more men of the cloth, more convents, more of the faithful,

more beggars, more thieves . . ."[2] After returning to the capital from her Legislative Commission, the empress told Nikita Panin that "Petersburg seems like paradise in comparison to Ispahan . . ."[3] The plague, riots, and archbishop's murder reinforced her opinion, which she voiced to Voltaire: "Moscow is a crowd and not a city."[4]

As in many areas, Catherine's attitude toward Moscow was influenced by Peter the Great, who visited rarely. When a fire in 1701 destroyed and gutted much of the Byzantine-style Kremlin, Peter built an enormous European-style arsenal inside the fortress. Six years later, the threat of an attack on Moscow by Sweden forced Peter to refortify the Kremlin with eighteen enormous bastions, a project that required 30,000 workers. When Peter moved his court to St. Petersburg, writes Catherine Merridale, the Kremlin was reduced from Russia's religious and administrative center to a ceremonial prop.[5]

In February 1718, Peter the Great staged the treason hearing of his eldest son Alexei at the Kremlin Banqueting Hall. Peter's infant son Peter Petrovich was immediately proclaimed Russia's new heir in the nearby Dormition Cathedral. After weeks of torture ordered by his father, Alexei died that June. In preparation for the coronation of his wife Catherine in the Dormition Cathedral, Peter the Great repaired the Kremlin cathedrals, whitewashed the Banqueting Hall, and refurbished the Faceted Palace. In 1737, a dozen years after Peter's death, the Kremlin suffered another devastating fire. By the mid 18th century, the fortress was decaying; its palace uninhabitable.

Despite her aversion for Moscow, Catherine understood the Kremlin's symbolic power and chose the city for her extravagant coronation. In 1770, Catherine approved a much-needed renovation of the Kremlin's three main cathedrals. She ordered the head of the church to make sure their wall painting "be renovated with the same skill as the ancient ones, without any change," and cautioned that "the painters sent to do this work of icon painting and frescoes must not be secular, but religious people, and your Holiness should make sure that they carry out their work with the decorum appropriate to God's holy churches." To repair the fire and weather-damaged frescoes, she also required that pious artists be hired, "the type of people that you find in monasteries."[6] Unfortunately, Catherine

also approved their use of longer-lasting oil-based pigments. Along with subsequent retouching and cleaning for future coronations, the modern pigments ruined much of the original medieval decoration.[7]

One of Catherine's early Moscow projects was Kolomenskoye, a royal residence several miles southeast of the city on the road to Kolomna. Set on scenic 964 acres overlooking the steep banks of the Moscow River, Kolomenskoye had been the favorite residence of Peter the Great's father, Tsar Alexis I. Around the time Louis XIV was transforming Versailles, Alexis demolished an existing hunting lodge to make room for a second royal court. Remarkably, carpenters, upholsterers, painters, gilders, carvers, and blacksmiths built a 250-room wooden palace without saws, nails, or hooks.

Elaborate carved windows and gabled and shingled roofs with weathercocks and gilded double-headed eagles gave the palace a fairy-tale appearance. Inside the "Eighth Wonder of the World," flanking the Byzantine-style throne, a pair of fur-clad mechanical lions roared at the touch of a lever. An avid falconer, Alexis I also built country estates on an artificial island at Izmailovo, five miles northeast of the Kremlin, and Preobrazhenskoe, some six miles farther. As a teenager, the future Peter the Great learned to sail a small boat at Izmailovo; before founding St. Petersburg, he governed Russia from Preobrazhenskoe.

Peter spent part of his youth at Kolomenskoye; Empress Elizabeth was born there in 1709. Coronation festivities for Catherine I, Peter II, and Empresses Anna and Elizabeth were also held here. But when Peter moved his court north, the residence fell into disrepair. Refusing to make the dilapidated century-old structure her Moscow residence, Catherine ordered it demolished in 1768. In its place, she built a modest stone-and-brick structure with the help of architect and lieutenant colonel Prince P. V. Makulov. "There is no need for any sort of rich decoration inside," she said after six months of involvement with the plans.[8] (Catherine's palace was razed in 1872; in 2010, a replica of Alexis's palace was built based on several surviving drawings and a wood model commissioned by Catherine; Ascension Church, built by Vasily III in 1532 to celebrate the birth of his son, Ivan the Terrible, is now a UNESCO site.)

"As you know, the building frenzy is as powerful as ever with us, and hardly any earthquake can knock down as many buildings as we are putting

up," Catherine wrote Grimm in August 1779.[9] Catherine's focus was St. Petersburg, and many of her Moscow commissions were never completed. The most stunning of these doomed projects was the Great Kremlin Palace, an ambitious plan to transform the Kremlin into an Athenian acropolis. Catherine awarded the prestigious undertaking to Vasily Bazhenov, a Muscovite who'd won a scholarship to study architecture in Paris and Italy. Bazhenov spent several years drawing up blueprints for what promised to be Europe's largest palace complex—a gigantic triangular edifice half a mile in length with a grand façade facing south along Moscow's riverbank. When a mob stormed the Kremlin during the plague, Bazhenov personally guarded his palace model filled with 60,000 rubles' worth of miniatures.

At first Catherine liked Bazhenov's plan and several old structures were razed, including a church, two towers, and part of the Kremlin wall. When Catherine attended the inaugural ceremony in August, work had already begun. In a giant square dedicated to Europe, Asia, Africa, and America, Bazhenov erected four Doric columns. One bore an inscription comparing the Kremlin to the finest buildings of classical Greece and Rome. Rather than set the vast four-story palace on the top plateau of Kremlin Hill, Bazhenov chose the steep slope between the plateau and Kremlin wall—slated for demolition. The proposed changes to the Kremlin provoked vocal critics, including court poet Gavriil Derzhavin. In June 1773, when Bazhenov laid the ceremonial bricks with emblems of the empress and Grand Duke Paul, Catherine was conspicuously absent. After word that demolition had caused cracks in the walls of the Archangel Cathedral, Catherine lost heart and canceled the entire project.

Following Pugachev's execution, Catherine thought it politically wise to shore up support by celebrating the end of the Russo-Turkish War in Moscow. After seven years away from the city, the empress staged a triumphal entry on January 25, 1775, accompanied by the grand duke and grand duchess. To Catherine's great dismay, her son received a more enthusiastic reception than she did from Muscovites, who knew about her disdain for the city. As Hugh Ragsdale writes, ". . . [I]t was only natural that xenophobic and misogynist Russians discontent with the government of an illegitimate foreign woman would turn their hopes onto a legitimate native man, an heir raised in Russia by Russians."[10]

Tensions between mother and son had been worsening since the previous summer when she'd rejected Paul's efforts to join her state councils and he'd written a memorandum critical of her policies. By the time of the Moscow visit, Catherine had also soured on the daughter-in-law she'd called the "golden girl" for overspending and failing to learn a word of Russian. Catherine spent the good part of the year at Kolomenskoye Palace, where she had apartments redesigned for Potemkin. She received ambassadors and entertained at the rambling Prechistensky Palace, three houses formerly owned by the Golitsyns, Dolgorukys, and Lopukhins and remodeled by Matvey Kazakov.[11]

Around this time, Catherine commissioned two new imperial residences in Moscow. In 1774, Catherine purchased the village of Chernaya Griaz near Moscow and renamed it Tsaritsino (the village of the tsarina). She'd discovered the charming wooded property known as "Black Earth" on a walk the previous year. According to Catherine, owner Serban Kantemir, Prince of Moldavia, "took no interest in waters, forests or majestic scenery" but spent his life playing cards.[12] It was gambling debts that forced the aging prince to sell his estate to Catherine, who ordered work begun right away. Some historians believe that it was there, in a cozy six-room cottage, that Catherine and Potemkin spent their secret honeymoon.[13] Catherine rehired Vasily Bazhenov to design Tsaritsino. The architect designed his neo-Gothic and Moorish style palace around a huge English park with lakes, isles, bridges, grottos, pavilions, and a separate theatre.

Catherine also hired Matvey Kazakov to build Petrovsky Palace north of Moscow. Like Chesme, Petrovsky was intended as an imperial transit palace between St. Petersburg and Moscow. The son of a sailor, Kazakov had never traveled outside of Russia or visited St. Petersburg. Combining Gothic style with medieval Russian accents, Petrovsky Palace featured turreted wings with fortress-style towers flanking the main building topped by a huge decorated dome over the central rotunda. Kazakov also added a hexahedral "Turkish" tower resembling a Muslim minaret to the surrounding park. Catherine visited the romantic red brick palace just once in 1785, staying in the royal apartments on the first floor, calling it "a very good pied-a terre."[14] Starting with Paul, Catherine's heirs used Petrovsky

as their last stop before coronations at the Kremlin. It was also here in 1812 that Napoleon watched the Kremlin "besieged by an ocean of fire."[15]

The dilapidated Kremlin continued to be an embarrassment for Catherine. Kazakov had just finished Chudov Palace, the official residence for Moscow's new Archbishop Platon, beside the Chudov Monastery. In 1776, Catherine hired him to design a meeting hall on Kremlin Hill, known as the attendance place (today's Senate). The site's unusual shape informed Kazakov's triangular plan for a neoclassical building with a pentagonal interior. At the apex of the triangle, Kazakov added a ceremonial round chamber with a large spherical cupola some eighty feet in diameter. The striking deep yellow building with white accents became a model for neoclassical buildings across Russia.

When Empress Elizabeth's Golovin Palace burned down in December 1771, Catherine was surprised it had lasted that long. As a replacement, Catherine herself drew up plans to remodel nearby Menshikov Palace (Peter the Great's twelve-year-old grandson Peter II stayed here before his coronation in 1727 and died here of smallpox three years later). "Ask [architect] Prince Makulov if he agrees to take on the construction work, and tell him that he will see from my plan that the internal wall of this palace should be rebuilt and pushed out into the courtyard so that we obtain a double room whose width is indicated on the plan," she wrote Prince Volkonsky, Moscow's governor-general.

Prince P. V. Makulov argued against renovating the old palace. ". . . [I]t would be better to knock almost all of it down and start anew," Catherine concluded. "Even then it would be bad since it is near a slope and it would cost up to 900,000 roubles, which I am certainly not prepared to spend on a temporary building."[16] Ultimately, Catherine opted to build a grandiose stone palace on the opposite side of the Yauza River from the burned down Golovin Palace. Catherine never got to enjoy it. Designed by Quarenghi, Rinaldi, and Camporesi, Catherine Palace was not completed until 1796, the year she died.

CHAPTER FOUR

BREAKING THE MOLD

After two years as Catherine's lover, Potemkin was one of the wealthiest men in Europe—richer than many crowned heads. In addition to titles, property, money, serfs, art, jewels, furniture, and furs, Catherine gave her lover a brandy distillery, a tannery, as well as mirror, sail-making, and rope factories. Among her smaller gifts was a gold carnet from Paris covered with cobalt blue enamel allegorical medallions. In addition to split pearls, opals, and emeralds, the diamond inscriptions read "Reminder" and "Gratitude." Inside were sheets of ivory and a pencil.

Count de Ségur described Catherine's favorite: "Never at the court or in civilian life or in the military has there ever been a courtier more wild and wonderful, a minister more enterprising or less industrious, a general more courageous and, at the same time irresolute . . . he had a kind heart and a caustic wit."[1] In 1776, Catherine ennobled Potemkin and rewarded him with the Anichkov House, a massive residence on the Neva whose previous occupant was Alexei Razumovsky. When Potemkin sold Anichkov

162

to pay his debts, Catherine repurchased it from him. Though he entertained and kept his library there, Potemkin preferred living at Shepilev House, a former stable linked to the Winter Palace. There, he and Catherine walked to each other's rooms along a private passageway by the palace chapel.

Catherine's infatuation with Potemkin inspired a gift considered among the 18th century's most magnificent dinner services. "The Sevres service I have ordered is for the first nail-biter of the universe, my dear and well-beloved Prince Potemkin and, in order to ensure that it's beautiful, I have said that it's for me."[2] Specializing in luxury porcelain, the royal manufactory at Sèvres had caught up with Saxony's Meissen as Europe's most prestigious factory. Founded in 1745, the factory enjoyed a monopoly for producing "Saxony-style" porcelain and marked its porcelain with the royal monogram.

Legend has it that Louis XV's official mistress, Madame de Pompadour, became smitten with the painted soft paste porcelain being produced at Vincennes, outside of Paris. On one occasion, she reportedly filled her garden with porcelain flowers and sprayed the air with perfume. When Louis stooped to pick one of the porcelain flowers, he was so delighted that he bought a percentage of the factory and relocated it to Sèvres, on the outskirts of Paris in 1756. Within three years, the king was sole owner.

Potemkin coordinated the order through Prince Ivan Bariatinsky, Russian ambassador at Versailles. By using official channels, Catherine may have been trying to mend fences with Louis XVI, proprietor of the Sèvres factory since the death two years earlier of his grandfather. Potemkin instructed Bariatinsky that the dinner, dessert, tea, and coffee service for sixty should be "in the best and newest style [classicism], with Her Majesty's monogram on every piece" and "without any deviation from antique models, with reproductions of cameos."[3] The diplomat visited Sèvres regularly during production, supervising the selection of the ground color, bas-reliefs, and cameos.

Work on other orders was put on hold. Most of the factory's artisans, thirty-seven painters and five gilders, were assigned to the empress's commission. The plates, which featured thirty different patterns, underwent eight redesigns before Catherine signed off. Catherine's colored monogram, EII, was woven in a garland of flowers and topped by a gold crown on

every piece of the richly decorated service (except cups, ice cream bowls, and teapots). Many of the pieces were rimmed with white beading made to look like pearls.

The service's stunning color, *bleu celeste* (turquoise blue), was also known as *bleu Hellot* after chemist Jean Hellot, who replicated the brilliant glaze invented by Chinese ceramicists in the late 17th century. In 1753, the year after Hellot's discovery, Sèvres created the first turquoise porcelain service for Louis XV. The formula was a closely guarded secret known only to Sèvres painters and their counterparts in China. But *bleu celeste* proved unachievable in the newly invented hard paste porcelain. The ground for Catherine's order had to be made in the more demanding soft paste formula, a European invention designed to imitate Chinese and Japanese porcelain. The absorptive qualities of soft paste gave the Cameo Service a beautiful depth of color—from the turquoise ground to the gold vignettes and pink rosettes.

In order for the enamels to seep into the soft paste, each piece required at least four rounds in the kiln. The plates, which featured a double layer of tooled gold, demanded eight or nine firings at the following stages: biscuit (once), glazing (twice), ground color (three times), painting (once), and gilding (twice).[4] To make the creamy gilding, Sèvres artisans crushed gold leaf to a very fine powder and mixed it with an extract of acacia sap. After melting and adhering to the glaze in the fiery kiln, the gold was burnished and chased with tools.[5] After visiting the factory, Josiah Wedgwood's cousin Samuel Wedgwood observed: "The Gold burnt in when laid on is of an umber colour. It is all the most pure Gold of 24 Carratts."[6]

Due to the complex production, losses on the service proved staggering. The factory fired three thousand pieces to get eight hundred flawless items. Costs were also driven up by new models and molds, since the baroque forms created at Sèvres a generation earlier did not reflect Catherine's neoclassical taste. Against the turquoise background artisans added wine-colored oval cartouches and round medallions with scenes from mythology and classical history. The images were applied using a new transfer-printing technique invented by Nicolas Pierre Berthevin, never used at Sèvres. With over two thousand images of heads and bas-reliefs on the plates alone, the Cameo Service became a veritable encyclopedia of antique art.

Larger pieces like wine coolers featured "carved" cameo heads made separately from polished biscuit. Cut on a stone-cutter's wheel in a lapidary workshop at Sèvres, these cameos contained layers of brown and white paste to imitate agate and onyx. For the brown, artists used the recently discovered hard paste porcelain with kaolin (white clay); for the white, biscuit (unglazed porcelain). After firing, the cameos were set into oval recesses against dark red marbled background and fixed in place with a gilt copper laurel wreath frame. The grandest pieces featured four cameo heads in relief. Many of these carved cameos were copied from Louis XVI's own gem collection, one of Europe's largest.

Louis XVI and Marie Antoinette were Sèvres's best patrons, filling the apartments of Versailles and other royal palaces with garnitures of vases and hundreds of biscuit figures. On one occasion, workers arriving at Versailles to unpack porcelain for the annual Sèvres exhibition were quite surprised to discover the king on his hands and knees opening boxes and breaking several pieces in the process.[7] Among the royal couple's numerous Sèvres orders were diplomatic presents—including an elaborate dressing table set with gilded figures inspired by antique reliefs presented by Marie Antoinette to Catherine's daughter-in-law, Maria Feodorovna, during her 1782 visit to Paris.

Falconet's successor at Sèvres, Louis-Simon Boizot, pulled out all the stops to create the ambitious *surtout de table*. With 110 molds and a price tag of 8,820 livres, the spectacular allegorical biscuit centerpiece featured a helmeted bust of Catherine as Minerva atop a fluted column. At the base of the nearly three-foot tall sculpture were some two dozen figures evoking Catherine's patronage of the arts, letters, and sciences. Other figures included copies of famous marble sculptures—including a group of three scantily dressed women carrying Cupid after *Les Trois Graces portant l'Amour* by François Boucher.

Meanwhile, Catherine's relationship with Potemkin was in deep trouble. Potemkin's passion was waning, and by mid-1775 he was often in a violent rage, charging into Catherine's room to quarrel and slamming the door behind him. Growing tired of his outbursts, Catherine wrote: "I ask God to forgive you your vain despair and violence but also your injustice to me. I believe that you love me in spite of the fact that often there is no trace of love in your words."

Catherine continued to express her hurt and frustration with Potemkin in letters. "You are angry. You keep away from me, you say you are offended . . . ," she wrote. "What satisfaction can you want more? Even when the Church burns a heretic, it doesn't claim any more. . . . You're destroying all my happiness for the time that is left to me. Peace, my friend. I offer you my hand—will you take it, love?"[8] In the end, the relationship proved so tempestuous, the couple could no longer live together. After a wildly passionate two and a half years, their romance was over.

Catherine and Potemkin worked out a mutually beneficial partnership, one that shocked Europe. They both took younger sexual partners, while remaining completely, if platonically, devoted to one another. Potemkin loved women, especially married ones, often wives of his officers and relatives. After the death of Potemkin's sister, Catherine had named her two eldest daughters, Alexandra and Varvara Engelhardt, maids-of-honor. Now Potemkin fell in love with the first in a series of his beautiful young nieces. Potemkin's own mother tried unsuccessfully to stop her son's incestuous relationships.

For Catherine's part, in February 1776, when Potemkin left for an inspection tour, she began an affair with 37-year-old lieutenant colonel Peter Zavadovsky. Catherine named him minister of education, senator, and count of the Holy Roman Empire. But the unusual intimacy of Catherine's continued, if altered, relationship with Potemkin made life for Zavadovsky and Catherine's successive favorites extremely challenging. "Their relationship with Serenissimus [Potemkin] was almost as important as their love for the Empress," writes Potemkin biographer Simon Sebag Montefiore.[9]

Though she was increasingly self-conscious of her graying hair and expanding waistline, the middle-aged empress continued to seek out younger men, usually procured by Potemkin. ". . . [I]t is a most disagreeable thing to grow old," she wrote Madame Bielke.[10] If Catherine liked Potemkin's candidate, her "official sampler" would take him for a test run. As part of the vetting process, Scottish doctor John Rogerson examined prospects for venereal disease. One of many Scots who pursued medical career in Russia, Rogerson became Catherine's personal physician in 1776. He would stay for fifty years, returning to Great Britain in 1816 with a considerable fortune.

Around this time, another court menage à trois took a tragic turn. Everyone except Grand Duke Paul knew about the passionate affair his 21-year-old wife was having with his best friend, Count Andrei Razumovsky. Catherine tried to have the charming Razumovsky exiled, but Paul wouldn't hear of it. In April 1776, Grand Duchess Natalia Alekseyevna died days after delivering a stillborn son. Paul was disconsolate—until Catherine informed him that the baby probably wasn't his.

The news seemed to do the trick. In June, Paul left for Berlin with Prussia's Prince Henry. By September, he returned with another German princess. Born in Stettin like Catherine, Sophia Dorothea of Württemberg was a great-niece of Frederick the Great. Catherine moved quickly, arranging Paul's second marriage to the princess, who took the name Maria Feodorovna. As a wedding present, Catherine gave her daughter-in-law a spectacular emerald-and-diamond brooch. Gregory Orlov returned to Catherine's side for the wedding, and to mediate Catherine and Zavadovsky's impending breakup.

Also that summer, Melchior Grimm arrived in St. Petersburg for an extended visit. After several months, Grimm wrote economist Ferdinando Galiani urging him to join him in Russia as Naples's ambassador. ". . . [H]ow does Ferdinando Galiani dare live in the same century as Catherine without ever seeing her?" Grimm wrote his friend. "How can he allow me to have this advantage over him . . . it is now more than three months that I've been here—spending my life with her, often from morning to night, going only to the court, dining with her in public or privately, chatting, talking for hours on end—freely, with complete confidence: doesn't that sound like a dream? I don't know how long this dream will last. . . ."

Grimm returned to Paris the following August as Catherine's full time agent and art buyer with an annual salary of 2,000 rubles. Delegating his newsletter to his Swiss assistant, Grimm began executing a number of commissions for Catherine. But his increasing conservatism alienated his circle. "My friend, I no longer recognize you," wrote Denis Diderot. "You have become, perhaps unwittingly, one of the best disguised, but also one of the most [dangerous?] anti-philosophes. You live among us, but you hate us. . . . My friend, be the favourite of the Greats, serve them, I am all for

it, as your talents and your age allow you to do with the greatest dignity; but be not their apologist, neither in your mind nor in your heart."

Catherine relished Grimm's amusing letters. "So go on!" she wrote, "Bombard me, bombard me with letters: it is a good thing to do, for it entertains me, I read and re-read your pa'ckages, and I say: 'How he understands me! Oh, heaven! Almost no one understands me as well as he does.'" Unlike her polished letters to Voltaire, Catherine's letters to Grimm are remarkably frank, touching on her love life, favorite books, and newest paintings. In 1787, she thought better of this and begged Grimm to destroy her notes. "Burn them, so that they are not printed in my lifetime, they are in lighter vein than those to Voltaire and may do harm. I tell you, burn them. Do you understand? Or else put them in safe keeping so that no one can unearth them for a century." Fortunately Grimm did not destroy Catherine's letters (they were published by the Imperial Historical Society in 1878).

Meanwhile, relations between Peter Zavadovksy and Catherine continued to sour. Zavadovsky had fallen in love with Catherine, but his jealousy toward Potemkin caused him great unhappiness. Catherine's clear prioritizing of her official responsibilities and her art acquisitions over him was another source of contention. "Petrusa," she wrote him, ". . . I have set myself the rule to be assiduous to state affairs, to lose the least time possible, but whereas a time of relaxation is absolutely necessary for life and health, so these hours are dedicated to you, and the time remaining belongs not to me, but to the Empire. . . ."[11]

In April 1777, Zavadovsky knew that the relationship was officially over and asked Catherine's permission to marry Countess Vera Apraksina, who the empress later appointed a lady-in-waiting (the couple's surviving daughter, Countess Sophia Zavadovsky, was the maternal grandmother and namesake of Leo Tolstoy's wife, Sophia Tolstoy). Years later, when Zavadovsky retired as Catherine's state secretary, Catherine lent her favorite Italian architect, Giacomo Quarenghi, to build him a magnificent country home at Lyalichy in south Russia. Among the palace's 250 rooms was a library with a life-size statue of Catherine. The splendor did not console Zavadovsky, who compared the lonely mansion to an aviary for crows.[12]

The following month, Catherine arrived at Potemkin's new summer residence at Ozerki, two and a half miles outside St. Petersburg. Among

the dinner guests was Catherine's newest favorite—31-year-old Semyon Gavrilovich Zorich, a handsome, athletic major from a Hussar regiment. The son of a Serbian officer, Zorich had gained celebrity status by surviving five years as a Turkish prisoner of war by pretending to be a count. The ambitious officer became an adjutant to Potemkin, who introduced him to the Russian court, where he was dubbed the Adonis. Catherine thought his face "sublime."

Potemkin's power continued to grow after his romantic split from Catherine. Sharing Catherine's ambition, he had matured since their breakup and became one of the century's most brilliant statesmen. Over the next fifteen years, he would help Catherine vastly expand Russia's empire, create its Black Sea fleet, and build the Crimean cities of Sevastopol and Odessa. In 1777, Catherine presented Potemkin the St. Petersburg Glassworks "in perpetual rights of hereditary ownership." Potemkin adopted the factory as his pet project, moving it from Nazya on the southern shore of Lake Ladoga to Ozerki, near his summer residence. With some two hundred employees, the factory produced a variety of items for the imperial family and aristocracy—everything from horseradish and mustard bowls to chandeliers, decanters, and colored glass vases.

Meanwhile, after three years, the Sèvres Cameo Service was finally complete. To celebrate, Louis XVI visited the factory in May 1779, giving employees a quarter of their monthly salaries as bonuses. Five months later, all 744 pieces arrived in St. Petersburg on a Dutch ship that sailed from Rouen. As Catherine had planned, the service made a powerful statement about her sophistication and Russia's wealth. But presented with the astronomical bill of 62,324 rubles (equivalent to about $40 million today), Catherine negotiated an installment plan.

In thanks for the magnificent porcelain service, Potemkin needed to give Catherine something truly special. But what does one get for the woman who has everything? Knowing he couldn't possibly match Catherine's extraordinary gift, Potemkin thanked her with an angora cat, which Catherine called "the cat of all cats" and "he of the velvety paws." The feline wasn't alone at the Winter Palace.

As a souvenir from his trip to Holland, Peter the Great brought back a large cat for the original wooden Winter Palace. In 1745, Elizabeth had a

carriage full of male mousers brought to the palace from Kazan, some five hundred miles from Moscow. Her order: "to find in Kazan . . . the best and biggest cats capable of catching mice, and send them to . . . the Court of her Imperial Majesty, along with someone to look after and feed them, and send them by cart and with sufficient food immediately."[13] Concerned about mice chewing up her new artworks, Catherine introduced more cats to court, elevating them to guard status with salaries and special rations. For palace pets she liked Russian Blues. But humble backyard cats still made the best rat catchers.

CHAPTER FIVE

BROTHER GU

For Potemkin's masquerade ball in late June 1779, glowing wreaths made at his nearby Glassworks Factory were hung from shrubs to light the way from the main road to the house. From across the lake, buildings glimmered with multicolored lights. The evening's entertainment featured whimsical inventions—like a floating painting representing a temple with the names of members of the imperial family. In a nod to one of Potemkin's vice-regencies, an area was decorated like a grotto in the Caucasus, complete with a cascading brook and myrtle and laurel trees. In Catherine's honor, a choir accompanied by an organ performed songs originally composed in Hellenic Greek.

The following week, forty-three-year-old Gregory Orlov married his sixteen-year-old cousin, Ekaterina Zinovyeva, in St. Petersburg. Catherine graciously promoted the teenage Princess Orlova to lady-in-waiting and dined with the newlyweds at Gatchina. That afternoon, Catherine met her cousin Gustav for the first time when the young Swedish king paid a

month-long visit to St. Petersburg. Though Gustav purported to want to get to know Catherine, his real mission was to broker a political alliance. The trip sparked an outcry by Sweden's ally France, which opposed any diplomatic ties with Russia.

Though Catherine's letters to Gustav were friendly, privately she was wary of the cousin she called "brother Gu." Like Catherine a decade earlier, Gustav came to power with a coup. He immediately suspended Sweden's constitution, putting an end to the country's two-party system that had thrived on bribes from Russia, France, and England. Frederick the Great called his nephew's coup "the most foolhardy and hare-brained action imaginable." "Keep on good terms with Russia," Frederick wrote Gustav's mother, "that's my advice to you as a brother. Whatever the French say, the fate of the Swedish king lies in the hands of the empress of Russia."[1]

Traveling incognito as Count Gotland, Gustav arrived with a squadron of royal Swedish warships anchored off the Russian naval base of Kronstadt. The initial meeting in Catherine's study was followed by the performance of a French comedy, a game of chess, and dinner. "Her presence transcends her reputation," Gustav wrote his brother, Duke Karl.[2] Gustav liked his powerful cousin but had reservations about the Russians: "These people are not like those in the rest of Europe," he wrote Karl. "They have the politeness, the brilliance, the grandeur, the wit and the vices, but they do not have the virtues."[3] After meeting the Swedish king, Catherine's confidante Princess Dashkova described him as cultivated, intelligent, and eloquent, but vain and conceited, affecting a superficial Frenchness.[4]

The day after his arrival, Catherine dusted off the Green Frog Service for a formal luncheon for three dozen people at La Grenouillère. The fête followed the laying of the foundation stone by Catherine and Gustav at the nearby Church of St. John the Prophet by the two rulers. Catherine proudly showed off the interiors of her castle. A highlight was the royal portrait gallery with pictures of Gustav and his family, including his estranged wife, Sofia Magdalena of Denmark, and his mother, Louise Ulrika, dowager queen. Gustav's father, Sweden's King Frederik, was the brother of Catherine's mother, Johanna Elizabeth of Holstein. Catherine presented her cousin with an album of architectural drawings documenting the palace.

Gustav mistakenly thought he could charm Catherine, but he wound up smitten with his charismatic cousin. "We are on the most friendly footing, the empress and I, and she continues to treat me with a cordiality which makes the minister of my dear uncle [Frederick II of Prussia] furious," he wrote his brother. "I come to her toilet and stand in her internal apartments on a more familiar footing than prince Heinrich of Prussia has done. Consequently, I have all reason not to repent a voyage, which is going to make epoch for the rest of my life"[5]

In between galas, balls, and theatre performances, Gustav went sightseeing. With Potemkin as his guide, he toured the Imperial Porcelain Factory, where he received an exquisite chinoiserie tiled stove. Gregory Orlov welcomed him at Gatchina, where some eight hundred construction workers were still at work. An excursion to the Chinese Palace at Oranienbaum nearly ended in a disaster when Gustav's carriage almost landed in a canal. Gustav called at the studios of Swedish portraitist Alexander Roslin and the French sculptor Falconet, admiring the plaster model of Peter the Great. Gustav's itinerary also included the Mint on the Peter-Paul Fortress and the Mining Institute and Cadet School for the Nobility, attended by Alexei Bobrinsky, Catherine's fifteen-year-old son with Gregory Orlov. A highlight was the Academy of Science with its wax figure of Peter the Great and the famous 17th-century Gottorp Globe, one of the world's earliest globe-shaped planetariums. In honor of Gustav's visit, the walk-in globe was filled with fruit and delicacies.

Rival monarchs brought out Catherine's competitiveness. On the fifteenth anniversary of her rule, she hosted a lavish party at Tsarskoe Selo with Gustav as guest of honor. After dinner, Catherine suggested that her cousin and courtiers stroll through the palace gardens. To her gold brocade gown and the ribbon, badge, and diamond-studded chain of the Order of St. Andrew, Catherine added a jaw-dropping walking stick. The knob sported a large diamond solitaire surrounded by a string of pearls ending with a pair of tassels set with 450 diamonds. After Gustav praised the spectacular cane, Catherine presented it to him. Two years later, Gustav's Paris jeweler repurposed the gift into an aigrette and an epaulet.

It turns out that Catherine had walking sticks to spare. Some bore her monogram in diamonds with gold and enamel embellishments. One

especially spectacular stick came from Danish court jeweler Frederik Fabritius. To the diamond and garnet handle, Fabritius added a series of oval enamel medallions with Catherine's portrait, Russia's double-headed eagle, a seascape, and scenes from the Russo-Turkish War. A handy watch mechanism was added under the empress's monogram at the top of the gold knob.

In preparation for his trip, Gustav had commissioned gifts for Catherine and her circle from Paris. But after receiving Catherine's stunning diamond walking stick, he realized his presents were mere trifles. With his departure approaching, Gustav sent an urgent request to his brother, asking him to retrieve the "Swedish Ruby" from the treasury. The 226-carat raspberry-shaped ruby tourmaline pendant set with gold and enamel was believed to have belonged to Rudolf II, taken from Prague with other art by Swedish troops during the Thirty Years' War. To avoid getting approval from Sweden's Council, Gustav claimed that he'd be wearing the spectacular royal jewel himself.

On the eve of Gustav's departure in mid-July, Catherine's vice chancellor handed out gifts to the Swedish entourage. The two highest-ranking Swedes received a timepiece with Catherine's portrait studded with diamonds. After dinner, Gustav gave Paul a diamond ring with his portrait; Maria Feoderovna accepted a jeweled writing tablet. Rising from his seat, Gustav presented Catherine with a jeweled ivory tablet with his portrait, enclosed with an ode he'd written. Then he placed the enormous ruby in Catherine's hand. Lastly, Gustav spoke politics. In the event Prussia tried annexing Swedish Pomerania, he hoped he could count on Catherine's support. That evening, Catherine wore the ruby attached to a clasp holding the ribbon of the Order.

Catherine hosted a farewell masquerade ball at Peterhof. After rounds of toasts and a long private conversation, she and Gustav embraced. She had not made a single political concession. At nearby Oranienbaum, Gustav's squadron lay at anchor. Catherine's new favorite, Semyon Zorich, was there to present the king with a final parting gift—a luxurious black fox fur. Before setting sail for Stockholm, Gustav named Zorich knight and commander of the Order of the Sword, and he sailed back to Sweden, materially richer but with nothing to show, politically, for his journey.

The elation Catherine might have felt over her triumph over Brother Gu was short lived, however. That September, Catherine and her subjects woke to a howling gale in the early morning hours. Rising eleven feet above its normal level, the Neva flood killed one hundred people and dumped a fleet of merchant vessels onto the embankment. The storm also flooded the cellars and damaged the roof at the Winter Palace. The deadly flood helped to expedite Yury Velten's ambitious embankment project. By 1787 much of the river's edge was finished in granite. Catherine's predecessors had focused their efforts on buildings for the new capital, ignoring the muddy riverbanks and rickety wooden pilings and docks. Velten transformed this eyesore into an impressive foundation for Catherine's elegant neoclassical buildings. The powerful granite embankment was only interrupted by an occasional stairway down to the water. Several graceful bridges channeled the Fontanka and Moika rivers and smaller canals into the Neva.

Later that month, at a party to celebrate Potemkin's name day at Anichkov Palace, the guests included Seymon Zorich along with three of Catherine's former lovers—Potemkin, Gregory Orlov, and Peter Zavadovsky. Catherine enjoyed cordial relations with most of her exes, thanks to extravagant gifts of titles, property, serfs, cash, and art both during and after the affairs. She even chose Zavadovsky as guardian for her son with Orlov, Alexei Bobrinsky.

That December 23, Maria Feoderovna gave birth to a robust son (the first of four boys and six girls). Two days later, Catherine wrote Grimm: "Do you know Monsieur Alexandre? . . . He is not Alexander the Great, but Alexander the very little who has just been born, on the 12th of this month at a quarter to eleven in the morning. In other words the Grand Duchess has just given birth to a son who, in honour of St. Alexander Nevsky, has been given the pompous name of Alexander, and whom I call Monsieur Alexandre."[6] By whisking Paul away at birth, Empress Elizabeth had denied Catherine a maternal role. Now she did exactly the same to her son and daughter-in-law, assuming parenting responsibilities for Alexander and his younger brother Constantine a year later. Her actions went far beyond those of a doting grandmother. The empress chose her grandsons' names, wrote them fairy tales, designed play outfits, and got them smallpox inoculations. To Catherine, the boys, not their father, represented the

continuation of the Romanov dynasty. As they grew older, she took charge of their education, preparing them for their future roles as tsar.

Besides savoring her role as grandmother, Catherine found happiness in collecting. In 1777, Diderot helped her add pictures from the prestigious French collections of Receiver General (Pierre-Louis-Paul) Randon de Boisset (Boucher was his adviser) and the Prince de Conti. A cousin of Louis XV, the Prince (Louis-François de Bourbon) retired from court after a fall out with the king's mistress, Madame de Pompadour. De Conti focused on his art collection, which he displayed in a special gallery in the Temple. Besides his art treasures, the prince is famous for the vineyard he bought in 1760, Romanée-Conti, one of the world's most expensive wines today.

"This winter I have the most admirable lodgings. . . . I have a whole labyrinth of apartments, even though I am alone; in all this there is a kind of delirious luxury . . . ," Catherine confided to Grimm in late 1777. "We have baptized it the Imperial Museum, and when in the midst of it one finds so many things to see that it is impossible to tear oneself away."[7]

Potemkin gave a tour of the Hermitage to France's new chargé d'affaires Chevalier de Corberon. "The gallery is too narrow; there is not enough space to see them and the windows don't reach high enough, or rather, they descend too low," wrote the Frenchman. "These are ordinary casements, unlike those in the gallery at Kassel. Here I noticed, with sorrow, Greuze's *Paralytic*: it has lost its colour and its effect; it is diminished now."[8] Sensitive to criticism, with her collection growing, Catherine hired Velten to design a new addition, the Large Hermitage.

CHAPTER SIX

CATEAU AND THE HERMIT OF FERNEY

For fifteen years, Voltaire sang Catherine's praises throughout Europe, defending her invasions of Poland and Turkey. Despite the long correspondence, the two had never met in person. Catherine did not want Voltaire to see the discrepancies between her descriptions of Russia and reality, whether it was the persistence of serfdom or the empire's antiquated penal code. "For God's sake, advise the old octogenarian to remain in Paris," she wrote Grimm. "Tell him that Cateau is only good to see from a distance."[1]

After two decades of exile in Ferney, Switzerland, the ailing 83-year-old philosopher returned to a hero's welcome in Paris. Anxious to compete with the numerous portraits of Voltaire, sculptor Jean-Antoine Houdon offered to donate a bust of the celebrated writer to the Comédie-Française. After a performance of Voltaire's *Irene* at the Comédie-Française in late March,

the curtain rose, revealing Voltaire's portrait bust atop a pedestal. When the lead actor placed a laurel wreath on Voltaire's head, the audience burst into applause and the frail celebrity rose in his box to a standing ovation.

With a gift for capturing his subjects, Houdon had become famous for portraits of leading Enlightenment writers and politicians. Reflecting the current interest in physiognomy, Houdon took measurements of his subjects with calipers, and often made life and death masks to record their features. To animate his sitters' eyes, the sculptor left a small rectangular peg of marble just under the inner eyelid. By carving striations around the pupil, he also managed to convey a sense of light. Houdon often rendered mouths slightly open in a half smile, making his subjects appear as though they were about to speak.

In 1770, a group of literary figures led by Jean le Rond d'Alembert hired Jean-Baptiste Pigalle, then France's premier sculptor, to create a tribute to Voltaire. Ignoring his sitter's concerns, Pigalle sculpted Voltaire naked except for a flowing drapery that crosses a shoulder and covers his loins. Though the human body was considered beautiful and heroic in antiquity, Pigalle's portrayal of the old man's emaciated body and sagging flesh did not go over well. After seeing the marble in Pigalle's studio, Gustav III sarcastically offered to donate a suit of clothes. Though Voltaire was embarrassed by the overly realistic work, he staunchly defended Pigalle's artistic freedom. "Monsieur Pigalle must be left the absolute master of his Statue," Voltaire wrote François Tronchin. "It is a crime against the fine arts to place impediments on genius . . ."[2]

Though it had been eight years since Voltaire sat for Pigalle, he had to be dragged back to Houdon's studio in the Bibliotheque Nationale by his young friend, the Marquis de Villevieille. He needn't have worried. Houdon's took a strikingly different approach. He quickly went to work on a life mask of Voltaire, smearing his face with grease and then smoothing wet plaster over his face, leaving holes at the nostrils for him to breathe. At Voltaire's final sitting, the marquis produced the laurel wreath from the Comédie-Française and pretended to crown him.

"I informed M. Houdon that, at an agreed-upon-signal, I would leap onto the platform where M. de Voltaire was placed, and would hold the wreath over his head," the marquis later wrote. "No doubt then, I told

him, movement would return to his face, and in a flash you will seize the moment to add the life, wit, and truth that ought to animate it and which breathe in this masterpiece." Voltaire waived the laurel aside, exclaiming, "What are you doing young man! Place that on my tomb—it opens before me." He stood up and lifted his hand toward Houdon. "Adieu, Phidias." Then, turning to the marquis, Voltaire said, "My friend, let us go and die."[3]

News of Voltaire's sittings for Houdon reached Catherine, who ordered her own portrait bust. Melchior Grimm covered the event in the May issue of *Correspondence litteraire*: ". . . M. Houdon required only two or three sittings, to which the patriarch yielded with infinite complaisance and good cheer, for him to succeed beyond words. Of all the thousands of portraits that have been done of M. de Voltaire over the last sixty years, this is the only one with which he was completely satisfied. It must be admitted that never have his features been rendered with so much grace or with so much spirit; every curve of his face is most accurate in its truth, without the slightest trace of exaggeration; all the fire, all the subtlety, all the character of his physiognomy is captured at the most agreeable and striking moment . . ."[4]

On May 30, shortly after sitting for Houdon, Voltaire died. Houdon raced to the *philosophe*'s deathbed to cast a mold of his hands and a funerary mask. Catherine, who reportedly had a portrait of Voltaire in her bedroom, was devastated. "I feel a sense of universal discouragement and a great contempt for all the things of this world," she wrote Grimm. Irate that France denied the anti-clerical philosopher an honorable burial, Catherine wanted his body brought to Russia. "Why did you not personally take possession of his body, in my name?" she asked Grimm. "You should have sent it to me, and morbleau! I can promise you he would have had the most splendid tomb possible."[5] In lieu of a tomb, Catherine made plans to build a replica of Voltaire's Ferney at Tsarskoe Selo.

Months later, Catherine was still affected by the loss, writing Grimm: "I do good for doing good, and then that is all; well, that is what has kept me from the discouragement and the indifference for the things of this world which I have felt at the news of Voltaire's death. Furthermore, he is my master. It was he—or rather his writings—who formed my mind. I am

his pupil; in my youth I loved to please him. To be satisfied with any step I took it had to be worthy of telling him."[6]

Catherine was familiar with Jean-Antoine Houdon—his portrait bust of her some five years earlier had become one of her official portraits. That fall, Catherine received two of his busts of Voltaire—a bronze *tête nue* (bare head) and a plaster "*à la française*" (with a large curly wig). "The famous desk [Chesme-Desk by Augustin-Barnabe de Mailly] is the ornament of my hermitage, as well as the two busts of Voltaire," Catherine wrote Grimm. "I like the bust without a wig better; you know of my aversion to wigs and busts with wigs in particular; it always seems to me that wigs are used to inspire laughter."[7] On this subject, Voltaire had agreed. Of his many portrait busts by Houdon, only the bare-headed version completely pleased Voltaire. In November, Grimm advised Catherine that her classical bust of Voltaire "*à l'antique*" was under way. The most Roman of all Houdon's portraits, the bald Voltaire is depicted as an ancient philosopher in the toga of a Roman senator. Symbolically, Catherine installed the marble bust in the center of a gallery overlooking the Hermitage's Hanging Garden, beside a hall leading to the imperial throne room.

Through Grimm, Catherine learned that Voltaire's niece, Madame Denis, had commissioned a life-size marble version of her uncle for the Académie-Française (she wound up giving the work to the Comédie-Française, today's Theatre d'Odeon). After receiving a gilt bronze maquette of the statue, just over a foot tall, Catherine commissioned her own life-sized marble in 1780 (In addition to the two marble versions for the Comédie-Française and Hermitage, Houdon produced three versions in plaster and two in terra-cotta). In *Seated Voltaire*, Houdon portrayed the philosopher seated and bent over in a chair, draped in a loose Roman gown. (In 1786, Houdon wanted to portray George Washington in similar classical robes, an idea the general nixed in favor of modern attire.)[8] Voltaire's wrinkled face is slightly cocked to the side, the wizened left hand resting on the arm of the chair. Despite working in the cold medium of marble, Houdon managed to capture both Voltaire's physical frailty and his timelessness.

Shortly before Voltaire's death, three months before her fiftieth birthday, Catherine penned her own epitaph, noting that this gave her time to correct it. "Some two weeks remain until the fast, and meanwhile we shall have

eleven masquerades, not counting the lunches and dinners to which I am invited. Afraid it might be the death of me, I commissioned my epitaph yesterday," she joked. "Here lies Catherine the Second, born at Stettin on 21 April [2 May] 1729. She came to Russia in 1744 to marry Peter III. At the age of fourteen she conceived the triple project to be pleasing to her husband, to [the empress] Elizabeth, and to the nation. She overlooked nothing to achieve this. In eighteen years of boredom and solitude she read many books. Once she had reached the throne of Russia, she wanted only the good and sought to procure for her subjects happiness, freedom, and property. She forgave with ease and did not hate anyone; indulgent, happy to be alive, of a cheerful nature, with a republican soul and a good heart, she had friends; work was easy for her, company and the arts pleased her."[9]

But Catherine's current company was no longer pleasing. A disappointment outside the bedroom, Semyon Zorich had held onto his position as favorite for eleven months. Then, in early May 1778, grossly underestimating Potemkin's position, the impetuous Zorich foolishly challenged him to a duel. The incident gave Catherine a good excuse to part ways. As with all her lovers, she gave Zorich a generous golden parachute that included an estate near Mogilev, 4,000 serfs, and a 200,000-ruble annuity. Corberon wrote his brother about the empress's generosity toward her ex-lovers. "You must agree, my friend, that it's not a bad line of work to be in here."[10]

This time, Potemkin introduced Catherine to a very different lover. Elegant and artistic, Ivan Rimsky-Korsakov's classic features led Catherine to nickname him "Pyrrhus," after the Greek general and king of Epirus. She described her new favorite to Grimm as "the failure of painters, the despair of sculptors." After discovering the 24-year-old had a voice "like a nightingale," Catherine arranged singing lessons. (Russian composer Nikolai Rimsky-Korsakov was a relative.) Catherine lavished half a million rubles worth of gifts on her vain favorite and named him adjutant general. Rimsky-Korsakov rarely removed the Golden Eagle, a gift from Catherine's former lover, Stanislaus Poniatowski, King of Poland. "Adieu mon bijou," Catherine wrote Potemkin. "Thanks to you and the king of Epirus, I am as happy as a chaffinch and I want you to be just as happy."[11]

Potemkin lent the couple one of his many residences, Eschenbaum on the Finnish coast. "What a view from each window," Catherine wrote Grimm

during one of their romantic trysts. "I can see two lakes from mine, three manticules, a field and a wood."[12] Despite Catherine's ebullience, there were warning signs that the relationship was one-sided. The clever, confidant empress is absent in her needy letters to Rimsky-Korsakov. "I'm unable to forget you for a moment," she wrote. "When will I see you?" On another occasion Catherine wrote: "Thank you for loving me."[13]

Before taking Rimsky-Korsakov as her lover, Catherine had him spend the night with her tester, lady-in-waiting Countess Bruce. The sister of nobleman Peter Rumyantsev and wife of Count James Bruce, governor of St. Petersburg, "Brussja" was Catherine's own age—the person she trusted and confided in. It seems Rimsky-Korsakov did more than pass muster during his test run. For months, everyone at court knew about his affair with Bruce—except for Catherine. Finally, in October 1779, Potemkin arranged for Catherine to find her lover and best friend in bed.

After his relationship with Bruce was discovered, Rimsky-Korsakov promptly began an affair with the beautiful Countess Ekaterina Stroganov, who left her husband and child, something that even the permissive culture of the Russian aristocracy saw as taboo. Affairs were tolerated, but the actual dissolution of a family was highly discouraged. Thoroughly humiliated, Catherine banished the handsome couple to Moscow, where they lived in luxurious exile in the Stroganov Palace and the Countess's estate, Bratzeva. After following Rimsky-Korsakov to Moscow, the lovesick Countess Bruce returned to her long-suffering husband. Succeeding Bruce as Catherine's tester was Anna Stepanovna Protasova, daughter of Russian senator Stephan Protasov and a cousin of Gregory Orlov and likely mistress of Alexei Orlov. Catherine was particularly fond of Protasova, and gave her the title of lady-in-waiting of the Order of St. Catherine.

After the scandal with Rimsky-Korsakov and Brussja, Catherine would wait six months before taking a new lover. During this hiatus, she channeled her frustration and worked to ensnare England's finest masterpieces.

PART FIVE

A SECOND ROME

CHAPTER ONE

CAT AND MOUSE

H orace Walpole's coach rolled north, wheels and horses clattering over the cobblestone streets toward King's Lynn. After a two and a half day journey from London, he finally crossed through the park gates of his family's estate. White fallow deer ran ahead of his carriage through clusters of oak, beech, and chestnut trees.

Houghton Hall was never his favorite place. As the youngest child, he'd stay with his beloved mother in London while his father installed his mistress at the grand Palladian country estate. After his mother's death in 1737, his father married 36-year-old Maria Skerrett. Just three months later, while giving birth to their second child, the new Lady Walpole died of a miscarriage.

That was five years ago. Back from a two-year Grand Tour of Europe, Horace found his ailing father alone in Houghton's library, lying on his daybed in a gray silk nightgown. Over the purple marble fireplace hung Sir Godfrey Kneller's full-length portrait of George I, a gift from the

king. Hundreds of gilt leather-bound volumes lined the handsome carved mahogany shelves, a collection that included architecture books in English, French, and Italian as well as classical history and literature. Blue damask chairs crowded the relatively small study, a holdover from the days when his father conducted state business here.

Retirement had been forced on Robert Walpole. Suffering from gout and kidney stones, he'd gradually begun losing control of Parliament. A week after his resignation in February 1742, George II raised him to the peerage with a newly created title, Earl of Orford. It was Walpole who pulled off a reconciliation between the feuding George I, England's first Hanover king, and his son. After George I died unexpectedly in 1727, his savvy daughter-in-law Caroline convinced her husband to keep Walpole as prime minister.

Under Walpole's watch, political power shifted from the throne to the Whig Party. Britain became a superpower; its parliamentary democracy lauded by the likes of Voltaire. Nicknamed "the fat old squire of Norfolk," burly, red-faced Walpole dodged corruption charges, an insider trading scandal, and a dysfunctional royal family to hold onto power longer than Margaret Thatcher and Tony Blair combined.

As Robert Walpole's star rose, he developed a thirst for fine wine and Old Master paintings. In 1718, he bought his first pictures at a London auction—*Seaport* and *Landscape with Ruins* by Dutch Golden Age painter Jan Griffier I. Walpole assembled his storied collection quickly as a statement of social standing, power, and influence. Like Pierre Crozat in Paris, he sought works by specific artists and delighted in paintings with prestigious provenances. Even political opponents were impressed by his highly personal gallery. "We took then another view of the pictures, and indeed they are very exquisite; the more one sees the more one admires and desires to see," wrote Lord Oxford.[1]

Too busy to travel abroad, Walpole recruited a network of agents to search for Old Masters. In 1724, his spy and sometime art dealer, Scotsman John Macky, obtained four monumental market scenes by Frans Snyders in Brussels. Some picture deals crossed the line between art and politics. Scottish painter and art dealer Andrew Hay avoided prosecution for Jacobite sympathies by securing a bust-length oil sketch *Portrait of Pope Innocent X*

THE EMPRESS OF ART

for the prime minister by Diego Velázquez. The following year, Walpole attended Hay's art sale in London, buying *Hercules and Omphale* by Giovanni Franceso Romanelli, a follower of 17th-century Roman painter Carlo Maratta.

Coining the phrase "Every man has his price," the shrewd prime minister kept his Tory rivals at bay by showering supporters with rewards.[2] Title seekers now presented Walpole with art. Sir Joseph Danvers gave him Anthony van Dyck's portrait of his great uncle, Henry Danvers, 1st Earl of Danby, a Knight of the Order of the Garter, England's highest order of chivalry. Walpole, who became the first commoner to be elevated to the order in 1726, finagled a baronetcy for Henry Danvers in 1746. James, 1st Earl Waldegrave, ambassador at the French court, secured two paintings by Nicolas Poussin and gave Walpole *The Entombment* from Jacopo Bassano's workshop around the time he also received the Order of the Garter. Not long after Tory MP and collector James Brydges, 1st Duke of Chandos, presented Walpole with *Sarah Leading Hagar to Abraham* by Adriaen van der Werff, the duke's son was appointed first lord of the bedchamber to the Prince of Wales.[3]

In his quest for masterworks, Walpole skillfully exploited his colleagues' misfortunes. The collapse of the South Sea Bubble triggered one of the 18th century's largest picture sales. Among the casualties was connoisseur Henry Bentinck, 1st Duke of Portland, who sold Walpole Jacob Jordaens's *Self-Portrait with Parents, Brothers and Sisters.* Opportunity knocked again in 1725 when Walpole nabbed nineteen portraits by Anthony van Dyck for £1,500 from the dissolute grandson of Philip, 4th Lord Wharton. Lord Wharton's van Dyck collection, which included portraits of his family, the royals, Inigo Jones, and Sir William Challoner, was second in quality and quantity to that of Charles I. Walpole was well acquainted with van Dyck from a tapestry series in his dressing room. In 1672, Surrey-based Mortlake Manufactory used several of the artist's Stuart portraits for *Kings and Queens*, tapestries featuring Charles I, Henrietta Maria, and their sons Charles and James (the future Charles II and James II).

As his art collection grew, Walpole needed a fittingly grand "temple of the arts" to show it off. To his ancestral property in the Norfolk village of Houghton, he added thousands of acres from nearby landowners. To

make room for his new estate, Walpole demolished his grandfather's brick Tudor mansion where he'd been born, along with the surrounding estate village because it spoiled his view (like Louis XIV at Versailles, Walpole rebuilt the village down the road). Walpole spared no expense for the 106-room manor, which Scottish architects James Gibbs and Colen Campbell covered in creamy gold Yorkshire stone.

For Houghton's interiors, the fifty-year-old collector engaged fashionable royal painter-decorator William Kent. Fresh from refurbishing 10 Downing Street, a gift to Walpole from George II, "Kentino" was already familiar with his patron's artworks. With his painterly approach to decorating, Kent drew on multiple sources and styles—from antiquity to the late Baroque and Palladio. Throughout the staterooms of the first floor, Kent chose colors and themes to complement Walpole's paintings which he double and triple hung, often in frames of his own design.

Kent's stunning three-flight mahogany Great Staircase led to the vast gray and white Stone Hall where Walpole's bust presided over a portrait gallery of sixteen Roman emperors. Overhead, dancing putti spread garlands around roundels of Walpole, his first wife, eldest son, and daughter-in-law. The Walpole family crest, the Saracen, adorned the center of the ceiling; each of the four corners sported a garter star, after Walpole's Order of the Garter for which he was dubbed "Sir Blue String."

From the Stone Hall, double doors opened into the crimson and gilded Saloon, where the mahogany and gilt armchairs, settees, and stools matched the crimson wool and silk velvet walls. From Kent's coffered octagonal ceiling painting of Apollo's sun chariot to Venus's scallop shells on the carved mirrors, tables, and seats, the Saloon was brimming with rich imagery. Walpole's anti-Jacobite mindset didn't stop him from collecting religious paintings and many of the largest hung here, including Murillo's *Adoration of the Shepherds* and Albano's *Baptism of Christ*.

Francis, Duke of Lorraine (later Holy Roman Emperor Charles VII), slept in the sumptuous Embroidered Bedchamber where Walpole's coat of arms and Order of the Garter were embroidered in gold, white, red, and blue thread at the head of the bed and on each corner of the canopy. Overhead in matching blue, gold, and white, Kent depicted the eternally young shepherd Endymion and his lover Selene, goddess of the moon.

Above the fireplace in a spectacular Kent-designed frame hung the costliest of Walpole's eight Poussins—*The Holy Family with SS Elizabeth and John the Baptist* (1655) which Horace Walpole called "one of the most Capital Pictures in this collection."

Horace dubbed the nearby Green Velvet Bedroom a "pompous room of state." VIP guests slept on a fifteen-foot-tall canopy bed made of luxurious green silk velvet and gold fringe with a scallop-shaped headboard and carved acanthus leaf cresting. The gold trim on the velvet hangings set Walpole back over 1,200 pounds (equivalent to about 150,000 pounds or $230,700 today).[4] Tapestries woven in Brussels depicted Venus and her lovers Adonis and Vulcan in lavish landscapes, while cupids aimed their arrows at a human heart hanging from a tree trunk.

Houghton's charismatic owner entertained lavishly. For the Duke of Lorraine's visit "relays of horses were provided on the road to bring rarities" and guests "dined in a hall lit by 130 wax candles from the remotest parts of the Kingdom with all possible speed," while "eight carriages were constantly passing night and day between London and Houghton," noted Charles Latham.[5] Bacchus, Roman god of feasting, wine, and excess, reigned in the Marble Parlor, where candlelight from chandeliers and silver candelabra reflected off the mirrors and silver. Kent matched the green velvet dining chairs and green vines in his *Ode to Bacchus* ceiling painting to the greens in a pair of van Dyck portraits, *Henry Danvers, Earl of Danby* and *Sir Thomas Wharton*.

Behind John Michael Rysbrack's fireplace relief, *Sacrifice to Bacchus*, Kent tucked a hidden corridor for servants. Forks were placed face down on the mahogany table so the men wouldn't catch their frilly cuffs. Food arrived in Paul de Laramie's elegant silver vessels and soup was served in Kent-designed tureens. In addition to claret bought by the cask, Walpole enjoyed champagne and white Lisbon, sometimes ordering one thousand bottles at a time. In 1733, the bon vivant returned more than 6,200 empty bottles of French wine to his wine merchant. In a letter to the Prince of Wales, Lord Hervey noted that he and thirty guests found themselves "up to the chin in beef, venison, geese, turkeys, etc; and generally over the chin in claret, strong beer and punch."[6] After dinner, guests retired to the Cabinet Room to smoke cigars and drink. Walpole hung some fifty small pictures

on the green velvet walls, including Annibale Carracci's sensual *Venus*. For Rubens's *Portrait of Helene Fourment*, featuring the artist's beautiful young second wife, Kent designed a striking picture frame featuring a triangular front, pearl motif, and scallop-shell-and-garland frontispiece.

Walpole's private rooms, including his mahogany-lined bedroom, were located on Houghton's south side. Family members dined in the Common Parlor surrounded by portraits. These included van Dyck's *Inigo Jones*, Rembrandt's *Portrait of an Elderly Lady*, Jordans's *Self-portrait with His Family*, Hals's *Portrait of a Young Man*, and Rubens's *Head of a Franciscan Monk*. Kneller's *Portrait of Grinling Gibbons* hung over the marble fireplace inside carved pear-wood swags attributed to the virtuoso carver. Walpole would buy two works from Gibbons's posthumous sale—Snyders's *Concert of Birds* and Giordano's *Vulcan's Forge*.

In contrast to Kent's "floor of taste, expense, state and parade," the plain basement suited Walpole and his legendary hunting parties. An avid hunter, Walpole reportedly opened his gamekeeper's reports before his government papers. "The base, or rustic story, is what is chiefly inhabited at the Congress," Lord Hervey wrote the Prince of Wales. "There is a room for breakfast, another for supper, another for dinner, another for afternooning and the great arcade with four chimneys for walking and quid-nuncing [gossiping]. The rest of this floor is merely for use, by which your Royal Highness must perceive that the whole is dedicated to fox-hunters, hospitality, noise, dirt and business."[7]

After Horace Walpole returned from his Grand Tour, his father persuaded him to "sacrifice the Joys of the Beau-monde to ye amusements of dull rural life."[8] While spending the summers of 1742 and 1743 at Houghton, Horace helped curate his father's art collection and wrote *Aedes Walpolianae*, a tribute and catalogue (published in 1747, *Aedes* was the first book by an English author on a private English picture collection). While a shared love of art brought them closer, the cultivated Horace could barely tolerate his father's guests. "Only imagine that I here every day see men, who are mountains of roast beef, and only seem just roughly hewn out into the outlines of human form, like the giant rock at Pratolino!" wrote Horace. "I shudder when I see them brandish their knives in act to carve, and look on them as savages that devour one another."[9]

In his retirement, Robert Walpole turned Houghton's north wing greenhouse into a rectangular picture gallery. Here, against wall coverings of Norwich (wool) damask, he hung some four dozen paintings including Snyders's large-scale market scenes and a Rubens workshop cartoon of the *Hunt of Meleager and Atalanta*. In 1745, the 68-year-old's health took a turn for the worse, aggravated by a new lixivium treatment for kidney stones. Robert Walpole intended Houghton Hall to be a lasting monument to his heirs, one that would rival England's greatest aristocratic homes. But with his lavish lifestyle and princely art collection, he'd amassed huge debts, a situation he hid from his family by burning the bills.

Only after Walpole's death in March 1745 did Horace and his other children learn of the £50,000 debt (equivalent to over $8 million today). Though the prime minister's eldest son and namesake, Robert Walpole, 2nd Earl of Orford, sold off his father's London paintings and Houghton silver, it didn't make much of a dent. He died just six years after his famous father, leaving Houghton Hall, his title, and the family debt to his unstable 21-year-old son, George. "The most ruined young man in England," according to his uncle Horace, George Walpole added to the family's financial woes.

An ardent falconer, George Walpole spent some one hundred pounds a year on each of his birds of prey, sending them to the continent during molting season. In addition to gambling, he indulged his mistress, Mrs. Patty Turk, a former Houghton maid. To pay his growing debts, George Walpole sold Houghton's two exterior stone staircases. By 1773, Horace found Houghton "half a ruin, though the pictures, the glorious pictures, and furniture are in general admirably well preserved. All the rest is destruction and devastation. The two steps exposed to all weathers, every room in the wings rotting with wet; the ceiling of the gallery in danger . . ."[10] But the worst was yet to come, what Horace described as the "shipwreck of my family."

In Fall 1778, George Walpole hired James Christie, founder of the eponymous auction house, to value his grandfather's paintings in the "most profound secrecy." Being knowledgeable about gems, not pictures, young Christie consulted with painters Benjamin West, Giovanni Cipriani, and Philip Tassaert in preparation for an auction. Alexey Musin-Pushkin,

Russia's ambassador to the Court of St. James, quickly informed Catherine of the impending auction: "Your Majesty has perhaps heard of the collection of paintings of the celebrated Robert Walpole . . . His grandson Lord Orford is taking the liberty of placing everything, or part of it, at Your Imperial Majesty's feet. It is worthy, in the opinion of all connoisseurs, of belonging to one of the greatest sovereigns."[11] Wasting no time, Catherine instructed the diplomat to make an *en bloc* offer of £40,550 (equivalent to around $10 million today) for 204 of Walpole's best paintings. Catherine's talent for clandestine negotiation paid off. By July 1779, the empress and George Walpole had struck a deal.

News of the sale unleashed a firestorm of protest, similar to the reaction in Paris seven years earlier to Catherine's Crozat acquisition. Not since the auction of Charles I's paintings had such treasures been sold in England. The closest thing to a national art collection, Walpole's masterworks included eight Titians, nineteen Rubenses, twenty van Dycks, five Murillos, three each by Veronese, Holbein, and Rembrandt, and two each by Velazquez and Raphael. Adding to the outcry was a sense that the English people had helped pay for the paintings; that Walpole's fortune had come from decades of his control of the state coffers. It didn't help that in April, Parliament had rejected radical MP John Wilkes's proposal to buy Houghton's paintings for the newly founded British Museum. Writer Samuel Johnson now petitioned Parliament to block the pictures' export.

Ever since Catherine's coup d'état, Horace Walpole had harbored a visceral dislike for the Russian empress, labeling her the Crocodile, the Grand Usurperess, the Northern Fury, and Ursa Major of the North Pole.[12] Now that dislike turned personal. ". . . [A] miserable bargain for a mighty Empress!" he wrote in August 1779. ". . . Well! adieu to Houghton!—about its mad master I shall never trouble myself more. . . . The happiness my father entailed on this country . . . has been thrown away."[13] Desperate to save his father's paintings, Horace appealed to art-loving George III to buy the trove for the Royal Collection. Two years after succeeding his grandfather, the king had acquired a celebrated collection of Italian paintings and had helped found the Royal Academy and Royal Society of Arts. But by 1779, George III was preoccupied with the American War of Independence which had snowballed into a war with France, Spain, and the

Netherlands. Neither the British government nor the royal family stepped up to save the Walpole collection.

When Grimm wrote Catherine informing her that the Houghton collection was no longer available, she cheerfully replied: "The Walpole pictures are no longer to be had, for the simple reason that your humble servant has already got her claws on them, and will no more let them go than a cat would a mouse."[14] To transport her precious cargo across some one thousand miles of perilous seas, Catherine dispatched the naval frigate *Natalia* to King's Lynn, the closest port to Houghton Hall. By spring 1779, 204 of Robert Walpole's finest paintings were stripped from Houghton's opulent staterooms, taken by wagon to King's Lynn, and loaded onto the *Natalia*.

Memory of the lost Braankamp pictures must have come rushing back to Catherine in early August when she learned that the *Natalia* had been damaged off the coast of Holland. Fortunately, the Walpole crates were transferred to another ship and reached the Winter Palace safely that fall. Catherine relished their arrival, personally supervising the unpacking. Most spectacularly, fourteen paintings by Anthony van Dyck joined her eleven Crozat van Dycks. The Antwerp-born artist's influence on generations of portraitists was so great that the British adopted him as their own.

According to a 17th-century biographer, van Dyck's father "was a merchant of cloths, which in Flanders surpass all others in fineness and workmanship; his mother occupied herself with embroidery, and she painted with her needle, fashioning landscapes and figures in stitchery."[15] This background helps explain the artist's talent for painting costumes. At sixteen, after an apprenticeship to cabinet picture painter Hendrik van Balen, van Dyck joined the workshop of Peter Paul Rubens, who described him three years later as "the best of my pupils."[16] In 1632, when Charles I appointed van Dyck "principalle Paynter in Ordinary to their Majesties" and knighted him, he was already one of Europe's most popular court painters.

Van Dyck adopted a number of new techniques in England. His palette widened to include an array of blues, pinks, yellows, and greens. He placed his subjects outdoors, portraying men as Arcadian shepherds and women in shimmering silks and satins. The fantasy was executed so well, writes Emilie Gordenker, it "came across as effortless, entirely convincing, and

perfectly suited to the courtiers."[17] With their sumptuous costumes and luxe backdrops, van Dyck made his royal and aristocratic sitters look down-to-earth and magnificent at the same time. Most notably, he did much to glamorize England's short, stammering king and his consort, French Bourbon Princess Henrietta Maria. The Queen's niece, who only knew her aunt from van Dyck's lovely portraits, was surprised to discover that she was actually ". . . a little woman with long lean arms, crooked shoulders, and teeth protruding from her mouth like guns from a fort."[18]

With courtiers clamoring for their own stylish portraits, van Dyck found himself swamped with commissions. Charging fifty to sixty pounds for a full-length, thirty for a half-length, and twenty for a head and shoulders portrait, the ambitious artist turned out some four hundred portraits in seven and a half years, an average of at least one painting a week. Choosing from a repertoire of poses, van Dyck started by sketching his ideas for a portrait. After just a quarter of an hour, he'd hand a finished sketch on a small piece of blue paper to his assistants, who would enlarge it and paint it on canvas. During subsequent sittings, van Dyck painted the sitter's head and hands, delegating landscape, drapery, and costume to his assistants before adding the finishing touches himself. Paris-based banker and collector Everhard Jabach, who sat for van Dyck three times, observed that he "never worked more than an hour at a time on each portrait, either when sketching it out or when finishing it. . . . After which his servant came to clean his brush and bring him another palette whilst he welcomed the next sitter. . . . In this way he worked on several portraits in the same day with extraordinary speed."[19]

Among Catherine's new van Dycks was one of his most enchanting, *Philadelphia and Elizabeth Wharton* (1640), the daughters of Philip, 4th Lord Wharton from his first marriage. A spaniel (symbol of fidelity) paws at the cream-colored dress of five-year-old Elizabeth, while four-year-old Philadelphia, in blue, touches her arm. Though their elegant dresses, pearls, and ringlets make the sisters look like miniature ladies-in-waiting, their expressions convey the joy of childhood. Scholars agree that the charming figures of the girls, including their finely painted heads, are by van Dyck. The underlying images, or *pentimenti*, in the outlines of their dresses indicate the artist's own revisions. The less refined gray curtain and leaning

tree (symbol of the loss of the girls' mother who died five years earlier) were painted by van Dyck's assistants.[20]

Catherine could not have been happier with the Walpole pictures. As a token of thanks, she sent George Walpole her full-length portrait on the same ship that carried his grandfather's paintings to St. Petersburg. Painted in the style of Sweden's Alexander Roslin, the portrait of Catherine in an ermine robe still hangs over the gray and white marble fireplace in Houghton's Saloon. In return, George Walpole penned "a code of the laws of coursing" for Catherine and named his favorite greyhound "Czarina." After seeing Catherine's portrait, Mrs. Lybbe Powys observed: ". . . Tis really melancholy to see the hangings disrob'd of those beautiful ornaments, and only one picture now there, a portrait of the Empress herself, which she made my Lord a present of; but though 'tis said to be a striking likeness, and well painted, it rather gives one pain, to see the person who must deprive everyone who now visits Houghton of the entertainment given to them by these pictures, and their going out of the kingdom makes it still worse."[21]

The *European Magazine* summed up popular sentiment when it published a list of the paintings sold to Catherine along with an angry article addressed to the publisher. "The removal of the Houghton Collection of Pictures to Russia is, perhaps, one of the most striking instances that can be produced of the decline of the empire of Great Britain, and the advancement of our powerful ally in the North. . . . But it is too late to lament; the disgrace has been sustained; and the capital of Russia now boasts what formerly drew crowds into the county of Norfolk to see and to admire. . . ."[22]

No one was more distressed about the loss than Walpole's son. "To be sure," wrote Horace, "I should wish they [the paintings] were rather sold to the Crown of England than to that of Russia where they will be burnt in a wooden palace on first insurrection."[23] His concern for the safety of the art would be justified as violence erupted in St. Petersburg during the 20th century. But ironically, the sale may have saved many of his father's paintings from a fire after all. On December 7, 1789, a decade after the sale, a fire broke out at Houghton, destroying Robert Walpole's picture gallery in the north wing.

While England mourned, Catherine rejoiced. The glory days of the British Empire, once stretching from India to North America, were fading. Thanks to her cultural and military campaigns, Russia was a rising superpower. By March 1780, the empress wrote Grimm: "The Natalie is washed ashore while she went to get what was already onboard, shipped and delivered; the Walpoles are doing great and are spending winter crowded in my gallery."[24]

CHAPTER TWO

RAPHAELISM

On September 1, 1778, Catherine sent Melchior Grimm an uncharacteristically melodramatic letter: "I'll die, I'm sure I'll die: there's a strong wind blowing from the sea, the worst kind for the imagination; this morning I went to the baths, which made my blood rise to my head, and this afternoon the ceilings of the Raphael loggias fell into my hands. I am sustained by absolutely nothing but hope; I beg you to save me: write at once to Reiffenstein, I beg you, to tell him to get these vaults copied life-size, as well as the walls, and I will make a vow to Saint Raphael that I will have loggias built whatever the cost and will place the copies in them, for I absolutely must see them as they are. I have such veneration for these loggias, these ceilings, that I am prepared to bear the expense of this building for their sake, and I will have neither peace nor repose until this project is under way."

Catherine added a practical request: "And if someone could make me a little model of the building, the dimensions taken with accuracy in Rome,

the city of models, I would get nearer to my aim. Well, the divine Rei-
ffenstein could have this lovely commission as well, if Monsieur the Baron
Grimm so desires; I admit that I would rather charge you with this than
Monsieur Shuvalov [Empress Elizabeth's former lover], because the latter
is always raising doubts about everything, and doubts are what make people
like me suffer more than anything else in the world."[1]

By November, scaffolding was up at the Vatican.

What fell into Catherine's lap that blustery fall afternoon was an exqui-
site book of hand-colored engravings of the Vatican's Raphael Loggia.
Catherine received Giovanni Volpato's engravings in early 1776 as a gift
from Count Nikolai Repnin, her Constantinople-based ambassador to the
Ottoman Empire. Volpato, the Bassano-born, Venice-trained son of an
embroiderer, was considered one of the great masters of etching. Smitten
with Raphael and Rome, Catherine found Volpato's engravings irresistible.
Known as "Raphael's Bible," the vaulted gallery reflected Renaissance Italy's
rediscovery of the classical world—the same revival sweeping 18th-century
Europe. Catherine wasn't the first ruler to replicate a masterwork. For his
villa at Tivoli, Roman Emperor Hadrian had copied the temple of Aph-
rodite of Knidos, shrine of the Praxiteles masterpiece. France's Louis XIV
adorned a gallery at Tuileries after the interior of the gallery of Annibale
Carracci's 1598 Palazzo Farnese.[2] Catherine saw the Vatican replica as
part of her program to turn St. Petersburg into a second Rome, symbol of
early Christianity and imperial power. "Oh, Rome! Rome!" she enthused.
"The rest of the world cannot compete with you in the arts, in the ruins
and in many other things."[3]

Per Catherine's instructions, Melchior Grimm consulted Johann
Friedrich Reiffenstein, her well-connected Rome art dealer. Reiffen-
stein's choice for the project was Christopher Unterberger, a Tyrolian-
born artist specializing in decorative Renaissance-style painting who'd
worked on the restoration of the loggia. Unterberger had also collabo-
rated with neoclassical painter Anton Raphael Mengs on an elaborate
ceiling for the Vatican Library's Papyrus Room decorated with Roman
fresco motifs. That led to commissions to decorate Pius VI's residences
and the Museo Pio-Clementino, started during the pontificate of
Clement XIV.

Along with a lucrative payment, the prestigious commission from Russia offered Unterberger a chance to expand his reputation internationally. But his new patroness couldn't have her loggia soon enough. Six months into the project, Catherine wrote: "The slightest indigestion of the Holy Father sends me into agonies, for a conclave would delay the work tremendously."[4] Unterberger began by painting cartoons in the original size in tempera. From these cartoons, along with Volpato's engravings, Unterberger's team created large oil copies on canvas. Giovanni Battista Dalera, Felice Gianni, and Andrea Nessenthaler copied Old Testament scenes. Giovanni Angeloni and his son Vincenzo worked on the decorative elements. "When the sea opens at end of winter, at the start of the new year . . . a large quantity of pillars, vaults, and parts of the galleries will be ready to be shipped," wrote Reiffenstein.[5]

By November 1779, Reiffenstein recommended Bergamo native Giacomo Antonio Domenico Quarenghi to design a gallery to house the replicas by Catherine's Large Hermitage. Before Quarenghi left for St. Petersburg, Reiffenstein asked him to work up a blueprint for the loggia. As a model, Quarenghi consulted a cork model of the Vatican Loggia by Antonio Chichi. The artist's detailed architectural recreations in cork—including a set of three dozen of ancient Rome's great sites—had become prized collector's items.

The original Vatican Loggia was also a collaborative effort. In 1508, after completing his famous series of Madonnas in Florence, 25-year-old Raphael was summoned to Rome by Pope Julius II. The irascible "warrior pope" was looking for an artist to decorate the middle room of his new state apartments along the north side of the Vatican Palace, known today as the Stanza. After well-known painters Perugina and Signorelli fell through, architect Donato Bramante convinced his patron to give young Raphael a chance. Raphael passed his test with flying colors with triumphs that included Julius II's library (Stanza della Segnatura) and the magnificent *School of Athens.*

It didn't take long before Raphael was dominating Rome's artistic scene and competing with Michelangelo. "Heaven sometimes showers infinite riches on one sole favorite," wrote Vasari, who called men like Raphael "mortal gods who leave such fame on earth that they may hope for sure

rewards in heaven thereafter."[6] After five successful years, Raphael landed an even more enthusiastic papal patron—37-year-old Leo X. The second son of art-loving Medici ruler Lorenzo the Magnificent, Leo X devoted much of his papacy to the arts. When Bramante died the year after Leo X's accession in 1513, the new pope appointed Raphael as his successor. As commissioner of antiquities, Raphael was responsible for conserving Roman antiquities and supervising excavations. Raphael also took over Bramante's unfinished Loggia begun in 1512 on the third level of the Vatican Palace overlooking the Cortile San Damaso and St. Peter's Square.

Approximately 215 feet long and 13 feet wide, the Loggia was designed to display Julius II's antiquities. For the vaulted ceiling, Raphael chose fifty-two biblical episodes—forty-eight from the Old Testament and four from the New Testament. Each of the thirteen bays contained four frescoes—beginning with the Creation and ending with the Last Supper. With the exception of Moses who rated two vaults (eight paintings), each great biblical protagonist occupied one bay. Ten more biblical scenes in grisaille adorned the walls below the mirrors. Raphael's inspiration came from a wide variety of pagan and Christian sources—including the Hellenistic Farnese Cup, antique reliefs and sculpture, and early Christian mosaics from Santa Maria Maggiore.[7] He also consulted book and manuscript illustrations, sculpture, frescoes, and the great mosaic cycles of basilicas in Rome, Florence, and Venice.

To help him execute the commission quickly, Raphael turned to his accomplished group of painters, draftsmen, and sculptors. Raphael entrusted the first vault to his two most talented recruits, Roman Giulio Romano and Florentine Giovan Francesco Penni (the project's superintendent). Most likely, Raphael sketched the important biblical figures, leaving his assistants to finish the scenes.[8] To complement the ceiling, Raphael added stucco bas-reliefs and trompe l'oeil festoons of fruit and flowers. The frescoed humans and animals known as grotesques were inspired by the recently discovered paintings from the grotta, or caverns, of the Emperor Nero's Golden House. A "mad extravagance" is how Roman historian Suetonius described Nero's pleasure palace on Rome's Palatine Hill. By Raphael's day, the grotesques were all that remained of the sumptuous ancient decoration.

Though Vasari called grotesques "a very ridiculous and licentious species of painting," he praised the birds, fish, and sea monsters in Raphael's Loggia as the "most lovely and capricious inventions, full of the most varied and extravagant things you could possibly imagine." For Giovanni da Udine, who'd trained in Giorgione's Venice workshop, the Loggia offered a chance to express his wildest imagination.[9] In creating his fantastic creatures, Udine turned to the ancient art of stucco. Unlike marble which required carving and chiseling, stucco could be modeled like clay and also colored.

The Loggia was an instant hit. Shortly before its completion in 1519, courtier Baldassar Castiglione raved to Isabella d'Este: "A loggia decorated with paintings and stucco in the style of antiquity . . . as beautiful as possible, and maybe more so than what one sees nowadays. . . ."[10] As the finishing touches were being made, the first seven of Raphael's spectacular tapestries depicting the Acts of the Apostles were being hung in the Sistine Chapel below Michelangelo's celebrated ceiling. The ten-tapestry cycle set Leo X back 16,000 ducats—over five times Michelangelo's fee for the glorious ceiling.

The following April, Raphael died suddenly on his thirty-seventh birthday. The cause of his death remains a mystery, though Vasari attributed it to "amatory excess." During his funeral mass at the Vatican, Raphael's altarpiece *Transfiguration* was placed at the head of the bier, finished by his colleague Giulio Romano. In just a dozen years, Raphael had gone from relative obscurity to a legend. England's Henry VII, France's Louis XIV, and Hapsburg emperor Charles V wanted to own his tapestries. In 1623, England's Charles I paid 300 pounds for seven of Raphael's Sistine Chapel cartoons. (In 1865, Queen Victoria loaned them to London's Victoria & Albert Museum, where they remain.) Raphael and his Loggia inspired generations of artists; by the time of Catherine's reign, he was widely regarded as Western art's greatest painter.

Catherine showed a keen interest throughout the decade-long loggia project. "I am fascinated by the replica of the Raphaelian Logge, and I just cannot stay away from them. . . ."[11] In May 1779, Catherine wrote Grimm about the arrival of the copy of two pillars. "Thank God and thanks to divine Rieffenstein and to painter Unterpeger . . . the two are already

finished."[12] Safe passage of the Vatican replicas became a real concern as war made the high seas increasingly dangerous. In February 1780, a Russian ship loaded with grain for Malaga was seized by the Spanish, who suspected the cargo was bound for Gibraltar (which the Spanish were trying to recapture from Britain).

Catherine ordered fifteen ships fitted for service in Spanish waters, but made it clear to British envoy Harris that she had no intention of entering the war. In a letter to Grimm days later announcing her Armed Neutrality declaration, Catherine revealed that the transport of her art acquisitions was a top priority. "You will hear one of these days that a certain declaration has been issued which you will probably find truly volcanic," she wrote. "There was nothing else to do. . . . This spring and during the summer a number of Russian vessels will touch Livorno and they may even bring home the Raphaels."[13]

Catherine's order generated great interest in Rome. By the end of August 1780, Christopher Unterberger transferred the first part of the commission to the Quirinale, where the paintings were displayed for the public and Pope Pius VI. Seven years later, Goethe wrote admiringly of another installment with the paint still fresh. Beginning in 1782, the copies were rolled up, transported to Livorno, and loaded onto a Russian ship for St. Petersburg. On the south wall of Quarenghi's Loggia, against a blue background, Catherine replaced Leo X's Medici family coat of arms with her profile portrait and Russia's double-headed eagle.

Catherine's passion for Raphael didn't end with the Loggia. When Paul remarried in September 1776, Catherine threw an engagement party at Tsarskoe Selo. In preparation for the gala, Catherine asked to have her future daughter-in-law's bedroom decorated with a tapestry with golden thread and gold and blue velvet border inspired by drawings of the Raphael Loggias. Also at Tsarskoe Selo, Catherine had Yury Velten build a mini Stanza di Raphael, a small room to be decorated with twenty-six original engravings from the Loggia. In a 1781 letter to Grimm, Catherine shared that of two of eleven newly decorated rooms were dedicated to "Raphaelism." Though Catherine rejected Reiffenstein's idea to commission more copies of Raphael's works for these rooms, she authorized him to obtain a pattern with motifs by Raphael to be made in the experimental encaustic technique.

In 1784, Prince Nicholas Yusupov, Catherine's newly appointed pleni-potentiary minister in Italy, discussed his proposal to copy Raphael's frescoes of the Stanza with Vatican officials. Though Catherine agreed, the project was never executed. Yusupov also suggested Catherine buy copies of Raphael's cartoons for the Sistine Chapel tapestries that belonged to England's Royal Collection, as well as copies of his tapestries whose cartoons had been lost. But by this point, Catherine's taste seems to have shifted from Renaissance painting to the new fashion for ancient Roman painting sparked by the discovery of the Domus area at Pompeii. As a collector, Catherine was also leaning toward more cheerful subjects. "I cannot imagine what they are like, but if their subject matter is sad or too solemn, I am not interested in them," she wrote.[14]

CHAPTER THREE

SASHENKA

I n the spring of 1780, Catherine installed Alexander Lanskoy in the favorite's apartments of the Winter Palace, promoting him to aide-de-camp. Another Potemkin protégé, the beautifully mannered officer of the Horse Guards had passed Catherine's selection process—including a doctor's check and an evening with her new *eprouveuse*, Anna Protasova. The son of a Smolensk military officer, Lanskoy had grown up at court as a playmate and schoolmate of Catherine's children—Grand Duke Paul and Alexei Bobrinsky, her son with Gregory Orlov. The fact that Lanskoy was thirty years her junior mattered little. As she aged, Catherine sought out increasingly younger men.

Catherine fell head-over-heels for her good-natured lover, calling him "Sashenka," an affectionate diminutive of Alexander. Though the passion was less fiery than with Orlov or Potemkin, writes Robert Massie, ". . . his gentleness and devotion inspired in her an almost maternal affection. He was intelligent and tactful; he refused to take in any part in public affairs;

he was artistic, had good taste, and was seriously interested in literature, painting, and architecture."[1]

Around this time, Potemkin conducted a series of incestuous affairs with his nieces, the Engelhardt sisters, who Catherine had made maids-of-honor at court. A relationship developed that would repeat itself with both of their future lovers. Lanskoy addressed Potemkin as "father" or "dear uncle." Catherine similarly assumed a maternal role in the young women's lives. Douglas Smith explains the complicated relationships: "Catherine, Potemkin, and her favorites constituted a family of sorts. . . . These young men, together with Potemkin's nieces, represented the children they never had."[2]

With his discerning eye and interest in art, Lanskoy proved the perfect companion. Encouraged and bankrolled by Catherine, Lanskoy started collecting books and miniatures copied from the imperial collection. From there, he added gems, coins, and several dozen small bronzes, including Giambologna's *Hercules and the Sacred Hind of Arcadia*. A print collection followed. Lanskoy displayed his new artworks at a Velten-designed residence on Palace Square facing the Winter Palace. Giacomo Quarenghi also designed a house for Lanskoy in Sophia, along with a palace in the Pskov province at Vele with a park by James Meader.

Catherine joked that she acquired art not just for herself but for those she had infected with her "gluttony," and Lanskoy was chief among them. "The head of Greuze is much coveted by General Lanskoy," Catherine wrote Grimm playfully. "If you procure him a miniature copy of it in enamel, he will jump like a deer, and his already beautiful coloring will become still more vivid. . . ." Grimm carried out Catherine's order and responded to Lanskoy's illness. "As for these *maladies*, part and parcel of general gluttony, I have seen some formidable symptoms in my role as imperial *archiatre* (doctor) for this sort of infirmity." Pretending to be Lanskoy, Grimm described the disease's progression: "Until now I have been quite happy with a fine black and white sheet representing [Raphael's] School of Athens; now, however, should I not require a colored one? Then it will be an Aurora by Guido, and then a third print, after which the malady becomes incurable."[3]

At the same time, Catherine was cultivating a blossoming relationship with another Alexander, her grandson. "When he leaves my apartments

under his own steam, he does so quite happily; but if I leave him, he cries loudly . . . ," she shared with Grimm. "He is a very unusual infant; he is a composite of instincts: those who do not observe him do not believe he has either spirit or imagination, but I maintain that he will be a very particular composite of instinct and knowledge; he already knows more things than other children of four or five. In addition analogies strike him in particular, and again it is I who has to explain them to him, and as I always speak simple reason to him and I have never deceived him about anything, he believes that he does not really know something until he knows it from me."[4]

In early May 1780, Catherine left Tsarskoe Selo with an entourage that included Lanskoy and her adviser Alexander Bezborodko. The first part of the trip involved inspections of the newly reformed provincial vice-regencies including territories annexed eight years earlier in the partition of Poland. Catherine generously rewarded her lovers and military leaders with land, serfs, and cash; now mansions began appearing in the south. Catherine granted Field Marshal Rumyantsev a huge tract of land and 5,000 serfs confiscated from the Polish Czartoryskys in the new province of Chernigov. Rumyantsev built Gomel, a magnificent house designed by Ivan Starov. Two weeks into the trip, Catherine's former favorite Semyon Zorich hosted the party at his estate on the Dnieper.

The final stop was Mogilyov (today's Belarus), a port on the Dnieper that had become part of the Russian Empire in 1772. Potemkin and his niece Aleksandra Engelhardt had left for Mogilyov earlier to prepare for a reception between Catherine and Austria's Joseph II. The purpose of the meeting was to explore closer ties between Russia and Austria, a major foreign policy shift away from Prussia, as Austria was vital to Russia's expansion south. After their first meeting, Catherine wrote her son and daughter-in-law about the abstemious emperor who rose early and drank only water: "He likes talking, he is learned, he wants to put everyone at ease, one has no idea what he looks like if one hasn't seen him, his portraits don't look like him at all." Catherine also reassured Paul about Joseph's upcoming visit to St. Petersburg: "Don't sweat, the conversation with Monsieur de Falkenstein [Joseph II's alias] will not cause you any trouble. . . . He will be a lot less of a pain than the King of Sweden, believe me."

Catherine and Joseph II attended an Orthodox liturgy and Roman Catholic mass. At the end of May, the rulers overnighted in Smolensk, part of the Russian Empire since 1654. Catherine felt more comfortable here than in the new territories she called "godforsaken towns of White Russia." In mid-June, while Potemkin showed Joseph around Moscow, Catherine and Lanskoy arrived back at Tsarskoe Selo. Later that month, Joseph attended the consecration for the Gothic church at La Grenouillère. Both castle and church were renamed Chesme after Russia's naval victory over the Turks; the church was dedicated to St. John the Baptist, whose birthday coincided with the date of the naval triumph. Resembling a pink and white wedding cake, Yury Velten's church featured striped crenellated walls, Gothic arches, and roof lanterns like those at Stowe's Gothic temple. Velten replaced the traditional Russian onion domes with five Gothic turrets.

Catherine continued to lavish Alexander Lanskoy with art—including a spectacular *surtout de table*. During the 18th century, elaborate centerpieces from antiquity developed into grand decorative table ornaments. The *surtout* represented the epitome of luxury, a fantastic miniature world inspired by ancient Rome and Greece. With Grimm's help, Catherine bought the centerpiece from spendthrift Louis Charles Auguste le Tonnelier, Baron de Breteuil, ambassador of the Knights of Malta in Rome. Catherine reassured Grimm that the *surtout* ". . . was very well received and it is my 'middle floor' [floor between the ground floor and the 1st floor], in the room called Museum, with its friends in gold, silver and gemstones coming from the four corners of the World to keep it company, and a large number of jaspers and agates from Siberia. There (only) the mice and I see it."[5]

Created for Baron de Breteuil, the neoclassical ensemble was the work of famed Roman goldsmith Luigi Valadier. Over several feet in length, the *surtout* featured Roman buildings and monuments in gilded bronze and gemstones. A superb draughtsman and master of silver, gold, and *pietre dure* (mosaic designs of semiprecious stones), Valadier ran a busy workshop with 180 craftsmen. In 1779, Pius VI put Valadier in charge of ancient cameos and the restoration of bronzes in the papal collection. But in 1785, plagued by severe financial problems possibly related to casting the bell for St. Peter's, Valadier committed suicide by drowning in the Tiber. (His son, architect Giuseppe Valadier, finished the monumental cathedral bell.)

Catherine also gave Lanskoy a late Renaissance bronze statuette from the workshop of Giambologna, part of the Flemish-born sculptor's series of the twelve labors of Hercules. Just fifteen inches tall, *Hercules and the Arcadian Stag* shows the mythical hero capturing Ceryneia's golden horned deer. Born in Douai, Flanders, Giambologna spent his career in Rome and Florence where he gained renown for his supple modeling and technical skill in bronze casting. By 1570, he was considered one of Europe's most influential sculptors.

In 1784, Catherine presented her young favorite with an extraordinary gift—119 Flemish and Dutch pictures from French collector Silvain-Raphaël, Count Baudouin. "Another collection is being offered to Your Majesty if this fatal passion still persists. . . . ," Grimm wrote her several years before. After studying the catalogue of Baudouin's cabinet, she finally gave him the green light: "The world is a strange place, and the number of happy people in it is exceedingly small. It is quite clear that Count Baudouin will not be numbered among these unless he sells his collection of pictures and it appears that I have been destined to give him this happiness."[6] To this she added, "You would do well . . . to make haste to Lubeck so that by spring the whole will arrive here," she added. "Truth to tell, it is not for me, but I will pay you, if you please, out of my own money and as if it were for me."[7]

A brigadier of the king's armies and captain of the French Guards, Baudouin was also an amateur etcher and printmaker. As with the Crozat collection, Paris was irate over Baudouin's masterworks leaving Paris for St. Petersburg (Baudouin would flee France during the Revolution and eventually return). Among the highlights of Baudouin's Flemish school paintings were Rubens's *Portrait of George Gage* and van Dyck's *Portrait of Jan van den Wouwer* (Pushkin Museum, Moscow). From the Dutch Golden Age came and three landscapes by Jacob van Ruisdael and four genre scenes by Haarlem-born Adriaen van Ostade, pupil of Frans Hals and founder of the peasant genre in 17th-century Dutch painting.

The treasures of Baudouin's collection were nine Rembrandts, mainly portraits. Rembrandt entered Amsterdam's burgeoning portrait market at age twenty-five and soon became the city's most fashionable portraitist. His sitters included merchants, officials, and members of his extended family,

usually in bust-length or half-length, frequently in the popular oval shape. Though these early finely painted faces were remarkable, it was in the last years of his life that Rembrandt achieved what Quentin Buvelot calls "an unprecedented degree of expressiveness."[8] According to Jonathan Bikker and Gregor J. M. Weber, the final third of Rembrandt's career represents the "most daring and individualistic period of his creativity," a "search to understand and represent humanity's most profound motivations and emotional states" using "a relentlessly experimental approach."[9] That included loose, sweeping brushwork often rendered with a palette knife and the back end of the paintbrush.

Rembrandt's unconventional techniques coincided with financial setback and personal tragedy. In 1656, after years of overspending on his house and artworks, the debt-ridden artist went bankrupt. Two years later, Rembrandt moved to a modest rental with Hendrickje Stoffels, their daughter, Cornelia, and Rembrandt's son, Titus, the only surviving child from his first marriage to Saskia Uylenburgh. In 1663, Rembrandt lost Hendrickje to the plague; five years later, 27-year-old Titus died. The following March, Titus's widow, Magdalena van Loo, gave birth to a baby girl, Titia. Six months later, the heartbroken 63-year-old artist died, buried in an unmarked grave in Amsterdam's Westerkerk.

During his difficult last years, Rembrandt counted on a cadre of loyal supporters, notably poet Jeremias de Decker. Rembrandt biographer Simon Schama calls Rembrandt's small half-length *Jeremias de Decker* "the greatest of the late portraits."[10] "Rembrandt depicts himself in the eyes of the other, so fixed and sharp is the poet's gaze, whose depth is intensified by the shadow of the broad brim of a hat that covers half the face."[11] Though *Jeremias de Decker* has always been dated 1666, making it one of Rembrandt's latest, new scholarship suggests that Rembrandt may have painted this portrait a decade earlier.[12] In 1666, the last year of his life, *Jeremias de Decker* thanked the artist for his gift with "Homage to the Great Rembrandt": ". . . Oh if I could reward your art with art, in place of with gold, and portray you as masterfully in my paper verse, as you drew me on a piece of wood . . . Just as fine vineyards need no wreaths of ever-green ivy, Oh your fine brush needs ask no one's praise; it is renowned through itself. . . ."[13]

Around the same time Alexander Lanskoy was hanging Jeremias de Decker's portrait along with his other Rembrandts, Catherine acquired a neoclassical painting under very unusual circumstances. In January 1779, shortly after setting sail from Livorno, Italy, the twenty-six-gun British privateer frigate *Westmorland* found itself being chased by four French ships—men-of-war *Caton* and *Destin* along with two smaller vessels (France and England were engaged in the Revolutionary War). Initially, the *Westmorland*'s experienced captain tried outrunning the warships, but after being outgunned he allowed the French to board and commandeer the ship. In stormy waters, the *Westmorland* was escorted to Málaga in southern Spain, then a neutral port (Spain would declare war on England six months later).

The next day, the captain disembarked and made a declaration of the ship's cargo. The French wasted no time seizing the cash on board— payment for an inbound hold of Newfoundland salt cod (Livorno was a trading hub for the popular fish). Alongside 3,837 barrels of anchovies and 32 wheels of Parmesan cheese were 57 crates filled with artworks, 800 souvenirs acquired by wealthy Britons. To the declaration, port authorities added a note: "The captain affirms that there are numerous portraits and statues of considerable value, and among them some that were destined for His Royal Highness, the Duke of Gloucester, brother of the King of England. There is also a painting worth 80 Roman scudi, or 40 Tours pounds, equivalent to 10,000 pesos of our currency."[14]

The captain, crew, and handful of passengers were released, but the painting worth 80 Roman scudi was about to unleash an international row. During a visit to Rome in late 1768, wealthy young Welshman Sir Watkin Williams-Wynn commissioned *The Liberation of Andromeda by Perseus* from Anton Raphael Mengs. The nineteen-year-old intended Mengs's picture to be a companion piece to another tale from Ovid's *Metamorphoses—Bacchus Comforts Ariadne on the Island of Naxos* by Pompeo Batoni, another rescue of an abandoned woman from an island. As Rome's most important history painters, Mengs and Batoni would add prestige to Williams-Wynn's London townhome.

Mengs, who was still in Madrid working for Charles III, repeatedly postponed the commission. After becoming ill in 1777, Mengs received

permission from Spain's king to return to Rome, where he finished the commission the next year. Before rolling up the large canvas for a three-month, 2,700-mile voyage on the *Westmorland*, Mengs hosted a public exhibition at his studio in the Palazzo Barberini (today home to Galleria Nazionale d'Arte Antica). The reception was mixed. While painter Joseph-Marie Vien and sculptor Alexander Trippel lavished praise, Jacques-Louis David was unimpressed and Welsh painter Thomas Jones jotted in his diary that the painting decorated with a "Superb frame and green silk curtain . . . made a stir in Rome in proportion to the Celebrity of the Painter." According to Jones, its principal merit "consisted in its laborious high-Finishing—The Result of German flegmatic Industry."[15]

Sir Watkin Williams-Wynn never saw his painting. In January 1779, the French consul in Málaga whisked the stolen canvas off to the French ambassador in Madrid, who in turn forwarded it to France's naval minister, Antoine Gabriel de Sartine, Comte d'Alby, in Paris as personal booty for the vessel's capture. By February, Johann Friedrich Reiffenstein wrote Melchior Grimm about the ship, suggesting he buy the "sublime" painting for Catherine. It seems that Reiffenstein got the idea from Mengs himself, guilt ridden about accepting 2,000 scudi from the Russian empress for two pictures he hadn't painted.[16]

With Spanish diplomat José Nicolás de Azara also vying for the picture for Charles III, Grimm persuaded Sartine to sell it to Catherine for 9,000 scudi. France's former foreign minister Charles Gravier, Comte de Vergennes, appears to have intervened on Catherine's behalf. Joseph-Marie Vien, director of the Académie de France in Rome who'd admired the painting the previous year in Mengs's studio, was critical of the sale, believing the picture would have made a good gift for Marie Antoinette. The acquisition of another collector's painting caused Catherine some concern. "I see that in order to give me pleasure you intend to rob an honest English gentleman," she wrote Grimm on May 18, 1779. ". . . My conscience troubles me a little that this will be done to the detriment of my neighbor. If the good gentleman contacts me I shall give the painting over to him."[17] She never heard from Williams-Wynn. Naval minister Sartine was dismissed for embezzling government funds.

The painter behind the dispute had caught Catherine's eye several years earlier while in service to the Dresden and Madrid courts. Anton Raphael Mengs's ambitious father, Ismael, a painter at the Saxon court, named him after two Italian greats—Antonio Correggio and Raphael. By his late teens, the precocious artist was court painter to the Elector of Saxony. In Rome, Mengs competed with Pompeo Batoni for portrait commissions from affluent Brits on the Grand Tour. There, Mengs met German antiquarian Johann Joachim Winckelmann; their decade-long relationship proved mutually beneficial. Winckelmann would proclaim Mengs ". . . the greatest painter of his time and perhaps of the following age as well. He has arisen like a phoenix, as it were, out of the ashes of the first Raphael to instruct the world about beauty in art and to achieve in it the highest flight of human powers."[18] The adventurer Casanova, whose brother Giovanni studied with Mengs, had another opinion, describing the artist as overbearing and totally without humor.[19]

According to the artist's biographer Gian Ludovico Bianconi, Mengs promised Sir Williams-Wynn a second Andromeda. But before the artist could make good on that promise, he became seriously ill from what's believed to be lead poisoning from mixing paints. "The fever takes hold of me, too, when I think of the state Mengs is in," Catherine wrote Grimm after hearing of his illness.[20] In June 1779, at the height of his fame, the 51-year-old artist died at his Rome residence (the former home of 17th-century painter Salvator Rosa). Catherine and Pope Pius VI sent condolences. *Perseus and Andromeda*, Mengs's last finished work, arrived at the Hermitage a year later.

With Reiffenstein's help, Catherine also bought all the paintings in Mengs's studio from his estate. The artist's 48-year-old wife had died the year before; the large acquisition helped provide for their seven children. In addition to several British portraits, Catherine added *Saint John the Baptist Preaching*, a late *Self-portrait* (1775), and *The Judgment of Paris* to her collection. Frederick the Great had commissioned *The Judgment of Paris* after his sister Wilhelmine von Bayreuth called Mengs the "Raphael of our day." Frederick, who became more interested in Old Master paintings for his new picture gallery, refused to pay for the finished canvas.

Also from Mengs's estate, Catherine paid 3,000 crowns for an ancient sardonyx cameo that may have inspired her new painting. In

the carved gem Perseus sits on a rock besides a grateful Andromeda, holding the Gorgon's head up in the air. "With much festivity the cameo with *Perseus and Andromeda* has been placed in the museum on the ground floor of the imperial suites . . . ," Catherine wrote Grimm. "When I saw it I was astonished, as had been predicted, and I exclaimed, 'What's this rubbish that the connoisseurs are admiring! . . . We should take a closer look at it, give us a pair of glasses and a magnifying glass!' The scrutiny turned out to the benefit of the cameo because it is indeed close to perfection. . . ."[21] Catherine's next delivery from Rome elicited a very different reaction.

Two years earlier, she'd agreed to buy works purportedly by Correggio and Poussin, provided experts like Mengs and Batoni inspected the canvases. But Reiffenstein proceeded without getting the artists' opinions. "Reiffenstein though he lives in Rome, moves among artists and sees the works of the great masters every day, apparently knows no more about art than a newborn babe, whereas we, thanks to our continual inspection of the Hermitage galleries, can tell the good from the bad at a glance," she wrote Grimm.[22] "To my great astonishment, except for the Mengs and a few other trifles, all the rest . . . are nasty daubs: I have told Martinelli (the painter who takes care of my gallery), to choose [the best] and send the daubs to auction for the benefit of the civic hospital. Heavens above! It is incredible how the divine one [Reiffenstein] has allowed himself to go wrong this time: I beg you to ask him expressly to buy no more from Monsieur Jenkins. It is scandalous to pass off such banalities under the name of this or the other painter. My guests at the Hermitage were ashamed to go in there ahead of me."[23]

Around the same time, Catherine hosted fifty-year-old Charles Joseph, Prince de Ligne. Joseph II sent the witty aristocrat in the hopes that he'd charm Catherine. In a September letter to Grimm, Catherine called the prince "one of the pleasantest people and easiest to get on with that I have ever met." She also confirmed the arrival of the pirated Mengs picture and offered her opinion on art appreciation: "[Andromeda] has been here for a fortnight in my Hermitage, on display to the eyes of both those who know how to look and those who take a quarter of an hour to see all that there is to see in this place. Great lords know everything

without having learnt anything, says the proverb; by God, there are also plenty of people who see everything without seeing anything or who see everything in a single moment."

Then in a rare show of frugality, Catherine voiced concern to her agent about her expensive collecting habit. "After the paintings bought from Mr. Jenkins I will buy no more, and all my acquaintances are forbidden to send me catalogues or suggest purchases to me, for I have no more money."[24] Catherine's remorse may have been caused by the growing size and cost of her court, over-the-top entertaining, and the millions of rubles she lavished on her young favorites. With her Old Masters picture gallery rivaling Europe's best, Catherine shifted gears. From now on, she would redirect her energy and the state coffers to building.

CHAPTER FOUR

PALLADIO'S SHADOW

As with foreign policy, Catherine was Peter the Great's self-appointed successor in architecture. Considered among the most energetic builders in Russia's history, Catherine used architecture as another way of transforming Russia's image. Embracing neoclassicism, the aesthetic expression of the Enlightenment, Catherine gave Russian architecture an entirely new direction. With its models of ancient Greece and Rome, neoclassicism had the added benefit of helping Catherine build her "imperial" image. Russia's nobility followed Catherine's lead. Soon Russian cities and provinces boasted elegant, finely proportioned palaces and country houses inspired by antiquity. Cosmopolitan Prince de Ligne pronounced St. Petersburg "the finest city" in the world.[1]

Though Catherine rarely left St. Petersburg, she experienced Roman antiquity vicariously through an impressive library of drawings, maps, albums, and books. In the summer of 1772, Catherine received a sketchbook from Falconet filled with furniture designs and mural decorations

inspired by Rome. From the sketches, Catherine got an idea for her favorite summer getaway, Tsarskoe Selo. ". . . [T]he designs lead me to ask you to write to Cochin [an engraver] or to some other artist friend of yours for the name of someone able to do the following for me," Catherine wrote the sculptor. "—I should like a design for an antique house laid out on the antique plan. Each of its rooms would have to be decorated according to its particular purpose and furnished in the style of the decorations," Catherine continued. "The house should not be too large nor too small. I could build a Greco-Roman house of the sort in my park at Tsarskoe Selo, provided it were not too large. I dream of a long dining hall with benches alongside the table; I desire all this and need your help to indulge my fancy, for which I will naturally pay."[2]

The next year, Catherine announced a design competition for her "antique house." "The object," she explained in a letter to the French Academy, "is to recreate the age of the Emperors, Augustus, the Ciceros and the Maecenases . . ."[3] Charles de Wailly's "Palace of Minerva" submission lacked the sensual revival of antiquity and a specific tie to ancient Rome or Greece that Catherine was after. Charles-Louis Clérisseau, known for incorporating Roman ruins into his classical designs, didn't get Catherine's memo on the size of the house. The Frenchman sent eighteen cases of drawings for a grandiose ensemble based on Diocletian's Baths, which Catherine rejected, along with his bill. Several years later, when she learned Joseph II was interested in these plans, Catherine bought up one thousand of the drawings and gave her architects access to the trove. Some seventeen of Clérisseau's gouaches of ancient Roman monuments hung in the empress's boudoir at the Winter Palace. (In 1785, Clérisseau collaborated with Thomas Jefferson on the Virginia State Capitol.)

Catherine had experimented with German and French architects, along with Vasily Bazhenov, the Russian architect trained in Italy. All had come up short. In 1778, she wrote to Grimm asking to have Johann Friedrich Reiffenstein hire "two good architects, Italian of nationality, because the Frenchmen we have here know too much and build dreadful houses—all because they know too much."[4] Reiffenstein selected Giacomo Trombara and Giacomo Quarenghi. Trombara would work mainly in the provinces

while Quarenghi became the foremost exponent of Palladian architecture, creating over forty neoclassical buildings in St. Petersburg.

Traveling from Venice to Vienna and Berlin and then the Baltic States, 35-year-old Quarenghi arrived in St. Petersburg in January 1780 with his pregnant wife. Quarenghi had made a name for himself by transforming the interior of Santa Scholastica Church at Subiaco in an elegant classical style. Given the competitive scene in Italy, Quarenghi eagerly accepted Melchior Grimm's three-year contract to be Catherine's court architect. At the time, neither Catherine nor Quarenghi could have imagined the impact he'd have on Russian architecture.

For the next thirty-seven years, the workaholic designed nonstop for Catherine and her successors, earning the kind of acclaim enjoyed by Francesco Bartolomeo Rastrelli during Elizabeth's reign. Of all of Catherine's architects, it was Quarenghi who gave St. Petersburg its elegant, stately aura. Quarenghi applied his restrained Palladian style to the Winter Palace where he built the Raphael Loggia, Hermitage Theatre, and the St. George and Apollo Halls. His other major buildings include the Academy of Sciences on Vasilevsky Island, the State Bank, Alexander Palace, and Smolyni Institute.

Like Quarenghi's buildings, there was nothing decorative about the architect's attire, which included a military-style coat. Short and ugly, with a booming voice and heavy eyebrows knit in a frown, Quarenghi was frequently the subject of ridicule. One observer described "a great bluish bulb that Nature had stuck on his face where his nose should have been." It didn't help that the first syllable of his name sounded like the Russian word for a croaking frog. But appearances didn't matter to Catherine, who shared a passion for antiquity with Quarenghi. She found his austere designs charming and he soon became her go-to architect.

The influential designer began his career as a painter. Born in Rota d'Imagna into a well-connected family, Quarenghi graduated from the nearby Bergamo Academy. Traveling through Italy, he arrived in Rome in 1763 just as neoclassicism was taking off, studying with Anton Raphael Mengs. After Mengs left to work for Spain's Charles III, Quarenghi entered the studio of Stefano Pozzi. It's there he met architect Vincenzo Brenna, who would also later work in Russia. Around this time, the budding artist

happened to read Andrea Palladio's *Four Books of Architecture* (*Quattro Libri d'archittetura*). The 16th-century Vicenza born Palladio based his style on ancient Roman architecture, which he studied in books and surviving buildings. "You could never believe," Quarenghi wrote his friend Marchesi, "the impression that this book made. Then it struck me that I had every reason to consider myself badly guided."

Seduced by Palladio and Rome's extraordinary ruins, Quarenghi switched career paths from painting to architecture. For instruction in neo-classicism, he turned to Johann Winckelmann's friend Antoine Decrézet, along with Winckelmann's former pupil Nicola Giansimoni. Quarenghi was a master draftsman, producing lyrical sketches of Rome's ruins along with copies of works by Scottish architect Robert Adam and Frenchmen De Wailly, Desprez, Gondoin, and Ledoux. In Venice, Quarenghi met a British aristocrat who helped him land several small English commissions, including garden pavilions and chimneypieces, along with an altar for the private Roman Catholic chapel of Henry Arundell at New Wardour Castle. For the Venetian Cardinal Rezzonico, nephew of Pope Clement XIII, Quarenghi also designed the décor for a music room in the Campidoglio, along with Clement's tomb, later executed by Antonio Canova.

The first of Quarenghi's numerous commissions for Catherine was the English Palace at Peterhof. After Peter the Great founded St. Petersburg, he ordered construction of a number of imperial complexes nearby, notably Tsarskoe Selo and Peterhof Palace on the Gulf of Finland. From its monu-mental cascade with water piped through twenty-four miles of underground pipes to its gilded onion shape cupolas, Peterhof was a worthy rival to Ver-sailles. With Yury Velten's help, Catherine gave Peterhof's Throne Room a classical makeover. To the portraits of Peter the Great and his relatives, Catherine added one of herself over the red velvet throne—Eriksen's equestrian portrait depicting her en route to arrest her husband at Peterhof.

In May 1779, Catherine invited Scottish landscape gardener James Meader to St. Petersburg. The author of *The Planter's Guide*, Meader's past clients included the Earl of Chesterfield and Duke of Northumberland. After five weeks at Tsarskoe Selo, Catherine sent Meader to Peterhof to design the New Park and choose the site for a secluded new palace. "The spot allotted to me is a park through a great part thereof is full of fine

Trees," wrote Meader. "Here are fine pieces of Water which want but little help to make them elegant, with a vale where I propose to form a magnificent Cascade, the water being above & in these affairs I am under no restraint either to extent of land or water; the bounds are only limited by the Gulf of Finland."

Over the winding streams, the landscaper installed a series of bridges, including "a most remarkable Bridge with petrified Moss & roots; numbers of People come to see it; also four curious Bridges of an Original construction (I detest copying)." To create an appearance of icicles inside the grotto, Meander obtained Catherine's approval to order two barrels of Derbyshire spar. Groves of Russian birch planted by Meader created a romantic setting for Quarenghi's Birch Cabin, an unassuming wood cabin with a thatched roof, "tiny windows, bast mats and an ugly-looking door." Stepping inside the six-room cabin, astonished guests found themselves standing on a magnificent parquet floor, surrounded by walls and ceilings lined with mirrors.

James Meader and his team were well into the park when "a very ingenious Italian architect" arrived at Peterhof in July 1781. The English Palace was "the first and in many ways the paradigm of Quarenghi's work," writes George Heard Hamilton. As Hamilton puts it, "The quality of the palace is antique, the ordonnance Palladian, the scale Russian." Simple, austere, and elegant, the plan included Quarenghi's signature rotunda (after the Pantheon) for the entrance hall and a circular staircase at either end of the vestibule opening onto a loggia. From the garden, steps led to an eight-column Palladian-inspired portico, while the opposite façade sported a six-columned loggia set back between two wings.

To decorate the interiors, Quarenghi hired marble workers, decorative painters, and specialists in gilding and artificial marble. But completion of the palace would have to wait. In 1783, Catherine redeployed Quarenghi to the Winter Palace to design an extension to house her Raphael Loggia. Occasionally, Catherine lent the talented architect to her favorites and courtiers. Peter Zavadovsky's Palladian villa at Lyalichi featured a massive six-columned Corinthian portico flanked by semicircular wings leading to orangeries. Inside, a grand staircase led from the ground floor to the impressive two-story Catherine Hall, columned and crowned with a cupola. When Paul, jealous of his mother's paramours, expressed displeasure at the

mansion's height, Zavadovsky terraced the grounds around the main house to make it look lower. In the Apollo Hall, Zavadovsky hung a full-length portrait of Catherine wearing the imperial crown.

Giacomo Quarenghi's Palladianism was just what Catherine was seeking. As architecture historian Howard Burns explains: "Palladianism gave Catherine, and the modern European Russia that she strove so hard to create, just the architecture it required: rational, universal, not associated with any particular country or regime, inspired by antiquity. . . . In the hands of a brilliant, but industrious and systemic designer like Quarenghi, the Palladian inheritance . . . could provide solutions to all the building types which the new, expanding Russia needed. . . . The character of Palladio's architecture . . . was intelligently exploited by Quarenghi and his collaborators to provide for functions that Palladio himself had not even imagined."[5]

Meanwhile, Catherine was on the lookout for archeological remnants for her various building projects. In early June 1779, she notified Grimm about "a recent discovery of two mosaic fragments from floors of Ancient Roman rooms, which once decorated the boudoir of the Empress Claudia. . . . See to it that you obtain them . . . they might go in the apartment that. . . . in two thousand years' time they might be taken from here by an emperor of China or some other idiotic tyrant ruling most of the world."[6] After Grimm bought the mosaic pieces in Rome, Catherine worked them into a music pavilion at Tsarskoe Selo.

CHAPTER FIVE

THE GREEK PROJECT

J ust months before the arrival of her two Italians, another architect arrived in St. Petersburg. "I have someone else besides Quarenghi and Trombara," wrote Catherine, "his name is Cameron—he has spent many years in Rome studying architecture."[1] She had hired Charles Cameron based on his 1772 book *The Baths of the Romans*. Though he appeared in St. Petersburg having never actually constructed a building, his knowledge of Greek and Roman art and architecture won Catherine over. It didn't hurt that the architect padded his resume, exaggerating his time in Rome and claiming to be the namesake of aristocratic Jacobean rebel Charles Cameron of Lochiel. "I am quite taken up at present with Mister Cameron, Scottish by nationality; Jacobite by persuasion, a great designer nourished on Antiquity and famous for his book on ancient baths," she wrote Grimm on August 23, 1779.[2]

Little is known about Cameron's career between his two years in Italy and departure for St. Petersburg a decade later. Born in London, he learned

basic architecture from his father, Walter Cameron, a London mason and carpenter. After a seven-year apprenticeship in his father's guild as a master carpenter, Cameron studied under Isaac Ware, an expert on Italian Renaissance architecture and translator of Andrea Palladio's *Four Books of Architecture*. After Ware's death, Cameron left for Rome to complete his mentor's dream of publishing a revised edition of Palladio's drawings. There, Cameron got permission to survey a number of ancient baths.

According to Frank Salmon, what Cameron thought were the Baths of Titus turn out to have been the Baths of Trajan, built on top of Nero's Golden House on the Esquiline Hill. One room, famous today for its central vault image of Achilles at Scyros, would prove the most thrilling of Cameron's excavations and would inspire his work for Catherine. "It was with great difficulty that I got into this room," wrote Cameron. "I was obliged to cut a hole through the wall B and let myself down a rope, and afterwards to creep through a hold in the wall O, upon my hands and knees. It was nearly full of earth to the ceiling. . . . This room was painted, the top of the niche fluted, and in the flutes were painted trophies of musick."[3]

Back in London in 1769, Charles Cameron published his research in English and French. But unlike fellow Scot Robert Adam, who'd returned from Rome and catapulted to success, Cameron failed to gain commissions. Instead, he sued his father for selling his books and busts. The elder Cameron was already in Fleet Prison for failing to pay his dues to the carpenters' guild. For Cameron, Catherine's invitation to Russia represented the opportunity of a lifetime—a chance to apply his knowledge of Roman architecture for an enthusiastic, well-funded client. Catherine rolled out the welcome mat, giving her new architect his own house at Tsarskoe Selo. He'd later marry a daughter of John Bush, Catherine's English gardener. Except for a brief visit to England around 1800, Cameron would spend the rest of his life in Russia.

Though neoclassicism was Russia's official architectural style, the exoticism of China continued to fascinate Catherine. "In the next world, when I see Caesar and Alexander and other old friends, I shall be sure to find Confucius . . . ," she wrote Grimm. "I want to have a discussion with him." Catherine read avidly about the Fast East. "Tell me, have you read the description of China in the three volumes published in Paris last year? Do

you know that great little ruler Huan-Huan . . . whom Confucius served?" she asked Grimm.[4] She instructed Russia's ambassador in London to secure a replica of William Chambers's pagoda at Kew's Royal Botanic Gardens to serve as the centerpiece of a Chinese village at Tsarskoe Selo and had his book *Designs of Chinese Buildings* translated into Russian.

To Antonio Rinaldi and Yury Velten's Chinese Village at Tsarskoe Selo, Cameron added additional living quarters and redesigned the pagoda, replacing the faience wall tiles with frescoes "in the Chinese taste." To allow guests to stroll from the palace to the village, Cameron installed a series of four successive bridges over the canal. For the first stone bridge, Cameron created railings made of vases linked by a red coral-like grille; Chinese figures holding lanterns topped four pink granite pedestals. Brightly colored flowers and dragons, and roofs painted like golden fish scales were among his fantastic decorations.

In 1780, Catherine assigned Cameron to completely redo the Great Palace. The imperial compound had begun as a modest stone summer dacha and garden for Peter the Great's second wife, Catherine I. Their daughter Elizabeth, who'd spent childhood and adolescence there, inherited the estate which she affectionately called "little homeland." During the 1740s, Elizabeth refurbished the original residence and added a new wing. Four years after these additions were finished, she hired Francesco Rastrelli (architect of the Winter Palace) to design a new rococo palace.

The resulting Great Palace (renamed Catherine Palace after Catherine I at its bicentenary in 1910) embodied Rastrelli's opulent baroque style, from the massive gilded and mirrored Great Hall to the extraordinary Amber Room. Rastrelli's lavish furniture designs included a table "fashioned in the image of Babylon" that seated Elizabeth and 362 of her closest friends. Though Catherine used Rastrelli's opulent staterooms to impress foreign visitors, she found the décor of his reception rooms and private apartments pretentious.

For the next four years, Cameron reorganized and redecorated three suites of rooms known as the First, Fourth, and Fifth Apartments. Having chosen to move her personal apartments to the south end of the palace, Catherine ordered the main palace staircase here demolished. Cameron relocated the staircase in mahogany to the center of the palace, in place of

Elizabeth's Chinese Hall. Borrowing from Palladio, Clérisseau, and Robert Adam, Cameron created a series of intimate, distinctive, and sophisticated spaces using a repertoire of classical forms and motifs. In addition to neo-classical elements like molded plaster reliefs, marble columns, and wall facings, he chose luxurious semiprecious stones for wall panels and molded glass for columns and ornaments. Cameron introduced a completely new palette, substituting bronze for gold, lavender for blue, olive and pistachio for bright green, and gray-blue for azure.

Like William Kent at Houghton Hall, Cameron designed the entire decorative scheme—from furniture and mantelpieces to the parquetry floors and ceiling paintings. Catherine had established Russia's imperial bronze foundries in the last half of the 1760s, but their success between 1780 and 1800 was due to Charles Cameron. The factories began producing Cameron-designed fireplace furnishings, fire irons, and grates shaped like griffons and sphinxes, dragons and exotic birds. Cameron also used bronze for the capitals and bases of columns. Along with pottery and porcelain, the designer embellished the walls with bronze garlands and eagles after stuccoes in ancient Roman tombs. Large chandeliers, small lamps with bronze gilding, candlesticks with marble pedestals, and hundreds of cressets and candelabra illuminated the palace apartments.

Starting in the Fourth Apartment at the south end of the palace, Cameron razed two of Rastrelli's baroque antechambers to the Great Hall to make room for the Arabesque Hall and Lyons Drawing Room. Russian historian S. N. Vilchkovski observed that the drawing room along with the neighboring Arabesque room "welcomed the whole life of the Court that had been led before in the Picture, the Amber and the Pillar rooms; only the Chinese Room separated the 'Lyon Drawing-room' from the personal rooms of the Empress. It was in the 'Lyon Room' that readers of reports waited to be called to the Study; it was there that the Empress used to play cards in the evening . . ."[5]

Catherine was thrilled with Cameron's imaginative rooms. "I have an architect here named Kameron . . . the man has a fertile brain . . . and a great admiration for Clérisseau, so the latter's drawings will help Kameron to decorate my new apartments here, and these apartments will be superlatively good," she wrote Grimm in the summer of 1781. "So far

only two rooms have been furnished, and people rush to see them because they have never before seen anything like them. I admit that I have not grown tired of looking at them for the last nine weeks; they are pleasing to the eye."[6]

One of Catherine's favorite spaces was the Lyons Drawing Room. Measuring 36 by 32 feet with a 28-foot-tall ceiling, the luxe room set the empress back some 40,000 pounds, not including the lapis lazuli from Lake Baikal that adorned the a pair of console tables, doors, and cornices. To create the intricately patterned parquet floor, Cameron used mother-of-pearl and fifty types of wood. The Italian Renaissance–style wall frieze featured garlanded cattle and sheep along with bronze bull heads. The sumptuous creamy yellow silk wall panels from Lyon, France, featured delicately embroidered peacocks, ducks, pheasants, and swans against a garden background with cartouches formed by garlands and vines. Framed in gilded carved wood, the 13-by-4-foot hangings were hung like paintings between a dozen mirrors.

The gorgeous panels came off the loom of Philippe de Lasalle, Lyon's "Raphael of silk." Lasalle studied with history painter Pierre Sarabat in Lyon and decorative painter François Boucher in Paris before partnering with Lyonese businessman Camille Pernon in 1760. Pernon sent his son Claude Camille Etienne to Russia to win commissions from Catherine. In 1773, the empress named the House of Pernon Furnisher by Appointment to the Russian Court and paid a large sum for hundreds of meters of Lasalle silk to decorate the walls and furniture of her palaces. Because her commissions represented a considerable share of Lasalle's international business, many of his best works went to Russia.

Lasalle's singular textiles combined innovative technique and decorative flair. To his signature flowers in garlands, bouquets, baskets, and vases, the designer often added vibrant birds and butterflies, along with temples and fountains, and shepherds and shepherdesses. By using different yarns, Lasalle created patterns through contrasts in the weave—like satin against taffeta or silk twill. When combined with lustrous silk, new silk chenille yarns added richness to the colors and a velveteen finish. Lasalle's textiles graced the walls and furniture of the French and Spanish royal palaces, including Marie Antoinette's bedroom at Fontainebleau.

For Catherine, Lasalle created tapestries and upholstery fabrics glorifying Russia's military victories over the Turks. His Chesme silk brocade commemorating Russia's naval victory featured the imperial eagle and orb alongside pink flowers and brilliant green foliage. Lasalle also wove several silk cameo-style portraits of Catherine, with Voltaire's flattering verses embroidered below: "From the Nile to the Bosphorus The Ottoman trembles: Her people adore her. The world applauds."[7] Though Louis XVI ennobled Lasalle with the order of St. Michel and granted him an annual pension of 6,000 livres, the designer would only collect a fraction of this during the Revolution. In 1793, during the siege of Lyon, Lasalle's celebrated looms were destroyed.

Cameron's circular Rotunda led to either the Chinese Hall on the left or straight to the Fifth Apartment, a suite of the empress's six private rooms. Catherine used the Silver Cabinet for private audiences and official correspondence. Catherine called the boudoir "La Tabatière" (the Snuffbox) after the enameled snuffboxes she liked to give as gifts. Cameron paneled the walls in sheets of white opaline and translucent blue glass. A glass table and two stools sported plates of milky white and blue transparent glass over crumpled silver foil. Slender columns of blue translucent glass flanked the doors, matching three pieces of lapis lazuli furniture. "One might be in a fairy tale!" exclaimed Ségur.[8]

While Cameron was designing the Fifth Apartment in 1783, Giacomo Quarenghi was beginning work on the Hermitage's Raphael Loggia. Both the Silver Cabinet, lined with panels of precious metal, and the small Mirror Room next to Catherine's bedroom were reminiscent of the Raphael Loggia, which Cameron may have known from either Clérisseau's drawings or his visit to the Vatican. In 1781, Catherine wrote Grimm that her new private rooms were "more or less Raphaelesque."

Cameron saved his most imaginative ideas for Catherine's bedroom, paneled in milky white opaline glass. Separating the bed alcove from the main room were slender, ten-foot-tall colonnettes of amethyst-colored glass with chased gilt bronze capitals. Between the columns, Cameron added large mirrors to add space and depth. To recreate the look of Pompeiian panels, Cameron decorated the walls with some two dozen blue and white Wedgwood medallions and blue glass frames. Glass furniture included an

exquisite small table with a white opaline top and gilt bronze molding, and blue glass legs and frieze.

When Paul and Maria Feodorovna departed for their European tour, Cameron began work in the opposite north end of the palace, replacing Rastrelli's hanging garden with an eight-room ducal suite known as the First Apartment. Cameron complemented the patterned silk wall hangings in the large blue Drawing Room with candelabras and torchères of royal blue crystal and specially designed carved and gilded furniture. Below the geometric ceiling with its mythological scenes, Cameron installed a striking parquetry floor (the ceiling painting, destroyed by fire in 1820, was recreated in 1959 after Cameron's drawing).

The Green Bedroom featured soft pistachio walls with white stucco decorations and fifty slender green and white porcelain columns. The grand duchess's bedroom combined the intimacy of a private apartment with official stateroom luxury. Around a white silk canopy bed, Cameron formed an alcove with slender faience columns decorated with gold stripes and garlands of wildflowers. Cameron painted the series of doors with fantastic animals inset into circles, ovals, and rectangles. Framing the walls, Cameron added molded medallions with allegorical scenes of family love. A sleeping Venus and cupids adorned the fireplace.

Cameron drafted three sets of plans before getting the nod from Catherine on the Green Dining Room. Among the most Pompeian of the interiors, the pale green room featured doors painted with grotesques and molded white stucco decoration. Between figures of youths in antique garb and garlands of foliage and vases, Cameron added rectangular mythological reliefs and round medallions with playful cupids. A white marble fireplace featured a pair of carved lions and gilded bronze fire dogs. The grand duke and grand duchess dined seated on painted white chairs with green upholstery.

In 1782, Catherine asked Cameron to start work on her long awaited antique house, "a Graeco-Roman rhapsody in my Tsarskoye Selo garden."[9] In addition to a small army of Russians, Cameron recruited workmen and masons from Scotland to build the two-story structure. Above slabs of weathered Pudost travertine, the yellow upper floor featured classical decoration and a low Pantheon-like dome. French sculptor Lambert-Sigisbert

Adam added depictions of the elements, Air, Water, Fire, and Earth to the façade. As always, Catherine played an active role in the design. "I have just settled down with Mr. Cameron," she wrote. ". . . We're sitting here designing a terrace with hanging gardens, with a bathing pool below and a gallery up above."[10]

Baths had been a popular tradition in Russia for centuries. Though she was German, Catherine took to the Russian "banya" tradition, which involved long periods spent in a steam room. It was during her reign that the Russian word for bath, *vanna*, from the German *wanne*, entered into Russian vernacular. According to contemporaries, the empress preferred not to steam alone but with her favorites and loved to eat and drink in the bathhouse. In 1779, Ilya Neyelov created two stone baths on the banks of Tsarskoe Selo's Mirror Pond. The lower bathhouse, inscribed "XVIII century court swimming," was designed for Catherine; the upper bathhouse for family members.

Now, Charles Cameron produced something completely different on the pavilion ground floor—a luxurious spa inspired by the public baths, or *thermae*, of ancient Rome. Cameron based his design on Palladio's measurements from the ruins of Rome's Constantine Baths. The spa followed the ancient Roman tradition of gradually lowering the water temperature from room to room—from the steam bath to the large Bath Hall featuring a thirteen-cubic-foot circular tin swimming pool with a submerged bronze seat coated with polished gold. For one of the baths, Cameron copied a white marble Roman model, complete with a stone canopy supported by four columns and taps of gilded bronze.

Russian craftsmen had perfected a mosaic technique combing pieces of opaque colored glass (smalti) with various semiprecious stones. Cameron applied this mosaic work to various rooms of the Cold Bath. He fitted one pair of massive doors with mosaic panels in geometric patterns of red and green jasper. Apparently Cameron was more focused on the historical accuracy and luxe materials of the baths than creature comforts. Catherine complained to her secretary Alexander Khrapovitsky that it was impossible to actually bathe in them.

When Cameron asked Catherine if she'd like the stairs leading from the spa upstairs to the Agate Pavilion to be made of Russian marble or wild

stone, she'd replied "from wild stone, but peaceful." Following her wish, Cameron created a single winding flight of forty-one steps made of gray fine-grained granite. The ends of the steps (up to sixteen inches in length) were inserted into a special channel cut in the wall and wedged in with stone. The simple elegant balustrade featured vertical rods and smooth gilded rosettes with a polished handrail of Eastern Juniper; the stairwell floor was paved with white and gray marble.

Cameron lined the upstairs suite with stunning red jasper from the Urals. Because this material was known as jasper agate at the time, these rooms became known as the Agate Pavilion. Discovered in the 16th century, the hard, dense material did not lend itself easily to large projects. Cameron changed that, setting up a workshop at Tsarskoe Selo to cut the stone into panels for walls and strips for fireplaces and columns. For the striking Jasper Cabinet, Cameron contrasted deep red jasper with gray-green Kalkan jasper and red-and-green-striped Kushkuldin jasper.[11] The neoclassical Vestibule, Great Hall, Oval Room, and Agate Rooms boasted more jaw-dropping varieties and colors—"blood" agate (maroon with white veins), malachite, agate, jasper, lapis lazuli, porphyry, alabaster, and colored marbles.

With her imperial palaces in mind, Catherine sponsored mining expeditions in the Urals and Altai mountains of central Asia. Adding to Peter the Great's Imperial Lapidary Works at Peterhof, she helped establish lapidary workshops for polishing and grinding in Ekaterinburg in the Urals and Kolyvan in the Altai mountains. Popular varieties of colored stone included "Siberian" marble in gray with white veins (from the Urals), pink Tivda marble, red Shokshin quartzite (also known as red marble, similar to antique porphyry), black Urals marble, and pink-veined Karelian marble from Rusol.

Cameron's Great Hall featured pale pink faux-marble walls and eight fluted columns in gray-pink Olonets marble from Karelia. The dramatic coffered ceiling was divided into an elaborate geometric design of panels with gilded gesso framing. Each panel was either painted or molded, mainly with dancing female figures. Much of the sculptural work was executed by Jacques Dominique Rachette, including candlesticks in the form of marble goddesses, large mythological wall medallions, and unique chimney pieces

after Cameron's designs. Cameron paneled the walls below the dado in heavily veined dark gray-green marble.

Flanking the Great Hall were the Agate Hall and Jasper Cabinet, both lavishly decorated with several types of polished jasper and other semiprecious stones. Cameron created the walls and columns with small pieces of red agate veined in white Jasper, known as meat agate; walls were lined with green jasper, with green jasper moldings, and red agate columns. The variety of colored stone, opulent paintings, ornate moldings, and gilded bronze produced a striking effect. Pompeian-style furniture on the handsome floor was inlaid with palissander (a rosewood) and palm wood. Excluding the jasper and agate from the Kolyvan mines, the bill for the Agate Pavilion exceeded 463,000 rubles. When touring her new pavilion in 1787, Catherine reportedly took Cameron by the arm, telling him: "It is indeed very handsome, but it is costing."[12]

To connect the Agate Pavilion and Catherine's private apartments, the Scot designed a ninety-yard long colonnade which became known as the Cameron Gallery. The addition of a door to Catherine's Mirror Room allowed her to step out onto a terrace and stroll along the covered colonnade to the Pavilion. Cameron topped a massive rusticated ground floor of pudost stone with a delicate upper story colonnade of forty-four slender white columns, reminiscent of the Erechtheum, the beautiful Ionic temple at the Acropolis. Between the wide set white columns he placed some fifty busts of Catherine's favorite philosophers and statesmen, cast in bronze from Italian copies of antique marble sculptures. The only contemporary figures were Russian scholar Mikhail Lomonosov, Austria's Joseph II, and British politician Charles James Fox, who helped avert war with Russia. In the winter, the busts were taken in to protect them from the cold.

The Cameron Gallery became Catherine's favorite promenade. In rainy weather, the empress strolled through the central section, enjoying views of her formal flower gardens on one side and an English park and Great Pond on the other. Cameron designed special furniture for the gallery, including large carved wood candelabra and folding armchairs in wrought iron inspired by ancient Greece. "I am presently quite infatuated with Master Cameron . . . who is inspired by his study of the Ancients,"

Catherine wrote Voltaire. "With him we are making at Tsarskoe Selo a terraced garden, with baths below and a gallery above." Catherine also wrote Melchior Grimm, describing the gallery's sculpture as "the most beautiful ancient and modern statues in existence."[13]

At the gallery's east end, Cameron built an impressive entrance by merging two graceful rounded staircases into one. He topped the pylons with Fiodor Gordeyev's enormous bronze statues of Hercules and Flora, modeled after ancient originals. Catherine bragged to Grimm about Cameron's elegant neoclassical complex: "To drive you wild, monsieur le chevalier, I have to tell you that you will no longer be able to find me here after dinner, because apart from seven rooms garnished in jasper, agate, and real and artificial marble, and a garden right at the door of my apartments, I have an immense colonnade which also leads to this garden and which ends in a flight of stairs leading straight to the lake. So, search for me after that, if you can!"[14]

The Cameron Gallery and Agate Pavilion had a powerful effect on visitors. Gavriil Derzhavin described the colonnade as "a temple where the graces dance to the sound of the harp" and Ippolit Bogdanovich proclaimed "it is only possible for the Gods to have created" such a space. Alexander Pushkin called the Cameron Gallery "the temple of the Minerva of Rus" and "a mansion rushing to the clouds."[15] (Pushkin studied at the nearby Lyceum, built by Catherine for her grandchildren.)

"The most interesting park in the world" is how Ligne described Catherine's ensemble in 1781. ". . . Tsarskoe Selo which contains what the Empress calls her fantasies presents on all sides the most charming of pictures. These fantasies, so called, are water and optical effects, well imagined and varied, such as a bridge of Siberian marble in an architecture styled by Palladio, baths, a Turkish pavilion, the Admiralty—a sort of town that has been set up—iron gates, a ruin, monuments to the victories of Romianzov and Orlov, a superb rostral column in the middle of the lake to commemorate Chesme . . . Chinese bridges and kiosks, a temple with thirty-two marble columns, a colonnade and above all the grand staircase of Hercules on the garden side. . . . It is here that the great princess, the honour of her sex, dropping for a moment the reins of government, takes up a pencil, a rake, a pruning hook . . ."[16]

Along with the ideals of Greek and Roman antiquity, Catherine used her summer compound to express her ambitious political aspirations and military successes. In the fall of 1780, Catherine dismissed Nikita Panin, her long-serving pro-Prussian foreign minister. Succeeding Panin as foreign affairs adviser, Alexander Bezborodko drafted a plan in which Russia would gain a large swath of land around the Black Sea and Austria would take Belgrade and Bosnia. The following spring, after months of negotiations and the death of Joseph's mother and co-ruler Maria Theresa, Russia and Austria became allies. Catherine soon wrote to Austrian Emperor Joseph II detailing the "Greek Project."

Still angry over the loss of Silesia to Prussia's Frederick the Great during his mother's reign, Joseph II was now looking to expand the Habsburg Empire. Among his ambitions was trading the Austrian Netherlands (today's Belgium) for Bavaria, a plan thwarted by Frederick. Joseph saw an alliance with Russia as protection against Prussia, which he feared, along with a means to gain Turkish territory in the Balkans and eastern Mediterranean. He also had his eye on the Republic of Venice. Catherine's ultimate goal, meanwhile, was to restore the Greek Orthodox Empire—the eastern half of the former Roman Empire that would be ruled from Byzantium, or Constantinople, by her grandson. Born in April 1779, christened Konstantin Pavlovich after Constantine the Great, the baby was groomed for the job from the start. Catherine imported a Greek wet nurse named Helena and relocated several Greek families to Tsarskoe Selo so the youngster could learn Greek before Russian.

For over a millennium, Greece had been part of the Byzantine Empire, established in 330 A.D. by Constantine the Great. He'd moved the capital of the Roman Empire east to the small town of Byzantium (today's Istanbul) and converted to Christianity. Renamed for him, Constantinople came to represent splendor and power. Greek replaced Latin as the official language; theology, scholarship, and artistic production flourished. According to medieval Russian documents, Prince Vladimir had founded the Russian Orthodox Church in Crimea. In 988, after seizing Chersonesos, he negotiated for the hand of Emperor Basil II's sister, Anna. Baptized at Chersonesos, Vladimir took the Christian name Basil after his future imperial brother-in-law and wed Anna.

In 1453, the Turks vanquished the Byzantine Empire and seized Constantinople. Because the daughter of the Empire's last ruler, Constantine XI Paleologus, married a Russian tsar, Byzantium was regarded as Russia's historical and cultural birthplace. Peter the Great added "King of Greece" to his titles. Reportedly, Peter's dying wish was "to conquer Constantinople, to chase the infidel Turks and Tatars out of Europe, and thus to reestablish the Greek monarchy."[17] With the same crusade-like fervor, Catherine took up Peter's quest. Thanks to Russia's gains from the war against Turkey, Constantinople was tantalizingly close—just across the sea from Crimea.

As Dmitry Shvidkovsky describes, Catherine's guests at Tsarskoe Selo were transported to Constantinople architecturally starting at the Orlov Gate, where a banner proclaimed: "Through the waves you will enter the shrine of Sophia."[18] Catherine's complex ideologies were expressed in a tower ruin by Velten that combined a large antique column, small Turkish pavilion, and wall fragment from the Kremlin—a symbol of Russian history. On Catherine's order, Cameron designed a church inspired by the architecture of the Hagia Sophia, Constantinople's iconic Byzantine basilica. Ivan Starov would supervise the construction of the church—classical on the outside, with an interior dome, large open space, and red granite colonnade.

Cameron's church stood in a wide square, the epicenter of Sophia, a miniature ideal city Catherine ordered from him in 1780 to offer her guests a picturesque view. The fan-shaped town became home to merchants, workmen, and a colony of British craftsmen recruited to help Cameron execute his projects. The part of the town facing Catherine Palace was especially elegant, with houses sporting three-story façades. In addition to a huge post office complex with stables and accommodations, Cameron built a spinning mill, linen and silk factories, office buildings, and an arcade. Cameron's streetlights were only lit when Catherine was in residence.

Catherine's carefully choreographed visual allegory centered on a man-made lake called the Great Pond, representing the Black Sea. Around this, Catherine's architects designed numerous classical-style monuments with clear symbolic messages. "When this war is over," wrote Catherine, "my gardens at Tsarskoe Selo will look like a children's playground, after each successful military action we put of a fitting monument there. The

Battle of Kagul . . . resulted in an obelisk with an inscription . . . the Sea Battle of Chesma produced a Rostral Column in the middle of the Great Pond. The taking of the Crimea . . . is commemorated in different ways in different places."[19]

With her embrace of neoclassical architecture, Catherine vividly connected Russia's capital with the Rome of antiquity. Poets likened St. Petersburg to ancient Rome and Catherine to Minerva, while she compared herself to Augustus. "August said that he found Rome built of brick and would leave it built of marble; I say that I found Petersburg virtually wooden and will leave its buildings dressed in marble," she wrote Frau Bielcke.[20] More than any of her fellow rulers, writes Dmitry Shvidkovsky, Catherine used architecture and garden design to embody her aspirations. This was especially true of her overarching ambition, the Greek Project—retaking Istanbul from the Turks and creating a new Christian Byzantium.

Though Catherine, like Peter the Great, curtailed the Church's power in order to strengthen her own rule, there was something deeply rooted in Russian culture about the Church and Orthodoxy that the German-born empress needed to play up politically. Since converting to Orthodoxy as a teenage bride, Catherine had made it a point to make pilgrimages, observe church festivals, and regularly attend services. Her very public displays of devotion included stops at the church of the Kazan Bogoroditsa whenever she left and returned to St. Petersburg. This focus on Orthodoxy likely played a part and perhaps fed into this desire to remodel St. Petersburg on Rome, Christendom's flagship city.

PART SIX

EMPIRE
BUILDING

CHAPTER ONE

MOTHER OF THE FATHERLAND

O
n August 7, 1782, the centenary of Peter the Great's coronation
and the twentieth anniversary of her accession, Catherine and
her courtiers sailed down the Neva from the Winter Palace.
After tying up at a Peter's Pier and enjoying a welcome from her troops,
Catherine took her place on the balcony of the Senate. Throngs crowded
the large square and filled the rooftops that Sunday afternoon; a flotilla
of riverboats and warships anchored in the Neva. Eight Guards regi-
ments—some 15,000 soldiers—led by Gregory Potemkin gathered along
the embankment. Catherine blessed her people and declared a general
amnesty for criminals and debtors. Then at the signal of her hand, the
curtains below fell.

Triple life-size, fifty feet in the air, Peter the Great appeared on his
rearing horse. With an outstretched arm, he seemed to be pointing past
the Neva toward the west. At the sight of the monumental bronze tribute,
the warships hoisted flags, cannons boomed, and troops fired off guns and

presented their regimental colors. Music and fireworks continued into the evening.

The unveiling of Russia's first public monument was a historic moment witnessed by all of St. Petersburg—all, that is, except its creator. After twelve years of setbacks and disputes, Étienne-Maurice Falconet had returned to Paris four years earlier. The Frenchman compared his west-bound journey across Russia to an escape from prison. "I felt my chest expanding and my blood, more fluid, circulating with a smoothness which I have almost ceased to experience," he wrote.[1] After the unveiling, when Falconet and Marie-Anne Collot received gold and silver medals, he wrote his collaborator: "You see, in spite of all the poison launched against us, those who knew us a little have not forgotten us."[2]

In 1775, Falconet's first attempt to cast Peter failed and Collot left for Paris, spending a year in Houdon's studio before returning to St. Petersburg. It's there she entered into an ill-fated marriage with Falconet's abusive son, Pierre-Étienne Falconet in July, 1777. By early 1778, Falconet's second try at casting succeeded; Thunder Rock was shaped and hewn. All that remained was to create the supporting serpent, and install the statue. But instead of celebrating, the sculptor got the silent treatment from Catherine, who called him "Falconet the difficult." Denis Diderot stopped writing. Pierre-Étienne took off for Paris shortly before Collot gave birth to their daughter. When Falconet left Russia in 1779, his equestrian statue seemed destined for oblivion.

In Falconet's absence, architect Yury Velten set the gilded bronze inscription "To Peter the First from Catherine the Second" in Russian and Latin on either side of the granite base. Catherine's monumental tribute to Peter was arguably her most impressive use of art to legitimize her reign. To many observers, it was Catherine, not Peter, who stole the show. Two days after the unveiling, Sir James Harris, England's envoy to Russia wrote: "I could not avoid, during this ceremony, reflecting on how impossible it was that any successor of Her Imperial Majesty, who might, in some future day, erect a statue in commemoration of Her great Actions, ever should be so much superior to Her, as she Herself is superior to Peter the Great, both in the art of governing, and in that of making Her People respected and happy."[3]

But following the ancient Roman convention of defining oneself as great by glorifying others, Catherine refused a tribute. "As far as my statue is concerned, it will not exist in my lifetime," she insisted.[4] Similarly, Catherine also declined extravagant titles. After Prince de Ligne and Grimm began calling her Catherine the Great in the salons of Paris, and Grimm addressed her with the epithet in a 1788 letter, she corrected them. "Please don't call me the sobriquet Catherine the Great because (i) I don't like any nickname (ii) my name is Catherine II and I don't want people to say of me like Louis XV that they thought me wrongly named," she wrote Grimm.[5] Russians added "Great" to Catherine's name after her death.

During her lifetime, Potemkin commissioned two full-scale statues of the empress as a lawgiver. One, by Wilhelm Christian Meyer in 1782, was erected in Ekaterinoslav in 1846 and melted down during the Nazi occupation in 1941; the other by Fedot Shubin in 1789–90 for Potemkin's Tauride Palace (The Russian Museum, St. Petersburg). It would take nearly a century for Catherine's great-grandson to commission the kind of tribute envisioned by Voltaire, Falconet, and Grimm.

The year that Peter's tribute was unveiled, Gregory Orlov's brothers brought him back to Russia. Five years earlier, Catherine had arranged for the Holy Synod to set aside its ban on marriages of people from the same family to allow Orlov to marry his fifteen-year-old second cousin, Catherine Zinovieva. Her death four years later from tuberculosis sent Orlov on a downward mental spiral. He tried taking the waters and other cures, but nothing helped relieve the guilt he felt over his young wife's death.

Refusing to have her former lover confined, Catherine moved Orlov into the Winter Palace, where her own doctors attended to him. The gaunt, white-haired Orlov roamed the halls ranting, "It's my punishment!" and calling himself Peter's assassin. "His wild and incoherent discourse ever affect her [Catherine] to tears and discompose her so entirely, that for the remainder of the day she can enjoy neither pleasure nor business," observed Sir James Harris.[6]

With Orlov's madness spiraling out of control, Catherine moved him to a house in Moscow, where he died in April 1783 at age forty-six. His death caused Catherine "the most acute affliction." Orlov was "the man to whom I have the greatest obligations in the world," she wrote Grimm. ". . . General

Lanskoy is tearing himself apart to help me bear my grief, but that makes me melt even more." Field Marshal Golitsyn's death six months later prompted Catherine to tell Potemkin: "It has been a black year for me. It seems that whoever falls into Rogerson's hands [her physician] is already a dead man."[7]

Orlov left his vast fortune to Alexei Bobrinsky, his son with Catherine. Catherine bought back her spectacular gift, the Roettiers silver service, and ordered Orlov's coat of arms removed. The empress also purchased Gatchina and the Marble Palace, the extravagant suburban and city palaces she'd given him. In 1784, Catherine presented the five-hundred-room Gatchina to Paul to mark the birth of his first daughter, Alexandra. Despite the fact that Gatchina had been owned by the man who helped depose and murder his father, the castle became Paul's favorite residence. For Catherine, its remote location thirty miles south of the capital kept her son conveniently out of the way. "I am thirty years old and have nothing to do," a bored grand duke declared that year.[8] Paul kept himself busy by turning Gatchina into a military camp, where he drilled his two thousand troops.

Meanwhile Paul's nemesis was busy leading a real battle. After the unveiling of Peter the Great's statue, Gregory Potemkin ordered an invasion of the Crimea in which four hundred rebels were killed and the capital Bakhchisaray was taken. He also oversaw construction and shipbuilding in the new town of Kherson, along with the Kinburn fortress opposite the Ottoman stronghold Ochakov. As hoped, Russia's alliance with Austria proved to be an effective deterrent, preventing the Ottomans from declaring war. By late October, Potemkin returned to St. Petersburg noticeably changed. "He rises early, attends to business, is become not only visible but affable to everybody," noted Sir James Harris.[9]

Potemkin set about organizing his estate—selling his numerous houses, horses, and jewels—and settling his debts. Reportedly, he offered his resignation to Catherine, who quickly rejected it. Potemkin was also masterminding a daring move. With Britain wrapping up its war with France and America, and plague-ravaged Istanbul consumed with rioting, he urged Catherine to annex the Crimea, the 18,000-square-mile peninsula jutting into the northern shore of the Black Sea—something she had been focused on doing throughout the entire Ottoman War. The prized peninsula had

been controlled by various peoples throughout history, including the ancient Greeks, the Byzantines, and the Mongols. And now it was vulnerable enough to potentially be the subject of a successful annexation.

In late November, Potemkin sent Catherine an impassioned letter: "Imagine the Crimea is Yours and the wart on your nose is no more. . . . Gracious Lady . . . You are obliged to raise Russian glory! See who has gained what: France took Corsica, the Austrians without a war took more in Moldavia than we did. There is no power in Europe that has not participated in the carving-up of Asia, Africa, America. Believe me, that doing this will win you immortal glory greater than any other Russian Sovereign ever. This glory will force its way to an even greater one: with the Crimea, dominance over the Black Sea will be achieved." Potemkin ended his stunning letter, "Russia needs paradise."[10]

Catherine knew the window of opportunity was closing. But could Russia grab the strategic peninsula without triggering war with the myriad of other nations who had their eye on the region? By mid-December, having apprised Joseph II, she made her decision. "We hereby declare our will," she wrote Potemkin, "for the annexation of the Crimea and the joining of it to the Russian Empire with full faith in you and being absolutely sure that you will not lose convenient time and opportune ways to fulfill this."[11]

During the first months of 1783, Potemkin remained in the capital making preparations. He devised a plan to defend Russia's borders in case of war and created Cossack-inspired uniforms for Russia's troops. On April 8, 1783, Catherine signed an annexation manifesto to be made public only after its execution, and gave Potemkin detailed instructions in case Turkey declared war. Potemkin left for the south, taking along his beautiful niece Tatiana Engelhardt.

In the rush to annex the Crimea, Potemkin ran into a number of snags. The issues dated back to the history of the region. Starting in the 13th century, Italian merchants from Genoa controlled trade along Crimea's southern coast for two centuries. Crimean Tatars, a mainly Muslim, Turkic-language speaking people descended from the Mongols, inhabited the steppe north of the coast. Together with the Ottoman Empire, the Tatars expelled the Genoese from their key trading port, Caffa (today's

Feodosia). Since that time, from 1441 on, the Crimean Khanate had ruled the region, partly subject to the Ottomans.

Now after nearly 350 years of a khanate, the current khan had to renounce his throne before the Tatars could swear an oath of allegiance to Catherine. In 1777, three years after the Treaty of Küçük Kaynarca, Catherine installed handsome Shagin Girey as the Crimea's puppet ruler (similar to Stanislaus Poniatowski in Poland). In preparation for Russian annexation, Girey had agreed to a generous pension and a new state in the eastern Caucasus on the border with Persia. But instead of leaving for his new realm, the shrewd politician demanded more money from Potemkin, and dragged his feet hoping to see how the Ottomans would respond to Russia's gamble.

Catherine's patience was wearing thin. On July 15, she chided Potemkin from Tsarskoe Selo: "You can imagine how worried I must be not having received a word from you in more than five weeks. . . . I expected the Crimea would be occupied by the middle of May at the latest, and here it is in the middle of July and I still don't know anything more about the situation than the Pope himself. . . ." Five days earlier, Potemkin had written Catherine a congratulatory note: ". . . The entire elite has already taken the oath, and now all the others will follow. . . . So far nothing has been discerned on the Turks' side. It seems to me they are afraid we might attack, and all their troops have been placed on the defensive. . . . The plague surrounds the camp, but so far God protects us. Goodbye, matushka, I kiss your tender hands."[12]

By the end of August, Potemkin contracted a fever that left him so weak he had to be physically carried out of the Crimea. In a letter to Catherine a month later, Potemkin heightened her anxiety by hinting he was gravely ill. "I shall be mortally worried if you leave me without news for a long time," Catherine replied from the Winter Palace. "Farewell, my dear friend, take care of yourself. Once you take care of yourself, everything else will go fine." Despite assurances from Potemkin that his health was improving, Catherine remained anxious through the fall. ". . . [A]lthough you assure me that you are better, still I worry and will continue to till I know that you have fully recovered, for I know how you are when you're ill. . . . God grant you get well soon and return here to us. Oh, for truth, I'm very often lost without you," she confessed.[13]

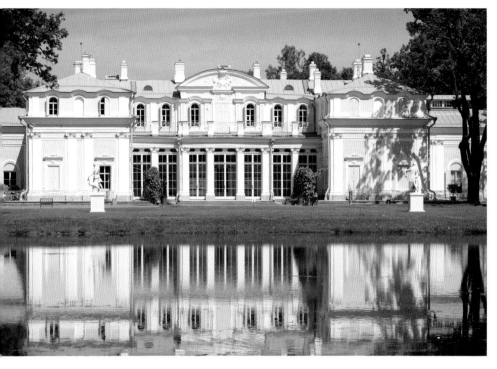

ABOVE: The Chinese Palace at Oranienbaum by Antonio Rinaldi © *Konstik, Dreamstime.com.*

BELOW: Gatchina Palace by Antonio Rinaldi, © *Pavel Savchenkov, Dreamstime.com.*

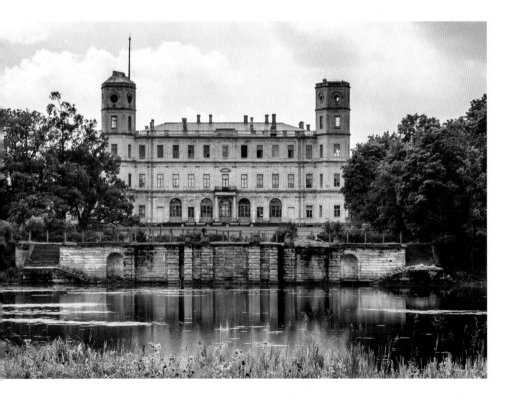

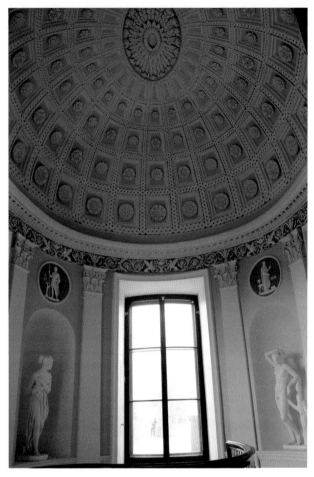

ABOVE: Ceiling above the Staircase, The Agate Pavilion, *photo by Ruth Cousineau.*
BELOW: The Agate Pavilion by Charles Cameron, Tsarskoe Selo, *photo by Ruth Cousineau.*

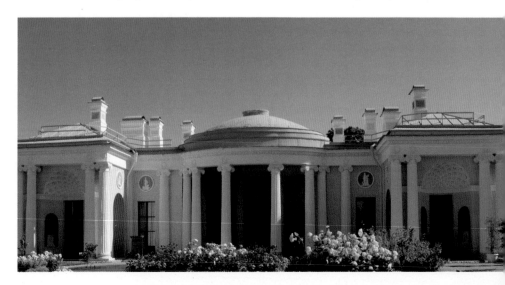

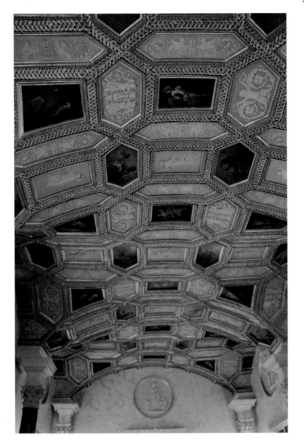

ABOVE: Coffered Ceiling, Great Hall, Agate Pavilion, *photo by Ruth Cousineau.*
BELOW: View from the Cameron Gallery, *photo by Ruth Cousineau.*

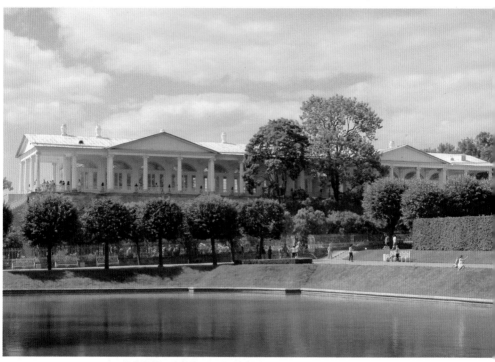

ABOVE: The Cameron Gallery by
Charles Cameron, Tsarskoe Selo,
photo by Ruth Cousineau.

LEFT: Catherine II's Wheel Chair,
The Agate Pavilion, *photo by Ruth
Cousineau.*

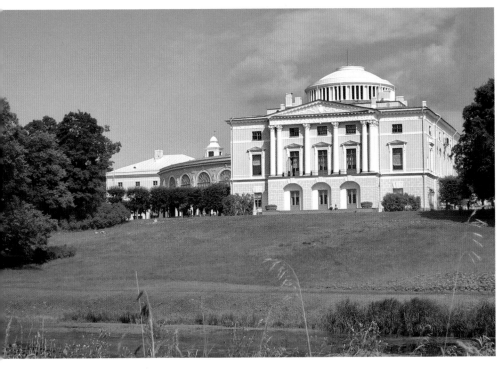

ABOVE: Pavlovsk Palace by Charles Cameron, © *Viacheslav Dyachkov, Dreamstime.com.*

BELOW LEFT: Temple of Friendship, Pavlovsk by Charles Cameron © *Konstik, Dreamstime.com.*

BELOW RIGHT: The Chesme Church by Yury Velten © *Anton Samsonov, Dreamstime.com.*

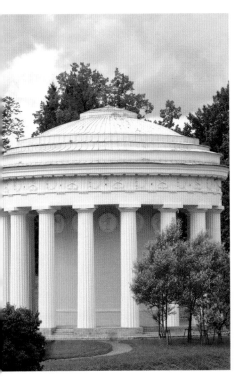

ABOVE: Colonnade of Alexander Palace by Giacomo Quarenghi, © *Dmitriy Raykin, Dreamstime.com.*

BELOW: The Marble Palace, St. Petersburg by Antonio Rinaldi © *Konstantin Semenov, Dreamstime.com.*

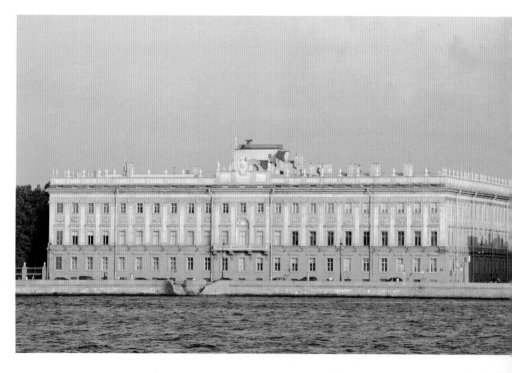

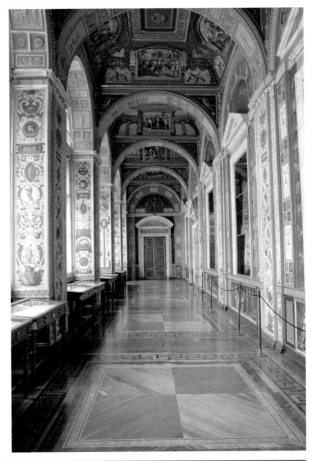

RIGHT: The Raphael Loggia,
State Hermitage Museum,
© *Nimblewit, Dreamstime.com.*

BELOW: The State Hermitage
Museum, St. Petersburg,
© *Tatjana Keisa, Dreamstime.com.*

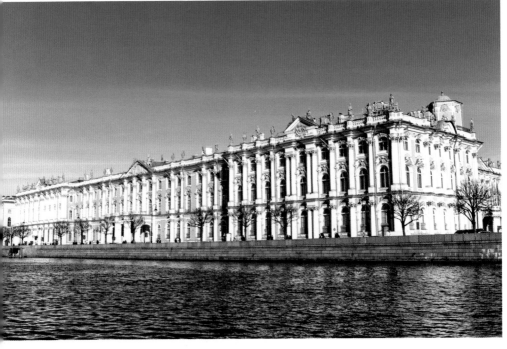

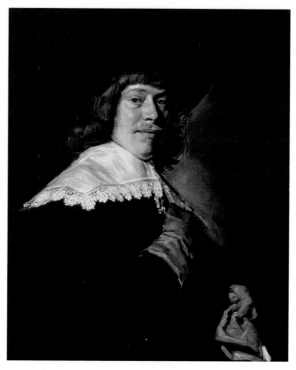

ABOVE: *Portrait of a Young Man with a Glove*, Frans Hals (1582/3–1666), c. 1640 (oil on canvas), Hermitage, St. Petersburg, Russia, *Bridgeman Images*.

BELOW: *Perseus liberating Andromeda*, Peter Paul Rubens (1577–1640), c. 1620 (oil on canvas), Hermitage, St. Petersburg, Russia, *Bridgeman Images*.

ABOVE: *Return of the Prodigal Son*, Rembrandt Harmensz. van Rijn (1606–69), c. 1668-69 (oil on canvas), Hermitage, St. Petersburg, Russia, *Bridgeman Images.*

BELOW: *The Flight into Egypt*, Titian (Tiziano Vecellio) (c. 1488–1576), 1500s (oil on canvas), Hermitage, St. Petersburg, Russia, *Bridgeman Images.*

ABOVE: *Boy with a Dog*, Bartolome Esteban Murillo (1618–82), c. 1650, Hermitage, St. Petersburg, Russia, *Bridgeman Images*.

LEFT: *Judith* (oil on panel), Giorgione, (Giorgio da Castelfranco) (1476/8–1510), Hermitage, St. Petersburg, Russia, *Bridgeman Images*.

BELOW: *Philadelphia and Elisabeth Wharton*, 1640, Sir Anthony van Dyck (1599–1641), Hermitage, St. Petersburg, Russia, *Bridgeman Images*.

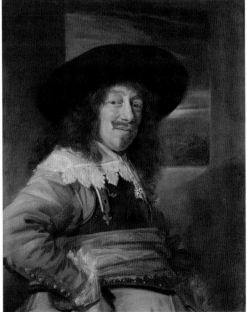

ABOVE: *Saint George and the Dragon*, Raphael, Marchigian (1483–1520), c. 1506 oil on panel, 11¼ × 8⁷⁄₁₆ in., Andrew W. Mellon Collection, from the Crozat collection, National Gallery of Art, Washington, D.C.

RIGHT: *Portrait of a Member of the Haarlem Civic Guard*, Frans Hals (c. 1582/1583–1666), 1636/1638 oil on canvas, 33⅞ × 27³⁄₁₆ in., Andrew W. Mellon Collection, National Gallery of Art, Washington, D.C.

ABOVE: *The Finding of Moses,* Paolo
Veronese (1528–88), probably 1570/1575, oil
on canvas, 22¹³⁄₁₆ × 17½ in., Andrew W.
Mellon Collection, from the collection of
Louis-Michel van Loo, National Gallery
of Art, Washington, D.C.

RIGHT: *The House of Cards,* Jean-Siméon
Chardin (1699–1779), probably 1737, oil on
canvas, 32⅜ × 26 in., Andrew W. Mellon
Collection, National Gallery of Art, Wash-
ington, D.C.

ABOVE LEFT: *Philip, Lord Wharton*, Anthony van Dyck (1599–1641), 1632, oil on canvas, 52⅜ × 41¾ in., Andrew W. Mellon Collection, from the Walpole collection, National Gallery of Art, Washington, D.C.

ABOVE RIGHT: *Pope Innocent X*, Circle of Diego Velázquez, c. 1650, oil on canvas, 19⅜ × 16¼ in., Andrew W. Mellon Collection, from the Walpole collection, National Gallery of Art, Washington, D.C.

BELOW: *The Birth of Venus*, Nicolas Poussin, 1635 or 1636, oil on canvas 38¼ × 42½ in., from the Crozat collection, Philadelphia Museum of Art: The George W. Elkins Collection, 1932.

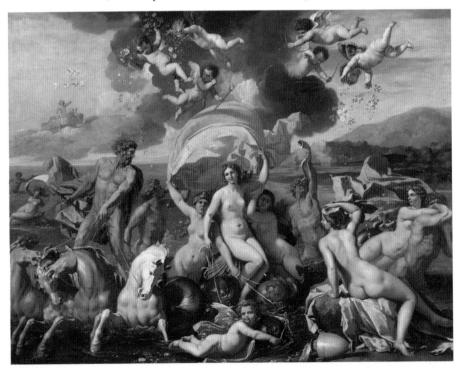

ABOVE LEFT: *Portrait of Count Heinrich von Brühl* (1700–1763), Georg Friedrich Schmidt, German, 1762, Etching and engraving, Philadelphia Museum of Art: The Muriel and Philip Berman Gift.

ABOVE RIGHT: *Portrait of Robert Walpole, 1st Earl of Orford*, Jakob Houbraken, Dutch, 18th century, Engraving Philadelphia Museum of Art: The Muriel and Philip Berman Gift.

BELOW: *Presumed Portrait of the Duc de Choiseul and Two Companions* (Choiseul on left with his mistress Madame de Brionne and the Abbé Barthélemy), Jacques Wilbaut, French, c. 1775, Oil on canvas, 35 × 43⅝ in., The J. Paul Getty Museum, Los Angeles.

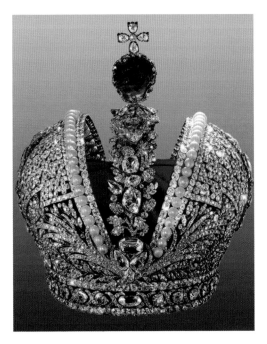

ABOVE LEFT: The imperial coronation crown commissioned by Catherine II, 1762 (mixed media), Jérémie Pauzié (1716–79) / Kremlin Museums, Moscow, Russia / *Bridgeman Images.*

ABOVE RIGHT: Potpourri Vase with Classical Figures, Jean-Pierre Ador, 1768, multicolored gold, en plein and basse-taille enamel; *photo courtesy of the Walters Art Museum, Baltimore, Maryland.*

BELOW: Coffee Pot from the Orlov Service, Imperial Porcelain Factory, Hillwood Estate, Museum, & Gardens; *photo by Edward Owen.*

ABOVE LEFT: Plate from the Wedgwood "Green Frog" Service, 1773–74 Earthenware (cream-ware), 9 in., Lent to Milwaukee Art Museum by the Chipstone Foundation; *photo courtesy of the Chipstone Foundation.*

ABOVE RIGHT: Ice Cup from the Cameo Service, Sèvres Porcelain Manufactory, Paris, 1779, soft paste porcelain, decorated with overglaze enamels and gilding, Hillwood Estate, Museum, & Gardens; *photo by Edward Owen.*

BOTTOM: Writing desk with small cabinet, by David Roentgen (1743–1807), Neuwied, 1785 (oak, amboyna, mahogany, bronze, and brass) / Hermitage, St. Petersburg, Russia / *Bridgeman Images.*

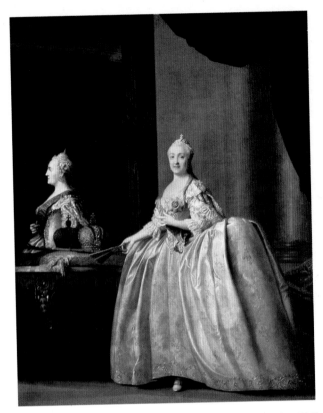

ABOVE: *Empress Catherine II before the mirror*, 1779 (oil on canvas), Vigilius Eriksen (1722–82) / State Russian Museum, St. Petersburg, Russia / *Bridgeman Images*.

BELOW LEFT: *Portrait of Peter III*, Emperor of Russia, Johann Esaias Nilson, German, mid-18th century, Etching, Philadelphia Museum of Art: The Muriel and Philip Berman Gift.

BELOW RIGHT: *Portrait of Paul I, Emperor of Russia*, Ignaz Sebastian Klauber, German, 1797, Etching and engraving, Philadelphia Museum of Art: The Muriel and Philip Berman Gift.

ABOVE: *Portrait of Grand Duchesses Alexandra Pavlovna and Elena Pavlovna of Russia*, 1796 (oil on canvas), Elisabeth Louise Vigee-Lebrun, (1755–1842) / State Hermitage Museum, St. Petersburg, Russia / *Bridgeman Images.*

RIGHT: *Portrait of Catherine II,* Pierre-Etienne Falconet, 1773, Hillwood Estate, Museum, & Gardens, *photo by Edward Owen.*

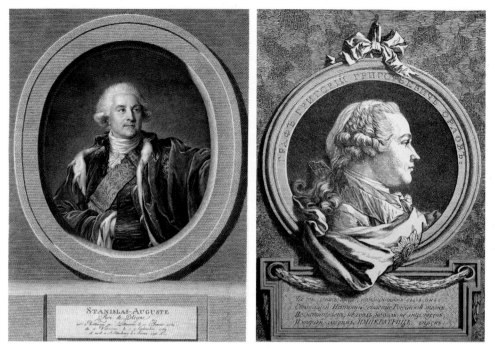

ABOVE LEFT: *Portrait of Stanislas-Auguste, King of Poland,* Ignaz Sebastian Klauber, German, 1754–1817, 1798 Etching and engraving, Philadelphia Museum of Art: The Muriel and Philip Berman Gift.

ABOVE RIGHT: *Portrait of Gregory Orlov,* Hillwood Estate, Museum, & Gardens Archives & Special Collections.

BELOW LEFT: *Portrait of Prince Grigory Aleksandrovich Potemkin (1739–91),* c. 1790, Johann Baptist Lampi (1751–1830) / Hermitage, St. Petersburg, Russia / *Bridgeman Images.*

BELOW RIGHT: *Portrait of Alexander Lanskoy,* Hillwood Estate, Museum, & Gardens Archives & Special Collections.

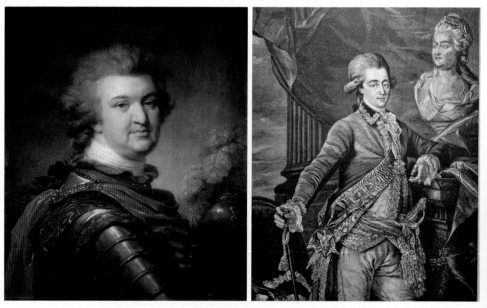

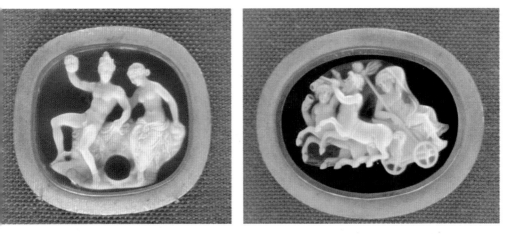

ABOVE LEFT: Perseus and Andromeda. Sardonyx and gold cameo. Rome, 1st century B.C. or 1st century A.D., acquired from the collection of Anton Raphael Mengs, 1780, *photo courtesy of Ruth Cousineau.*

ABOVE RIGHT: Dionysius in the Chariot. Sardonyx, gold cameo. Alexandria. 1st century B.C., from the Louis Philippe d'Orleans collection, 1787, *photo courtesy of Ruth Cousineau.*

BELOW: Gonzaga Cameo, sardonyx, silver, Alexandria, 3rd century B.C., gift to Alexander I from the Collection of Josephine Bogarne, 1814.

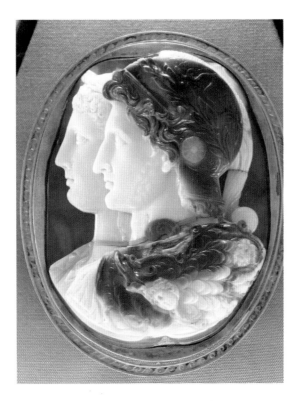

SCULPTURE

RIGHT: Seated Voltaire, Jean-Antoine
Houdon, 1781, marble, H 54 in., *photo by
Ruth Cousineau.*

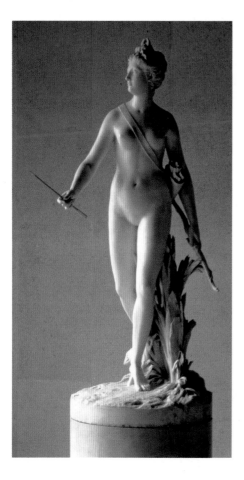

ABOVE: Diana the Huntress, Jean-Antoine
Houdon (1741–1828) 1780, marble, H 82.7
in. / Museu Calouste Gulbenkian, Lisbon,
Portugal / *Bridgeman Images.*

RIGHT: Crouching Boy, c. 1530–34 (marble),
Michelangelo Buonarroti (1475–1564)
H 21¼ in. / Hermitage, St. Petersburg,
Russia / Lyde Brown collection, *Bridgeman
Images.*

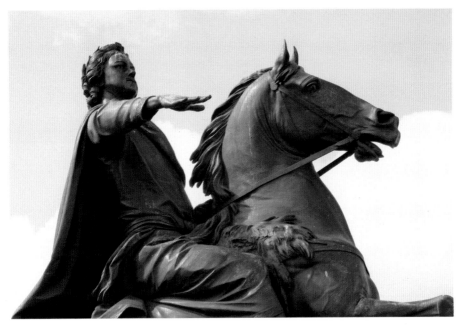

ABOVE AND BELOW: Equestrian Monument of Peter the Great, Etienne-Maurice Falconet, 1766–82, bronze, Senate Square, St. Petersburg, *photo by Ruth Cousineau.*

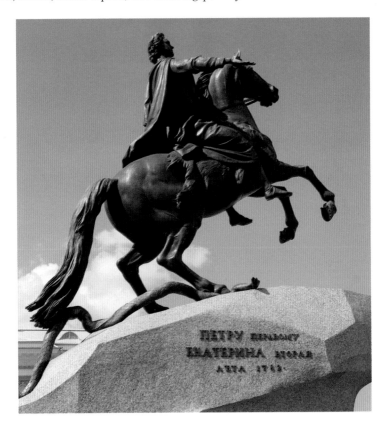

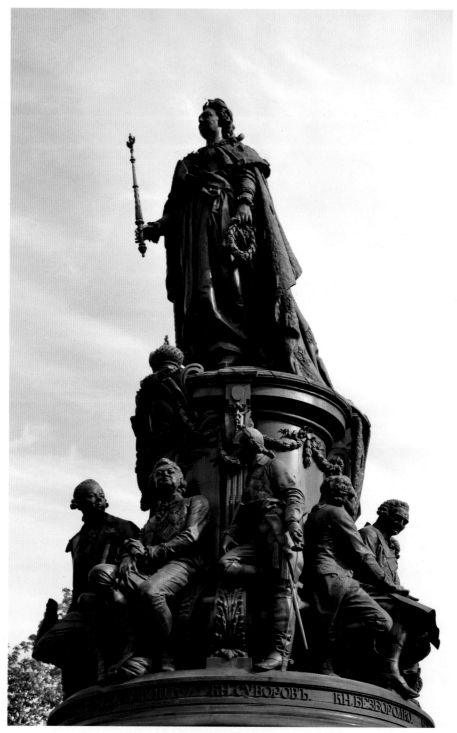

Monument to Catherine the Great by Michael Mikeshin, 1873, © *Konstantin Semenov, Dreamstime.com.*

Meanwhile, Shagin Girey devised his own exit strategy. Instead of traveling to the eastern Caucasus as discussed, he landed in Tasman. There, he incited a group of Tatar nomads to rebel against Catherine. Potemkin quickly dispatched General Alexander Suvorov. On October 1, Suvorov's troops crushed the rebels, but the khan eluded capture. Potemkin had snagged another sparkling jewel for Catherine's crown, the coveted Crimea, but there was much work to be done. As viceroy for southern Russia, Potemkin began developing the sparsely populated region and strengthening security with a Black Sea fleet.

Catherine rewarded Potemkin with the titles of field marshal, Russia's highest military rank, and governor-general of the new district of Tauride—after the ancient Roman name for Crimea (Chersonesus Taurica). In 1783, Catherine hired Ivan Starov to design the Tauride Palace for Potemkin, a luxurious Greek-inspired palace near the Smolny Institute. A winner of the prestigious gold medal from Academy of Fine Arts, the St. Petersburg–born architect had studied with Charles de Wailly in Paris (along with Vasily Bazhenov). As chief architect of the "Commission of the stone construction of St. Petersburg and Moscow," Starov helped plan cities like Yaroslavl, Voronezh, Pskov, and Mykolaiv. In 1775, Catherine had been delighted with Starov's bold neoclassical cathedral for the Alexander Nevsky Monastery (where he was buried in 1808).

Occupied with the War of American Independence, France and England watched nervously from the sidelines. Most anxious were the retreating Turks who saw their vast empire reduced by a former German princess. Peter the Great had opened the Baltic Sea by wresting swampland from Sweden and building St. Petersburg. Now Catherine completed the mission, securing Russia's access to the Black Sea by annexing the Crimea. The land grab brought Catherine a step closer to realizing her dream of stripping Turkey of Constantinople and resurrecting a Russian-ruled Greek Empire.

CHAPTER TWO

A Rose without Thorns

In the summer of 1784, an unusual group of passengers disembarked a small ship in the middle of St. Petersburg. In the name of the empress of all the Russias, some sixty Scottish stonemasons, plasterers, smiths, and bricklayers had answered a help wanted ad in the *Edinburgh Evening Courant*. Shortly after their arrival, William and George Lyon wrote home to their mother:

"There is no posibily [possibility] of getting any money raised at present as the Empres only pais 4 times in the year," wrote the Lyon brothers. "Than she pais it in great sooms [sums]. It is out of Mr. Cameron's own poket that we are subsisted till the end of the quarter. The Empres is pleased just now to give us a chance of a prize which wil be drawn by lotry tikets. The prize is a hous which the Empres means throw curiosity to give away. This hous is valued about 4000 roubles. . . . All that 15 miles betwixt Petersburgh and the sumar palace is ful of lamps on both sides of the road and large marrable pillars at the end of every mile. . . ."[1]

244

It was just five years since Mr. Cameron had made the same voyage. Desperate for skilled craftsmen to help execute his royal commissions, the Scot advertised for a group of his compatriots and built their families a street of cottages in Sophia. Now he was anxious to get them started on Pavlovsk, a country villa two and a half miles from Tsarskoe Selo.

The forested nine-hundred-acre property on the Slavianka River, formerly Romanov hunting grounds, was a gift from Catherine to Grand Duke Paul and Grand Duchess Maria Feodorovna to celebrate the birth of their son Alexander in December 1777. In 1778, Catherine built the couple two small wood residences—Paullust (Paul's Consolation) and Marienthal (Maria's Valley), along with a road several years later connecting Pavlovsk and Tsarskoe Selo. With the birth of their second son, Constantine, that year, the couple approached Catherine about bankrolling a larger residence. "Dear children," the empress replied. "You may well imagine how disagreeable it is to me to see You in need; people must be constantly stealing from You, and this is why You are in need despite wanting for nothing. Farewell, I embrace You."[2]

Catherine did lend the couple her favorite architect. On the afternoon of May 25, 1782, a priest led the traditional Russian service for the laying of a foundation stone. Charles Cameron and his future father-in-law, Tsarskoe Selo's English gardener John Bush, were in attendance along with a group of construction workers. After the ceremony, participants helped themselves to several buckets of vodka and barrels of beers. Missing from the service were the property owners, who'd left the previous fall on a fourteen-month European grand tour. At Catherine's insistence, they traveled under the pseudonyms Comte and Comtesse du Nord.

Catherine was thrilled to have her young grandsons to herself and used their parents' absence as an opportunity to have them inoculated against smallpox. In response to a 1767 epidemic that killed some 20,000 people in Siberia, followed by an outbreak the next year in St. Petersburg, Catherine made headlines when she had herself and her son Paul inoculated against the disease. Her pioneering decision not only helped establish the credibility of inoculation, it proved a great public relations coup in improving Russia's image as progressive and civilized. Despite this, the feared inoculation was still not widely practiced in Europe and smallpox continued to be a

leading cause of death. Monarchs were not immune. During Catherine's reign, Austria's Maria Theresa contracted smallpox but survived; however, her daughter-in-law Maria Josepha died, as did France's Louis XV and Maximilian III Joseph, elector of Bavaria.

Meanwhile, Charles Cameron was drawing inspiration for the ducal villa from a woodcut of Andrea Palladio's unfinished Villa Tressino at Meledo (Thomas Jefferson would later use the Villa to design the University of Virginia). In what Dmitry Shvidkovsky calls one of Cameron's most daring inventions, he capped the central, three-story yellow and white building with a shallow dome ringed by sixty-four columns. "Seen from the park, this light and rich cupola reads as an unusual, enormous round temple, of a kind that had never existed in antiquity . . . ," writes Shvidkovsky.[3] Two single-story colonnaded galleries flanked the central building; Ivan Prokofiev's molded friezes and relief decorations united the four façades.

But splitting time between Pavlovsk and ongoing projects for Catherine at Tsarskoe Selo, Cameron was stretched thin. In one of his many progress reports from late November 1781, Pavlovsk's picky German supervisor Karl Kuchelbecker wrote Maria Feodorovna: "Monsieur Cameron is already complaining quite enough about the great number of tasks burdening him, and I shall be extremely glad when I have received from him all the drawings for his new edifice. I am not mentioning the aviary to him at the moment for fear of distracting him."[4] Cameron was not a master draftsman like Giacomo Quarenghi, and his blue and brown drawings filled with broken lines were difficult for his clients to follow.

Cameron dotted Pavlovsk with a series of garden pavilions. Among the most poetic was the Temple of Friendship, a circular Doric temple surrounded by silver poplars and Siberian pines. The start of work in the summer of 1780 coincided with a visit by Joseph II, who participated in its founding. ". . . I was made to take part in laying the foundation stone of a temple, dedicated to Friendship. I could not refuse. All this was accompanied by many courtesies and declarations of eternal friendship, at which Panin [foreign minister], Potemkin and various other people were present," Joseph wrote his mother, Empress Maria Theresa.[5]

Like William Chambers's Temple of Pan at Stowe, Cameron added sixteen fluted Doric columns to the temple rotunda; friezes of classical

garlands and dolphins decorated the entablature. An inscription over the oak door read: "We dedicate this with love, respect, gratitude, and thankfulness."[6] Inside the windowless temple, beneath a coffered dome, he installed a statue of Catherine as Ceres, the Roman goddess of motherly relationships. Maria Feodorovna hoped this gesture would ease tensions between her husband and mother-in-law. That was wishful thinking.

Catherine's relationship with Paul was one of the most nagging problems of her reign. Snatched at birth, raised by his aunt Empress Elizabeth and a series of tutors, Paul was just eight years old when Peter III was murdered and his mother seized power. Despite rumors that his biological father was the nobleman Sergei Saltykov, Paul always believed he was Peter's son and heir apparent. It's widely believed that with Alexander's birth, Catherine began to consider bypassing Paul altogether in favor of her beloved grandson. With the threat of disinheritance constantly looming over him, Paul's insecurity and pessimism grew to the point that he appeared mentally unsound. Meanwhile young Alexander was caught in the middle of the ongoing power struggle between his grandmother and father.

Not surprisingly, Paul deeply resented his mother and loathed her string of lovers—especially Orlov and Potemkin, whom she involved in government. The vast sums Catherine lavished on her favorites didn't help matters. Neither did Catherine's overreaching in his own children's lives. Just as Empress Elizabeth had done with Paul, Catherine took over the rearing of Alexander and Constantine. From naming them after Greek and Roman heroes to designing their play clothes and controlling their diets, Catherine was consumed with being a grandmother.

Perhaps this was Catherine's way of making up for what she'd missed as a mother. As Isabel de Madariaga describes, Catherine was "frustrated in her maternal feelings first of all by the physical deprivation of her children inflicted on her by Elizabeth, then by the political fact of life that her son Paul was her most dangerous rival and her son by Orlov, Bobrinsky, could not be acknowledged. . . ."[7] In November 1782, Maria Feodorovna returned from her European grand tour to this warning from Catherine: ". . . I would ask of you to be more restrained in your expression of the great joy the sight of your children will arouse in you. Do not frighten them with a display of too much ardour. . . ."[8]

Before the ducal couple left, Charles Cameron had given them a shopping list with building materials and objects to decorate his "museum of antiques." Cameron eagerly unpacked cases of Roman portrait busts, cinerary urns, bronze sculptures, and antique pottery. But the architect didn't get everything he'd asked for. In a letter to Kuchelbecker, Maria Feodorovna's secretary Baron Andrei Lvovich Nikolai wrote: "As far Monsieur Cameron's memorandum concerning chimney pieces, furniture, etc. I must . . . warn you . . . that he must give up all his grand designs of having marble sent from Carrara to build a staircase, line a hall or erect pillars eleven and eighteen feet high."[9]

Much to Cameron's frustration, Paul and Maria Feodorovna purchased large quantities of furnishings, clocks, tapestries, and fabrics that clashed with his vision for Pavlovsk. They spent 13,000 rubles for furniture by David Roentgen, Dominique Daguerre, and Pierre Denizot, and ordered sixteen more sets of furniture by Henri Jacob—including a magnificent carved bedroom suite upholstered in Lyon silk. Marie Antoinette's gift of a sixty-piece lapis-blue Sèvres toilette set decorated with Maria Feodorovna's coat of arms worth 60,000 livres triggered a 300,000-livre spending spree at the porcelain factory.

At Tsarskoe Selo, Cameron enjoyed Catherine's complete confidence. But that wasn't at all the case at Pavlovsk. Maria Feodorovna didn't care for the muted décor or the Pompeiian arabesques and medallions he'd used in her suite at Catherine Palace. She questioned the Scotsman's decisions, altered his half-finished plans, and insisted he incorporate her new Parisian purchases. Though Paul was less involved on a daily basis, Cameron's moatless, fortless villa did not match his concept of an imperial residence. It was precisely because his mother liked Charles Cameron so much that Paul disliked him.

Tensions continued as Cameron began work began on Pavlovsk's interiors. French designer Charles-Louis Clérisseau congratulated Cameron on the Italian Hall, the heart of the palace. Featuring eight arched openings and a high coffered dome with a round glazed aperture (like the Pantheon), the circular room was intended to evoke a classical temple. Cameron separated this rotunda from the other ground-floor rooms with a continuous windowless corridor containing over two dozen niches with antique statues, busts, and urns.

Flanking the Italian Hall were the Grecian Hall and the Staircase and Egyptian Vestibule. The Hall featured Corinthian columns in *verde antico*, statues in the antique style placed in niches, and decorative vases of porphyry and alabaster. Cameron tinted the rusticated walls of the Egyptian Vestibule the color of Pudost limestone, and set mirrors into the doors to add an illusion of spaciousness. Below a grisaille ceiling fresco of cupids, Cameron installed Ivan Prokofiev's large replicas of ancient Egyptian statues along with blue and white medallions with the signs of the zodiac. Many of the sculptured stone works for the palace halls, including the fireplaces, came from Cameron's own workshops. Also on the ground floor, Cameron completed the private apartments including the White Dining Room, Billiard Room, Old Drawing Room, and Ballroom.

In early 1784, Cameron built a charming aviary with a trio of small yellow pavilions. Sunlight poured in through semicircular windows onto exotic trees, white divans trimmed in blue, and white muslin curtains with blue ribbons. Between galleries and columns, Cameron stretched a netting intertwined with plants and embossed with the imperial coat of arms. Nightingales, goldfinches, starlings, and quails sang in the early morning hours and dusk while a flock of ducks and gaggle of geese swam in a small pond outside. Later that year, after finishing the romantic aviary, Cameron married Katherine Bush, daughter of Catherine's landscape designer.

In 1786, after several years of disagreement, Paul fired Cameron, replacing him with his 41-year-old assistant, Vincenzo Brenna. Before studying architecture in Paris, the Florentine decorative painter had befriended Giacomo Quarenghi in Rome. "I have found the palace already built and what is more mutilated by the English architect Cameron, who has used it to line his own pockets, and is now wealthy to the tune of one hundred thousand rubles or more," Brenna wrote Polish noble Stanislaw Kostka Potocki, who had introduced him to the ducal couple.[10]

Brenna made several dramatic changes to Cameron's villa. He replaced the airy colonnaded galleries with massive semicircular blocks and added side wings. In addition to remodeling Maria Feodorovna's private suite, Brenna reworked Cameron's staterooms, including the Italian and Greek Halls, adding the martial splendor that Paul loved with imperial ciphers, crowns, and Roman trophies. Brenna added sculpture and sumptuous

painted ceilings, along with rich color and lustrous French silks and furniture acquired by the ducal couple.

Cameron meanwhile was relegated to work on the grounds. He succeeded in transforming the wooded acreage into one of Russia's largest parks, with a series of landscapes to harmonize with his villa. One of his most successful Greek pavilions was the earlier Apollo Colonnade located at the park entrance on the riverbank. Inside the open-air colonnade he placed a replica of the famous 4th century B.C. Belvedere Apollo. To give the temple the look of an antique ruin, Cameron used limestone with a coarse finish (Maria Feodorovna later ordered the colonnade rebuilt and moved to another location in the park).

While the grand duchess was abroad, Cameron built her a picturesque dairy, with logs, a straw-thatched roof, and walls faced with granite boulders. To this rustic structure, he added gilded furniture and Chinese porcelain vases atop marble tables and shelves. Fresh milk was always available from a large Japanese vase with a silver tap. Now Cameron added a Charcoal Burner's Hut and Chalet, which became Maria Feodorovna's favorite retreat for reading. It was a refreshing change given the typically combative dynamic between the architect and grand duchess.

One of Catherine's more fascinating building projects at this time was just getting underway: the Alexander Dacha, which spoke volumes about her political ambitions for her grandsons. She had ordered Alexander's rooms in all the imperial palaces decorated with scenes from the life of Alexander the Great. Her gifts to him included a saber with a cameo of Greece's ruler on the handle. To develop the young grand dukes' moral character, Catherine wrote fairy tales and had them read to Alexander and Constantine at bedtime. One of these, *Tsarevich Chlor*, published in 1782, inspired the empress to commission the Alexander Dacha between Tsarskoe Selo and Pavlovsk.

The hero of Catherine's fairy tale, Chlor, requires special virtues in order to locate a rose without thorns. "I have heard tell of a rose without thorns which does not prick from our teacher; the meaning of that rose is virtue. . . . You see that hill in front of you—that is where the rose with no thorns grows. . . ." After climbing to the top of the hill with the help of an elderly couple named Honesty and Truth, Chlor and his servant Reason discover

the special rose. "As soon as they had plucked it from the bush, trumpets and kettledrums sounded from the church there, and word spread everywhere that at such a young age the Tsarevich had found the rose with no thorns which does not prick. . . ."[11]

Catherine had the elements of her fairy tale appear in the Dacha's English garden—including a round antique temple on a hill with a flowering rosebush on a pedestal. Inside, a fresco depicted Alexander the Great cutting the Gordion knot. A fusion of Palladian and chinoiserie styles, the house featured a neoclassical ground floor and an Oriental tented belvedere above with a gilded dome. As a counterpart to the antique temple with the rosebush, a columned rotunda was added to an island in the lake. Between the Dacha and Tsarskoe Selo were wheat fields belonging to an agriculture school. It's here, under the tutelage of agronomist and priest Father Andrei Samborsky, that Catherine's grandsons studied agriculture.

In November 1784, Catherine also commissioned a neoclassical summer palace for seven-year-old Alexander. The empress chose the former estate of Pallila which she'd purchased from the heirs of General Ivan Neplyuev. On the left bank of the Neva, some eighteen miles east of St. Petersburg (today's Otradnoye), Pallila was conveniently located next door to Potemkin's Ostrovsky Palace. Before construction began, Catherine and her courtiers occasionally stayed in the original two-story wood manor house and four guest houses. Catherine renamed the property Pella, after the birthplace of Alexander the Great and the celebrated future she planned for her grandson, his namesake. Catherine instructed Ivan Starov to recreate the palace of the ancient rulers of Macedon in her favorite neoclassical style, and to decorate its interiors with antique *objets d'art*.

In March 1785, Catherine approved Starov's plan for Russia's largest, most complex imperial palace. Double colonnaded galleries connected two dozen Palladian style buildings encircling a large central building. Around the vast palace, Catherine envisioned an English park. Work had already begun by the groundbreaking ceremony in mid-July. ". . . [A]ll my country palaces are hovels compared with Pella which rises like a phoenix," wrote Catherine. As Dmitry Shvidkovsky writes, Catherine saw herself living on through her grandson, like the mythical bird.[12] She clearly hoped to put Russia's future in the hands of Alexander. Paul could not have been more unhappy.

CHAPTER THREE

THE MASTER OF NEUWIED

While Sir Robert Walpole's masterworks were a hard act to follow, Catherine wanted to keep her acquisitions from abroad rolling, although she felt a change in medium was due. After the arrival of the prime minister's trove, Catherine shifted her focus and resources from paintings to sculpture and decorative art. Perhaps in reaction to having grown up in comparatively modest circumstances and finding Empress Elizabeth's decorating lacking, Catherine adorned her many urban and suburban palaces with beautiful furnishings.

"The court at that time was so poorly furnished that mirrors, beds, chairs and chests-of-drawers would be removed from the Winter Palace to the Summer Palace, from there on to Peterhof and once we even went to Moscow with them," Catherine recalled of her days as grand duchess. "When moving the furniture we broke much of it but would put it back in its place without it being repaired."[1]

In late 1751, Catherine took matters into her own hands. "I decided to buy, little by little and out of my own pocket, commodes, tables and the most essential items of furniture both for the Winter Palace and for the Summer Palace, and so when we decamped from one place to the other I could find everything I needed without the slightest difficulty and with no losses in transit."[2] With these purchases, dragging furniture from palace to palace each season was no longer necessary.

Enjoying a seemingly unlimited budget, she redecorated the Romanov palaces with objects by Europe's most fashionable artisans and cabinet-makers. As Isabel de Madariaga explains, Catherine's prodigious building proved a huge boon not just to painting and sculpture, but to all the decorative arts—including furniture—as new pieces were needed to decorate and furnish the new buildings in appropriate style.[3] Like her other art collections, the ostentatious display of decorative arts was intended to advertise the sophistication of her court and her enlightened rule.

According to Catherine's secretary, she began her day at a small kidney-shaped table. "She came into the bedroom at 10 and sat on a chair upholstered in silk, in front of a curbed table," wrote Adrian Gribovsky. "A similar table and chair, for her secretary, faced her. The table tops were adorned with inlaid bouquets, landscapes and diverse ornamentation." Catherine's often ended her day over a card game like racamboul or whist.[4]

In 1783, Melchior Grimm introduced Catherine to Europe's most celebrated furniture maker. "May I tell you about a man who at this time is on his way to St. Petersburg," Grimm began. "This is Monsieur Roentgen, famous Herrnhuter, undoubtedly the best cabinet-maker of this century. He comes to you because the finest minds attract each other. Since Your Majesty cannot go to Neuwied am Rhine, the celebrated Roentgen is on his way to St. Petersburg on the Newa. Neuwied is the theatre of his glory as the universe is that of Catherine II. France, Germany and Holland ring with his fame. However, all this does not suffice to serve his ambition.

"He is leaving his large establishment to bring a piece of furniture to Your Majesty's attention. It is unique and has been built especially for you. It has no equal nor will have. He asks nothing better than to submit it to Your Majesty's judgment. If your majesty does not care for it, he will take it back to Neuwied and, as a good Herrnhutian, seek consolation in

Christ Who is dear to him. Do, I beg you, favor him by inspecting his work because this alone is the purpose of this noteworthy man's journey."[5]

Catherine responded to Grimm's glowing reviews: "The Herrnhuter cabinet maker/mechanic will be welcome here, because we are building more than ever."[6] When Roentgen arrived at the Winter Palace the following May for an audience with Catherine, he was already supplying furniture, clocks, and musical instruments to the Vatican and royal palaces of Paris, Brussels, Berlin, and Stockholm. He employed some one hundred artisans at his factory in Neuwied, a port on the Rhine River north of Koblenz. After visiting the workshop, Goethe compared its cabinetry to "palaces in a fairyland."

When David Roentgen took over his father Abraham's factory in 1772, he introduced mechanical innovations, neoclassical styling, and personalized marketing. Business boomed as his distinctive designs became status symbols for Europe's royals. The workshop's earlier rococo-style furniture was distinguished by refined marquetry—designs inlaid in different woods. Unlike many of their competitors, the Roentgens did not use hot sand to shade wood or engraving tools to add detail. Every detail was executed in different colored wood.

David Roentgen seized the opportunity to add Russia's trendsetting empress to his A-list clientele. Among the fifty pieces of furniture he hauled 1,100 miles from Neuwied to St. Petersburg were two writing desks, a monumental clock, a chest of drawers, large and small desks with writing stands, and an architect's table for Catherine's five- and six-year-old grandsons. But the pièce de résistance was the extraordinary Apollo Desk. After Roentgen learned from Grimm that the empress loved antiquity, architecture, and dogs, he cleverly packaged all three together in a neoclassical mahogany desk.

A statue of the sun god Apollo and the muses on Mount Parnassus (by François Rémond after Louis-Simon Boizot's model) topped the bureau, while bronze sphinxes, an ancient symbol of female wisdom, flanked the slanted front lid. Opening the lid for Catherine, Roentgen revealed a palace façade guarded by a bronze figure of Zémira, her favorite greyhound (Zémira slept in Catherine's bedroom in a cradle lined in pink silk and accompanied the empress on her daily walks).

When Catherine touched the dog-shaped knob, the palace façade dropped down, exposing compartments for documents and precious objects. To Catherine's delight, Zémira also activated a carillon of flute and clavichord music. A single brass cylinder carried a playlist of four melodies—changeable with a lever underneath the desktop. To improve the acoustics, Roentgen covered the lower central panel with cloth. The musical mechanism was the invention of master clockmaker Peter Kinzing, who also engineered levers and knobs that made panels fling open revealing hidden pigeonholes. Roentgen added a stand for paper and side containers for quill pens and ink. Deep inside the desk was a cabinet for secreting medals and jewelry. Its seven mahogany drawers featured bronze medallions decorated with ring-shaped handles and men and women in profile.

Not only did Catherine pay Roentgen's asking price of 20,000 rubles for the desk, she threw in a gold snuffbox and a 5,000 ruble bonus. To put this in perspective, St. Petersburg's Yusupov Palace sold around the same time for a similar amount. The Apollo Desk would come to be regarded as a Russian national treasure. But Roentgen's second meeting with Catherine the following month didn't go nearly as well.

While chatting in German, Roentgen, a member of the dissident Protestant sect known as the Moravian Brethren (German Quakers), expressed his strong opposition to slavery, a clear reference to Russian serfdom. Catherine got up and left. The next day, she informed the cabinetmaker that she'd buy two desks but only pay for one—punishment for his proselytizing. "Your Mr. Roentgen fell upon us with a cargo of furniture which you cannot imagine," Catherine wrote Grimm. "He would also have liked to have 'herrnhutized' us at the Hermitage, but it is all too much a question of sheep and lambs in this business, his mealy-mouthed manner was not to our taste; the furniture paid for, keys delivered, he had to pack up his beliefs, and all the people at the Hermitage were saved from the bore of all bores. . . ."[7]

By raising the subject of slavery, Roentgen had touched a raw nerve. There's no doubt that Catherine, who saw herself as Europe's enlightened monarch, must have felt some lingering guilt about her decision not to reform serfdom. Confronted with resistance from Russia's powerful landowners in 1764, she made the politically expedient decision to abandon her

early efforts and focus instead on territorial expansion through war with the Ottomans. Eliminating the institution of serfdom, the foundation of Russia's nobility and economy, was not as simple as "freeing" the serfs. It would have required extensive legislation to see the transition through smoothly without uprooting the entirety of Russian society. Not only did Catherine fail to eliminate the institution, serfdom increased during her reign. She herself granted hundreds of thousands of serfs to her favorites and advisers.

Even as Roentgen's politics made her uncomfortable, Catherine could not resist his remarkable furniture. Ten days later, she wrote, "We [she and Roentgen] conversed in a very civil way on the subject of furniture and I have bought for Pella its second collection. . . ." A month after Roentgen left St. Petersburg, she wrote that "his furniture is very finely and precisely made, especially those pieces with mechanical devices."[8]

Shipments of Roentgen furniture continued. With their neoclassical proportions and gilded bronze, the magnificent tables, desks, consoles, and clocks were perfect for Catherine's new Large Hermitage. Catherine installed the Apollo Desk here alongside her art. "The rooms overlooking the Neva are decorated with very refined taste: the floors are inlaid, the ceilings have painted inserts," noted Johann Georgi. "There are big rounded plate-glass windows, crystal chandeliers, silk curtains with tassels, richly embellished fire-places or ceramic stoves, doors with mirrors, corner tables, clocks, sofas and the like furnishings filling the rooms."[9]

For Catherine, one of the world's most cultivated women of letters, Roentgen's desks were especially prized. Every day, she spent hours corresponding with lovers, officials, philosophers, and art agents. With their hidden compartments, Roentgen's bureaus also allowed the added benefit of secrecy. Roentgen also designed his desks and chairs with the mathematics of writing in mind. In his article on writing for the *Encyclopédie*, French master scribe Piassot identified three things that make good writing: a beautiful day (good, natural light), a solid table, and a comfortable chair. According to Carolyn Sargentson, Roentgen calibrated chair and desk heights so his patrons could sit at the correct angle to the table and hold a quill at the proper angle—four to five finger widths from the body.[10]

But in late June, three months after Roentgen's first visit to St. Petersburg, tragedy struck. After four years together, 26-year-old Alexander

Lanskoy, the beloved Sashenka, died in Catherine's arms, a victim of diphtheria. The suddenness of his passing proved overwhelming. "My happiness is over," Catherine wrote Grimm from Tsarskoe Selo. "I thought I too would die at the irreparable loss of my best friend just eight days ago. Sobbing and in deep sorrow, I must tell you that General Lanskoi is no more."[11] Potemkin rushed back from the south to comfort Catherine. For a month, she refused to allow her lover to be buried. When Lanskoy was finally buried in the park at Tsarskoe Selo, she did not attend. It wasn't until September that Catherine appeared in public.

In addition to art, Catherine had lavished Lanskoy with gifts estimated at seven million rubles. These include two houses in St. Petersburg, a house at Tsarskoe Selo, and 80,000 rubles' worth of buttons for his ceremonial caftan.[12] Though Catherine also gave Lanskoy's relatives promotions and awards, her largesse failed to win over his disapproving family who considered the couple's age disparity scandalous. Alexander's disdainful brother Yakov Lanskoy commissioned the painting *The Last Judgment* showing the Lanskoys residing in heaven while atoning Alexander is disfigured by the fires of Gehenna.

Lanskoy left his fortune, including artworks and library, to Catherine. She had the splendid parquet floors from his St. Petersburg residence reinstalled in her new Agate Pavilion at Tsarskoe Selo. On her order, Karl Leberecht created a medal representing Lanskoy on one side and an obelisk with the inscription "From Catherine, to friendship" on the other. Charles Cameron erected a monument to the young man at Tsarskoe Selo emblazoned with a large version of Leberecht's medal, along with the inscription: "What great pleasure for noble souls to see virtue and merit crowned by praise from all." Lanskoy's monument was located near the pyramid tomb for Catherine's greyhounds and various monuments to the Orlovs, Romanovs, and heroes of Chesme. That prompted Charles François Philibert Masson, author of *Secret Memoirs of the court of Petersburg* to write: "Are we from this to imagine that a dog, a lover, and a hero, are of equal importance in the eyes of an autocrat?"[13]

Back in Neuwied, David Roentgen was busy applying what he'd learned about Catherine's taste and lifestyle. With her deep pockets, Catherine wooed the talented furniture maker away from other royal patrons,

including Louis XVI and Marie Antoinette. Roentgen developed a special architectural style for Russia, distinguished by beautiful mahogany veneer and gilt bronze, precise and rigorous proportions and monumentality. Roentgen furniture continued to arrive in St. Petersburg, adding splendor to the Winter Palace and imperial summer residences. A shipment in March 1786 containing 126 items set back Russia's treasury by 72,704 rubles. Among the pieces were three roll top desks, a desk with writing stand, a secretary, two clocks, and a pair of little tables.[14]

Catherine paid another 19,600 rubles for a large mahogany and oak desk she could use for writing while sitting or standing. Once again, Roentgen flattered his patroness, crowning the desk with a bronze allegorical group depicting Justice with Athena at her side, hanging a medallion struck with Catherine's profile. On the pedestal, Time writes Catherine's name in Latin, while History enters the empress's deeds in a book. A Latin inscription on the lower step of the pedestal reads: "Offered and dedicated to the German muse in the year 1786 by the inventor Roentgen of Neuwied." In 1787, Roentgen's third shipment of furnishings arrived for Pella Palace.

With the "Catherine Effect" in high gear, Russian courtiers like Count Stroganov also ordered Roentgen furniture. By 1789, Catherine and her courtiers had bought hundreds of pieces of Roentgen cabinetry. Four of Roentgen's five visits to Russia were connected to commissions for the empress. During one visit, Roentgen helped repair furniture at the Hermitage. Around the same time, another German cabinetmaker, Christian Meyer, was worked exclusively on orders for Catherine's court. In addition to creating glass-fronted cabinets for the empress's jewels and medium-size cabinets for her precious minerals, Meyer was also responsible for the woodwork in the Raphael Loggia. Catherine was so pleased, she hired Meyer to teach her grandchildren the art of carpentry.

CHAPTER FOUR

AN ACCIDENTAL MICHELANGELO

I n 1783, British diplomat and antiquary Sir William Hamilton returned to England from Italy, bringing with him a 9½-inch-tall vase with a delicate frieze. He'd bought the vase from a dealer for £1,000; it had once belonged to Maffeo Barberini, future Pope Urban VIII. Unearthed in the 16th or early 17th century, the beautiful object was carved from cameo glass by a Roman artist around the 1st century A.D. Catherine's agents offered Hamilton £2,000 for the vase, but he sold it instead to the 2nd Duchess of Portland. The Portland Vase, as the celebrated glass came to be known, was later gifted by her heirs to the British Museum. It was one of the few instances in which Catherine and her agents were not successful.

Undeterred, Catherine indulged her love of antiquity two years later by acquiring the collection of Russian aristocrat Count Ivan Shuvalov. Dubbed the "Russian Marquis de Pompadour" by Voltaire, Shuvalov had become Empress Elizabeth's lover after helping her seize power. In the

mid 1750s, Shuvalov founded Moscow University and the Academy of Fine Arts, supporting homegrown talents like architects Vasily Bazhenov and Ivan Starov, painter Feodor Rokotov, and sculptor Fedot Shubin. At the same time, Shuvalov recruited foreign artists and architects to teach in the capital. In 1758, Shuvalov donated roughly one hundred of his paintings to the Academy (these works were transferred to the Hermitage after the 1917 Revolution).

For reasons that remain a mystery, Shuvalov deeply offended Catherine, who banished the 35-year-old courtier from Russia as soon as she seized power. After stints in Paris and at Voltaire's Swiss estate, Shuvalov landed in Rome, where he assembled an outstanding art collection and cultivated a circle that included Anton Raphael Mengs, Giovanni Battista Piranesi, and sculptor Bartolomeo Cavaceppi. During the late 1760s, Shuvalov sent plaster casts of the best antique masterpieces back to St. Petersburg's Academy. In an effort to mend fences with Catherine, Shuvalov sent her a dozen volumes of Piranesi engravings from Rome.

In the early 1780s, sculpture professor Fiodor Gordeyev used the Academy's casts to make copies of some of the finest statues in Florence, Rome, and Naples—including Apollo, the Furietti Centaurs, the marble Niobe Group, Medici Mercury, and Callipygian Venus. The models were cast by Vassili Mozhalov and Edme Gastecloux and installed in key places at Charles Cameron's park at Pavlosk. Around the same time, bronze copies of the Farnese *Hercules* and *Flora* were installed at the entrance of the Cameron Gallery at Tsarskoe Selo. In addition to busts for the Cameron Gallery, portraits of ancient celebrities like Seneca, Marcus Aurelius, Cicero, and Homer were copied in marble and cast in plaster as ornaments for Catherine's libraries.

When Ivan Shuvalov finally returned to Russia after a fifteen-year exile, he brought with him a collection of antique sculptures, urns, and mosaics. "I remember the following antique pieces," wrote visiting German astronomer Johann Bernoulli in 1778: "a splendid colossal head of Juno, with, in front of the sculpture, a leg found nearby . . . a helmeted head of a man, much appreciated by Mengs, who thought it represented Achilles . . . an antique copy of the Medici Venus . . . a fragment of mosaic paving . . . an imitation of the Capitol Pigeons mentioned by Pliny."[1] It seems his judicious choice

of gifts to the empress and indulgence in her appetite for all things classical had finally absolved him of his transgressions.

With her appetite for antiquity still strong, and reflected in her continued architectural politics around St. Petersburg, Catherine also sought out Roman decorative objects and sculpture. "Nothing matched imperial Rome when it came to bestowing legitimacy and status on a ruler," write Magnus Olausson and Solfrid Soderlind. ". . . A fragment of an authentic work conferred almost magical power."[2] Peter the Great had acquired one of Russia's first ancient sculptures—a Roman copy of Aphrodite of Cnidus by Hellenistic master Praxiteles. After two years of negotiations, Clement XI allowed the tsar to export the beautiful marble in exchange for the relics of the 14th-century Swedish mystic, St. Brigitta. But the deal ended in controversy when Peter failed to deliver the relics. Ever since Catherine transferred the 5½-foot-tall marble from Peter's Summer Garden to Potemkin's Tauride Palace, it's been known as the *Venus of Tauride*. But she was not alone in her quest for relics and antiques.

In her pursuit of antiquities, Catherine found herself in a bidding war with two popes, Frederick the Great and Gustav III, Cardinal Albani (Clement XI's art-loving nephew), and a group of British connoisseurs. Swedish admiral Carl August Ehrensvard summed up the highly competitive environment: "The king of Prussia and the empress of Russia [do so] more often than not [buy poor specimens of antiquities]. We who are here [in Rome] and see it laugh at their purchases. The pope takes everything that is any good, and Cavaceppi [restorer Bartolomeo Cavaceppi], a wretched and rich sculptor, has large warehouses full. They are antiques, indeed, but ugly."[3]

Catherine was a late entrant into the booming antiquities market. Artifacts from the ancient cities of Pompeii and Herculaneum sparked a craze among Europeans for everything classical. Threatened by the loss of Rome's newly unearthed treasures to European collectors, cultured Pope Clement XIV built an antiquities museum to add to the Vatican's Belvedere statues. Named Museo Pio-Clementino after Clement and his successor Pius VI, the neoclassical museum combined rooms inside and adjacent to the small 15th-century Belvedere Palace. The collection started with ancient sculpture (often with the addition of missing body parts), then

grew to include ancient coins and cameos, Etruscan vases, papyrus fragments, a print cabinet, and a modern painting gallery. Clement enriched the museum's holdings by sponsoring excavations.

With demand and tighter papal control driving up the price of antiquities, connoisseurs looked for alternatives. Highly refined, small-scale reproductions of famous originals became tremendously popular. In 1786, Catherine commissioned Roman sculptor Francesco Righetti to create a marble model of Mount Parnassus, populated with small bronze statuettes of Apollo, the Muses, and the winged horse Pegasus. With the exception of Pegasus, the figures were miniature versions of a statuary group from Museo Pio-Clementino. For Catherine "the imitative nature enhanced rather than detracted from the value of the bronzes," writes James Harper, "[T]he admiration of such specifically identifiable antiquities as the Vatican Muses was a signal of taste and cultivation."[4] Righetti, who trained with silversmith Luigi Valadier, eventually succeeded his mentor's son Giuseppe Valadier as director of the Vatican foundry.

Despite Clement XIV's stringent export restrictions, high priced antiquities continued to leave Rome during the last quarter of the 18th century. Many landed in Great Britain at the estates of wealthy private collectors. "English barbarians are taking everything away," lamented Johann Winckelmann. "Who else but representatives of that nation have the means and the audacity to pay for objects worth so much?" Italian archeologist Paolo Maria Paciaudi expressed his anger to a French colleague: "I am enraged by the fact that those damned Englishmen are taking with them all the magnificent antiquaries."[5]

One of the most acquisitive "barbarians" was British merchant and banker John Lyde Browne. In 1785, Catherine bought Lyde Browne's highly prized trove, some 250 objects for £23,000, considered a large sum. According to Jonathan Scott, the successful merchant couldn't resist trading in the popular antiquities market, selling "marbles" to fellow collectors like Rome's Cardinal Albani along with British Lords Rockingham, Egremont, and Bessborough.[6]

But coming on the heels of her stealthy Walpole acquisition, the sale of another British collection abroad unleashed new resentment. Among the critics was Catherine's potter Josiah Wedgwood, who saw the deal

as another example of Russia's rise at the expense of Britain. "I had seen in the public prints, and lamented the approaching fate of the Houghton collection of paintings; but that so fine a collection of marbles was taking its flight after them, was new to me, and doubly mortifying," Wedgwood wrote Thomas Bentley. ". . . Everything shews we have past our meridian, and we have only to pray that our decline may be gentle, and free from those sudden shocks which tear up Empires by the roots, and make the most dreadfull havock amongst the wretched inhabitants. Russia is sacking our palaces and museums . . ."[7]

John Lyde Browne displayed his possessions at his townhouse on Foster Lane in London's Cheapside and Wimbledon's Warren House, part museum and part show room. Eventually the modest country manor was overflowing with antiquities, which may help explain his surprising decision to sell off a large part of the collection to Russia's empress. As a non-aristocratic merchant, silver refiner, and financier, Lyde Browne represented a new kind of connoisseur. Nicknamed the "virtuoso" by his contemporaries, he assembled his collection over the course of three decades, buying from antiquarians, archeologists, and wealthy collectors in Italy. At the center of London's antiquarian circle, he was a fellow of the Society of Antiquaries of London and a member of the Society of Dilettanti.

The British banker developed his connoisseurship during two visits to Rome. On his first trip in 1753, he met Rome-born dealer Thomas Jenkins, who became his primary agent. Enjoying a close friendship with Clement XIV, Jenkins had become one of the leading figures of the Roman antiquities trade. "My countryman Mr. Jenkins is continually using his influence here in Rome and is said to be the principal favourite with the pope," wrote painter Ozias Humphrey. ". . . The Romans themselves I believe wou'd hardly be surprised if one of the Vacant Hats was given to him."[8]

Lyde Browne also bought objects excavated by Jenkins's partner, Gavin Hamilton, a Scottish painter turned archeologist. Though Hamilton thought the collector had "more acquired than natural taste," he wrote that "Mr. Brown is very busy in search of antiquity; no cortile, Villa or Pallace escapes his diligent scrutiny."[9] After his 1776 Rome trip, Lyde Browne told fellow collector Charles Townley, "there is not a sculptors shop in Rome

which I have not visited . . . Cavaceppi has little & tho I shall lay out some money with Piranesi, yet you know they are but Pasticcios."[10]

To keep his clients apprised of archeological discoveries, Thomas Jenkins sent reports to London's Society of Antiquaries, which Lyde Browne shared at the group's meetings. Most of Jenkins's drawings depicted sculptures he sold to Lyde Browne, including *Endymion* and *Hercules* from the Palazzo Barberini and *Hercules Strangling the Serpents*, dug up at the 2nd-century Villa of the Quintilii. Jenkins also sold Lyde Browne a colossal 1st century head of Minerva, which Johann Winkelmann called "the most perfect and beautiful ever recovered from the earth."[11]

Jenkins unwisely made an enemy of Catherine by sending her a fake Correggio painting that had been returned to him in 1779 by British collector James Hugh Smith Barry. After rejecting the picture, Catherine instructed Johann Reiffenstein to have no further dealings with Jenkins. Around the same time, Catherine passed on a monumental *Seated Zeus*. The work was offered to her for 800 pounds by Hamilton, a friend of her architect Charles Cameron. Unearthed at Tivoli's uninhabited Villa d'Este and exported illegally, the sculpture landed at Marbury Hall in Cheshire after Barry paid Hamilton 600 pounds (today, the work resides at the Getty Museum, Los Angeles).

Thanks to two catalogues compiled by Lyde Browne, as well as drawings by Thomas Jenkins and Italian artist Giovanni Battista Cipriani, art historians have identified many of the sculptures sent to Catherine. Lyde Browne's first catalogue was published in 1768, the same year he became director of the Bank of England. Written in Latin, it included a number of sculptures, mainly busts, obtained from excavations, Roman palaces, and villas along with a few objects acquired from Cardinal Albani.

The most valuable parts of Lyde Browne's collection were the Roman portrait busts and Roman decorative sculpture. Among the gems is the *Portrait of Emperor Lucius Verus*. Excavated by Hamilton at Hadrian's Villa in 1769 and sold by Jenkins to Lyde Browne in 1775, the portrait is considered one of the best images of Marcus Aurelius's co-ruler. Carved in the 2nd century, the bust represents the realistic style of Republican period portraiture. Dressed in armor with drapery flung over his shoulder, the emperor's chiseled features contrast with his thick curly hair and beard.

Another exceptional Roman bust, *Portrait of Emperor Philip the Arab*, was unearthed in Rome in 1763. Carved in the second half of the 3rd century, the expressive 27½-inch-tall marble depicts Marcus Julius Philippus, aka Philip the Arab. After killing his co-ruler, he ruled for five years before dying in a battle for the throne. One of Lyde Browne's most beautiful sculptures is the finely chiseled head of *Velletri Athene*, the 4th century B.C. work of a talented copyist from Kresilas's original a century before.

Among Lyde Browne's marbles were two imperial spouses. The 1st-century *Portrait of Livia* depicts Livia Drusilla in the guise of Ceres-Augusta, high priestess of the cult of Divine Augustus. The first Roman woman to have altars and statues erected in her honor, Livia Drusilla married Augustus at age twenty. She enjoyed nearly unlimited power after his death. The superbly polished marble *Portrait of Julia Cornelia Salonina* depicts the wife of Emperor Gallienus as Venus. Though her body is ideally beautiful, her expression depicts a woman torn by suffering.

In addition to ancient originals, Lyde Browne bought replicas from Bartolomeo Cavaceppi's Rome workshop. Among these were a version of the Capitoline Faustina and a basalt portrait of Agrippina Maior (Hermitage). As well as finding and restoring antique statues, Cavaceppi made copies and created original works in the antique style. But Cavaceppi rarely signed his works, leading to great deal of confusion between his copies and the real thing. Eighteenth-century collectors liked to "improve" excavated sculptures by adding heads, arms, and other missing body parts. Cavaceppi's name became synonymous with these restorations. With authentic antiquities getting harder to come by, Catherine also engaged Cavaceppi to purchase antiquities for her.

Lyde Browne not only collected antique marbles—he also had a collection of Renaissance works. An entry in his second catalogue listed "an unfinished statue of a boy removing a thorn from his foot, a celebrated work by Michelangelo. The boy is naked and has superbly rendered anatomy. It is said that the statue was formerly in the Villa Medici."[12] Lyde Browne acquired the small marble on one of his collecting trips to Italy. From a preparatory drawing by Michelangelo in the British Museum, art historians have traced *Crouching Boy* to the Medici Chapel in Florence's Church of San Lorenzo.

Michelangelo amazed contemporaries with his Pietà (St. Peter's Basilica) and ceiling for the Sistine Chapel. In 1520, Giulio de' Medici commissioned him to create a family burial vault inside Florence's Basilica of San Lorenzo, parish church for the Medicis, along with the Laurentian Library. In his sketch of a double wall tomb for Lorenzo the Magnificent and his brother Giuliano, Michelangelo included two crouching figures above the entablature to the left of the central sarcophagus. The crouched boys face one another below a large swag in the left attic.[13] Flanking the socle supporting the sarcophagus, Michelangelo also sketched recumbent river-gods, *fiumi*, symbols of Medici territory.[14]

The project was personal for Michelangelo. It was Lorenzo de' Medici who discovered him as a teenager and invited him to join his household where he met his future papal patrons Giovanni de' Medici (Leo X, 1513) and his cousin Giulio (Clement VII, 1523). Ultimately, Michelangelo's design for the Medici Chapel did not include the crouching boys. With no surviving documents to explain the development of Michelangelo's designs for the Medici Chapel, mystery surrounds the nearly five-century-old *Crouching Boy*. Despite standing just twenty-two inches tall, the boy appears monumental with his head down and muscular back hunched over the unfinished feet. Some scholars interpret the work as an allegory for the unborn soul, while others see the figure as a wounded soldier or representation of genius or the emotional suffering of spiritual mourning.

Sergey Androsov, head of the Hermitage Museum's Western European Department, attributes the work's sorrowful mood to events unfolding in Michelangelo's life.[15] While *Crouching Boy* was being chiseled in the artist's Via Mozza studio, Florence was under siege by Charles V's troops. In 1532, the 57-year-old Michelangelo fled his beloved city for Rome where he fell in love with a 23-year-old nobleman, Tommaso de Cavalieri. Neither the Medici Chapel nor the Laurentian Library was finished when the artist was summoned to Rome two years later to paint the *Last Judgement*. For the next thirty years, Michelangelo dominated the art world from Rome.

"The compact figure inevitably reminds one of Rodin, perhaps the greatest student of Michelangelo's unfinished ideas," writes Michelangelo scholar William Wallace.[16] According to Wallace, the soft, uncertain use of the toothed chisel differs from Michelangelo's technique. "It surely

was a sculpture for the Medici Chapel, and Michelangelo did have a large crew of talented carvers working for him. It is likely that the actual carving was by someone like Niccolo Tribolo or Silvio Cosini, but because Michelangelo is making all the decisions and approving all the carving, the sculpture—at least in the 16th century perception—would be considered a 'Michelangelo."[17]

The only Michelangelo in the Hermitage, *Crouching Boy* originally joined other Lyde Browne objects at Tsarskoe Selo. Catherine placed his antique busts, reliefs, and marble tombstones in the pyramid (like that of Kew), next to which she buried her Italian greyhounds. When her favorite greyhound Zémira died in 1785, Catherine was inconsolable, shutting herself in her room for days. Zémira was buried in the largest tomb etched "Beloved dog of the Great Queen." The engraved inscription included a poem by the Comte de Ségur: "Here lies Zemira and the mourning graces ought to throw flowers on her grave. Like Tom, her forefather, and Lady, her mother, she was constant in her loyalties and had only one failing . . . she was a little short tempered. . . ."[18]

After the sale to Catherine, Lyde Browne continued to buy from Thomas Jenkins. But the antiquarian only received one installment of £10,000 from Russia, less than half of the agreed upon selling price. It's not clear whether Lyde Browne's agent in St. Petersburg declared bankruptcy or the empress failed to honor their agreement. Lyde Browne also lost art on the pirated *Westmorland*. The resulting financial straits ended his collecting. When he died in September 1787, there were rumors that the cause was stress from the St. Petersburg deal. What remained of his possessions, including decorative marbles, was sold at auction in London by Christie's the following spring.

Meanwhile, Catherine was enjoying her new trove of classical marbles. "In my old age I have become an antiquarian in the true sense of the world," she wrote Grimm in 1786.[19]

CHAPTER FIVE

SLINGS AND ARROWS

C atherine installed Michelangelo's *Crouching Boy* alongside Houdon's *Seated Voltaire* in the lakeside grotto at Tsarskoe Selo, where she enjoyed having her early morning coffee. "The statue of Voltaire sculpted by Houdon has been unpacked and placed in the Morning Salon," she wrote Melchior Grimm, ". . . To enter this salon is literally to have one's breath taken away, and—marvelous to report!— Houdon's statue of Voltaire is in no way diminished by all that surrounds it. . . . He gazes upon everything that is most beautiful in statues both antique and modern."[1]

The year *Seated Voltaire* arrived, Catherine also bought Houdon's *Diana the Huntress*. Carved in 1780, the masterpiece had a tumultuous history. The marble was initially commissioned by another client of Melchior Grimm—Duke Ernest II of Saxe-Gotha. According to H. H. Arnason, when the duke rejected Houdon's designs for his mother's tomb in 1775, Grimm suggested he compensate the sculptor for several

years of work by ordering a statue for his English garden at Schloss Frie-
denstein in Gotha. Grimm suggested Diana—a subject Houdon had been
experimenting with for several years.[2] After accepting the proposal, the
duke received Houdon's large plaster model in 1776.

Diana, goddess of the moon and the hunt, had long been a popular
figure in sculpture and painting. Since antiquity and the Renaissance,
she'd either been depicted bathing (from the story of Diana and Actaeon
in Ovid's *Metamorphoses*), or clothed for the hunt, usually wearing a belted
tunic and sandals. Breaking with tradition, Houdon depicted Diana entirely
nude, a crescent moon in her hair, holding an arrow in her right hand and
a bow diagonally in her left hand. To support the heavy marble figure,
Houdon set the athletic goddess against a bush of reeds, to which she is
attached at points of the left leg and thigh (similar to the technique used
by the Greeks and Romans, and Renaissance and Baroque sculptors). To
support the left arm, Houdon placed a quiver slung behind her suspended
by the shoulder strap.[3]

Houdon intended to display *Diana* at the 1777 Paris Salon, but a
watchdog commission rejected it along with *Frileuse*. With its nudity and
explicit modeling of the vulva, *Diana* was deemed obscene and prurient.
Grimm staunchly defended the work, arguing that nudity of gods and god-
desses conformed to norms of modesty. Grimm's praise did not convince
the Duke of Saxe-Gotha, who no longer wanted the statue. In early 1783,
Catherine agreed to purchase the marble for 20,000 livres.

The controversy surrounding the sculpture may have added to its
popularity. *Diana* (today at the Calouste Gulbenkian Museum in Lisbon,
Portugal) is now considered one of Houdon's masterpieces, a work of great
beauty, originality, and technical sophistication. "Its nudity and impas-
siveness of the face call to mind the Venuses of classical antiquity: the
elongation of the female proportions, the inner torsion of the figure, the
multiplicity of viewpoints it prompts, the tip of the foot as sole support all
recall the art of the 16th century," writes Guilhem Scherf, chief sculpture
conservator at the Louvre. ". . . All the features compose a harmonious,
timeless ideal of womanhood."[4]

After Alexander Lanskoy's death, Catherine waited nearly a year before
taking a new lover. Around Easter 1785, Potemkin introduced her to

another one of his aides—31-year-old Alexander Yermolov. After passing muster with Anna Protasova, the Semyonovsky Life Guards warrant officer moved into Lanskoy's former Winter Palace apartment. ". . . [E]xtremely capable and worthy of his position" is how Catherine described her tall, blond favorite with almond shaped eyes and a flat nose. ". . . [H]e's a good boy," Count Cobenzl reported, "but quite limited."[5]

After a long period of sadness, Catherine wrote Potemkin that her "inner self has regained its calm and serenity."[6] With Catherine happy, Potemkin was free to run the southern provinces. But the aging empress's continued selection of younger men was increasingly becoming a source of derision. A French diplomat wrote: "It would be better if she had only these loves for the physicality, but it's a rare thing among older people and when their imagination is not dead, they make a hundred times more a fool of themselves than a young man."[7]

On her birthday, April 21, Catherine enacted the Charter to the Nobility and the Charter to the Towns. A month later, Catherine and Yermolov left Tsarskoe Selo on an inspection trip of a major canal project (part of today's Volga-Baltic Waterway). Catherine had replaced the wood of Peter the Great's locks with stone, and directed new water sources into the canals. New canals were under construction—one to join the Caspian and Black seas and a second to connect the Black Sea to the Baltic via the Dneiper River. In addition to Yermolov, Catherine's sixteen-person entourage included Gregory Potemkin, Countesses Protasova and Rostopchin, Count Ivan Chernyshev, Grand Chamberlain Ivan Shuvalov, and Master of the Horse Lev Naryshkin.

Also in Catherine's twenty-carriage convoy were her "pocket ministers"—Austria's Cobenzl, France's Count de Ségur, and England's Alleyne Fitzherbert. Catherine's tacit arrangement with the trio was that in exchange for her hospitality, they'd sing her praises back home. Ségur noted the empress's appearance at this time: "In order to disguise the corpulence of advancing years, which efface all the graces, she wore a full gown with wide sleeves, very like the ancient Muscovite dress. The whiteness and brilliance of her complexion were the attractions she kept the longest."[8]

Catherine extended the excursion south to Moscow where she stopped to visit her collection of imperial palaces. In June, she arrived to inspect

her nearly complete new imperial estate, Tsaritsyno Palace, southeast of Moscow. After ten years of construction, the walls for both Catherine's and Paul's palaces along with a third building for Paul's children were finished and work had begun on a vast two-story kitchen and service wing connected to the main palace compound by a colonnade and gate. In what William Brumfield calls one of the most bizarre forms in Russian architecture, Bazhenov designed a semicircular brick arch with limestone "teeth" flanked by intertwined coronets.[9]

In a letter to Paul and Maria Feodorovna, Catherine expressed frustration with Tsaritsyno which ". . . needs to be changed inside, or else it will be uninhabitable . . . The city of Moscow is improving, much is being built there and very well; the aqueduct is a great work in progress."[10] In fact, Catherine was furious with Bazhenov. After the inspection, "she returned to her carriages in a rage, and commanded . . . that [the new complex] should be razed to the ground."[11] By the following February, Catherine signed a formal decree to demolish Bazhenov's imperial palaces. The main issue may have been Bazhenov's identical mother and son palaces. By 1785, Catherine's relationship with Paul had deteriorated even more. She felt threatened by her son and his support among Moscow's grandees. After the elegance of Charles Cameron's additions at Tsarskoe Selo, Bazhenov's heavy style and elaborate façades may have also seemed oppressive, and provided the perfect fodder on which she could lash out.[12]

Catherine may have taken exception to the addition of cryptic symbols of Freemasonry, a secret male society she deeply suspected and to which Bazhenov belonged. In 1786, with Bazhenov's work demolished, she authorized new plans by his assistant Matvey Kazakov. The new plan featured a palace for Catherine only with Paul's palace eliminated altogether. On-again, off-again, the ill-fated project was canceled after Catherine's death, leaving grand ruins for over two centuries. In 2007, the property was finally turned into a convention center.

In July 1785, Catherine took another short trip to inspect her new palace at Pella, returning by boat along the Neva. Again, she invited her pocket ministers along with Yermolov and Potemkin's niece Countess Alexandra Branicka. "Monsieur Kelchen assured us on the way that is was impossible

to die from laughing; this must be true, as no one is dead, even though we laughed fit to burst from morning to night," she wrote about the excursion.[13]

The mid 1780s marked the height of splendor at Catherine's court. Each Sunday, the empress hosted large diplomatic fêtes at the Hermitage. To hide her increasing weight, Catherine wore Russian gowns with long sleeves, allowing her to go corset- and panier-free. One guest described her "dressed in a purple tissue petticoat and long white tissue sleeves down the wrist and the body open . . . of a very elegant dress." Often the sleeves, skirt, and body of the empress's dress were different colors. Princess Dashkova and Countess Branicka followed Catherine's lead, but other women continued to wear French fashions.[14]

Like Catherine, Potemkin entertained lavishly at his residences in St. Petersburg and Tsarskoe Selo. In the capital, Ivan Starov added a third story to Anichkov Palace and embellished the façade with Doric columns. After Potemkin traded the huge palace to repay a large debt, Catherine reacquired it for him (a gesture she'd repeat with Tauride Palace). Smitten by Horace Walpole's neo-Gothic Strawberry Hill outside London, Potemkin had Starov remodel Ozerki and Ostrovsky Palaces with towers and spires. In a wooded forest adjoining Tsarskoe Selo, architect Ilya Neyelov designed Bablovo, complete with a central medieval tower and Gothic arches.[15]

Enjoying unprecedented power, Potemkin set up his own virtual court in the south, with Vasily Popov as chancellor. As Catherine developed health problems associated with obesity, Potemkin managed to ruin his health by working obsessively; supervising the building of cities, naval ports, and ships; recruiting foreign settlers; and developing industry. As Simon Sebag Montefiore describes, Potemkin was effectively co-ruler with Catherine, running an "empire within an empire."[16] Mutually dependent on one another, Catherine assumed the role of wife and mother during Potemkin's long absences, nagging him to take his medicines and mending his jackets. As Catherine aged, Potemkin's procurement of young favorites drew increasing ridicule.

CHAPTER SIX

BABY HERCULES

C atherine continued to bring seemingly unlimited resources to her art collecting. In August 1785, she added the Breteuil collection of carved stones to her trove. "I came back to town yesterday," she wrote Melchior Grimm, ". . . I pass by like a tomcat without anyone noticing . . . meanwhile your very humble servant strolls around the Hermitage, looks at pictures, plays with her monkey, looks at her doves, her parrots, her blue, red and yellow birds from America, and lets everyone say what they like as they do in Moscow."[1]

That year, she offered British portrait miniaturist Richard Cosway 10,000 pounds for four tapestries, part of the twelve-work series *Fructus Belli* (*The Fruits of War*) commissioned by Mantua's Ferrante Gonzaga. With its brutal images of military conflicts, the Brussels tapestries had inspired reflection on the use of weapons and the bitter hardships of war. Rejecting Catherine's offer, Cosway gave them instead to Louis XVI the next year in return for four Gobelins Don Quixote tapestries.

Catherine's interest in British culture led her to collect English paintings. In 1774, when Joseph Wright of Derby was a virtual unknown in his own country, she acquired *The Iron Forge Viewed from Without*, a night scene of a forge lit with a glowing orange light. Exhibited in 1773 at the London Society of Artists, the picture was bought for Catherine by her consul Alexander Baxter. Five years later, Catherine added two more dramatic Wrights inspired by his trip to Italy: *A Firework Display at the Castel Sant' Angelo* and *Vesuvius Erupting*.

Princess Dashkova introduced Catherine to the work of Angelica Kauffmann, Europe's most famous woman painter, with a portrait of a Greek beauty in honor of Russia's victory of the Turks (now lost). Like Mengs, Kauffmann was a child prodigy with an artist father. In 1763, the 22-year-old got a career break when she met and painted scholar Johann Joachim Winckelmann in Rome (Winckelmann's influential career ended five years later with his murder in Trieste). For fifteen years, from 1766 to 1781, Angelica Kauffmann enjoyed great success in London. Along with still life artist Mary Moser, Kauffmann became one of two women founding members of the Royal Academy (it would take another two centuries before another woman was named an Academician). Starting with her history paintings for the Academy's first show in 1769, Kauffmann exhibited regularly. To broaden her reach, she mastered etching and engraving.

After marrying her second husband, Venetian view painter Antonio Zucchi in 1781, Kauffmann returned to Venice. Later that year, Kauffmann moved to Rome, leasing Anton Raphael Mengs's former palazzo. Her salon became a gathering place for an international coterie of poets, artists, and scholars. The multilingual artist's international clientele included Russian Prince Nikolai Yusupov and Stanislaus Poniatowski, King of Poland. Catherine too sought her works, writing Grimm, "this divine one who goes for walks in Castel Gandolfo and Frascati with Angelica Kauffmann, what would it cost him to say to this famous woman: My dear friend, if you have the time, take a brush and paint a lovely painting in your style for the Emp[ress] of R[ussia], who loves paintings."[2] Today, the Hermitage's eleven Kauffmanns include a pair of tondos (circular paintings) commissioned by Catherine during the artist's English period. *The Monk of Calais*

and *The Insane Maria* (1780) were both based on episodes from Laurence Sterne's 1768 novel *Sentimental Journey through France and Italy*. Catherine seems to have also bought another of Kauffmann's literary inspired tondos based on a scene from Alexander Pope's "Abelard to Héloise."

Thanks to Prince Nicolai Yusupov, who commissioned many works from Kauffmann, the artist immortalized Catherine's new "tester" and lady-in-waiting, Anna Protasova. In 1788, to help Kauffmann paint *Portrait of Countess Anna Protasova and Her Nieces*, Yusupov sent her six half-length images. In the group portrait, Protasova wears one of her royal gifts—a diamond-studded locket with a miniature portrait of the empress. The five young nieces depicted with her, daughters of her brother Lieutenant General Peter Protasov, lived with Protasova at the Winter Palace.

One of the best known British painters working for Catherine was Richard Brompton. A pupil of Mengs in Rome in the 1760s, he'd returned to London where he painted the Prince of Wales and his brother Prince Frederick. Brompton often exhibited his work at London's Society of Artists, which elected him president in 1773. But by 1779, the irascible artist landed at the King's Bench debtors' prison. After securing Brompton's release by paying his debts, Catherine summoned him to St. Petersburg the following year as court painter (the spot opened after Stefano Torelli's death). English philosopher Jeremy Bentham, who dubbed Potemkin "the prince of princes," called Brompton "a harum-scarum ingeneous sort of painter."[3]

That spring, before her departure to meet Joseph II in Mogilyov, Catherine commissioned Brompton to paint a portrait of Alexander. But the young grand duke could not sit still, requiring Brompton to commit his appearance to memory. The following year, with her Greek Project front and center, Catherine commissioned an unusual double portrait of her grandsons. Catherine dreamed of putting Alexander on the throne instead of her son Paul. She also envisioned a brilliant future for Constantine who'd rule the revived Byzantine Empire after she expelled the Turks from Constantinople. Brompton depicted Alexander cutting the Gordian knot like Alexander the Great while his younger brother bears the banner and cross of the Christian Emperor Constantine the Great. "Brompton, the

English painter, is established here and has great talent," Catherine wrote Grimm, "he is a student of Mengs, he has painted my two grandsons. . . . this picture looks no worse in my gallery beside the Van Dycks."[4] Catherine kept the "charming" double portrait in her apartments and sent a full-size copy to Grimm in Paris.

Brompton's portraits of Catherine included a variation on an earlier half-length by Roslin, his own half-length portrait, and a full-length allegorical portrait with the Russian fleet in the background. For a portrait commissioned by Joseph II, Potemkin ordered changes to Catherine's hair. Austria's emperor complained this "daubing" was "so horribly painted that I wanted to send it back." In Brompton's original half-length likeness, he shows Catherine wearing an imperial crown and laurel wreath, with an ermine mantle, yellow and black ribbon of the Order of St. George, and the chain and star of the Order of St. Andrew the First Called. The formal portrait appears to be the model for an allegorical painting of the empress still on the easel when the 49-year-old artist died unexpectedly at Tsarskoe Selo in January 1783. To help settle Brompton's 5,000-ruble debt, Potemkin paid his widow 1,000 rubles.[5]

In 1785, Lord Carysfort convinced Catherine and Potemkin that their art collections were lacking in British paintings, specifically works by celebrated Sir Joshua Reynolds, founder of London's Royal Academy. Catherine commissioned two history paintings from Reynolds—one for herself and the other for Potemkin. When Sir Joshua landed the prestigious Russian commission, he was putting the finishing touches on a portrait of George IV. Britain's foremost portraitist, Reynolds's glamorous clients included royals and celebrities. Despite this success, he yearned to be a history painter. Now, nearing the end of his career, he'd been given the chance to work in what he considered the most elevated, intellectually challenging of art genres.

Catherine left the subject of the paintings to Reynolds. Horace Walpole suggested the artist paint Peter the Great, who'd spent almost three months at the Deptford naval yard in 1697 learning shipbuilding. "What a fine contrast might have been drawn," wrote Walpole, "as Peter threw off the imperial mantle, and prepared to put on trowzers, between the sullen indignation of his Russian attendants, and the joy of the English tars at

seeing majesty adopt their garb! Peter learning navigation here in order to give a navy to his own country—how flattering to both nations!"[6]

Reynolds chose a very different subject for "a sovereign to whom all the Poets, Philosophes and Artists of the time have done homage."[7] In a February 1786, he wrote Charles 4th Duke of Rutland: ". . . I have received a Commission from the Empress of Russia to Paint an Historical Picture for her, the size, the subject, and everything else, left to me, and another on the same condition, for Prince Potemkin. The subject I have fixed on for the Empress is Hercules strangling the Serpents in the Cradle as described by Pindar of which there is a very good translation by Cowley."[8]

As told by Greek poet in the *Nemean Odes*, baby Hercules, son of Alcmene and Zeus, became the object of the bitter jealousy of Zeus's wife, Hera. The vengeful goddess sent two huge serpents to kill the infant and his brother. To everyone's astonishment, the robust baby crushed the monsters from his cradle. Reynolds populated the canvas with several recognizable portraits. At the left, the blind soothsayer Tiresias bears a striking resemblance to writer Samuel Johnson. Hera, who watches her plan go wrong from the clouds above, strongly resembles Shakespearean actress Sarah Siddons (who Reynolds had recently painted as the tragic muse). Reynolds was famous for obsessively reworking his paintings, but he spent more time on *Infant Hercules* than any other work. He's also known to have reused paintings. About Catherine's painting, the artist is reported to have said, ". . . there are several pictures under it, some better, some worse."[9]

In 1788, Reynolds finished Potemkin's *The Continence of Scipio*, a story taken from Livy's *History of Rome*. Despite temptations of wine, women, and gold, Roman General Scipio Africanus, hero of the Second Punic War, showed restraint by returning a captured Carthaginian maiden to her fiancé. For this virtuous gesture, Scipio came to represent mercy during warfare. Rediscovered in the Renaissance, the tale continued to be popular with painters like Poussin, Rubens, van Dyck, and Batoni. Reynolds's action-packed version was an obvious nod to Potemkin, a military commander and hero of the Turkish-Russo War.

Along with *Scipio*, the artist sent Potemkin a second painting as a gift, the sensual *Cupid Untying the Zone of Venus*. Reynolds painted multiple versions of the picture—including one for Lord Carysfort and another

owned by British architect Sir John Soane. While Venus hides her face from immodest glances with her arm, Cupid pulls at the blue silk ribbon around her waist and looks up at his mother to see her reaction. The model for Reynolds's original painting is thought to have been the beautiful Emma Hart, future wife of Naples envoy Sir William Hamilton and mistress of Lord Nelson.

Before shipping *Continence of Scipio* and *Infant Hercules* to St. Petersburg, Reynolds exhibited the works at the Royal Academy. The *St. James Chronicle* observed that *Scipio* was overly busy but beautifully colored "equal to the finest works of the Flemish School . . . We also think the woman presented to Scipio too young. She represents beautiful infancy, not captivating youth." A review in *The Public Advertiser* concluded: ". . . the canvas is perhaps too small for the design, and the figures are, consequently, thrown together too closely; but upon the whole it may be said that this picture is worthy of the pencil of the President of the Royal Academy; and that, however the invidious and spiteful may rail, it is such as will adorn the cabinet of some future connoisseur; although it should happen that envy and detraction should gain an ascendancy at the present."[10]

Horace Walpole, never a fan of Reynolds or Catherine, also weighed in: "I called at Sir Joshua's while he was at Amthill, and saw his *Hercules* for Russia. I did not at all admire it. . . . if Sir Joshua is satisfied with his own departed picture, it is more than the possessors of posterity will be . . . the passions of a nursery, and the common expression of affrighted parents . . . The parents would feel the same emotions if two large rats had got into the cradle."[11] Amthill Park's owner Lady Ossory was also unimpressed: "I called at Sir Joshua's . . . and saw his Hercules for Russia; I did not at all admire it: the principal babe put me in mind of . . . the monstrous craws . . . Blind Tiresias is staring with horror at the terrible spectacle."[12]

After many delays, at year-end Catherine received *The Infant Hercules Slaying Serpents* along with copies of Reynolds's *Discourses on Art*, a series of lectures he'd delivered to the Royal Academy during the 1770s. In choosing Infant Hercules, a metaphor for the might of the young, powerful Russia, Reynolds had intended to flatter Catherine. But apparently she did not appreciate having her vast empire depicted as a baby. James Walker,

THE EMPRESS OF ART



Catherine's British imperial engraver, witnessed the unveiling of the large canvas at the Winter Palace:

". . . I am rather disposed to think it was not entirely pleasing to her Imperial majesty, who perhaps did not quite agree with the painter, that her empire was in its leading-strings. . . . the picture was placed in the Hermitage for her Majesty's inspection, and when she came with her courtiers, Doyen [French painter Gabriel Francois Doyen] and myself were present," Walker recalled. "Her Majesty spoke to me of the great talents of Sir J.R., whom she admired not only as a painter, but as an author, and gave me a copy of his excellent discourses to the Royal Academy. . . .The picture was not so much admired as it ought to have been. The style was new to them and his mode of loaded colouring not understood; in short it was too voluptuous for their taste. . . . Doyen was asked his opinion, he added sarcastically 'Turn it upside down, it's still a nice painting.' I could have strangled him. In short, turn it topsy-turvy, it is always a fine picture."[13]

There was another problem. To achieve the depth of color of Renaissance painters like Titian and Tinteretto, Reynolds experimented widely with different materials. Unorthodox mixtures of gum varnish, wax, eggs, and Venice turpentine caused some of his colors to fade and his paint surfaces to flake and crack. Blistering and cracking also resulted when Reynolds applied color before allowing the white under-paint to dry. *Infant Hercules* is no longer displayed at the State Hermitage Museum; nearly the entire surface is covered with cracks, some almost a half an inch wide; its pigments have darkened and sunk into the canvas. In October 1899, Sir Lionel Cust, director of London's National Portrait Gallery, wrote from St. Petersburg: "The countenance of Scipio is in very bad condition. In the catalogue it is stated to be unfinished, but I think that it only means that it has gone to pieces. There is a blue streak down the young woman's face. Taken all in all, it is a great failure."[14]

Catherine appears to have been more keen on Sir Joshua's art theories than his paintings, as she made her displeasure of the *Infant Hercules* painting known by delaying payment of the 1,500-guinea invoice until 1794—two years after the artist's death at age sixty-eight from chronic liver failure. The empress did send Reynolds a gold snuffbox with her

portrait cameo surrounded by diamonds in 1790. Inside the jeweled box, he discovered her handwritten thank you note: "For the knight Reynolds in exchange for the pleasure I felt when I read your excellent speech on paintings."[15]

The same year, a Russian translation of Sir Joshua's *Discourses* appeared. Though there was no official reaction from Catherine on *Infant Hercules*, British engraver James Walker was clearly embarrassed by Gabriel François Doyen's sarcasm. Ironically, it seems that Catherine and Horace Walpole may have been in agreement on the painting, one of the hallmark "misses" in her collection.

PART SEVEN

WAR AND REVOLUTION

CHAPTER ONE

CENTER STAGE

Like Empress Elizabeth, who required courtiers to attend dramas, operas, and ballets, Catherine made performing arts an integral part of court life. A year into her reign, she hosted the first performance at her new opera house designed by Yury Velten and Vallin de la Mothe in the southwest corner of the Winter Palace. In addition to pre-dinner shows for her coterie, Catherine organized lavish productions for court and diplomatic circles. Later, she staged performances on the first-floor octagonal room of Velten's Large Hermitage.

Catherine also supported public theatres, whose audiences included the nobility, merchants, and clergy. In addition to funding training academies for actors, the theatre-loving empress had Antonio Rinaldi build a 2,000-seat public Stone Theatre in St. Petersburg. Completed in 1783, the theatre later became known as the Bolshoi Theatre (replaced in 1896 by the Rimsky-Korsakov Conservatory in Theatre Square). Giacomo Quarenghi also renovated Elizabeth's Wooden Theatre in

Tsarina's Meadow near the Summer Gardens, renamed the Malyi Theatre in 1783.[1]

With the roof on the Raphael Loggia installed in August 1785, Catherine tapped Quarenghi to design a dedicated theatre at the east end of the Hermitage across the Winter Canal. "Quarenghi makes charming things for us," she wrote Melchior Grimm.[2] For her personal theatre, Catherine chose the site of Peter the Great's original Winter Palace. Since Anna Ionnovna's reign, the aging palace known as Theatrical House had been used for lodging musicians and actors.

Several years before Peter's palace was built, engineers had linked the Neva and Moika rivers by digging the Winter Canal. Over half a century later, Velten spanned this canal with an arched bridge. Now, to connect the Hermitage with Catherine's new theatre, Quarenghi topped the bridge with a gallery. The elegant light-filled space became a reception area and foyer for the empress's pre-theatre entertaining.

"I don't have a need for a theatre this winter, so that you can let the paint dry, I will not use it for 14 or 15 months to finish," Catherine told her architect.[3] Quarenghi lined the theatre walls with colorful imitation marble and topped the faux-marble columns with the type of grotesque masks he'd seen in Rome's Pompeo Theatre. Statues of Apollo and the Muses filled the niches between the columns; above were busts and medallions of contemporary figures. For seating, Quarenghi installed six rows of semicircular benches and two boxes.

In a sketch of his finished theatre, Quarenghi noted that his models were ancient Greece and Rome, and Vicenza's Olympic Theatre—among the last works of Andrea Palladio and one of the world's oldest surviving Renaissance theatres. The Padua-born architect designed the theatre after studying classical texts and excavating Vicenza's ancient Berga Theatre.[4] Like his ancient Roman predecessors, Palladio placed the stage in front of an elaborate architectural backdrop.

Palladio's audience sat in a semi-elliptical auditorium below a ceiling of painted trompe l'oeil clouds and blue sky. To improve the acoustics, Palladio continued the flat ceiling over the stage. Behind the last row of seats he installed an open Corinthian colonnade which became a closed wall in the center. Adorning the stage niches were dozens of statues of

Olympic Academy members dressed in ancient Roman attire. In 1580, just five months after inaugurating the site, the 71-year-old architect died; his disciple Vincenzo Scamozzi finished the interiors.

Two hundred years later, on November 22, 1785, Catherine's miniature Teatro Olimpico opened with the premiere of the popular comic opera, *The Miller-Sorcerer, Matchmaker and Cheat*. Recruiting continental composers, musicians, actors, and stage designers, Catherine produced nearly the entire European theatrical repertoire of her day—from Molière's *Tartuffe*, Sheridan's *School for Scandal*, and *The Barber of Seville* to plays by Russian writers like Krylov, Sumarokov, and Fonvizin. Empress Elizabeth's recycled 15,000-dress wardrobe provided endless costume changes.

The Count de Ségur described Quarenghi's addition: "At the end of the palace is a beautiful theatre, a reproduction in miniature of the ancient theatre in Vicenza. It is semi-circular in shape: it has no boxes but rising tiers of seats arranged to form an amphitheater. Twice a month the Empress invites the diplomatic corps here and those persons privileged to have access to the Court. On other occasions the number of spectators does not exceed a dozen."[5]

To make room for the theatre, Catherine had ordered Peter the Great's Winter Palace demolished and it was long assumed that Quarenghi had razed the crumbling structure. In 1992, a theatre restoration unearthed some of the original palace's basement, ground-floor walls, and rooms. Today, the extant sections in the theatre basement are open to the public, complete with Bartolomeo Rastrelli's life-size wax and wood seated figure of Peter the Great (wearing a wig made of the tsar's own hair).

With the Hermitage Theatre, Catherine added a new genre to her literary career. Starting in the early 1770s, she wrote some two dozen theatrical works in Russian and French, including neoclassical comedies, Shakespearean adaptions, dramas with Russian folksongs, and proverb plays. Ten of the empress's dramatic works were penned during construction of the theatre in collaboration with her secretary of state Alexander Khrapovitsky. Though Catherine described herself as tone deaf, she also wrote libretti for comic operas. Her comic opera *Fevei*, with music by Vasily Pashkevish, was staged eleven times.

"You ask me why I write so many comedies . . . ," Catherine wrote Grimm. "Primo, because it amuses me; secundo, because I should like to

revive the national theater, which has been somewhat neglected for lack of new plays; and tertio, because it is a good thing to give a bit of a drubbing to the visionaries, who are becoming quite arrogant. The Deceiver and The Deceived One was a prodigious success. . . . The cream of the jest was that at the opening, people called for the author, who . . . remained completely incognito."[6]

Like art and architecture, Catherine's "anonymous" dramatic works were also a political tool, and included plays like *The Siberian Shaman*, part of a trilogy against Freemasonry, and *Oh, These Times!*, a satire about Russian religious hypocrisy and superstition (adapted from a German comedy by Christian Gellert). After seeing her plays, Catherine hoped influential theatergoers in St. Petersburg and Moscow would spread her ideas. "Through her characters' perspectives and their dialog, through the construction of her plots, through her use of imagery and symbolism . . . Catherine the Great the playwright advanced her own political agenda—an amalgam of Enlightenment philosophy, Russian cultural pride, and her belief in the value of authoritarian rule," writes Lurana O'Malley.[7]

Among the Hermitage Theatre regulars was Catherine's music-loving architect. In a gesture of thanks, Catherine reserved a loge for Giacomo Quarenghi and his family. She even turned her grandsons Alexander and Constantine into opera buffs. During a trip to Pella in July 1786, Catherine wrote Grimm: "I'm telling you the time at which I'm beginning to write this letter, because my hand is shaking with laughter . . . they [the grandsons] . . . are kicking up a dreadful racket; I have had to chase them away to have a moment's peace; what's more, they have gone out singing a march from an opera, each holding a dog by the paw in the guise of a princess."[8]

Soon, a real-life drama was playing out at the Winter Palace. Like Semyon Zorich eight years earlier, Alexander Yermolov greatly underestimated Potemkin's pull. In a bad miscalculation, the favorite accused Potemkin of misappropriating funds. "Don't worry," Potemkin told Ségur, "a child isn't going to topple me, and I don't know who dare . . . I scorn my enemies too much to fear them."[9] Potemkin confronted Yermolov at court, yelling, "You cur, you monkey, who dares to besmatter me with the mud of the gutters from which I have raised you." As Robert Massie describes,

"Yermolov . . . put his hand on his sword hilt, but a sudden blow from Potemkin sent him reeling."[10]

Insisting Catherine choose between them, Potemkin threatened to quit and never step foot in the palace again. Yermolov was immediately ordered to leave Russia for five years. Peter Zavadovsky, Catherine's former favorite and current state secretary, dispensed the severance package—130,000 rubles, a silver dinner service, 4,300 serfs in Belorussia, and the Polish Order of the White Eagle.

That evening, 26-year-old Alexander Dmitriev-Mamonov, Potemkin's handsome adjutant and distant cousin, accompanied the 57-year-old empress to her apartment. Catherine's secretary noted that the couple slept until nine o'clock the next morning. Catherine installed Mamonov in the Winter Palace, nicknaming her new favorite "Red Coat" after his favorite uniform jacket. By mid-December, she'd fallen head over heels, writing Grimm: "This Redcoat envelops a being who combines a most excellent heart with a great honesty; he has wit enough for four, a fund of inexhaustible gaiety, much originality both in how he conceives of things and how he expresses them, an excellent education. . . . We hide like murder our liking for poetry; we love music passionately; . . . we have two superb dark eyes with eyebrows traced as one hardly ever sees them; above average height, a noble air, an easy gait; in a word, we are as sound in our inner self, as we are dexterous, strong and brilliant on the outside."[11]

CHAPTER TWO

CAMEO FEVER

Alexander Mamonov was among those who caught Catherine's "gem disease." Around 1780, with the galleries of the Hermitage brimming with Old Master paintings, Catherine redirected her attention to building another world-class collection. It became a self-described affliction, a "species of gluttony that spreads like scabies."

The objects of Catherine's obsession were tiny gemstones, exquisitely engraved or carved with mythological and historical motifs. Known as glyptics from the classical Greek word "to cut," these gems fit neatly in the palm of Catherine's hand. "God knows the pleasure to be had from handling all these stones every day, and the endless knowledge to be gleaned from it," the empress confessed to Grimm.[1]

As a lover of glyptics, Catherine was following a long tradition. One of the oldest art forms in history, carved gems had been status symbols for discerning collectors since antiquity. First-century Roman poet and astrologer Manilius expressed their magical power: "Gems! In pursuit of

these stones, men will risk their all, Cross the width of the world, challenge the might of the sea."[2]

Intaglios—gems with incised or hollowed out designs—go back to the 4th and 3rd millennia b.c. in Mesopotamia and the Aegean. During Alexander the Great's reign, artisans also began producing a raised relief image, known as a cameo, by carving the background of the gem. Greek and Roman artists perfected intaglio engraving and cameo carving. The Hellenistic period (late 4th to 1st centuries b.c.) brought the discovery of new precious and semiprecious materials like aquamarine, garnet, and hyacinth. Polychromatic hardstone cameos were the most coveted. By working contrasting bands of color into intricate compositions, the best carvers evoked painting and sculpture.

During the Middle Ages, glyptics adorned jewelry and religious objects like shrines, reliquaries, and book covers. By the 15th century, antique cameos, carnelians, sardonyx, and other hardstone intaglios were unearthed from the ruins of ancient Rome and the eastern Mediterranean, becoming prized additions to antiquarian collections. After Pope Paul II's death in 1471, the Medici family bought his prestigious gem collection. When Lorenzo the Magnificent died in 1492, his finest cameos were valued several times more than his Botticelli paintings.

Like Lorenzo de' Medici, Catherine pursued the world's most coveted gems. She began her collection the year after her accession, buying a small cache of forty carved stones from the estate of court engraver and medalist Lorenz Natter. As she did with paintings, Catherine began acquiring entire glyptic collections, known as cabinets. In 1782, with the help of her diplomats and art agents, she bought important cabinets in Rome, Paris, and London. "My little collection of carved stones is such that yesterday four men had difficulty in carrying two baskets of jewel cases which contained barely half of the collection," Catherine boasted to Grimm. "To avoid misunderstanding I should point out that these were the same baskets we use to carry logs in winter."[3]

In 1785, Catherine talked Princess Dashkova, president of the Academy of Sciences, into exchanging a large part of the institution's carved gems for a mineralogical cabinet. The main prize was a spectacular cameo-encrusted gold cup—a diplomatic gift from the Queen of Denmark to Peter's wife Catherine

during their visit to Copenhagen in 1716. Sixteenth- and seventeenth-century engraved gems covered the three-footed cup from lid to base.

"As to the vase and its antiques," Catherine wrote Dashkova, "I will receive them only from your hands, and in exchange for the cases of natural history. . . ." Catherine ordered the cameos removed and placed in her gem cabinet, and the gold cup melted down.[4] From a detailed drawing from the 1730s, art historians have identified a number of the gems, including the Renaissance pieces *Nymph and Faun* in agatonyx, *Judgment of Paris and Phaeton in the Chariot of the Sun* in chalcedony and gold, and *Adam and Eve* in green sardonyx and gold.

Dashkova, who called herself "Catherine the Small," shared Catherine's passion for stones. Among her gifts were a 17th-century intaglio of Oliver Cromwell dressed as a Roman general and a sardonyx intaglio thought to be a 16th-century original. Catherine advised her differently. "I have just received your report and with it a magnificent gem, for which many heartfelt thanks," she wrote. "I accept it with the greatest pleasure . . . though with one reservation, my dear Princess—it is not really Michelangelo's famous antique gem, which, according to Montfaucon, belongs to the French royal cabinet. I think your information from Italy is not worth translating; I am not sure where the truth lies, but I for my part believe in my expert."[5]

In 1787, Catherine took her collection to a new level by acquiring the Orléans cabinet in Paris. Faced with gambling debts, Louis Philippe Joseph Duke d'Orléans (Philippe Égalité) published his family's illustrious gem collection in a sumptuous engraved volume dedicated to his cousin, Louis XVI. Writing Grimm that the dispersal would cause Philippe II to turn in his grave, Catherine begged her agent to stall the auction and negotiate for the 1,500-piece trove.

With the Orléans acquisition, Catherine became the proud owner of some of the world's most famous gems. The prestigious gemmae had been amassed by several generations, starting in the 16th century with Count Palatine Otto-Heinrich. In 1685, the count's granddaughter Elisabeth-Charlotte, Princess Palatine, inherited the collection and passed it on to the Dukes of Orléans with her arranged marriage to Philippe I, Duke d'Orléans, Louis XIV's younger brother (the Sun King invaded the Palatinate that year, destroying the castle where the cabinet was originally

housed). First cousin of England's George I, Elisabeth-Charlotte added another six hundred stones—ancient glyptics by master engravers along with Renaissance pieces.

In 1741, Elisabeth-Charlotte's grandson, Louis III, Duke d'Orléans, added further luster to the family cabinet by acquiring Pierre Crozat's 1,400 beloved gems. Three had belonged to Lorenzo de' Medici, including *The Head of a Greek Woman* in cornelian. Among Crozat's ancient masterpieces was the stunning 1st century cameo *Venus and Eagle* from the workshop of Alexandria carver Sostratus. Against a blue-black night sky, Sostratus carved Zeus as an eagle from a pale blue-gray layer. Venus, carved in white and pink layers, is shown embracing the eagle.

With the arrival of the Orléans cabinet, Catherine transferred her growing gemmae collection from the North Pavilion of the Small Hermitage to the Large Hermitage. To house the treasures, Catherine ordered five large identical oak and mahogany cabinets from cabinetmaker David Roentgen. Behind the adornment of rosettes, garlands, and ormolu were four rows of twenty-five drawers each to store the empress's "bits and pieces."[6] (Roentgen's cabinets are still used to store Catherine's carved gems at the State Hermitage Museum.)

Though Catherine prized her antique stones the most, she also assembled a large contemporary collection. Catering to the craze for everything neoclassical, Rome-based engravers made replicas of famous ancient gems and sculptures. Dominating the Rome gem trade was the celebrated Pichler family. Patriarch Antonio Pichler specialized in copying ancient gems. His son Giovanni followed in his footsteps, as did Giovanni's son Giacomo, and half brothers Giuseppe and Luigi. Of the dynasty, Luigi was the most renowned, enjoying commissions from the Vatican and French and Austrian courts. Naturally, Catherine was a huge fan.

In 1781, Catherine instructed fellow gem lover Prince Nikolai Yusupov to "Give the carved gems to be engraved to Pichler, Weder, and Marchand. The subjects? I shall note them on a separate sheet . . ."[7] Weder, a German engraver working in Rome, created fifteen pieces for the empress, including a sardonyx cameo of Peter the Great wearing a laurel wreath. Catherine also ordered portraits of herself from over a dozen other European masters and foreign and Russian engravers working in St. Petersburg. Over fifty of

these cameos and intaglios portraits of Catherine survive; some thirty are at the State Hermitage Museum.

When Catherine discovered the talented Brown brothers in 1786, her gem collection already neared 10,000 pieces. She bought 180 of the London engravers' cameos and intaglios—half their entire output. William favored portraits; his younger brother Charles preferred animal and sporting themes. Once or twice a year, the Browns shipped Catherine their newest miniature artworks. Playing to Catherine's love for antiquity, the brothers depicted historic events in allegorical form.

A two-layered pink-gray sardonyx cameo features a figure of the winged goddess of Victory (Russia) with her foot on a half-moon (Turkey); another has Catherine placing a wreath on the head of Potemkin, shown as a Roman general carrying a curved sword and half-moon. The striking golden brown topaz intaglio, *On Catherine's Recovery from Illness*, features Asclepius and Hygieia holding a medallion with the empress's portrait.

Known as "engravers of cupids," the Browns also sent Catherine over a dozen pieces starring the eternally young god of love. Catherine later acquired another charming Cupid from the Saint-Moryce collection through Alphones Miliotti. In the sardonyx intaglio *Cupid Sailing on His Quiver*, Romain-Vincent Jeuffroy shows young Cupid in a windsurfing pose, using one of his arrows as a mast. Jeuffroy, director of the Paris mint and knight of the Legion of Honor, was one of France's leading stone engravers.[8]

With demand for signed gems soaring, replicas passed off as originals became a serious problem for collectors. To address the issue, Catherine ordered over 5,000 casts of the most famous ancient and modern gemstones from Scottish chemist James Tassie. With Catherine's patronage, Tassie was able to gain access to more gem collections across Europe, eventually creating some 15,800 casts. He made two copies of each cast for Catherine, in white enamel and a colored glass that imitated the original gemstone. Arranged according to subject and chronology, Tassie's casts arrived in St. Petersburg between 1783 and 1788 in four special wood cabinets.

Catherine used Tassie's replicas both to learn about her competitors' collections and check her acquisitions. This proved invaluable in 1786 when she bought half the collection of Lord Algernon Percy from Alnwick Castle, Northumberland. By consulting Tassie's casts from Alnwick,

Catherine discovered the Earl had "kept back several good stones" she'd paid for.[9] "We have cabinets with a number of drawers designed for carved gems which you wish to augment by adding the items from the Orleans collection," she wrote Grimm. "But beware of a substitution, such as already happened to us in the case of Percy. Now we have the collection of casts by Tassie which will easily reveal such a fraud."[10]

As Catherine's secretary Adrian Gribovsky describes, the empress incorporated cameos into her daily routine. "On normal days in the Winter Palace the Empress would rise at seven and work in her mirrored study until nine, mostly composing statutes for the Senate. At ten she would go to her room . . . for an audience until twelve. The Empress would then go to her small study to dress her hair. This lasted no longer than a quarter of an hour. At this time her grandchildren came to wish her good day," he wrote.

"After dressing she spent the time until lunch reading books or making molds of cameos which she sometimes presented as gifts. At two o'clock she would sit down at table. After lunch she read her foreign correspondence, worked on legislation or copied her cameos. The evening assembly began at six o'clock in her apartments or the Hermitage Theater. By ten everyone had left and by eleven the Empress had retired for the night."[11]

In addition to Alexander Mamonov, Catherine's daughter-in-law caught her "cameo fever." With the help of imperial gem cutter Karl von Leberecht, Maria Feodorovna became an accomplished carver. For Catherine's sixtieth birthday, the grand duchess gave her a veined gray-pink Siberian jasper cameo depicting her as Minerva in a helmet topped with a laurel wreath and winged sphinx. On another occasion, Catherine was thrilled with her daughter-in-law's "charming and touching" opaline glass cameo featuring carved profiles of her "adorable children."

In September, Catherine sent Grimm engravings of Maria Feodorovna's cameo. "Here, long-suffering Sir, are two prints of the six urchins, who are growing before one's very eyes. In body, as in heart and spirit, Monsieur Alexander is of a rare beauty, goodness and understanding; lively and composed, quick and reflective, with deep thoughts and singular ease in all he does . . . in a word, that boy is a mass of contradictions, which makes him peculiarly dear to all around him. . . . When Alexander is ill . . . he surrounds himself with the arts: engravings, medals and copies of intaglios are his amusements."[12]

CHAPTER THREE
RUSSIA'S PARADISE

With Catherine happily involved with Mamonov, Potemkin resumed his work incorporating the southern territories into the Russian Empire. In preparation for annexing the 18,000-plus square mile Crimean peninsula, Potemkin had weakened the Muslim Tatars by arranging for a mass migration of Greeks, Armenians, and Georgians. To help protect the newly settled territories, Potemkin also lured Albanians, Italians, and Corsicans. Potemkin and other Russian officials had received large parcels of land—now Russian serfs worked their orchards and vineyards.

As Catherine seized territory, she secured the loyalty of local elites by granting them nobility. In 1785, Don and Zaporozhets Cossacks became members of Russian nobility for the first time; Crimea's Tatar aristocracy also received full privileges of Russia's nobility, something that had been denied to them for centuries. ". . . [N]o other state on earth contains such a variety of inhabitants," declared academician Heinrich Storch. "Russians

and Tatars, Germans, Mongols, Finns, and Tungus, live in an immense territory in the most varied climates . . . one seeks in vain another example in the history of the world."[1]

With the end of the Crimean Khanate, Potemkin built cities and naval bases for the new Black Sea fleet at Kherson, Nikolaev, and the Bay of Sebastopol. He named the new cities after the ancient Greek colonies along the Crimean coast settled in the 9th to 6th centuries B.C. Per Catherine's instruction, Potemkin also began tapping the region's agricultural potential, importing cattle, silkworms, and mulberries and planting melons, grapes, and botanical gardens. Throughout Potemkin's nine years in the south, his enemies often questioned his efforts, some suggesting he'd appropriated vast sums of money while accomplishing little militarily. Now Potemkin couldn't wait to show off his achievements to Catherine and the rest of the world.

To celebrate Catherine's silver jubilee, Potemkin organized a public relations extravaganza for the spring and summer of 1787. Traveling by land and water, the imperial party would visit New Russia, Kherson and Ekaterinoslav (today's Dnepropetrovsk), and the Crimea, including the old Khanate capital and new naval port at Sebastopol. As Robert Massie puts it, Catherine's 4,000-mile itinerary represented ". . . the longest journey of her life and the most spectacular public spectacle of her reign."[2]

With just a year until the tour, Catherine dispatched Charles Cameron to remodel the decrepit Bakhchisaray Palace in the Crimea's ancient capital. Built in the first half of the 16th century as a smaller version of Istanbul's Topkapi Palace, the palace had been home to a succession of Crimean khans. The walled enclosure contained a mosque, harem, cemetery, living quarters, and gardens. According to Potemkin's biographer, the palace was "a compound of Moorish, Arabian, Chinese and Turkish architecture, with fountains, little gardens, paintings, gilt ornaments and inscriptions in every corner."[3] Cameron redid the palace, preserving the original style.

On January 7, 1787, Catherine led a convoy of fourteen sledges out of snowy St. Petersburg. Another 124 smaller sleighs and sledges followed that morning, carrying a support staff of doctors, musicians, cooks, laundresses, hairdressers, silver polishers, and servants.[4] Besides Mamonov, passengers riding in Catherine's six-seat carriage included Master of the Horse

295

Lev Naryshkin, chief chamberlain Ivan Shuvalov, and lady-in-waiting Anna Protosova. To the enormous relief of Paul and Maria Feodorovna, Catherine did not abscond with ten- and eight-year-old Alexander and Constantine, who'd come down with chicken pox. Also absent was Frederick the Great's nephew and successor Frederick William, whom Catherine disliked.

During the long winter nights, a coat of snow and ice was applied to the roads so sledges could travel at great speed. Comte de Ségur, who described the journey in his memoirs, compared the vast snow-filled plain to "a frozen sea" and their carriages to "fleets of light boats." When the sun disappeared each afternoon, Potemkin ordered that blazing torches light the way. ". . . [T]here were raised enormous pyres of firs, cypresses, birches, pines, that had been set aflame; so we traveled through a route of fires more brilliant than the rays of daylights. It was thus that the proud *autocratice* of the North, in the middle of the most somber nights, wished and commanded, *Let there be light.*"[5]

A crop failure had caused widespread famine among Moscow's peasants. For Catherine's stop, Potemkin made sure that beggars were driven out of the city.[6] Traveling southwest toward Kiev, Catherine and her entourage passed Potemkin's Krichev estate. By late January, they reached Kiev, located on the high west bank of the Dneiper River. To house the large imperial party, Potemkin built mansions for Catherine's "pocket ministers"—Cobenzl, Ségur, and Fitzherbert.[7] Future Venezuelan dictator Francisco de Miranda became part of the entourage, along with Belgian-born Prince Charles de Ligne, Joseph II's witty fifty-year-old field marshal. Potemkin and his retinue also arrived from the south, moving into the massive medieval Monastery of the Caves.

While waiting for the ice to melt on the Dneiper, Catherine amused herself by playing whist with Mamonov and Ségur. In April, she sat for her portrait by Potemkin's talented serf, Mikhail Shibanov. To keep the artist sober, court engraver James Walker reportedly had to lock him in his room. The resulting half-length *Catherine II in Travelling Costume* portrays the empress wearing a red coat with gold embroidery, lace collar, and sable fur hat with a gold tassel. Despite the realistic middle-age portrayal with double chin and gray hair, Catherine loved it. She gave several copies of

Walker's engraving to relatives and foreign dignitaries and had the portrait copied in enamel by court miniaturist Peter Zharkov.[8]

Kiev's ethnic melting pot included Don Cossacks, Tatars, Kirghiz tribesmen, and Kalmucks. While Catherine called the city "abominable," Ségur was more poetic. "It was like a magic theatre where there seemed to be combined and confused antiquity and modern times, civilization and barbarism, finally the most piquant contrast of the most diverse and contrary manners, figures, and costumes," wrote the Frenchman.[9]

Russia had gained most of modern day Ukraine in the first Russo-Turkish War. For centuries, Ukraine had been conquered and divided by the Polish, the Austrians, and the Russians. After her troops swept into Ukraine's southeast to fight the neighboring Ottoman Empire, the region became known as "New Russia." To glorify Catherine's presence, Potemkin erected her statue in Odessa, another of his new cities. Initially, Catherine controlled the fertile eastern Ukraine, where she developed vast coal and iron industries to feed Russia's expansion. Later, Russia grabbed the forested west as well.

In late April, after a six-week wait, Catherine and her entourage boarded seven red and gold Roman-style galleys embellished with double-headed eagles. Built to Potemkin's specifications, each vessel was equipped with its own orchestra. Catherine's galley, the *Dnieper*, featured a sumptuous bedroom decorated in gold and scarlet silk brocade, along with a drawing room, library, music room, and dining room. Before setting sail, Catherine invited fifty guests to a bon voyage party aboard the *Dnieper*. They dined on the Imperial Porcelain Factory's luxurious Yacht Service, featuring a medallion with a two-headed eagle holding a laurel wreath and the flag of the Russian merchant marine.

By late afternoon "Cleopatra's fleet," as Ligne called it, was on its way, sailing downstream. The seven galleys were followed by eighty smaller vessels carrying a 3,000-person support staff. That evening, another small group of guests were rowed to the empress's galley for dinner.[10] Six days later, Catherine's flotilla anchored off Kaniev, where the Dneiper's east bank belonged to Russia and the west bank to Poland. It was here, after twenty-eight years apart, that she met her former lover, 56-year-old Stanislaus Poniatowski.

The couple had parted after the death of their infant daughter and discovery of their affair by Empress Elizabeth and Peter III. Five years later, Catherine installed the handsome aristocrat as her puppet king in Poland. Before the summit, Potemkin traveled twenty-eight miles to Chwastow to meet the king. Donning his Polish uniform and orders, Potemkin got Stanislaus to agree to a treaty to support Russia in the event of another war with the Turks. Personally, he was also looking after his new two-million-ruble investment—300,000 acres in Poland abutting Russian territory where he wanted to establish a feudal principality. According to Simon Sebag Montefiore, this vast property was Potemkin's safety net in the event that Catherine's son Paul came to power.[11] The grand duke, who hated Potemkin, had already threatened him with imprisonment. In return, Stanislaus wanted Russia's agreement on reforming the Polish constitution. What he got instead was an audience with Catherine.

Poland's king was rowed to the *Dneiper*. To Stanislaus's great disappointment, his reunion was limited to a private half-hour talk and dinner with the empress. Despite pressure from Potemkin, Catherine could not be persuaded to attend the ball Stanislaus had planned in her honor at a palace specially built for her visit. Instead she and Mamonov watched the fireworks from her private deck. Prince de Ligne remarked sarcastically: "He [Stanislaus] spent three months and three million to see the empress for three hours."[12]

Downriver at Kherson, Joseph II was waiting for the entourage. Unlike Catherine, the emperor traveled light with just a single equerry, two servants, and little luggage. Catherine welcomed his arrival as an opportunity to strengthen her new alliance with Austria. Joseph weighed in on Catherine's new lover: "The new favorite is good-looking, but does not appear to be very brilliant and seems astonished to find himself in this position. He is really no more than a spoiled child."[13]

From Kherson, Catherine and Joseph traveled together by carriage to Ekaterinoslav (Catherine's Glory, today's Dniepropetrovsk). With the help of Ivan Starov, Potemkin envisioned a grandiose southern capital with a naval academy, music conservatory, Orthodox college, and a dozen factories for wool and stockings using silk produced at Crimea's mulberry plantations. The grandeur and scale of Potemkin's overly ambitious city

invited derision from political opponents and observers. It didn't help that Potemkin hired Italian musicians for the conservatory before the city was even built. Among those who considered Potemkin's future capital a pipe dream was Joseph II. After joining Catherine in laying the foundation stone for the city's cathedral, he wrote a friend in Vienna: "I performed a great deed today. The empress laid the first stone of a new church, and I laid—the last."[14]

Potemkin's detractors need only to have looked at Kherson, twenty miles up the estuary from the Black Sea, for evidence of Potemkin's capabilities. By 1787, Potemkin had transformed the marshy region into a fortified city with churches, public buildings, barracks for 20,000, houses, shops, and a shipyard. The centerpiece was his own enormous four-story palace, one of his many residences throughout the south (these included a mosque-like palace in Nikolaev and Starov's pink marble palace at Karasubazaar). Over Kherson's entrance, Potemkin installed an arch emblazoned with the Greek inscription: "This is the way to Byzantium." As the imperial entourage arrived, over one hundred ships were riding at anchor in the port. During their visit, Catherine and Joseph launched three warships.

Russia's minister in Constantinople joined the party, reminding Catherine that the Ottoman Empire had never accepted Russia's annexation of the Crimea. Originally, Potemkin planned for the flotilla to proceed down the estuary from Kherson all the way to the Black Sea. But the Turks had other ideas, sending four men-of-wars and ten frigates to guard the estuary. The imperial party continued by carriage.

By late May, Catherine and her entourage arrived in Bakhchisaray, the balmy former capital of the Crimean Khanate. Lanterns were placed strategically so that during her two-night stay, the empress felt she was in a "mythical Arabian palace." While she entertained Joseph II and the local muftis, Catherine put herself in the hands of a Tatar honor guard. "We beheld a numerous body of Tatar cavalry, richly clothed and armed, who appeared before the Empress in the character of guard of honor," wrote Ségur. "That Princess, whose ideas were all grand, elevated and bold, had come to the resolution that, during her sojourn in the Crimea, her escort should always be composed of Tatars, of men disdainful of her sex, constant enemies to Christians, and recently subjugated by her."[15]

SUSAN JAQUES

About the "Moorish, Arab, Chinese and Turkish" Bakhchisaray Palace, Prince de Ligne commented: "I don't know anymore where I am, or in what century I am." Ségur meanwhile fantasized he was a pasha. Unable to sleep "amidst the infidel and the faith Mohammedan," Catherine penned a poem to Potemkin from the "summer-house of the Khan": ". . .Oh, miracles of God! Who amongst my kin of yore Slept calmly, free from the Khans and their hordes? And disturbed from my sleep amidst Bakhchisarai By tobacco smoke and cries . . . Is this place not paradise? Praise to you, my friend! This land you did seize, Secure it now with your vigilance, as you please."[16]

After two nights in Bakhchisaray, Catherine's entourage left for Sebastopol. In nine years, Potemkin had assembled a Black Sea fleet at Kherson and a shipyard at Nikolaev—altogether an estimated two dozen battleships. Along with the roughly three dozen Baltic Fleet ships, Russia's navy now rivaled that of Spain. To house the new fleet, Potemkin constructed a naval base at Sebastopol. After Potemkin proudly showed off his creation, Joseph II declared it the most beautiful port he'd seen.

Meanwhile, Prince de Ligne traveled east of Sebastopol to visit his new estate, a gift from Catherine. The property was once part of the ancient Greek colony Chersonesus, where Iphigenia, daughter of Agamemnon and Clytemnestra, was believed to have served as a priestess. Surrounded by fruit orchards and olive trees, Ligne considered staying at what he described as "the most beautiful and interesting place in the world."

Throughout the journey, Catherine and her retinue only disembarked at picturesque tableaus. Thanks to landscape architect William Gould, dubbed the "Emperor of Gardens," port stops bloomed. On one occasion, a replica of Mount Vesuvius erupted in spectacular fireworks. "Towns, villages, country houses, and sometimes rustic cabins were so ornamented and disguised by arches of triumph, by garlands of flowers, by elegant decorations of architecture, that their aspect completed the illusion to the point of transforming them, to our eyes, into superb cities, into palaces suddenly constructed, into gardens magically created," wrote Ségur.[17]

At Balaklava, south of Sebastopol, Potemkin delighted Catherine with an "Amazon company." A troop of rifle-toting Greek women were dressed in raspberry velvet skirts, green velvet jackets, and white gauze turbans with ostrich feathers fringed in gold. The Amazon company, along with

elaborate façades and singing locals, were all part of a show Potemkin staged for Catherine and her entourage in the south. In reality, he still had quite a lot of work ahead of him. The stage sets inspired the famous expression "Potemkin villages"—recently used to describe Vladimir Putin's Olympic village at Sochi.

At the end of the trip, Joseph II took a walk with Ségur. "What a singular journey," he told the French envoy, ". . . and who would have dreamt of seeing me with Catherine the Second and the ministers of France and England, wandering in the desert of the Tatars! It is altogether a new page in history." But Ségur saw the experience more as drama than history. "It appears to me," he replied, ". . . rather like a page from the Arabian Nights' Entertainments, and that I am walking with the caliph Haround-al-Raschild, who, according to his custom, is disguised."[18]

En route back to St. Petersburg, Potemkin staged a splendid finale—a reenactment of the Battle of Poltava in the Ukraine where Peter the Great defeated Charles XII. Two weeks after Catherine said goodbye to Potemkin, she received his request: "The Yetakerinoslav Province and the Tauride region possess excellent lands, yet they lack the inhabitants to cultivate them, and these beautiful places remain uninhabited. Since it is my duty to care for the welfare of Your Majesty's lands entrusted to me, I dare to solicit from the senate a Royal Edict whereby subjects desirous of moving to this province and to Tauride from throughout the provinces be sought . . ."[19]

Though the main purpose of the Crimea voyage was to intimidate the Turks and impress Europe, Catherine also used the trip to bolster support and loyalty among Russia's nobility. During her provincial stops, Catherine gave out a half a million rubles in jewelry, including watches, rings, and some four hundred gold snuffboxes adorned precious stones and enamel.[20] Though snuff was waning in popularity, snuffboxes continued to be fashionable status symbols.

Catherine's last stop was Tula, 125 miles south of Moscow. After Peter the Great founded the State Armory here in 1712, the city had become the main supplier for the Russian army. The munitions maker had expanded its production to include highly prized decorative objects. By cutting steel into "diamond facets" and burnishing and decorating the steel with

bronze-gilt, gold, silver, and copper, Tula craftsmen produced sparkling furniture, mirrors, samovars, and candlesticks. In 1775, Catherine merged her large Tula collection with the imperial crown jewels in one of her new galleries at the Winter Palace. Among the exceptional objects was a steel chess set with knights resembling sea horses and kings and queens topped with spired cupolas.

Now Catherine accepted the factory's gift of a writing set, armchairs, tables, and candelabras and placed an order for several more items. "On the road to Moscow, we saw nothing more beautiful than the city of Tula which can be considered as one of Catherine's works, so much has she done to beautify it," wrote Ségur. ". . . [T]hanks to the Empress's impetus, this branch of production has been brought to such a high degree of perfection that it quite easily rivals the English factories. Her Majesty gave us gifts of works from the Tula factories, all made with the greatest of artistry."[21]

From a triumphal arch and fireworks to lavish banquets, Tula's nobility went to great lengths to welcome their empress. But when Catherine failed to show up at festivities, the organizers were stunned. It turns out that the guest of honor had just received bad news. The fragile peace treaty between Russia and the Ottomans had broken down. For the second time in Catherine's reign, the Ottoman Sultan declared war on Russia. Catherine's triumphant Crimea trip, combined with Russia's new fleet of warships and naval bases, had been viewed as an implicit threat to Constantinople. Under Austria's secret treaty with Russia, Joseph was also obligated to declare war on the Turks.

CHAPTER FOUR

BETRAYALS

Perhaps as a diversion from the new war, Catherine encouraged her closest friends to write one act comedies based on familiar proverbs. ". . . [I]t rains them here and we have decided that it's the unique means to restore good comedy to the theatre," she wrote Grimm.[1] Some seventeen of these comedies, including several by Catherine herself, were published and performed for a small audience at the Hermitage Theatre.

Eager to surprise Alexander Mamonov, Catherine arranged for an English theatrical troupe to stage a performance in his apartments. He also hosted a production of one of Catherine's plays in French. True to form, Catherine showered Mamonov with titles and gifts. From a promotion to premier major of the Preobrazhensky Guards, Redcoat was elevated to the rank of lieutenant general by May 1788 and count of the Holy Roman Empire. Catherine's largesse extended to Mamonov's family; she promoted his father to the Senate and sent a jeweled snuffbox to his mother.

Catherine's other extravagant gifts for Mamonov included a silver dinner service acquired from British ambassador Alleyne Fitzherbert, a team of English horses bought for 2,000 rubles from Procurator-General Viazemsky, and a jeweled walking stick. Reportedly unhappy with the last gift, Mamonov confided to a friend that he really wanted to join the Order of St. Alexander Nevsky. Ten days later, Catherine bestowed the prestigious award.

With Russian troops battling the Turks in the south, Gustav III decided it was a good time to test his cousin's strength and try to retake land lost early in the century to Russia and Peter the Great. In June 1788, against the advice of his naval commanders, the Swedish fleet attacked Russian naval ships in a bid to control the Baltic and land forces near St. Petersburg. ". . . [T]he behavior of this treacherous sovereign [Gustav] resembles madness," Catherine wrote Potemkin as Russia declared war on Sweden.[2] In the fight with Gustav, Russia got help from Denmark, whose troops marched from Norway into western Sweden. After Russia's Scottish Admiral Samuel Grieg bottled up the Swedish fleet in Sveaborg in July, Catherine received a letter from a group of Swedish officers proposing peace negotiations. Gustav managed to crush the mutiny, halt any negotiations, and the unpopular war continued.

Like Catherine, Gustav loved the theatre, writing, and acting in plays. But there was one production he would not have appreciated. In late January 1789, Catherine and her coterie gathered at the Hermitage Theatre for the premiere of her political satire, *The Woeful Knight Kosometovich*. The story-line alluded to the Russo-Swedish War; the main character was a parody of Gustav as a cowardly wannabe knight.

"The person of Gustavus III was disguised in a grotesque manner," wrote Ségur. "He was exhibited in the form of a blustering captain, a dwarfish prince. This searcher for adventures . . . was represented selecting, in an old arsenal, the armor of an ancient and celebrated giant, whose helmet, when placed upon his head, would come down to his belly, whilst the boots would reach his waist. . . . the Empress, who received many awkward and insipid compliments . . . might, I trust, have discovered by my countenance, as well as by my silence, how much I felt grieved at seeing so great a Princess demeaning herself in this manner."[3]

Another member of Catherine's circle also disliked her latest comic opera, but for a different reason. After two years in the south, Potemkin returned to St. Petersburg in late February 1789. After watching the third performance of *The Woeful Knight*, he pulled the curtain, warning Catherine that it would infuriate Gustav and prolong the war. The next day, Catherine withdrew the satire from Russia's public theatres; it was not performed again for over two centuries.

Potemkin remained in the capital for three months, procuring provisions and planning his next campaigns. He intended to place Russian ground forces on the offensive, directing them against the Turks in Bessarabia. After bolstering Russia's fleet, he also planned to engage the Turkish navy. Sultan Abdul Hamid I died in March, succeeded by the more bellicose young Selim III. On May 6, Potemkin left Tsarskoe Selo to lead the battle in the south.

That same month, the Polish Diet seized an opportunity to get out from under Russia's thumb, raising an army of 100,000 men and ordering Russian troops to leave Poland immediately. Resentment against Russia had been growing since the 1772 partition of Poland. Against warnings by Stanislaus Poniatowski, the Diet confederated and adopted a majority vote for decision making. With her troops stretched to the limit across both northern and southern fronts, Catherine's hands were tied. She pledged to deal with the ultimatum later. In the face of the growing patriotic move- ment, Stanislaus Poniatowski attempted to carve out a new role for himself, eventually influencing Poland's new constitution in 1791.

Meanwhile, France's monarchy was facing its biggest challenge—this time from the inside. Despite ruinously onerous taxes, France's treasury was empty, drained in part by the latest war with England. The majority of the French was fed up with the gluttonous lifestyle of Louis XVI, along with his courtiers and ministers. A grain shortage caused by poor harvests had caused bread prices to skyrocket, triggering unrest in the cities and leading to famine. While George Washington was taking the presidential oath, the Estates-General met at Versailles for the first time in 175 years. Though Louis doubled the number of representatives for the Third Estate, or commoners, each Estate continued to have one vote. Ninety percent of France's 27 million citizens had the same voting power as the 10 percent of nobles and clergy.

With wars raging against the Swedes in the north and Turks in the south, as well as insubordination in Poland, Catherine experienced a personal crisis. She'd chosen Alexander Mamonov as her lover, hoping he'd turn out like her beloved Lanskoy. Because her new favorite was "clever as the very devil" as well as handsome, Catherine occasionally consulted him on political matters. After a year and a half, the relationship turned frosty. Mamonov, who was rarely allowed out of Catherine's sight, compared court life to "surviving in the jungle."[4] With Mamonov "cold and preoccupied," the empress spent her sixtieth birthday by herself. In early June, Catherine decided to let her lover of three years loose, suggesting he marry one of the richest heiresses in Russia. That's when the ball fell. Mamonov wrote back, confessing to a yearlong, secret affair with Catherine's maid-of-honor, Princess Daria Shcherbatova.

"I nearly collapsed from shock," Catherine wrote Potemkin, "and I had still not recovered when he entered my room, fell at my feet and confessed to me his entire intrigue. . . . I said to him . . . that I did not stand in the way of anything, and that I was only offended that for one whole year instead of deceiving me he hadn't told me the truth, and that if he had he would have spared me, and him too, much grief and worry. . . ."[5] To add insult to injury, Mamonov and Shcherbatova had enjoyed a romantic rendezvous at Dubrovitsy, a luxe estate near Moscow which Catherine had given Potemkin.

Catherine put on a brave face a week later when Mamonov married his pregnant 26-year-old lover at the palace church at Tsarskoe Selo. "After marrying Princess Shcherbatova on Sunday, Count Aleksandr Matveevich Dmitriev-Mamonov departed on Monday with his spouse for his parents," Catherine reported to Potemkin, "and were I to tell you everything that happened during these two weeks, you would say he has gone completely mad; . . . imagine, there were signs that he desired to remain at court with his wife just as before, in short, a thousand contradictions and contradictory ideas."[6]

Potemkin was among the many courtiers who knew about Mamonov's affair. He'd kept it from Catherine—both to protect her from humiliation and to serve his own purposes. In response to Mamonov's letter asking to be freed from the relationship the previous year, Potemkin replied: "It is your

duty to remain at your post. Don't be a fool and ruin your career."[7] Now Potemkin tried to comfort Catherine: ". . . he [Mamonov] is a combination of sloth and selfishness. Because of the latter he became an extreme Narcissus. Thinking of no one but himself, he demanded everything without giving anything in return; being lay he even forgot decency . . . why keep him here with his wife who is an execrable schemer? You did very well in sending him to Moscow. . . ."[8]

Mamonov's betrayal hurt more than Catherine acknowledged. Ivan Rimsky-Korsakov's affair with dear friend Countess Bruce was still a painful episode after a decade. She was no longer the beauty who dazzled courtiers and foreign envoys twenty-five years earlier. Though Catherine's complexion was still good and she kept her white hair coiffed, she'd become extremely overweight, with swollen legs. "Though seventy years of age, Catherine still retained some remains of beauty," observed Charles Masson, author of the controversial *Secret Memoirs*. "Her hair was always dressed in the old stile of simplicity, and with peculiar neatness. . . . She was of middle stature, and corpulent; few women, however with her corpulence, would have attained the graceful and dignified carriage for which she was remarked. In private, the good-humour and confidence with which she inspired all about her, seemed to keep up an unceasing scene of youth, playfulness, and gaiety."[9] At the same time, Masson wrote scathingly about her two passions—". . . the love of men which degenerated into licentiousness; and the love of glory, which sank into vanity."[10]

A younger Catherine had written in her *Memoirs*: "I cannot live one day without love."[11] This still held true decades later. Within days of discovering Mamonov's affair, the sixty-year-old empress noticed a swarthy 22-year-old officer in the Horse Guards. Catherine's introduction to young Platon Zubov was not by chance. The young man had been planted by two of Potemkin's foes—distant relative Field Marshal Nikolai Saltykov, vice president of the War College, and Catherine's confidante Anna Naryshkina, sister-in-law of Lev Naryshkin. By early August, Catherine told Potemkin she'd returned to life after a long winter slumber. "I'm well and merry and have revived like a fly in summer."[12] Potemkin did not attach much importance to the newest favorite, described by contemporaries as medium in stature, polite, and fluent in French.

Like her fellow monarchs, Catherine reacted with outrage to the events in Paris, even though Franco-Russo relations had never been terribly friendly. Nevertheless, a threat against a monarchy in this fashion stoked fear in the hearts of monarchs across the continent. After the Third Estate defected, Louis XVI had no choice but to order the nobles and clergy to join the newly formed National Assembly. But worried about the Assembly's growing radicalism, Louis gathered troops outside Paris, sparking a demonstration at the Palais Royal. In response, Parisians scoured the city for arms. On July 14, when guards at Bastille refused to open the gates, the crowd stormed the prison.

After English statesman Charles James Fox declared the fall of the Bastille "the greatest event to ever happen in the World," Catherine removed his bronze portrait bust from between those of Cicero and Demosthenes in the Cameron Gallery at Tsarskoe Selo. The bust wasn't worth selling, Catherine confided to Princess Dashkova, because she couldn't even get 30 rubles for it.[13] British political cartoonist James Sayers Patriot published a caricature of Catherine removing Fox's bust with the Demosthenes and Cicero fleeing.

CHAPTER FIVE

FRENCH MADNESS

W hile worrying that unrest abroad might reignite tensions between the classes at home, Catherine found diversion in her new lover. As usual, it was important she get Potemkin's blessing on Platon Zubov, and she enclosed his flattering letters with hers. "I know that you love me and would not offend me in any way," she wrote Potemkin in early July. "And just think what a fatal condition for my health I might be in without this man. Farewell, my friend, caress us, so that we can be completely happy."

A month into their relationship, she described Zubov like one of her grandchildren: "We have a kind heart and a most agreeable disposition, without malice and cunning, and a very determined desire to do good. We have four rules which we try to keep, namely: to be loyal, modest, devoted and extremely grateful . . ."[1]

The 22-year-old had his own rule—reaping maximum benefit for himself and family members while he could. Potemkin promoted Zubov's

older and younger brothers Nikolai and Valerian to officers. According to Simon Sebag Montefiore, Zubov spent hours in front of a mirror having his hair curled, and watched in amusement while his pet monkey humiliated respected petitioners by pulling off their wigs.[2]

August 1789 proved a good month on both the romantic and military fronts for Catherine. Russia's army won an important victory against the Turks at Fokshany; after a fourteen-hour battle, its navy took seven Swedish ships at Svenskund. More victories followed that fall, culminating in the capture of Bender from the Turks. By mid-month, just as the French National Assembly was passing the Declaration of the Rights of Man and of the Citizen, Catherine developed severe colic. After a long convalescence in bed with chamomile pillows placed around her, Catherine wrote to Grimm, predicting Louis XVI's fate. By October, Parisian women led a mob to Versailles and forced the royal family back to Paris and house arrest at the Tuileries Palace.

The stress from France's anti-monarchial crisis and fighting two simultaneous wars began to take a toll on Catherine's health. In early December, she suffered another bout of colic. At year-end, after learning about a secret alliance between Prussia and the Ottomans, Catherine told her secretary, "Now we are in a crisis; either peace or a triple war with Prussia."[3] On top of this development, in early February, Joseph II died after an agonizing operation for an anal abscess. His successor and brother Leopold was not a fan of Catherine's territorial expansion.

By the following May, fighting between Swedish and Russian fleets came so close to Russia's coast that Catherine heard the ships' guns all day. The empress kept calm by translating Plutarch into Russian with Platon Zubov.[4] At month end, Catherine traveled to Kronstadt via Peterhof, where cannon fire rattled the windows. "We've pulled one paw out of the mud," Catherine wrote Potemkin about the grueling final months of the Russo-Swedish War. "Once we pull out the other, we'll sing Hallelujah."[5]

But it was too early to celebrate. In May 1790, Alexander Radischev published *Journey from St. Petersburg to Moscow* anonymously. Calling Catherine's Enlightenment a sham, the aristocrat declared that Russia would remain barbaric until serfs were freed and predicted a far worse uprising than the Pugachev Rebellion if reforms were not made. His

scathing depictions of serfdom and government corruption drew the wrath of Catherine, who called the author "a rabble-rouser, worse than Pugachev . . . inciting the serfs to bloody rebellion."[6]

Catherine ordered *Journey* confiscated and destroyed. Of the original 650 copies, only 17 survived to be reprinted in England five decades later. In addition to writing rebuttals in the margins of her copy, she penned the ten-page *Notes on the Journey*. "The purpose of this book is clear on every page," she wrote, "its author, infected and full of the French madness, is trying in every possible way to break down respect for authority and for the authorities, to stir up in the people indignation against their superiors and against the government."[7] After his arrest and imprisonment in the Fortress of St. Peter and St. Paul, Radischev was sentenced to death for sedition. Disowning his book, Radischev begged the Catherine for forgiveness. But it was Potemkin who would save him from execution.

Though Radischev had depicted Potemkin as an oriental tyrant, he urged Catherine to show leniency. "I've read the book sent to me. I am not angry. . . . It seems, Matushka, he's been slandering you too. And you also won't be angry. Your deeds are your shield." In honor of the peace treaty with Sweden, Catherine commuted Radischev's death sentence to a decade of exile in Ilimsk, eastern Siberia (she also revoked his status as a member of the gentry, rank in the service, and order of knighthood). After Count Alexander Vorontzov, brother of Russia's ambassador to England, intervened on behalf of his lifelong friend, Catherine allowed Radischev to make the two-year, 4,500-mile journey to Siberia without chains.

Ironically, not long before *Journey* was published, Catherine had named its author chief of St. Petersburg's Custom House. Born into a minor noble family on an estate just outside of Moscow, Radischev's father was known for treating his three thousand serfs humanely. Thanks to family connections, Radischev became a page in Catherine's court in 1765. After the first Russo-Turkish War, Radischev received an honorable discharge with a rank of second major. He married and resumed his civil service career, enjoying a series of promotions and honors. In 1785, Radischev was made a Knight of the Order of St. Vladimir.

Catherine's early enthusiasm for progressive ideas and a humane legal system proved fleeting. In 1787, she had ordered a raid of bookstores across

Russia to impound seditious titles. Censorship, including works of her idol Voltaire, became harsher and more repressive. By April 1790, Catherine issued orders to stop the spread of the "epidemic" of new ideas. The same year, Catherine advised Marie Antoinette that she and Louis should show indifference to recent political events. "Kings ought to go their own way without worrying about the cries of the people, as the moon goes on its course without being stopped by the cries of dogs."[8]

Meanwhile Austria's Leopold II signed the Convention of Reichenbach establishing an armistice between Austria and the Ottoman Empire. Over in Prussia, Frederick William's next move was a defensive alliance with Poland. He deployed 40,000 Prussian soldiers toward Livonia in the north and 40,000 more in Silesia. Armed with this false sense of security, the Diet adopted a new constitution in May 1791 aimed at weakening the old nobility. Under the new political structure, Stanislaus would rule until his death, at which time the Polish crown would pass back to his predecessors, the electors of Saxony.

In August, after a series of losing battles that summer, Gustav III ended his costly two-year gamble by signing the Treaty of Värälä in Finland. Though Gustav didn't get the territory he sought, he succeeded in gaining Russia's formal recognition of his sovereignty and government. The meaningless war caused heavy human losses on both sides. But what was clear is that Catherine's alliances and hold over neighboring European powers were no longer what they once were.

CHAPTER SIX

CURTAIN CALL

A decisive moment in the second Russo-Turkish War came in late December 1790 when Russian troops stormed and captured the fortress of Ismail in Bessarabia. Turkish forces inside the fortress had been given an order to stand their ground to the end. Gavriil Derzhavin glorified the event with Russia's first national anthem. "Let the thunder of victory sound!" he wrote, with the refrain "Hail to you for this, o Catherine Gentle mother to us all!"[1]

In early January 1791, Étienne-Maurice Falconet, creator of the Peter the Great equestrian monument, died in Paris. The sculptor's son, Pierre-Étienne Falconet, died just five months later. Marie-Anne Collot, who'd nursed the elder Falconet after a debilitating stroke, retired to Lorraine and never returned to sculpting. Catherine would write Grimm that she'd been so affected by the French Revolutionary army's victory at Valmy that she could hardly pay attention to the sculptor's death.[2]

Potemkin returned to the capital in late February, hoping to contain Count Nikolai Saltykov's influence at the War College and counter Platon Zubov's growing political power. Punning with the word *zub*, Russian for tooth, Potemkin likened Catherine's favorite to an irritating molar that needed to be removed.[3] But these plans were interrupted. Weeks after Potemkin's arrival in St. Petersburg, he and Catherine were faced with another urgent situation, the Ochakov crisis.

After watching Russia's land grab in the Ukraine and Crimea, Britain and Prussia issued a joint ultimatum. If Russia did not make peace with the Ottomans within ten days, the Royal Navy would sail for the Baltic and Black seas and Prussian troops would march into Livonia, where some 90,000 troops were gathering. Initially, Catherine refused to compromise Russia's war gains. But after weeks of arguing with Potemkin, she agreed to negotiate with Prussia and Britain while secretly ordering him to prepare for war with both. Fortunately for Russia, faced with strong opposition in Parliament, William Pitt was forced to withdraw his ultimatum in early April. The Ochakov crisis took several more months to resolve; Russia got to keep Ochakov and the land between the Bug and Dniester rivers.

To celebrate Russia's capture of the fortress of Ismael, Potemkin threw a ball in Catherine's honor at Tauride Palace on April 28, 1791. Located near Smolny Convent on the left bank of the Neva, the palace was a gift from Catherine on Potemkin's return from the Crimea in 1789. Ivan Starov's design featured a low cupola, austere six-columned Doric portico, and three-cornered pediment. Narrow galleries connected the main block to two long wings—each with a Doric portico of four columns. The minimal façade contrasted with the rich interiors. ". . . [I]n each case," writes William Craft Brumfield, "an elegant neoclassical restraint dominates."[4]

The grand manor soon became a symbol of Potemkin's power and status. "Its exterior is resplendent with neither carved nor gilded nor any other kind of rich ornament," raved Gavriil Derzhavin. "Its quality is the fine taste of Antiquity! It is simple, it is sublime."[5] Known for his lavish parties, Potemkin outdid himself, spending 200,000 rubles to recreate a tale from *A Thousand and One Nights*. A century later, M. I. Pylyayev offered a description of the sumptuous decoration: "The platform on which the

the vast glass structure. Tropical birds flitted among orange and myrtle trees, and fragrant rose and jasmine bushes; brilliant red and silver fish swam in glass globes. Beyond the glass walls, guests could see into Gould's English garden, where "sanded paths wind, hills rise up, valleys fall away, cuttings open groves, ponds sparkle . . ."[10] In the center of his huge tropical conservatory, on a diamond-studded pyramid, Potemkin installed Fedot Shubin's *Catherine the Legislatrix* depicting the empress holding a cornucopia brimming with money and the crosses of Russia's knightly orders. Potemkin penned the inscription at the base: "To the Mother of her country and more than Mother to me."

Potemkin showcased his other sculptures throughout the palace. "One of the immense wings is fitted up as a museum; it contains an infinite collection of foreign marbles and busts, principally antiques, which were purchased by Potemkin at a high price, and must, in the present day, be still more valuable," wrote Raikes.[11] Contemporary Russian sculpture also featured prominently, including *The Vigil of Alexander the Great*. In an allusion to Potemkin, Mikhail Kozlovsky depicted the great military leader sleeping before the eve of the decisive battle of Gaugamela.

Potemkin's theatrical paintings added more drama. Among his pictures were the monumental *Taking of Izmail* by London-born, Venice-trained Francesco Casanova, and melodramatic *Landscape with Dido and Aenaes* (1769), which Welsh artist Thomas Jones considered his best work. Potemkin's furnishings included a Roentgen chinoiserie desk, a full choir organ with clock by William Winerow, and a clavichord with mother-of-pearl and tortoise shell made by St. Petersburg's Gabran workshop.

Potemkin also showed off objects from the late Duchess of Kingston. Twenty-five years before marrying the fabulously wealthy Duke of Kingston, Elizabeth Chudleigh had secretly married naval lieutenant Augustus Hervey, later the 3rd Earl of Bristol. Never the retiring type, she'd attended the Venetian ambassador's ball naked. After being tried for bigamy by the House of Lords, the duchess escaped to the Continent with Kingston treasures, which she carted to Russia. She hoped to regain her social status by a lady-in-waiting to Catherine, but that didn't happen. "Talking of madness: the Duchess of Kingston has arrived here in her own yacht flying a French flag," Catherine wrote Grimm. "That's an astute

Empress was to sit was covered with a precious Persian silk carpet, and similar platforms stood along the walls, on each of them a huge vase of white Carrera marble on a pedestal of grey marble; suspended above the vases were two chandeliers of black crystal with musical clocks set inside. The chandeliers cost Potemkin 42,000 roubles."[6]

At seven o'clock on the rainy spring evening, the imperial coach arrived at Tauride Palace. As Catherine stepped out in her full-length Russian-style gown and tiara, two lines of footmen in yellow with blue and silver livery lit the path with candelabra. Potemkin greeted her wearing a diamond-studded black and gold lace cape over his scarlet tailcoat. As he knelt on one knee before Catherine, his aide carried his hat on a pillow. Diamonds made it too heavy to actually wear.[7]

Taking Potemkin's arm, Catherine proceeded from the elegant foyer to a tall domed octagonal hall with marble columns. Making her way to the Colonnade Hall, Catherine was greeted by triumphal hymns sung by choirs accompanied by an organ and wind orchestra of three hundred musicians. At 246 feet in length with 50-foot-tall ceilings, the hall was the largest of its kind in Europe, with three dozen artificial marble columns inspired by Athens' Erechtheum Temple.[8]

"In shape and height it may be likened to a vast cathedral," wrote travel guide author Thomas Raikes, "the body of which, appropriated to dancing, is separated from the two aisles or wings, on each side, by a range of marble columns and statues so vast and gigantic, that the eye loses all idea of human proportions, and the chairs become so diminutive that they only seem fitted for a race of pigmies. Here is no gilding would be lost in the grandeur of the design; all is pure white."[9]

That night, the hall was lit by 20,000 candles. Massive black crystal chandeliers along with some five dozen smaller ones illuminated the vast room where 3,000 costumed guests awaited her arrival. (Potemkin left Platon Zubov and his relatives off the invite list.) At one point, curtains rose to reveal a theatre where two French comedies and a ballet starring Alexander and Constantine were staged.

From the Hall, another spectacular space awaited. William Gould, a pupil of Capability Brown, designed a glass-roofed Winter Garden, where palm tree–shaped columns doubled as warm water pipes and support for

thing to do; she certainly isn't lacking in intelligence: she likes me very much but as she is rather deaf, and I cannot shout, she will not profit by it much."[12]

Among the duchess's possessions was an enormous wine cooler with lion-shaped handles made by London silversmith Philip Rollos. Catherine presented the superb vessel to Potemkin, who used it to serve fish soup for two hundred at the gala in her honor. In his description of the lavish party, Smolny Institute director T. P. Kiryak mentions the vessel: ". . . the fish soup alone cost more than 1,000 roubles. It filled a vast seven or eight pood silver chalice. Two people standing served the whole table and when the serving was finished there was still enough soup left for the same number of guests."[13] Flanking the tureen on the table was a pair of large silver vases from the duchess's estate. Nearly three feet tall and weighing over thirty pounds each, the vases were created in 1770 by Andrew Fogelberg, one of the leading silversmiths working in the Adam style in England.

A musician was playing a cantata on the Duchess of Kingston's gilded organ when Catherine prepared to leave Tauride Palace at two o'clock in the morning. Potemkin had written the romantic refrain years earlier: "The only thing that matters in the world is you." In the vestibule, Potemkin fell to his knees before her, and they both wept. He kissed her hand repeatedly before she left in her carriage.[14] Back at the Winter Palace, unable to sleep, Catherine penned a note to Grimm: "There you are, Monsieur, that is how, in the midst of trouble and war and the menaces of dictators, we conduct ourselves in Petersburg."[15]

Less than a week later, Catherine received word that Poland's Sejm had adopted a new constitution creating a hereditary monarchy with a strong executive running the government and army. With its slogan "The King with the Nation," the constitution actually strengthened Poland's monarchy. But to Catherine, it represented the spread of the French Revolution into her realm. Potemkin extended his stay in St. Petersburg to discuss next steps in Poland with Catherine.

Wars against the Swedes and Turks may have slowed the flow of Catherine's art acquisitions, but it didn't stop them. From her perspective, it was more important than ever to demonstrate Russia's prosperity to the rest of the world despite the fact that the empire was waging two wars. *Tower–Ruin*

by Hubert Robert soon arrived at the Winter Palace. Collector Alexander Stroganoff had sent the French artist a drawing of Yury Velten's artificial ruin at Tsarskoe Selo. But for the second time, Robert declined Catherine's invitation to visit Russia. With Paris engulfed in chaos, Catherine cleverly wrote Grimm that the famous painter of ruins was unlikely to leave France when surrounded by his favorite subject.

Catherine was justifiably proudly of her various collections, which in 1791 was nearing the height of their size and prestige. "Besides the paintings and the Raphael Loggia," she wrote Grimm, "my museum in the Hermitage contains thirty-eight thousand books; there are four rooms filled with books and prints, ten thousand engraved gems, roughly ten thousand drawings and a natural history collection that fills two large galleries."[16]

PART EIGHT

REACTION

TEARS AND DESPAIR

"Prince Potemkin has never consented to be painted," Catherine told Grimm, "and if there exists any portrait or silhouette of him, it is against his wish."[1] During Potemkin's stay in the capital, Catherine twisted his arm, convincing him to sit a second time for Italian-born, Austrian-trained portraitist Johann Baptist Lampi the Elder. Sensitive about his bad, half-closed eye, Potemkin again insisted on a three-quarter face pose. For Potemkin's first half-length portrait seven years earlier, Lampi contrasted his subject's armor and smooth features. This time, Lampi depicted Potemkin in his white Grand Admiral's uniform with the Black Sea for the background.

"Goodbye my friend, I kiss you," Catherine wrote as Potemkin left Tsarskoe Seloe for Jassy on July 24.[2] After concluding a peace treaty with the Turks, he was anxious to supervise construction of additional battleships along with his new palace in Nikolaev. But by August, Potemkin's health began to fail. Plague had broken out in Constantinople, and the

epidemic swept quickly across the south. In mid-August, Grand Duke Paul's brother-in-law, one of Potemkin's officers, died. Catherine traveled to Pavlovsk to comfort Maria Feodorovna, unaware that Potemkin had collapsed after the funeral.

Around this time, France's royal family was arrested at Varennes while trying to flee the country. France's queen Marie Antoinette was the youngest child of Holy Roman Emperor Francis I and Empress Maria Theresa. Her brother, Leopold II, now appealed to other royal houses for support. With the August Declaration of Pillnitz, Austria and Prussia vowed to stop the French Revolution if Russia or England also intervened, a proviso that was very unlikely. While publicly deploring the situation in France, Catherine was not about to intervene militarily when Russia's interests were not directly threatened. When Louis swore an oath of loyalty to France's new constitution, Catherine dashed off a letter to Grimm: ". . . These are really unworthy acts of cowardice; one could say they had neither faith nor law, nor probity. I am terribly angry; I stamped my foot reading these . . . these . . . these . . . horrors."[3]

Louis XVI went on trial for treason in early December. "The scoundrels in Paris have no principles," Catherine angrily wrote the Prince de Ligne. "They have overturned Christianity, law and morality. . . . All that one can reproach Louis XVI for is his excessive goodness and lack of firmness. He is accused of having wanted to subvert that constitution which everybody agreed was worthless. But who are his accusers? The very men who overturned that same constitution and the monarchy, the abominable instigators of that so-called republic which will make the word 'liberty' forever detestable, because with that word on their lips, these rebels commit every crime."[4]

With anti-monarchial sentiment growing in France, Russia's Orthodox Church assumed new importance in Catherine's fight against what she called "this irreligious, immoral, anarchical, evil and diabolical plague, the enemy of throne and altar."[5] As a public display of her faith, Catherine personally presented lavish gifts to the Church. Among the most spectacular were liturgical sets for the 15th-century Dormition Cathedral in the Moscow Kremlin, St. Sergius Monastery of the Trinity northeast of Moscow, and the newly consecrated Holy Trinity Cathedral in St. Petersburg's Alexander Nevsky Monastery.

Peter the Great had made 13th-century warrior prince Alexander Nevsky patron saint of Russia's new capital, transferring his remains from Vladimir to St. Petersburg. To hold Alexander Nevsky's relics, Empress Elizabeth commissioned a massive silver sarcophagus decorated with symbols of his military victories, including the Neva Battle against Sweden. Catherine moved this impressive shrine to Ivan Starov's neoclassical cathedral. Now, she hired Norwegian-born goldsmith Iver Windfeldt Buch to design a liturgical set for the cathedral to honor Potemkin's military victories. For the chalice, Catherine selected cameos from her own collection and gave her goldsmith gems and diamonds from the state treasury.

Catherine approved Buch's highly symbolic design. Three of the four stones adorning the bowl were made of bloodstone, symbolic of Jesus's sacrifice. The fourth stone was the oldest—a 13th-century grayish chalcedony cameo of Archangel Michael, a popular figure in medieval Russia. Four carved cameos adorned the base: Saints Justa and Rufina in blue glass paste, Annunciation in green nephrite, Madonna and Child in carnelian, and a pagan subject in white chalcedony. Bush framed each stone with an oval circle of diamonds and diamond-studded floral sprays; matte gold acanthus leaves and diamond rosettes separated the cameos and intaglios. Stalks of wheat and bunches of grapes (references to the communion bread and wine) adorned the stem. Around the lip was a Cyrillic inscription from the Old Church Slavonic text of Matthew: "Drink of it all of you! This is My Blood of the New Testament, which is shed for you and for many, for the remission of sins!"[6]

For maximum political impact, Catherine presented Buch's stunning liturgical set on Saint Alexander Nevsky's annual feast day. But by late August 1791, with Potemkin ailing, the gift took on a more personal meaning. After delivering the chalice (along with a paten, asterisk, two plates, spoon, and spear) to the altar, Catherine prayed for Potemkin's recovery. Meanwhile, 1,000 miles away, Potemkin composed a liturgical canon. "Incessantly my anxious soul gazes at the abyss of my iniquities and longs for help, yet does not achieve it," he wrote. "Extend to me, you Immaculate Virgin, your hand, which held my Savior, and let not my soul perish forever."[7]

Potemkin couldn't shake his fever and headaches, and after a week and a half at Gusha he returned to Jassy. He'd suffered fevers for years, possibly malarial. Decades of compulsive work and gluttony had finally caught up with him. On September 27, Potemkin could no longer write himself, and dictated a note to his confidant Vasily Popov: "Beloved matushka, my not seeing you makes it even harder for me to live." Catherine sent Potemkin a fur coat and reply: "I'm so extremely worried about your illness. . . . I beg God to hurry and give you back your strength and health. Farewell my friend. . . ."[8] Potemkin reportedly sobbed as he read her letters.[9]

On September 30, his fifty-second birthday, Potemkin woke up struggling to breathe—possibly the result of bronchial pneumonia. On October 4, he scribbled a note to Catherine: ". . . I've no more strength to endure my torments. My only remaining salvation is to abandon this town, and I have ordered myself conveyed to Nikolaev. I don't know what's to become of me."[10] Potemkin left Jassy the next afternoon for Nikolaev, accompanied by Cossacks, doctors, and his niece Alexandra. After overnighting, the party continued the next morning. On a remote hillside in the Bessarabian steppe some forty miles from Jassy, Potemkin stopped his six-seat carriage. "That's enough now, there is no point in going any further," he said. "Take me out of the carriage, I want to die in the field."[11] Wearing a silk dressing gown from Catherine, he was laid on a Persian rug spread on the grass. He died that morning with Catherine's tear-stained letters in his pocket.

It took a week for Catherine to receive word. At half past two in the morning, she poured her sorrow out in a letter to Grimm: "A terrible crushing blow struck me yesterday," she began. ". . . You can have no idea of how afflicted I am: he joined to an excellent heart a rare understanding and an extraordinary breath of spirit; his views were always great and magnanimous. . . . But his most rare quality was a courage of heart, mind and soul which distinguished him completely from the rest of humankind, and which meant that we understood one another perfectly and could let those who understood less rattle away to their hearts' content. I regard Prince Potemkin as a very great man, who did not fulfil half of what was within his grasp."[12]

After being bled by her doctors, Catherine locked herself in her room, refusing to see anyone. According to her secretary, the next days were

filled with "tears and despair."[13] Throughout their volatile twenty-year relationship, Catherine and Potemkin remained devoted to each another. Though she needed Potemkin in the south, Catherine missed him terribly, often begging him to return. The practical reality of governing without her indispensable right-hand man began to sink in. "Prince Potemkin did me a cruel turn by dying! Every burden now falls upon me," she wrote Grimm. "Be so good as to pray for me."[14]

For months after Potemkin's death, Catherine avoided public appearances. ". . . I am still profoundly afflicted by it," she wrote Grimm. "To replace him is impossible, because someone would have to be born as he was, and the end of this century announces no geniuses. . . . As for me, be assured that I will be unchanging and that, preaching perseverance to others, it will not be I who varies."[15]

Alexander Bezborodko took Potemkin's place at the peace talks. By year-end, the talented negotiator sealed the highly advantageous Treaty of Jassy. After four and a half years of war, Catherine won a large area on the Black Sea. Vasily Popov arrived in St. Petersburg to present Potemkin's papers and letters to Catherine, who locked them away and hid the key. At the end of January, Catherine received the ratified peace treaty from Potemkin's decorated nephew, Alexander Samoilov. After dismissing everyone from the room, Catherine wept with the war hero.[16]

CHAPTER TWO

A TICKING CLOCK

Catherine never recovered from losing Potemkin. The person who benefited most from the resulting power vacuum was Platon Zubov, who at age twenty-two had helped the sixty-year-old empress forget the humiliating episode with Alexander Mamonov. One of the few favorites not pre-approved by the absent Potemkin, the handsome young courtier had been planted by Potemkin enemy Count Nikolai Saltykov who ran Paul's household.

In his ground floor palace apartments, connected to Catherine's by a private staircase, the ambitious favorite began holding his own version of Louis XIV's *lever*. Each morning, dozens of petitioners paid Zubov court; his secretaries became wealthy taking bribes from those seeking an audience with him. In January 1792, Catherine gave Zubov his own chancery headed by Adrian Gribovsky. Increasingly Catherine consulted her lover on domestic and foreign policy decisions.

Health problems seem to have blinded Catherine to her government's rampant corruption. After four months in St. Petersburg, Britain's John Parkinson observed: "She [Catherine] does everything in her power to keep the great people here attached to her. They are left to do almost what they please with impunity. The most severe punishment they have to fear is a dismissal from their places but this is but rarely given. On their relations and dependents all the good things in the gift of the Crown are bestowed; and to this it is owing that the Army and Navy are so ill officered."[1]

In 1791, an investigation exposed a scandal involving British court banker Richard Sutherland, who Catherine had made a baron of the Russian Empire three years earlier. After embezzling over two million rubles, Sutherland made large loans to Grand Duke Paul, Potemkin, and other leading figures of Catherine's government. Sutherland and Potemkin had died back-to-back in October, and Catherine ordered the treasury to write off the biggest debts the following spring.[2] In another public embarrassment, Catherine's former lover, Peter Zavadovsky, chief director of the Loan Bank, was implicated in a swindling case. Catherine ordered Zubov and Bezborodko to cover up the scandal.[3]

On March 1, 1792, after just two years in power, Austria's Leopold II died unexpectedly. Two weeks later, Catherine received shocking news from Stockholm. Gustav III had been shot at a masked ball at his opera house and was clinging to life. Though his assassin was a Swedish aristocrat angry over the war with Russia and reduced privileges for the nobility, Catherine saw her cousin's murder as part of the revolutionary violence sweeping France and Poland. Conspiracy theorists viewed the shooting as the work of Freemasons determined to overthrow Europe's monarchs. Catherine became convinced that she was the next target.[4] Security was stepped up, especially around Tsarskoe Selo.

That spring, with Prussia and Austria at war with France and the Russo-Turkish War finally over, Catherine turned her attention to Poland. Unlike Leopold II and Prussia's Frederick William, Catherine had refused to acknowledge Poland's constitution of May 3, 1791. Though there was nothing radical about the constitution, it would have strengthened the country's central government, a problem for Catherine who wanted Poland to remain under Russia's control. At the urging of a confederation of

ultra-conservative Polish nobles known as the Confederation of Targowica, and with Prussia's support, Catherine unleashed 100,000 Russian troops into eastern Poland. As she predicated, Austria did nothing and Prussia reneged on its 1790 defensive treaty. Stanislaus Poniatowski joined the Targowica conservatives. With Russian troops occupying the confederation and the conservative Poles fighting among themselves, opportunity knocked again. In January 1793, Russia and Prussia repealed Poland's new constitution and signed a treaty partitioning the country for a second time.

Russia seized another 89,000 square miles of eastern Poland, including the remaining Polish Ukraine, along with three million people. Prussia's take included 23,000 square miles including Danzig and Thorn along with land in western Poland, and one million people. Reduced to one third of its original size, Poland effectively became "a Russian province" as a Polish deputy put it. Catherine maintained she was simply retaking lands belonging to the 16th-century Russian principality of Kiev—"lands still inhabited by people of the Russian faith and race."[5] "My part is sung," Catherine wrote Field Marshal Peter Rumyantsev. "It is an example of how it is not impossible to attain an end and to succeed if one really wills it."[6]

In reaction to the violence in Sweden and France, Catherine also took an increasingly hard line at home. Just as Alexander Radischev was beginning his exile in Siberia, Catherine targeted his mentor, Freemason publisher Nicholas Novikov. After Novikov's publication *The Drone* criticized her government and the continuation of serfdom, Catherine confiscated his printing house. In 1792, without a formal trial, Novikov was imprisoned at Schlüsselburg fortress in the cell where Ivan VI had died. Correspondence between Novikov and architect Vasily Bazhenov seemed to indicate the Freemasons hoped to recruit the Catherine's son Paul, a charge the grand duke vehemently denied. On August 1, by Catherine's order, Novikov received a fifteen-year prison sentence. Much of his writing was destroyed.[7]

In his final years, Potemkin had tempered Catherine's growing paranoia. In his absence, Platon Zubov encouraged her reactionary decisions, including the persecution of Radischev and Novikov. Catherine ordered Russia's provincial governors to stop publishing books "likely to corrupt morals, concerned with the government, and, above all, those dealing with the French revolution." Because of its regicide theme, even Shakespeare's

Julius Caesar disappeared from bookstores. Catherine's paranoia grew on August 10 when a mob stormed Paris's Tuileries Palace. Over one thousand people died that day—courtiers, soldiers, and members of the Swiss Guards who'd been hired to protect the royals. The royal family escaped massacre but was locked up in the medieval fortress known as the Temple.

Also in August, Catherine concluded negotiations with Potemkin's heirs. She agreed to pay them 2.6 million rubles for most of his property and possessions, including Tauride Palace. Architect Fyodor Volkov began turning the immense residence into the empress's fall townhouse. The remodel included additions of a church and theatre to the west and east wings, along with a harbor and canal linking the palace to the Neva. Catherine also ordered a Palladian villa built on the grounds for Potemkin's gardener William Gould. Catherine's one-week stay at Tauride in 1792 was short but sweet, filled with memories of Potemkin. "The palace is the height of fashion since it is all on the ground floor, with a large and beautiful garden, right in the middle of the barracks on the bank of the Neva, the cavalry to the right, the artillery to the left, and the Preobrazhensky [Guards] behind the garden," she wrote Grimm. "There is nowhere better for the spring and autumn."[8]

Potemkin's estate also included some 368 paintings and dozens of sculptures. A number of works remained with his nephews, one of whom wrote in a biography of his uncle: "The prince was, to a maximum degree, a lover of the fine arts. In architecture, he favored the vast and majestic . . . in painting and sculpture he liked perfection."[9] Among the objects transferred from Tauride to the Winter Palace were the Duchess of Kingston's silver wine cooler and the spectacular 700-piece Sèvres Cameo Service. One Tauride Palace treasure—a tour de force of clock making—was currently in the repair shop.

In late 1781, at Potemkin's request, Catherine paid 11,000 rubles (roughly 1,800 pounds sterling) for a spectacular clock designed with a large bronze oak tree and mechanical birds. British master jeweler James Cox was celebrated throughout Europe for his richly decorated musical automata and *objets d'art*. To fulfill Potemkin's order as quickly as possible, the clockmaker repurposed an existing mechanical peacock, a symbol of the cosmos, sun, and moon. To this Cox added two more life-size birds—an

owl representing wisdom and night, and a rooster symbolizing life and resurrection—along with a squirrel and a fox, and a dragonfly to mark the seconds on the clock.

Dismantled for the journey to St. Petersburg, the clock remained in pieces for nearly a decade with its parts stored in ten boxes in the Tauride Palace storeroom. During Potemkin's last visit to St. Petersburg, he hired engineer Ivan Kulibin to reassemble the clock. After Potemkin's death, Catherine ordered the repair, paying Kulibin 1,200 rubles from the treasury. Kulibin went to work replacing lost parts, reapplying gold and silver, cleaning internal and external mechanisms, and straightening bent leaves on the tree branches and plants. After two years, Kulibin returned the reassembled clock to Tauride Palace. Today, the Peacock Clock is a crowd favorite at the Hermitage.

While condemning the French Revolution, Catherine took full advantage of the resulting buyer's market. Like many elite collectors, she enriched her holdings with bargains from desperate refugees and treasures confiscated by the revolutionary government.[10] Among the carved gems Catherine purchased from emigré antiquarian Alphonse Miliotti in 1792 were those from the collections of Prince de Conti (Louis François de Bourbon, art connoisseur and wine maker), Saint-Morys (conseiller of the French parliament), the Dazencour family, and Madame Baudeville. The same year, Catherine added the glyptic cabinets of neoclassical painter Giovanni Battista Casanova, director of the Dresden Academy of Arts; and Joseph Angelo de France, director of the Vienna Historical Cabinet.[11]

In 1792, Catherine transferred the jewels from the diamond chamber in her private apartments at the Winter Palace to the Large Hermitage near the Raphael Loggia. Decorated in neoclassical style and hung with van Dyck paintings, the new Diamond Room sparkled with gems and *objets de vertu* in elegant cases by cabinetmakers Hermann Meyer and Heinrich Gambs. Johann Georgi described the dazzling display: "boxes and caskets of silver filigree, finely woven, partly gilded, some of them decorated with gems and pearls. . . . there are also salt cellars of precious stones . . . various pitchers . . . pocket watches of the former Sovereigns and their families . . . snuff-boxes collected from various periods and most varied in size, appearance and the material, some with precious gems and pearls. . . ."[12]

That same year, suffering from gout and rheumatism, Catherine asked Charles Cameron to add a ramp from the terrace opposite the entrance of the Agate Pavilion at Tsarskoe Selo. Inspired by a Roman aqueduct, Cameron supported the gently sloping limestone *pente douce* with a series of gradually descending arches whose keystones he decorated with Renaissance-style carved masks. Around this time, Catherine became consumed with finding a suitable bride for fourteen-year-old Alexander. In October, thirteen-year-old Louise Maria Augusta of Baden and her younger sister Frederica arrived in St. Petersburg (the sisters' maternal aunt was Grand Duke Paul's first wife Natalia).

The beautiful Princess Louise enchanted Catherine, but Alexander was a harder sell. "I looked at the Grand Duke Alexander as much as good manners permitted, and thought him very good-looking, but not as handsome as he had been described to me," Louise confided to Countess Golovine. "He did not come up to me, and gave me a very hostile glance."[13] The shy grand duke gradually warmed up to the charming German princess. At a ball at the Winter Palace, the couple joined their siblings and other young dancers for minuets.

"The eldest Grand Duke is a very handsome young man with a fine open countenance," noted attendee John Parkinson. ". . . His brother's countenance [Constantine's] is quite the reverse of his, exceedingly disagreeable and unpromising. His character and temper likewise are not well spoken of. They [the Princesses of Baden] are both fine girls, but particularly the eldest."[14] Six weeks after Princess Louise's arrival, while playing cards in the Winter Palace's Diamond Room, Alexander passed her a note. He was "authorized by his parents to tell me that he loved me," Louise wrote, "he asked me whether I could accept the expression of his affection and return it, and if he might hope that I could find my happiness in marrying him."[15] Accepting the proposal, Louise stayed in St. Petersburg to learn Russian.

To celebrate Alexander's name day, Catherine threw a ball at the Winter Palace in December. "The Empress seemed this morning to be uncommonly cheerful; and so she did I thought at the ball in the evening where she stood in the front of the circle and talked very affably with several people," Parkinson observed. "For the first time I got a view this morning of Zeuboff: he is of the middle size, a genteel figure but not handsome."[16]

On Christmas Day, Zubov made his first appearance at court in his new Order of the Black Eagle, sent to Catherine by Prussia's Frederick William. Catherine participated in the evening's celebrations, including a variety of games. "She is said indeed to be so fond of such pastimes, that not a week passes, but she amuses herself with something of that kind," added Parkinson.[17] In mid-January, crowds gathered near the Admiralty to celebrate the blessing of the waters. Just days later, the celebratory mood at court came to an abrupt end.

On the morning of January 21, Louis XVI was executed by guillotine at the Place de la Concorde in Paris. According to his chief executioner, the king's final words before being strapped down were: "Gentlemen, I am innocent of everything of which I am accused. I hope that my blood may cement the good fortune of the French."[18] As Louis XVI's head was held up for the crowd to see, there were cries of "Vive la Nation!" and "Vive la République!" along with an artillery salute heard by the king's imprisoned family.

When news of the regicide reached St. Petersburg, Catherine became physically ill and retreated from public. On February 1, she ordered six weeks of official mourning "For the death of the King of France who has been cruelly murdered by his rebellious subjects."[19]

CHAPTER THREE

WARSAW'S OURS

Newly Francophobic, Catherine severed diplomatic ties with the revolutionary government. French citizens wanting to stay in Russia were required to pledge an oath to the crown. In March, Catherine tumbled down a staircase while walking to her baths. Banged and bruised, she recovered though her knee continued to bother her.

Contemporaries noticed the empress's excessive weight gain and declining health. In 1792, French chargé d'affaires Edmond Genet wrote his wife: "Catherine is getting noticeably worse. She can see this and is consumed by melancholy. The empress's physical condition gives cause for alarm. . . ."[1] In addition to headaches and indigestion, Catherine suffered from rheumatism and frequent colds. She required glasses for reading and sometimes used a magnifying glass.[2]

While Platon Zubov's star was rising at court and his influence throughout St. Petersburg grew, Paul became further estranged. After meeting the grand duke at a ceremony at the Winter Palace, Parkinson

described him as having "the most ridiculous air of dignity and importance as if he was aping or burlesquing it. The Duke is a spare man with a very vulgar, insignificant, disagreeable countenance."[3] As his relationship with his mother hit at an all-time low, Paul retreated to Gatchina in constant fear that she might have him jailed or killed. As Vladislav Khodasevich puts it, "He [Paul] had evoked in her [Catherine] a subtle malice, contempt, and disgust. In his eyes she was the murderer of a man who he (rightly or not) believed to have been his father. . . . He hated her and virtually everyone and everything that was connected with her, perhaps even his two eldest sons, whom she had taken into her care."[4]

Zubov's growing political power was also of great concern to Alexander Bezborodko, Catherine's influential chief minister. Born to modest circumstances in Ukraine, Bezborodko had become the architect of Catherine's foreign policy thanks to his remarkable memory and diplomatic skills. Inspired by Catherine, Bezborodko became an avid collector, displaying his art in a neoclassical palace designed by Giacomo Quarenghi near St. Isaac's Cathedral. Like Catherine, Bezborodko enriched his collection with works from fleeing French aristocrats and revolutionaries.

"The Count Bezborodko is a tall, lusty man with swelled legs, the effect I believe of intemperance and debauchery, in which however it is said he is no longer able now to indulge," wrote John Parkinson. ". . . Besides presents from the Empress, his appointments and estate amount to 70,000 roubles a year."[5] For his loyalty and as compensation for Zubov's meddling in foreign affairs, Catherine awarded the count the ribbon of St. Andrew and 50,000 rubles. From the Imperial Porcelain Factory, she also commissioned a remarkable 900-piece service for her minister. After Bezborodko's death in 1799, the service was transferred to the crown and named the Cabinet Service.

The consummate armchair traveler, Catherine spent hours browsing through Giovanni Piranesi's engravings of Roman monuments and ruins. For Bezborodko's service, she personally selected specific views for plates, creating a kind of virtual tour of Italy (these views were identified on the bottom of each piece). At the same time, Catherine ordered the imperial factory to produce dowry services for her granddaughters Alexandra and Elena. Like the Cabinet Service, the dowry services featured central oval or

round medallions with painted topographic views of Italy. The only difference was in the borders. The Cabinet Service sported colorful wild flowers; the dowry services featured lavender roses and lilacs against a yellow border.

In September 1793, Louis XVI's 37-year-old widow Marie Antoinette was found guilty of high treason and condemned to death. The revolutionary tribunal accused Marie Antoinette of sexual promiscuity and incest with her son Louis-Charles, who was forced to testify that his mother molested him. After Marie Antoinette's October execution, Catherine proclaimed another period of mourning.

The one bright spot that fall was Grand Duke Alexander's marriage to Louise, who'd taken the name Elizabeth Alexeievna. "Everyone said that it was two angels getting betrothed; one could not imagine a more beautiful sight than these 15- and 14-year old fiancés; in addition they are quite in love with one another," Catherine wrote Grimm after the couple's engagement.[6] For the September ceremony in the Winter Palace chapel, Elizabeth Alexeievna wore the diamond-studded Order of St. Andrew on her silver brocade wedding gown. Catherine gave the couple a gold goblet studded with diamonds, silver, rubies, and enamel. It would be used at subsequent royal weddings.

Wedding guest Countess Golovine described the nuptials: ". . . and when the two beautiful children—for they were little more—appeared in their places, general enthusiasm broke out. . . . When the ceremony was over, the Grand Duke and Grand Duchess came down from the platform holding hands, and the Grand Duke fell on one knee before the Empress to thank her. She raised him, took him in her arms and kissed him, sobbing, then turned to the Grand Duchess, who received the same demonstration of affection. . . ."[7] The celebration continued that evening with a dinner and ball in the great hall of Alexander's apartments.

Within months of the wedding, Platon Zubov began making advances to the beautiful grand duchess. "Without my husband, who alone makes me happy, I should have died a thousand deaths," Elizabeth Alexeievna confided to her mother. After Zubov trained his telescope on the window of Elizabeth Alexeievna's apartment, Countess Golovine had to pin the curtains together.[8] Alexander felt complete frustration with the lecherous favorite and his grandmother's ignorance of the situation, but was afraid to

tell her the truth. Catherine remained oblivious to Zubov's behavior until May 1796, when she warned him to shape up.

By that point, she'd awarded Zubov the title of count; he was also named Prince of the Holy Roman Empire, the fourth and last Russian to receive the title. She'd also given him her portrait to wear along with the Order of St. Andrew and named him governor-general of Ekaterinoslav and the Crimea, and head of the Black Sea Fleet—titles previously held by Potemkin. "In his elevation he displayed no genius, no virtues, no passions, unless we account as such the vanity and avarice which distinguished him . . . ," wrote Charles Masson, French major domus to minister of war Nikolai Saltykov.[9] Despite his clout and wealth, Zubov knew he could never fill Potemkin's shoes. "Although I won a partial victory over him, there was simply no way I could entirely remove him from my path; and it was necessary to remove him because the empress herself always met his desires and quite simply feared him as if he were an exacting husband," he wrote. "Me, she only loved and frequently pointed to Potemkin as an example for me to follow."[10]

The fiftieth anniversary of her arrival in Russia put Catherine in a reflective mood. "Day before yesterday, on February ninth, it was fifty years since I arrived with my mother in Moscow," she wrote Grimm. "I doubt there are ten people living today in St. Petersburg who remember. There is still Betskoy, blind, decrepit, gaga, asking young couples whether they remember Peter the Great. . . . There is one of my old maids, whom I still keep, though she forgets everything. These are proofs of old age and I am one of them. But in spite of this, I love as much as a five-year-old child to play blind-man's bluff, and the young people, including my grandchildren, say that their games are never so merry as when I play with them. And I still love to laugh."[11]

Around this time, Catherine's chief librarian, Alexander Ivanovich Luzhkov, finished classifying her 10,000-piece cameo cabinet. "All the cabinets in Europe are mere child's play compared to ours," Catherine bragged to Grimm. "It is all arranged systematically, beginning with the Egyptians and passing via every aspect of history, up to the present day! . . . Only images of the present war are lacking; perhaps in time we shall have a depiction of the capture of Prague, and the heroes Souvoroff, Fersen and Derfelden. Valerian [Zubov] is already there."[12]

Catherine's newly organized cameos along with many other treasures were featured in a new Russian language edition of Johann Georgi's guide to St. Petersburg. Dedicating the publication "To Her Highness, the Most Sovereign, the Great Empress Catherine Alexeyevna, the Sole Rule of All Russia," Georgi gave room-by-room descriptions of the Winter Palace's galleries and buildings, along with highlights of the imperial art collection. "The paintings hang in three galleries and partly in the rooms of the Hermitage and are placed not so much in the precise order of the schools, masters etc, as by the appearance they create," wrote Georgi. ". . . Since there is not enough space to hang the paintings, some of them are not only stored separately, but according to circumstances those which are hung are removed and replaced with new, or more important ones. . . . The frames are highly varied, the greater part are gilded, but of simple design; a small number of paintings have elegantly worked frames, but many are totally without frames.

"In all rooms there are . . . paintings and rich vases, urns, groups, statues, busts of national heroes and great ancient individuals, pillars and different art objects of plaster, marble, jasper, ruby, emerald, rock crystal, porphyry and other stones; also [there are] modeled porcelain and bronze works, carved wooden [works] and so on. Cases and cabinets in which the cameos and other precious items—watches and such—are kept, are in essence the most refined work of Roentgen, Meyer and other renowned masters of this art."[13]

As Georgi's guide hit St. Petersburg's bookstores, tensions in the newly partitioned Poland were escalating. Russia's attempt to disarm the Polish army in March 1794 was the final straw, triggering a popular uprising led by Thaddeus Kościuszko. The charismatic officer had fought beside George Washington and Lafayette in the American War of Independence, earning Thomas Jefferson's praise as "the purest son of liberty."[14] He was certainly not philosophically inclined to have his country remain a part of the Russian Empire. In late March, Kościuszko led 4,000 soldiers and 2,000 peasants in a revolt in Krakow. The successful insurrection quickly spread to Warsaw, where 3,000 Russian soldiers were killed. Catherine's portrait from the Russian embassy was shredded; Prussia's Frederick William was denounced. Rebellions continued in Vilna, Lithuania, and Courland.

In April, Catherine retreated to Tsarskoe Selo, adding a morning walk in the park with her greyhounds to her daily schedule. By this time, she'd taken to wearing her hair unpowdered and preferred loose Russian-style dresses. In 1794, Ukrainian portraitist Vladimir Borovikovsky painted *Catherine II Walking at Tsarskoe Selo* by studying the aging empress as she set out from the palace for her daily strolls. Borovikovsky convinced Catherine's maid, Maria Perekusichina, to model for him wearing one of the empress's dresses. Though Catherine found Borovikovsky's portrait too informal, it became popular and was copied in numerous paintings and prints.

Borovikovsky, one of St. Petersburg's leading portraitists, had been discovered by the empress seven years earlier during her Crimea tour. Catherine was so pleased with his two large allegorical depictions of her that decorated her Kiev residence (as Minerva surrounded by Greek philosophers, and sowing land plowed by Peter the Great) that she invited the young artist to St. Petersburg. There he trained with Dmitry Levitsky and Johann Baptist Lampi. It was Lampi who influenced Borovikovsky's palette and style and helped him become an academician at the Academy of Fine Arts.

By spring 1794, an impatient Catherine told Frederick William and Austria's Francis II that it was time "to extinguish the last spark of the Jacobin fire in Poland."[15] Backed by Prussia and Austria, Russian troops attacked Kościuszko's rebel militia in May. By mid-July, 25,000 Prussian and 14,000 Russian soldiers were advancing on Warsaw, with Frederick William arriving to direct the siege of the capital. But by September, the Prussian ruler withdrew his troops, maintaining he needed them to deal with France. Determined to quash the Kościuszko Uprising, Catherine gave tactical command to her field marshal Alexander Suvorov.

With a nearly two-to-one advantage in soldiers, Suvorov defeated Thaddeus Kościuszko in the Battle of Maciejowice in October. Badly wounded, Kościuszko was taken to St. Petersburg and imprisoned in the Schlüsselburg Fortress. In early November, Ukrainian Cossacks under Suvorov's command massacred between 13,000 and 20,000 Polish civilians in the Warsaw suburb of Praga.[16] About the three-hour carnage that included women and children, Suvorov wrote: "the whole of Praga was strewn with bodies, and blood was flowing in streams."[17]

Facing a similar fate, Warsaw surrendered. Suvorov disarmed Poland's forces and arrested rebel leaders along with Stanislaus Poniatowski, who'd been trying to hedge his bets between Russia and his compatriots. To Suvorov's message "Hurrah, Warsaw's ours!" Catherine replied, "Hurrah, Field-Marshal!" On November 25, Stanislaus Poniatowski abdicated, pleading with Catherine to let some part of his country survive. By January 1795, the ousted ruler left Warsaw and was placed under house arrest at Grodno. Catherine advised him to move to Italy, best suited to his love for art and political situation, but he stayed in Grodno.

In early 1795, Russia and Austria agreed to Poland's final partition. Busy fighting France during Poland's second partition two years earlier, Austria's Francis II now enjoyed his share of the spoils, taking Krakow and expanding northward along the banks of the Bug River. After concluding its war with France in May, Prussia grabbed Warsaw and the area west of the Vistula. Russia seized Courland, the remainder of Lithuania and Belorussia, and western Ukraine. Catherine gave 107,000 Polish serfs to her advisers, including over 13,000 to Platon Zubov.[18] After eight centuries, Poland ceased to exist (it reemerged as an independent republic after World War I). In the three partitions of Poland under Catherine's rule, Russia absorbed six million people, half the country's entire population. Once again, Catherine defended her actions by claiming she was taking back ancient Russian and Lithuanian lands and reuniting Orthodox residents with the Russian motherland.[19]

"Peace is better than the finest war in the world," Catherine had written at the start of her reign. English ambassador Sir Robert Gunning praised her court as "a paradise of peace."[20] In the ensuing three decades, Catherine had become one of the world's most bellicose rulers. She'd succeeded in turning Russia into a global power by partitioning Poland into oblivion, fighting two wars with the Ottoman Empire, and grabbing land in the Ukraine and the Crimea.

Meanwhile, Catherine's beloved seventeen-year-old grandson wrote a chillingly prescient letter. To Alexander's great dismay, his Swiss-born tutor Frederick-Cesar de La Harpe's contract ended on December 31, 1794. While Catherine publicly stated that her married grandson no longer needed a tutor, privately she was anxious to get rid of liberal-minded La

Harpe, whom she suspected of being a Jacobin. In a goodbye letter to his tutor, Alexander wrote: ". . . you will therefore know my dear friend, what pain I must feel in thinking that I must soon be separated from you, especially staying alone at this Court which I abhor, destined for a condition the idea alone of which makes me shudder . . ."[21] Catherine could not have ever known that it would not be the Jacobians, but a group far more brutal who would bring about the downfall of her heirs.

In early January 1795, Maria Feodorovna gave birth to a sixth baby girl. But the happy event was short lived. The day after Anna's baptism, her two-year-old sister Olga died after a painful four-month illness. Dressed in mourning, a distraught Catherine attended the toddler's funeral at the Alexander Nevsky Monastery accompanied by her two eldest granddaughters, Alexandra and Elena. It had been nearly twenty years since Paul lost both his son and first wife in childbirth, a double tragedy which had left him inconsolable—until Catherine informed him that the infant was probably not his. Catherine had taken over the rearing of his two eldest sons with Maria Feodorovna, but allowed the couple to raise their daughters.

Increasingly, Paul sought out the companionship of Catherine Ivanovna Nelidova, a member of his wife's circle. He swore to both his mother and wife that the intimate friendship, started in the mid-1780s, was strictly platonic. After Olga's death, Paul and Maria Feodorovna would have two more children together, Grand Dukes Nicholas and Michael, born in 1796 and 1798.

CHAPTER FOUR

CATHERINE'S LIBRARY

T hat spring, Catherine immersed herself in a new building project. The idea for a public library had been suggested to her nearly three decades earlier by art patron Count Alexander Stroganov. Since then, the personal library she'd originally started as a grand duchess had mushroomed into an encyclopedic 44,000 volumes. Catherine saw the Imperial Public Library, like her art collection, as a symbol of enlightened Russia. Like Europe's finest libraries, she envisioned a repository for Russian and foreign language books with borrowing privileges for courtiers.

The chosen site was Nevsky Prospect near the Winter Palace. Catherine approved Yegor Sokolov's design featuring a curving Ionic colonnade. Inside, six columns topped with statues support a quarter-circle peristyle. A vast rotunda housed the manuscripts; some 6,000 incunabula were housed in a neo-Gothic cabinet. In her customary fashion, Catherine took a hands-on approach, receiving regular progress reports and weighing in on what one report called "Catherine's library."[1] The empress's Cabinet, the office

that administered her purse and property, provided construction funds on her verbal order, later confirmed in writing.

As Dimitri Ozerkov explains, Catherine modeled her Hermitage Library after the Vatican's, and symbolically moved her growing collection below the Raphael Loggia.[2] As she did with paintings and cameos, Catherine bought entire libraries en masse. These included the libraries of French mathematician and encyclopedist Jean Le Rond d'Alembert and some 1,000 books in 1776 assembled by archeologist Bernardo Galiani. After Alexander Lanskoy's death in 1784, Catherine added his art history titles to her shelves. In 1791, Catherine expanded Russian history holdings with historian Prince M. M. Scherbatov's library. A year later, she incorporated 4,500 military titles belonging to her late husband Peter III, covering weapons, knights' tournaments, and wars and battles.

Of the many genres she collected, it is no surprise that Catherine especially prized art and architecture books. "I am passionately interested in books on architecture. They fill my room and even that is not enough," Catherine wrote about the richly illustrated trove featuring works by Andrea Palladio, Giovanni Piranesi, and Giovanni Volpato. Installed at Tsarskoe Selo, Catherine's architecture collection proved an invaluable resource for architects Cameron and Quarenghi. In spring 1778, she described her plans to Grimm: ". . . there is in Tsarskoe selo a horrible set of rooms. . . . The grand staircase is moved to a small wing which looks towards Gatchina. Here she [Catherine] has ten rooms for the decoration of which her entire favorite library will be used; and her imagination is given a free reign. . . ."[3]

Catherine's collection of drawings and engravings would inspire many commissions over the decades, including Chesme Palace, the Green Frog Service, and the Raphael Loggia. In 1773, Charles de Wailly sent the empress eleven drawings in album for a proposed Pavilion of the Sciences and Arts for Tsarskoe Selo. In 1780, she bought some 1,120 sheets by Charles-Louis Clérisseau, including monuments and picturesque spots in Italy, architectural fantasies, and studies for the Palace of the Roman emperors. With Grimm's help, Catherine added 264 watercolor and gouache landscape drawings by Jean Houel in 1782. Catherine framed Clérisseau's works and hung them in her private apartments. "The arrival

of the paintings of Clérisseau is most opportune," she wrote Grimm, "since I have decorated my boudoir in St. Petersburg with his drawings under glass."[4] Like other collections, drawings were initially considered Catherine's personal property. Kept in the library, some remaining in crates, sheets were brought to Catherine upon her request.

The Hermitage Library also included Catherine's own publications. Between plagues and fires, wars and rebellions, she wrote poems, chronicles, memoirs, plays, opera librettos, magazine articles, fairy tales, a treatise on Siberia, history of the Roman emperors, and six-volume *Notes on Russian History* as a textbook for Alexander and Constantine. As source material, Catherine collected some 150 ancient Russian manuscripts. Catherine drew on this knowledge to author plays based on ancient Russian history, performed at the Hermitage Theatre.

Catherine mastered French as a child in Germany and learned Russian as a teenager during the first years of her marriage. Though she spoke Russian with a heavy German accent, she became a champion of the language. Thanks to the translator's society Catherine founded, one in four books published in Russian during her reign was translated from French. In 1783, Catherine established the Russian Academy to compile a Russian Dictionary and systemize the language's rules. She also assembled a dictionary of comparative languages. In 1786, Catherine wrote Thomas Jefferson for help translating several hundred words in the Shawnee and Delaware Indian languages; George Washington contributed a translation of Cherokee and Chocktaw words. ". . . [T]he breadth of her [Catherine's] ability and range of her interests are reminiscent of Thomas Jefferson . . . ," writes Jay Winik.[5]

Of Catherine's library deals, the most prestigious were those of Voltaire and Diderot. After Voltaire's niece and heir Madame Denis rejected two German offers for her uncle's library, Melchior Grimm began the delicate negotiations on Catherine's behalf. Catherine finally sealed the deal for 30,000 rubles, throwing in diamonds, furs, and a small jeweled box with her portrait.[6] To house Voltaire's library, Catherine originally intended to build a replica of his Swiss château at Tsarskoe Selo. But either due to financial constraints or diplomatic issues with France (which had talked about confiscating the library), this plan did not materialize. In early October

1779, coachmen helped Voltaire's secretary Jean-Louis Wagnière unpack twelve large crates by Catherine's study in the Oval Room of the Winter Palace. With the 6,760 volumes, Catherine installed Houdon's portrait bust of Voltaire and a model of Ferney.

Denis Diderot died in July 1784, six years after Voltaire. The following November, his 2,904-volume library also arrived at the palace, where it was installed next to that of Voltaire. Two decades earlier, facing great financial difficulties, Diderot had sold his library to Catherine for 16,000 livres. By letting Diderot keep his books until his death, and paying him another 50,000 livres to be her librarian (1,000 livres per year paid fifty years in advance), Catherine earned his unwavering loyalty. "Great Princess, I bow down at your feet," a grateful Diderot gushed. "I stretch my arms towards you but my mind has contracted, my brain is confused, my ideas jumbled, I am as emotional as a child, and the true expression of the feeling with which I am filled dies on my lips. . . . Oh, Catherine! Remain sure that you rule as powerfully in Paris as you do in St. Petersburg."[7]

With Diderot's library in her fold, Catherine acquired the only uncensored copy of his masterpiece, *Encyclopédie, or a Systematic Dictionary of the Sciences, Arts, and Crafts*. According to Diderot, the mammoth work was intended "to assemble the knowledge scattered over the face of the earth; to explain its general plan to the men with whom we live, and to transmit it to those who will come after us, so that the labors of past centuries may not be useless to future times. . . ." "Indispensable" is how Catherine described the two-decade effort. "Catherine could not be without her copy," writes Frank T. Brechka. "Constantly quoting its wisdom, always thumbing through it . . ."[8]

Ironically, by 1792, the *philosophes* whose libraries Catherine coveted were now personae non gratae due to the heightened political paranoia. "Do you remember how the late King of Prussia claimed that Helvetius had confessed to him that the project of the *philosophes* was to overturn all thrones and that the *Encyclopédie* had been made with no other aim than the destruction of all kings and all relations?" Catherine asked Grimm. "Do you also remember that you never wanted to be counted among the *philosophes*? Well, you are right never to have wanted to be included among

the illuminati, the enlightened ones, or the *philosophes*, for their only objective is destruction, as experience has shown."[9]

Catherine's personal volumes, some 4,000 with red morocco bindings and gold edges, along with those of Voltaire and Diderot, were featured in Alexander Luzhkov's catalogue of the Hermitage Library. The titles reflected the bibliophile empress's broad intellectual interests—from ancient and modern history, philosophy and politics to science, atlases, and travel guides. Before Catherine's reign, publishing in Russia had been a state monopoly. In the quarter century before Catherine's censorship decree in 1795, the number of independent Russian presses multiplied and published some 8,000 titles—more than three times the total created in the previous two centuries.

The newest addition to Catherine's Imperial Russian Library was not an acquisition, but war booty. After the Kościuszko Uprising in 1794, Russian troops executed her order to confiscate the Załuski Library in Warsaw.[10] Founded earlier in the century over four decades by aristocratic brothers Joseph and Andrew Załuski, both Roman Catholic bishops, the famed library was located in the 17th-century Daniłowicz Palace. One of Europe's earliest public libraries, it was also one of the largest with some 260,000 volumes and 10,000 manuscripts. That summer and fall, Catherine ordered the Załuski holdings transported from Warsaw to St. Petersburg—by cart as far as Riga and then by ship to the capital.[11] En route, parts of the collection were damaged, destroyed, or stolen.

In July 1796, Catherine took a second look at Sokolov's design for the library. She decided to add an observatory and donated a telescope previously owned by British astronomer Sir William Herschel. To relieve tensions of its users, the library also featured "a most pleasant garden" with a pool, recalled librarian and publisher Mikhail Antonovsky. In October 1796, Catherine issued funding instructions.

Newly arrived in St. Petersburg, Italian stage designer and architect Pietro Gonzaga wrote home about Russia's capital: "The city is big and beautiful: construction continues hurriedly, despite all the wars, and the buildings grow like mushrooms. . . . most of the buildings are in good taste, and among the best are those of Quarenghi."[12]

CHAPTER FIVE

QUEEN OF THE WORLD

I n the aftermath of the French Revolution, Catherine stood in solidarity
with fleeing aristocrats. She rolled out the red carpet for noble émigrés,
including the Duc de Richelieu, who she made governor of Crimea,
and Admiral de Traversay, who became her naval minister. Among the
non-noble arrivals in the summer of 1795 was celebrated Parisian portraitist
Élisabeth Vigée Le Brun. At twenty-one, Vigée Le Brun raised eyebrows
by marrying a man twice her age, art dealer Jean-Baptiste-Pierre Le Brun.
The marriage was short lived, but Vigée Le Brun's well-connected husband
helped her attract the notice of Marie Antoinette. With her flattering
depictions and talent for rendering luxurious silk and taffeta, Vigée Le
Brun soon won the queen's confidence.

In 1783, Marie Antoinette helped her become one of just four women
members of the prestigious Royal Academy. But because of her close rela-
tionship to the queen, the artist and her nine-year-old daughter fled Paris
in disguise at the start of the French Revolution. While working in Vienna,

she met the Prince de Ligne and Russian ambassador Count Razumovsky, who convinced her that St. Petersburg should be her next stop. Vigée Le Brun stayed for six years, calling Russia her second homeland. As a septuagenarian, the artist dictated her memoirs to her niece, including vivid descriptions of Russia.

The day after her arrival, Vigée Le Brun was presented to Catherine at Tsarskoe Selo by Count Valentin Esterhazy, diplomatic envoy of exiled Louis XVIII. Self-conscious about her plain muslin dress and surprised by the appearance of the 65-year-old empress, the artist forgot the count's instructions to kiss Catherine's ungloved hand. "The truth is, that the sight of this famous woman made such an impression upon me that I could not possibly think of anything else but to look at her," she recalled. "I was at first extremely surprised to find her short; I had imagined her a great height—something like her renown. She was very stout, but still had a handsome face, which her white hair framed to perfection.

"Genius seemed to have its seat on her broad, high forehead. Her eyes were soft and small, her nose was quite Greek, her complexion lively, and her features very mobile. She at once said in a voice that was soft though rather thick: 'I am delighted, madame, to see you here; your reputation had preceded you. I am fond of the arts, especially painting. I am no connoisseur, but I am a great art lover.' Everything else she said during this interview, which was rather long, in reference to her wish that I might like Russia well enough to remain a long time, bore the stamp of such great amiability that my shyness vanished, and by the time I took leave of Her Majesty I was entirely reassured."[1]

That reassurance proved fleeting. In the fall, Count Alexander Stroganov informed Vigée Le Brun that the empress wanted a double portrait of her eldest granddaughters. The picture, for which she received a generous 3,000 rubles, depicted Elena holding the portrait medallion of her grandmother hanging from Alexandra's neck. "Their complexions were so fine and delicate that one could have believed they lived on ambrosia," wrote the artist. "I grouped them together, holding and looking at a portrait of the Empress; the costume was a little Greek but very modest."[2]

Catherine loathed the sentimental picture. "Mme Vigée Le Brun has them both curling up on a divan, twisting the neck of the youngest one,

giving both of them the air of two pug dogs warming themselves in the sun, if you prefer, two ugly little Savoyardes [French peasant girls], combed like Bacchi with bunches of grapes in their hair, and dresses them in bright red and purple. In a nutshell, not only has she failed to capture proper likenesses, but the two sisters are so disfigured that some people ask which is the older and which the younger," she complained to Grimm. "The partisans of Mme. Le Brun praise this to the skies, but in my opinion it is bad, for this portrait bears neither resemblance, nor taste, nor nobility, and one would have to be a simpleton to miss one's subject like this, especially with it right in front of one's eyes: all one had to do was copy Mother Nature and not invent the attitudes of a monkey."[3] Vigée Le Brun started over, replacing the grapes in the princesses' hair with wreaths of flowers and covering their "pretty arms" with modest long sleeved dresses. She finished the tondo in 1796.

After the redo which met with Catherine's approval, Vigée Le Brun began a full-length state portrait of Grand Duchess Elizabeth Alexei-evna, who was considered one of Europe's most beautiful women. Their first meeting at Tsarskoe Selo made a dramatic impression on the artist: ". . . She was seventeen years old at most; her features were well formed and regular, her face a perfect oval; her fine complexion was not bright, but was of a paleness completely in harmony with the expression of her countenance, whose sweetness was angelic. Her fair hair floated over her neck and forehead. She was clad in a white tunic, a carelessly knotted girdle surrounding a waist as slender and supple as a nymph's. . . . so ravishingly did this young person stand out . . . that I exclaimed, 'That is Psyche!' . . . She addressed me, and kept me long enough to tell me a thousand flattering things. She then added, 'We have wanted you here for a long time, Mme. Lebrun—so much so that I have sometimes dreamed you had already come.' I parted from her with regret, and have always preserved a memory of that charming vision."[4]

Vigée Le Brun had learned her lesson. Catering to Catherine's conservative taste, she painted the grand duchess dripping sapphires, diamonds, and pearls, wearing a luxurious white satin embroidered dress with three-quarter lace sleeves and a blue velvet train embroidered with gold. Jewel-studded ornaments and a silk ribbon of the Order of St. Catherine adorned

her blue velvet bodice. To the left, draped over a chair was an ermine-lined mantle of red velvet. Wisely, the artist included a large marble bust of Catherine. The grand duchess sat for Vigée Le Brun many times, during which time they became good friends.

Vigée Le Brun had a chance to observe the empress at one of the city's frequent balls. "The double doors opened and the Empress appeared. I have said that she was quite small, and yet on the days when she made her public appearances, with her head held high, her eagle-like stare and a countenance accustomed to command, all this gave her such an air of majesty that to me she might have been Queen of the World; she wore the sashes of three orders, and her costume was both simple and regal; it consisted of a muslin tunic embroidered with gold fastened by a diamond belt, and the full sleeves were folded back in the Asiatic style. Over this tunic she wore a red velvet dolman with very short sleeves. The bonnet which held her white hair was not decorated with ribbons, but with the most beautiful diamonds."[5]

Vigée Le Brun's preferred sentimental style enjoyed a better reception with Russia's aristocrats. At her popular studio on Palace Square, she competed successfully for portrait commissions with Dmitry Levitzky and Vladimir Borovikovsky, along with French émigrés Jean Louis Voille and Jean Laurent Mosnier. "I cannot say how eagerly and with what kind-hearted affability a stranger is sought after in this country, especially if possessing some talent," she wrote.[6] Vigée Le Brun learned to be careful around Platon Zubov's portraitist, Johann Baptist Lampi. The powerful favorite disparaged her to Catherine.

Born in Romano, Italy, and trained in Salzburg and Verona, Lampi became the preferred portraitist at the Vienna court before working for Stanislaus Poniatowski in Warsaw and Catherine in December 1791. In the monumental *Portrait of Grand Dukes Alexander and Constantine Pavlovich*, Lampi painted the brothers against a classical backdrop, wearing costumes of the Orders of St. Andrew and St. Alexander Nevsky. Alexander points to a sculpture of Minerva associated with his grandmother. At the foot of the sculpture, a medallion in a laurel wreath depicts Castor and Polydeuces, symbols of brotherly love and heroism. According to myth, the brothers' stars light up in the morning and evening.[7]

Lampi continued the allegorical tradition in his portraits of Catherine starting with a state portrait in 1793. The initial version featured a palace interior backdrop with Saturn and History at Catherine's feet. But Catherine found her face "too serious and malicious" and Lampi went back to the drawing board. According to Charles Masson, the retouched portrait eliminated a sinister "wrinkle at the base of the nose" and made the septuagenarian look like a "young nymph" wearing the sashes of the Orders of St. Andrew, St. George, and St. Vladimir.[8] The crown and orb are beside her; an ermine cape is draped across a throne behind her decorated with Themis, goddess of justice. With a scepter in her right hand, Catherine points with her left to a relief with Peter the Great's profile portrait. Next to it is an eagle with raised wings, bird of Jupiter, symbol of the powerful Roman emperors. The portrait was widely distributed, with numerous versions and copies.

The following year, Lampi painted a second portrait of Catherine looking directly out at the viewer and wearing an ermine robe and a pearl-trimmed gown. Lampi also painted a more informal half-length portrait of the empress holding a mask and wearing a gold dress and an elaborate jeweled Russian headdress and hanging choker. In 1795, he painted Catherine's daughter-in-law Maria Feodorovna holding her own sketch of her children with a bust of Paul in the background. In addition to portraits of members of the royal family, Lampi was sought after by Russian officials and courtiers.

Catherine continued to reward Russia's military leaders and her friends with gifts. In July, she sent Field Marshal Count Alexei Orlov-Chesmensky a rectangular snuffbox by the Théremin brothers. The lid featured a miniature enamel of the monument at Tsarskoe Selo commemorating his naval victory at Chesme a quarter century earlier. Around this time, Catherine also gave her longtime friend Lev Naryishkin an exquisite gold box with a painted enamel of fruits and vegetable and basketwork by Charles-Jacques de Mailly. The French painter had executed enamels for two gold boxes during a trip to Moscow in 1775, along with a portrait of none other than rebel leader Emelyan Pugachev—an ironic subject at a time when the primary fear among the upper class was another serf rebellion.

CHAPTER SIX

JOINED IN DEATH

Since 1789, Catherine's court had been running a two-million-ruble deficit. The cost of wars, her spectacular court, palaces, and art collections had drained Russia's treasury, leaving a huge debt and debased currency. Despite the financial crisis, Catherine didn't skimp on grandson Constantine's wedding. In February 1796, the sixteen-year-old grand duke married fourteen-year-old Princess Juliana Henrietta of Sachsen-Coburg (the future aunt of England's Queen Victoria). In addition to the extravagant nuptials, Catherine spent some 120,000 rubles redecorating the couple's Winter Palace apartments near the Hermitage.

"I've been so tired all these days by Constantine, and everything concerning him . . . that I haven't had a moment to myself," Catherine complained to Grimm about the Sachsen-Coburg sisters' visit to St. Petersburg the previous October. ". . . [I]t is a pity that our groom-to-be can have only one, as all three would be good to keep, but it looks as though our Paris will give the apple to the youngest: you'll see it will be Julie who carries

it off."[1] After converting to the Orthodox Church, Juliana took the name Anna Feodorovna.

Following the royal wedding, dinner was served in Giacomo Quarenghi's spectacular new St. George's Hall—a specially built wing added to the eastern side of the Winter Palace within the great courtyard. The neoclassical masterpiece featured an allegorical plafond, double Corinthian pink marble columns, multicolored marble walls, and a patterned parquet floor. At the far end of the hall, Quarenghi installed the empress's new throne crowned by allegorical figures holding a shield with her monogram. Wedding toasts were made to a fanfare of trumpets, drums, and cannons.

After dinner the newlyweds led a procession of carriages to the Marble Palace. Despite speculation that Catherine might bequeath Gregory Orlov's Marble Palace to their out-of-wedlock son, Alexei Bobrinsky, she gave the luxurious abode to Constantine. Having been driven mad by the death of his young wife, Gregory Orlov's ghost was rumored to haunt the palace. Catherine was sensitive to criticism about the expensive palace. John Parkinson, who managed to see it "by stealth" in 1773, raved about the flowered velvet upholstery from Lyon and noted that the empress was "very angry" about a forgotten stove. "The furniture is all of silk, yet there was also velvet and cloth of gold," he wrote. "The Drawing [room] is excessively handsome. In this room nothing is wood but the floor: the doors cost 15,000 roubles, being veneered with silver . . . The walls are covered with marble and ornamented with marble pilasters. . . ."[2]

Unfortunately for Anna Feodorovna, Constantine took after his father and grandfather in both personality and appearance. Among those who observed his cruel streak was Countess Golovine. "Sometimes he [Constantine] twisted her arm and bit her, but these were only the preliminaries to what awaited her after marriage." According to Golovine, Constantine would "amuse himself with gun practice, in the riding school of the Marble Palace, with rats, which were loaded alive into the cannons, as ammunition."[3] Constantine's behavior also troubled his older brother, Alexander. ". . . [H]e often causes me grief; he is hotter than ever, very self-willed, and his desires do not often coincide with reason," Alexander wrote La Harpe. "The military turns his head, and he is sometimes brutal with the soldiers of his regiment . . ."[4]

In June, Alexander and Constantine greeted their new baby brother Nicholas, the eleventh child between Maria Feoderovna and Paul. From Tsarskoe Selo, Catherine wrote Grimm about the robust infant, her tenth surviving grandchild and third grandson: "His brothers will prove to be dwarfs before this colossus. His hands are only a bit smaller than my own." By that summer, Catherine's voice had turned hoarse and she'd developed phlebitis. To treat the open sores on her swollen legs, she soaked her feet and legs every day in ice-cold seawater. Catherine had joked about the track record of her Scottish physician, Dr. Rogerson, with other patients. Now Rogerson's doubts about the unconventional treatment convinced her that the ice bath was having "marvelous effects."

Also that month, Alexander and Elizabeth Alexeievna moved into their new summer palace at Tsarskoe Selo. As sunlight streamed down on the regal double Corinthian colonnade, Catherine greeted the couple on the staircase with bread and salt, traditional gifts of blessing for a new house. Catherine had been planning this moment ever since Alexander was a young boy. Four years earlier, Catherine commissioned Giacomo Quarenghi to design the palace as a present for Alexander's wedding the following year.

Catherine originally intended the palace to be a year-round city residence with an ornate façade and complex interior plan. At some point, she changed her mind, ordering a summer palace at Tsarskoe Selo on a low hill in the picturesque northeastern part of the park. The grand project fueled already rampant rumors that Catherine wanted her beloved grandson to succeed her in lieu of her son. Quarenghi moved his large family to Tsarskoe Selo to be close to the project. His elegant U-shaped design featured a courtyard created by two wings. The south façade, overlooking the formal section of the park, featured a semi-rotunda with a tall Palladian window. As the palace went up, underground rivers beneath the site caused the building to shift; major cracks appeared in the main vault of the semicircular hall. To support and reinforce the central hall vaults, Quarenghi had a large terrace built outside the garden entrance.

Though the palace's foundations were made of stone, the rest of the huge residence was almost entirely built with bricks made from local clay. At first, the palace exterior was left as exposed brick. It took a number of

years for the brickwork to dry and final stuccoing and painting to occur. Quarenghi also contributed to the surrounding Alexander Park. Concerned that builders would strip trees around Tsarskoe Selo to fire their kilns, Catherine ordered the local forests protected.

In contrast to Charles Cameron, Quarenghi used color conservatively. A team of British, Russian, and Italian craftsmen executed his austere interior designs. Columns and pilasters, cornices and door surrounds were the main decoration of the large, well-lit rooms. Under vaulted ceilings adorned with neoclassical paintings, walls of the staterooms were lined with imitation marble. As construction progressed, Catherine scaled back the interiors. Though some new furniture was ordered, much of it arrived from her other residences, including Tauride Palace.

Over fifteen years, the detail-oriented empress and her virtuoso architect developed an unusually close working relationship. "He [Quarenghi] does not feel himself under the smallest restraint with her," noted John Parkinson. "He has now been here thirteen years yet he never went to her when he did not find her employed in reading or writing. From two to four is the Time of Mystery. She seldom speaks German; Quarenghi had never heard her speak [it] but once; it seems as if she studiously avoided it. He spoke of her with great candour, acknowledging that with all her faults she was possessed of very splendid and noble qualities."[5]

Catherine's hands-on approach to building is illustrated by a series of architectural sketches she sent to Quarenghi, recently discovered among over seven hundred of the architect's own sketches at the public library in his native Bergamo. Executed in red pastel and pencil, the sketches include Catherine's ideas for a charity hospital, a Chinese Pavilion, a colonnade, and a C-shaped building. To the drawings, Catherine added handwritten notes in French covering a wide-range of subjects—from Voltaire-style armchairs and the slope of a colonnade to the type of stone she wanted used for the exterior of a music pavilion at Tsarskoe Selo.

Along with specific directives, Catherine gave Quarenghi a degree of artistic freedom. Frequently in her notes, she refers to historic buildings and artworks. For example, to the top left of her sketch for a garden pavilion she wrote: "Monsieur Quarenghi, I'm asking you to please make a drawing for a sun room in the same shape as this one here and in the middle we could

put the Apollo Belvedere statue or another one you like from which I have the mold and I can have it cast."

No detail escaped her. "The wooden house the sketch of which I sent you this morning has to be placed as close as possible to the colonnade without cutting any trees," she instructed. On another occasion, Catherine added several requirements to a bedroom design. "I forgot to tell you three things yesterday about the bedroom for which I gave you the plan—1) the stove should be heated from the outside, 2) That you have the ceiling whitened to lighten the room, 3) When working in that bedroom, the workers should enter through the windows and not by the doors from the other apartments. Furthermore I recommend that you make sure the doors close properly and for that reason that you make them in a way that the planks boards don't split easily."

Catherine's most elaborate instructions accompanied her sketch for the Smolny Institute. Though the Institute eventually became a school for the education of noble girls, she conceived it as a charity hospital, "a refuge for the sad poor widows and daughters from officers and civilians employees who very often are left without bread and a roof and don't know where to go and they fall into vice or misery. . . . I would like that there's a church and several buildings separated rather than one big structure . . . every house will have a kitchen and several bedrooms to host several women under management of one and each house can be one or two stories with a little garden . . . the priest and male visitors will stay outside the wall . . . We can connect all the houses with a gallery to go to church in bad weather."[6]

Age did not lessen Catherine's competitiveness as a collector. In 1796, at the age of sixty-seven, Catherine commissioned sixty-year-old Swiss portraitist Anton Graff to copy the best paintings at Dresden's Gemälde-galerie Alte Meister—masterpieces like Raphael's *Sistine Madonna*, Titian's *Portrait of a Lady in White*, Rembrandt's *Rape of Ganymede*, and Johannes Vermeer's *Girl Reading a Letter*. Like the Hermitage, the esteemed Old Masters Picture Gallery had been assembled remarkably fast—over the course of just half a century by passionate collectors Augustus the Strong and his son Augustus III. The prestigious gallery did not want to allow its works to be copied, but Russia's ambassador intervened and an exception was made.

Also that year, Catherine acquired two paintings by another successful contemporary artist. Hubert Robert had developed a passion for architectural ruins during eleven years in Rome, where he'd first gone with France's ambassador to the Vatican, Duc de Choiseul. While studying under Giovanni Paolo Panini at the French Academy, Robert met Jean-Honoré Fragonard, with whom he traveled to Herculaneum, Pompeii, and Villa d'Este in Tivoli. Robert also befriended and sketched with Giovanni Battista Piranesi. Robert's architectural landscapes enjoyed an avid following and he became designer of the king's gardens and keeper of the king's pictures. Voltaire hired him to paint the scenery for his theatre at Ferney; his large following of Russian aristocrats included Counts Alexander Stroganov, Shuvalov, Rostoptchin, and Bezborodko, and Princes Nicolai Yusupov and Dimitry Golitzine.

Catherine had tried on several times to lure Robert to St. Petersburg. Unlike his friend Élisabeth Vigée Le Brun, Robert chose to stay in Paris during the revolution. During his ten-month imprisonment at Saint-Lazare, Robert produced some fifty paintings, watercolors, and drawings. Released after the fall of Robespierre in August 1794, the sixty-year-old was appointed to the Conservatoire, a group supervising the Louvre's remodel from royal palace to national art museum. During living and working at the Louvre, Robert produced several dozen views, including Catherine's pendants.

Project for the Grande Galerie of the Louvre, exhibited at the Salon of 1796, depicts Robert's plan for transforming the corridor of Louis XIV's sumptuous palace into a public art gallery. The Grand Gallery was built to connect the Louvre to the Tuileries Palace. Below a skylight and coffered vaults, spectators stroll through an elegant gallery, admiring Italian masterpieces formerly from the royal collection. To the right foreground, Robert added himself at an easel, copying from Raphael's *Holy Family*. Robert expressed his inventiveness in the pendant, *Imaginary View of the Grande Galerie of the Louvre in Ruins*. In the futuristic view, the proposed gallery is destroyed, emptied of masterpieces, its famous statuary in pieces. In the middle of the decay, an artist sketches the only surviving artwork, the Vatican's antique sculpture Apollo Belvedere with a bust of Raphael at its feet.[7] According to Vigée Le Brun, Robert died in 1808, a paintbrush in his hand.

Also that year, Catherine hired Vladimir Borovikovsky to paint Persian Prince Murtaza Kuli. Catherine had given the prince protection at her court after his unsuccessful coup against his brother, the shah. With its attention to weapons and opulent long fur and brocade caftan and hat, Borovikovsky's full-length dress portrait highlighted the émigré prince's exotic and regal status.

With Constantine wed, Catherine turned her attention to arranging an advantageous marriage for thirteen-year-old Alexandra. Bragging to Grimm, Catherine noted her eldest granddaughter's "extraordinary gentleness," along with dancing and musical skills. It was Potemkin who'd suggested a marriage between one of the grand duchesses and the son of her late cousin Gustav III as a way to improve relations with Sweden. After his father's assassination, fourteen-year-old Gustav IV had assumed the crown under the regency of his uncle, Charles, Duke of Södermanland. Like Grand Duke Paul, Gustav IV's paternity was uncertain. Since his birth, rumors abounded that his biological father was Swedish nobleman Adolf Fredrik Munck, hired as a sex instructor to help Gustav consummate his marriage with Sophie Magdalena.

The young king's paternity was unimportant to Catherine, who considered the handsome Swede good son-in-law material as well as good for foreign policy. After Gustav's November 1795 engagement to Luise Charlotte, daughter of the Duke of Mecklenburg-Schwerin, Catherine intimated that she would subsidize Sweden's treasury by hundreds of thousands of rubles if Gustav married Alexandra instead. Meanwhile, young Gustav had fallen in love with one of his aunt's ladies-in-waiting. Between this romance, Catherine's offer, and an uninspiring self-portrait of Luise Charlotte, Gustav called off his engagement.

That August, Catherine pulled out all the stops for a 140-member Swedish delegation, hosting lavish balls and galas in Gustav's honor. Before meeting Alexandra for the first time, Gustav saw her portrait in Élisabeth Vigée Le Brun's studio. The artist recalled that the Swedish royal dropped his hat when he saw Alexandra's portrait. But Platon Zubov, to whom Catherine delegated responsibility for betrothal logistics, forgot to work out the issue of religion. Gustav assumed Alexandra would convert to Lutheranism; Catherine insisted her granddaughter keep her Russian

Orthodox faith. After reading the fine print in the marriage contract that guaranteed his bride the right to remain Orthodox, Gustav was a no show at his September betrothal ceremony in the Winter Palace throne room.

After a three-hour wait, jilted Alexandra began to cry. Her grandmother, dressed in a gold brocade gown and a crown, turned red. Rising from her throne, scepter in hand, Catherine tried to speak but was unintelligible. Witnesses thought the 67-year-old tsarina may have suffered a mild stroke. With the exception of an appearance at a Winter Palace ball marking the thirty-fourth anniversary of her coronation, Catherine was not seen in public for several weeks. As Isabel de Madariaga puts it, Catherine "never recovered from the shock of the public humiliation inflicted on her by a lad of seventeen."[8] When Gustav married Fredericka of Baden, Elizabeth Alexeievna's younger sister, on November 1, he became Grand Duke Alexander's brother-in-law as originally intended. Three years later, Alexandra was unhappily married off to Austria's Archduke Joseph.

After the engagement fiasco, Catherine's health took a turn for the worse. In October, she institutionalized censorship in Russia's major cities and made private printing presses illegal, a right she'd granted thirteen years earlier. On October 31, Catherine hosted a lunch in the Diamond Room for a small circle of friends that included Anna Protasova, Arkady Morkov, Ivan Shuvalov, and Fyodor Baryatynsky (master of the household). That evening, Catherine's grandchildren joined the group to watch a performance of a French comedy at the Hermitage Theatre.

A few days later in the palace throne room, Vigée Le Brun showed Catherine the sumptuous portrait of her daughter-in-law Elizabeth Alexandrovna. This time, she received a more positive response; Catherine even agreed to sit for her portrait. On November 4, Catherine hosted a get-together for her close friends in the Small Hermitage. The empress had a good laugh when Lev Naryshkin dressed up as a peddler and pretended to sell a tray of toys.[9] After writing Austrian minister Cobenzl a humorous note, Catherine retired early. She'd recently given Alexander Suvorov the green light to fight the French. Suvorov and 60,000 Russian soldiers were scheduled to depart for northern Italy in three days. The old general couldn't wait to battle France's ambitious young commander, Napoleon Bonaparte. Two months earlier, Napoleon had defeated the Austrians at

Bassano in the Republic of Venice, the first in his series of victories in Italy and Egypt.

The next morning, Catherine began her day as usual at six A.M. When Maria Perekusikhina asked the empress if she'd slept well, Catherine reportedly replied she had not slept so well in a long time. After her morning coffee, the empress started work, meeting briefly with Zubov and her secretaries. At nine, she asked the last secretary to wait in the antechamber and went to her dressing room. When Catherine didn't emerge, her valet Zakhar Zotov knocked and entered. The dressing room was empty. Zotov and Perekusikhina forced open the door of the adjacent water closet. Catherine was slumped on the floor against the door, eyes closed, face purplish, and foam dribbling from her mouth.

A group of servants moved Catherine into her bedchamber, placing her on a leather mattress on the floor. Zubov rushed to her side; Dr. John Rogerson arrived within the hour. With the exception of an occasional bloodletting or laxative, she'd managed to keep her physician at arms-length. Now, diagnosing a stroke, Rogerson insisted on trying "all means" to save the empress. This included opening a vein in her arm to bleed her and placing an application of the blister-producing Spanish fly on her feet.

Zubov dispatched his older brother Nicholas to Gatchina to inform Grand Duke Paul. Grand Duke Alexander also sent Count Fyodor Rostopchin to Gatchina to reassure his paranoid father that he wasn't about to seize the throne. Halfway between Gatchina and the capital, the grand duke and count met at a staging post on the road. "I saw the grand duke fix his gaze on the moon, tears filled his eyes and flowed down his face," wrote Rostopchin. "I seized his hand. 'My lord, what a moment this is for you!' He pressed my hand. 'Wait, my dear friend, wait. I have lived forty-two years. Perhaps God will give me the strength and good sense to bear my appointed destiny.'"[10]

Around 8:30 P.M., Alexander and Constantine greeted their parents at the Winter Palace. While Zubov sat by himself in the corner, Paul and Maria Feodorovna kept a vigil through the night beside the unresponsive empress. At dawn, Dr. Rogerson informed Paul that there was no hope. Summoning Alexander Bezborodko, Paul ordered him to prepare a manifesto announcing his accession. He also instructed him to sort and seal his

mother's papers in her study under the supervision of his sons, and to lock the room and bring him the key. Among Catherine's packets was an envelope tied with a black ribbon inscribed "To be opened after my death, in the Council." Some historians believe it contained a manifesto she planned to announce later that month on St. Catherine's Day, changing the order of succession to Alexander. Paul is thought to have gone through his mother's papers, tossing the manifesto into the hearth.

By the early evening, Catherine's pulse had weakened and her shallow breathing became even more labored. Metropolitan Gavril performed the last rites, anointing her forehead, cheeks, mouth, breast, and hands with holy oil. Informed by Dr. Rogerson that the his mother's time was near, Paul entered her bedroom along with Maria Feodorovna, their four eldest children, Zubov, Madame General-Lieven, and Counts Osterman, Bezborodko, and Samoilov. Catherine never regained consciousness. Around 9:45 P.M., thirty-six hours after being stricken, Russia's empress died.

Within an hour, Catherine's attendants dressed her body in a simple white gown. According to Rostopchin, Maria Perekusikhina cared for Catherine in her last hours: ". . . occupied solely with the Empress, she attended her precisely as if she expected her to awaken: continually fetching the handkerchiefs with which the doctors sponged away the fluid from [Catherine's] mouth, rearranging now her hands, now her head, and now her legs; despite the fact that the Empress had already passed away, she remained constantly beside the body and her spirit strove to follow the immortal soul of the Empress Catherine."[11] The following day, the grand duke was crowned Paul I in the palace chapel.

A week later, Catherine's embalmed body was carried from her bedroom through the Knights Guard room shrouded in black and into the throne room. "A mournful silence reigned in the apartment, interrupted only by sobs and sighs," wrote Countess Golovine. "I saw the clergy appear, then the candle-bearers, the choristers, and the Imperial family, and lastly the corpse, which was carried on a magnificent bier covered with the imperial mantle, the ends of which were borne by persons holding the highest offices at Court. When I caught sight of my sovereign, I began to tremble all over and ceased to weep, while my sobs changed to involuntary little cries."[12] Catherine was dressed in a silver silk brocade robe, with a gold brocade

mantle trimmed with ermine. When the ceremony ended, members of the imperial family kissed Catherine's hand.

On November 25, Catherine's corpse was moved to a coffin; a gold crown placed on her head. The casket was carried to the Great Gallery, where Antonio Rinaldi, architect of the Chinese Palace, Gatchina, and Marble Palace, had built a chamber of mourning. The dome-shaped structure featured classical pillars and a bronze imperial eagle. Catherine's coffin was placed on an elevated structure beneath a black velvet canopy with a silver fringe. Candles were lit.

In her handwritten Last Will and Testament, Catherine had left specific instructions for her funeral. "In case I should die in Tsarskoe Selo, then lay me in the graveyard of the [town of] Sofia. In case—in the city of St. Peter's—in the Saint Alexander Nevskii Monastery's cathedral or burial church. In case—in Moscow—in the Donskoy Monastery in the new city graveyard. In case—in Peterhof—in the Saint Sergius Monastery . . . The coffin shall be borne by Horse Guards and no one else."[13] Ignoring her wishes, Paul announced that his mother would be interred at the Peter-Paul Cathedral necropolis.

That wasn't all. Paul ordered his father's skeletal remains exhumed from the vaults of the Alexander Nevsky Monastery and placed in a golden coffin. As eight horses pulled Peter III's coffin on a wheeled platform, octogenarian Alexei Orlov, responsible for Peter's murder at Ropsha, was ordered to lead the procession and carry his victim's imperial crown on a pillow. Paul also required Orlov's two accomplices—Prince Fyodor Baryatynsky and Governor-General Passek—to join the procession. Paul, his family, and high-ranking court officials followed the coffin to the Winter Palace. There, Peter's coffin was placed on a bier beside Catherine's below a banner emblazoned "Divided in life, joined in death." With bishops and priests chanting requiem services around the clock, Petersburgers filed by the double catafalque to pay their respects.

On a bitterly cold December 5, with bells chiming, the imperial funeral cortege made its way through the snow-covered capital, crossing the frozen Neva to the Cathedral of Saints Peter and Paul. Paul walked behind his parents' coffins, followed by Maria Feodorovna, their sons, and courtiers. Inside the incense-filled cathedral, the coffins were placed side-by-side

on a catafalque designed by Vincenzo Brenna. Priests in black chasubles performed the double funeral ceremony. As soon as the service concluded, Paul ditched his mourning cloak and proceeded to the Millionaya to review the troops.[14]

Following two more weeks of requiem masses, Catherine was finally laid to rest, six weeks after her death. Her coffin was lowered into the vault beside that of the husband she despised. Paul forbade Metropolitan Amvrosy from reading a graveside oration in her memory. To make it look like his parents had co-reigned, he left off the dates of their deaths on their marble tombs.[15]

PART NINE

LEGACY

CHAPTER ONE

A SON'S REVENGE

C ontemptuous of his mother and everything she valued, Paul set about to erase her memory and achievements. The changes at court were dramatic. "Everything in the palace immediately took on a different appearance: spurs, Hessian boots, and cutlasses thundered and clanged, and, almost as if the city had been captured, military people burst into rooms everywhere with a great noise," observed Gavriil Derzhavin.[1]

The day of his coronation, Easter 1797, Paul changed Russia's law of succession to allow only men to rule, specifically denying the crown to the widow of a tsar. (To allow his second wife to succeed him, Peter the Great had changed the long-standing male-only primogeniture law.) Reversing his mother's anti-French foreign policy, Paul switched his support to Napoleon, who had overthrown the French government in 1799 and become First Consul, and dismissed her long-serving field marshal Alexander Suvorov.

Catherine had long considered Paul unfit to rule. "He is mad," Platon Zubov said. "I know it as well as you," Catherine replied. "Unfortunately, he is not mad enough to [enable us to] protect the state from the evils that he is preparing for it."[2] In fact, Paul's sometimes cruel and bizarre behavior earned him the name "the mad tsar." Challenging Europe's rulers to a series of duels and planning to send Cossacks to India to drive out the English were among his stranger ideas.[3]

Ten days after his mother's death, Paul dropped in on Zubov and toasted to his prosperity. The favorite soon found himself stripped of his posts and properties and told to leave Russia. Paul reserved the ultimate revenge for Potemkin, whom he'd once threatened with imprisonment. After destroying the mausoleum Catherine built, Paul had his remains exhumed and secretly buried elsewhere. Elegant Tauride Palace was turned into a barracks for the Imperial Guard Mounted Regiment. Ivan Starov's magnificent rotunda became a riding arena, stalls were added between the elegant white marble columns of the Great Hall, and manure covered the splendid parquetry floors.

With the help of Starov, Giacomo Quarenghi, and Charles Cameron, Catherine had turned neoclassicism into Russia's national architectural style. Now Paul demolished many of her elegant monuments and buildings. Less than three weeks after his mother's death, Paul fired Cameron and repossessed Grace and Favor, the house she'd given the architect at Tsarskoe Selo. In nearby Sophia, Cameron's Rose Field Pavilion and New Gallery disappeared, as did the unfinished Temple of Memory commissioned by Catherine to mark Russia's 1792 victory over the Turks.

Giacomo Quarenghi fared better, though he too experienced some casualties. Paul turned his English Palace at Peterhof into barracks and ordered two of his unfinished buildings torn down. Meanwhile at the Winter Palace, Vincenzo Brenna began making changes to the Hermitage Theatre. Fortunately, Quarenghi's newly completed Alexander Palace was spared. During Paul's reign, the enormous residence was stuccoed and painted deep yellow and white.

Catherine envisioned Pella as Russia's largest imperial palace with a riverside frontage stretching nearly one-third of a mile. A month after she died, Paul ordered Ivan Starov's vast complex demolished, scavenging

building materials for Pavlovsk and his new city palace, Saint Michael's Castle. By January 1801, six of Pella's nine building were destroyed (the rest were razed during Alexander's reign). Not only were the buildings demolished, images of the palace also vanished. Pella's only surviving depiction is a drawing on a fan that may have belonged to Catherine, based on Quarenghi's watercolor sketches.[4]

As a result of his father's murder and his mother's coldness, Paul lived in constant fear. Feeling unsafe at the Winter Palace, he hired Vincenzo Brenna and Vasily Bazhenov (the Muscovite architect whose work Catherine repeatedly rejected) to build Saint Michael's Castle. Symbolically, he chose the site of his birthplace, his great-aunt Elizabeth's former wooden palace. Surrounded by canals and the Moika and Fontanka rivers, the castle was accessible by drawbridge. After Paul dreamed that Archangel Michael instructed him to build a church at his birthplace, Brenna added a church to the west façade. In the castle's octagonal courtyard, Paul installed Carlo Rastrelli's bronze monument of Peter the Great with the inscription "Great-grandson to Great-grandfather." Catherine had disliked the baroque depiction.

In early 1797, Paul invited Catherine's former lover Stanislaus Poniatowski to live in the Marble Palace she'd built for his successor, Gregory Orlov. Russia, Prussia, and Austria agreed to pay Stanislaus's debts and Paul threw in a 100,000 ducat pension. Of his 2,200-plus paintings, the deposed Polish king brought 100 with him to Russia. After visiting Gatchina, Catherine's second palace for Orlov, Stanislaus wrote: "Pavlovsk was only a small treasure in comparison with Gatchina, where everything was grandeur."[5] Stanislaus also visited Voltaire's library at the Hermitage, and sat for two half-length portraits by Élisabeth Vigée Le Brun.

The following February, with Paul by his side, 66-year-old Stanislaus died of an apoplectic seizure. Paul pulled out all the stops for his funeral. Guard Regiments lined both sides of Nevsky Prospect from the Marble Palace to the Catholic Church of St. Stanislas. Wearing his drawn sword reversed, Paul rode in front of the hearse at the head of the Life Guards. A herald carried the White Eagle standard embroidered with the shields of Poland and Lithuania; ministers and dignitaries followed in parade carriages.[6]

For all their acrimony, Catherine's passion for collecting rubbed off on Paul. In the late 1780s, he bought a set of six exquisite 15th-century gouache and gold miniatures removed from a manuscript at the Dominican Monastery of Saints Giovanni e Paolo in Venice. In 1782, the government of Venice had thwarted his bid to buy the Farsetti sculptures. In 1800, with the Venetian Republic fallen to Napoleon, Paul bought the collection.[7] The highlight was Gian Lorenzo Bernini's terra-cotta model for his marble masterpiece *The Ecstasy of Saint Theresa* (Santa Maria della Vittoria, Cornaro Chapel, Rome).

Rubens's monumental *The Union of Earth and Water* is considered among Paul's best painting acquisitions. Starring a voluptuous Cybele, goddess of the Earth and the sea god Neptune, the sensuous picture is an allegory for the reopening of Antwerp's Scheldt River to commerce. According to contemporaries, Thomas de Keyser's *Portrait of a Knight with a Banner* (now titled *Portrait of Loef Vredericx as a Standard-Bearer*, 1626) decorated Paul's bedroom at Saint Michael's Castle, and Nicolas Lancret's sensual *The Bathers* hung in his study at Gatchina. After appointing Prince Nicholas Yusupov director of the picture gallery, Paul ordered a new catalogue of the collection in Russian, not French. Paintings with "indecent subject matter" like Pierre Crozat's *Danaë* by Rembrandt were relegated to storage.

For a new picture gallery at Pavlovsk, Paul sent Vincenzo Brenna to the Hermitage to select two hundred of his mother's paintings. Hung close together in decorative style, the works included Pierre Crozat's *Christ and the Samaritan Woman* by Pierre Mignard, *St. Bartholomew* by Ribera, and *St Justine* by Veronese; along with Robert Walpole's *Holy Family* by Matteo Ponzone and *View of a Harbour* and *Landscape with Fountain* by Jan Griffier the Elder. In addition, Paul transferred many of Catherine's best sculptures, busts, and statues from Tsarskoe Selo to Pavlovsk.

Like his mother at the end of her reign, Paul banned foreign books and required Russian books to be submitted to a censorship office. Ignoring her wish for an Imperial Public Library, he fired Vasily Popov, who'd overseen the library's construction and organization. In January 1800, Paul appointed Count Alexander Stroganov, one of the authors of the original Plan for a Russian Public Library in St. Petersburg, as director of the imperial

libraries. Stroganov convinced Paul not to take the nearly finished building away from the library.

As Catherine feared, Paul proved to be one of Russia's most disliked tsars. During his reign, 12,000 people were arrested, exiled, or dismissed from office without trial. Seven Russian field marshals, 333 generals, and 2,156 officers resigned.[8] Paul's restrictive edicts involved everything from dress (round hats, waistcoats, and tailcoats were banned) and foreign travel to further cracking down on private printing presses and even regulating sheet music. He also alienated Russia's landowners by reinstituting corporal punishment for the gentry and decreeing that serfs could be forced to work no more than three days a week—a decree not so much out of concern for the well-being of the serfs, but to further antagonize the landowners.

On the night of March 12, 1801, a small group of aristocrats and military men stormed Saint Michael's Castle and forced their way into the tsar's private apartments. Among the intruders was a commander of the elite Semeonovsky Regiment and Platon Zubov's brother, General Nicholas Zubov (Zubov's sister Olga Zherebtsova was the suspected leader of the conspiracy).[9] The conspirators forced the 46-year-old tsar to a table and tried to get him to sign his abdication. When Paul tried to hide behind a curtain, an assailant hit his head with a heavy snuffbox—said to have belonged to Platon Zubov himself. The injured tsar was then strangled to death just like the man he always believed to be his father.

After less than five years, Paul's unpopular reign was over. Apoplexy was the official cause of death. It was widely believed that his 23-year-old son and heir, in a nearby bedroom at the time, knew about the plot. Like his grandmother after Peter III's murder, Alexander did not punish his father's assassins. Just days after Paul's murder, his seventeen-year-old daughter Alexandra died in Vienna after giving birth to his granddaughter.

CHAPTER TWO

ART-LOVING GRANDSONS

I n his accession manifesto, Alexander I pledged to follow Catherine's "heart and laws."[1] The timing of Alexander's accession with the start of the new century, writes Simon Dixon, led to his being associated with the glories of the prior century—including those of his grandmother. Many of Catherine's histories, plays, and letters were reissued.

Like his grandmother, Alexander began his reign with attempts at reform. As a snub to Catherine, Paul had pardoned exiled writer Alexander Radischev. In 1801, Alexander restored Radischev's ranks and appointed him to the Commission on Revision of the Laws. But by the following fall, with peasant reform thwarted, Radischev committed suicide by drinking poison (suppressed until 1905, *A Journey from St. Petersburg to Moscow* became a best seller during the Soviet era).

As grand duke, Alexander had just three months to enjoy the palace his grandmother built for him before she died. He used Alexander Palace as a summer residence through his father's brief rule before moving to the

larger Catherine Palace as tsar. Alexander resurrected Charles Cameron's career, appointing him chief architect at the Russian Admiralty (though Alexander razed most of the houses in the unfinished model town of Sophia for bricks). Ironically, Paul I had spared Alexander Dacha, expanding Catherine's adjacent agricultural school into a state institution. But after Andrei Samborsky left to become one of Grand Duchess Alexandra's priests, the school was abandoned. Later, during Nicholas I's reign, private owners bought the property; in 1851 the dacha was demolished.

In May 1802, Alexander put Luigi Rusca in charge of renovating damaged Tauride Palace, and made it his town residence the following fall. For the restored interiors, the new court architect relocated many sculptures from Saint Michael's Castle. The finest of the palace statues was the Venus acquired by Peter the Great in Rome. Rusca and Potemkin's English gardener William Gould recreated the dramatic Winter Garden and re-landscaped the neglected gardens, which had been used as a carriage park during Paul's reign.

Catherine left her adored grandson two of her most prized possessions—her books and engraved gem collection. "My library including all manuscripts and all papers I bequeath to my beloved grandson, Alexander Pavlovich; likewise my jewels, and I bless him with my soul and with my heart," read her 1790 will.[2] In 1805, Alexander revitalized his grandmother's plan for the Imperial Russian Library by acquiring the manuscript collection of Russian diplomat Peter Dubrovsky. During the French Revolution, the bibliophile managed to save papers from the Bastille archives. The trove featured medieval manuscripts, letters by Erasmus, Leibniz, Diderot, Rousseau, and Voltaire, and Old Slavonic and Eastern writings.

The Dubrovsky acquisition led to the creation of a manuscript department at the Imperial Russian Library. It was among his grandmother's personal effects that Alexander discovered a treasure for the new department—the Ostromir Gospel. Named for its patron, the governor of Novogorod, the richly decorated 11th-century gospel is the oldest surviving Russian manuscript. Alexander also acquired twenty-seven Latin manuscripts from the Weissenau Monastery in Swabia. In 1810, Alexander's Regulations for the Administration of the Imperial Public Library declared Catherine's library opened "for general use" and funded by the

SUSAN JAQUES

state.³ Enlarged by Carlo Rossi and again at the end of the 19th century, today's Russian National Library is the world's fifth largest, occupying an entire city block.

Catherine saw to it that Alexander's education included an appreciation for the arts. Though the young tsar viewed the Hermitage as his grandmother's legacy, he began making his own mark. Under his watch, the museum was reorganized and professionalized; the first engravings of its famous paintings were published. Franz Labensky, keeper of the Hermitage paintings, established a restoration studio and a school to train restorers to transfer paintings from wood to canvas. In 1808, Alexander sent Labensky to Paris. After almost a year, Labensky returned to St. Petersburg with Caravaggio's *The Lute Player* and Pieter de Hooch's *Woman and a Maid*.

Early on, Alexander admired Napoleon. After Russia's defeat in the Battle of Friedland in 1807, the two rulers met at the Neman River and signed the Treaty of Tilsit, establishing peace and pledging mutual cooperation. During the accord, Napoleon's art adviser Baron Dominique Vivant-Denon helped Alexander acquire some forty pictures for the Hermitage, including Botticelli's *Adoration of the Magi* (National Gallery of Art, Washington, D.C.), *Jacob's Dream* by Murillo, *The Appearance of the Virgin to St. Lawrence* by Guercino, and *Deposition* by Luca Giordano.

The rapprochement between Alexander and Napoleon came to an abrupt end five years later when France's massive continental army, some half a million strong, invaded Russia. Several hundred thousand people were killed as Napoleon's army advanced to Moscow. By mid-September 1812, with Napoleon poised to take the city, the population of Moscow was evacuated and the city intentionally set on fire. Though the desperate measure destroyed two thirds of the city, it left Napoleon's army without food or supplies to survive Russia's brutal winter; 400,000 French soldiers died as a result.

As Napoleon retreated in defeat, Alexander's popularity soared. The tsar led his troops on a European victory march, arriving in 1814 for the Treaty of Paris. Boasting the world's largest army and holding parts of the former French empire including Poland, Saxony, and Holstein, Russia was the global superpower Catherine envisioned.⁴ Ironically, the Catherinian revival from early in Alexander's reign dwindled. "Once Alexander had

made his own glory by defeating Napoleon, any lingering need to cling to his grandmother's skirts was finally removed," writes Simon Dixon.[5] Even Catherine's court poet Derzhavin celebrated Alexander's entry into Paris, questioning whether "Peter and Catherine were as great as you."[6]

The Napoleonic Wars rocked the art market and Alexander exploited the opportunity to enhance his grandmother's collection. Spanish resistance to Napoleon had endeared the country to Russians. In 1814, Alexander addressed the Hermitage's dearth of Spanish Old Masters when he paid 100,000 guilders for sixty-seven pictures belonging to London-based banker William Coesvelt. Among the works were Velazquez's *Portrait of Count-Duke Olivares* and Murillo's *Annunciation*.[7] Like Catherine, Alexander's most important acquisitions came from Paris. The first was a gift his grandmother would have applauded.

While visiting Napoleon's ex-wife Joséphine in May 1814, Alexander assured her that riverfront Malmaison would go to her son and daughter from her first marriage (four years earlier, Napoleon annulled their marriage when she'd failed to produce a son). In gratitude, France's former empress handed Alexander the *Gonzaga Cameo*, one of the world's most coveted carved gems. Stolen by Napoleon, the cameo was the last great buy of Pope Pius VI, who died as a French prisoner after signing the Treaty of Tolentino (and also after handing over some one hundred masterworks, including the Apollo Belvedere, the Dying Gaul, and Raphael's *Transfiguration*).[8]

Carved in 3rd century B.C. Egypt, the three-layer sardonyx cameo depicts Arsinoë II and Ptolemy II Philadelphus. "It is, of course, a lover's gift, because it's an image of a couple," explains Paul Mosterd, deputy director of the Hermitage Amsterdam. "But it is also a very smart move on her part, a brilliant move of a lady who needs protection. . . . The symbolism is strong: She's saying, 'You can do this to me.'"[9] The stunning gift proved timely.

In late May, around the time Napoleon was moving into a former biscuit warehouse on the island of Elba, Joséphine caught a cold and died of pneumonia. Along with a three-million-franc debt, she left a trove of four hundred paintings and drawings, sculptures, furniture, antiquities, and jewels. The next year, Alexander paid Joséphine's daughter, Hortense de Beauharnais, the enormous sum of 940,000 francs for thirty-eight

paintings (among them Gerard ter Borch's *A Glass of Lemonade*, Gabriel Metsu's *Breakfast*, Paulus Potter's *Farm*, and three David Teniers the Younger pictures) and four Antonio Canova sculptures, including *Cupid and Psyche*. Thanks to Russia's tsar, Joséphine's children settled their mother's debt and enjoyed a large inheritance.

Some of Joséphine's paintings had been looted by the French army in 1806 from William IX, landgrave of Hesse-Kassel, when his electorate was annexed by the kingdom of Westphalia (ruled by Napoleon's brother, Jérôme Bonaparte). The Dutch-rich picture gallery had been assembled by generations of collectors from the German house. Alexander refused to return the works to the landgrave, arguing that he was not involved in their seizure and had paid fairly for them.[10]

Napoleon's defeat, like Catherine's military victories over the Turks, inspired a number of commissions. Alexander ordered St. Petersburg's architects to "build this capital to such a level of beauty and perfection that would be appropriate to greatness in every respect."[11] Leading this effort was Carlo di Giovanni Rossi, protégé of Giacomo Quarenghi and Vincenzo Brenna. In addition to remodeling the center of St. Petersburg, Rossi built the tsar an estate on Yelagin Island at the mouth of the Neva. In 1826, Rossi designed the National War Gallery at the Winter Palace housing George Dawe's portrait series of Russian generals who helped defeat Napoleon. Alexander's gallery may have been inspired by George IV's Waterloo Chamber at Windsor Castle, lined with twenty-plus military portraits by Thomas Lawrence, and the Duke of Wellington's Apsley House, where Dawe, Lawrence, and Jan Willem Pieneman contributed to a gallery of military heroes.[12]

When handsome, six-foot-tall Alexander married beautiful Elizabeth Alexeievna, Catherine described the teenagers as angels. But their fairy-tale marriage proved to be just that. The tsar and tsarina led separate lives, both taking other lovers. After the light-haired couple produced a dark-haired daughter, rumors spread that the father was Polish prince Adam Czartoryski, Alexander's best friend. Both of Elizabeth Alexeievna's daughters would die young. Meanwhile, Alexander had several illegitimate children with Polish Princess Maria Narishkiva, with whom he had a fifteen-year relationship. "His sexual appetites were insatiable," writes David King,

"already rivaling those of his grandmother Catherine the Great." Napoleon too was a fan. "If he were a woman," Napoleon once said, "I think I would make him my mistress."[13]

Alexander's role in his father's assassination is the subject of much debate. Whatever his involvement was, the crime haunted him for the rest of his life. "He would long be tortured in his sleep, hearing his father's awful screams over and over in his head," writes King.[14] Increasingly religious, Alexander confided to family members that he wanted to abdicate. On November 19, 1825, while traveling in South Russia with his ailing wife, the 48-year-old tsar died unexpectedly from typhus.

Alexander had converted the Round Hall at Catherine's Chesme Palace into a church. Now, his body lay in state here before burial in the Peter and Paul Fortress. Or did it? A rumor began to circulate that Alexander staged his own death and became a monk in Siberia. The theory gained a wider following in the early 20th century when Soviet officials opened his grave and reportedly found an empty casket.[15]

⚬

Alexander's unexpected demise led to a succession crisis when Grand Duke Constantine was proclaimed tsar by mistake. In 1801, Constantine's miserable wife, Anna Feodorovna, had returned to Germany permanently. Forbidden to divorce by Dowager Empress Maria Feodorovna, Constantine proceeded to father two illegitimate sons with two French actresses. While commanding Russia's forces in Poland, Constantine fell in love with a twenty-year-old beauty. When his first marriage was finally annulled in 1820, the couple became husband and wife.

Because of Constantine's morganatic marriage, Alexander signed a secret manifesto in 1823 naming his youngest brother Nicholas heir to Russia's throne. When Constantine announced his abdication upon Alexander's manifesto coming to light, a group of army officers led several thousand soldiers to Senate Square in a protest known as the Decembrist Revolt. In a sign of things to come, 29-year-old Nicholas ordered his troops to open fire. After the bloodbath, the new tsar executed many of the leaders and exiled participants to Siberia. Dubbed "the gendarme of Europe," Nicholas

I would rule Russia for three repressive decades, almost as long as his grandmother. A secret police force enforced his "autocracy, Orthodoxy and nationality" policy.

Like his father, Paul, Nicholas was extremely hostile to Catherine's memory.[16] The ultra-conservative tsar found his grandmother's love life a complete embarrassment. Deeming it "too compromising for the dynasty," Nicholas removed the bronze plaque above Cameron's monument to her beloved Alexander Lanskoy at Tsarksoe Selo. Similarly, he pulled Lanskoy's portrait off the wall of the Hermitage, declaring "It has no place here!"[17] Nicholas also opposed the reprinting of Catherine's memoirs and diaries that had circulated during Alexander's reign. His censorship committee prevented further publication of the intimate diary of Catherine's secretary Alexander Khrapovitsky.

The new tsar abandoned Tauride Palace. Chesme became a dilapidated almshouse for invalids, Moscow's Tsaritsyno Palace a barracks. Despite his neglect of Catherine's palaces, Nicholas would rival his grandmother as a builder and art patron, impacting both the architecture and collection at the Winter Palace and Hermitage. Along with his older brother, he helped complete Catherine's vision for St. Petersburg. "The extent of her [Catherine's] ambitious projects was realized in the reigns of her grandsons Alexander I and Nicholas I," write Dimitry Shvidkovsky and Yulia Revzina. ". . . [N]eoclassicism became the definitive style of the Russian Empire, and St. Petersburg was the 'new Rome.'"[18]

Between 1819 and 1829, Carlo Rossi designed a large administrative complex for the government's general staff and ministry of finance. Located across from the Winter Palace, Rossi's General Staff Building featured a curving neoclassical façade with a triumphal Roman-style arch topped by a victory chariot. Catherine, who celebrated her military victories with numerous monuments, would have been thrilled with Nicholas's next addition—a column marking Russia's victory over Napoleon. Richard Wortman describes Auguste Ricard de Montferrand's creation as "a votive object in the emerging cult of dynasty."[19]

Carved out of Finnish rocks and transported by barge 100-plus nautical miles to St. Petersburg, the 155-foot Alexandrine Column trumped both Paris's Vendome Column and Rome's Trajan Column as the world's

tallest.[20] From the top of the column, Boris Orlovsky's bellicose angel with the face of Alexander looks down on the square below while crushing a snake and pointing his cross to the heavens. On Alexander's name day, August 30, 1832, over 2,000 soldiers helped erect the 600-ton stone block, which stood on its own weight. Two years later, 120,000 troops gathered in Palace Square for the official dedication. In the distance, participants could see Falconet's equestrian statue of Peter the Great.

Alexander Palace had been gifted to Nicholas by his older brother, and it became a favorite summer residence for successive generations of his family. In 1812, Napoleon had turned Catherine's Petrovsky Palace into his headquarters, waiting there for Moscow to surrender. But instead of receiving the keys to the city, Napoleon watched from the palace as flames consumed the Kremlin. As a parting gesture, the humiliated French ruler burned down the palace. In the 1830s, Nicholas had Petrovsky rebuilt.

Nicholas blamed Voltaire for the French Revolution and the Decembrist Revolt against him. When he saw Houdon's *Seated Voltaire* for the first time, he reportedly exclaimed, "Smash that grinning monkey!"[21] Fortunately, the offending marble was transferred to a less conspicuous spot in the Hermitage Library. Nicholas would later sell his grandmother's bronze statuette of Voltaire. Fearing the writings of Voltaire and Diderot would fuel opposition, Nicholas issued a court order prohibiting public access to their libraries. An exception was made for poet Alexander Pushkin, who he'd allowed to return to St. Petersburg after a six-year exile in South Russia.

In 1829, Nicholas acquired another thirty Malmaison paintings from Joséphine's daughter. Two years later, Russia's ambassador in Paris, Pozzo di Borgo, brokered a secret deal for thirty-three pictures assembled in Rome by Manuel Godoy, Spain's exiled prime minister. Among the cache that included pictures by Honthorst and Murillo was a work thought to be a Raphael. *Christ Leading the Apostles to Mount Tabor* was later identified as a predella panel from an altarpiece by Venetian artist Lorenzo Lotto. In 1834, Nicholas added over one thousand painted vases belonging to the Italian physician Pizatti, among them ancient Greek masterworks by Exekias and "the Amasis painter." In 1836, Franz Labensky traveled to London where he paid 23,400 pounds for seven Italian paintings from

William Coesvelt's second collection. The gem was Raphael's *The Alba Madonna* costing 14,000 pounds.[22]

But the following December, these masterworks along with thousands of Catherine's treasures were nearly lost. While attending an evening performance, Nicholas got word that the Winter Palace was on fire. Smoke from the ventilation system was filling the Field Marshals' Hall lined with full-length portraits of Russia's military leaders. Nicholas had hired Montferrand to restore the hall; the fire was traced to ventilation canals littered with leftover building materials. It took just minutes for the wooden hall to collapse and the fire to spread throughout the palace.

The fire raged for two days. "The last hours of the phoenix building were grandly mournful," recalled court chamberlain Alexander Bashutsky. ". . . We watched through the broken windows as the fire strolled victorious in the empty space, illuminating the broad passageways: at one moment it cracked and tossed down the marble columns, at another it impudently blackened the precious gilding, the next it fused the crystal and bronze decorative chandeliers together in deformed heaps and then tore the sumptuous brocades and damasks from the walls."[23]

To protect the artworks in Catherine's Small Hermitage and Large Hermitage, passageways were taken apart, doors were closed, and water doused on the walls. These efforts saved the art, but not the dazzling interiors. Nicholas insisted on restoring the palace at breakneck speed, causing many construction workers to lose their lives. Fifteen months following the fire, the royal family moved back into the palace. Nicholas inaugurated the War Gallery created by Alexander. Architect Vasily Stasov restored the staterooms, Jordan Staircase, Small Throne Room, and Field Marshals' Hall.

On Nicholas's order, Stasov redid the walls and columns of Giacomo Quarenghi's St. George Hall with white Cararra marble instead of the original multicolored marble; a plain ceiling with gilded embellishments replaced the painted allegorical plafond. In the 1840s, reconstruction work started in the Small Hermitage, including the hanging garden and Southern Pavilion. In the Northern Pavilion, the former greenhouse was replaced by a new Pavilion Hall, with floor mosaics copied from the Roman bath at Ocriculum.

In 1838, Nicholas visited Munich's two new public museums, the Glyptothek and Pinakothek, built to house Ludwig I of Bavaria's sculptures and paintings. His tour guide was the museums' architect, Leo von Klenze. In addition to Munich, public museums had opened across Europe—in Berlin (Altes Museum), Rome (Capitoline and Museo Pio-Clementino), Florence (Uffizi), Paris (Louvre), Madrid (Prado), and London (Dulwich Picture Gallery and British Museum). Not wanting Russia to be left behind, Nicholas invited Klenze to St. Petersburg to design a public museum beside the Winter Palace.

To give the New Hermitage a façade facing the Neva, Klenze proposed demolishing Catherine's Large Hermitage and Raphael Loggia. Nicholas doesn't seem to have even been aware of his grandmother's Loggia, reportedly remarking on a visit to the original in 1845: "It would have been better had they stayed here."[24] Fortunately, a commission whose members included Russia's leading architects nixed Klenze's plan, sparing the Large Hermitage and incorporating the Loggia into the new museum. During construction, the Loggia's tempera paintings were removed from the walls, damaged areas were restored, and the gilding reapplied.[25]

Having studied painting as a boy, Nicholas considered himself an expert. He assembled a commission of artists, headed by Hermitage picture curator Fiodor Bruni, to review the entire 4,500 work paintings collection—most of which was amassed by Catherine. With Nicholas making a daily appearance, the commission identified 815 paintings to hang in the new galleries, 804 to display elsewhere, 1,369 to store, and 1,564 to sell. The deaccessioned pictures were transferred to Tauride Palace; 1,219 of them were sold at auction in 1854. The sales earned a paltry 16,500 rubles, less than 14 rubles per painting.[26]

Though many of the sold paintings were of lesser quality, mistakes were made. For example, *Portrait of Saint Andrew* by Andrea Sacchi bought by Catherine in 1770 from François Tronchin had lost its attribution and was deemed unworthy. Chardin's *Still Life with Attributes of the Arts*, a work Catherine liked so much that she hung it in her private apartments at the Winter Palace, was also sold. Geoffrey Kneller's *Portrait of Joseph Carreras* from Robert Walpole's collection eventually returned to Houghton Hall.

Nicholas began buying art for the New Hermitage. During a trip to Italy in 1845, he added to Catherine's neoclassical sculpture collection by commissioning marble works from Tenerani, Bienaimé, and Rinaldi. In 1846, the Hermitage gained 182 pictures, mainly Italian, and Italian bronze statuettes bequeathed by Count Dmitry Tatishchev, Russia's ambassador to Spain. From Paris, Nicholas bought the lavish 15th-century *Grandes Chroniques de France*, considered a masterpiece of the Imperial Russian Library's illuminated manuscripts.

In 1850, Nicholas acquired the Barbarigo collection, one of the oldest in Venice. Bought sight unseen, most of the Italian Renaissance paintings were in terrible condition and were later sold. But among the disappointments was a treasure—five Titians sold by the artist's son to Cristoforo Barbarigo in 1581. These included *Portrait of Pope Paul III*, *The Carrying of the Cross*, and *The Repentant Mary Magdalene* which "moves whoever sees it extremely . . . to compassion," wrote Vasari.[27] Also that year, Nicholas bought van Eyck's *Annunciation* (1425–30) from a Brussels dealer. In 1852, Fiodor Bruni negotiated for Marshal Nicholas Jean de Dieu Soult's collection in Paris. Like Napoleon's brother Joseph Bonaparte, Soult had amassed an enormous collection by looting art in Spain. Francisco de Zurbaran's *St. Lawrence* and Murillo's *Liberation of St Peter* and *Infant Jesus and St. John* were among the new pictures arriving in St. Petersburg.

After Catherine's death, Paul had recalled her silver governor's services to St. Petersburg for his own use; Nicholas now melted most of this down for coin. But there was another kind of metal he'd fancied since his teenage years. As tsar, he built a small Neo-Gothic castle to house his vast collection of antique arms and armor.[28] In May 1842, he hosted a knightly procession from the Arsenal to Alexander Palace. Heralds led the procession, followed by fifteen men in armor and fifteen women in 16th-century dress. Nicholas and his son Alexander were clad in armor from Holy Roman Emperor Maximilian's era; the younger grand dukes were dressed as pages from the same period. In front of Alexander Palace, the group performed quadrilles and other moves on horseback. To mark the occasion, Nicholas commissioned Horace Vernet to paint the *Knightly Festival*.

The sudden death of Nicholas's brother-in-law, William II of the Netherlands, in 1849 led to a small but fine acquisition of Renaissance art

(the tsar's youngest sister Anna Pavlovna married William, then Prince of Orange, at a Winter Palace ceremony in 1816). William had secretly borrowed one million guilders from Nicholas, using his paintings as collateral. When he died, William's brother Prince Frederik paid off the debt to Nicholas with proceeds from an auction of the splendid royal collection. Outbidding collectors like the Marquess of Hertford (Wallace Collection, London) and the Rothschilds, Nicholas came away with thirteen gems, including Francesco Melzi's *Flora* (then attributed to Melzi's teacher, Leonardo), Jan Gossaert's *Descent from the Cross*, Sebastiano del Piombo's *Lamentation*, Bronzino's *Portrait of Cosimo I de' Medici*, and Dierick Bouts's Annunciation (Calouste Gulbenkian Museum, Lisbon; attributed to the circle of Bouts).

In 1852, Nicholas launched the ancient sculpture collection at the New Hermitage by transferring Catherine's choicest works from Tsarskoe Selo and Pavlosk. These included over twenty classical statues and thirty heads and busts, along with vases and bas-reliefs. To his grandmother's antiquities Nicholas added three hundred more ancient vases and over fifty sculptures from the daughters of Count Ivan Stepanovich and Countess Alexandra Grigoryevna de la Valle, starring marble portraits of Gaius Julius Caesar and Emperor Balbinus.[29]

A dozen years in the making, the New Hermitage opened in February 1852. Though access to the galleries increased, the museum remained an imperial collection with ticket applicants screened and a strict dress code enforced.[30] Twenty-eight full-sized sculptures of artists adorned the façade; ten colossal gray granite atlantes appeared to be holding up the portico. Inside, Spanish, Flemish, and Italian paintings filled a trio of huge sky-lit halls. In contrast to Catherine's "tapestry" method of hanging her pictures, Nicholas organized the canvases by national school, all in uniform frames. Over two hundred Dutch paintings lined the Tent Room; Catherine's Rembrandts were hung in three rows in a large hall nearby.[31]

To celebrate the grand opening, Nicholas hosted a special performance at the Hermitage Theatre followed by dinner for six hundred guests. "Thousands of candles rising in pyramids above huge lapis-lazuli vases comprised the chief adornment of this hall, and lit with their reflection the magnificent works of Murillo, Velazquez, and other painters," observed Florian

Gilles, head of the Imperial Library. "The Italian, van Dyck, and Rubens halls, with their huge vases and candelabra of malachite and jasper—the products of the Urals and Altai—were lit almost as splendidly. . . ."[32]

By the following fall, the celebrations were over. In 1853, while trying to establish a Russian Orthodox presence in the Ottoman Empire, Nicholas entangled Russia in the disastrous Crimean War, a territory Catherine herself had annexed in 1783. He considered the humiliating defeat by the Ottomans, France, Britain, and Austria a personal failure. On the morning of February 18, 1855, the 58-year-old tsar died of a bad cold at the Winter Palace.

CHAPTER THREE

THE END OF THE LINE

With Russia's image as a global power shattered, Nicholas's son Alexander II signed the Treaty of Paris in 1856, ending the Crimean War. Though Alexander II did not share his great-grandmother's passion for art, he seized a chance to enrich her antiquities collection in 1861. Giovanni Pietro Campana, Marchese di Cavelli, had assembled a vast collection featuring four thousand ancient painted vases and five hundred statues from his archeologist grandfather and his own excavations. After the marchese's conviction for embezzlement, his property was confiscated and put up for sale. From the trove, Hermitage director Stepan Gedeonov chose 500 vases, 78 statues, and 193 bronzes, along with nine frescoes from Raphael's studio. Among the highlights were an enormous statue of Jupiter once offered to Catherine, along with the coveted 4th century B.C. "Cumae Vase"—a large black-glazed water vessel with painted and gilded relief decoration.

Also that year, Alexander II ordered volumes from the Hermitage, including those of Voltaire and Diderot, moved to Catherine's Imperial Public Library at Nevsky Prospekt (Russian books along with books on the fine arts and archeology stayed at the Hermitage).[1] By the late 1860s, Voltaire's titles and manuscripts were installed in the Round Hall of the Imperial Russian Library, surrounding Houdon's *Seated Voltaire*. (In 1884, the sculpture was transferred to the Hermitage where it remains today.)

In the two-volume, handwritten Hermitage paintings catalogue compiled by Johann Ernst Münnich in the 1770s, a dozen pictures were attributed to Raphael and half a dozen to Leonardo da Vinci. In reality, Catherine had acquired two Raphaels (both from Pierre Crozat) and no Leonardos.[2] In 1865, Stephan Gedeonov negotiated the purchase of four paintings in Milan for 100,000 francs from Duke Antonio Litta. The prize was Russia's first Leonardo—*Madonna with the Child* (1490–91), acquired by the Litta family in 1813 from Prince Alberico XII di Belgioioso. Today, the masterpiece is known as the *Litta Madonna*.

Another cash-strapped Italian nobleman, Count Scipione Conestabile, informed Count Stroganov in Rome that he planned to sell Raphael's early *Madonna and Child* (1504), a work that had been in his family for 350 years. Gedeonov left for Florence in pursuit of the painting (and frame) Raphael produced for Perugian noble Alfani Diamante before moving from Urbino to Florence. Count Conestabile's sale of the beautiful tondo to Russia in 1871 for 310,000 francs sparked outrage in Italy; Alexander II's wife Maria Alexandrovna bequeathed the work, known as the *Conestabile Madonna*, to the Hermitage in 1880.

The bicentenary of Peter the Great's birth in 1872 was followed the next year by the dedication of Catherine's monument. As Richard Wortman writes, both commemorations represented an opportunity for Alexander to link himself with two of Russia's most charismatic rulers.[3] Driving the project was a group of Academy of Art professors who raised funds to honor their institution's "protector." Though Alexander didn't endorse their appeal, he called for submissions for a statue to be installed in Tsarskoe Selo at Catherine Palace. In the end, the St. Petersburg City Duma prevailed. The monument was located in the city by Catherine's Imperial Public

Library, Carlo Rossi's Alexandrinsky Theatre, and Nevsky Prospect—the intersection of "power, science and the arts."[4]

During a visit to sculptor Michael Mikeshin's studio in July 1861, Alexander chose a rococo-style design of his great-grandmother holding a lyre. But faced with criticism by Academy members, Mikeshin went back to the drawing board. His second design depicted Catherine surrounded by her close advisers: Ivan Betzkoy; Field Marshals Gregory Potemkin, Alexander Suvorov, and Rumantsev-Zadunaisky; and poet Gavriil Derzhavin. Alexander insisted Mikeshin add four more figures: Admiral Vasily Chichagov, Count Gregory Orlov, Princess Dashkova, and chancellor Alexander Bezborodko.

After more than a decade of planning, Alexander and his family attended the dedication ceremony for the Catherine the Great Monument on November 24, 1873. Standing thirteen feet tall, Catherine is depicted as a larger-than-life military leader and patroness of culture. Dressed in an ermine robe with the Order of St. Andrew around her neck, she holds the imperial scepter in her right hand and a laurel wreath in her left. Below, her colleagues seem to be conversing.

Though the artistic merits of the monument were debated, it led to praise for Catherine and her legacy. "We are becoming more conscious of ourselves and therefore we value the memory of past figures, past deeds, and cannot indifferently regard the memory of those who worked for the benefit of our self-consciousness," wrote the newspaper *Golos*.[5] Prince Obolensky, governor of Kharkov, thought the dedication did not do justice to Russia's "Great Tsaritsa" whose "sincere and unaffected love for the Russian people" extended to her advisers. Peter the Great was a Russian who's fallen in love with Germans, while "Catherine, being German by nature, fell in love with Russians . . . not in a single degree or word of Hers can one find hypocrisy directed against the Russian Spirit."[6]

The Great Tsaritsa would have been mortified by her great-grandson's next decision. "Seizing objects is never disagreeable to us. It's losing them we don't like," she'd written Potemkin after claiming the coveted Crimean peninsula, which had caused so much damage to Russia in the recent war. In 1867, with Russia in financial straits from that war and fearing the British might seize its territory, Alexander sold Alaska and the Aleutian

Islands to the United States—over 586,000 square miles, for $7.2 million, about 2 cents per acre. A decade later, with the Russo-Turkish War of 1877–1878, Alexander succeeded in annulling conditions imposed by the Treaty of Paris two decades earlier.

Catherine's repressive grandsons maintained serfdom long after Western Europe had industrialized, carrying on a legacy that was a black mark on her quest to be an enlightened despot. In 1861, Alexander II emancipated Russia's roughly 20 million serfs, for which he was called "the Liberator." He also reorganized the judicial system, set up elected local judges, abolished capital punishment, and promoted local self-government. At the same time, however, his brutal secret police exiled thousands of dissidents to Siberia. Ironically, the tsar who finally ended serfdom was assassinated on March 13, 1881, by a bomb thrown by a member of the left wing terrorist group, the People's Will. The day he died, Alexander had backed Russia's first-ever legislative assembly.

Alexander II's gruesome murder, witnessed by his eldest son and grandson, triggered a major suppression of civil liberties, if not art collecting. A year into his reign, Alexander III acquired part of a wall with a fresco by Fra Angelico from the ruins of the San Domenico Monastery in Fiesole, Italy. Two years later, he enriched the Hermitage's medieval art collection by acquiring some 762 objects for 2.2 million gold rubles from Russian diplomat Alexander Basilewski. While assigned to Paris, Basilewski assembled a unique collection of early Christian and Byzantine art, which he displayed in a gallery at his home. Among the treasures that arrived in St. Petersburg were carved ivories, Limoges enamels, Venetian and German glass, Italian majolica, and French and Spanish-Moorish faience.

The following year, Alexander III accidentally launched a renaissance of Russian jewelry making when he surprised his consort with an Easter present. The goldsmith, Peter Carl Fabergé, had begun his career repairing imperial jewelry at the Hermitage assembled by Catherine and Empress Elizabeth. The gold and white enamel Hen Egg opened to reveal a yellow gold yolk, concealing a chased gold hen, containing a tiny diamond imperial

crown with a small ruby pendant egg. The delightful gift launched a thirty-two-year annual tradition; Alexander's son Nicholas II continued to give jeweled Easter eggs to his wife and mother. Fabergé's luxurious creations were made each year until the 1917 Revolution (with the exception of 1904 and 1905, the Russo-Japanese War).

In 1886, Alexander acquired 102 paintings and part of the library of the Princes Golitsyn for 800,000 rubles.[7] The trove had been assembled by generations of a branch of the Golitsyn family, relatives of Catherine's art agent Prince Dmitry Golitsyn. Highlights were Palma il Vecchio's *Portrait of a Man* (c. 1512–15) and Pietro Perugino's *Crucifixion* (c. 1485) acquired by the Golitsyn family in Rome in 1800 (National Gallery of Art, Washington, D.C.). In addition, Alexander decorated Gatchina, Anichkov, and the Winter Palace with acquisitions of furniture and 19th-century Russian, French, and Danish paintings.[8]

In 1894, the tsar known for his physical strength died unexpectedly of nephritis (inflammation of the kidneys) at Livadia Palace in the Crimea at age forty-nine. His 26-year-old son Nicholas ascended the throne, marrying German Princess Alix of Hesse, Queen Victoria's favorite granddaughter, who took the name Alexandra Feodorovna. From the start, Nicholas II's reign was marked by tragedy. At a coronation celebration, 1,389 people were trampled to death at a stampede at Moscow's Khodnynka Field. After the new tsar proceeded with other festivities, including a ball at the French Embassy, an outraged public dubbed him "Nicholas the Bloody." The couple's only son, Tsarevich Aleksei, was diagnosed with hemophilia. That year, Giacomo Quarenghi's Alexander Palace became the family's permanent residence.

Like Catherine, who introduced traditional Russian dress at court, Nicholas considered restoring 17th-century Muscovite dress. Ironically, at a 1903 ball to celebrate the bicentenary of the founding of St. Petersburg by Westernizer Peter the Great, guests were asked to wear costumes of the boyars, Russia's pre-Petrine aristocracy. Nicholas donned a copy of a robe worn by Peter's father, Tsar Aleksei Mikhailovich; Alexandra dressed as Aleksei's first wife, Maria Miloslavskaia.[9]

In 1904, Nicholas led Russia into the disastrous Russo-Japanese War, in which the Far Eastern fleet was destroyed. A year into the war, on

January 22, 1905, a crowd gathered at the Winter Palace to demonstrate for better working conditions. Government troops opened fire, killing and wounding hundreds in a travesty known as Bloody Sunday. In response to the massacre, strikes and riots broke out throughout Russia. Nicholas tried to defuse the situation by forming the Duma, an elected legislature. But with little progress, discontent continued to grow with socialist groups like Vladimir Lenin's Bolsheviks gaining popularity.

Though Nicholas was not an art lover, he made several major contributions. In 1910, he bought the collection of geographer and civil servant Peter Semenov-Tianshansky. Among the roughly 700 Dutch and Flemish paintings were works by many lesser-known artists like 17th-century Dutch still life painter Willem Kalf, Dutch Caravaggist Matthias Stomer, and Flemish genre painter David Teniers II. With his father's collection of Russian realist paintings, Nicholas founded the Alexander III Museum (today's Russian Museum) and continued to buy enamel and jeweled works from Fabergé.

In 1914, Nicholas acquired the Hermitage's second work by Leonardo—the "Benois" Madonna or *Madonna with Flower* (1478–80) paying the astronomical price of 1.5 million dollars (equal to roughly 35.5 million dollars today).[10] Five years earlier, architect Leon Benois had caused a sensation in St. Petersburg by exhibiting the long lost painting, part of his father-in-law's collection. Ernst Friedrich von Liphart, the Hermitage's expert paintings curator, correctly identified the work as Leonardo's.

That August, Nicholas led Russia into the catastrophic World War I. Ten million soldiers were mobilized as St. Petersburg was renamed Petrograd and the capital moved back to Moscow. But unspeakable horrors soon befell Russia. After advancing into East Prussia, one million Russian soldiers died at the Battle of Tannenberg. The following spring, with munition factories unable to keep up with demand, Russia was forced to abandon Lithuania, Galicia, and Poland. In 1915, the Winter Palace staterooms were turned into a hospital for wounded soldiers.

The war stretched Russia to the breaking point. Throughout 1916 and early 1917, Russia barely held back the Germans; soldiers lacked basic food and clothing. Soaring prices and food shortages led to a political crisis, with Nicholas blamed for the catastrophe. Defeated on the Eastern Front and

abandoned by his generals, Nicholas was forced to abdicate in 1917 and power was transferred to the provisional government. Later that year, the Hermitage prepared to evacuate its artworks to Moscow. The three trains carrying the treasures never made it to Moscow.

Revolution had begun. In February, Nicholas was arrested by the revolutionary government and confined with his family at his birthplace, Alexander Palace. In August 1917, to prevent the tsar and his family from fleeing overseas, they were evacuated to the western Siberian town of Tobolsk. After the Bolsheviks seized power, the imperial family was relocated to Ipatiev House in Ekaterinburg. On the evening of July 17, 1918, Nicholas II, Alexandra, and their five children (ages thirteen to twenty-two) were led to the basement of the house. By Vladimir Lenin's order, the entire family was executed by a firing squad. After 305 years, the Romanov dynasty had come to a bloody, brutal end.

<center>⌒∞⌒</center>

After the Bolsheviks' seizure of power in October 1917, imperial palaces and aristocratic residences in St. Petersburg, Moscow, and the surrounding countryside were stormed and looted. Similar to the French Revolution, paintings and decorative arts were considered symbols of Russia's decadent Romanov rulers and nobility. During a rampage of the Winter Palace on October 25, objects were stolen and vandalized; eyes were poked out of portraits of the imperial family.

After protests by art historians and museum officials, the Kremlin and Winter Palace were closed and placed under guard. Imperial property, long regarded as personal property of the tsars, now became property of the state. This included the Hermitage. Renamed the State Hermitage Museum, its holdings doubled with the addition of nationalized imperial and private art, including collections of the Bezborodkos, Stroganovs, Yusupovs, and Sheremetevs. Efforts were made to safeguard the contents of Tsarskoe Selo and Pavlovsk, but Gatchina was looted by Red Guards.

By mid-1918, Peterhof, Pavlovsk, Gatchina, and the Catherine and Alexander Palaces were open to the public. Tsarskoe Selo (Tsar's Village) was renamed Detskoe Selo, or Children's Village. In Moscow, eight museums

were founded in former aristocratic homes. With the government's gold reserves badly depleted from World War I, the Bolsheviks nationalized banks in January 1918 to recover money and jewels from Russia's elite. Some 300 to 400 million dollars in jewels were smuggled to the West.[11] In February 1919, the Petrograd antiquarian evaluation commission selected objects to sell abroad in order to procure much-needed funding for the new government.

Vladimir Lenin, who led the Bolsheviks to victory over the Provisional Government, negotiated peace with Germany. Under the Treaty of Brest-Litovsk, Russia ceded Finland, the Baltic States, and Poland—386,000 square miles (a million square kilometers) with 80 percent of her coal mines and 30 percent of her population. But Lenin could not avoid civil war. From 1918 until early 1921, the Bolsheviks faced opposition from a variety of political, military, and national groups. Leon Trotsky, the Bolsheviks' Commissar for War, created the Red Army and founded the Politburo.

At the end of 1920, art that had been evacuated to Moscow during the war was returned to the Hermitage and the staff began giving guided tours. Regarded as decadent, Russian avant-garde paintings and two French Impressionist collections assembled in Moscow by Sergei Shchukin and Ivan Morozov were placed in storage. After more than two centuries, Russia's capital switched back to Moscow. Hundreds of Hermitage artworks were sent south to today's Pushkin Museum of Fine Arts in Moscow; other works were transferred to regional collections. A statue of Lenin and Politburo members replaced St. Petersburg's Catherine the Great Monument.

Western illuminated manuscripts from Pavlovsk and Peterhof along with those from the Stroganov and Yusupov mansions were moved to Catherine's Imperial Russian Library, renamed the Russian National Library. Among these were illuminated manuscripts from the 14th and 15th centuries, primarily books of hours. Under the Treaty of Riga, the Soviets returned some of the Załuski Library holdings to the newly established Second Polish Republic in the 1920s. (These materials were deliberately destroyed by German troops during the destruction of Warsaw in October 1944. Only 1,800 manuscripts and 30,000 printed materials from the original library survived.)

By the end of 1921, some 20 million people were starving in Russia's central and southern regions. In February 1922, Lenin ordered the seizure of church valuables, supposedly for famine relief.[12] Armed gangs hauled off gospels, icon mounts, chalices, candlesticks, and silver coffin lids in Moscow. In former St. Petersburg, now Petrograd, a similar team ransacked Romanov coffins in the Peter-Paul Cathedral. "They ripped a string of pearls from the long-dead neck of Catherine the Great," writes Catherine Merridale, "but when they opened Peter's coffin and were confronted by the formidable and surprisingly lifelike body inside they stepped back, abandoning the mission in terror."[13]

In addition to churches, authorities combed imperial palaces, country estates, and city mansions for items to sell. Confiscated religious and secular artworks filled warehouses and storerooms. The ensuing fire sale included everything from icons, jewelry, and rare books and manuscripts to furniture, objects d'art, and Old Master paintings. By 1923, Moscow's eight proletariat museums were closed. Gradually, Petrograd's museums also folded. In honor of Lenin, who died in January 1924, Petrograd was renamed Leningrad.

In 1921, the Soviets had begun to inventory the Romanov's crown jewels, which had been moved to Moscow at the start of the war. Jeweled Fabergé eggs from Alexander, Anichkov, and Gatchina Palaces, along with paintings and other art from the Hermitage, had also been evacuated in late 1917 in case of an attack on Petrograd by Germany. The eggs and crown jewels remained in crates in the Kremlin Armory until January 1922. Many of the most sumptuous of the Diamond Room jewels, some 110 objects, were assembled by Catherine, including the Orlov Diamond and Gustav III's gift of a tourmaline pendant. Despite terrible conditions, treasures from the former Diamond Room, renamed the Diamond Fund, had stayed intact.

That changed in 1925 with the issuance of an album translated into English, French, and German, along with a year-end exhibition. As Natalya Semyonova and Nicolas V. Iljine describe, the Diamond Fund "became an immense 'currency reserve' for the Bolshevik government."[14] By 1932, the Diamond Fund numbered just seventy-one pieces of jewelry, reduced by two hundred objects.[15] Retaining the coronation regalia and historic diamonds, the Soviets sold nearly 20 pounds of the Diamond Fund jewels

for 50,000 pounds sterling to English antiques dealer Norman Weis. He in turn resold the gems to Christie's.

In March 1927, Christie's auctioned off 120 lots of crown jewels, including floral diamond ornaments from Catherine's reign and the diamond nuptial crown worn by Alexandra Feodorovna at her wedding to Nicholas II in 1894. Mounted in silver, set on crimson velvet, the crown featured diamonds from a lapel produced by Leopold Pfisterer's workshop in 1767. In 1966, the crown landed in the Washington, D.C., collection of U.S. cereal heiress Marjorie Merriweather Post.

One of America's wealthiest women, Post became smitten with Russian imperial art while in Moscow with her third husband, Joseph Davies, U.S. ambassador to the USSR. Among her acquisitions was the pair of chalices commissioned by Catherine from Iver Buch for the Kazan Cathedral and Alexander Nevsky Monastery. Both are believed to have been confiscated by the Soviets in 1922.[16] Post's collection also features plates from Catherine's Order Services by the Gardner Factory, and fourteen pieces from the Cabinet Service she gave Alexander Bezborodko. Today the imperial artworks, including later Fabergé eggs, are on view at Hillwood, Post's former Washington, D.C. residence.

The cash-strapped Soviet government continued to make major sales on the international art market during the second half of the 1920s. American businessman Armand Hammer and his brother Victor Hammer acquired large numbers of objects, which they sold in U.S. department stores and their New York gallery. Catherine's magnificent silver and porcelain services were not spared. Between 1926 and 1928, some 3,652 silver objects and 9,849 pieces from porcelain services were transferred from the Winter Palace to state channels for sale.[17]

The Orlov Service, Catherine's spectacular silver commission from Roettiers, had remained in the imperial collection. But by 1907 when Baron A. de Foelkersam published his imperial silver inventory, 2,000 of the original 3,000 pieces had disappeared, believed to have been melted down in the 19th century. Now the Soviets began selling off much of the rest of the service privately in Berlin. Among the buyers was Jacques Helft, who sold many pieces to Parisian collector Moïse de Camondo in 1935. A large quantity of Catherine's silver was also sold in September 1930 by Berlin auction house Ball & Graupe.

Today just 169 pieces of the original 3,000-piece Orlov Service are in Russia—46 at the Hermitage and 123 at the Kremlin's Armory Museum. Two hundred and thirty pieces of the service have been identified at institutions outside Russia, including the Metropolitan Museum of Art, the Louvre, and Musée Nissim de Camondo in Paris. In 1928 and 1929, American art collector and Walters Art Museum founder Henry Walters bought objects from Russian émigré and dealer Alexander Polovtsov. The highlight was another of Catherine's gifts to Gregory Orlov, the gold potpourri vase by Jean-Pierre Ador.

CHAPTER FOUR

RAIDING THE HERMITAGE

After Lenin's death, Joseph Stalin consolidated power, proposing an ambitious industrialization program, known as the First Five-Year Plan. To finance this effort, the Politboro authorized a major art sale in 1928 with a goal of raising 30 million rubles in two years. Twenty five million of this sum was to come from the sale of masterpieces.[1] The money from the Old Masters sale was supposedly used to build a tractor factory in Stalingrad, later turned into a tank factory.

In November 1928 and June 1929, auctions of nationalized artworks were held in Berlin and Vienna. European painting, furniture, and decorative arts from private Russian collections along with the Winter Palace, Anchikov, and Gatchina went on the block. The auctions gained worldwide attention and were followed by lawsuits by the artworks' owners, many Russian émigrés in France. Germany's Weimar Republic, the first country to recognize Soviet Russia, honored the Bolsheviks' nationalization decrees. The unwanted publicity from these legal actions

revealed the Soviet Union's desperate economic situation and forced a change in strategy.

The Soviets quietly put the word out to Western art dealers and collectors that the Hermitage paintings were on the market. In February 1928, the State Hermitage Museum and the Russian Museum were ordered to make a list of artworks worth at least two million rubles for export. A special agency called Antiquariat headed by Nikolai Ilyin compiled lists of the most valuable art. Ilyin first approached the Hammer brothers. When that deal fell through, he turned to Calouste Sarkis Gulbenkian, an Armenian oil tycoon whose Iraq Petroleum Company was prospecting for oil in the Ukraine. The Turkish-born, British-educated magnate had endeared himself to the Soviets by offering advice on how to dump oil on the world market.

Known as "Mr. Five-Percent" for negotiating a 5 percent share of the newly discovered Iraq oil fields, Gulbenkian applied his legendary business acumen to art collecting, building an impressive trove. Gulbenkian dispatched Parisian jeweler Andre Aucoc to the Hermitage to inspect the condition of various paintings. In 1929, the tycoon offered ten million rubles for eighteen Hermitage masterpieces. His wish list included Rembrandt's *Return of the Prodigal Son* and *Titus*, Giorgione's *Judith*, Botticelli's *Adoration of the Magi*, Rubens's *Portrait of Hélène Fourment* and *Landscape with a Rainbow*, Raphael's *Alba Madonna*, and Watteau's *Mezzetin*. Moscow countered with a list of less-valuable works.

In April 1929, Gulbenkian paid 54,000 pounds for two dozen French silver and gold objects from the collections of Catherine and Empress Elizabeth, two paintings of Versailles gardens by Hubert Robert (acquired by Alexander III), *The Annunciation* attributed to Dirc Bouts (bought by Nicholas I), and a Louis XVI marquetry rolltop desk by royal cabinetmaker Jean-Henri Riesener. Gulbenkian paid another 155,000 pounds in February 1930 for fifteen pieces of French jewelry commissioned by Catherine and Elizabeth, along with several paintings—notably *Portrait of Hélène Fourment*, which Catherine acquired with Robert Walpole's collection in 1779.[2]

That June, the oil tycoon clinched his third deal, paying 140,000 pounds sterling for five of Catherine's paintings: Rembrandt's *Pallas Athene* and *Portrait of Titus*, Lancret's *The Bathers*, Watteau's *Mezzetin*, and Ter Borch's

Music Lesson.[3] In October, Gulbenkian paid 30,000 pounds for his fourth Rembrandt—the highly expressive *Portrait of an Old Man*, which Catherine acquired with the Crozat acquisition. With the paintings came Houdon's *Diana the Huntress* for 20,000 pounds sterling. Catherine had installed the marble in the grotto at Tsarskoe Selo; deeming it obscene, her successors had it removed. Gulbenkian installed the sculpture at the base of the staircase in his elegant Paris mansion. Today, *Diana* and Rembrandt's *Pallas Athene* and *Portrait of an Old Man* star at Gulbenkian's eponymous museum in Lisbon, Portugal.

Gulbenkian sold *Mezzetin*, *The Bathers*, and *Portrait of Titus* to art dealer George Wildenstein, who then sold them to the Metropolitan Museum of Art, a private collector, and Parisian art collector Etienne Nicolas, respectively. The fate of the picture of Rembrandt's 21-year-old son Titus took a dramatic turn when Adolf Hitler's art adviser Karl Haberstock paid Etienne Nicolas 60 million French francs for the portrait along with Rembrandt's *Landscape with a Castle* for the proposed Führermuseum in Linz. After the war, *Portrait of Titus* was recovered and returned to Nicolas, who gave it to the Louvre in 1948. From 1956 to 1979, the painting was on loan to the Rijksmuseum, Amsterdam.

After spending 1.5 million dollars on Hermitage masterworks, Gulbenkian advised the Soviets not to sell their national heritage off piecemeal. "You know that I have always held the opinion that the objects which have been in your museums for many years should not be sold," he wrote the governor of the State Bank of Moscow. "Not only do they represent a national heritage, but they are also a great source of culture and a source of pride for the nation. . . . Sell anything you want which is not out of museums, but to touch the national patrimony will only arouse serious suspicions . . . but if you do sell, then I would like to have first refusal at the same price you would offer them to others and I have asked to be kept informed about which works of art you wish to sell."[4]

The advice went unheeded. Disappointed with the proceeds from Gulbenkian, the Soviets began looking for other buyers. They found deeper pockets in 75-year-old Andrew Mellon, America's silver-haired secretary of the treasury. Having made several fortunes in banking and oil, Mellon served as secretary of the treasury under three presidents—or as one senator

put it, three presidents served under Mellon. The international economic meltdown following the October 1929 stock market crash created an unprecedented buyer's market for art. Stuck with paintings bought during the twenties boom, art dealers were forced to sell at losses. Mellon was anxious to make deals.

At first, Mellon seemed an unlikely candidate. An arch-conservative hostile to communism, Mellon had supported the U.S. decision not to recognize the USSR. As an art collector, he was extremely cautious, insisting on inspecting pictures at his home before buying. Yet Mellon could not resist the prospect of owning extraordinary paintings from the storied Hermitage. An Anglophile who visited England many times and married an Englishwoman, Mellon dreamed of founding a museum modeled after London's National Gallery. In 1928, with Herbert Hoover's approval, he'd reserved a five-acre site for his national art gallery. Like Catherine II, Mellon had both unlimited resources and a sense of the glory a fabulous collection conveyed. "Every man wants to connect his life with something he thinks eternal," he said.[5]

In April 1930, Mellon seized one of the greatest opportunities in the history of collecting. Ignoring a strict trade embargo on the Soviet Union, Mellon struck nine secret deals over the next year. Sight unseen, he bought twenty-one masterpieces for 6,654,033 dollars (equivalent to about 90 million dollars today). "I have gone deeper into the Russian purchases— perhaps further than I should go in view of the hard times and shrinkage in values, but as such an opportunity is not likely to again occur, and I feel so interested in the ultimate purpose, I have made quite [a] large investment," Mellon wrote his son, Paul, in April 1931. "However, I have confined myself entirely to examples of ultra-quality. The whole affair is being conducted privately, and it is important that this be kept confidential."[6]

Mellon hid the masterpieces in a cupboard in the basement of the Corcoran Gallery in Washington, D.C. Of the twenty-one pictures, fifteen had been acquired by Catherine. They include Raphael's *Saint George and the Dragon*, Veronese's *The Finding of Moses*, five Rembrandts, three van Dycks, Adriaen Hanneman's *Henry Duke of Gloucester*, Velazquez's *Pope Innocent X*, Hals's *Portrait of a Young Man* and *Portrait of a Member of the Haarlem Civic Guard*, and Chardin's *The House of Cards*. Most had arrived

in St. Petersburg with the collections of Heinrich von Brühl, Pierre Crozat, and Robert Walpole. Two of the Rembrandts—*Joseph Accused by Potiphar's Wife* and *A Man in Oriental Costume*—originated with Johann Gotzkowsky. Catherine's nemesis, the Duc de Choiseul, had owned *Susanna Fourment and Her Daughter* (reattributed from Peter Paul Rubens to Anthony van Dyck).[7]

Besides Catherine's treasures, Mellon bought four masterpieces acquired by her grandsons Alexander I and Nicholas I: Sandro Botticelli's *The Adoration of the Magi*, Jan van Eyck's *The Annunciation*, Titian's *Venus with a Mirror*, and Raphael's *The Alba Madonna*. At $1,166,400, *The Alba Madonna* set a new record for a single painting. In 1909, Isabella Gardner had acquired the country's first two Raphaels. In 1928, Mellon spent $836,000 for Raphael's *Niccolini-Cowper Madonna*. With the gem-like *Saint George and the Dragon* and *The Alba Madonna*, Mellon became the only American to own three Raphaels. (In 1942, Joseph E. Widener donated Raphael's *Small Cowper Madonna* to the new National Gallery of Art; the next year, Samuel Kress donated Raphael's portrait of his friend, Florentine banker *Bindo Altoviti*.)

In 1932, Herbert Hoover named Mellon ambassador to Britain. But Franklin Roosevelt's landslide victory that November ended the Republican's public service career. Mellon returned to Washington to face charges of tax evasion, an accusation he fought. The federal government maintained that Mellon's trust to hold paintings and money for a national gallery was a sham to avoid taxes. Though Mellon was eventually acquitted, his reputation suffered. On the afternoon of New Year's Eve 1936, Mellon met with Roosevelt at the White House, seeking approval to donate his art collection, a museum building, and an endowment to the nation.

After denying the politically charged Hermitage purchase for years, Mellon launched the National Gallery of Art in 1937 with the twenty-one Russian paintings, along with money to build and endow the museum. He hired John Russell Pope to design the neoclassical National Gallery of Art, one of the largest single gifts to the American people. Mellon returned to Washington in 1937 to supervise construction. But stricken with cancer, the 82-year-old philanthropist died that August, four years before his museum opened to the public.

The sale of Catherine's pictures didn't end with Gulbenkian and Mellon. Since 1932, Giovanni Battista Tiepolo's *The Banquet of Cleopatra* has resided at the National Gallery of Victoria, Melbourne. Bought for Saxony's Frederic Augustus III by Francesco Algorotti, the painting was purchased by Catherine at a sale of the elector's art in Amsterdam in 1765. Poussin's *The Birth of Venus* landed at the Philadelphia Museum of Art. Purchased by Catherine in 1771, the painting still bears a Russian inscription on the frame and a Hermitage Museum inventory number on the lower left corner of the canvas.

Through the Rembrandt Society, Amsterdam's Rijksmuseum bought three of Catherine's paintings: Rembrandt's *St. Peter's Denial* (Baudouin), Anthonis Mor's *Portrait of Sir Thomas Gresham* (founder of England's Royal Bank and Gresham College in London), and *Portrait of Anne Fernely*, his wife (Brühl). In 1934, the German National Museum in Nuremburg acquired Johann Georg Platzer's *The Concert*, part of a pair of Catherine's paintings that included the artist's erotically charged *Orgy*. The Austrian rococo painter filled his elaborate *fêtes galantes* with people, accessories, and drapery, creating an enamel-like effect by applying oil to copperplate.

To conceal the gaps on the walls from the public, the Hermitage staff was ordered to rehang the paintings. In their efforts to preserve art treasures, museum employees were fired, demoted, sent to prison camps, and exiled. The raid of the museum finally ended in 1934. Five years of sales between 1928 and 1933 alone reduced the Hermitage's holdings by over 24,000 objects.[8]

⚜

CHAPTER FIVE

PRESERVATION

B y the time the National Gallery of Art opened in Washington, D.C., in 1941, Europe was engulfed in World War II. In September, Hitler's high command made its intention clear: "The Fuehrer has decided to wipe the city of St. Petersburg/Leningrad from the face of the earth." The infamous 900-day Siege of Leningrad, one of history's deadliest blockades, had begun.

Among the most ambitious conservation efforts during the siege was the evacuation of artworks from the Hermitage and the fight to save the historic buildings. Once maligned as signs of the decadent aristocracy, the Hermitage and surrounding historic buildings of the city were now synonymous with what it meant to be Russian in the minds of the Soviets. With Hitler's troops advancing, paintings were cut from their stretchers so they could be rolled up quickly, with the frames left hanging on the gallery walls. Monumental sculptures like the 19½-foot-tall *Jupiter* were too large to remove.

Three trains fitted with gun carriages on the front and the back were loaded with over 1.5 million works of art—from *Voltaire Seated* and the *Venus of Tauride* to Rembrandt's *Return of the Prodigal Son*. The first two trains packed with over a million artworks including precious gold objects made it out of Leningrad, arriving safely at Sverdlovsk (Ekaterinburg) some 1,500 miles away in the Urals. Part of the collection was stored in the house where Nicholas II and his family were executed twenty-three years earlier. The third train had to turn back.

The Hermitage, along with the city's food stores, was targeted for bombing campaigns. Thousands of people took refuge in the basement of the Hermitage, which was converted into a dozen air raid shelters. The museum's fate literally rested in the hands of a museum guide, storekeeper, archaeologist, and roofer who kept a constant watch from a rooftop shelter. Firefighters extinguished incendiary bombs and hauled mountains of sand into the marble halls. Despite bombs and artillery shells, the museum survived.

Tragically, Leningraders didn't fare as well. A plaque on the stairs of the Hermitage commemorates the one hundred staff members who died. Between September 1941 and January 1944, an estimated three quarters of a million people died of starvation.[1] Given this mass murder, lost art and architecture must be kept in perspective.

After the war, the arduous process of rebuilding and restoration began. On Hitler's orders, most of the Romanov's imperial palaces were looted and destroyed. Antonio Rinaldi's sprawling Gatchina had been one of the largest palace museums, with some 54,000 objects on display. After the Nazi invasion, curators evacuated over 11,000 items.[2] Severely damaged by German forces, the palace restoration began in 1944; a fire six years later interrupted work for another quarter century. In 1985, Gatchina opened as a public museum with eight restored interiors.

Another casualty was Tsarskoe Selo, Catherine's favorite 1,500-acre summer retreat. Used during the siege as headquarters for the German military command, Catherine Palace was burned down by retreating Nazi forces, leaving a shell of Rastrelli's original building and Cameron's elegant interiors. Much of the palace has been reconstructed, including the pilfered Amber Room. After twenty-five years of restoration work and six tons of amber, the famous room opened in 2006.

After the execution of Nicholas II and his family, Alexander Palace was turned into a museum. In 1941, with the German army rapidly approaching, museum staff evacuated a large part of the art and furnishings to storage facilities east of Leningrad. The remaining objects were looted by occupying forces. Unlike Catherine Palace, Pavlovsk, and Peterhof, which were severely damaged, Quarenghi's interiors survived relatively unharmed. In 1996, the World Monument Fund undertook emergency roof repairs. Today, as part of the Museums of Tsarskoe Selo, the palace showcases the history of Russia's last tsars. Nearby Pavlovsk was also severely damaged by German forces. Much of its contents was evacuated before the siege. After decades of restoration, Cameron's creation is once again a beautiful palace and park ensemble with a fine art collection.

The English Palace at Peterhof was Quarenghi's first major project for Catherine, and he supervised its renovation during Alexander's reign (Paul had turned the residence into barracks). In the 19th century, the palace hosted receptions, imperial tea parties, and diplomats attending functions at Peterhof. In the 1860s, the Peterhof Home for Veterans Committee occupied the palace; from 1885 to 1917 it housed the court choir. For many years after the revolution, the palace stood empty. During World War II, the frontline ran through James Meader's English Park, which Stanislaus Poniatowski called "one of the most beautiful gardens of its kind." In 1942, the Germans blew up the neoclassical palace; what was left was later demolished by the Soviet government.

Just west of Peterhof, Rinaldi's Chinese Palace at Oranienbaum managed to escape occupation. The collections of all the Oranienbaum palaces were evacuated and the complex was even opened briefly during the war. Before Leningrad was besieged, Tiepolo's spectacular ceiling painting for the Great Hall, *Mars Resting*, was transferred to Pavlovsk for safekeeping. But at some point, the painting vanished—possibly sold to an individual.[3] In the early 1950s, decorations at the Chinese Palace were reinstalled.

In the 1990s, Oranienbaum Palace was added to the UNESCO World Heritage List, along with St. Petersburg's historic center. A decade ago, Britain's World Monument Fund repaired the roof of the Chinese Palace and installed new drainage pipes and monitors to measure temperature and humidity. Currently seven rooms are open to the public; restoration on the

THE EMPRESS OF ART

Great Hall is underway with plans to restore the damask bedchamber and one of Grand Duke Paul's rooms. The Sliding Hill Pavilion where Catherine and Alexander careened down the course together remains closed.

Ivan Starov's Tauride Palace housed the Provisional Government Duma and was later used by various Bolshevik and Communist organizations. Today, the palace is a meeting venue for the Commonwealth of Independent States. Rinaldi's riverfront Marble Palace, built for Gregory Orlov, is now home to the encyclopedic Russian Museum with over 350,000 objects of Russian art. In 1923, Catherine's Petrovsky Palace in Moscow was repurposed as the Zhukovsky Air Force Academy. During the 1990s, the building underwent reconstruction, and it was reopened in 2009 as the House of Receptions of the Government of Moscow. Today, it has a new life as a hotel on the way to Moscow's Sheremetevo Airport.

With its artworks returned from safekeeping in the Urals, the restored State Hermitage Museum reopened on November 8, 1945. At the end of the war, the Soviets made the decision to seize art in Germany as reparations. During the 1950s, some of these works were returned to East Germany, including the Pergamon Altar. Assumed lost, the paintings were stashed away in Russian museum vaults for some forty years. In 1995, the Hermitage hosted an extraordinary exhibition featuring dozens of the missing paintings, including works by Monet, Degas, Cézanne, Gauguin, and Picasso.

Restitution remains a highly controversial topic. After the collapse of Soviet Union in 1991 (when Leningrad was renamed back to St. Petersburg), the Parliament of the Russian Federation passed a law prohibiting the return or exchange of artworks. Despite this, Germany has repeatedly asked for the paintings back, most recently during Chancellor Angela Merkel's Hermitage visit in June 2014. (Merkel reportedly keeps a portrait of German-born Catherine the Great in her office.) Russia has refused these requests, claiming the art as compensation for wartime losses. A German-Russian Museum Dialogue group continues to wrestle with restitution issues. During the 1990s, Russia also passed a law prohibiting the sale of artworks to foreign countries.

Renovations continue. Charles Cameron's remarkable Agate Pavilion at Tsarskoe Selo, used as an officers' club by the Nazis, remained intact but

fell into disrepair during the Soviet period. Thanks to support from the Kress European Preservation Program, the interiors have been restored. Seven stunning rooms reopened in June 2014: the Staircase, Library, Agate Cabinet, Large Hall, and Jasper, Oval, and Little Cabinets.[4]

In 2014, the State Hermitage Museum celebrated its 250th birthday. Catherine launched the fêted gallery in 1764 to embarrass her cash-strapped political rival Frederick the Great. From those 225 pictures from Berlin, Catherine proceeded to amass literal boatloads of Old Masters, antique marbles, neoclassical furniture, porcelain and silver, and carved gems—all part of an overarching plan to turn Russia into a European superpower. With her sensational, often controversial acquisitions, Catherine turned the Hermitage into a showcase for the Russian Enlightenment, rivaling Louis XIV's Versailles and surpassing Frederick's Sanssouci. Along the way, the self-described "glutton" for art found fulfillment and romance in the competitive art market of the late 18th century.

Today, Catherine's private picture gallery is one of the world's most popular museums, attracting over three million visitors a year. The storied Hermitage collection numbers fifteen thousand paintings and three million objects, with many of its crown jewels a result of Catherine's passion and determination. To mark the museum's 250th birthday, Dutch architect Rem Koolhaas renovated a wing of Carlo Rossi's landmark General Staff Building to showcase modern and contemporary art.

"A city" is how Koolhaas describes the six historic buildings that comprise the Hermitage complex: Empress Elizabeth's Winter Palace; Catherine's Small Hermitage, Large Hermitage, and Hermitage Theatre; and Nicholas I's New Hermitage and General Staff Building. "When compared with other museums, in terms of scale, the Hermitage is equivalent in size to the Metropolitan Museum, the Centre Pompidou, the National Gallery, the Altes Museum, and the Victoria & Albert all added together," says Koolhaas. ". . . One of the most unique aspects of the Hermitage is that it is not simply a repository of artifacts, but is itself a living artifact of Russian history" with "incredibly potent historical spaces."[5]

Catherine's spirit is tangible throughout these potent spaces. "The museum has become a monument to the woman herself and it cannot be separated from her extraordinary personality," writes Hermitage director

Mikhail B. Piotrovsky. "She stares down at us from portraits, and everywhere we find objects linked to Catherine. . . . In a century dominated by the accomplishments of men, Catherine the Great stands as one of the greatest European leaders of her time."[6]

In parallel with collecting, Catherine built. During her thirty-four-year reign, she transformed swampy St. Petersburg into a splendid neoclassical capital with a distinctive Russian atmosphere. Thanks in large part to Catherine, St. Petersburg continues to captivate as it did when Élisabeth Vigée Le Brun arrived in 1795: "The embankments of the Neva are of granite and so too are many of the big canals dug by Catherine inside the city," she wrote. "On one side of the river is the Academy of Arts, the Academy of Sciences and many other buildings which are reflected in the water . . . there was no finer sight than these buildings in the moonlight . . . they look like ancient temples."[7]

Despite the traumas of the 20th century, many of Catherine's extraordinary accomplishments survive—from the Hermitage and its masterpieces to the "ancient temples" lining the Neva by moonlight. Perhaps the best symbol of Catherine's legacy is the Bronze Horseman, the river-facing statue she commissioned as a tribute to her idol and mentor, Peter the Great. It was a piece that remained prized by all her successors—and the successive governments—and protected accordingly.

During World War II, St. Petersburg's citizens encased Peter and his horse with sand and boards, safeguarding it through the Nazi siege. Like the Statue of Liberty, the Bronze Horseman has become a national icon in Russia, a symbol of pride and survival. School children today still memorize the opening lines of Pushkin's famous poem: "On the shore of empty waves *He* stood, filled with great thoughts, and stared out."

Like Peter, indefatigable Catherine the Great loved a challenge. In the middle of the costly, high stakes project, she spurred her temperamental sculptor Étienne-Maurice Falconet through the homestretch to the finish line. "This blasted horse is already running on its own steam," she told him, "and will run from your clay-covered hands into posterity, where he will be appreciated even more than by his own contemporaries."[8]

BIBLIOGRAPHY

Alexander, John T. *Catherine the Great: Life and Legend*. Oxford: Oxford University Press, 1989.

Allard, Sebastien, Robert Rosenblum, Guilhem Scherf, and MaryAnne Stevens. *Citizens and Kings: Portraits in the Age of Revolution 1760–1830*. London: Royal Academy of Arts, 2007.

Allen, Brian, and Larissa Dukelskaya, eds. *British Art Treasures from Russian Imperial Collections in the Hermitage*. New Haven, CT: Yale University Press, 1996.

Althaus, Frank, and Mark Sutcliffe, eds. *The Triumph of Eros: Art and Seduction in 18th-Century France*. London: Fontanka, 2006.

Amelëkhina, Svetlana A., and Alexey K. Levykin. *Magnificence of the Tsars: Ceremonial Men's Dress of the Russian Imperial Court, 1721-1917 from the Collection of the Moscow Kremlin Museums*. London: V&A Publishing, 2009.

Ancient Rome, The State Hermitage Museum App, http://www.hermitageapp.com/en/museum/app/rome.html, 8.

Anderson, Jaynie. *Giorgione: The Painter of "Poetic Brevity."* New York: Flammarion, 1997.

Anderson, Troels. "Vigilius Eriksen in Russia." *Artes: Periodical of the Fine Arts* 1 (1965): 52.

Angelini, Piervaleriano, A. Bettagno, G. Mezzanotte, F. Rossi, and C. Zanella. *Giacomo Quarenghi: Architetture e Vedute*. Milan: Electa, 1994.

Angelini, Piervaleriano, and Vanni Zanella. *I disegni di Giacomo Quarenghi nella Civica biblioteca di Bergamo* [videorecording]. Bergamo: Osservatorio Quarenghi, 2008.

Anisimov, Evgenii V. *Five Empresses: Court Life in Eighteenth Century Russia*. Translated by Kathleen Carroll. Westport, CT: Praeger, 2004.

Arnason, H. H. *The Sculptures of Houdon*. Oxford: Oxford University Press, 1975.

Artemieva, Irina. "The Sources of Italian Renaissance Paintings in the Hermitage." In *Florence and Venice: Italian Renaissance Paintings and Sculpture from the State Hermitage Museum*, edited by Kokuritsu Seiyo Bijutsukan, 241–45. Tokyo: National Museum of Western Art, 1999.

407

Asvarishch, Boris. "Paintings from the Collection of Willem II in the Hermitage." In *Willem II and Anna Pavlovna: Royal Splendour at the Dutch Court*, exhibition catalogue, 190–255. St. Petersburg: The State Hermitage Publishers, 2013.

Atkins, Christopher D. M. *The Signature Style of Frans Hals: Painting, Subjectivity, and the Market in Early Modernity*. Amsterdam: Amsterdam University Press, 2012.

Babina, Natalya. *Flemings through the Eyes of David Teniers the Younger (1610–1690)*, exhibition catalogue. St. Petersburg: The State Hermitage Publishers, 2010.

Bain, Robert Nisbet. *The Last King of Poland and His Contemporaries*. London: Methuen, 1909.

Balfour, Ian. *Famous Diamonds*. New York: Christie's Books, 1997.

Barker, Emma. "Imaging Childhood in Eighteenth-Century France: Greuze's Little Girls with a Dog." *The Art Bulletin* 91 (2009): 426–45.

Barker, Emma. "Mme Geoffrin, Painting and Galanterie: Carle Van Loo's 'Conversation Espagnole' and 'Lecture Espagnole,'" *Eighteenth-Century Studies*, 40 (2007): 604.

Barkhatova, Yelena. *The National Library of Russia, 1795–1995*. Translated by Paul Williams. St. Petersburg: Liki Rossii, 1995.

Barnes, Susan J., and Arthur K. Wheelock, Jr., eds. *Studies in the History of Art*. Vol. 46, *Van Dyck 350*. Washington: National Gallery of Art, 1994.

Basbanes, Nicholas A. *A Splendor of Letters: The Permanence of Books in an Impermanent World*. New York: HarperCollins, 2003.

Bellori, Giovan Pietro. *The Lives of the Modern Painters, Sculptors, and Architects: A New Translation and Critical Edition*. Translated by Alice Sedgwick Wohl. New York: Cambridge University Press, 2005.

Beltramini, Guido, and Howard Burns, eds. *Palladio*. London: Royal Academy of Arts, 2008.

Belyakova, Zoia. *The Romanov Legacy: the Palaces of St. Petersburg*. Edited by Marie Clayton. New York: Viking Studio Books, 1995.

Berenson, Bernard. *The Study and Criticism of Italian Art*. London: George Bell & Sons, 1901.

Bettagno, Alessandro, and Gianni Mezzanotte. *Giacomo Quarenghi: Architecturre e Vedute*. Milan: Electa, 1994.

Bietoletti, Silvestra. *Neoclassicism & Romanticism, 1770–1840*. New York: Sterling, 2005.

Bignamini, Ilaria, and Clare Hornsby. *Digging and Dealing in Eighteenth Century Rome*. New Haven, CT: Yale University Press, 2010.

Bikker, Jonathan, Gregor J. M. Weber, Marjorie E. Wieseman, and Erik Hinterding. *Rembrandt: The Late Works*. London: National Gallery Company; Amsterdam: in association with the Rijksmuseum, 2014.

Bischoff, Ilse. "Etienne-Maurice Falconet: Sculptor of the Statue of Peter the Great." *Russian Review* 24 (1965): 369–386.

Black, Will. *The Chinese Palace at Oranienbaum*. Boston and London: Bunker Hill Publishing, 2003.

Black, Will. "Tsarist Treasures Reborn." *World Monument Fund*, Spring 2003.

Blakesley, Rosalind P. "Pride and the Politics of Nationality in Russia's Imperial Academy of Fine Arts, 1757–1807." *Art History* 33 (2010): 800–35.

Bondil, Nathalie, ed. *Catherine the Great: Art for Empire, Masterpieces from the State Hermitage Museum*. Montréal: Montréal Museum of Fine Arts; Gand, Belgium: Snoeck, 2005.

Börsch-Supan, Helmut. "History's Melody—Nature's Rhythm." In *Sanssouci*, edited by Gerhard Ullmann, 129–37. Berlin: Propyläen Verlag, 1993.

Boucher, François. *20,000 Years of Fashion: The History of Costume and Personal Adornment*. New York: H. N. Abrams, 1967.

Bradbury, Malcolm. *To the Hermitage*. New York: The Overlook Press, 2002.

Bradford, Gamaliel. "Portrait of a Lady: Madame de Choiseul." *The Sewanee Review* 23 (1915): 299–312.

Brechka, Frank T. "Catherine the Great: the Books She Read." *The Journal of Library History* 4 (1969): 39–52.

Brett, C. E. B., and Shaun Tyas. *The Towers of Crim Tartary*. Donington, UK: Paul Watkins Publishing, 2005.

Brown, Christopher, and Hans Vlieghe. *Van Dyck*. London: Royal Academy Publications, 1999.

Brown, David Alan, and Sylvia Ferino-Pagden. *Bellini, Giorgione, Titian, and the Renaissance of Venetian Painting*. Washington: National Gallery of Art; Vienna: Kunsthistorisches Museum; New Haven, CT, and London: Yale University Press, 2006.

Brownell, Morris R. *The Prime Minister of Taste: A Portrait of Horace Walpole*. New Haven, CT: Yale University Press, 2001.

Brumfield, William Craft. *Gold in Azure: One Thousand Years of Russian Architecture*. Boston: David R. Godine, Inc., 1983.

Brumfield, William Craft. *A History of Russian Architecture*. Cambridge: Cambridge University Press, 1993.

Brumfield, William Craft. *Landmarks of Russian Architecture: A Photographic Survey*. Gordon and Breach Publishers, 1997.

Brumfield, William Craft. *Lost Russia: Photographing the Ruins of Russian Architecture*. Durham, NC, and London: Duke University Press, 1995.

Burg, Tobias. "Two Works by Chardin in the Collection of Count Heinrich von Brühl." *The Burlington Magazine* 150 (2008): 529–33.

Butler, Rohan. *Choiseul* Vol. 1. Oxford: Clarendon Press; New York: Oxford University Press, 1980.

Cabanne, Pierre. *The Great Collectors*. London: Cassell, 1963.

Cannadine, David. *Mellon: An American Life*. New York: Alfred A. Knopf, 2006.

Catherine, Empress of Russia. *Letters from Empress Catherine II to Grimm (1774–1796)*. St. Petersburg: Anthology of the Imperial Russian Historical Society, 1878.

Chenevière, Antoine. *The Golden Age of Russian Furniture, 1780–1850*. New York: Vendome Press, 1988.

Cholmondeley, David, and Andrew Moore. *Houghton Hall: Portrait of an English Country House*. New York: Skira Rizzoli, 2014.

Chrisman-Campbell, Kimberly. *Fashion Victims: Dress at the Court of Louis XVI and Marie-Antoinette*. New Haven, CT: Yale University Press, 2015.

Chrisman-Campbell, Kimberly. "Getting Technical: Shedding New Light on Two Masterpieces of 18th-Century Sculpture." *Huntington Frontiers*, Spring/Summer 2008.

Citizens and Kings: Portraits in the Age of Revolution, exhibition. London: Royal Academy of Arts, 2007.

Cole, Teresa Levonian. "St. Petersburg: the Cats of the Hermitage," *Telegraph*, May 23, 2013.

Coxe, William. *Travels into Poland, Russia, Sweden, and Denmark*. London: T. Cadell, 1784.

Coutts, Howard, and Ivan Day. "Sugar Sculpture, Porcelain and Table Layout 1530–1830" (paper presented at the Taking Shape talk series, Henry Moore Institute, Leeds, England, October, 2008).

Cracraft, James, and Daniel Rowland, eds. *Architects of Russian Identity: 1500 to the Present*. Ithaca, NY, and London: Cornell University Press, 2003.

Cresson, William Penn. *Francis Dana: A Puritan Diplomat at the Court of Catherine the Great*. New York: L. MacVeagh, The Dial Press; Toronto: Longmans, Green & Co., 1930.

Cross, Anthony. *By the Banks of the Neva: Chapters from the Lives and Careers of the British in Eighteenth-Century Russia*. Cambridge: Cambridge University Press, 1997.

Cross, Anthony. *Catherine the Great and the British*. Nottingham, UK: Astra Press, 2001.

Cross, Anthony, ed. *Engraved in the Memory: James Walker, Engraver to the Empress Catherine the Great, and His Russian Anecdotes*. Oxford and Providence: Berg, 1993.

Cross, Anthony, ed. *Russia under Western Eyes, 1517–1825*. London: Elek Books, 1971.

Cross, Anthony. "Russian Gardens, British Gardeners," *Garden History* 19 (1991): 12–20.

Cruse, Mark, and Hilde Hoogenboom, eds. and trans. *The Memoirs of Catherine the Great*. New York: Modern Library, 2005.

Dacier, Emile. "Choiseul as a Collector." *Gazette des Beaux-Arts* 36 (1949): 150–58.

Dacos, Nicole. *The Loggia of Raphael: a Vatican Art Treasure*. Translated by Josephine Bacon. New York: Abbeville Press, 2008.

Davidson, Bernice F. *Raphael's Bible: A Study of the Vatican Logge*. University Park: Pennsylvania State University Press, 1985.

D'Elia, Una Roman. "Grotesque Painting and Painting as Grotesque in the Renaissance." *Notes in the History of Art* 33 (2014): 5–12.

Dellac, Christiane. *Marie-Anne Collot: Une sculptrice francaise a la cour de Catherine II 1748–1821*. Paris: L'Harmattan, 2005.

Denisov, Alexei. "Monarchs' Menu: Feasts Fit for Russian Tsars and Emperors." *Russia beyond the Headlines*, July 9, 2014. http://rbth.com/arts/2014/07/09/monarchs_menu_feasts_fit_for_russian_tsars_and_emperors_38051.html.

Descargues, Pierre. *Art Treasures of the Hermitage*. Translated by Matila Simon. New York: H. N. Abrams, 1970.

Dianina, Katia. "Art and Authority: The Hermitage of Catherine the Great." *Russian Review* 63 (2004): 630–54.

Dixon, Simon. *Catherine the Great*. New York: HarperCollins, 2009.

Dixon, Simon. "The Posthumous Reputation of Catherine II in Russia 1797–1837." *The Slavonic and East European Review* 77 (1999): 646–79.

Dmitrieva, Elena. "On the Formation of the Collection of Gem Impressions in the State Hermitage Museum." *Journal of the History of Collections* 25 (2013): 77–85.

Dolan, Brian. *Josiah Wedgwood: Entrepreneur to the Enlightenment.* London: HarperCollins, 2004.

Dorgerloh, Hartmut, and Michael Scherf. *Prussian Residences: Royal Palaces and Gardens in Berlin and Brandenburg.* Translated by Wendy Wallis. Munich: Deutcher Kunstverlag, 2005.

Dubin, Nina L. *Futures & Ruins: Eighteenth-Century Paris and the Art of Hubert Robert.* Los Angeles: Getty Research Institute, 2010.

Ducamp, Emmanuel, ed. *Pavlovsk: The Palace and the Park.* Paris: Alain de Gourcuff, 1993.

Ducamp, Emmanuel, ed. *Summer Palaces of the Romanovs: Treasures from Tsarskoye Selo.* Translated by Barbara Mellor, photography by Marc Walter. New York: Thames & Hudson, 2012.

Durand, Jannic, ed. *Decorative Furnishings and Objects d'Art in the Louvre from Louis XIV to Marie Antoinette, Musée du Louvre.* Paris: Louvre éditions, 2014.

Ekkart, Rudolf, and Quentin Buvelot. *Dutch Portraits: The Age of Rembrandt and Frans Hals.* Translated by Beverly Jackson. Zwolle, Netherlands: Waanders Publishers; Royal Picture Gallery Mauritshuis; National Gallery Company, 2007.

Felicetti, Chiara, Maria Barbara, and Guerrieri Borsoi, eds. "La copia delle logge di Raffaello di Cristoforo Unterperger." In *Cristoforo Unterperger: Un pittore fiemmese nell'Europa del Settecento.* Rome: Edizioni de Luca, 1998.

Ferino-Pagden, Sylvia, and Giovanna Nepi Scirè, eds. *Giorgione: Myth and Enigma.* Milan: Skira; Vienna: Kunsthistorisches Museum, 2004.

Fitzlyon, Kyril, ed. and trans. *The Memoirs of Princess Dashkova.* Durham, NC: Duke University Press, 1995.

Flit, Marina Alexandrovna. *Pavlovsk: The Palace and the Park.* Paris: Gourcuff, 1993.

Fletcher, Banister F. *Andrea Palladio: His Life and Works.* London: George Bell and Sons, 1902.

Forbes, Isabella, and William Underhill, eds. *Catherine the Great: Treasures of Imperial Russia from the State Hermitage Museum.* London: Booth-Clibborn Editions, 1990.

Fraser, Antonia. *Marie Antoinette: The Journey.* New York: Anchor Books, 2002.

Freudenheim, Tom L. "'The Lost Museum: The Berlin Sculpture and Paintings Collections 70 Years after World War II' Review," *Wall Street Journal*, July 1, 2015. http://www.wsj.com/articles/the-lost-museum-the-berlin-sculpture-and-paintings-collections-70-years-after-world-war-ii-review-1435789134.

Gaines, James R. *Evening in the Palace of Reason.* New York: HarperCollins, 2005.

Gaxotte, Pierre. *Frederick the Great.* Translated by R. A. Bell. London: G. Bell and Sons, 1941.

Georgi, Johann Gottlieb. *Russia: or, a compleat historical account of all the nations which compose that Empire. . . .* [electronic resource]. London : printed for J. Nichols: T.

Cadell, in the Strand; H. Payne, Pall-Mall; and N. Conant, Fleet-Street, MDC-CLXXX. 1780–83.

Georgi, Johann Gottlieb. *Description of the Imperial Russian Capital City of St. Petersburg and the Sights in Its Environs.* St. Petersburg: 1794.

Goffen, Rona. *Museums Discovered: The Calouste Gulbenkian Museum.* Greenwich, CT: New York Graphic Society, 1982.

Golovine, V.N. *Memoirs of Countess Golovine: A Lady at the Court of Catherine II.* Translated by G. M. Fox-Davies. London: David Nutt, 1910.

Gooch, G. P. "Catherine the Great and Grimm," *The Contemporary Review* 182 (1952).

Goodman, Dena. "Pigalle's Voltaire nu: The Republic of Letters Represents Itself to the World." *Representations* 16 (1986): 86–109.

Goodman, John, ed. and trans. *Diderot on Art I: The Salon of 1765 and Notes on Painting.* New Haven, CT: Yale University Press, 1995.

Goodwin, J. *Lords of the Horizons.* New York: Henry Holt and Company, 1998.

Gorbatov, Inna. *Catherine the Great and the French Philosophers of the Enlightenment: Montesquieu, Voltaire, Rousseau, Diderot and Grimm.* Bethesda, MD: Academica Press, 2006.

Gorbatov, Inna. "From Paris to St. Petersburg: Voltaire's Library in Russia." *Libraries & the Cultural Record* 42 (2007): 308–24.

Gorbunova, Xenia. "Classical Sculpture from the Lyde Brown Collection." *Apollo* 99 (1974): 460–67.

Gordenker, Emilie. "Aspects of Costume in Van Dyck's English Portraits." In *Van Dyck 1599–1999: Conjectures and Refutations,* edited by Hans Vlieghe, 211–26. Turnhout, Belgium: Brepols, 2001.

Graves, Algernon, and William Vine Cronin. *A History of the Works of Sir Joshua Reynolds, P.R.A.,* vol 4. London: Henry Graves and Co., 1901.

Gray, Rosalind Polly. *Russian Genre Painting in the Nineteenth Century.* Oxford: Oxford University Press, 2000.

Griffiths, David M. "Catherine II Discovers the Crimea." *Jarbucherfur Geschichte Osteuropas* 56 (2008): 339–48.

Grigorieva, Irina. "Western European Drawings in the Hermitage Museum." In *Master Drawings from the Hermitage & Pushkin Museums.* New York: The Pierpont Morgan Library, 1998.

Gritsay, Natalya. *Anthony van Dyck.* Bournemouth: Parkstone; St. Petersburg: Aurora Art Publishers, 1996.

Gritsay, Natalya. "Rubens and His Followers." In *Rubens and His Age: Treasures from the Hermitage Museum, Russia,* edited by Christina Corsiglia, 34–35. London: Merrell in association with Art Gallery of Ontario, 2001.

Gritsay, Natalya, and Natalya Babina. *Seventeenth- and Eighteenth-Century Flemish Painting, State Hermitage Museum Catalogue.* New Haven, CT, and London: Yale University Press, 2008.

Gritsay, Natalya, and Seiro Mayekawa. *Seventeenth Century Dutch and Flemish Paintings and Drawings from the Hermitage.* Tokyo: National Museum of Western Art, 1983.

Grosskurth, Brian. "Shifting Monuments: Falconet's Peter the Great between Diderot and Eisenstein," *Oxford Art Journal* 23 (2000).

Guseva, Natalya. "Catherine's Apartments in Her Imperial Palaces." *The British Art Journal* 1 (2000/2001): 100–109.

Guseva, Natalya, and Catherine Phillips, eds. *Treasures of Catherine the Great: Hermitage rooms at Somerset House.* London: Christie's International Media Division, 2000.

Hamilton, Adrian. "The Empress Strikes Back: Catherine the Great Exhibition at the National Museum of Scotland." *The Independent*, August 15, 2012. http://www.independent.co.uk/arts-entertainment/art/the-empress-strikes-back-catherine-the-great-exhibition-at-the-national-museum-of-scotland-8046701.html.

Hamilton, George Heard. *Art and Architecture of Russia.* Baltimore: Penguin Books, 1975.

Haskell, Francis, and Nicholas Penny. *Taste and the Antique: The Lure of Classical Sculpture 1500–1900.* New Haven, CT: Yale University Press, 1981.

Hearn, Karen, ed. *Van Dyck & Britain.* London: Tate Publishing; New York: H. N. Abrams, 2009.

Henry, Tom, and Paul Joannides, eds. *Late Raphael.* Madrid: Museo Nacional del Prado, 2012.

Houghton Revisited: The Walpole Masterpieces from Catherine the Great's Hermitage. London: Royal Academy of Arts, 2013.

Hunter-Stiebel, Penelope. *Stroganoff.* New York: H. N. Abrams, 2000.

Huth, Hans. *Roentgen Furniture: Abraham and David Roentgen, European Cabinet-makers.* n.p.: Sotheby Parke Bernet, 1974.

The Imperial Residences around St. Petersburg. St. Petersburg: Alfa-Colour Art Publishers, 2003.

Ingamells, John, and John Edgcumbe, eds. *The Letters of Sir Joshua Reynolds.* London: Paul Mellon Centre for Studies in British Art; Yale University Press, 2000.

Ivanova, Elena. "Gardner Factory Porcelain." In *Porcelain in Russia, 18th–19th Centuries,* 5–18. St. Petersburg: State Russian Museum, Palace Editions, 2003.

Jenkins, Susan. "Power Play: James Brydges, 1st Duke of Chandos, and Sir Robert Walpole: The Politics of Collecting in the Early 18th Century." *The British Art Journal* 4 (2003): 80–82.

Justi, Johann Heinrich Gottlob von. *The life, [electronic resource]: character, rise and conduct, of Count Bruhl, prime minister to the King of Poland, Elector of Saxony; in a series of letters, by an eminent hand. Throwing a Light on the real Origin of the past and present War in Germany, And the Intrigues of Several Powers.* London: printed for M. Cooper, in Pater-Noster-Row, and C. G. Seyffert, in Pall-Mall, MDCCLXI. 1761.

Kauffmann, C. M. *Catalogue of Paintings in the Wellington Museum Apsley House.* Revised by Susan Jenkins; contributions from Marjorie E. Wieseman. London: English Heritage and Paul Holberton Publishing, 2009.

Kennett, Audrey, and Victor Kennett. *The Palaces of Leningrad.* London and New York: Thames & Hudson, 1973.

Khodasevch, Gala. *Tsarskoye Selo: Palaces & Parks.* Translated by Valery Fateyev. St. Petersburg: Alfa-Color Art Publishers, 2008.

Khodasevich, Vladislav. *Derzhavin: A Biography.* Translated by Angela Brintlinger. Madison: University of Wisconsin Press, 2007.

King, David. *Vienna, 1814*. New York: Random House, 2008.

Kirin, Asen. *Exuberance of Meaning: The Art Patronage of Catherine the Great (1762–1796)*. Athens, GA: Georgia Museum of Art, University of Georgia, 2013.

Koeppe, Wolfram. *Extravagant Inventions: The Princely Furniture of the Roentgens*. New York: Metropolitan Museum of Art, 2012.

Koeppe, Wolfram. "Gone with the Wind to the Western Hemisphere—Selling off Furniture by David Roentgen and Other Decorative Arts of the Eighteenth Century." *Canadian American Slavic Studies* 43 (2009): 245–72.

Koeppe, Wolfram. *Vienna circa 1780: An Imperial Silver Service Rediscovered*. New Haven, CT: Yale University Press, 2010.

Koolhas, Rem. "The Hermitage: Masterplan 2014," lecture, January 24, 2008. oma.eu/lectures/the-hermitage-masterplan-2014/.

Korshunova, Militsa. "Peter the Great's St. Petersburg." In *Peter the Great: An Inspired Tsar*, 72–81. Amsterdam: Hermitage Amsterdam, 2013.

Korshunova, T. T. "Secular Dress," The State Hermitage Museum, http://www.hermitagemuseum.org/wps/portal/hermitage/explore/collections/master/sub/1254020112.

Kostjuk, Olga G. *Gold of the Tsars: 100 Masterpieces of the Hermitage, St. Petersburg*. Stuttgart: Arnoldsche, 1995.

Kuznetsova, Irina. *From Poussin to Matisse: The Russian Taste for French Painting*. Chicago: The Art Institute of Chicago; New York: The Metropolitan Museum of Art and Harry N. Abrams, Inc., 1990.

Le Corbeiller, Clare. "Grace and Favor." *The Metropolitan Museum of Art Bulletin*, 27 (1969): 289–98.

Lentin, Anthony. "The Princess Dashkova, Part Two." *History Today* 19 (1969): 18–24.

Lentin, Anthony, ed. and trans. *Voltaire and Catherine the Great: Selected Correspondence*. Cambridge, UK: Oriental Research Partners, 1974.

Levinson-Lessing, V. F., ed. *The Hermitage Leningrad: Medieval & Renaissance Masters*. London: Paul Hamlyn, 1967.

Levitine, George. *The Sculpture of Falconet*. New York: New York Graphic Society Ltd., 1972.

Lewis, Wilmarth Sheldon. *Horace Walpole*. New York: Pantheon Books, 1961.

Lincoln, W. Bruce. *Sunlight at Midnight: St. Petersburg and the Rise of Modern Russia*. New York: Basic Books, 2012.

MacDonough, Giles. *Frederick the Great: A Life in Deed and Letters*. New York: St. Martin's Griffin, 1999.

Madariaga, Isabel de. *Russia in the Age of Catherine the Great*. London: Phoenix Press, 2002.

Mansel, Philip. *Prince of Europe: The Life of Charles-Joseph De Ligne*. London: Phoenix, 2003.

Maranzani, Barbara. "5 Romanovs You Should Know." February 21, 2013. http://www.history.com/news/5-romanovs-you-should-know.

Mariuz, Adriano. "Giambattista Tiepolo: Painting's True Magician." In *Giambattista Tieplo: 1696–1770*, edited by Keith Christiansen, 3–13. New York: The Metropolitan Museum of Art, Distributed by H. N. Abrams, 1996.

Massie, Robert K. *Catherine the Great*. New York: Random House, 2011.

Massie, Suzanne. *Pavlovsk: The Life of a Russian Palace*. Boston: Little, Brown and Company, 1990.

Masson, Charles Francois Philibert. *Secret Memoirs of the Court of Petersburg*. New York: Arno Press and the New York Times, 1970.

Matveyev, Vladimir, ed. *The Hermitage: Selected Treasures from a Great Museum*. London: Booth-Clibborn Editions, 1996.

Mazzotta, Antonio. *Titian: A Fresh Look at Nature*. London: National Gallery Company, 2012.

McIntyre, Ian. *Joshua Reynolds: The Life and Times*. London: Allen Lane, 2003.

Menshikova, Maria, and Jet Pijzel-Dommisse. *Silver Wonders from the East: Filigree of the Tsars*. Amsterdam: Lord Humphries, 2006.

Merridale, Catherine. *Red Fortress: History and Illusion in the Kremlin*. London: Picador, 2013.

Millar, Oliver. "Philip, Lord Wharton and His Collection of Portraits." *The Burlington Magazine* 136 (1994): 517–30.

Montefiore, Simon Sebag, *Potemkin: Catherine the Great's Imperial Partner*. New York: First Vintage Books, 2005.

Montefiore, Simon Sebag. *Potemkin: Prince of Princes*. London: Phoenix, 2001.

Moore, Andrew. *Norfolk & the Grand Tour*. Norwich, UK: Norfolk Museums Service, 1985.

Moore, Andrew, ed. *Houghton Hall: The Prime Minister, the Empress and the Heritage*. London: Philip Wilson, 1996.

Moore, Andrew, and Larissa Dukelskaya, eds. *A Capital Collection: Houghton Hall and the Hermitage*. New Haven, CT: Yale University Press, 2002.

Moreau, Veronique, and Marie Thomas. *Chanteloup: Un moment de grace autour de duc de Choiseul*. Paris: Somogy; Tours: Musée des Beaux-arts de Tours, 2007.

Munro, George E. "Catherine Discovers St. Petersburg." *Jahrbucher fur Geschichte Osteuropas, Neue Folge* Bd. 56 (2008): 330–38.

Murdoch, Tessa, and Heike Zech, eds. *Going for Gold: Craftsmanship and Collecting of Gold Boxes*. Eastbourne, UK: Sussex Academic Press, 2013.

Neverov, Oleg. *Antique Cameos in the Hermitage Collection*. St. Petersburg: Aurora Art Publishers, 1971.

Neverov, Oleg. *Antique Intaglios in the Hermitage Collection*. St. Petersburg: Aurora Art Publishers, 1976.

Neverov, Oleg. "Catherine the Great: Public and Private Collector." *The British Art Journal* 2 (2000): 121–26.

Neverov, Oleg. "Gems from the Collection of Princess Dashkov." *Journal of the History of Collections* 2 (1990): 63–68.

Neverov, Oleg. *Great Private Collections of Imperial Russia*. London and New York: Thames & Hudson, 2004.

Neverov, Oleg. "The Lyde Browne Collection and the History of Ancient Sculpture at the Hermitage Museum." *American Journal of Archaeology* 88 (1984): 33–42.

Neverov, Olga, and Dmitry Pavlovich Alexinsky. *The Hermitage Collections: Volume I: Treasures of World Art*. New York: Rizzoli; St. Petersburg: ARCA Publishers, 2010.

Neverov, Oleg, and Mikhail Piotrovsky. *The Hermitage: Essays on the History of the Collection*. St. Petersburg: Slavia Art Books, 1997.

Norman, Geraldine. *The Hermitage: The Biography of a Great Museum*. London: Pimlico, 1997.

Odom, Anne. *What Became of Peter's Dream? Court Culture in the Reign of Nicholas II*. Washington, DC: Hillwood Museum & Gardens, Middlebury College Museum of Art, 2003.

Odom, Anne, and Wendy R. Salmond, eds. *Treasures into Tractors: The Selling of Russia's Cultural Heritage, 1918–1938*. Washington, DC: Hillwood Museum & Gardens, University of Washington Press, 2009.

O'Malley, Lurana Donnels. *The Dramatic Works of Catherine the Great: Theatre and Politics in Eighteenth-Century Russia*. Hants, England, and Burlington, VT: Ashgate, 2006.

Opperman, H. N. "Marie-Anne Collot in Russia: Two Portraits." *The Burlington Magazine* 107 (1965): 408–15.

Orloff, Alexander (photographer), and Dmitri Shvidkovsky. *St. Petersburg, Architecture of the Tsars*. Translated by John Goodman. New York: Abbeville Press, 1996.

Ozerov, Dimitri. "Catherine II et les *Loges* de Volpato," In *Giovanni Volpato: Les loges de Raphaël et la galerie du Palais Farnèse*, edited by Annie Gilet, 75-85. Milan: Silvana; Tours: Musée des beaux-arts, 2007.

Papi, Stefano. *Jewels of the Romanovs, Family & Court*. London: Thames & Hudson, 2010.

Paredes, Liana Arend. *Sèvres Porcelain at Hillwood*. Washington, DC: Hillwood Museum & Gardens, 1998.

Parkinson, John. *A Tour of Russia, Siberia and the Crimea 1792–1794*. Edited by William Collier. London: Cass, 1971.

Pearson, Irene. "Raphael as Seen by Russian Writers from Zhukovsky to Turgenev." *The Slavonic and East European Review* 59 (1981): 346–69.

Pelzel, Thomas Anton. *Raphael Mengs and Neoclassicism*. New York: Garland Publishing, 1979.

Penny, Nicholas, ed. *Reynolds*. London: Royal Academy of Arts, 1986.

Petrova, Olga. *Gatchina Palace*. St. Petersburg: Gallery Art Publishers, 2007.

Phillips, John Goldsmith. "Monsieur Houdon's Frileuse." *Metropolitan Museum of Art Bulletin* 22 (1963): 29–36.

Phillips, John Goldsmith. "A Silk Portrait of Catherine the Great." *The Metropolitan Museum of Art Bulletin* 36 (1941): 151–53.

Pignatti, Terisio, and Filippo Pedrocco. *Giorgione*. New York: Rizzoli, 1999.

Piotrovsky, Mikhail B. *The Hermitage: 250 Masterworks*. New York: Skira Rizzoli, 2014.

Piotrovsky, Mikhail B. *The Legacy of Catherine the Great*. Melbourne: National Gallery of Victoria, 2015.

Piotrovsky, Mikhail B. *Treasures of Catherine the Great: Hermitage Rooms at Somerset House*. St. Petersburg: State Hermitage Museum, 2000.

Piotrovsky, Mikhail B., et al. *Dining with the Tsars: Fragile Beauty from the Hermitage*. Amsterdam: Hermitage Amsterdam, 2014.

Pitman, Joana. *The Dragon's Trail: The Biography of Raphael's Masterpiece.* New York: Simon & Schuster, 2006.

Plumb, J. H. *Sir Robert Walpole: the Making of a Statesman.* London: The Cresset Press, 1956.

Pomeroy, Jordana, Rosalind P. Blakesley, Vladimir Yu. Matveyev, and Elizaveta P. Renne. *An Imperial Collection: Women Artists from the State Hermitage Museum.* London: Merrell, 2003.

Poulet, Anne. L. *Jean-Antoine Houdon, Sculptor of the Enlightenment.* Washington, DC: National Gallery of Art; Chicago and London: University of Chicago Press, 2003.

Radisich, Paula Rea. *Hubert Robert: Painted Spaces of the Enlightenment.* Cambridge: Cambridge University Press, 1998.

Rae, Isobel. *Charles Cameron: Architect to the Court of Russia.* London: Elek Books, 1971.

Raeburn, Michael, Ludmila Voronikhina, and Andrew Nurnberg. *The Green Frog Service.* London: Cacklegoose Press in association with the State Hermitage, St. Petersburg, 1995.

Ragsdale, Hugh. "Evaluating the Traditions of Russian Aggression: Catherine II and the Greek Project." *The Slavonic and East European Review* 66 (1988): 91–117.

Ragsdale, Hugh. *Tsar Paul and the Question of Madness.* Santa Barbara, CA: Greenwood Press, 1988.

Raikes, Thomas. *A Visit to St. Petersburg in the Winter of 1829–30.* http://stpetersburgrussia .ru/Architecture/tauride_tavrichesky_palace_st_petersburg_russia.

Reid, Anna. *Leningrad: The Epic Siege of World War II, 1941–1944.* New York: Walker & Co., 2011.

Reyburn, Scott. "Who's Rich Enough for a Picasso?" *The New York Times,* June 12, 2015. http://www.nytimes.com/2015/06/15/arts/international/whos-rich-enough-for-a-picasso.html?_r=0.

Rice, Tamara Talbot. *Charles Cameron: Architectural Drawings and Photographs from the Hermitage Collection, Leningrad and Architectural Museum.* Moscow: The Arts Council, 1967.

Rinke, Andreas. "Merkel Tells Putin Germany Wants Looted Art Returned." Reuters.com, June 21, 2013. http://www.reuters.com/article/2013/06/21/germany-russia-merkel -art-idUSL5N0EX3G220130621.

Roettgen, Steffi. *Anton Raphael Mengs and His British Patrons.* London: A. Zwemmer Ltd./English Heritage, 1993.

Rosenthal, Angela, and Angelica Kauffman. *Art and Sensibility.* New Haven, CT, and London: Yale University Press, 2006.

Rounding, Virginia. *Catherine the Great: Love, Sex, and Power.* London: St Martin's Griffin, 2006.

Ross, Marvin Chauncey. "A Golden Vase by I. Ador." *Gazette des Beaux-Arts* 2 (1942): 122–24.

Ruane, Christine. *The Empire's New Clothes: A History of the Russian Fashion Industry, 1700–1917.* New Haven, CT: Yale University Press, 2009.

St. Petersburg Jewellers: 18th and 19th Centuries. St. Petersburg: Slavia, 2000.

Salmon, Frank. "Charles Cameron and Nero's Domus Aurea: 'Una piccola esplorazione.'" *Architectural History* 36 (1993): 69–93.

Sanchez-Jauregui, Maria Dolores, and Scott Wilcox. *The English Prize: The Capture of the Westmorland.* New Haven, CT: Yale University Press, 2012.

Sargentson, Carolyn. "Reading, Writing, and Roentgen." Paper presented at "Extravagant Inventions—the Princely Furniture of the Roentgens" exhibition at the Metropolitan Museum of Art, New York, November 18, 2012.

Scarisbrick, Diana. Sotheby's 2005 catalogue note, http://www.jewelsdujour .com/2013/04/a-highly-important-bow-necklace-from-the-collection-of-the-russian- imperial-family/.

Schama, Simon. "Simon Schama on Rembrandt's Late Works." *Financial Times*, October 17, 2014. http://www.ft.com/cms/s/2/a4230272-552e-11e4-b616-00144feab7de .html#slide0.

Schenker, Alexander M. *The Bronze Horseman, Falconet's Monument to Peter the Great.* New Haven, CT: Yale University Press, 2003.

Schepkowski, Nina Simone. *Johann Ernst Gotzkowsky: Kunstagent und Gemaldesammler im friderizianischen.* Berlin: Akademie Verlag, 2009.

Scherf, Guilhem. *Cast in Bronze: French Sculpture from Renaissance to Revolution.* Paris: Musée du Louvre Editions, 2009.

Scherf, Guilhem. *Houdon at the Louvre: Masterworks of the Enlightenment.* Translated by Jane Marie Todd. Paris: Musée du Louvre Editions, 2008.

Scherf, Guilhem. *Houdon 1741–1828 Statues, portraits, sculptes.* Paris: Louvre Museum, 2006.

Schönle, Andreas. "Garden of the Empire: Catherine's Appropriation of the Crimea." *Slavic Review* 60 (2001): 1–23.

Schwartz, Selma, and Pippa Shirley, eds. *The Duc de Choiseul: Essays in Honour of Mrs. Charles Wrightsman: Waddesdon Miscellanea*, vol. 1. Waddesdon, UK: The Alice Trust, Waddesdon Manor, 2009.

Scott, Barbara. "The duc de Choiseul: A Minister in the Grand Manner." *Apollo* 97 (1973): 42–53.

Scott, Barbara. "La Live de Jully: Pioneer of Neo-Classicism." *Apollo* 97 (1973): 72–77.

Scott, Barbara. "Pierre Crozat: A Maecenas of the Regence." *Apollo* 97 (1973): 11–18.

Scott, Jonathan. *The Pleasures of Antiquity: British Collections of Greece of Rome.* New Haven, CT: Yale University Press, 2003.

Semyonova, Natalya, and Nicolas V. Iljine, eds. *Selling Russia's Treasures.* New York: Abbeville Press, 2013.

Shvidkovsky, Dmitry. *The Empress & the Architect: British Architecture and Gardens at the Court of Catherine the Great.* New Haven, CT: Yale University Press, 1996.

Shvidkovsky, Dmitry. *Russian Architecture and the West.* Photographs by Yekaterina Shorban; translated by Antony Wood. New Haven, CT: Yale University Press, 2007.

Siegal, Nina. "In Amsterdam, a Tale of Wars, Friendship and Loves Lost," *The New York Times*, June 17, 2015. http://www.nytimes.com/2015/06/18/arts/international/ alexander-napoleon-josephine-hermitage-amsterdam-a-tale-of-wars-friendship-and- loves-lost.html.

Smith, Douglas, ed. and trans. *Love & Conquest: Personal Correspondence of Catherine the Great and Prince Grigory Potemkin*. DeKalb: Northern Illinois University Press, 2004.

Sokolova, Irina. "The Hermitage: Known and Unknown." Paper presented at the International CODART Symposium, Rijksmuseum Amsterdam, October 14, 2013.

Solodkoff, Alexander von. *Russian Gold and Silver*. Translated by Christopher Holme. London: Trefoil Books, 1981.

Sparke, Cynthia Coleman. *Russian Decorative Arts*. London: Antique Collectors' Club Ltd, 2014.

The State Hermitage Guide, eds. Irina Kharitonova and Irina Lvova (St. Petersburg: P-2 Art Publishers, 2010), 13.

Steegmuller, Francis. *A Woman, a Man and Two Kingdoms*. New York: Knopf, 1991.

Steward, James Christian, and Sergey Androsov. *The Collections of the Romanovs: European Arts from the State Hermitage Museum, St. Petersburg*. London and New York: Merrell, 2003.

Stolyarova, Galina. "Renaissance Man: The Genius of Michelangelo Seen in a New Light." PetersburgCity.com, July 20, 2007. http://petersburgcity.com/news/culture/2007/07/20/David/.

Stuart, Mary. "Creating Culture: The Rossica Collection of the Imperial Public Library and the Construction of National Identity." *Libraries & Culture* 30 (1995): 1–25.

Taplin, Phoebe. "Discover Moscow' Estates and Palaces in All Their Glory." *Russia beyond the Headlines* September 27, 2012. http://www.telegraph.co.uk/sponsored/rbth/features/9570893/moscow-estates-palaces.html.

Tarabra, Daniela. *European Art of the Eighteenth Century*. Translated by Rosanna M. Giammanco Frongia. Los Angeles: The J. Paul Getty Museum, 2008.

Tinker, Chauncey Brewster. *Painter and Poet: Studies in the Literary Relations of English Painting*. Cambridge, MA: Harvard University Press, 1939.

The Treasure Gallery, The State Hermitage Museum App, http://www.hermitageapp.com/en/museum/app/treasure.html, 42.

Troyat, Henri. *Catherine the Great*. Translated by Joan Pinkham. New York: Meridian, 1994.

Tummers, Anna, with contributions by Christopher D. M. Atkins, et al. *Frans Hals: Eye to Eye with Rembrandt, Rubens and Titian*. Rotterdam: Frans Hals Museum; Haarlem: NaioIo Publishers, 2013.

Vasari, Giorgio. *Lives of the Artists*. Translated by George Bull. London and New York: Penguin Books, 1987.

Vaughan, Gerard. "James Hugh Smith Barry as a Collector of Antiquities." *Apollo* 126 (1987): 4–11.

Vernova, Nina, et al. *The Imperial Residences around Saint Petersburg: Peterhof, Tsarskoye Selo, Pavlovsk, Oranienbaum, Gatchina*. Translated by Paul Williams. St. Petersburg: Alfa-Colour Art Publishers, 2003.

Vigée-Le Brun, Elisabeth, *The Memoirs of Elisabeth Vigée-Le Brun*. Translated by Siân Evans. London: Camden Press, 1989.

Vilinbakhov, George, and V. Fedorov. *Catherine the Great: An Enlightened Empress.* Edinburgh: National Museums of Scotland and NMS Enterprises, 2012.

Vilinbakhov, George, and Magnus Olausson. *Catherine the Great & Gustav III.* Stockholm: Nationalmuseum; Saint Petersburg: State Hermitage Museum, 1998.

Vogtherr, Christoph Martin. *Jean de Julienne: Collector and Connoisseur.* London: Wallace Collection, 2011.

Volkov, Solomon. *St. Petersburg: A Cultural History.* Translated by Antonina W. Bouis. New York: Free Press Paperbacks, 1995.

Voltchkova, Tatiana. "The Russian Commissions of Philippe de Lasalle." *CIETA Bulletin* 76 (1999): 115–25.

Vrieze, John, ed. *Catherine, the Empress and the Arts: Treasures from the Hermitage.* Zwolle, Netherlands: Waanders, 1996.

Walker, John. *Self-Portrait with Donors; Confessions of an Art Collector.* Boston: Little, Brown and Company, 1974.

Wallace, William. *Michelangelo: The Complete Sculpture, Painting, Architecture.* Fairfield, CT: Hugh Lauter Levin Associates, 1998.

Wardropper, Ian, ed. *From the Sculptor's Hand: Italian Baroque Terracottas from the State Hermitage Museum.* Chicago: Art Institute of Chicago, 1998.

Weber, Susan, ed. *William Kent: Designing Georgian Britain.* New Haven, CT, and London: Yale University Press, 2013.

Wetering, Ernst van de. *A Corpus of Rembrandt Paintings: A Complete Survey.* Translated and edited by Murray Pearson Springer. Dordrecht, Netherlands: Stichting Foundation, Rembrandt Research Project, Springer: 2015.

Whitehead, John. *Sèvres at the Time of Louis XVI.* Paris: Editions Courtes et Longues, 2010.

Whittaker, Cynthia Hyla, ed. *Russia Engages the World, 1453–1825.* Cambridge, MA: Harvard University Press, 2003.

Wilde, Johannes. *Michelangelo and His Studio: Italian Drawings in the Department of Prints and Drawings in the British Museum.* London: British Museum, 1953.

Wilde, Johannes. *Michelangelo: Six Lectures.* Edited by John Shearman and Michael Hirst. Oxford: Clarendon Press, 1978.

Williams, Robert, ed. *French Drawings and Paintings from the Hermitage: Poussin to Picasso.* London: Thames & Hudson, 2001.

Williams, Robert C. *Russian Art and American Money 1900–1940.* Cambridge, MA: Harvard University Press, 1980.

Winckelmann, Johann Joachim. *History of the Art of Antiquity.* Edited by Alex Potts; translated by Harry Francis Mallgrave. Los Angeles: Getty Research Institute, 2006.

Winik, Jay. *The Great Upheaval: America and the Birth of the Modern World, 1788–1800.* New York: HarperCollins, 2007.

Wolff, Larry. *Inventing Eastern Europe: The Map of Civilization on the Mind of the Enlightenment.* Stanford, CA: Stanford University Press, 1994.

Wortman, Richard S. *Scenarios of Power: Myth and Ceremony in Russian Monarchy,* Vols. 1 & 2. Princeton, NJ: Princeton University Press, 1995.

Wulf, Andrea. *Chasing Venus: The Race to Measure the Heavens*. New York: Alfred A. Knopf, 2012.

Yawein, Oleg. *The Hermitage XXI: The New Art Museum in the General Staff Building*. Edited by Georgi Stanishev with contributions by Mikhail Piotrovsky et al. Photography by Will Pryce. London: Thames & Hudson, 2014.

Young, Hilary. *The Genius of Wedgwood*. London: Victoria & Albert Museum, 1995.

Zamoyski, Adam. *Holy Madness: Romantics, Patriots, and Revolutionaries 1776–1871*. London: Weidenfeld & Nicolson, 1999.

Zamoyski, Adam. *Phantom Terror: Political Paranoia and the Creation of the Modern State, 1789–1848*. New York: Basic Books, 2015.

Zek, Yuri, Yuri Semenov, and Mikhail Guryev. *The Peacock Clock*. St. Petersburg: State Hermitage Publishers, 2011.

Ziskin, Rochelle. *Sheltering Art: Collecting and Social Identity in Early Eighteenth Century Paris*. University Park: Pennsylvania State University Press, 2012.

ENDNOTES

INTRODUCTION

1 Isabella Forbes and William Underhill, eds., *Catherine the Great: Treasures of Imperial Russia from the State Hermitage Museum, St. Petersburg* (London: Booth-Clibborn Editions, 1990), xvii.

2 Nathalie Bondil, ed., *Catherine the Great: Art for Empire, Masterpieces from the State Hermitage Museum* (Montréal: Montréal Museum of Fine Arts; Gand, Belgium: Snoeck, 2005), 169.

3 George Vilinbakhov and Magnus Olausson, eds., *Catherine the Great & Gustav III* (Stockholm: Nationalmuseum, 1998), 397.

4 W. Bruce Lincoln, *Sunlight at Midnight: St. Petersburg and the Rise of Modern Russia* (New York, Basic Books, 2000), 45–46.

PART ONE: EXTREME MAKEOVER
CHAPTER ONE: THIS HEAVY THING

1 Andrea Wulf, *Chasing Venus: The Race to Measure the Heavens* (New York: Knopf Doubleday, 2012), 112.

2 *St. Petersburg Jewelers: 18th–19th centuries, the State Hermitage Museum* (St. Petersburg: Slavia, 2000), 24.

3 Stefano Papi, *Jewels of the Romanovs, Family & Court* (London: Thames & Hudson, 2010), 29–30.

4 Natalya Semyonova and Nicolas V. Iljine, eds., *Selling Russia's Treasures* (Abbeville Press, 2013), 28.

CHAPTER TWO: THE BRIGHTEST STAR OF THE NORTH

1 Robert K. Massie, *Catherine the Great* (New York: Random House, 2011), 274.

2 Ibid., 327.

3 Simon Dixon, *Catherine the Great* (New York: HarperCollins, 2009), 20.

4 Anthony Lentin, *Voltaire and Catherine the Great: Selected Correspondence* (Cambridge, England: Oriental Research Partners, 1974), 10.

5 Ibid., 44.
6 Massie, *Catherine*, 338.
7 Ibid., 465.
8 Lentin, *Voltaire*, 10–12.
9 Ibid., 13.
10 Nathalie Bondil, ed., *Catherine the Great: Art for Empire, Masterpieces from the State Hermitage Museum* (Montréal: Montréal Museum of Fine Arts; Gand, Belgium: Snoeck, 2005), 218.
11 George Vilinbakhov and Magnus Olausson, *Catherine the Great & Gustav III* (Stockholm: Nationalmuseum; Saint Petersburg: State Hermitage Museum, 1998), 97.
12 Isabella Forbes and William Underhill, eds., *Catherine the Great: Treasures of Imperial Russia from the State Hermitage Museum* (London: Booth-Clibborn Editions, 1990), xviii.
13 Troels Anderson, "Vigilius Eriksen in Russia," *Artes: Periodical of the Fine Arts* 1 (1965): 56.
14 Vilinbakhov and Olausson, *Catherine & Gustav*, 98.
15 Bondil, *Art for Empire*, 150.
16 Wolfram Koeppe, *Vienna circa 1780: An Imperial Silver Service Rediscovered* (New Haven, CT: Yale University Press, 2010), 28.
17 Lentin, *Voltaire*, 103.
18 Bondil, *Art for Empire*, 150.
19 Ibid., 152.
20 Ibid., 149.
21 W. Bruce Lincoln, *Sunlight at Midnight: St. Petersburg and the Rise of Modern Russia* (New York: Basic Books, 2000), 88.

CHAPTER THREE: THE AMBROSIA OF ASIA
1 Massie, *Catherine*, 266.
2 Virginia Rounding, *Catherine the Great: Love, Sex, and Power* (London: St Martin's Griffin, 2006), 198.
3 Mark Cruse and Hilde Hoogenboom, trans., *The Memoirs of Catherine the Great* (New York: Modern Library, 2006), xi.
4 Bondil, *Art for Empire*, 218.
5 Forbes and Underhill, *Catherine the Great: Treasures*, xviii.
6 *The Imperial Residences around St. Petersburg* (St. Petersburg: Alfa-Colour Art Publishers, 2003), 191.
7 David Porter, "Chinoiserie and the Aesthetics of Illegitimacy," *Studies in Eighteenth-Century Culture*, 28 (1999): 27.
8 Maria Menshikova and Jet Pijzel-Dommisse, *Silver Wonders from the East: Filigree of the Tsars* (Amsterdam: Lord Humphries, 2006), 51.
9 Will Black, *The Chinese Palace at Oranienbaum* (Boston and London: Bunker Hill Publishing, 2003), 7.

CHAPTER FOUR: COLLECTING DEBUT
1 Giles MacDonogh, *Frederick the Great: A Life in Deed and Letters* (New York: St. Martin's Griffin, 1999), 236.
2 Helmut Börsch-Supan, "History's Melody— Nature's Rhythm," in *Sanssouci*, ed. Gerhard Ullmann (Berlin: Propylaen Verlag, 1993), 132.
3 Bondil, *Art for Empire*, 21.
4 Massie, *Catherine*, 202.

5 Christopher D. M. Atkins, *The Signature Style of Frans Hals* (Amsterdam: Amsterdam University Press, 2012), 25.
6 Natalya Guseva and Catherine Philips, eds., *Treasures of Catherine the Great: Hermitage Rooms at Somerset House* (London: Christie's International Media Division, 2000), 24.
7 Vilinbakhov and Olausson, *Catherine & Gustav*, 397.
8 Ibid.

CHAPTER FIVE: BUILDING FRENZY
1 Oleg Yawein et al., *The Hermitage XXI: The New Art Museum in the General Staff Building* (London: Thames & Hudson, 2014), 23.
2 Forbes and Underhill, *Catherine the Great: Treasures*, 180.
3 George Vilinbakhov and V. Fedorov, *Catherine the Great: An Enlightened Empress* (National Museums Scotland and State Hermitage Museum; Edinburgh: NMS Enterprises, 2012), 57.
4 Rosalind Polly Gray, *Russian Genre Painting in the Nineteenth Century* (Oxford: Oxford University Press, 2000), 1.
5 Vilinbakhov and Fedorov, *An Enlightened Empress*, 56.
6 William Coxe, *Travels into Poland, Russia, Sweden, and Denmark* (London: T. Cadell, 1784), 193–94.
7 Katia Dianina, "Art and Authority: The Hermitage of Catherine the Great," *Russian Review* 63 (2004): 648.
8 Vladimir Matveyev, *The Hermitage: Selected Treasures from a Great Museum* (Booth-Clibborn Editions: 1996), 13.
9 Natalya Guseva, "Catherine's Apartments in her Imperial Palaces," *The British Art Journal* 2 (2000/2001): 106.
10 Guseva and Philips, *Treasures of Catherine the Great*, 17.

CHAPTER SIX: MY FALCON, MY GOLDEN PHEASANT
1 Palace and Gatchina Park documents, letters, and memoirs (1712–1801) (St. Petersburg, 2006) 26, 28.
2 George Heard Hamilton, *The Art and Architecture of Russia* (New York: Penguin Books, 1975), 201.
3 Coxe, *Travels*, 311.
4 Forbes and Underhill, *Catherine the Great: Treasures*, 181.
5 Massie, *Catherine*, 321.
6 Simon Sebag Montefiore, *Potemkin: Prince of Princes* (London: Phoenix Press, 2000), 101.
7 Massie, *Catherine*, 316.

PART TWO: RUSSIA IS A EUROPEAN NATION
CHAPTER ONE: A MONUMENT TO PETER AND TO YOU
1 John Vrieze, ed., *Catherine, the Empress and the Arts* (Zwolle: Waanders, 1996), 9.
2 Alexander M. Schenker, *The Bronze Horseman, Falconet's Monument to Peter the Great* (New Haven, CT: Yale University Press, 2003), 100.
3 Ilse Bischoff, "Etienne-Maurice Falconet— Sculptor of the Statue of Peter the Great," *Russian Review*, 24 (1965), 372.
4 George Levitine, *The Sculpture of Falconet* (New York Graphic Society Ltd, 1972), 15.
5 John Goodman, trans., *Diderot on Art, The Salons of 1765 and Notes on Painting* (New Haven, CT: Yale University Press, 1995), 163–64.

6 Bischoff, "Etienne-Maurice Falconet," 376.

7 Ibid.

8 Schenker, *Bronze Horseman*, 101.

9 Bischoff, "Etienne-Maurice Falconet," 378–79.

10 Ibid., 377.

11 Robert K. Massie, *Catherine the Great* (New York: Random House, 2011), 529.

12 Schenker, *Bronze Horseman*, 58.

13 H. N. Opperman, "Marie-Anne Collot in Russia: Two Portraits," *Burlington Magazine* 107 (1965): 412.

14 Christiane Dellac, *Marie-Anne Collot: Une sculptrice francaise a la cour de Catherine II* (Paris: L'Harmattan, 2005), 38.

15 Ibid., 37.

CHAPTER TWO: MAKE PEACE WITH YOUR ENEMY

1 John T. Alexander, *Catherine the Great: Life and Legend* (Oxford: Oxford University Press, 1989), 107.

2 Frank T. Brechka, "Catherine the Great: The Books She Read," *The Journal of Library History* 4 (1969): 43.

3 Schenker, *Bronze Horseman*, 46.

4 Bischoff, "Etienne-Maurice Falconet," 378.

5 Schenker, *Bronze Horseman*, 219.

6 Ibid., 280.

7 Ibid., 279.

8 Ibid., 130.

9 Ibid., 281.

10 Opperman, "Marie-Anne Collot in Russia," 412.

11 Bischoff, "Etienne-Maurice Falconet," 378.

CHAPTER THREE: MY PRODIGAL SON

1 Christoph Martin Vogtherr, *Jean de Julienne: Collector and Connoisseur* (London: The Wallace Collection, 2011), 40.

2 Goodman, *Diderot on Art*, 22.

3 Irina Kuznetsova, *From Poussin to Matisse: The Russian Taste for French Painting* (Chicago: The Art Institute of Chicago; New York: The Metropolitan Museum of Art and Harry N. Abrams, Inc., 1990), 56.

4 Charles Isaac Elton and Mary Augusta Elton, *The Great Book Collectors* (London: Kegan Paul, Trench, Trübner & Co., Ltd., 1893), 153.

5 Joanna Pittman, *The Dragon's Tail: The Biography of Raphael's Masterpiece* (Simon & Schuster, 2006), 190.

6 Simon Dixon. *Catherine the Great* (New York: HarperCollins, 2009), 194.

CHAPTER FOUR: THE SAXON RICHELIEU

1 Natalya Semyonova and Nicolas V. Iljine, eds., *Selling Russia's Treasures* (New York: Abbeville Press, 2013), 350.

2 Oleg Neverov and Dmitry Alexinsky, *The Hermitage Collections: Treasures of World Art* (New York: Rizzoli; St. Petersburg: ARCA Publishers, 2010), 18.

3 James R. Gaines, *Evening in the Palace of Reason* (New York: HarperCollins, 2005), 72.

4 Tobias Burg, "Works by Chardin in the Collection of Count Heinrich von Brühl," *Burlington Magazine* 150 (2008): 533.

5 Carolin C. Young, *Apples of Gold in Settings of Silver: Stories of Dinner as a Work of Art* (Simon & Schuster, 2002), 156.

6 Tessa Murdoch and Heike Zech, eds., *Going for Gold: Craftsmanship and Collecting of Gold Boxes* (Sussex Academic Press, 2013), 186.

7 Pierre Gaxotte, *Frederick the Great*, trans. R. A. Bell (London: G. Bell and Sons, 1941), 271.

8 Young, *Apples of Gold*, 150–51.

9 Ibid., 153.

10 Ibid., 156.

11 Johann Heinrich Gottlob von Justi, "The life and character, rise and conduct, of Count Bruhl, prime minister to the king of Poland, elector of Saxony" (London: n.p., 1761), 16.

12 Murdoch and Zech, *Going for Gold*, 187.

13 Antonio Mazzotta, *Titian: A Fresh Look at Nature* (London: National Gallery Company, 2012), 13.

14 Ibid., 30.

15 *Rubens and His Age: Treasures from the Hermitage Museum, Russia* (Art Gallery of Ontario, Merrell, 2001), 34.

CHAPTER FIVE: THE EARTH AND SEA TREMBLED

1 Nathalie Bondil, ed., *Catherine the Great: Art for Empire, Masterpieces from the State Hermitage Museum* (Montréal: Montréal Museum of Fine Arts; Gand, Belgium: Snoeck, 2005), 173.

2 Virginia Rounding, *Catherine the Great: Love, Sex, and Power* (London: St Martin's Griffin, 2006), 223.

3 Ibid., 228.

4 Irina Artemieva, "The Sources of Italian Renaissance Paintings in the Hermitage," in *Florence and Venice: Italian Renaissance Paintings and Sculpture from the State Hermitage Museum*, ed. Kokuritsu Seiyo Bijutsukan (Tokyo: National Museum of Western Art, 1999), 242.

5 Emma Barker, "Mme Geoffrin, Painting and Galanterie: Carle Van Loo's 'Conversation Espagnole' and 'Lecture Espagnole,'" *Eighteenth-Century Studies*, 40 (2007): 604.

6 Rounding, *Catherine*, 231.

7 Anthony Lentin, ed. and trans. *Voltaire and Catherine the Great: Selected Correspondence* (Cambridge, UK: Oriental Research Partners, 1974), 116.

8 W. Bruce Lincoln, *Sunlight at Midnight: St. Petersburg and the Rise of Modern Russia* (New York: Basic Books, 2000), 141.

9 Neverov and Alexinsky, *Treasures of World Art*, 19.

PART THREE: WAR AND LOVE
CHAPTER ONE: QUEEN OF FEASTS

1 Virginia Rounding, *Catherine the Great: Love, Sex, and Power* (London: St Martin's Griffin, 2006), 225–26.

2 Anthony Lentin, ed. and trans., *Voltaire and Catherine the Great: Selected Correspondence* (Cambridge, UK: Oriental Research Partners, 1974), 93.

3 Diana Scarisbrick, Sotheby's 2005 catalogue note, http://www.jewelsdujour.com/2013/04/a-highly-important-bow-necklace-from-the-collection-of-the-russian-imperial-family/.

4 Alexei Denisov, "Monarchs' Menu: Feasts Fit for Russian Tsars and Emperors," *Russian beyond the Headlines*, July 9, 2014. http://rbth.com/arts/2014/07/09/monarchs_menu_feasts_fit_for_russian_tsars_and_emperors_38051.html.

5 Mikhail B. Piotrovsky, et al., *Dining with the Tsars: Fragile Beauty from the Hermitage* (Amsterdam: Hermitage Amsterdam, 2014), 14.

6 Isabel de Madariaga, *Russia in the Age of Catherine the Great* (London: Phoenix Press, 2002), 573.

7 Denisov, "Monarchs' menu."

8 Piotrovsky, *Dining with the Tsars*, 29.

9 Ibid.

10 Ibid., 30.

11 Wolfram Koeppe, *Vienna circa 1780: An Imperial Silver Service Rediscovered* (New Haven, CT: Yale University Press, 2010), 7.

12 Ibid.

13 Clare Le Corbeiller, "Grace and Favor," *Metropolitan Museum of Art Bulletin* 27 (1969): 289.

14 Ibid., 290.

15 Ibid., 292.

16 Nathalie Bondil, ed., *Catherine the Great: Art for Empire, Masterpieces from the State Hermitage Museum.* (Montréal: Montréal Museum of Fine Arts; Gand, Belgium: Snoeck, 2005), 173.

17 Jannic Durand, ed., *Decorative Furnishings and Objects d'Art in the Louvre from Louis XIV to Marie Antoinette* (Paris: Louvre éditions, 2014), 496.

18 Howard Coutts and Ivan Day, "Sugar Sculpture, Porcelain and Table Layout 1530–1830" (paper presented at the Taking Shape talk series at the Henry Moore Institute, Leeds, England, October, 2008).

19 George Vilinbakhov and Magnus Olausson, *Catherine the Great & Gustav III* (Stockholm: Nationalmuseum; Saint Petersburg: State Hermitage Museum, 1998), 135.

CHAPTER TWO: DRESSED TO "EMPRESS"

1 V. N. Golovine, *Memoirs of Countess Golovine: A Lady at the Court of Catherine II*, trans. G. M. Fox-Davies (London: David Nutt, 1910), 38.

2 François Boucher, *20,000 Years of Fashion: The History of Costume and Personal Adornment* (New York: Abrams, 1967), 329.

3 Svetlana A. Amelëkhina and Alexey K. Levykin, *Magnificence of the Tsars* (London: Victoria & Albert Publishing, 2009), 16.

4 Christine Ruane, *The Empire's New Clothes: A History of the Russian Fashion Industry, 1700–1917* (New Haven, CT: Yale University Press, 2009), 152.

5 T. T. Korshunova, "Secular Dress," State Hermitage Museum, http://www.hermitage museum.org.html.

6 Kimberly Chrisman-Campbell, *Fashion Victims: Dress at the Court of Louis XVI and Marie-Antoinette* (New Haven, CT: Yale University Press, 2015), 317.

7 Olga G. Kostjuk, *Gold of the Tsars: 100 Masterpieces of the Hermitage, St. Petersburg* (Stuttgart, Germany: Fritz Falk Arnoldsche, 1995), 21.

8 Richard S. Wortman, *Scenarios of Power*, Vol. 1 (Princeton, NJ: Princeton University Press, 1995), 136.

9 *St. Petersburg Jewellers: 18th and 19th Centuries.* (St. Petersburg: Slavia, 2000), 24.

10 Alexander von Solodkoff, *Russian Gold and Silver*, trans. Christopher Holme (London: Trefoil Books, 1981), 32.

11 *The Treasure Gallery*, The State Hermitage Museum App, http://www.hermitageapp.com/en/museum/app/treasure.html, 42.

12 Diana Scarisbrick, Sotheby's 2005 catalogue note, http://www.jewelsdujour.com/2013/04/a-highly-important-bow-necklace-from-the-collection-of-the-russian-imperial-family/.

13 von Solodkoff, *Russian Gold and Silver*, 70.

14 Rosalind Savill, "Cameo Fever: Six Pieces from the Sèvres Porcelain Dinner Service Made for Catherine II of Russia," *Apollo*, 116 (1982): 309.

15 Charles Truman, *The Gilbert Collection of Gold Boxes* (Los Angeles: Los Angeles County Museum of Art, 1991), 363.

16 Scarisbrick, Sotheby's 2005 catalogue note.

17 Diana Scarisbrick, *Portrait Jewels* (London: Thames & Hudson, 2011), 222.

18 Tessa Murdoch and Heike Zech, eds., *Going for Gold: Craftsmanship and Collecting of Gold Boxes* (Eastbourne, UK: Sussex Academic Press, 2013), 127.

19 von Solodkoff, *Russian Gold and Silver*, 157.

20 Bondil, *Art for Empire*, 38.

21 Vilinbikhov and Olausson, *Catherine & Gustav*, 135.

CHAPTER THREE: PEACE OFFERINGS

1 Rounding, *Catherine*, 235.

2 Merridale, *Red Fortress*, 195.

3 Rounding, *Catherine*, 239.

4 Ibid., 241.

5 Montefiore, *Prince*, 77.

CHAPTER FOUR: CROZAT THE POOR

1 Ian McIntyre, *Joshua Reynolds: The Life and Times* (London: Allen Lane, 2003), 228.

2 Joanna Pitman, *The Dragon's Trail: The Biography of Raphael's Masterpiece* (Simon & Schuster, 2006), 192.

3 Lentin, *Voltaire*, 131.

4 Pitman, *Dragon's Trail*, 151.

5 Thomas E. Crow, *Painters and Public Life in Eighteenth-Century Paris* (New Haven, CT: Yale University Press, 1985), 40.

6 Barbara Scott, "Pierre Crozat: a Maecenas of the Regence," *Apollo* 97 (1973): 16.

7 Ibid.

8 Rochelle Ziskin, *Sheltering Art: Collecting and Social Identity in Early Eighteenth Century Paris* (University Park: Pennsylvania State University Press, 2012), 24.

9 Susannah Kathleen Rutherglen, "Ornamental Paintings of the Venetian Renaissance" (PhD diss., Princeton University, 2012), 322.

10 Bernard Berenson, *The Study and Criticism of Italian Art* (London: George Bell & Sons, 1901), 89.

11 Berenson, *Study and Criticism*, 76.

12 Rutherglen, "Ornamental Paintings," 133.

CHAPTER FIVE: THE COACHMAN OF EUROPE

1 Bondil, *Art for Empire*, 6.

2 Lentin, *Voltaire*, 22.

3 F. J. B. Watson, "The Choiseul Boxes," in *18th Century Gold Boxes of Europe*, ed. Kenneth Snowman (Boston: Boston Book and Art Shop, 1966), 146.

4 Selma Schwartz and Pippa Shirley, eds., *The Duc de Choiseul: Essays in Honour of Mrs. Charles*

Wrightsman: Waddesdon Miscellanea, vol. 1. (Waddesdon, UK: The Alice Trust, Waddesdon Manor, 2009), 20.

5 Ibid., 72.

6 Rohan Butler, *Choiseul Volume I: Father and Son; 1719-1754* (Oxford: Clarendon Press, 1980), 797.

7 Barbara Scott, "The duc de Choiseul: A Minister in the Grand Manner," *Apollo* 97 (1973): 44.

8 Lentin, *Voltaire*, 22.

9 Emma Barker, "Imaging Childhood in Eighteenth-Century France: Greuze's Little Girls with a Dog," *The Art Bulletin* 91 (2009): 437.

10 Emile Dacier, "Choiseul as a Collector," *Gazette des Beaux-Arts* 36 (1949): 155.

11 Natalya Semyonova and Nicolas V. Iljine, eds., *Selling Russia's Treasures* (New York: Abbeville Press, 2013), 350.

12 Natalya Babina, *Flemings through the Eyes of David Teniers the Younger* (St. Petersburg: State Hermitage Museum Publishers, 2010), 107.

13 Pierre Cabanne, *The Great Collectors* (London: Cassell, 1963), 11.

CHAPTER SIX: TIGER IN THE FOREST

1 Jay Winik, *The Great Upheaval: America and the Birth of the Modern World* (New York: HarperCollins, 2007), 345.

2 Stefano Papi, *Jewels of the Romanovs, Family & Court* (London: Thames & Hudson, 2010), 33–34.

3 Ian Balfour, *Famous Diamonds* (New York: Christie's Books, 1997), 195.

4 Marcia Pointon, *Brilliant Effects: A Cultural History of Gem Stones & Jewellery* (New Haven, CT: Yale University Press), 159.

5 Rounding, *Catherine*, 228.

6 Francis Steegmuller, *A Woman, a Man and Two Kingdoms* (New York: Knopf, 1991), 27.

7 G. P. Gooch, "*Catherine the Great* and Grimm," *The Contemporary Review* 182 (1952): 358.

8 Larry Wolff, *Inventing Eastern Europe: The Map of Civilization on the Mind of the Enlightenment* (Stanford, CA: Stanford University Press, 1994), 225.

9 Bondil, *Art for Empire*, 21.

10 Brian Grosskurth, "Shifting Monuments: Falconet's Peter the Great between Diderot and Eisenstein," *Oxford Art Journal* 23 (2000): 29.

11 Wolff, *Inventing Eastern Europe*, 228.

12 Malcolm Bradbury, *To the Hermitage* (New York: The Overlook Press, 2002), 451–52.

13 Wolff, *Inventing Eastern Europe*, 230.

PART FOUR: PEACE AND PROSPERITY

CHAPTER ONE: SLEEPLESS NIGHTS

1 Douglas Smith, ed. and trans., *Love & Conquest: Personal Correspondence of Catherine the Great and Prince Grigory Potemkin* (DeKalb: Northern Illinois University Press, 2004), 8.

2 Virginia Rounding, *Catherine the Great: Love, Sex, and Power* (London: St Martin's Griffin, 2006), 273.

3 Oleg Neverov, *Great Private Collections of Imperial Russia* (London and New York: Thames & Hudson, 2004), 76.

4 Rounding, *Catherine*, 275.

5 Smith, *Love*, 10.

6 Rounding, *Catherine*, 274.

7 Robert K. Massie, *Catherine the Great* (New York: Random House, 2011), 416.

8 Smith, *Love*, xxxvii.

9 Simon Sebag Montefiore, *The Prince of Princes: The Life of Potemkin* (London: Weidenfeld & Nicolson, 2000), 153.

10 Jay Winik, *The Great Upheaval: America and the Birth of the Modern World, 1788-1800* (New York: HarperCollins, 2007), 347.

11 Ibid., 351.

12 Montefiore, *Prince*, 157.

13 Ibid., 159.

14 George Vilinbakhov and V. Fedorov, *Catherine the Great: An Enlightened Empress* (Edinburgh: National Museums of Scotland and NMS Enterprises, 2012), 139.

CHAPTER TWO: ANGLOMANIA

1 Brian Dolan, *Josiah Wedgwood: Entrepreneur to the Enlightenment* (London: HarperCollins, 2004), 268.

2 Ibid., 266.

3 Ibid.

4 Brian Allen and Larissa Dukelskaya, eds., *British Art Treasures from Russian Imperial Collections in the Hermitage* (New Haven, CT: Yale University Press, 1996), 119.

5 Hilary Young, *The Genius of Wedgwood* (London: Victoria & Albert Museum, 1995), 139.

6 N. McKendrick, "Josiah Wedgwood: An Eighteenth-Century Entrepreneur in Salesmanship and Marketing Techniques," *The Economic History Review*, new series, 12 (1960): 433.

7 Allen and Dukelskaya, *British Art Treasures*, 121.

8 Peter Hayden, "British Seats on Imperial Russian Tables," *Garden History* 13 (1985): 18–19.

9 Asen Kirin, *Exuberance of Meaning: The Art Patronage of Catherine the Great (1762–1796)* (Athens, GA: Georgia Museum of Art, University of Georgia, 2013), 285.

10 Young, *Genius*, 208.

11 Ibid.

12 Alexander Orloff and Dmitri Shvidkovsky, *St. Petersburg: Architecture of the Tsars* (New York: Abbeville Press, 1996), 94.

CHAPTER THREE: A CROWD AND NOT A CITY

1 Catherine Merridale, *Red Fortress: History and Illusion in the Kremlin* (London: Picador, 2013), 189.

2 Ibid., 190.

3 John T. Alexander, *Catherine the Great: Life and Legend* (Oxford: Oxford University Press, 1989), 116.

4 Merridale, *Red Fortress*, 195.

5 Ibid., 181.

6 Ibid., 192.

7 Ibid.

8 Simon Dixon, *Catherine the Great* (New York: HarperCollins, 2009), 170.

9 Vilinbakhov and Fedorov, *Enlightened Empress*, 57.

10 Hugh Ragsdale, *Tsar Paul and the Question of Madness* (Santa Barbara, CA: Greenwood Press, 1988), 6.

11 Vilinbahkhov and Fedrov, *Enlightened Empress*, 214.
12 Phoebe Taplin, "Discover Moscow's Estates and Palaces in All Their Glory," *Russia beyond the Headlines*, September 27, 2012, http://www.telegraph.co.uk/sponsored/rbth/features/9570893/moscow-estates-palaces.html.
13 Montefiore, *Prince*, 155.
14 Rounding, *Catherine*, 412.
15 Merridale, *Red Fortress*, 213.
16 Dixon, *Catherine*, 213.

CHAPTER FOUR: BREAKING THE MOLD
1 Isabella Forbes and William Underhill, eds., *Catherine the Great: Treasures of Imperial Russia from the State Hermitage Museum* (London: Booth-Clibborn Editions, 1990), xviii.
2 Rounding, *Catherine*, 325.
3 Rosalind Savill, "Cameo Fever: Six Pieces from the Sèvres Porcelain Dinner Service Made for Catherine II of Russia," *Apollo* 116 (1982): 304.
4 Ibid., 306.
5 John Whitehead, *Sèvres at the Time of Louis XVI* (Paris: Editions Courtes et Longues, 2010), 136.
6 Ibid., 110.
7 Ibid., 84.
8 Montefiore, *Prince*, 170.
9 Ibid., 166.
10 Alexander, *Catherine*, 160.
11 Ibid., 346.
12 Ibid., 169.
13 Teresa Levonian Cole, "St. Petersburg: the Cats of the Hermitage," *Telegraph*, May 23, 2013.

CHAPTER FIVE: BROTHER GU
1 George Vilinbakhov and Magnus Olausson, *Catherine the Great & Gustav III* (Stockholm: Nationalmuseum; St. Petersburg: State Hermitage Museum, 1998), 54.
2 Ibid., 156.
3 Ibid., 55.
4 Ibid., 53.
5 Ibid., 20.
6 Rounding, *Catherine*, 320.
7 Neverov, *Great Private Collections*, 22.
8 Dixon, *Catherine*, 260.

CHAPTER SIX: CATEAU AND THE HERMIT OF FERNEY
1 Lentin, *Voltaire*, 31.
2 Dena Goodman, "Pigalle's *Voltaire* nu: The Republic of Letters Represents Itself to the World," *Representations* 16 (1986): 99.
3 Guilhem Scherf, *Houdon at the Louvre: Masterworks of the Enlightenment* (Paris: Musee du Louvre Editions, 2008), 48.
4 Ibid., 50.
5 Anne L. Poulet, ed., *Jean-Antoine Houdon, Sculptor of the Enlightenment* (Washington, DC: National Gallery of Art; Chicago: University of Chicago Press, 2003), 163.

6 Ibid., 165.
7 Ibid., 164.
8 H. H. Arnason, *The Sculptures of Houdon* (Oxford: Oxford University Press, 1975), 50.
9 Poulet, *Houdon*, 51.
10 Henri Troyat, *Catherine the Great*, trans., Joan Pinkham (New York: Meridian, 1994), 226.
11 Montefiore, *Prince*, 171.
12 Ibid., 355.
13 Ibid., 189.

PART FIVE: A SECOND ROME
CHAPTER ONE: CAT AND MOUSE

1 *Houghton Revisited: The Walpole Masterpieces from Catherine the Great's Hermitage* (London: Royal Academy of Arts, 2013), 29.
2 Wilmarth Sheldon Lewis, *Horace Walpole* (New York: Pantheon Books, 1961), 16.
3 Susan Jenkins, "Power Play: James Brydges, 1st Duke of Chandos, and Sir Robert Walpole: The Politics of Collecting in the Early 18th Century," *The British Art Journal* 4 (2003): 82.
4 *Houghton Revisited*, 154.
5 Ibid., 124.
6 Andrew Moore and Larissa Dukelskaya, eds., *A Capital Collection: Houghton Hall and the Hermitage* (New Haven, CT: Yale University Press, 2002), 38.
7 Ibid.
8 Ibid., 59.
9 Andrew Moore, *Norfolk and the Grand Tour* (Norwich, UK: Norfolk Museums Service, 1985), 49.
10 Ibid., 60.
11 *Houghton Revisited*, 31.
12 Ibid., 43.
13 Morris R. Brownell, *The Prime Minister of Taste: A Portrait of Horace Walpole* (New Haven, CT: Yale University Press 2001), 65.
14 David Cholmondeley and Andrew Moore, *Houghton Hall: Portrait of an English Country House* (New York: Skira Rizzoli, 2014), 126.
15 Giovan Pietro Bellori, *The Lives of the Modern Painters, Sculptors, and Architects: A New Translation and Critical Edition*, trans. Alice Sedgwick Wohl (New York: Cambridge University Press, 2005), 215.
16 Natalya Gritsay, "Rubens and His Followers," in *Rubens and His Age: Treasures from the Hermitage Museum, Russia*, ed. Christina Corsiglia (London: Merrell in association with Art Gallery of Ontario, 2001), 35.
17 Emilie Gordenker, "Aspects of Costume in Van Dyck's English Portraits," in *Van Dyck 1599–1999: Conjectures and Refutations*, ed. Hans Vlieghe (Turnhout, Belgium: Brepols, 2001), 223.
18 Karen Hearn, ed., *Van Dyck & Britain* (London: Tate Publishing, 2009), 72.
19 Natalya Gritsay, *Anthony van Dyck* (St. Petersburg: Aurora Art Publishers, 1996), 132.
20 Mikhail B. Piotrovsky, *The Hermitage: 250 Masterworks* (New York: Skira Rizzoli, 2014), 133.
21 Moore, *A Capital Collection*, 76.
22 Ibid., 76.
23 Anthony Cross, *Catherine the Great and the British* (Nottingham, England: Astra Press, 2001), 18.
24 Moore and Dukelskaya, *A Capital Collection*, 74.

CHAPTER TWO: RAPHAELISM

1 Virginia Rounding, *Catherine the Great: Love, Sex, and Power* (London: St Martin's Griffin, 2006), 332.

2 Oleg Neverov, *Great Private Collections of Imperial Russia* (London and New York: Thames & Hudson, 2004), 23.

3 Nathalie Bondil, ed., *Catherine the Great: Art for Empire, Masterpieces from the State Hermitage Museum* (Montréal: Montréal Museum of Fine Arts; Gand, Belgium: Snoeck, 2005), 201.

4 Nicole Dacos, *The Loggia of Raphael: A Vatican Art Treasure* (New York: Abbeville Press, 2008), 322

5 Dimitri Ozerov, "Catherine II et les Loges de Volpato," in *Giovanni Volpato: Les loges de Raphaël l et la galerie du Palais Farnèseed*, ed. Annie Gilet (Milan: Silvana; Tours: Musée des beaux-arts, 2007), 81.

6 Giorgio Vasari, *Lives of the Artists*, trans. George Bull (London and New York: Penguin Books, 1987), 219.

7 Dacos, *Loggia*, 199.

8 Tom Henry and Paul Joannides, eds., *Late Raphael* (Madrid: Museo Nacional del Prado, 2012), 34–35.

9 Una Roman D'Elia, "Grotesque Painting and Painting as Grotesque in the Renaissance," *Notes in the History of Art* 33 (2014): 5.

10 Dacos, *Loggia*, 15.

11 Chiara Felicetti, Maria Barbara, and Guerrieri Borsoi, *Cristoforo Unterperger: Un Pittore Fiemmese Nell'Europa del Settecento* (Rome: Edizioni de Luca, 1999), 189.

12 Ibid.

13 W. P. Cresson, *Francis Dana: A Puritan Diplomat at the Court of Catherine the Great* (New York: L. MacVeagh, The Dial Press; Toronto: Longmans, Green & Co., 1930), 111.

14 Joana Pitman, *The Dragon's Trail: The Biography of Raphael's Masterpiece* (New York: Simon & Schuster, 2006), 201.

CHAPTER THREE: SASHENKA

1 Robert K. Massie, *Catherine the Great* (New York: Random House, 2011), 454.

2 Douglas Smith, ed. and trans., *Love and Conquest: Personal Correspondence of Catherine the Great and Prince Grigory Potemkin* (DeKalb: Northern Illinois University Press, 2004), xli.

3 Neverov, *Great Private Collections*, 79–80.

4 Rounding, *Catherine*, 50.

5 Catherine, Empress of Russia, *Letters from Empress Catherine II to Grimm* (1774–1796) (St. Petersburg: Anthology of the Imperial Russian Historical Society, 1878), 76–77.

6 Pierre Cabanne, *The Great Collectors* (London: Cassell, 1963), 15.

7 Neverov, *Great Private Collections*, 80.

8 Rudolf Ekkart and Quentin Buvelot, *Dutch Portraits: The Age of Rembrandt and Frans Hals*, trans. Beverly Jackson (Zwolle, Netherlands: Waanders Publishers; Royal Picture Gallery Mauritshuis; National Gallery Company, 2007), 212.

9 Jonathan Bikker and Gregor Weber, *Rembrandt: The Late Works* (New Haven, CT: Yale University Press, 2014), 13.

10 Simon Schama, "Simon Schama on Rembrandt's late works," *Financial Times*, October 17, 2014.

11 Piotrovsky, *250 Masterworks*, 141.

12 Ernst van de Wetering, *A Corpus of Rembrandt Paintings: A Complete Survey*, trans. and ed. Murray Pearson Springer (Dordrecht, Netherlands: Stichting Foundation, Rembrandt Research Project, Springer, 2015), 636.

13 Jeremias de Dekker, "An Expression of Gratitude to the Excellent and Widely Renowned Rembrandt van Rijn," in *Lof der Geldsucht ofte Vervolg der Mijmoeffeningen*, trans. Benjamin Binstock (Amsterdam, 1667), www.learn.columbia.edu/monographs/remmon/pdf/art_hum_reading_32.pdf.

14 Maria Dolores Sanchez-Jauregui and Scott Wilcox, *The English Prize: The Capture of the Westmorland* (New Haven, CT: Yale University Press, 2012), 173.

15 Ibid., 101.

16 Ibid., 102.

17 Olga Neverov and Dmitry Pavlovich Alexinsky, *The Hermitage Collections: Volume I: Treasures of World Art* (New York: Rizzoli, 2010), 26.

18 Johann Joachim Winckelmann, *History of the Art of Antiquity*, ed. Alex Potts, trans. Harry Francis Mallgrave (Los Angeles: Getty Research Institute, 2006), 213.

19 Rounding, *Catherine*, 357.

20 Simon Dixon, *Catherine the Great* (New York: HarperCollins, 2009), 261.

21 John Vrieze, ed., *Catherine, the Empress and the Arts: Treasures from the Hermitage* (Zwolle, Netherlands: Waanders, 1996), 157.

22 V. F. Levinson-Lessing, ed., *The Hermitage Leningrad: Medieval & Renaissance Masters* (London: Paul Hamlyn, 1967), vii.

23 Dixon, *Catherine*, 262.

24 Rounding, *Catherine*, 358.

CHAPTER FOUR: PALLADIO'S SHADOW

1 Jay Winik, *The Great Upheaval: America and the Birth of the Modern World, 1788–1800* (New York: HarperCollins, 2007), 432.

2 Tamara Talbot Rice, *Charles Cameron c. 1740–1812 Architectural Drawings and Photographs from the Hermitage Collection, Leningrad and Architectural Museum, Moscow* (Moscow: The Arts Council, 1967), 7.

3 Dmitry Shvidkovsky, *Russian Architecture and the West* (New Haven, CT: Yale University Press, 2007), 254.

4 Geraldine Norman, *The Hermitage: The Biography of a Great Museum* (London: Pimlico, 1997), 39.

5 Guido Beltramini and Howard Burns, eds., *Palladio* (London: Royal Academy of Arts, 2008), 376.

6 Shvidkovsky, *Russian Architecture*, 257.

CHAPTER FIVE: THE GREEK PROJECT

1 Ibid.

2 Ibid., 258.

3 Frank Salmon, "Charles Cameron and Nero's Domus Aurea: 'una piccolo esplorazione,'" *Architectural History* 36 (1993): 78.

4 Shvidkovsky, *Russian Architecture*, 241.

5 Tatiana Voltchkova, "The Russian Commissions of Philippe de Lasalle," *CIETA Bulletin* 76 (1999): 121.

6 Isobel Rae, *Charles Cameron: Architect to the Court of Russia* (London: Elek Books, 1971), 46.

7 John Goldsmith Phillips, "A Silk Portrait of Catherine the Great," *Metropolitan Museum of Art Bulletin* 36 (1941): 152.

8 Emmanuel Ducamp, ed., *Summer Palaces of the Romanovs: Treasures from Tsarskoye Selo*, trans.

Barbara Mellor, photography by Marc Walter (New York and London: Thames & Hudson, 2012), 14.

9 Dimitri Shvidkovsky, *The Empress & the Architect* (New Haven, CT, and London: Yale University Press, 1996), 45.

10 Ancient Rome, The State Hermitage Museum App, http://www.hermitageapp.com/en/museum/app/rome.html, 8.

11 Ducamp, *The Summer Palaces*, 164.

12 Anthony Cross, *By the Banks of the Neva: Chapters from the Lives and Careers of the British in Eighteenth-Century Russia* (Cambridge: Cambridge University Press, 1997), 289.

13 SIRIO (Collection of the Imperial Russian Historical Society), 23 (St. Petersburg: 1878), 313.

14 Dixon, *Catherine*, 259.

15 Shvidkovsky, *The Empress & the Architect*, 46.

16 Philip Mansel, *Prince of Europe: The Life of Charles-Joseph De Ligne* (London: Phoenix, 2003), 102.

17 Hugh Ragsdale, "Evaluating the Traditions of Russian Aggression: Catherine II and the Greek Project," *The Slavonic and East European Review* 66 (1988): 93.

18 Shvidkovsky, *Russian Architecture*, 259.

19 Ibid.

20 George E. Munro, "Catherine Discovers St. Petersburg," *Jahrbucher fur Geschichte Osteuropas, Neue Folge*, Bd. 56 (2008): 332.

PART SIX: EMPIRE BUILDING
CHAPTER ONE: MOTHER OF THE FATHERLAND

1 George Levitine, *The Sculpture of Falconet* (New York: New York Graphic Society Ltd., 1972), 20.

2 Ilse Bischoff, "Etienne-Maurice Falconet: Sculptor of the Statue of Peter the Great," *Russian Review* 24 (1965): 385.

3 Anne L. Poulet, *Jean-Antoine Houdon: Sculptor of the Enlightenment* (Washington, DC: National Gallery of Art; Chicago and London: University of Chicago Press, 2003), 56.

4 Ibid., 58.

5 Simon Sebag Montefiore, *The Prince of Princes: The Life of Potemkin* (London: Weidenfeld & Nicolson, 2000), 356.

6 Henri Troyat, *Catherine the Great*, trans. Joan Pinkham (New York: Meridian, 1994), 256.

7 Simon Dixon, *Catherine the Great* (New York: HarperCollins, 2009), 266.

8 Suzanne Massie, *Pavlovsk: The Life of a Russian Palace* (Little, Brown and Company, 1990), 39.

9 Montefiore, *Potemkin: Prince*, 274

10 Ibid., 275.

11 Ibid., 276.

12 Douglas Smith, ed. and trans., *Love & Conquest: Personal Correspondence of Catherine the Great and Prince Grigory Potemkin* (DeKalb: Northern Illinois University Press, 2004), 142.

13 Ibid., 153.

CHAPTER TWO: A ROSE WITHOUT THORNS

1 Tamara Talbot Rice, *Charles Cameron: Architectural Drawings and Photographs from the Hermitage Collection, Leningrad and Architectural Museum* (Moscow: The Arts Council, 1967), 21.

2 Marina Alexandrovna Flit, *Pavlovsk: the Palace and the Park*, vol. 1 (Paris: Gourcuff, 1993), 14.

3 Dmitry Shvidkovsky, *The Empress & the Architect: British Architecture and Gardens at the Court of Catherine the Great* (New Haven, CT: Yale University Press, 1996), 123–24.

4 Flit, *Pavlovsk*, 41.

5 Shvidkovsky, *Empress*, 148.

6 Ibid.

7 Isabel de Madariaga, *Russia in the Age of Catherine the Great* (London: Phoenix Press, 2002), 356.

8 Flit, *Pavlovsk*, 37.

9 Ibid., 25.

10 Ibid., 49.

11 Dmitry Shvidkovsky, *Russian Architecture and the West* (New Haven, CT: Yale University Press, 2007), 286.

12 Ibid.

CHAPTER THREE: THE MASTER OF NEUWIED

1 Isabella Forbes and William Underhill eds. *Catherine the Great: Treasures of Imperial Russia from the State Hermitage Museum* (London: Booth-Clibborn Editions, 1990), 189.

2 George Vilinbakhov and Magnus Olausson, *Catherine the Great & Gustav III* (Stockholm: Nationalmuseum; St. Petersburg: State Hermitage Museum, 1998), 510.

3 Madariaga, *Catherine the Great*, 533.

4 Forbes and Underhill, *Catherine the Great: Treasures*, 190.

5 Hans Huth, *Roentgen Furniture: Abraham and David Roentgen, European Cabinet-makers* (n.p.: Sotheby Parke Bernet, 1974), 3.

6 Antoine Cheneviere, *The Golden Age of Russian Furniture, 1780–1850* (New York: Vendome Press, 1988), 74.

7 Ibid.

8 Ibid., 76.

9 Mikhail B. Piotrovsky, *The Legacy of Catherine the Great* (Melbourne: National Gallery of Victoria, 2015), 12.

10 Carolyn Sargentson, "Reading, Writing, and Roentgen" (paper presented at "Extravagant Inventions—the Princely Furniture of the Roentgens" exhibition, The Metropolitan Museum of Art, New York, November 18, 2012).

11 Oleg Neverov, *Great Private Collections of Imperial Russia* (London and New York: Thames & Hudson, 2004), 80.

12 Evgenii V. Anisimov, *Five Empresses: Court Life in Eighteenth Century Russia*, trans. Kathleen Carroll (Westport, CT: Praeger, 2004), 336.

13 Charles Francois Philibert Masson, *Secret Memoirs of the Court of Petersburg*, 2nd ed. (London: TN. Longman & O. Rees, 1801), 91.

14 Wolfram Koeppe, "Gone with the Wind to the Western Hemisphere—Selling off Furniture by David Roentgen and Other Decorative Arts of the Eighteenth Century," *Canadian American Slavic Studies* 43 (2009): 251.

CHAPTER FOUR: AN ACCIDENTAL MICHELANGELO

1 Neverov, *Great Private Collections*, 57.

2 Magnus Olausson and Solfrid Soderlind, "Nationalmuseum/Royal Museum, Stockholm: Connecting North and South," *The First Modern Museums of Art: The Birth of an Institution in 18th- and Early 19th-Century Europe*, ed. Carole Paul (Los Angeles: The J. Paul Getty Museum, 2012), 193.

3 Ibid., 195.

4 James Harper, *Art in Rome in the Eighteenth Century* (Philadelphia: Philadelphia Museum of Art, 2000), 276.

5 Oleg Neverov, "The Lyde Browne Collection and the History of Ancient Sculpture in the Hermitage Museum," *American Journal of Archeology* 88 (1984): 39.

6 Jonathan Scott, *The Pleasures of Antiquity: British Collections of Greece of Rome* (New Haven, CT: Yale University Press, 2003), 138.

7 Andrew Moore, ed., *Houghton Hall: The Prime Minister, the Empress and the Heritage* (London: Philip Wilson, 1996), 62.

8 Gerard Vaughan, "James Hugh Smith Barry as a Collector of Antiquities," *Apollo* 126 (1987): 6.

9 Ilaria Bignamini and Clare Hornsby, *Digging and Dealing in Eighteenth Century Rome* (New Haven, CT: Yale University Press, 2010), 245.

10 Maria Dolores Sanchez-Jauregui and Scott Wilcox, eds., *The English Prize: The Capture of the Westmorland* (New Haven, CT: Yale University Press, 2012), 73.

11 Bignamini and Hornsby, *Digging*, 244.

12 Neverov, "The Lyde Browne Collection," 40.

13 Johannes Wilde, *Michelangelo and His Studio: Italian Drawings in the Department of Prints and Drawings in the British Museum* (London: British Museum, 1953), 54.

14 Johannes Wilde, *Michelangelo: Six Lectures*, eds. John Shearman and Michael Hirst (Oxford: Clarendon Press, 1978), 127.

15 Galina Stolyarova, "Renaissance Man: The Genius of Michelangelo Seen in a New Light," *Petersburg City*, July 20, 2007, http://petersburgcity.com/news/culture/2007/07/20/David/html.

16 William Wallace, *Michelangelo: the Complete Sculpture, Painting, Architecture* (Fairfield, CT: Hugh Lauter Levin Associates, 1998), 114.

17 William Wallace, e-mail message to author, August 20, 2014.

18 Shvidkovsky, *The Empress*, 101.

19 Neverov, *Great Private Collections*, 22.

CHAPTER FIVE: SLINGS AND ARROWS

1 Oleg Neverov, "Catherine the Great: Public and Private Collector," *The British Art Journal* 2 (2000): 123.

2 H. H. Arnason, *The Sculptures of Houdon* (Oxford: Oxford University Press, 1975), 43.

3 Kimberly Chrisman-Campbell, "Getting Technical: Shedding New Light on Two Masterpieces of 18th-Century Sculpture," *Huntington Frontiers*, The Huntington Library, Art Collections, and Botanical Gardens (Spring/Summer 2008): 8–9.

4 Guilhem Scherf, *Cast in Bronze: French Sculpture from Renaissance to Revolution* (Paris: Musee du Louvre editions, 2009), 476.

5 Montefiore, *Potemkin*, 353.

6 Dixon, *Catherine*, 271.

7 Montefiore, *Potemkin*, 356.

8 Rounding, *Catherine*, 411.

9 William Craft Brumfield, *Landmarks of Russian Architecture: A Photographic Survey* (Gordon and Breach Publishers, 1997), 172.

10 Rounding, *Catherine*, 412.

11 Shvidkovsky, *Russian Architecture*, 281.

12 William Craft Brumfield, *Lost Russia: Photographing the Ruins of Russian Architecture* (Durham, NC: Duke University Press, 1995), 71.

13 Rounding, *Catherine*, 413.

14 Montefiore, *Potemkin*, 353.

15 Ibid., 355.

16 Montefiore, *Potemkin*, 322.

CHAPTER SIX: BABY HERCULES

1 Rounding, *Catherine*, 415.

2 Bondil, *Art for Empire*, 173.

3 Montefiore, *Catherine the Great's Imperial Partner*, 307.

4 Oleg Neverov and Mikhail Piotrovsky, *The Hermitage: Essays on the History of the Collection* (St. Petersburg: Slavia Art Books, 1997), 24.

5 Montefiore, *Potemkin*, 307.

6 Chauncey Brewster Tinker, *Painter and Poet: Studies in the Literary Relations of English Painting* (Cambridge MA: Harvard University Press, 1939), 64.

7 Dixon, *Catherine*, 103.

8 John Ingamells and John Edgcumbe eds., *The Letters of Sir Joshua Reynolds* (New Haven, CT: Yale University Press, 2000), 158.

9 Tinker, *Painter and Poet*, 61–62.

10 Algernon Graves and William Vine Cronin, *A History of the Works of Sir Joshua Reynolds, P.R.A.* vol. 4 (Henry Graves and Co, 1901): 1139 (April 30 1789)

11 Tinker, *Painter and Poet*, 65.

12 Allen and Dukelskaya, *British Art Treasures*, 43.

13 Anthony Cross ed., *Engraved in the Memory: James Walker, Engraver to the Empress Catherine the Great and His Russian Anecdotes* (Oxford: Berg, 1993), 146–47.

14 Graves and Cronin, *History*, 1139.

15 Ingamells and Edgcumbe, *Letters*, 211.

PART SEVEN: WAR AND REVOLUTION

CHAPTER ONE: CENTER STAGE

1 Lurana Donnels O'Malley, *The Dramatic Works of Catherine the Great: Theatre and Politics in Eighteenth-Century Russia* (Hants, England, and Burlington, VT: Ashgate, 2006), 8.

2 Virginia Rounding, *Catherine the Great: Love, Sex, and Power* (London: St Martin's Griffin, 2006), 415.

3 Piervaleriano Angelini, A. Bettagno, G. Mezzanotte, F. Rossi, and C. Zanella. *Giacomo Quarenghi: Architetture e Vedute* (Milan: Electa, 1994), 70.

4 Banister F. Fletcher, *Andrea Palladio: His Life and Works* (London: George Bell and Sons, 1902), 31.

5 Vladimir Matveyev, ed., *The Hermitage: Selected Treasures from a Great Museum* (London: Booth-Clibborn Editions, 1996), 13.

6 O'Malley, *Dramatic Works*, 1.

7 Ibid.

8 Rounding, *Catherine*, 416.

9 Ibid., 417.

10 Suzanne Massie, *Pavlovsk: The Life of a Russian Palace* (Boston: Little, Brown and Company, 1990), 456.

11 Rounding, *Catherine*, 419.

CHAPTER TWO: CAMEO FEVER

1 Oleg Neverov, *Great Private Collections of Imperial Russia* (London and New York: Thames & Hudson, 2004), 24.

2 Oleg Neverov, *Antique Intaglios in the Hermitage Collection* (St. Petersburg: Aurora Art Publishers, 1976), 6.

3 Oleg Neverov, *Antique Cameos in the Hermitage Collection* (St. Petersburg: Aurora Art Publishers, 1971), 56.

4 Militsa Korshunova, "Peter the Great's St. Petersburg," in *Peter the Great: An Inspired Tsar* (Amsterdam: Hermitage Amsterdam, 2013), 128–29.

5 Oleg Neverov, "Gems from the Collection of Princess Dashkov," *Journal of the History of Collections* 2 (1990): 66.

6 Antoine Chenevière, *The Golden Age of Russian Furniture, 1780-1850* (New York: Vendome Press, 1988), 76.

7 *The Collections of the Romanovs: European Art from the State Hermitage* (London and New York: Merrell), 165.

8 Frank Althaus and Mark Sutcliffe, eds., *The Triumph of Eros: Art and Seduction in 18th-Century France* (London: Fontanka, 2006), 95.

9 George Vilinbakhov and Magnus Olausson, *Catherine the Great & Gustav III* (Stockholm: Nationalmuseum; Saint Petersburg: State Hermitage Museum, 1998), 309.

10 Elena Dmitrieva, "On the Formation of the Collection of Gem Impressions in the State Hermitage Museum," *Journal of the History of Collections* 25 (2013): 81.

11 Isabella Forbes and William Underhill, eds., *Catherine the Great: Treasures of Imperial Russia from the State Hermitage Museum* (London: Booth-Clibborn Editions, 1990), xix.

12 Ibid., 11.

CHAPTER THREE: RUSSIA'S PARADISE

1 Richard S. Wortman, *Scenarios of Power: Myth and Ceremony in Russian Monarchy Vol. 1 & 2* (Princeton, NJ: Princeton University Press, 1995), 136–37.

2 Robert K. Massie, *Catherine the Great* (New York: Random House, 2011), 490.

3 Isobel Rae, *Charles Cameron: Architect to the Court of Russia* (London: Elek Books, 1971), 63.

4 Massie, *Catherine*, 493.

5 Larry Wolff, *Inventing Eastern Europe: The Map of Civilization on the Mind of the Enlightenment* (Stanford, CA: Stanford University Press), 1994.

6 Wortman, *Scenarios*, 139.

7 Ibid., 140.

8 Vilinbakhov, *Catherine & Gustav*, 93.

9 Wolff, *Inventing*, 130.

10 Massie, *Catherine*, 496.

11 Simon Sebag Montefiore, *The Prince of Princes: The Life of Potemkin* (London: Weidenfeld & Nicolson, 2000), 400.

12 Wolff, *Inventing*, 133.

13 Massie, *Catherine*, 499.

14 Ibid.

15 Andreas Schönle, "Garden of the Empire: Catherine's Appropriation of the Crimea," *Slavic Review* 60 (2001): 21.

16 Douglas Smith, ed. and trans. *Love & Conquest: Personal Correspondence of Catherine the Great and Prince Grigory Potemkin* (DeKalb: Northern Illinois University Press, 2004), 178.

17 Wolff, *Inventing*, 130.

18 Schönle "Garden," 23.
19 Smith, *Love & Conquest*, 179.
20 Alexander von Solodkoff, *Russian Gold and Silver*, trans. Christopher Holme (London: Trefoil Books, 1981), 157.
21 Forbes and Underhill, *Treasures of Imperial Russia*, 192.

CHAPTER FOUR: BETRAYALS

1 O'Malley, *Dramatic Works*, 115.
2 Isabel de Madariaga, *Russia in the Age of Catherine the Great* (London: Phoenix Press, 2002), 401.
3 O'Malley, *Dramatic Works*, 188.
4 Simon Sebag Montefiore, *Potemkin: Catherine the Great's Imperial Partner* (New York: First Vintage Books, 2005), 422.
5 Smith, *Love*, 291.
6 Ibid., 293.
7 Massie, *Catherine*, 457.
8 Smith, *Love*, 297.
9 Charles Francois Philibert Masson, *Secret Memoirs of the Court of Petersburg* (New York: Arno Press and the New York Times, 1970), 45.
10 Ibid., 52.
11 Massie, *Catherine*, 414.
12 Smith, *Love*, 299.
13 John Parkinson, *A Tour of Russia, Siberia and the Crimea 1792–1794*, ed. William Collier (London: Cass, 1971), 78.

CHAPTER FIVE: FRENCH MADNESS

1 Rounding, *Catherine*, 450.
2 Montefiore, *Imperial Partner*, 424.
3 Montefiore, *Prince*, 487.
4 Rounding, *Catherine*, 454.
5 Smith, *Love*, 326.
6 Rounding, *Catherine*, 454.
7 Thomas Ria, ed., *Readings in Russian Civilization, Volume 2: Imperial Russia, 1700–1917* (Chicago: University of Chicago Press, 1969), 263.
8 Antonia Fraser, *Marie Antoinette: The Journey* (New York: First Anchor Books, 2002), 308.

CHAPTER SIX: CURTAIN CALL

1 J. Goodwin, *Lords of the Horizons* (New York: Henry Holt and Company, 1998), 244.
2 George Levitine, *The Sculpture of Falconet* (New York: New York Graphic Society Ltd., 1972), 21.
3 Simon Dixon, *Catherine the Great* (New York: HarperCollins, 2009), 307.
4 William Craft Brumfield, *Gold in Azure: One Thousand Years of Russian Architecture* (Boston: David R. Godine, Inc., 1983), 287.
5 Dmitry Shvidkovsky, *Russian Architecture and the West*, photographs by Yekaterina Shorban; trans. Antony Wood (New Haven, CT: Yale University Press, 2007), 266.
6 Brian Allen, and Larissa Dukelskaya, eds., *British Art Treasures from Russian Imperial Collections in the Hermitage* (New Haven, CT: Yale University Press, 1996), 133.
7 Shvidkovsky, *Russian Architecture*, 267.
8 Neverov, *Great Private Art Collections*, 66.

9 Thomas Raikes, *A Visit to St. Petersburg in the Winter of 1829–30*, http://stpetersburgrussia
.ru/Architecture/tauride_tavrichesky_palace_st_petersburg_russia.

10 Montefiore, *Prince*, 520.

11 Raikes, *A Visit*.

12 Rounding, *Catherine*, 317.

13 Geraldine Norman, *The Hermitage: The Biography of a Great Museum* (London: Pimlico, 1997), 44.

14 Montefiore, *Prince*, 522.

15 Ibid., 523.

16 Mikhail B. Piotrovsky, *The Legacy of Catherine the Great* (Melbourne: National Gallery of Victoria, 2015), 17.

PART EIGHT: REACTION

CHAPTER ONE: TEARS AND DESPAIR

1 Simon Sebag Montefiore, *The Prince of Princes: The Life of Potemkin* (London: Weidenfeld & Nicolson, 2000), 366.

2 Ibid., 532.

3 Virginia Rounding, *Catherine the Great: Love, Sex, and Power* (London: St Martin's Griffin, 2006), 462.

4 Anthony Lentin, ed. and trans., *Voltaire and Catherine the Great: Selected Correspondence* (Cambridge, UK: Oriental Research Partners, 1974), 268.

5 Simon Dixon, *Catherine the Great* (New York: HarperCollins, 2009), 308.

6 Asen Kirin, *Exuberance of Meaning: The Art Patronage of Catherine the Great (1762–1796)* (Athens, GA: Georgia Museum of Art, University of Georgia, 2013), 95.

7 Ibid., 94.

8 Douglas Smith, ed. and trans. *Love & Conquest: Personal Correspondence of Catherine the Great and Prince Grigory Potemkin* (DeKalb: Northern Illinois University Press, 2004), 389.

9 Montefiore, *Prince*, 537.

10 Smith, *Love*, 390.

11 Ibid., 391.

12 Rounding, *Catherine*, 464.

13 Montefiore, *Prince*, 541.

14 Ibid.

15 Rounding, *Catherine*, 466.

16 Ibid., 467.

CHAPTER TWO: A TICKING CLOCK

1 John Parkinson, *A Tour of Russia, Siberia and the Crimea 1792–1794*, ed. William Collier (London: Cass, 1971), 23.

2 Dixon, *Catherine*, 308.

3 Vladislav Khodasevich, *Derzhavin: A Biography*, trans. Angela Brintlinger (Madison: University of Wisconsin Press, 2007), 160.

4 Adam Zamoyski, *Holy Madness: Romantics, Patriots, and Revolutionaries 1776–1871* (London: Weidenfeld & Nicolson, 1999), 84.

5 Robert K. Massie, *Catherine the Great* (New York: Random House, 2011), 554.

6 Dixon, *Catherine*, 309.

7 Rounding, *Catherine*, 469.

8 Dixon, *Catherine*, 305.
9 Oleg Neverov, *Great Private Collections of Imperial Russia* (London: Thames & Hudson, 2004), 69.
10 Wolfram Koeppe, "Gone with the Wind to the Western Hemisphere—Selling off Furniture by David Roentgen and Other Decorative Arts of the Eighteenth Century," *Canadian American Slavic Studies* 43 (2009): 246.
11 George Vilinbakhov and Magnus Olausson, *Catherine the Great & Gustav III* (Stockholm: Nationalmuseum; Saint Petersburg: State Hermitage Museum, 1998), 310.
12 *St. Petersburg Jewellers, 18th and 19th Centuries* (St. Petersburg: Slavia, 2000), 28.
13 Rounding, *Catherine*, 471.
14 Parkinson, *Tour*, 54.
15 Rounding, *Catherine*, 473.
16 Parkinson, *Tour*, 67.
17 Ibid., 73.
18 UPI.com, "Louis XVI's last words: 'I am innocent,'" http://www.upi.com/Top_News/2006/04/08/Louis-XVIs-last-words-I-am-innocent/44251144528127/.
19 Rounding, *Catherine*, 473.

CHAPTER THREE: WARSAW'S OURS
1 Vilinbakhov and Olausson, *Catherine & Gustav*, 139.
2 Massie, *Catherine*, 561
3 Parkinson, *Tour*, 54.
4 Khodasevish, *Derzhavin*, 161.
5 Parkinson, *Tour*, 44.
6 Rounding, *Catherine*, 474.
7 Ibid., 475.
8 Rounding. *Catherine*, 482.
9 Charles Francois Philibert Masson, *Secret Memoirs of the Court of Petersburg* (New York: Arno Press and the New York Times, 1970), 159.
10 Smith, *Love*, 393.
11 Massie, *Catherine*, 574.
12 Neverov, *Great Private Collections*, 24
13 Johann Gottlieb Georgi, *Description of the Imperial Russian Capital City of St Petersburg and the Sights in Its Environs* (St. Petersburg, 1794), 336.
14 Jay Winik, *The Great Upheaval: America and the Birth of the Modern World, 1788–1800* (New York: HarperCollins, 2007), 357.
15 Massie, *Catherine*, 558.
16 Dixon, *Catherine*, 309.
17 Massie, *Catherine*, 559.
18 Dixon, *Catherine*, 310.
19 Zamoyski, *Holy Madness*, 94.
20 Winik, *Great Upheaval*, 433.
21 Rounding, *Catherine*, 478.

CHAPTER FOUR: CATHERINE'S LIBRARY
1 Yelena Barkhatova, *The National Library of Russia, 1795–1995*, trans. Paul Williams (St. Petersburg: Liki Rossii, 1995), 11.

2 Dimitri Ozerkov, "Catherine II et les Loges de Volpato," in *Giovanni Volpato Les Loges de Raphael et la Galerie du Palais Farnese*, ed. Annie Gilet (2007), 83.
3 Kirin, *Exuberance*, 28.
4 Ibid., xxi.
5 Winik, *Great Upheaval*, 431–32.
6 Inna Gorbatov, "From Paris to St. Petersburg: Voltaire's Library in Russia," *Libraries & the Cultural Record* 42 (2007): 313–14.
7 Joana Pitman, *The Dragon's Trail: The Biography of Raphael's Masterpiece* (New York: Simon & Schuster, 2006), 189.
8 Frank T. Brechka, "Catherine the Great: The Books She Read," *The Journal of Library History* 4 (1969): 42.
9 Rounding, *Catherine*, 477.
10 Nicholas A. Basbanes, *A Splendor of Letters: The Permanence of Books in an Impermanent World* (New York: HarperCollins, 2003), 155.
11 Yelena Barkhatova, *The National Library of Russia, 1795–1995*, trans. Paul Williams (St. Petersburg: Liki Rossii, 1995), 12.
12 George Vilinbakhov and V. Fedorov, *Catherine the Great: An Enlightened Empress* (Edinburgh: National Museums of Scotland and NMS Enterprises, 2012), 59.

CHAPTER FIVE: QUEEN OF THE WORLD
1 Elisabeth Vigée Le Brun, *The Memoirs of Elizabeth Vigée-Le Brun*, trans. Sian Evans (London: Camden Press, 1988), 160.
2 Ibid., 169.
3 Nathalie Bondil, ed., *Catherine the Great: Art for Empire, Masterpieces from the State Hermitage Museum* (Montréal: Montréal Museum of Fine Arts; Gand, Belgium: Snoeck, 2005), 234.
4 Le Brun, *Memoirs*, 159.
5 Ibid., 172.
6 Ibid., 160.
7 Bondil, *Art for Empire*, 272–73.
8 Anthony Cross, ed., *Russia under Western Eyes 1517–1825* (London: Elek Books, 1971), 250–51.

CHAPTER SIX: JOINED IN DEATH
1 Rounding, *Catherine*, 483.
2 Parkinson, *Tour*, 75.
3 Rounding, *Catherine*, 484
4 Ibid., 485.
5 Parkinson, *Tour*, 48.
6 Piervaleriano Angelini and Vanni Zanella, *I disegni di Giacomo Quarenghi nella Civica biblioteca di Bergamo* [videorecording] (Bergamo: Osservatorio Quarenghi, 2008).
7 Nina L. Dubin, *Futures & Ruins* (Los Angeles: Getty Research Institute, 2010), 153. (The Louvre acquired the pendants in 1975.)
8 Isabel de Madariaga, *Russia in the Age of Catherine the Great* (London: Phoenix Press, 2002), 576.
9 Massie, *Catherine*, 570.
10 Ibid., 571.
11 Simon Dixon, "The Posthumous Reputation of Catherine II in Russia 1979–1837," *The Slavonic and East European Review* 77 (1999): 651.

12 Dixon, *Catherine*, 318.
13 Ibid.
14 Henri Troyat, *Catherine the Great*, trans. Joan Pinkham (New York: Meridian, 1994), 352.
15 Rounding, *Catherine*, 504.

PART NINE: LEGACY

CHAPTER ONE: A SON'S REVENGE

1 Vladislav Khodasevich, *Derzhavin: A Biography*, trans. Angela Brintlinger (Madison: University of Wisconsin Press, 2007), 161.
2 Hugh Ragsdale, *Tsar Paul and the Question of Madness* (Westport, CT: Greenwood Press, 1988), 112.
3 Ibid., 90.
4 Dmitry Shvidkovsky, *Russian Architecture and the West*, photography Yekaterina Shorban; trans. Antony Wood (New Haven, CT: Yale University Press, 2007), 286.
5 Zoia Belyakova, *The Romanov Legacy: the Palaces of St. Petersburg*, ed. Marie Clayton (New York: Viking Studio Books, 1995), 78.
6 Robert Nisbet Bain, *The Last King of Poland and His Contemporaries* (London: Methuen, 1909), 174.
7 Ian Wardropper, *From the Sculptor's Hand: Italian Baroque Terracottas from the State Hermitage Museum* (Chicago: Art Institute of Chicago, 1998), 6.
8 Inna Gorbatov, *Catherine the Great and the French Philosophers of the Enlightenment: Montesquieu, Voltaire, Rousseau, Diderot and Grimm* (Bethesda, MD: Academica Press, 2006), 103.
9 Simon Dixon, "The Posthumous Reputation of Catherine II in Russia 1797–1837," *The Slavonic and East European Review* 77 (1999): 649.

CHAPTER TWO: ART-LOVING GRANDSONS

1 Ibid., 660.
2 Asen Kirin, *Exuberance of Meaning: The Art Patronage of Catherine the Great (1762–1796)* (Athens, GA: Georgia Museum of Art, University of Georgia, 2013), 18.
3 Inna Gorbatov, "From Paris to St. Petersburg: Voltaire's Library in Russia," *Libraries & the Cultural Record* 42 (2007): 318.
4 David King, *Vienna, 1814* (New York: Random House, 2008), 24.
5 Dixon, "Posthumous," 662.
6 Ibid.
7 W. Bruce Lincoln, *Sunlight at Midnight: St. Petersburg and the Rise of Modern Russia* (New York: Basic Books, 2012), 86.
8 King, *Vienna*, 98.
9 Nina Siegal, "In Amsterdam, a Tale of Wars, Friendship and Loves Lost," *New York Times*, June 17, 2015, http://www.nytimes.com/2015/06/18/arts/international/alexander-napoleon-josephine-hermitage-amsterdam-a-tale-of-wars-friendship-and-loves-lost.html.
10 Natalya Gritsay and Natalya Babina. *Seventeenth- and Eighteenth-Century Flemish Painting, State Hermitage Museum Catalogue* (New Haven, CT, and London: Yale University Press, 2008), 452.
11 Oleg Yawein, *The Hermitage XXI: The New Art Museum in the General Staff Building*, ed. Georgi Stanishev with contributions by Mikhail Piotrovsky et al.; photography by Will Pryce (London: Thames & Hudson, 2014), 28.
12 C. M. Kauffmann, revised by Susan Jenkins with contributions from Marjorie E.

Wieseman, *Catalogue of Paintings in the Wellington Museum* (Apsley House English Heritage and Paul Holberton, 2009), 17.

13 King, *Vienna*, 4.

14 Ibid., 26.

15 Barbara Maranzani, "5 Romanovs You Should Know," *history.com*, Feb. 21, 2013. http://www.history.com/news/5-romanovs-you-should-know.

16 Dixon, "Posthumous," 666.

17 Oleg Neverov, *Great Private Collections of Imperial Russia* (London: Thames & Hudson, 2004), 80. (Levitsy's portrait is now at the Tretyakov Gallery, Moscow.)

18 Yawein, *Hermitage XXI*, 35.

19 Richard S. Wortman, *Scenarios of Power: Myth and Ceremony in Russian Monarchy*, vols. 1 & 2 (Princeton, NJ: Princeton University Press, 1995), 316.

20 *The State Hermitage Guide*, eds. Irina Kharitonova and Irina Lvova (St. Petersburg: P-2 Art Publishers, 2010), 13.

21 Neverov, *Great Private Collections*, 25.

22 Robert C. Williams, *Russian Art and American Money* (Cambridge, MA, and London: Harvard University Press, 1980), 152.

23 Olga Neverov and Dmitry Pavlovich Alexinsky, *The Hermitage Collections: Volume I: Treasures of World Art* (New York: Rizzoli, 2010), 29.

24 Irene Pearson, "Raphael as Seen by Russian Writers from Zhukovsky to Turgenev," *The Slavonic and East European Review* 59 (1981): 347.

25 Neverov and Alexinsky, *The Hermitage: Treasures of World Art*, 24.

26 Ibid., 36.

27 Irina Artemieva, "The Sources of Italian Renaissance Paintings in the Hermitage," in *Florence and Venice: Italian Renaissance Paintings and Sculpture from the State Hermitage Museum*, ed. Kokuritsu Seiyo Bijutsukan (Tokyo: National Museum of Western Art, 1999), 241.

28 Gritsay and Babina, *Seventeenth- and Eighteenth-Century Flemish Painting*, 481.

29 Neverov and Alexinsky, *The Hermitage: Treasures of World Art*, 39.

30 Rosalind Polly Gray, *Russian Genre Painting in the Nineteenth Century* (Oxford: Oxford University Press, 2000), 19.

31 Irina Sokolova, "Hermitage: Known and Unknown" (paper presented at the International CODART Symposium, Rijksmuseum Amsterdam, October 14–15, 2013).

32 Neverov and Alexinsky, *The Hermitage: Treasures of World Art*, 31.

CHAPTER THREE: THE END OF THE LINE

1 Gorbatov, *Catherine*, 105.

2 Mikhail B. Piotrovsky, *The Legacy of Catherine the Great* (Melbourne: National Gallery of Victoria, 2015), 11.

3 Wortman, *Scenarios*, vol. 2, 120.

4 Ibid., 126.

5 Wortman, *Scenarios*, vol. 2, 127.

6 Ibid., 128.

7 Gray, *Russian Genre Painting*, 26.

8 Natalya Semyonova and Nicolas V. Iljine, eds., *Selling Russia's Treasures* (New York: Abbeville Press, 2013), 350.

9 Anne Odom, *What Became of Peter's Dream?* (Middlebury College Museum of Art in association with Hillwood Museum & Gardens, 2003), 17.

10 Scott Reyburn, "Who's Rich Enough for a Picasso?" *The New York Times*, June 12, 2015. http://www.nytimes.com/2015/06/15/arts/international/whos-rich-enough-for-a-picasso .html?_r=0.

11 Anne Odom and Wendy R. Salmon, eds., *Treasures into Tractors: The Selling of Russia's Cultural Heritage, 1918–1938* (Washington, DC: Hillwood Museum & Gardens, University of Washington Press, 2009), 9.

12 Ibid., 11.

13 Catherine Merridale, *Red Fortress: History and Illusion in the Kremlin* (London: Picador, 2013), 297.

14 Ibid., 39.

15 Ibid., 42.

16 Odom and Salmond, *Treasures*, 276.

17 Ibid., 283.

CHAPTER FOUR: RAIDING THE HERMITAGE

1 Ibid., 16.

2 Rona Goffen, *Museums Discovered: The Calouste Gulbenkian Museum* (New York: New York Graphic Society, 1982), 4.

3 Semyonova and Iljine, *Selling Russia's Treasures*, 263.

4 Goffen, *Museums Discovered*, 3.

5 John Walker, *Self-Portrait with Donors; Confessions of an Art Collector* (Boston: Little, Brown and Company, 1974), 132.

6 David Cannadine, *Mellon: An American Life* (New York: Knopf, 2006), 425.

7 Semyonova and Iljine, *Selling Russia's Treasures*, 138.

8 Ibid., 141.

CHAPTER FIVE: PRESERVATION

1 Anna Reid, *Leningrad: The Epic Siege of World War II, 1941–1944* (New York: Walker & Co, 2011), introduction.

2 Nina Vernova et al., *The Imperial Residences around Saint Petersburg: Peterhof, Tsarskoye Selo, Pavlovsk, Oranienbaum, Gatchina*, trans. Paul Williams (St. Petersburg: Alfa-Colour Art Publishers, 2003), 230.

3 Audrey Kennett and Victor Kennett, *The Palaces of Leningrad* (London and New York: Thames & Hudson, 1973), 243.

4 Will Black, "Tsarist Treasures Reborn," *World Monument Fund* (Spring 2003).

5 Rem Koolhaas, "The Hermitage: Masterplan 2014," www.oma.eu/lectures/ the-hermitage-masterplan-2014/.

6 Jordana Pomeroy et al., *Women Artists from the State Hermitage Museum* (London: Merrell, 2003), 17.

7 Elisabeth Vigée-Le Brun, *The Memoirs of Elisabeth Vigée-Le Brun*, trans. Siân Evans (London: Camden Press, 1989), 158.

8 Nathalie Bondil, ed., *Catherine the Great: Art for Empire, Masterpieces from the State Hermitage Museum* (Montréal: Montréal Museum of Fine Arts; Gand, Belgium: Snoeck, 2005), 176.

ACKNOWLEDGMENTS

I am very grateful to everyone who helped me with this book. On Catherine the Great's trail in St. Petersburg, Sergey Fedorov was an invaluable, knowledgeable guide—from visiting the restored Agate Pavilion at Tsarskoe Selo and off-the-beaten-path Chesme Church to navigating the vast Hermitage Museum in search of Catherine's artworks.

I owe a large debt of gratitude to the scholarship of many biographers and historians, most notably Anthony Cross, Simon Dixon, Robert K. Massie, Simon Sebag Montefiore, and Virginia Rounding. Dmitry Schvidkovsky's elegant books along with Oleg Neverov's illustrated studies were key to understanding Catherine's passions for architecture and carved gems.

Special thanks to Asen Kirin, Associate Professor of Art at the University of Georgia. His beautiful exhibition and catalogue "Exuberance of Meaning: The Art Patronage of Catherine the Great" inspired me in the early stages of this book; his continued encouragement is greatly appreciated. I also wish to thank William E. Wallace, Professor of Art History at Washington University in St. Louis, for his insights on Michelangelo's *Crouching Boy*.

I've had the privilege to do research in many outstanding libraries and archives including Hillwood Museum & Gardens, Washington, D.C., the

449

University of California, Los Angeles; the Getty Research Institute, Los Angeles; and the National Gallery of Art, Washington, D.C. I'd especially like to thank Ross Garcia and Jane Mandel at the Getty and Anne Halpern at the NGA's Department of Curatorial Records for their support.

For their assistance with images, a special thank you to Ruth Cousineau, Margaret Huang at Hillwood Museum & Gardens, Kristen Regina and Giema Tsakuginow at the Philadelphia Museum of Art, and Sarah Carter at the Chipstone Foundation. For their help with translations, I am most grateful to Alex Wolfe, Claudia Medl-Rilling, and Tiziana Serafini.

My thanks also go to my agent, Alice Martell, for her enthusiasm for this project from start to finish. I feel very fortunate to have worked with my editor, Jessica Case, at Pegasus Books. Jessica's talent and knowledge of Russian history added greatly to the book. I would also like to express my sincere appreciation to Mary Hern, Derek Thornton at FaceOut Studios for the cover design, and Maria Fernandez for her photo insert.

Last but not least, this book would not have been possible without my beloved family—Jon, Jasmine, Clara, Grace, Jack, and Doug.

Susan Jaques
November, 2015

INDEX